MW01070063

STEVEN SPIELBERG
ALL THE FILMS

The Story Behind Every Movie, Episode, and Short

STEVEN SPIELBERG ALL THE FILMS

The Story Behind Every Movie, Episode, and Short

Olivier Bousquet, Arnaud Devillard, and Nicolas Schaller

BLACK DOG
& LEVENTHAL
PUBLISHERS
NEW YORK

Contents

Spielberg sitting on Bruce, the animatronic
shark, on the set of *Jaws* in 1974.

Preface

George Miller

Steven Spielberg first came into my consciousness when I saw his film *Duel* (1971), about a man driving across America being pursued by an unseen driver in big malevolent tanker truck. I was interested in the evolution of film language and, in Steven's work, I saw the syntax honed by the silent master Buster Keaton in his film *The General* (1926) and in dynamic action sequences like the chariot race in *Ben-Hur* (1959).

When a few years later, I made my first feature, *Mad Max*, I quoted an image directly from *Duel*. Steven, meanwhile, had gone on to astound us with *Jaws, Sugarland Express, Close Encounters of the Third Kind*, and *Raiders of the Lost Ark*. It seemed to me he had an innate understanding that cinema is a series of images—pieces of time—orchestrated into visual music. As fate would have it, we met in his office at Universal after he saw *Mad Max 2*. He was playing with two Spaniel puppies while fielding troubled phone calls about *Poltergeist*, which he had written and produced but not directed. Someone arrived with a VHS tape of a trailer of another movie he had just completed. I was struck by how it promised something unique and deeply touching. The film happened to be *E.T.* He remarked that it was a small film he had enjoyed making and that he hoped it would find its audience. He made a couple of notes on the trailer and casually went back to the worried phone calls. When things settled down, he said that he, John Landis, and Joe Dante were about to make an anthology movie based on episodes of Rod Serling's *Twilight Zone*. He invited me to join them with an additional episode. So I found myself working at the Warner Bros. Burbank studios inside the Hollywood system.

In the company of like-minded filmmakers, I felt completely at home. I had the good fortune to work with the crew that had just completed *E.T.*—the wonderful cameraman Allen Daviau; his operator John Toll, also to become a great cinematographer; the polymath Garrett Brown, the Steadicam inventor; and producers Kathy Kennedy and Frank Marshall. With John Lithgow playing the lead character and Jerry Goldsmith composing the score, I was in movie-maker paradise. When I had finished shooting my episode, the crew went on to shoot Steven's. It happened that his wife was due to give birth. So on the last few days of the shoot, he invited me onto his set to watch what he was up to in case he had to run off to be present at the delivery.

Film sets can be stressful. There is footage of an interview in which Stanley Kubrick says, "I believe Steven Spielberg summed it up about as profoundly as you can. He thought the most difficult and challenging thing about directing a film was getting out of the car. I'm sure you all know the feeling." I believe he was referring to the unpredictable nature of the work ahead. Steven showed none of that. I saw someone completely at ease in the intense, sometimes chaotic milieu of the set. Knowing precisely what was required of the camera, the cast, the lighting, and all else that goes into the making of a scene. He was focused, calm, creatively agile, and never insisted on his status. If you know the African American fable of Brer Rabbit, Steven Spielberg on a movie set was like Brer Rabbit in the briar patch.

In the end, the production of the *Twilight Zone* was struck by a most horrific tragedy. While we shot at Warner, John Landis was shooting his story on the Universal backlot. The last shot of the sequence was set at night. The lead actor, Vic Morrow, was running through a swamp being chased by a helicopter. He was holding two child actors when the helicopter crashed onto them. The three died instantly. As things happen, one year later, almost to the day, my producing partner Byron Kennedy was killed in a helicopter crash while on a routine flight.

In time, Steven inadvertently had another big influence on me. I had read a children's book by a farmer, Dick King Smith. It was about a talking pig named Babe. I felt strongly that the best way to render this particular story was as live action with real animals. We had to wait a few years for the digital dispensation and CGI to make the animals talk. Once again Steven led the way. Universal Studios was about to release *Jurassic Park* (1993) and knew how epochal this new technological shift could be, so they were happy to greenlight *Babe* (1995) when other, less aware studio heads were reluctant. To be successful, one needs confidence. To be great, one needs to be humble. Steven's humility is evidenced by his unflagging curiosity. Most, having accomplished his body of work, might have succumbed to hubris and, claiming mastery, foreclosed on further learning. But Steven has a virtuous habit. He tries to apprehend why something works rather than point out why it doesn't. Finding the blemishes, seeing why something doesn't work, can be useful. But it is far more difficult to recognize and articulate why something works comprehensively. Steven is still hungry for that understanding.

This, along with all else, keeps giving humankind the gift of Spielberg movies.

Steven Before Spielberg 1946–1968

"I can always trace a movie idea back to my childhood." [1]

Steven Spielberg

PROLOGUE

February 1945: In Cincinnati, Ohio, Arnold Spielberg and Leah Posner, two Cincinnati natives from Jewish families with Ukrainian, Russian, and Polish roots, were married. Arnold served as a radio operator during the fighting against the Japanese in British India, then as a communications officer for the 290th Bomber Squadron. After running a few B-25 missions in Burma, he stayed on the ground most of the time and used his outstanding radio and electronic skills. He ended the war at Wright Field in Ohio.

August 1945: On the 6th and 9th, respectively, two American atomic bombs annihilated the Japanese cities of Hiroshima and Nagasaki. Japan surrendered on the 15th.

Second World War: *1941* (1979), *Empire of the Sun* (1987), *Saving Private Ryan* (1998), the miniseries *Band of Brothers* (2001), the documentary miniseries *Five Came Back* (Laurent Bouzereau, 2017)
Bomber: "The Mission" (episode from *Amazing Stories*, 1985), *Empire of the Sun*, *Always* (1989)
Radio Transmission: *E.T. the Extra-Terrestrial* (1982)
Atomic Bomb: *Empire of the Sun*, *Indiana Jones and the Kingdom of the Crystal Skull* (2008), *Bridge of Spies* (2015)

December 18, 1946

Steven Allan Spielberg came into the world at 4:16 p.m. at the Cincinnati Jewish Hospital. The Spielberg family lived in an apartment at 817 Lexington Avenue, in the Jewish community of the Avondale neighborhood of Cincinnati.

As an avid reader of the magazine *Amazing Stories*, and an inveterate handyman, Arnold Spielberg discovered a passion for the radio between the ages of nine and ten. He would be the inspiration for a large number of inventor characters and gadget and high-tech enthusiasts in his son's films (*The Goonies, Gremlins, Back to the Future*, etc.). When he was demobilized, Arnold enrolled at university and worked for a company making televisions.

Leah graduated in domestic science at the University of Cincinnati. As a music conservatory trained pianist, she abandoned her ambitions to become a concert pianist in order to bring up her children. Three daughters followed Steven: Anne, on December 25, 1949; Sue, on December 4, 1953; and Nancy, on June 7, 1956.

From an early age, Steven Spielberg was immersed in stories of the Jewish genocide. The Avondale

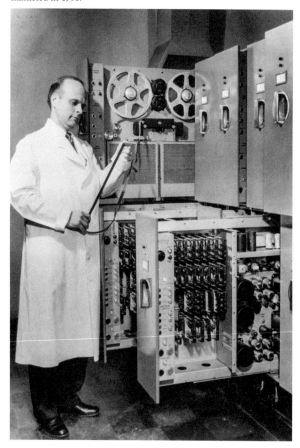

Arnold Spielberg was one of the designers of the RCA BIZMAC computer, shown here with project leader J. Wesley Leas and first marketed in 1956.

before his twenty-first birthday (at the time, the age of majority in California). The secret of Spielberg's real age was ultimately revealed in the press in 1995.

1949

The Spielberg household acquired a DuMont television set. Fascinated by the set, Steven would have to conform, over the years, to what his parents allowed him to watch (comedian Sid Caesar's shows) and what they forbid him to watch (TV series *Dragnet* or *M Squad*).

Television Set: *Close Encounters of the Third Kind, Poltergeist* (Tobe Hooper, 1982), *E.T. the Extra-Terrestrial, The Terminal* (2004), *Munich* (2005), *The Fabelmans* (2022)

June 1949

Having just graduated from the University of Cincinnati with a degree in electronic engineering, Arnold Spielberg was hired at RCA in Camden, New Jersey. His work led him to become involved in the design of one of the first American computers, the RCA BIZMAC.

The Spielberg family moved from Ohio to Camden, where they lived at 219 South 29th Street. This first move was not a good experience for the two-and-a-half-year-old Steven. The moves that followed would only amplify his feeling of being uprooted and abandoned.

New Jersey: *War of the Worlds, A.I. Artificial Intelligence,* filming of *West Side Story* (2021), *The Fabelmans*
Moving House: *Catch Me If You Can* (2002)

January 10, 1952

Cecil B. DeMille's *The Greatest Show on Earth* is released in theaters. This was the first film that Steven Spielberg saw in the cinema, with his father, at the Westmont Theater in Haddon Township. Although he was disappointed not to be attending a real circus show, the film's scenes featuring a train crash, lions, and Jimmy Stewart dressed as a clown nevertheless made an impression on young Spielberg. He asked his father to buy him some electric trains so he could re-create the crash sequence from the film. Exhausted by constantly having the trains repaired, Arnold Spielberg eventually demanded that his son stop re-creating the scene.

Circus: *Indiana Jones and the Last Crusade* (1989)
Electric Train Set: *Close Encounters of the Third Kind,*
E.T. the Extra-Terrestrial, "Ghost Train" (episode from *Amazing Stories*, 1985), *The Fabelmans*

neighborhood was home to many survivors of the "Great Murder,"[2] as they called the Holocaust. During a visit to his maternal grandmother Jenny Posner's home, Steven had one of his first confrontations with the horrifying breadth of the atrocities committed during World War II when a survivor of Auschwitz showed him the serial number that had been tattooed on his arm at the camp.

Ohio: *Ready Player One* (2018)
Inventors and Scientists: *Close Encounters of the Third Kind* (1977), *Back to the Future* (Robert Zemeckis, 1985), *Jurassic Park* (1993), *A.I. Artificial Intelligence* (2001), *Minority Report* (2002), *Ready Player One*
Shoah: *Schindler's List* (1993), *War of the Worlds* (2005)

December 18, 1947

For a long time, this was the date of birth claimed by Steven Spielberg, which was also cited in all articles and books about him. It even appears on his driver's license. This one-year subtraction to his age contributes to his legend: that of the director who got his first contract with a studio (Universal), in 1968,

Little Steven at four years old, between his mother, Leah, and his father, Arnold.

August 1952

The Spielbergs move to Haddon Township, a suburb of Camden whose residents use the name of the neighboring town of Haddonfield as their mailing address, resulting in a recurring confusion in articles about Steven Spielberg's childhood.

This first foray into life in the suburbs, with a much less communal atmosphere, was accompanied by a confrontation with anti-Semitism.

On family outings to Philadelphia, young Spielberg discovers a fascination with the dinosaur skeletons at the Academy of Natural Sciences, and with the old steam trains on display at the Franklin Institute.

Steven is known in the neighborhood for his lively temperament. At night, in his bed, he imagines monsters in the shadows cast by a tree in his room, and scares himself with shadow puppets he creates with a bare light bulb.

Dinosaurs: *The Land Before Time* (Don Bluth, 1988); *Jurassic Park*; *The Lost World: Jurassic Park* (1997)
Trees: *E.T. the Extra-Terrestrial, A.I. Artificial Intelligence, The BFG* (2016)

December 1952–February 1957

At school, Steven fell significantly behind in his learning. Mocked and withdrawn, he began to associate with students like himself who were a little on the fringes. It was not until the late 1990s that Steven realized the source of his academic problems: He was dyslexic.

Spielberg attended Hebrew school at Temple Beth Shalom. In his neighborhood of mostly Christian families, Steven felt different and gradually detached himself from his Jewish heritage, asking his parents to decorate the house for Christmas so that they could be like other families.

Outsiders: "The Private World of Martin Dalton" (episode from *The Psychiatrist*, 1971), *The Sugarland Express* (1974), *The Color Purple* (1985), *The Goonies* (Richard Donner, 1985), *An American Tail* (Don Bluth, 1986), *A.I. Artificial Intelligence, Catch Me If You Can, The Terminal, The BFG, West Side Story*
Christmas: *Gremlins* (Joe Dante, 1984), *Catch Me If You Can, The Fabelmans*

The 1965 Saratoga High School yearbook shows Steven Spielberg at center (left). Two years earlier, he was on the front page of the *Scottsdale Daily Progress* (right).

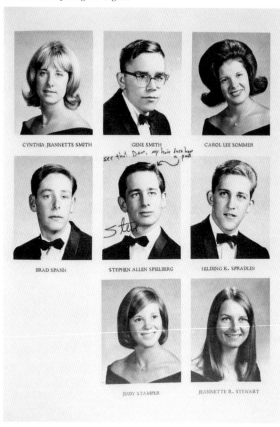

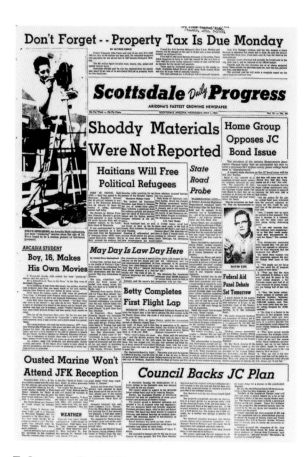

1953 or 1954

At around seven or eight years old, Steven Spielberg discovered the Walt Disney version of *Snow White and the Seven Dwarfs* (David Hand, 1937). He was terrified and marked forever. *The Thing* (1972) and *Minority Report* (2002) reproduce the scene where Snow White, panic-stricken, is clutched and tormented by trees of the forest.

Steven Spielberg's class visits the site of the discovery, in 1858, of the first complete dinosaur skeleton in North America (a hadrosaurus).

Snow White in the Cinema: *Gremlins*

1955

Arnold Spielberg joins General Electric to work on computer design in Schenectady, New York. He stays at a local YMCA during the week and is reunited with his family at weekends.

1957

One night, Arnold wakes up his son and takes him to the middle of a field to watch a meteor shower. This moment was Spielberg's inspiration for the shooting star images that appear in many of his films.

February 6, 1957

For her husband's birthday, Leah Spielberg gives him a Kodak Brownie 8 mm camera. Young Steven uses this camera to return to his obsession: the train collision in *The Greatest Show on Earth*. He refilms the sequence by turning the camera around to frame his two trains. The camera enables him to watch the accident over and over again without breaking his toys. This is his first short film, *The Last Train Wreck* (3 minutes).

Train Crash: *Super 8* (J. J. Abrams, 2011); "Ghost Train," an episode from *Amazing Stories*

February 1957

The Spielbergs move to Arizona, where Arnold is in charge of setting up an "industrial computer"[3] branch of General Electric.

After four months in an apartment in West Phoenix, the family moves to Scottsdale, to the Arcadia neighborhood at 3443 North 49th Street, an undeveloped area overlooking the desert. They experience typical American suburbia, where conformity competes with monotony. The Spielbergs are the only local Jews and are once again confronted with anti-Semitism.

As he tries to find his bearings, young Steven Spielberg clings to the unifying images conveyed by Norman Rockwell's front-page illustrations for the *Saturday Evening Post*, where the home is seen as a refuge.

Over the years, Steven harbors resentment toward his absent father, who is too absorbed in his work. But Arnold is also the parent who invents all sorts of stories and characters to help his children drift off to sleep. Spielberg spends his youth terrorizing his sisters. He dresses up, concocts macabre scenes, and tells them horror stories.

Suburbia: *Duel* (1971), *Close Encounters of the Third Kind, Poltergeist, War of the Worlds, The Fabelmans*
Norman Rockwell: the *Freedom from Fear* painting (1943) reproduced in *Empire of the Sun, The Problem We All Live With* (1964) in *Schindler's List, Triple Self-Portrait* (1960) in *Bridge of Spies, The Holdout* (1959) in *The Post* (2017)

1957–1961

As a student at Ingleside Elementary School, Spielberg continues to have a painful time dealing with formal education. He particularly hates mathematics, to the great displeasure of his father. For a long time, his father was disappointed that his son did not follow him into a technical/scientific career path.

As a clarinet player, Steven joins the school orchestra. He performs at various local events.

He first saw archival footage of Nazi atrocities in the 1956 NBC documentary *The Twisted Cross*, which he watched at school.

School: "Eulogy for a Wide Receiver" (episode from *Owen Marshall, Counselor at Law*, 1971), "The Daredevil Gesture" (episode from *Marcus Welby, M.D.*, 1970) *E.T. the Extra-Terrestrial, Back to the Future, Catch Me If You Can, Bridge of Spies, The Fabelmans*

1958

Steven Spielberg is a member of the Ingleside Boy Scouts. Unlike his experiences at school, he thrives there, winning the admiration of his fellow students for his ability to lead campfire parties. Determined to reach the rank of Eagle Scout, the highest in the organization's hierarchy, he must produce a kind of photo novel. Arnold Spielberg suggests instead that he make a film with their 8 mm camera. Steven Spielberg then shoots a western heist scene, *The Last Gunfight*. He does indeed become an Eagle Scout.

That same year, he hooked Thunder, the family dog, to a cart with a camera running on it. Steven left the dog to its wanderings before recovering the

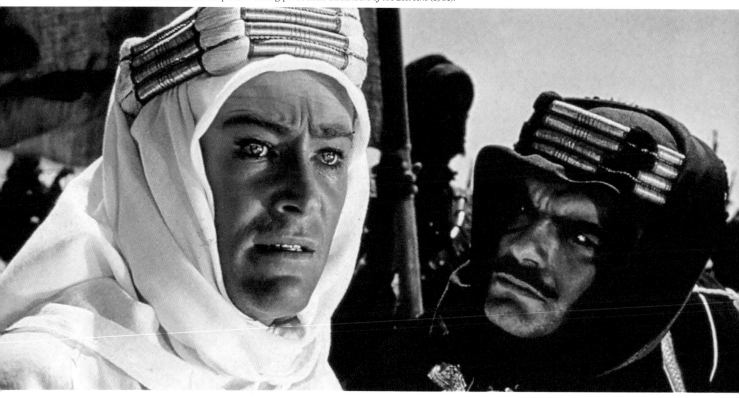

Lawrence of Arabia (David Lean, 1962) was one of Steven Spielberg's great early influences. He would later use the film as inspiration during production on *Raiders of the Lost Ark* (1981).

camera and watching what was captured. The result is the short film *A Day in the Life of Thunder* (8 mm).

Scout: *Indiana Jones and the Last Crusade*
Western: *Indiana Jones and the Last Crusade, Back to the Future III* (Robert Zemeckis, 1990), *Arkansas* (abandoned project)

January 9, 1960

Spielberg has his bar mitzvah at the synagogue of the orthodox congregation Beth Hebrew. The party continued at home where Steven, who was disdainful of the event and feeling boisterous as ever, climbed onto the roof to throw oranges.

Mid-1960

As part of a US-USSR exchange program, Arnold (who spoke Russian) joins a group of five engineers sent to Moscow. A few weeks before his arrival, an American U2 spy plane was shot down over the Urals and its pilot, Francis Gary Powers, taken prisoner. Arnold is able to see the wreckage of the plane and Powers's outfit on public display. He brings back pictures of it to his son.

Francis Gary Powers: *Bridge of Spies*

Summer 1960

Steven Spielberg sees Alfred Hitchcock's *Psycho* in a Scottsdale drive-in. He particularly remembers the power of suggestion of the film, where the horror emerges although we see nothing specifically shocking on the screen.

Steven also sees Irwin Allen's *The Lost World* in a Phoenix cinema with his buddies. They have prepared a concoction imitating vomit, which they pour from the balconies. The chaos is such that the screening is interrupted.

Steven Spielberg spends all his Saturdays at the movies: He consumes Westerns, adventure films, monster movies, and serials from the 1930s to 1940s, including *Commander Cody, Spy Smasher,* and *Zorro Rides Again* (1937).

Serials: *Raiders of the Lost Ark* (1981)
Naughty Kids: *The Sugarland Express, Gremlins, The Goonies, Hook* (1991)

September 1961–March 1964

In the eighth grade, as part of a project that was supposed to demonstrate his intended profession, Steven Spielberg shoots a western and makes his ambitions clear: "I am going to direct and produce movies."[4]

Spielberg eventually enrolls at Arcadia High School. While there, he makes an 8 mm film of a play staged at the high school, *Scary Hollow.*

His next project is much more ambitious than the previous ones. *Fighter Squad* is a fifteen-minute film about aerial combat. Steven uses archival footage

from World War II in 8 mm, and with an authorization obtained by his father, he films in the cockpit of a real P-51 fighter plane parked at Sky Harbor Airport in Phoenix. The actors are, as always, his friends and himself (in the role of a German). Arnold Spielberg builds a fake cockpit in the yard of the house to complete the scenes.

Steven Spielberg starts to hold regular screenings at his house for a fee of twenty-five cents. His sisters run the candy and drink stand.

Tensions between his mother and father escalate. Two parallel lives are established. Steven takes refuge in his room or at the movies. He often pretends to be sick so he can skip school and work on his films instead.

Aerial Combat: *1941*, "The Mission" (episode from *Amazing Stories*), *Empire of the Sun*, *War of the Worlds*, *Ace Eli and Rodger of the Skies* (John Erman, 1973)

1962

A new war film, *Escape to Nowhere* (40 minutes), shot in 8 mm and in color, was supposed to take place "somewhere in East Africa,"[5] as is indicated on the box it was stored in. Steven Spielberg filmed in the arid landscapes not too far from his home, with a jeep that his father brought back from an army surplus, and with fake German helmets. The film wins a prize at the Canyon Films Festival, which was dedicated to amateur films, and its filmmaker wins a Kodak 16 mm camera. On the advice of his father, he exchanged the camera for a Bolex H8 8 mm, whose film was cheaper to develop. He then bought a Bolex Sonorizer to add sound to his films.

Summer 1962

Steven Spielberg makes his first visit to a film studio when he goes to Warner Bros. in Burbank. With the other tourists, he attends the preparation of a scene of *PT 109* (1963), recounting the war years of John F. Kennedy. The filming takes place on enormous Soundstage 16.

Warner Bros., Soundstage 16: *1941*, *Jurassic Park*, *The Goonies*
The War in the Pacific: *1941*, *Empire of the Sun*, *Flags of Our Fathers* (Clint Eastwood, 2006), the miniseries *The Pacific* (2010)

July 19, 1962

The *Arizona Republic* features an article on four ticketed screenings of *Davy Crockett, King of the Wild Frontier* (1955) hosted by Steven Spielberg at his home. The proceeds go to the Perry Institute, a center for disabled children. Arnold Spielberg

came up with the idea, refusing to let his son earn money from films for which he did not own the exhibition rights.

October 1962

The Cuban missile crisis takes place. The impending threat of a nuclear war between the US and the USSR never felt so tangible. Federal Civil Defense Administration films on radioactive fallout are shown in school. The Spielberg parents return from a party to discover that their son, overcome by generalized paranoia, has filled bathtubs, sinks, and an inflatable pool to create a reserve of uncontaminated water.

Cold War: *Bridge of Spies*, *Indiana Jones and the Kingdom of the Crystal Skull*

January 31, 1963

Lawrence of Arabia (David Lean), released at the end of 1962 in the United States, is playing at the Palms Theater in Phoenix. Steven Spielberg saw it in the first week of its release. He left the screening in a state of near-shock.

May 1, 1963

On the front page of the *Scottsdale Daily Progress*, an article entitled "At 16, He Makes his Own Movies"[6] is dedicated to budding filmmaker Steven Spielberg.

Autumn 1963–Early 1964

Steven Spielberg takes advantage of a long weekend to visit Universal Studios in the Hollywood Hills. Thanks to a friend of his father's, he was welcomed by Chuck Silvers, an assistant in the editorial department of Universal Television. Silvers showed Steven the editing rooms and walked around with him, learning that the teenager was making amateur films.

September 1963

Arnold Spielberg leaves General Electric for a senior position at IBM in San Jose, California.

October 1963

Steven stars as Ray Gammar in *A Journey to the Unknown*, an amateur film shot by another aspiring Phoenix-based filmmaker, Ernest G. Sauer. The film is shown in a local cinema. In the program notes, Steven Spielberg states that he plans to be a motion picture producer with Universal International.[8]

March 24, 1964

First recognition: The Little Theater in Phoenix shows Steven Spielberg's latest film, *Firelight*. With an exceptional length of two hours and fifteen minutes,

this first feature film took up all the teenager's weekends for a year and prefigured *Close Encounters of the Third Kind* (1977), including special effects. His sister Nancy plays the role of a little girl abducted by aliens. The rest of the cast is made up of students from Arcadia High School. Steven Spielberg also composed the music on the clarinet and had it performed by the high school orchestra. The film cost $600 to make ($5,744 in 2023 dollars). The filmmaker appeared on *The Wallace and Ladmo Show*, a popular youth program on local television station KPHO-TV.

Aliens: *Night Skies* (an unfilmed screenplay, 1980), *Close Encounters of the Third Kind, E.T. the Extra-Terrestrial, War of the Worlds*

March 25, 1964

The Spielbergs follow Arnold to California. They first live in Los Gatos, south of San Jose. Steven Spielberg is said to have received his call-up for military service in 1964 while queuing to see *Doctor Strangelove* (Stanley Kubrick, 1964) in front of a San Jose cinema. It was to avoid the army and a trip to Vietnam that he decided to go to college.

Vietnam War: *The Post; The Twilight Zone*, segment "Ray" (John Landis, 1985)

Summer 1964

The Spielbergs move to a suburban area of Saratoga at 21143 Sarahills Drive. Chuck Silvers finds Steven Spielberg an unpaid assistant job in his offices in the editorial department of Universal Studios, where his colleague Julie Raymond is in charge of relations with contractors and subcontractors. The aspiring filmmaker performs all sorts of menial tasks (phone calls, errands, etc.), which gives him the opportunity to hang out everywhere, to attend the shooting of various television series (the shooting of feature films was monitored by security guards), and to observe film technicians at work.

Filming Location: *The Thing, Savage* (1973), *The Fabelmans*

September 1964–June 1965

Enrolled at Saratoga High School. His name is misspelled in the school's yearbook as "Stephen Allen Spielberg," an indicator of his difficulty in fitting in. He describes the year he spends there as "hell on earth."[9] He is the new kid, an introvert, and also a Jew. He was bullied throughout his time there.

Although he spends his year hugging the walls, Steven Spielberg remains eager to make a name for himself. He takes journalism classes and writes sports columns for the school newspaper, the

Falcon. He sometimes films games in order to write his articles.

He teams up with a student named Mike Augustine, who helps him on a three-minute short film about President John F. Kennedy. Against a sunset backdrop, the film shows a musical toy that was released during Kennedy's campaign: a rocking chair that plays the song "Happy Days Are Here Again" as it rocks.

Bullying: *Duel, The Color Purple, Back to the Future, The BFG, The Fabelmans*
President of the United States: *Amistad* (1997), *Lincoln* (2012), *The Post*

May 1965

Spielberg shoots *Senior Sneak Day*, an amateur film documenting the traditional Saratoga High School field trip to celebrate the end of the school year. The day takes place at the Santa Cruz amusement park and Steven shoots picturesque skits involving his classmates. More facetiously, he makes a parody of Alfred Hitchcock's *The Birds* (1965), alternating images of seagulls with those of students seemingly cowering on the beach to protect themselves. On the day of the screening, expecting reprisals from the heavies who persecute him, Steven Spielberg is instead congratulated by one of them.

June 18, 1965

Steven Spielberg and has ambitions to enroll at the film department of the University of Southern California (USC) or the University of California Los Angeles (UCLA) but his applications are rejected. Chuck Silvers, a lecturer at UCLA, failed to get his protégé into the film department there, and Steven eventually ends up at California State University, Long Beach, located to the south of Los Angeles.

Summer 1965

Spielberg's parents split up. Arnold moves to the Brentwood area of Los Angeles and Steven lives with him.

Spielberg spends another summer at Universal with Chuck Silvers and Julia Raymond. He becomes known around the lot, and is notified when a shoot is about to start so that he can attend editing and dubbing sessions.

John Cassavetes spots him on the set of an episode of the anthology *Bob Hope Presents the Chrysler Theatre*. Aware of the young man's ambitions, Cassavetes ends up taking him on for a few weeks as a production assistant (unpaid) on *Faces* (1968), which he had been directing independently since the beginning of the year.

The young Spielberg also manages to have lunch with Charlton Heston, Cary Grant, and Rock Hudson.

September 1965–January 1969

Spielberg studies humanities at California State University (Cal State), Long Beach. He also attends television production classes where he shows a degree of indifference. After living with his father for his first year of study, he moves in with a Cal State law student, Ralph Burris.

Steven Spielberg continues his visits and meetings at Universal. He tries to show his amateur work, but the people in the business will only accept 16 mm or 35 mm film, the only formats recognized as "professional." The young man takes a job at Cal State's university restaurant to buy 16 mm film and the camera that goes with it. The product of this was *Encounter*, a twenty-minute black-and-white 16 mm short film

made during his third year with Long Beach students as actors.

February 1966

The university newspaper, the *Forty-Niner*, mentions the start of filming of *The Great Race* by Steven Spielberg in the campus cafeteria. It is a black-and-white comedy with sound and music.

Comedy: *1941, Catch Me If You Can, The Terminal*

April 11, 1966

Leah and Arnold Spielberg begin divorce proceedings in Santa Clara County Court. Under the terms of their divorce agreement, Steven lives with his father, and his mother has custody of his three sisters. The house in Saratoga is sold and Leah Spielberg moves

back to Phoenix. The final divorce is granted one year later.

Divorce: *The Daredevil Gesture, E.T. the Extra-Terrestrial, Catch Me If You Can, War of the Worlds, The Fabelmans*

Spring 1967

With Ralph Burris, who had just dropped out of school with dreams of becoming a producer, Spielberg sets about making his first 35 mm film. His goal is to show the film to studio executives. Focused on a bicycle race and shot in Long Beach, the film is called *Slipstream*. The director gets some film stock from Chuck Silvers and Burris borrows $3,000 from his parents. A student, Andre Oveido, contributes $1,000. In order to rent filming equipment (Steven is still a minor), Arnold sets up a production company, Playmount Production, a literal English translation of Spielberg.[10] The second camera is held by Allen Daviau, who had been a set photographer on the TV series *The Monkees* (1966) and created psychedelic photographic effects for Roger Corman's *The Trip*, shot in March. Due to a lack of money, the shooting stops and the film remains unfinished.

Bicycle: *E.T. the Extra-Terrestrial, Empire of the Sun, The Fabelmans*

January 19, 1968

The Third National Student Film Festival takes place at UCLA's Royce Hall. USC film student George Lucas presents three short films, including a cutting-edge dystopian drama, *Electronic Labyrinth THX 1138 4EB*. Steven Spielberg is in the audience. Lucas's film is named "Best Dramatic Film" by the jury and leaves Spielberg stunned. Spielberg goes backstage to greet the director, whom he finds in the company of Francis Ford Coppola. This was the first meeting between Spielberg and Lucas.

Dystopia: "LA 2017" (episode from *The Name of the Game*, 1971), *A.I. Artificial Intelligence, Minority Report, Ready Player One*

July 1968

Losing patience while waiting for something to happen at Universal, Steven Spielberg directs another short film in 35 mm in the Mojave Desert, called *Amblin'*. His sister Anne is the scriptwriter and Ralph Burris is the production manager.

Anne Spielberg: screenplay for *Big* (Penny Marshall, 1988) and "What If?" (episode from *Amazing Stories,* 1986)

September 28, 1968

A contract is signed by Steven Spielberg and producer Denis Hoffman, who finances *Amblin'*. This document is the source of a long dispute. It stipulates that Spielberg must shoot a feature film for Hoffman within ten years of signing. In 1977, after the success of *Jaws* (1975) and *Close Encounters of the Third Kind* (1977), Hoffman claims his due. Spielberg's representatives then argue that the contract is not valid because Steven Spielberg was still a minor in 1968 (which is false). An out-of-court settlement awards Hoffman $30,000 and he abandons his claims. In 1987, Steven Spielberg invests in a doughnut company set up by Hoffman. The partnership goes sour, with Denis Hoffman failing to meet his financial obligations. In 1994, Hoffman discovers that Spielberg had lied about his age. He returns to the original lawsuit and asks for $33,000,000. Spielberg sues Hoffman for his failures in their doughnut business, and also for judicial harassment. Spielberg wins: The contract for *Amblin'* specified that the producer had to provide a script in order to have rights on a film by Spielberg, which Hoffman never did. This whole affair led to the revelation of the filmmaker's true date of birth.

End of Summer–Autumn 1968

Chuck Silvers watches *Amblin'*. Impressed, he contacts Universal Television boss Sid Sheinberg and convinces him to see it. Impressed by the technical proficiency as well as the emotion that emanates from the film, Sheinberg offers a directing contract to Steven Spielberg.

December 12, 1968

The *Hollywood Reporter* announces the signing of a seven-year exclusive contract between Steven Spielberg and Universal Television. *Amblin'* actress Pamela McMyler is also signed, around the same time she appeared in *The Boston Strangler* (Richard Fleischer, 1968). The article suggests that Spielberg, at twenty-one, is the youngest director ever to sign with the studio. The young man would turn twenty-two just six days later.

Epilogue

With his contract at Universal Television, Steven Spielberg leaves college in early 1969, before graduation. According to legend, he never went back to campus long enough to clean out his locker.

Right: Throughout his career, Steven Spielberg has never shied away from the fact that he takes pleasure in paying homage to his favorite films, many of which are featured here.

Following spread: Spielberg on the set of *Close Encounters of the Third Kind*.

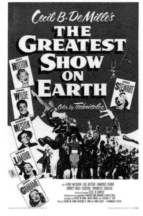

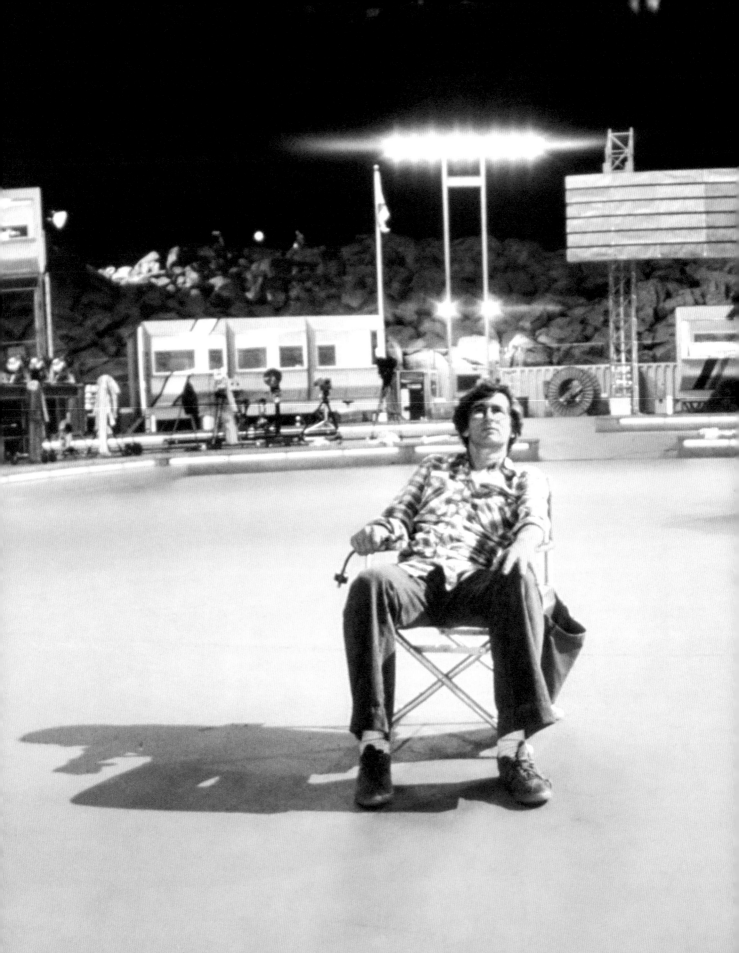

WINNER SILVER PHOENIX AWARD · ATLANTA FILM FESTIVAL
BEST SHORT SUBJECT

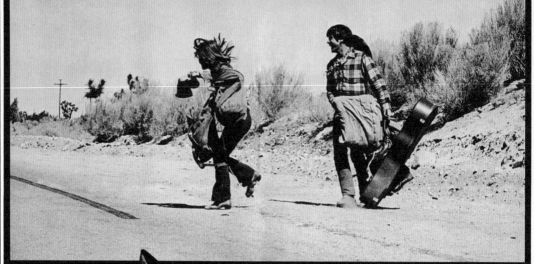

He and she were thumb-trippin'.

They had the makin's...

and the tail-end of summer

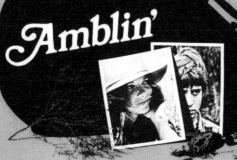

Amblin'

DENIS C. HOFFMAN'S *Amblin'*
STARRING
Pamela McMyler AND Richard Levin
PHOTOGRAPHED by ALLEN DAVIAU · MUSIC by MICHAEL LLOYD
PRODUCED by DENIS C. HOFFMAN
WRITTEN AND DIRECTED by STEVEN SPIELBERG
A ☆☆☆☆ FOUR STAR EXCELSIOR RELEASE R

TECHNICOLOR®

Amblin'

United States • 26 mins • Color • Mono • 1.37:1
(Technicolor)

Production Dates: July 6–14, 1968
United States Release Date: December 18, 1968

Producer: Denis Hoffman
Unit Production Manager: Murray Waymouth
In Charge of Production: Ralph Burris
Production Assistants: Elza Camacho, Thom Eberhardt,
Phil Harrott, Ronald Kline, Marty Williams

Screenplay: Steven Spielberg
Director of Photography: Allen Daviau
Camera Assistants: Donald Heitzer, Joseph Hernandez
Special Photographic Effects: Jim McIntyre
Film Editing: Steven Spielberg (uncredited)
Music: Michael Lloyd, song performed by October Country
Sound: Jerry Gottlieb
Script Supervisor: Anne Spielberg

Starring: Richard Levin (young man), Pamela McMyler
(young woman), Henry Axelrod (Porsche driver)

"[This character]
He was me,
basically. He
was dressed as
a hippie, but
he was a secret
square. It was
no secret that
I was a square.
And I think, to
my children
today, it's still
no secret."[1]

—Steven Spielberg

SYNOPSIS

Somewhere in California's Mojave Desert, a male hitchhiker carrying a guitar case meets a female hitchhiker. The two young people hit it off, and a romance forms as they walk along the road and wander through the barren landscape. Their plan is to reach the Pacific Ocean, but the young man always keeps his guitar case suspiciously shut.

GENESIS

Steven Spielberg has never hidden the fact that *Amblin'* is a work of opportunism. In fact, in some ways this is exactly what the film is about. During his high school and college years, Spielberg tried everything to break into the movie business. He visited the offices of various Los Angeles producers, dropping off samples of his early 8 mm and 16 mm films. He also made friends in the film department at the University of Southern California, including future filmmakers, film editors, and screenwriters like John Milius, Walter Murch, Hal Barwood, and Matthew Robbins.

On the Lot at Universal

Through his father, Spielberg got a foot in the door at Universal Studios, where he rubbed shoulders with the head of the editorial department at Universal Television, Chuck Silvers. Young Spielberg was able to observe daily life on a film set, and he also talked with members who told him that in order to attract attention to his work, it was better to present his films in 35 mm because it "looks professional." So, in 1967, he started working on *Slipstream*, a short 35 mm film about a bicycle race, which was never finished due to lack of money. Through his contacts at Universal, Spielberg met Denis Hoffman, who was the boss of a special effects studio in Hollywood called Cinefx. Hoffman wanted to produce films, and he agreed to invest $10,000 in Spielberg's next short film.

The Secret in the Guitar Case

Steven Spielberg was never a hippie, and he does not identify with counterculture. It was purely a case of opportunism that found him making a film about a couple of hippies. In *Amblin'*, his characters stroll aimlessly, smoke a joint, and make love by the campfire. Written in one day, the story ends with a surprise twist. The young girl opens her lover's guitar case and removes a white shirt, a tie, a pair of shoes, some deodorant, and some toilet paper. The costume of the perfect conformist. The hippie is not a hippie at all. No matter, *Amblin'* had only one purpose: to impress the directors of Universal.

FILMING AND PRODUCTION

Shooting on the film lasted for ten days in July of 1968. The campfire scene was shot first at Cinefx, and then production moved to actor Jack Palance's property in Malibu, where they shot the film's last scene (which is set on a beach). Finally, the cast and crew moved to the Mojave Desert and finished filming scenes near the town of Pearblossom, California.

Allen Daviau, a Trusted Associate

The heat during filming was infernal, and some of the crew did not make it to the end of the shoot. Spielberg, meanwhile, was so nervous that he vomited every day before starting work. However, he was always able to count on the support of his director of photography, Allen Daviau, who also worked as a cameraman on Stephen's short film *Slipstream*. This former photography equipment store employee had already worked on music videos (Jimi Hendrix, *The Animals...*) and on *The Trip* (1967) by Roger Corman. He would eventually work with Spielberg again on *E.T. the Extra-Terrestrial* and *Empire of the Sun*.

In the Psychedelic Desert

Amblin' is a demonstration of serious technical rigor, with impressive framing and zoom effects featured throughout. Every day, along with Daviau, Spielberg filmed sunsets and sunrises. He also orchestrated a convoluted sequence shot set in an abandoned corral. Many of Spielberg's signature motifs are present, including the use of rack focus—changing the focus of the camera in the course of a single shot—and the inclusion of back-lit figures. Spielberg spent six weeks editing images and sounds. *Amblin'* has no spoken dialogue, but it is bathed in music typical of the time, including folk rock and psychedelic rifts.

RECEPTION

While Denis Hoffman failed to attract Hollywood executives to a first screening, Steven Spielberg showed *Amblin'* to Chuck Silvers at Universal. Silvers was impressed by the film. He showed it to some of his colleagues, who were also won over. Silvers let three days pass and then he called Sid Sheinberg, then vice president of Universal Television, and asked him to watch Spielberg's twenty-six-minute film. The atmosphere, the characters, and the tone of the story all appealed to Sheinberg.

Exciting Things on the Horizon

What followed was a dream come true: The young director signed a seven-year contract with Universal Television, even though he would have preferred making feature films right from the start. *Amblin'* was released in Los Angeles during the same screening as Otto Preminger's *Skidoo*. A year later, it was voted best short film at the Atlanta Film Festival, and at the CINE competition in Washington, which promotes American films at European festivals.

Eyes

Series: Night Gallery • Season 1, Pilot

| United States | 26 mins | Color | Mono | 1.33:1 |

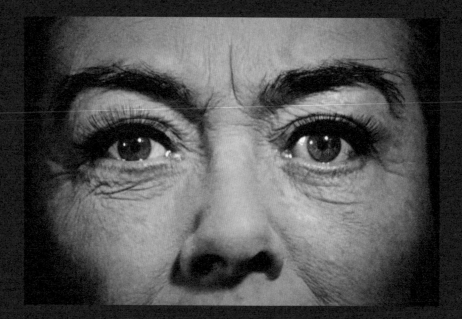

Production Dates: February 3–13, 1969
Broadcast Date in the United States: November 8, 1969, on NBC

Production Company: Universal Television
Producer: William Sackheim
Associate Producer: John Badham

Based on the eponymous novel by Rod Serling (1967)
Screenplay: Rod Serling
Director of Photography: Richard Batcheller
Film Editing: Edward M. Abroms
Music: William Goldenberg

Sound: Elbert W. Franklin, James T. Porter
Art Direction: Howard E. Johnson
Set Decoration: John McCarthy, Joseph Stone, Perry Murdock
Paintings: Jaroslav Gebr
Costume Design: Burton Miller
Hair Stylist: Larry Germain
Makeup: Bud Westmore

Starring: Joan Crawford (Miss Claudia Menlo), Barry Sullivan (Dr. Frank Heatherton), Tom Bosley (Sidney Resnick), Byron Morrow (George J. Packer), Garry Goodrow (Louis), Shannon Farnon (nurse), Bruce Kirby (artist), Rod Serling (narrator)

SYNOPSIS

Claudia Menlo, a rich and cantankerous New Yorker who has been blind since birth, blackmails her surgeon, Dr. Frank Heatherton, and asks him to perform an eye transplant. Her donor, Sidney Resnick, agrees to lose his eyesight in order to pay back the $9,000 he owes to the mafia. The operation succeeds, but Menlo has been told her new power of eyesight will only last for twelve hours. Just as she's removing her bandages, a power failure plunges the city into darkness.

GENESIS

Launched in the wake of the success of *The Twilight Zone*, a series created ten years earlier by Rod Serling that became a cornerstone of science fiction in popular culture, *Night Gallery* did not live up to its predecessor. However, it did take on many of the same governing principles: Each episode was presented by Serling himself, and consisted of an anthology of short, nightmarish stories that often drew moral and critical conclusions about American society.

An Offer He Couldn't Refuse

Steven Spielberg had promised himself that he would make his first professional film before he turned twenty-one. Unfortunately for Spielberg, he signed his contract with Universal on December 12, 1968, six days before his twenty-second birthday. Sid Sheinberg, who was the head of the television branch at Universal, soon enlisted Spielberg to direct the pilot of his new series, *Night Gallery*. Despite his respect for Rod Serling, Spielberg didn't like the story he was given, and he asked Sheinberg if he wouldn't rather do a script that focused on young people. His mentor advised him to take the opportunity.

An Improbable Scenario

Adapted from a short story that Rod Serling published in 1967, "Eyes" was the second of three short segments that made up the show's pilot episode. The premise was inspired by a blackout that occurred on November 9, 1965, and paralyzed large swathes of the Northeast, including the entire state of New York. Unfortunately, the plot doesn't stand up to even basic scrutiny. After all, why would anyone agree to give up their sight in order to pay off a gambling debt? And why would the rich blind woman (played by Joan Crawford) go to such great lengths only to be able to see for twelve hours when the countdown starts...in the middle of the night?

CASTING

Bette Davis, who was to play Claudia Menlo, refused to be directed by a twenty-two-year-old beginner. Against all odds, Sid Sheinberg chose to stick with Spielberg. The role then went to Davis's scene partner in *Whatever Happened to Baby Jane?* (1962), Joan Crawford, who was sixty-two years old at the time.

FILMING AND PRODUCTION

Spielberg had one obsession: to keep to the schedule (which allowed for seven days of shooting). This

was and is a quality that is much appreciated in the film business. However, the fates did not align to help him achieve his goal. When they saw the young director arrive, the veteran technical team balked; it would take two days before Spielberg began to be taken seriously. His relationship with Crawford was more easygoing. The director knew how to charm her by gifting her with a single red rose in a Pepsi bottle (Crawford's husband managed the company). Still, an inner ear infection kept Crawford away from set for twenty-four hours, and the day before shooting the scene where Claudia Menlo sees for the first time, Spielberg found Crawford in tears, distraught by the challenge ahead. He eventually chose to postpone the show's schedule, stayed with his star to rehearse, and finished the episode two days late, but having learned a valuable lesson on how to direct actors.

Style Above All

Postproduction on "Eyes" was also complicated. While producer William Sackheim was impressed by Spielberg's "avant-garde" choices, Spielberg hadn't made sure to get enough general and close-up shots (as is customary), and he was left without a lot of options when it came time to edit the footage into the final episode that would air on TV. Due to the lack of footage, the editor, Edward M. Abroms, superimposed two shots of the faces of Joan Crawford and Tom Bosley (who played the unwilling donor) to help fill space in the episode. It was an ungainly moment in an episode that taught Spielberg many valuable lessons in directing.

RECEPTION

Of the three segments featured in the pilot episode of *Night Gallery*, "Eyes" caught people's attention due to the presence of Joan Crawford and the production by this young unknown, which was "topnotch," according to the *Daily Variety*.[1] *The Hollywood Reporter*,[2] on the other hand, said the episode "looked as if it hadn't been completed." Perhaps Spielberg was too adventurous for the television of the time?

The Daredevil Gesture

Series: Marcus Welby, M.D. • Season 1, Episode 24

🏳 · 🕐 · 📀 · 🔊 · ▱

United States **50 mins** **Color** **Mono** **1.33:1**

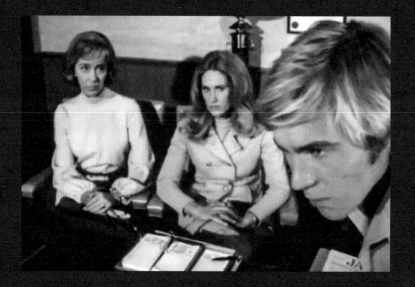

Production Dates: Early February 1970
Broadcast Date in the United States: March 17, 1970, on ABC

Production Company: Universal Television
Producer: David J. O'Connell
Executive Producer: David Victor
Unit Production Manager: Edward K. Dodds

Screenplay: Jerome Ross
Director of Photography: Walter Strenge
Film Editing: Richard G. Wray
Music: Leonard Rosenman
Sound: Robert R. Bertrand
Art Direction: George Patrick
Set Decoration: John McCarthy, George Milo

Hair Stylist: Larry Germain
Makeup: Bud Westmore
Wardrobe: Charles Waldo, Diana Wilson
Script Supervisor: Winnie Rich
Assistant Director: Joe Boston

Starring: Robert Young (Dr. Marcus Welby), James Brolin (Dr. Steven Kiley), Elena Verdugo (Consuelo Lopez), Frank Webb (Larry Bellows), Marsha Hunt (Mrs. Bellows), Susan Albert (Claudia Bellows), Ronne Troup (Ginny Peterson), Bill Fletcher (Mr. Beeman), Richard Dillon (Harv), Peter Hobbs (Mr. Craddock)

SYNOPSIS

High school student Larry Bellows has hemophilia. His disease disrupts his daily activities and his social relationships, and he also has to deal with an overprotective mother and a sister who sacrifices herself for his benefit. When he joins a new school, Larry insists that his hemophilia should not be made known to his classmates. Under the care of Dr. Marcus Welby, he is torn between his aspirations for a normal life and the knowledge that there are certain activities that just may be too much for him.

GENESIS

Together with *Medical Center* (1969–1976) and *Emergency!* (1972–1979), *Marcus Welby, M.D.* was part of a wave of popular television shows that focused on the medical profession. All of these shows came into existence following the success of yet another popular show called *Dr. Kildare* (1961–1966). In each episode of *Marcus Welby, M.D.*, an experienced general practitioner and his young associate, Steve Kiley, are presented with a particular medical case that gives rise to an educational experience. In the twenty-fourth episode of the show's first season, the two medical practitioners discuss the hereditary mechanisms of hemophilia, the latest treatments, and the famous case involving the son of Russia's Tsar Nicholas II, who suffered from the disease.

A Benevolent Authority Figure

It is not so much the medical treatment that is emphasized in this series, but the human qualities of the doctor himself. Marcus Welby, played by Robert Young, is a benevolent and paternalistic authority figure. Played by newcomer James Brolin, Steve Kiley is more of a disciple than a colleague. Each episode takes the shape of a heartfelt life lesson. In "The Daredevil Gesture," the themes are maturity, responsibility, and autonomy for a boy who will very soon be going off to school.

Anchored in Contemporary Values

The series was very much interested in taking on the hot-button issues of its day, and scenes in this episode refer to contraception, divorce from the point of view of the children, and the main character's health-related sense of isolation. The permanent anger that Larry feels also echoes the idea of a rebellious youth that became part of the popular mythos of the 1960s and 1970s, and that is suggested at the very end of the episode via the truncated scrawling of the phrase "Peace & Love" on Harv's cast.

FILMING AND PRODUCTION

Increasingly dissatisfied with the screenplays that Universal sent to him for consideration, Steven Spielberg stopped filming for a year to write his own projects. During this period, he tried in vain, and with much difficulty, to work for Fox. After eventually finding his way back to Universal, he was entrusted with this episode but given the instruction to curb his stylistic affectations. Shot at Universal Studios and in California's Temescal Canyon, "The Daredevil Gesture" alternates between very flat sequences and moments of minor formal innovation.

Steven Spielberg, M.D.

Dr. Welby's house existed as an exterior set built on Universal's backlot, and it can also be seen in other series like *Desperate Housewives* (2004). The fake house is now located on Steven Spielberg Drive.

A Virtuosic Move

A scene set in a gymnastics class at the beginning of the episode combines abrupt editing, low-angle shots taken from underneath a pommel horse, and tight shots that give the viewer the sensation that students are bumping into the camera. The tension of certain conversations is conveyed by placing a character on the right of the screen while his interlocutors are placed in the background. Later, Dr. Kiley's emergency appearance during a canyon hike offers an opportunity for Spielberg's camera to make some virtuosic moves: The camera follows Ginny Peterson, a classmate of Larry's, as she searches for him to the right, then as she changes direction and follows a car that enters the frame in the background, and finally as she walks to the left of the frame.

A Frustrating Episode

Steven Spielberg was still trying to free himself from the constraints of the television format via the use of handheld camera shots, abrupt dolly zooming, and changes of focus during a shot. While he was not responsible for the script, Spielberg seemed to find in Larry Bellows the articulation of his own frustrations, particularly when, in a fit of pent-up rage, the teenager recounts the divorce of his parents and his subsequent abandonment by his father. This marked the first occurrence of what would become a consistent theme for the director: the absent father. Throughout the episode, the young high school student seems to boil over with rage and frustration. Frank Webb is too closely supervised, too cramped, and too constrained…just like his director.

RECEPTION

"The Daredevil Gesture" remains a standard television product. The young man's skill was noted by people working behind the scenes on *Marcus Welby, M.D.*, including the show's production manager, Marty Hornstein, and an assistant director named Joe Boston. Boston was particularly impressed by a tracking shot that Spielberg used in a locker room scene at the beginning of the episode—especially when he learned that the director had devised it on the spot.

Make Me Laugh

Series: Night Gallery • Season 1, Episode 4

United States **24 mins** **Color** **Mono** **1.33:1**

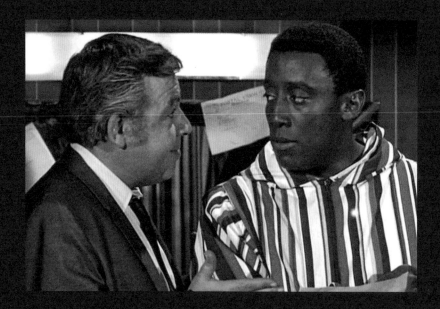

Production Dates: Fall 1970
Broadcast Date in the United States: January 6, 1971, on NBC

Production Company: Universal Television
Producer: Jack Laird
Executive Producer: Paul Freeman

Screenplay: Rod Serling
Director of Photography: Richard C. Glouner
Film Editing: Bud Hoffman, James Leicester
Music: Robert Prince
Sound: David H. Moriarty
Art Direction: Joe Alves
Set Decoration: Charles S. Thompson

Paintings: Thomas J. Wright
Costume Design: Grady Hunt
Hair Stylist: Larry Germain
Makeup: Bud Westmore

Starring: Godfrey Cambridge (Jackie Slater), Tom Bosley (Jules Kettleman), Jackie Vernon (Chatterje), Al Lewis (Mishkin), Sidney Clute (David Garrick), John J. Fox (heckler), Sonny Klein (first barman), Gene R. Kearney (second barman), Tony Russel (director), Michele Hart (Miss Wilson), Georgia Schmidt (florist), Sid Rushakoff (first laughing man), Don Melvoin (second laughing man), Rod Serling (narrator)

SYNOPSIS

Jackie Slater is a struggling stand-up comedian who hasn't gotten a laugh in a very long time. One day, he meets Chatterje, a self-described miracle worker who offers to grant him a wish. Slater asks for the ability to make people laugh, but he pays a terrible price.

GENESIS

Spielberg hadn't enjoyed filming the pilot episode of *Night Gallery*, which was his first official production, and he desperately wanted to escape from television so he could pursue his dream of filmmaking. As an employee of Universal Television, he asked his boss and mentor Sid Sheinberg for a leave of absence so he could try to make a feature film.

The Cinema Is Still a Distant Dream

After garnering new representation with the prestigious ICM (International Creative Management), Spielberg befriended the musician John Williams, who would become his regular composer, and the actor Cliff Robertson, an aviation enthusiast. He offered Robertson the title role in *Ace Eli and Rodger of the Skies*, a screenplay that was co-written with his friend Claudia Salter. The plot concerned a stuntman and ex–World War I pilot who takes his son along as he travels across 1920s America. Although 20th Century Fox bought the script, the studio refused to let Spielberg direct because they felt he was too inexperienced. Directorial duties were handed over to John Erman, who was credited under the pseudonym Bill Sampson. A few years later, Erman would receive wide acclaim as the director of the television miniseries *Roots*, but *Ace Eli and Rodger of the Skies* was a flop. Devastated, Spielberg vowed never to work for 20th Century Fox again (a promise he kept until *Minority Report*), and he returned to Universal Television determined to get his hands on any work that Sheinberg wanted to entrust to him.

Immersing Himself in the Job

Between the end of 1970 and the end of 1971, Spielberg made seven episodes of television, including "Make Me Laugh," which saw him return to Rod Serling's *Night Gallery* anthology. The episode was a fable of sorts about a failing comedian, and the commission was of little interest to Spielberg, who didn't seem interested in putting his stamp on the final product.

CASTING

Apart from Tom Bosley, who appeared as Jackie Slater's agent, and who also played the organ donor in "Eyes" (in addition to playing Richie Cunningham's father, Howard, on *Happy Days*), there were no familiar faces in this Spielberg production, nor any memorable acting performances.

A New Leading Man

Years before *The Color Purple* and *Amistad*, Jackie Slater was the first Black protagonist to appear in a Spielberg film. He was played by Godfrey Cambridge, a stand-up comedian who was popular on talk shows at the time. By the time he filmed "Make Me Laugh," Cambridge had earned a small reputation for his role as a racist white man who woke up as an African American in Melvin Van Peebles's *Watermelon Man* (1970).

FILMING AND PRODUCTION

Some viewers may detect echoes of the filmmaker's own temperament in Godfrey Cambridge's portrayal of Jackie Slater. Both men felt like outcasts as children, and each had an obsession with success, prizes, and recognition. "Make Me Laugh" also touches on a very Spielbergian trope—the idea that every miracle conceals a dark side. In spite of these parallels, it is difficult to find a trace of Spielberg's early talent in this particular piece of television. Even the final scene of the episode does not live up to the plot's tragic irony, despite the use of a crane in the final shot, which was the only flourish the filmmaker added to the production. Interestingly, after network executives at NBC saw the episode, they brought in Jeannot Szwarc, future director of *Jaws 2*, to reshoot some of the scenes. Szwarc later confided that he had redone things identically, not seeing where Spielberg had gone wrong!

RECEPTION

With his husky voice and his purposefully challenging performance, Godfrey Cambridge is the only saving grace of "Make Me Laugh." Aired alongside another thirty-minute *Night Gallery* segment called "Clean Kills and Other Trophies," the episode failed to make much of an impact and was quickly forgotten.

L.A. 2017

Series: The Name of the Game • Season 3, Episode 16

United States 1 hr 14 Color Mono 1.33:1

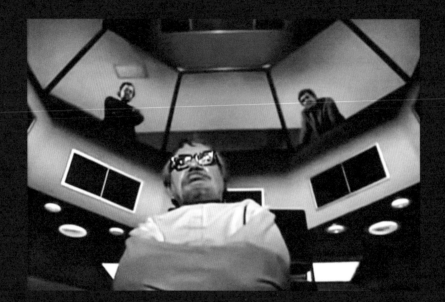

Production Dates: Fall 1970
Broadcast Date in the United States: January 15, 1971, on NBC

Production Company: Universal Television
Producer: Dean Hargrove
Associate Producer: Edward K. Dodds
Executive Producer: Richard Irving
Unit Production Manager: Edward K. Dodds

Screenplay: Philip Wylie
Director of Photography: Richard A. Kelley
Film Editing: Frank Morriss

Music: Billy Goldenberg, Robert Prince, Dave Grusin (series theme song)
Sound: Edwin S. Hall
Art Direction: William H. Tuntke
Set Decoration: Bert Allen
Costume Design: Grady Hunt
Hair Stylist: Larry Germain
Makeup: Bud Westmore

Starring: Gene Barry (Glenn Howard), Barry Sullivan (Dane Bigelow), Severn Darden (Cameron), Sharon Farrell (Sandrelle), Regis J. Cordic (Chairman Walt), Edmond O'Brien (John Bergman), Geoffrey Lewis (Bates), Jason Wingreen (Hammond)

SYNOPSIS

Glenn Howard, the head of Howard Publications, is driving through the hills of Los Angeles when he nods off and has an accident. He is revived by strangely dressed emergency responders who are wearing oxygen suits and masks. Once recovered, he is introduced to a man named Dane Bigelow, who reveals that Glenn has woken up in the year 2017, and that Los Angeles is now an underground city because pollution has made much of the planet uninhabitable.

GENESIS

Launched in 1968 on NBC, *The Name of the Game* stands in stark contrast to other popular series of the era. The program focused on three main characters who all worked at a fictional press group called Howard Publications, with each episode following the adventures of a single character. Benefiting from a considerable budget ($400,000 per episode), *The Name of the Game* dealt with serious subjects and gave viewers a glimpse into "a world of glamour and luxury that TV mostly wouldn't explore until *Dallas* and *Dynasty*,"[1] as journalist Michael Callahan summarized it. However, by the time the show reached its third season (1970–1971), the series was showing signs of weakness and producer Dean Hargrove was looking to experiment.

A Dreamlike Dystopia

A prolific author of screenplays, novels, short stories, and essays in which nuclear apocalypse is a common theme, Philip Wylie wrote a story for *The Name of the Game* in which one of the show's three heroes, publisher Glenn Howard, is confronted with the future consequences of environmental problems that were just beginning to be debated in the early 1970s. "LA 2017" is filled with references to *1984* and *Brave New World*, and many of the dystopian elements of the show also foreshadow later films like *Silent Running* (Douglas Trumbull, 1972), *Soylent Green* (Richard Fleischer, 1973), and *Logan's Run* (Michael Anderson, 1976). In order to convey this bleak vision of the future, the story was presented as a dream that Howard has while lying unconscious in his car.

Joan Crawford to the Rescue

Sid Sheinberg, the acting vice president of Universal Pictures, was a big fan of the series, and he reached out to Steven Spielberg about directing an episode. The show's producer, Richard Irving, was opposed to bringing Spielberg on board. Finally, actress Joan Crawford, who had worked with Spielberg on *Night Gallery* the year before, made a phone call to the big boss of Universal, Lew Wasserman, and she insisted that Wasserman hire the twenty-three-year-old director.

FILMING AND PRODUCTION

"LA 2017" was Steven Spielberg's first feature-length production. It had a twelve-day production window and a budget of $375,000. Spielberg filmed on the lot at Universal, and also in the barren hills of Calabasas, California (located to the north of Malibu), which stood in for the desolate landscapes of 2017. Spielberg also filmed on location at Hyperion, the huge wastewater treatment plant in Los Angeles. The plant had endless corridors clogged with pipes that appear in various scenes in the episode. The plant also famously appeared in 1973's *Soylent Green*.

Mad Max Before Its Time

Imagining the future provided the perfect opportunity for Spielberg to break free from the perceived shackles of television. The young director simulated the toxic air of Los Angeles with the help of orange filters, and he filmed multiple shots through the carcasses of abandoned cars that littered the sides of the road on set. The episode has the look of *Mad Max* (1979), but before its time.

A Climax of Anxiety

Humor and burlesque are not lacking in the episode's plot; however, the show's climax is reached during a meeting between Glenn Howard and John Bergman, a biochemist. Placed in isolation, Howard is forced into a straitjacket as he speaks with his captor, who looks down on him from above. The sets, the sound, the symmetry: Everything is cold and dehumanized in this scene. Steven Spielberg was strongly involved in the production of "LA 2017," and he was able highlight his expertise and his influences (Alfred Hitchcock and Stanley Kubrick, mainly). He followed the production through to the editing room, which is unusual in the world of television.

RECEPTION

The episode benefited from a stronger than usual promotional campaign from NBC, and it received rave reviews. Better still, it was screened at an annual science fiction festival in Trieste, Italy, in July 1971.

Ongoing Concerns

While it remains relatively unknown today, Spielberg's episode of *The Name of the Game* was exhumed by the Paley Center for Media in New York City and given a public screening on October 1, 2017. Given the state of the world today, it is difficult for modern viewers not to be disturbed by the show's prescient subject matter, which focuses on pollution, environmental disaster, a global pandemic, and the inaction of world leaders in the face of overwhelming calamity. With "LA 2017," Spielberg announced himself as a serious player, and as a director who could be trusted with longer formats and less conventional projects.

The Private World of Martin Dalton

Series: The Psychiatrist • Season 1, Episode 2

United States • **52 mins** • **Color** • **Mono** • **1.33:1**

Production Dates: Fall 1970
Date of Broadcast in the United States: February 10, 1971, on NBC

Production Company: Universal Television
Producer: Jerrold Freedman

Screenplay: Bo May
Director of Photography: Lloyd Ahern
Music: Gil Mellé
Art Direction: Joe Alves

Starring: Roy Thinnes (Dr. James Whitman), Stephen R. Hudis (Martin Dalton), Jim Hutton (Martin's father), Katherine Woodville (Martin's mother)

SYNOPSIS

Psychoanalyst James Whitman is called to the bedside of a twelve-year-old boy named Martin Dalton, who has completely lost touch with reality. The doctor soon realizes that the situation with the young boy's parents, who are in the middle of a divorce, is resulting in the child's desire to take refuge in a world that he has invented for himself, and that is heavily influenced by comic books and television.

GENESIS

Not yet thirty years old, Jerrold Freedman had already succeeded in breaking into the dusty hierarchy at Universal Studios. He wrote, directed, and produced for the television division, and seemingly did just about anything he wanted, including a series about a California psychiatrist who was convinced that the latest methods in his field—such as group therapy—were the most suitable for the times.

The show's pilot episode, "God Bless the Children," sets the stage for the series with a scene of young people frolicking in an abandoned factory and injecting drugs against a background of psychedelic rock music. Far from playing the role of a stern taskmaster, Dr. James Whitman (played by Roy Thinnes) speaks, listens, and often understands the distress of his patients. "At Universal, no one understood what we were doing," recalled screenwriter Bo May. "Basically no one at Universal Tower understood what we were doing. It was somewhat amazing that they ever agreed to the concept in the first place."[1]

A Band with Long Hair

Spielberg stepped somewhat hesitantly into the creative space that Freedman enjoyed at the time: "He had his own longhair film society right in the heart of Universal Studios. He employed a number of writers, directors, people dealing with esoterica, and he hired people from his college and people he knew from the East. I was just a young person, whom he liked at the time, and to whom he said: 'Here, do two *Psychiatrists* for me.'"[2] The young filmmaker did not hesitate before taking on directorial duties on "The Private Life of Martin Dalton" and "Par for the Course," two of the six additional episodes of *The Psychiatrist* that were planned after the show's pilot episode.

FILMING AND PRODUCTION

Spielberg shot two episodes of *The Psychiatrist* back-to-back in the autumn of 1970. Compared to his experiences on the series *Night Gallery* and *Marcus Welby, M.D.*, this latest adventure felt like a leisurely stroll in the park: There was no difficult production team to win over and no dubious star to contend with, and the show's plots were much more grounded in reality. This excited Spielberg's imagination and he enjoyed being involved in the development of the script. "The Private World of Martin Dalton" also took on a subject that was close to his heart: a child on the threshold of adolescence who is trying to make heads or tails of some of life's less savory aspects—in this case, the dissolution of his parents' marriage.

Under Protection

This episode of *The Psychiatrist* marked the first time that the young director worked with a child actor, which would eventually become a common occurrence on his film sets. The inventive Spielberg also created spectacular and terribly surprising dream sequences that were pretty groundbreaking for a standard network television series. Luckily, Spielberg was able to do pretty much whatever he wished: Freedman and May protected him from any possible interference from studio management. Additionally, although he was not involved in the editing process, the final product looked like what Spielberg had in mind from the start of production, which was a first in his career.

RECEPTION

As the second of six episodes (the pilot was broadcast on December 14, 1970), "The Private World of Martin Dalton" was scheduled to air on February 10, 1971, as part of NBC's Four in One evenings, which the network had been offering since September 16, 1970. The idea, which was newly in vogue with American television audiences, was to air four different shows one after the other, at the rate of one episode per week. In this case, the shows that were scheduled to air were *McCloud, San Francisco International Airport, Night Gallery* (including the episode "Make Me Laugh," which aired on January 6, and which had been directed by Spielberg), and *The Psychiatrist.* Of the four, only *McCloud* and *Night Gallery* were renewed for additional episodes.

Par for the Course

Series: The Psychiatrist • Season 1, Episode 6

| United States | 52 mins | Color | Mono | 1.33:1 |

Production Dates: Fall 1970
Date of Broadcast in the United States: March 10, 1971, on NBC

Production Company: Universal Television
Producer: Jerrold Freedman

Screenplay: Herb Bermann, Thomas Y. Drake, Jerrold Freedman, Bo May
Director of Photography: Lloyd Ahern
Music: Gil Mellé
Art Direction: Joe Alves
Makeup: Don Marando

Starring: Roy Thinnes (Dr. James Whitman), Luther Adler (Dr. Bernard Altman), Clu Gulager (Frank Halloran), Joan Darling (Mary Halloran), Bruce Glover (Stan Brewster), Michael C. Gwynne (Blaine), Carl Reindel (Larry)

SYNOPSIS

Psychiatrist James Whitman has the onerous task of supporting a professional golfer named Frank Halloran as he comes to terms with his terminal cancer diagnosis.

GENESIS

"Par for the Course" was the final episode of the series *The Psychiatrist*, which was canceled by NBC after only one season. In the show's final airing, Dr. Whitman is called to Frank Halloran's bedside after a terrible medical diagnosis. The doctor tries his best to comfort his patient, but he finds himself becoming increasingly distraught.

The episode's original script caused some difficulties for the show's writing team. Thomas Y. Drake left the process early to produce another series, and he was replaced by Herb Bermann, whose script treatment strongly displeased Jerrold Freedman and Bo May. In the end, Freedman and May rewrote the script themselves. May removed all references to LSD, which the studio might not have approved, and he also created a significant obstacle for his main character: Dr. Whitman was unable to find a way to save his patient.

A Closely Observed Death

Delighted to have been chosen by Freedman, Spielberg was put in charge of directing two episodes of *The Psychiatrist*, which were both shot in the fall of 1970. One episode was about a little boy who uses fiction as an escape from his family's troubles, and the other was about the acceptance of death, two subjects that touched Spielberg intimately. The little boy in "The Private World of Martin Dalton" represented Spielberg's own pain when his parents divorced, and "Par for the Course" allowed Spielberg to process the agony he felt while witnessing his grandfather's slow demise in a hospital bed. When asked how he was able to approach the show's subject matter with such subtlety, Spielberg spoke of the long hours he spent in the hospital with his dying grandfather, where he observed the pain of some patients and the silence of others in the face of their own mortality.

CASTING

After being discovered in *The Killers* (Don Siegel, 1964), Clu Gulager was an actor who was used to appearing on TV and his portrayal of the dying golfer Frank Halloran became one of his best-loved performances. Playing opposite him, Roy Thinnes had previously popularized the role of David Vincent in the series *The Invaders* (1967–1968), before taking on the titular role of *The Psychiatrist*.

FILMING AND PRODUCTION

Over the years, one anecdote from the set of *The Psychiatrist* has become something of a Spielbergian legend. One day, Chuck Silvers, the head of Universal Television's editorial department, was walking through the various parts of the studio when a technician came up to him and advised him to go to the set where Spielberg was shooting. Silvers resisted, but the technician insisted: "You've never seen a crew stand there and cry."[1] The scene that had drawn crew tears was the death of Frank Halloran, which Spielberg filmed with the camera placed as close as possible to Gulager's face, in an attempt to capture the actor's every breath and spasm. The team was also put to the test during a sequence where Halloran is visited by his golfing partners in the hospital. On the morning when the scene was set to be filmed, Spielberg had an idea: Instead of being frightened by their friend's condition as the script had intended, Spielberg wanted Halloran's fellow golfers to offer him a final gift: a shoebox containing dirt from the eighteenth and final hole of his favorite course, as well as the flag that marked it. Gulager, who was not warned of this change before the cameras started rolling, burst into tears and began to spill the dirt all over himself while the cameras captured every moment. Joan Darling, who played Halloran's wife, recalled that Spielberg had given her only one direction ahead of the death scene: to remember the images of Jackie Kennedy in front of her husband's body on the day of JFK's funeral—her demeanor, her manners, her dignity in spite of the pain and horror of the situation.

RECEPTION

"Young Steven Spielberg from his direction of that small film was firmly established as one of the most exciting talents in town," marveled the critic Cecil Smith in the *Los Angeles Times* in 1973. He was not the only one who felt that way about "Par for the Course," which would open many doors for the director, starting when the first cut of the episode circulated inside Universal's offices. After watching the episode, the creators of *Columbo* offered Spielberg an episode. Peter Falk himself was impressed, as was ABC vice president Barry Diller, who agreed to entrust the director with *Duel* that same year. With a reputation as an outstanding technician, Spielberg proved that he knew how to tell stories well and, above all, how to move an audience.

Steven Spielberg and Sid Sheinberg, then president of MCA/Universal, in Los Angeles in 1994.

A Kid from Universal City
The Childhood of a Filmmaker

In 1963, Gray Line buses had been taking tourists to Universal Studios for two years. That summer, Steven Spielberg, who was on vacation and still a high school student in Phoenix, Arizona, was among the passengers on the studio tour. For Spielberg, who had been making home movies since he was twelve, and who dreamed of being a filmmaker, the trip to the kingdom founded by Carl Laemmle in 1915 was like a pilgrimage. Taking advantage of a break in the tour, he let the bus leave without him and began to observe the filming in progress and the various editing rooms. He went so far as to offer to show technicians his 8 mm films.

"Steven Spielberg Room 23C"

Steven Spielberg has often told this story, adding details over the course of various interviews. For example, he had a chance meeting with Chuck Silvers, the assistant in the editorial department of Universal Television, who agreed to watch his films before giving him a day pass to the studio lot for the following day. Steven Spielberg then returned, dressed in a suit and carrying his father's (empty!) briefcase, in order to impress the security guard at the entrance. The highlight of the event was when he moved into a deserted bungalow and stuck the words "Steven Spielberg Room 23C" in plastic characters on a sign at the entrance.

At the time, Spielberg was a student at California State University, Long Beach, though he would have preferred to enter the film department at the University of Southern California (USC) in Los Angeles. Unfortunately, his academic record had worked against him. At Long Beach, there were no film classes, so Universal would have to be his school.

The backlot of Universal Studios, near Park Lake and James Stewart Avenue.

Assistant Factotum

This legend that Spielberg seems to enjoy embellishing refines the portrait of an obsessive filmmaker who was ready for all kinds of challenges. The reality was probably less exciting. In all likelihood it was his father, through an acquaintance, who enabled him to go and visit Universal while chaperoned by Chuck Silvers. Steven Spielberg kept in touch and came back the following summer for a small unpaid job as a handyman.

In the end, whether truth or fiction, the conclusion is the same: Filmmaker Steven Spielberg "grew up" at Universal, with Chuck Silvers as his mentor and Julia Raymond, head of purchasing for the editorial department, as his office mate. Steven Spielberg watched the Universal factory in operation while others were learning about film in college classrooms. He made friends with editor Tony Martinelli, actor Tony Bill, and writer and producer Jerrold Freedman; he was also introduced to Jeff Corey, an actor and acting teacher (he attended a few classes as an observer): These were all people with whom Spielberg would eventually work. Spotted by John Cassavetes while he was milling about on the lot, Spielberg found himself carrying coffees on *Faces*, which the actor-director had been filming since early 1965.

At the Heart of the Action, from the Sidelines

Spielberg was sometimes troublesome: He was kicked off the set by an assistant director during the filming of the ballet scene in Alfred Hitchcock's *Torn Curtain* (1966), but he became a kind of mascot as people started to think of him as the kid with the home movies. Even the vice president of Universal Television, Sid Sheinberg, had heard about him.

However, Steven Spielberg ended up going around in circles: He was both at the heart of the action and on the fringe. Having a foot in the door at Universal did enable him to move up a gear in his career. Julia Raymond introduced him to Denis Hoffman, an aspiring producer who agreed to finance a 35 mm film in Technicolor. This would be *Amblin'*, which came out in 1968. The same Julia Raymond found him a place to edit this short film of twenty-six minutes, and Chuck Silvers was amazed by the result. He insisted that Sid Sheinberg view it. The screening led to Spielberg signing a seven-year contract with Universal Television for $275 a week.

The Kindness of Sid Sheinberg

Steven Spielberg did not like the formatted framework of TV productions, or working with experienced technicians who tended to look down on him. He developed an aversion to medical series after working on an episode of *Marcus Welby, M.D.* (1970), and tried to sell a story to 20th Century Fox called *Ace Eli and Rodger of the Skies*, in the hope of making the film. Fox kept the story, but not the director, and so Spielberg returned to the fold at Universal.

Despite his frustrations, Steven Spielberg would always be able to count on the benevolence of Sid Sheinberg. "A lot of people will stick with you in success; I'll stick with you in failure,"[1] Sheinberg had said when he signed Steven's contract. When the shooting of *Jaws* turned into a disaster in 1974, Sid Sheinberg prevented his protégé from being replaced. When, in the 1980s, Steven Spielberg co-founded the production company Amblin, he set it up at Universal in a building built by the studio. It is still there today.

Murder by the Book

Series: Columbo • Season 1, Episode 1

🏳		🕐		🎞		🔊		◺
United States		**1 hr 16**		**Color**		**Mono**		**1.33:1**

Production Dates: Summer 1971
Date of Broadcast in the United States: September 15, 1971, on NBC

Production Company: Universal Television
Producers: Richard Levinson, William Link
Associate Producer: Robert F. O'Neill

Screenplay: Steven Bochco
Director of Photography: Russell Metty
Film Editing: John Kaufman
Music: Billy Goldenberg
Sound: David H. Moriarty
Art Direction: Archie J. Bacon
Set Decoration: Richard Friedman
Wardrobe: Burton Miller

Starring: Peter Falk (Lieutenant Columbo), Jack Cassidy (Ken Franklin), Martin Milner (Jim Ferris), Rosemary Forsyth (Joanna Ferris), Barbara Colby (Lilly La Sanka), Bernie Kuby (Mike Tucker), Hoke Howell (sergeant), Lynnette Mettey (Gloria Jr.), Haven Earle Haley (reporter)

SYNOPSIS

———

Jim Ferris and Ken Franklin are a famous duo of mystery writers whose heroine, Mrs. Melville, is always on the case. Between them, Ferris and Franklin have written fifteen best-selling books that have sold more than fifty million copies. When Ferris ends their collaboration and strikes out on his own, Franklin kills him using the same modus operandi that appears in one of their best-selling books. Lieutenant Columbo of the LAPD is put in charge of the investigation.

GENESIS

Universal's in-house producers and writers, William Link and Richard Levinson, created Lieutenant Columbo, a sleuth character who became famous for hiding his unerring intelligence under the guise of a seemingly haphazard cop. After producing a TV movie (*Prescription: Murder* in 1968) and a pilot ("Ransom for a Dead Man" in March 1971) that featured Peter Falk in the title role, Link and Levinson brought in Steven Spielberg to direct the show's first episode.

A Team of Top Players

In search of new blood, Link and Levinson wanted directors who would be able to revitalize the detective genre. Several episodes of *Columbo* were therefore shot by different directors during the summer of 1971, and Spielberg was chosen to go first. Nothing was gained, however, when the twenty-four-year-old prodigy began to arouse distrust among the veterans on his team. Among them, director of photography Russell Metty, a revered collaborator of Douglas Sirk and Orson Welles, who did not mince words with the producers: "He's a kid! Does he get a milk and cookie break? Is the diaper truck going to interfere with my generator?"[1] The writer of the episode was none other than Steven Bochco, a contemporary of Spielberg's and the future creator of popular shows *Hill Street Blues* and *NYPD Blue*, which would both renew public interest in the detective genre on television.

CASTING

Initially offered to Bing Crosby, the role of Columbo was taken by a then unknown: Peter Falk. Previously seen in small roles (*The Great Race* by Blake Edwards, 1965), he had also just appeared in *Husbands*, the first of three films he made under the direction of his friend, famed director John Cassavetes. The New York–based actor did not yet know that he had found the role of a lifetime in *Columbo*. The character's famous old raincoat and disheveled hair had already appeared in the pilot episode, but "Murder by the Book" marked the first appearance of his Peugeot 403 convertible.

FILMING AND PRODUCTION

After a complicated first day on set, during which a drunk actor had to be dealt with, the shooting went smoothly thanks to a good working relationship between Spielberg and Falk.

FOR SPIELBERG ADDICTS

In a 1974 episode of *Columbo* titled "Beyond Madness (Mind over Mayhem)," a gifted character named Steve Spelberg (sic) makes an appearance. In 1989, an episode titled "Shadows and Lights" features a successful director who kills a childhood friend that threatens to harm him. The nod to Spielberg in the later episode is supported by numerous clues, including action located in Universal Studios and an appearance of the shark from *Jaws*.

Just Like in the Cinema

As soon as the episode opens, with the pounding of a typewriter's keys as the only background sound, a dolly-like tracking shot takes a bird's-eye view of a Rolls-Royce (the assassin's) driving along Sunset Boulevard. Then the camera reveals an office on the high floor of a building where a man (the future victim) is busy writing his next novel. Spielberg immediately laid out his ambitions for his approach to this episode: "I treated it like a little movie....They're giving me a hundred and thirty thousand dollars, I'm gonna make it look like it cost a million bucks."[2]

In a few silent shots, the details of the plot are established using only images. The rest of the film follows suit, and the episode is a model of balance between staging done at the service of dialogue (alternating between the fluidity of long sequences captured in motion, and unsettling close-ups of faces when the situation becomes tense), clever use of interiors and natural settings, and stylish effects. Among these effects, some would become trademarks of the filmmaker, such as the very Hitchcockian reactive shot that distracts our gaze from a scene of violence while reinforcing its impact; or the use of the dual lens, underlining the duel that takes place when the murderer, in the foreground, and Columbo, in the background, are both in focus.

RECEPTION

Considered one of the best *Columbo* episodes ever made, "Murder by the Book" helped establish the basis of the series: A murder takes place, Columbo enters the scene and takes on the case; then a game of cat and mouse ensues between the murderer (usually rich and arrogant) and the detective, an ordinary, scruffy man who plays the fool in order to fool his prey. For Spielberg, this episode remains a precious memory of his time working in television.

Eulogy for a Wide Receiver

Series: Owen Marshall, Counselor at Law • Season 1, Episode 3

United States • **52 mins** • **Color** • **Mono** • **1.33:1**

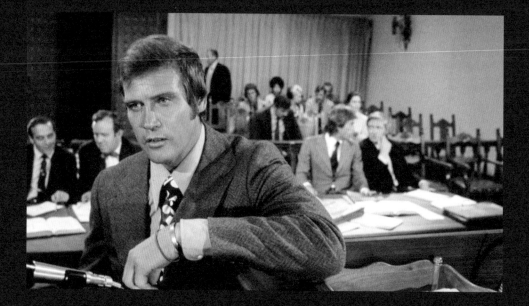

Production Dates: unknown
Date of Broadcast in the United States: September 30, 1971, on ABC

Production Company: Groverton Production, Universal Television
Producer: Jon Epstein
Executive Producer: David Victor

Screenplay: Richard M. Bluel

Director of Photography: Harkness Smith
Film Editing: Milton Shifman
Music: Elmer Bernstein
Art Direction: John J. Lloyd
Set Decoration: George Milo

Starring: Arthur Hill (Owen Marshall), Lee Majors (Jess Brandon), Christine Matchett (Melissa Marshall), Joan Darling (Frieda Krause), Stephen Young (Dave Butler), Brad David (Cliff Holmes), John David Carson (Martin Cardwell), Lou Frizzell (Sam Miller), Anson Williams (Steve Baggot), David Soul (Pete)

SYNOPSIS

———

After a hard-fought football game, a school's star player collapses in the locker room. His death is quickly attributed to amphetamines and his coach, an irascible and demanding character, is sued. Owen Marshall entrusts the defense of the accused to his partner Jess Brandon, who is a former football player.

GENESIS

By the summer of 1971, Steven Spielberg was on a roll at Universal. The "Par for the Course" episode of *The Psychiatrist* was a big hit at the studio, as was his "LA 2017" episode for *The Name of the Game*. There was also a new crime drama, *Columbo*, which Spielberg worked on with enthusiasm. And now he was invited to shoot an episode of a new series: *Owen Marshall, Counselor at Law*. Already, the concept was nothing extraordinary: Each episode was devoted to a case defended by a lawyer with humanist ambitions, the aforementioned Owen Marshall. This conceit was not enough to excite the imagination of a director eager to increase his stature in the business, and so Spielberg declined the initial offer to direct an episode.

A Screenplay Revised from Top to Bottom

Spielberg was obliged to honor his contract, especially since the producers, who had been impressed by his first steps at the studio, wanted him to take on the project. So, he took a look at a first script, which focused on a younger opera singer. Spielberg found the episode terribly flabby and rejected it immediately. Entitled "Eulogy for a Wide Receiver," the second script he was offered was better, even though the director still felt that it should be totally reworked.

CASTING

The title role of Owen Marshall was played by Arthur Hill, a Canadian actor with an extensive career in film and onstage. Among the actors who played his assistants was a thirty-year-old with considerable experience: Lee Majors. The latter had already made an impression with television audiences on the series *The Big Valley*, in which he played one of the main characters for four seasons; then he went on to become the bionic hero of *The Six Million Dollar Man*. Additionally, Joan Darling (who had become a friend of the director's after working with him on "Par for the Course") played Marshall's secretary.

FILMING AND PRODUCTION

The framework of the show was not very flexible: The first half of the episode typically set out the case of the week, and the second half followed the course of the ensuing trial. The young director was full of ideas, but many of them fell through when he discovered a newly released film called *Pretty Maids All in a Row* (1971) the day before shooting. Roger Vadim's film takes place in a high school and it included lots of shots and camera movements that Spielberg had planned for "Eulogy…," and which he thought were completely new.

Maximum Dynamism

Faces that occupy the foreground, unexpected changes of angle and crane movements: Each shot is conceived to instill new vitality to a classic plot, and the complexity of some of the shots threatened to upset the tight production schedule. In addition, "Eulogy…" enabled Spielberg to work a little more on his relationship with actors and to establish a certain rapport with them, to the great surprise of "veteran" Arthur Hill.

RECEPTION

Spielberg never had much regard for *Owen Marshall, Counselor at Law*. While filming in the corridors of a high school, there is no doubt that the twenty-year-old saw himself a few years earlier: a teenager dragging his loneliness through various schools according to the personal and professional ups and downs of his parents. He was struggling to integrate into the high school microcosm, to support its rituals, the glorification of athletes as well as the bullying of those who did not follow the implicit rules, the "different" ones, of which he was one.

Fallen into Obscurity

In his biography of Spielberg, Joseph McBride[1] highlighted this episode for its portrait of the coach, considering it to be the first true character study carried out by the future filmmaker. The character of the coach is initially despicable until his contradictions make him much more human. The series had a total of three seasons. When it was broadcast on September 30, 1971, on ABC, the episode of *Columbo* preceded it by fifteen days. There is no comparison between the two, to the detriment of "Eulogy…," which then sank into the limbo of an already burgeoning career.

FOR SPIELBERG ADDICTS

Lou Frizzell played the role of the prosecutor, Sam Miller. That year, the fifty-one-year-old actor experienced brief moments of glory: first as a pharmacist from whom a teenager wants to buy condoms in a cult sequence in *Summer of '42* (Robert Mulligan, 1971), then as a bus driver in *Duel*. He died in 1979, aged only fifty-nine.

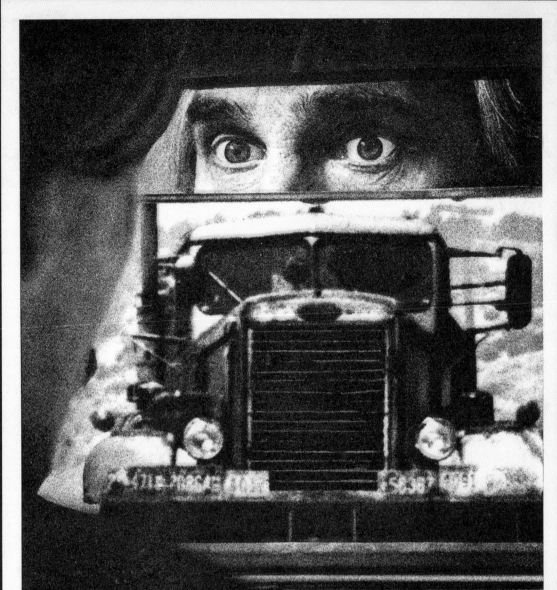

A duel is about to begin
between a man, a truck and
an open road.

Where a simple battle of wits
is now a matter of life and death.

DUEL

UNIVERSAL PICTURES Presents "DUEL"
The First Film Directed by STEVEN SPIELBERG Starring DENNIS WEAVER
Screenplay by RICHARD MATHESON Based on his Published Story
Produced by GEORGE ECKSTEIN A UNIVERSAL Re-Release

Duel

United States **1 hr 14** **Color** **Mono** **1.33:1**
(TV) (Technicolor) (Westrex Recording System) (TV)

1 hr 30 **1.85:1**
(film) (Film)

Production Dates: September 13–October 4, 1971
Date of Television Broadcast in the United States: November 13, 1971,
on ABC
Cinema Release Date in the United States: April 22, 1983

Production Company: Universal Television
Producer: George Eckstein
Unit Production Manager: Wallace Worsley Jr.

Based on the eponymous novel by Richard Matheson (1971)
Screenplay: Richard Matheson
Director of Photography: Jack A. Marta
Camera Operator: *Sherman* Kunkel
Insert Car Technician (*Hustis car*): Pat Hustis
Film Editing: Frank Morriss
Music: Billy Goldenberg
Sound: Edwin S. Hall
Sound Effects: Jerry Christian
Art Direction: Robert S. Smith
Set Decoration: Sal Blydenburgh
Assistant Director: James Fargo
Stunt Coordinator: Carey Loftin

Starring: Dennis Weaver (David Mann), Eddie Firestone (owner of Chuck's
Cafe), Lou Frizzell (bus driver), Jacqueline Scott (Mrs. Mann), Gene Dynarski
(client in Chuck's Cafe), Shirley O'Hara (waitress), Lucille Benson (the woman
at Snakerama), Tim Herbert (service station employee), Dick Whittington
(voice on the radio), Carey Loftin (truck driver), Alexander Lockwood (old
driver), Amy Douglass (old driver's wife)

"It's terrifying. It's like a Hitchcock movie, it's *Psycho* or *The Birds* only it's on wheels."[1]

—Steven Spielberg, on the short story "Duel," in 2001

SYNOPSIS

———

David Mann takes his car to go to a business meeting. He leaves his housing estate, drives through Los Angeles and onto the rural roads of California. After a tanker truck tries to prevent him from passing, David stops at a gas station. He takes the opportunity to call his wife to discuss their argument from the day before. Back on the road, he is confronted by the tanker truck again. The vehicle becomes increasingly aggressive. Set in a landscape of arid hills and dust, and on deserted roads, the tanker truck starts to terrorize David Mann.

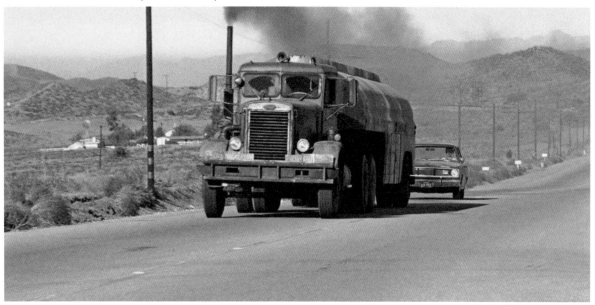

The first encounter between the Plymouth and the mysterious tanker.

GENESIS

The idea for *Duel* was hatched on November 22, 1963, the day of the assassination of President John F. Kennedy. Shaken by the tragedy, writer Richard Matheson was driving home from a golf game with a friend when a truck slammed into their car. Skidding and spinning, they narrowly avoided a major accident. Shocked and furious, Matheson imagined a story about a motorist being chased by a semitrailer truck, with no explanation of the driver's motives other than a desire to kill.

Monologues Spoken Aloud

The author of *I Am Legend* (1954), Richard Matheson was already writing a lot for television and cinema (including episodes of *The Twilight Zone* and adaptations of Edgar Allan Poe, or of his own books). For years, he had been submitting his strange ideas to television series producers without success. He then wrote "Duel" as a short story, and it appeared in an April 1971 issue of *Playboy* magazine.

At this point, Richard Matheson himself no longer believed in the possibility of adapting the minimalist plot of "Duel" to the screen. So when George Eckstein, a producer at Universal, acquired the rights to "Duel" and asked the author to write the script, Matheson was reluctant. On August 16, 1971, he finally handed in a ninety-one-page script, faithful to the original text but enriched as much as possible with monologues—either spoken aloud or internal—by his motorist character, David Mann, in order to achieve a less austere representation on the screen. For his part, George Eckstein tried to develop the project for the big screen, but for this he needed

a star and none were interested. Gregory Peck, in particular, declined an offer to play the lead role. The producer therefore marked *Duel* for ABC's flagship program "Movie of the Weekend," and set about searching for a director who could do the job.

Memories of Arizona

At the same time, Steven Spielberg was restless to get out of the television box at Universal. His assistant, Nona Tyson, spoke to him enthusiastically about *Duel*. She had read the story in *Playboy*, and she knew that George Eckstein was preparing the film for broadcast on ABC. Spielberg then immersed himself in Matheson's text. He saw a perfect opportunity to make a "visual narrative"[2] without the burden of a character-based plot. The atmosphere of *Duel* also seemed oddly familiar to him: "I grew up in Arizona and we subscribed to a magazine called *Arizona Highways*. It was always shots of roads going to infinity, going off into the vanishing point."[3] On an even more intimate level, this story reminded him of his own past as a high school student who was harassed and bullied for being Jewish.

He called George Eckstein. The two men had never met, but Spielberg knew that his own reputation at Universal did not necessarily work in his favor: He was the avant-garde "kid," the favorite of vice president Sid Sheinberg, and the youngster who wanted to move up the ladder. Moreover, George Eckstein was among those who were not impressed by *Amblin'*, the short film that earned Spielberg his contract with the studio.

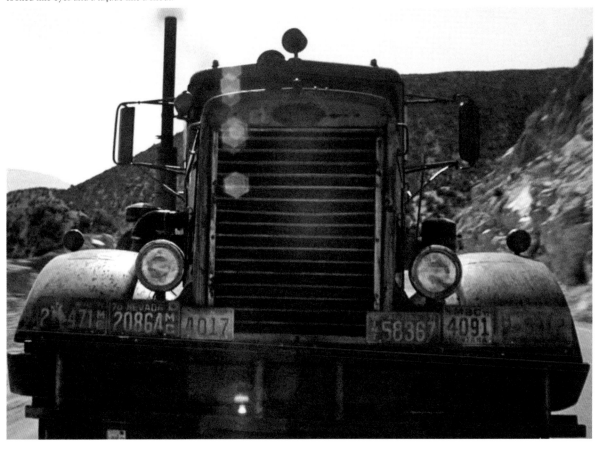

Steven Spielberg chose this truck for its animalistic look, including headlights that looked like eyes and a façade like a snout.

"Follow the Script"

At the producer's request, Spielberg showed him what he considered his best work at the time: a first cut of the unaired *Columbo* episode; in exchange, Eckstein gave Spielberg the script for *Duel*. On that basis, they met again. The producer was won over by *Columbo*, and now he wanted to know how the "kid" intended to bring *Duel* to the screen. And Steven Spielberg set out his vision: It would be a story told through editing, framing, movement, and sound. He even considered eliminating all the monologues from the screenplay; for him, the film should create tension and paranoia by focusing on the driver's point of view. The producer agreed. Fortunately, ABC head honcho Barry Diller, who was perplexed about the project and about the choice of Spielberg to direct, changed his mind after watching the "Par for the Course" episode of *The Psychiatrist*, which Spielberg had also directed. At the end of August 1971, it was official: The young director would take the helm of *Duel*.

Steven Spielberg did not touch the script, and especially not the principle of the invisible and anonymous driver (in the short story, his name is written on the truck, "Keller" like "killer"). He only added the opening scene, in which David Mann leaves his home. For the rest of the film, as Matheson summarized, "Steven did what I think every director should

A Road Killer

The star of the film is a 1955 Peterbilt 281, a tanker truck selected by Steven Spielberg for its face-like cab. The vehicle was literally made up as a monster—it was stained with oil, grease, dust, and crushed insects, and its bumper features half a dozen license plates, a sort of trophy gallery of past victims. There was only one truck used in the television version of *Duel.* For the added scenes that appeared in the movie version, two other 1961 models were obtained.

Inside Chuck's Café, a suffocating sequence featuring David Mann.

do: if you have a good script, stay with the script and add your own brilliance to it."[4]

CASTING

For the role of David Mann, who spends most of his time alone in a car, Spielberg chose Dennis Weaver. He was a television actor (in series like *Gunsmoke*, *Kentucky Jones*, and *Coogan's Bluff*), but the director remembered him most for his performance as a crazy motel clerk in *Touch of Evil* (Orson Welles, 1958). He wanted the same thing for the film's final outburst, after the "death" of the truck. The other actors are all from the small screen. Jacqueline Scott (Mrs. Mann) notably played Dr. Kimble's sister in the series *The Fugitive* (1963).

The Stuntman from *Bullitt*

All we see of the truck driver is an arm through the open door window, as well as his boots and hands behind the wheel in a few final shots. These appendages belong to a fifty-seven-year-old acclaimed stuntman, Carey Loftin. Loftin had previously worked on

several feature films known for impressive automotive sequences: *Bullitt* (Peter Yates, 1968), *The French Connection* (William Friedkin, 1971), and *Vanishing Point* (Richard C. Sarafian, 1971), a slick film released the previous March that left its mark on Steven Spielberg. In fact, *Duel* has many elements in common with *Vanishing Point*.

FILMING AND PRODUCTION

For Universal, *Duel* was just another production that needed to be completed in eleven days. Steven Spielberg was distraught: He wanted to shoot on real sets, but with such strict deadlines it was almost impossible (he exceeded the schedule by three days). The production manager, Wallace Worsley Jr., insisted on shooting all the vehicle interiors on a soundstage, with road and landscape shots in used to fill the background, but the director knew that with that kind of artifice, the film would fall flat. Worsley issued an ultimatum: Spielberg could start by shooting landscapes and if he failed to keep to the first three days' schedule, he would return to the studio.

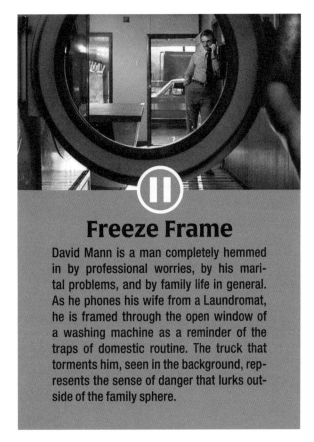

Freeze Frame

David Mann is a man completely hemmed in by professional worries, by his marital problems, and by family life in general. As he phones his wife from a Laundromat, he is framed through the open window of a washing machine as a reminder of the traps of domestic routine. The truck that torments him, seen in the background, represents the sense of danger that lurks outside of the family sphere.

The pressure was enormous, but Spielberg held firm thanks to his meticulous organization.

An Emergency in a Small Corner of Landscape

The entire filming of *Duel* took place in desolate areas north of the San Fernando Valley, on Highway 14, along Soledad Canyon Road and Vasquez Canyon Road. The film locations were in a small area between the Sierra Highway and the town of Acton, and the crew rushed from one location to another. Composer Billy Goldenberg, who was asked to create the music while the film was being shot, came along in a truck to soak up the atmosphere. For the opening scene, Spielberg went with the most practical location: David Mann's house, which was located at Toluca Lake just north of Universal Studios.

Instead of laying the film out on storyboards, Steven Spielberg literally drew a map of the film shoot. For each day of the shoot he indicated all the locations and the attendant action, the movements of the vehicles on the roads, and the positions of the cameras. The plan was posted on the four walls of his motel room in Pearblossom, California, so that he could "see" his film even before shooting it.

On the Road with the Hustis Car

Spielberg's other trick was to position several cameras on the same stretch of road, but bordered by two different geographical features: a cliff on one side and a plain or ravine on the other. Spielberg filmed the truck and car moving in one direction, and then he moved the cameras to the other side of the road and filmed the vehicles going in the other direction. The result gives the illusion of two different landscapes even though everything was shot in the same place.

But the centerpiece of his plan was the Hustis car. For *Bullitt*, technician Pat Hustis invented this strange device using a race car chassis: It enabled a camera to be mounted on board the car so that footage could be filmed on the road, and as close as possible to the moving vehicles. We have the Hustis car to thank for the long sequence that begins in David Mann's garage, and for the strikingly fluid shots of the camera passing from the back of the red Plymouth to the front of the truck in the same movement.

On the Back Seat

Steven Spielberg kept the intriguing images coming thick and fast during production. The front of the truck was framed at a low angle and cameras were placed on the front wing, the rear wing, the hood, and even inside the Plymouth, which was driven by Dennis Weaver as much as possible. In a technique tested on "LA 2017," the director sat in the back seat with a camera. The character is filmed looking tightly enclosed in his cabin or shown in the reflection of his car mirrors. The oppressive atmosphere is palpable, further accentuated by the sensation of dusty heat reflected by the colors and the light of the landscape. Spielberg relied on the skills of his director of photography, Jack A. Marta, who had worked on a number of westerns in the 1950s.

The sensation of speed was also an illusion created for the film: The vehicles were in fact driving slowly, but they were filmed against fixed backgrounds, such as a cliff. Even at low speed, such a background appears blurred in the image because the camera's focus is on the vehicle in the foreground. The vehicle then appears to be speeding along at an alarming rate.

An Ordinary Man

Despite his initial intentions, Steven Spielberg did not cut out all the lines from the script, and he added details about the character that were initially missing. His impersonal residential suburb, his fear of

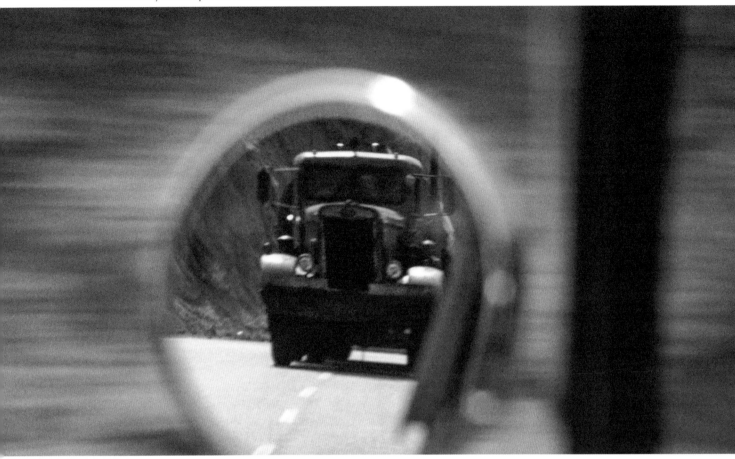

Duel was filmed entirely from the point of view of the car's driver.

losing a client, and the radio talk show he listens to in his car: Everything was used to evoke his insecurities, both familial and professional. In his shirt and tie, David Mann anticipates the ordinary men who are pushed into extraordinary adventures, a common theme that Spielberg often emphasized.

More than fifty years later, the bravura piece of *Duel* is its finale. The director envisaged it as the collapse and agony of a monstrous animal, but without an explosion. Aware that he would not be able to redo the take, Steven Spielberg recorded the fall of the semitrailer, using six cameras to complete the shot. This was unheard of for a TV production, but it was the only way to get enough shots to edit the sequence. One of the cameras managed to capture the entire stunt, a choreography of sheet metal, smoke, and dust, that no one in the crew would have dared dream of. This is the only shot that was ultimately retained.

Reshooting the Ending?

Once filming ended, what followed was a race against time: for three and a half short weeks, five editors worked on the final film at the same time.

FOR SPIELBERG ADDICTS

In April 1978, CBS broadcast "Never Give a Trucker an Even Break," an episode of *The Incredible Hulk*, which was produced by Universal. It reused many shots from *Duel* without agreement from Spielberg. Unfortunately, Spielberg's hands were tied: His Universal contract allowed for this kind of practice.

They worked wonders, but on the day the ABC executives saw the film, they were in for a nasty surprise: They wanted fireworks at the end, and they demanded that the final sequence be redone. For Spielberg, this was out of the question. It took all of George Eckstein's influence with the network to allow Spielberg to get his way.

RECEPTION

From the moment it was screened in-house, the film made its mark. On Richard Matheson, first of all, who approved of all Spielberg's choices, including

the closing scene; on Barry Diller, from ABC, who immediately understood that he was dealing with a movie...and not just a TV movie. When it was broadcast, the audience feedback was positive, but not record-breaking. The critics, on the other hand, were ecstatic. *Daily Variety*, the *Hollywood Reporter*, the *Los Angeles Times*, and the *Chicago Daily News* (which wondered if *Duel* was the best TV movie ever made) all raved about the audacity of the concept, the mastery of suspense, the wide shots worthy of a Western, and the experimental music. The absence of an explosion at the end was even praised because it avoided cliché.

Back into the Desert

This general enthusiasm gave Universal an idea: to release *Duel* in cinemas in Europe. However, the film was too short. So, in March 1972, Steven Spielberg stretched the opening sequence and went back to the desert with a model of a tanker similar to the type he used during initial filming. He filmed the enormous truck trying to push the car under a train. Based on an idea by George Eckstein, he staged a telephone conversation between David Mann and his wife, underlining the tensions between them, which Matheson and Spielberg found unnecessary. Finally, the director treated himself to a sequence involving a school bus and a threat to helpless children.

The film was extended by fifteen minutes and released in the UK in October 1972. The critics were effusive. In France, *Duel* won the Grand Prix at the very first Avoriaz International Fantastic Film Festival (Festival international du film fantastique d'Avoriaz), in February 1973. In July, at the Taormina Film Festival in Italy, it was awarded the title of "Best First Film."

A Fan Called Fellini

In September, Steven Spielberg went to present the film in Rome. It was his first trip to Europe. At his hotel, he was dragged out of bed by a fan of the film who insisted on congratulating him in person: Federico Fellini. Spielberg spent the afternoon explaining how he made *Duel* to the director of *La Dolce Vita* (1960). However, the press conference he gave later on during his trip was tense. The director was questioned about sociopolitical interpretations that he did not agree with and four journalists stormed out of the room. Richard Matheson, who was skeptical of the longer version of *Duel*, heard this criticism in the form of a compliment: "You can't expand perfection."[5] The effect was not immediate, but this film changed Steven Spielberg's career.

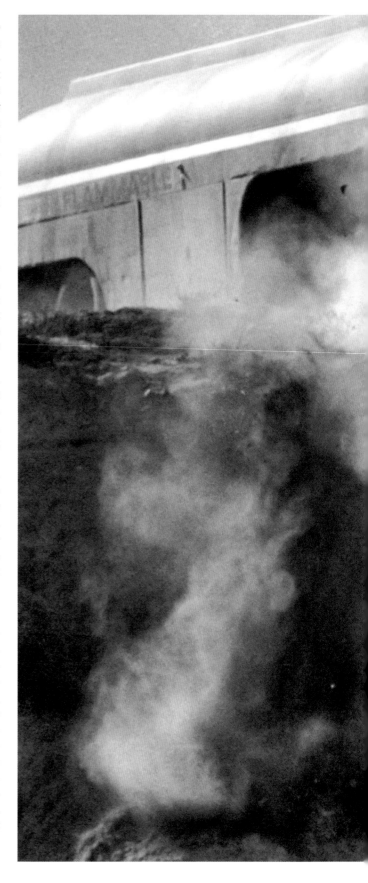

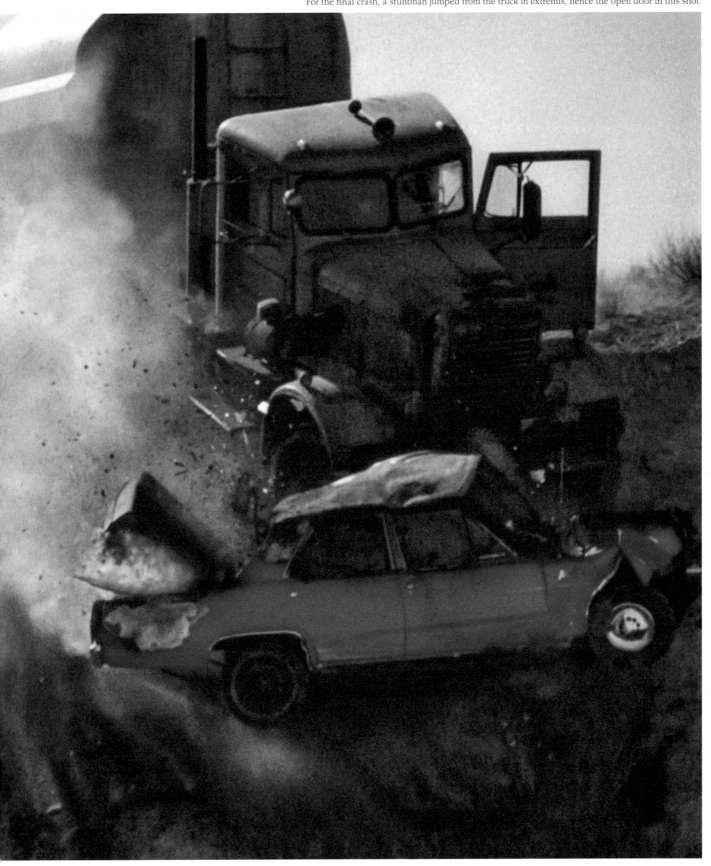

For the final crash, a stuntman jumped from the truck in extremis, hence the open door in this shot.

Something Evil

United States · **1 hr 13** · **Color** · **Mono** · **1.33:1**

Production Dates: Fall 1971
Date of Broadcast in the United States: January 21, 1972, on CBS

Production Company: Belford Productions, CBS Entertainment Production
Producer: Alan Jay Factor
Associate Producers: David Knapp, Harvey Lembeck
Unit Production Manager: Edward O. Denault
Screenplay: Robert Clouse
Director of Photography: Bill Butler
Film Editing: Allan Jacobs
Music: Wladimir Selinsky
Sound: George Ronconi

Art Direction: E. Albert Heschong
Set Decoration: Sandy Grace
Costume Design: Stephen Lodge, Agnes Lyon
Assistant Director: Jack Roe

Starring: Sandy Dennis (Marjorie Worden), Darren McGavin (Paul Worden), Johnny Whitaker (Stevie Worden), Ralph Bellamy (Harry Lincoln), Jeff Corey (Gehrmann), John Rubinstein (Ernest Lincoln), Laurie Hagen (Beth), Debbie and Sandy Lempert (Laurie Worden)

SYNOPSIS

A New York family—Paul and Marjorie Worden and their two children, Stevie and Laurie—buy a property in the Pennsylvania countryside. The seller, Gehrmann, tries to talk them out of it, but to no avail. The Wordens move in, but disturbing events soon start piling up. Marjorie is overcome by anxiety, while Paul is too busy with his work. An old man with a passion for the occult named Harry Lincoln tries to help them, but the situation soon grows dire.

GENESIS

The artistic and critical success of *Duel*, in November 1971, did not pave the way to a feature film for Steven Spielberg. Instead, Universal sent him to shoot a Friday night TV movie for CBS. Contemporary horror stories were in fashion following the success of *Rosemary's Baby* (Roman Polanski, 1968) and ABC was already exploiting this new market. In June 1971, William Peter Blatty's bestseller *The Exorcist* (adapted for the cinema by William Friedkin in 1973) confirmed the trend.

A Mother's Love

Filmmaker Robert Clouse wrote the script for *Something Evil* in this same vein as *The Exorcist*. It features a distraught mother and an aggressive child who turns out to be possessed, and the possession can be seen as a metaphor for preadolescent rebellion. In the case of Stevie Worden, the possession also represents an older child's fear of being less loved once a younger sibling arrives on the scene. The film's ending was calibrated for a family audience, focusing on the love that a mother, Marjorie Worden, has for her son.

CASTING

Two actors with proven television careers played the Worden parents. As a sign of the times, Sandy Dennis (Marjorie) appeared in another 1970 scary TV movie called *The Man Who Wanted to Live Forever* (John Trent), and Darren McGavin appeared in a horror TV movie called *The Night Stalker* (John Llewellyn Moxey) on ABC just ten days before *Something Evil* premiered. Johnny Whitaker, who played little Stevie, was known at the time for his involvement in the CBS series *Family Affair* (1966–1971).

Echoes of *Rosemary's Baby*

Ralph Bellamy, in the role of a fan of the occult, played an evil doctor in *Rosemary's Baby*, which helped maintain the viewer's distrust of his character in *Something Evil*. As for Gehrmann, he was played by Jeff Corey, an acting coach who was blacklisted by the studios in the early 1950s for not testifying against communist sympathizers or supposed communists. Steven Spielberg attended his classes in 1966, and Corey would eventually return in front of and behind the camera some twelve years later.

FILMING AND PRODUCTION

The story of *Something Evil* is set in Pennsylvania, but everything was filmed in California. The main house and barn are on the Golden Oak Ranch, a Walt Disney studio site, and the interiors were filmed on CBS sets located in Studio City, to the north of the Hollywood Hills.

Red Halo in Jars

Something Evil included few special or shocking effects, as well as a few holes in the screenplay, and the overall vibe is one of a film being made on a shoestring budget. Graphically, a pulsating red halo is the horrific peak reached by this TV movie. Spielberg compensated with his camera movements and frame compositions, which were unusual for a television format and included a slow-motion prologue, handheld camera, sequence shots, ground-level views, and low-angle shots behind a ladder. A complex superimposition of three images marks the final scene, and the focus sometimes changes within the same shot (rack focus): An image of a pensive Marjorie thus becomes completely blurred, replaced in the foreground by the dead leaves of a potted plant.

An Appearance by the Director

Something Evil marked Steven Spielberg's first collaboration with director of photography Bill Butler (*Jaws*). For the interiors, Butler composed a blinding backlighting that blurred the silhouette of the characters. Two reception scenes enable Spielberg to poke fun at social rituals. The first takes place at the Worden's house: The atmosphere is hushed and the guests (including the director himself and Carl Gottlieb as extras) are motionless. The contrast with the second reception scene is stark: a meeting of neighbors, noisy and agitated by the fatal accident of the Wordens' friends.

RECEPTION

While the director's technique attracted the attention of the critics, *Something Evil* did not impress many people. In retrospect, we can see in the character of Paul Worden, who leaves home to work in New York, the motif of the failing and flailing father, which would soon become a recurring theme in Spielberg's work.

Neither Original nor Scary

Two interesting facts: The image of a windshield cracking in *Something Evil* prefigures a similar effect in *The Lost World: Jurassic Park* (1997), and another image of Marjorie entangled in vines evokes a scene from *Minority Report* (2002). Nevertheless, this film does not rise to the level of *Duel*. Spielberg himself did not care much for it: By agreement with CBS, *Something Evil* was never released on video or DVD.

Savage

🏳 United States · 🕐 1 hr 13 · ◉ Color · 🔊 Mono · ▱ 1.33:1

Production Dates: December 1971–January 1972
Date Broadcast in the United States: March 31, 1973, on NBC

Production Company: Universal Television
Producer: Paul Mason
Executive Producers: William Link, Richard Levinson
Unit Production Manager: Edward K. Dodds

Based on the original story "The Savage Report" by Mark Rodgers
Screenplay: Mark Rodgers, William Link, Richard Levinson

Director of Photography: Bill Butler
Film Editing: Edward M. Abroms, Steven Spielberg (uncredited)
Music: Gil Mellé
Sound: John K. Kean
Art Direction: William H. Tuntke
Set Decoration: Joseph J. Stone

Starring: Martin Landau (Paul Savage), Barbara Bain (Gail Abbott), Barry Sullivan (Daniel Stern), Louise Latham (Marian Stern), Susan Howard (Lee Raynolds), Will Geer (Joel Ryker), Paul Richards (Peter Brooks), Michele Carey (Allison Baker)

SYNOPSIS

In Los Angeles, investigative journalist Paul Savage hosts a popular television magazine show called *The Savage Report*. After attending a press conference given by Judge Stern, who has been appointed to the United States Supreme Court, he is approached by a young woman named Lee Raynolds, who has a potentially incriminating photo of her and the judge. She demands $5,000 in exchange for the photo. As Paul Savage begins to investigate, Lee Raynolds is found dead.

GENESIS

From the outset, *Savage* was never on very firm footing. Steven Spielberg was under contract at Universal Television, but he only dreamed of making movies. However, the studio's president, Sid Sheinberg, offered Spielberg a script that combined a political thriller with a dive into the world of television. Sheinberg saw in it the material for the pilot of a new series for NBC, with whom the studio had a production and distribution agreement.

Transcending the Content

The William Link–Richard Levinson duo, who were the creators of *Mannix* (1967) and *Columbo* (1971), were asked to rework the story. The two authors were struggling with it, and they saw only one way to transcend this content: to call upon the services of an exceptional director. Without warning, they submitted the name of Steven Spielberg to Sid Sheinberg. Spielberg was so hostile to the idea of returning for a TV movie that Sheinberg threatened to suspend him. According to William Link, the director left his boss's office in tears…but he complied.

CASTING

Martin Landau played many supporting roles in notable films, including appearances in Alfred Hitchcock's *North by Northwest* (1959). He was then known as one of the agents on *Mission Impossible*, which had been broadcast on CBS since 1966. His *Mission Impossible* co-star and real-life spouse, Barbara Bain, was also cast in a supporting role.

The Return of a Couple

The judge character was played by Barry Sullivan. He had worked twice with Spielberg, for the episodes "Eyes" in *Night Gallery* and "LA 2017" in *The Name of the Game*. Louise Latham played Barry Sullivan's wife in "LA 2017," in a similar role as a self-effacing, almost catatonic woman. The manipulative Joel Ryker is played by a former victim of McCarthyism, Will Geer (suspected of supporting the American Communist Party, he had been blacklisted from Hollywood in the late 1940s). A man of the stage, he overplays his deceptively good-natured character with relish.

FILMING AND PRODUCTION

Steven Spielberg had set a scene at a publicity shoot in *Something Evil*. *Savage* was an opportunity to delve further into the world of show business by showing all the workings of a television show, from the set to the control room. His camera twirls, zooms, and threads between the cables and the projectors. Between inserts, handheld shots, low-angle shots, and close-ups of stressed faces, the scene that introduces the set of *The Savage Report* makes you dizzy.

Simulated Split-Screen

Exploiting the presence of the control monitors, during editing Spielberg sequenced what is seen on the screens and in the real scene, even filming the two images simultaneously in a simulated split-screen. He also slipped in another scene of a commercial, filmed in the very geometrical setting of the Los Angeles Music Center, at the foot of the cylindrical structure of the Mark Taper Forum: a way of getting away from the ubiquitous simulated studio sets.

A Climax in the Shadows

The classic field-to-field shot is unusual. Spielberg negotiates a press conference scene by turning around the protagonists, and the dialogue benefits from his favorite treatment: including all the characters in the visual field and playing with the foreground and background. The process borders on abstraction in the film's climax: an assassination attempt on the set of *The Savage Report* where everything is plunged into darkness. The murderer and his prey are reduced to two shadows moving in the same direction, at a distance from each other and without any real logic. Suspenseful indeed!

RECEPTION

Martin Landau found the TV movie promising, even avant-garde in its examination of the media machine. But the film did not do much to question the system, and the plot struggled to convince, as *Daily Variety* noted. The *Hollywood Reporter* deplored some of the "most improbable dialogue ever heard in a television studio."[1]

"Outstanding Photography"

According to the *Hollywood Reporter*, the confrontation between Paul Savage and the judge's wife, who comes over to confide her psychiatric problems and excuse her husband's errors, bordered on the ridiculous. In the end, and once again, Spielberg's "imaginative camerawork" and Bill Butler's "outstanding" photography are both applauded. *Savage* did not become a series. Spielberg, on the other hand, was caught up in the critical success of *Duel* in Europe when this 1971 TV movie was released.

Looking at the Stars
A Stellar Spectacle

Crowds filled with wonder, individuals fascinated or threatened: Characters with their eyes fixed on the heavens, facing the unknown, abound in Spielberg's films. Is this reminiscent of the meteor shower a young Spielberg witnessed alongside his father and a mass of anonymous people gathered in the middle of a field? It is impossible not to see in it a projection of ourselves, as spectators, with our eyes riveted to the big screen. The mirror effect, often supported by a tracking shot, intensifies our identification with the characters in a film and the impact of what is being watched. The fact that this motif of communion between the film and its audience has become a signature feature of Spielberg's films only further cements his reputation as a filmmagician.

E.T. the Extra-Terrestrial, 1982.

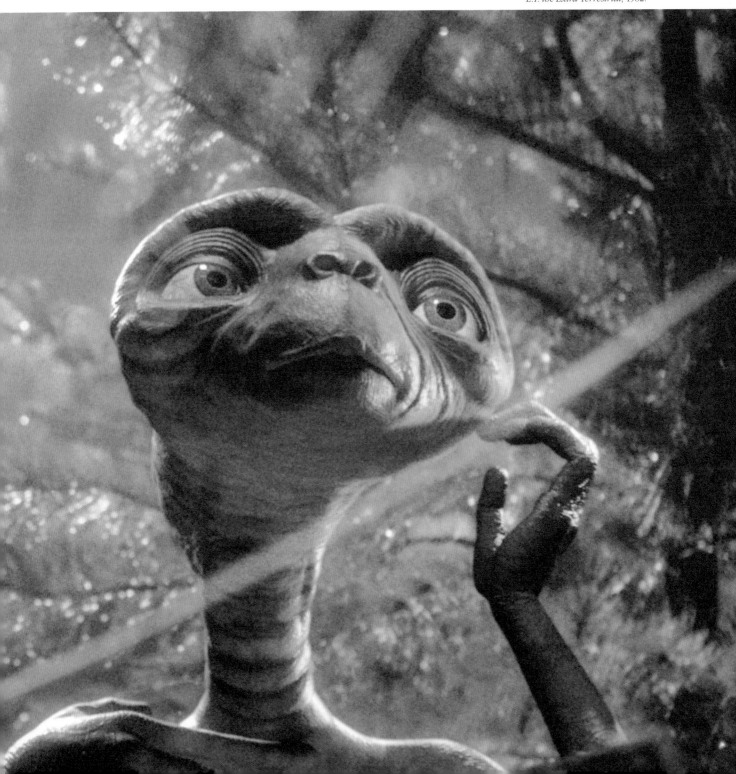

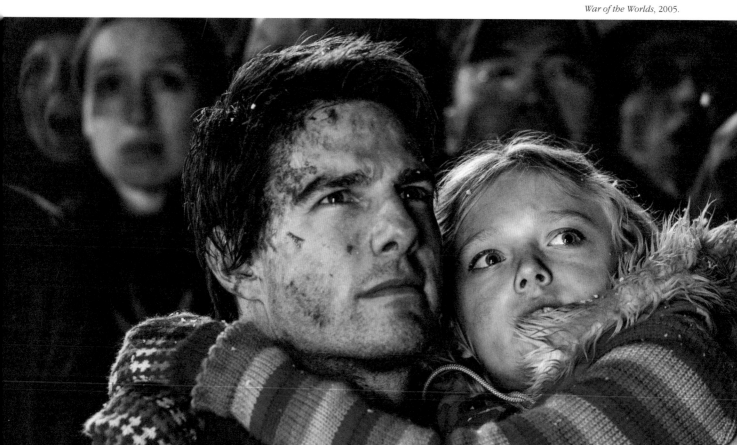

The Lost World: Jurassic Park, 1997.

Schindler's List, 1993.

Ready Player One, 2018.

The Sugarland Express

United States 1 hr 48 **Color** (Technicolor) **Mono** 2.39:1

Production Dates: January 15–end of March 1973
United States Release Date: March 30, 1974 (New York);
April 5, 1974 (rest of the country)

Worldwide Box Office: $7.5 million (equivalent to $45 million in 2022)

Production Company: Zanuck/Brown Company
Producers: Richard D. Zanuck, David Brown
Executive Producer: William S. Gilmore Jr.
Unit Production Manager: William S. Gilmore Jr.

Based on a story by Steven Spielberg, Hal Barwood, and Matthew Robbins
Screenplay: Hal Barwood, Matthew Robbins
Director of Photography: Vilmos Zsigmond
Camera Operator: Jack Richards
Film Editing: Edward M. Abroms, Verna Fields
Music: John Williams
Sound: John Carter, Robert Hoyt
Art Direction: Joe Alves
Set Decoration: Bill Dietz, Mike Fenton
Wardrobe: Robert Ellsworth, James Gilmore
Special Effects: Frank Brendel
Stunt Coordinator: Carey Loftin
Casting: Mike Fenton

Starring: Goldie Hawn (Lou Jean Poplin), Ben Johnson (Captain Tanner),
Michael Sacks (Maxwell Slide), William Atherton (Clovis Poplin), Gregory
Walcott (Mashburn), Steve Kanaly (Officer Ernie Jessup), Louise Latham (Mrs.
Looby), Harrison Zanuck (baby), A.L. Camp (Mr. Alvin T. Nocker), Jessie Lee
Fulton (Mrs. Nocker), Dean Smith (Russ Berry), Ted Grossman (Dietz), Bill
Thurman (Hunter), Buster Daniels (drunkard)

"They're nothin' but a couple of kids."

—

—Captain Tanner, referring to Lou Jean and Clovis

SYNOPSIS

—

When Lou Jean visits her husband Clovis in jail, she has received some bad news: Their baby will be placed in an adoptive home. Clovis says he only has four months left to serve, but Lou Jean won't listen and convinces him to escape to get their son back. After stealing a car, they are pursued by a highway patrolman, Maxwell Slide, who finally catches up with them after a near-fatal chase. But as he approaches them to save them, the duo takes advantage of a moment of inattention to steal his gun and take him hostage in his police car. Soon, all the authorities in the area are alerted: Two dangerous individuals are driving in a patrol car with an officer held captive. Once the press catches wind of the situation, the story arouses a particular fervor in the local population.

GENESIS

The Sugarland Express is based on a real news story. In its May 2, 1969, edition, the *Hollywood Citizen-News* published a short story about a chase in Texas involving a couple, Bobby and Ila Fae Dent, and a hundred local police cars. The man, who was fresh out of prison, and his wife took an officer hostage and threatened to kill him if they didn't get to see their children, who had been placed with the man's stepfather. After leading the authorities on a chase of over six hundred miles, the story ended with the release of the officer, the arrest of Ila Fae, and the death of Bobby, who was shot by the police.

Ripped from the Headlines

When Spielberg read the article, he quickly knew he had found the subject for his first feature film. *The Sugarland Express* was his film debut (*Duel* was a TV movie), but little did he know that it would be five years before it was released. The director submitted the project to Universal, but nobody at the studio believed in the financial potential of the story. Spielberg then continued to bide his time with television work while trying to break into the cinema with projects that were eventually realized without him (*Ace Eli and Rodger of the Skies*, which was directed by John Erman in 1973, and *White Lightning,* which was directed by Joseph Sargent the same year). And while he could always count on the protection of Sid Sheinberg, he also obtained the high esteem of Jennings Lang, a former heavyweight agent in Hollywood who became vice president of Universal Pictures. Lang liked Spielberg very much, to the point of introducing him to his family. Newly arrived at the studio, he was the one who gave the green light to the director to develop his idea into a feature film.

Carte Blanche

Young screenwriters and Spielberg acquaintances Hal Barwood and Matthew Robbins were brought in to develop the script, now titled *Carte Blanche.* The trio agreed to build on the reality of the original story. The chase now looked more like a slow-motion elopement, with the car containing the Poplins and the police officer they had taken hostage setting the pace for the entire film. Moreover, it was now the mother, Lou Jean, who was the focus of the screenwriters' attention: She made most of the decisions… especially the wrong ones. In April 1972, Barwood, Robbins, and Spielberg went to Texas for a week to experience the daily life of local cops: "We'd show up with our long hair, and we felt like these guys

The Sugarland Express marked Spielberg's feature film debut.

wanted to show the little guys from Hollywood the reality of life," Robbins recalls. "One day at the station, one of them opened his locker in front of us, which was lined with crime scene photos of dead bodies. He did it on purpose, to see our reactions. Pools of blood, a half-decapitated head…I've never forgotten those images."[1]

Nervous Breakdown

Carte Blanche did not completely convince the management at Universal, who put it on hold, even though Lang still believed in it. A few weeks later, freshly dismissed from 20th Century Fox by his own father Darryl, Richard D. Zanuck joined forces with his ex–Fox colleague David Brown to create an independent company called Zanuck/Brown Company, which quickly signed an exclusive production contract with Universal. "It was an explosive pairing." Robbins laughs about it to this day. "Brown was very poised, smiling. He wore a beautiful mustache, always chic. Zanuck was the opposite. He was very small, his eyes were absolutely hard. He was like a boxer who never lets go of his prey until he wins."[2] Jennings Lang bore the brunt of this relentlessness. At the Universal cafeteria, in the corner reserved for

executives, Zanuck made it clear to the table that he was ready to do whatever it took to produce *Carte Blanche*, especially since he had a major ace up his sleeve: Goldie Hawn was interested in playing the lead role. He made it clear to Lang that he would use all the means at his disposal, because he had nothing to lose. This was a needless show of force since Zanuck had already obtained the blank check from Lew Wasserman, the head of the studio. Wasserman was not impressed by the script, but he believed in Spielberg, and he thought that a producer of Zanuck's caliber and a major leading lady were enough insurance to entrust this multimillion-dollar project to an inexperienced director and two novice scriptwriters. The pressure eventually became too much for Lang, who had a nervous breakdown in the middle of the cafeteria and had to be escorted out.

CASTING

Zanuck knew what he was doing in terms of casting. In 1972, Goldie Hawn was one of Hollywood's rising stars. The sketch series *Laugh-In*, which began airing in 1968, won her the hearts of American viewers, who were captivated by her role as a charming ingenue with a sharp tongue. In addition, she had won an Oscar and a Golden Globe for Best Supporting Actress in Gene Saks's 1969 comedy, *Cactus Flower*. Spielberg was delighted when Hawn was cast, especially since he was convinced that she was the ideal actress to support the film's shift from comedy to drama in the final act.

The Look of a Western Shot on Location

The film's tragic finale was performed by William Atherton, a young stage actor who had only made a few film appearances. As for Michael Sacks, who played the police officer Maxwell Slide, he and Atherton "were deliberately cast to resemble one another—if not closely in body, then at least in spirit and attitude," noted Spielberg. "We wanted two actors cut from the same cloth, two characters who could have lived in the same neighborhood, grown up together, and then gone their separate ways."[3] Opposite the trio of young people, veteran actor

Led by Spielberg, the production team on *The Sugarland Express* used inventive methods during filming.

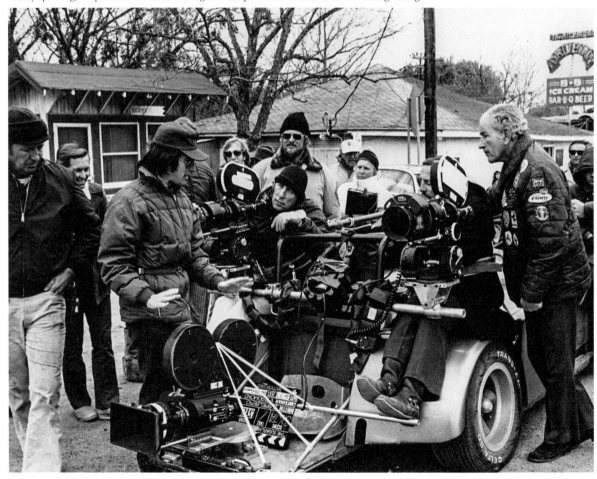

Ben Johnson contributed his rugged features to the role of Captain Tanner. Born in 1918, the actor was a "face" of the Western film tradition, and one of the favorite actors of directors like John Ford and Sam Peckinpah. He was perfect to play the quasi-paternal authority figure who would never stop trying to bring the fugitives to their senses.

Most of the secondary roles were given to Texans found on the streets of San Antonio, Dallas, and Houston. Spielberg insisted on giving his film an authenticity factor. In a nod to the original story, the policeman who was originally taken hostage in 1969, James Kenneth Crone, made an appearance in the film as the sheriff. As for the Poplins' baby, Richard D. Zanuck's son, Harrison, played the part of the Poplins' baby in the film.

FILMING AND PRODUCTION

Filming began on January 15, 1973. From the start, while the team would simply have wanted to see him get his bearings, Spielberg began by working out a complicated shot, a way for the apprentice filmmaker to show that he was in the driver's seat. However, he also demonstrated that he listened to everyone and would not hesitate to change his mind when presented with an idea that he considered to be excellent. Thus, when Spielberg informed Robbins that he had found hilarious excerpts from old Wile E. Coyote and Road Runner cartoons that he wanted to use to illustrate the drive-in scene, and the screenwriter made the connection between the fatal fall of the coyote and the fate of Clovis Poplin, the filmmaker was delighted: He modified the scene in order to reinforce a parallel between Clovis and Wile E. that he had not thought of.

Goldie Hawn was a rising star of Hollywood when *The Sugarland Express* was filmed.

A Cocoon for Steven

Zanuck had created a cocoon for his young protégé: Barwood and Robbins were removed from the set to avoid an excess of script changes, and he also made sure Spielberg got the cinematographer he wanted, a man named Vilmos Zsigmond. The two collaborators immediately agreed on using natural light in order to give the film an almost documentary-like quality. A denizen of the "New Hollywood," the forty-two-year-old Hungarian cinematographer had won over Spielberg thanks to his fantastic work on Robert Altman's *McCabe & Mrs. Miller* (1971). The two men shared the same love of cinema and the same passion for innovation. Hence their decision to use the new Panaflex camera, which they were the first to use on a feature film. Installed in the fugitives' car, the new camera enabled a 360-degree shot that followed Captain Tanner's car as he came up from behind, overtook from the left, stayed in front of the car, and then turned back to the right. The camera is silent, and it also enabled the

FOR SPIELBERG ADDICTS

While observing a nighttime police patrol in Texas, Hal Barwood, Matthew Robbins, and Spielberg discovered a man slumped over his steering wheel, dead drunk. As the officer they were with struggled to wake him up, the director had an idea: The man could play a drunk in *The Sugarland Express*! And indeed, this same man, Buster Daniels, appears in the back seat of Officer Slide's car at the beginning of the film.

recording of dialogue inside the car by using direct sound. For another circular shot around the car, Spielberg and Zsigmond put the car on a trailer at ground level, removing the tires; they surrounded it with a platform on which they installed the camera mounted on a dolly so that they could film around the car when it was in motion.

The Methodology of *Duel*

For the chase scenes, Spielberg lined his office with a gigantic storyboard where all the shots were detailed. While the original story involved a hundred cars, police and civilian alike, the production had to make do with forty. This was no problem for the filmmaker, who made use of scale models to help add a sense of overwhelming police force. He was also helped by stuntman Carey Loftin, who had also worked on *Duel*.

Shot mostly in chronological order in a number of towns between Houston and San Antonio, filming ended in March 1973 with everyone in a mostly warm and relaxed state of mind. Spielberg kept to his budget ($2.5 million, or about $16.7 million today). The schedule was exceeded by five days, two of which were due to weather-related delays. Zanuck was delighted.

Renamed *The Sugarland Express*, the film was edited during the summer of 1973, and Spielberg regularly invited Zsigmond to give his opinion on the process. In the editing room, Verna Fields, a seasoned and Oscar-winning editor, was in charge of the proceedings. This was the beginning of a fruitful collaboration, as Fields would later work on *Jaws*.

The Sugarland Express marked the beginning of another major Spielberg collaboration with composer John Williams. The musician was hired after Spielberg listened to the stripped-down soundtracks of *The Reivers* (1969) and *The Cowboys* (1972), which had both been directed by Mark Rydell. The music on *The Sugarland Express* was equally simple, featuring a soundtrack steeped in the sounds of Americana and shaded by the harmonica of Toots Thielemans.

RECEPTION

Universal gave Spielberg carte blanche for the film's promotional campaign, and the filmmaker wasted no time in involving himself in the design of the promotional material.

The Poplin couple, played by William Atherton and Goldie Hawn (left and center), form a strange trio with their hostage (right).

A Disoriented Public

In the autumn of 1973, a preview was organized in San Jose, California. *The Sugarland Express* was presented on a double bill with Peter Bogdanovich's *Paper Moon*. Convinced that they had created a masterpiece, the team was dismayed by the public's reaction to their film. The audience was confused by the change in tone that occurred in the middle of the film, going from comedy to drama as soon as the silent snipers appeared. This was a shift that did not seem to be in keeping with Goldie Hawn's status as a comedic actress, and audiences were caught off guard.

While Zanuck and Brown wanted to release the film as it was, Spielberg insisted on cutting about twenty minutes and rebalancing the film's tone by removing gags in the first half. Other screenings took place after these changes were made, and they were much more pleasing. "The director of that movie is the greatest young talent to come along in years,"[4] declared Billy Wilder in a 2007 book by Nigel Morris. But Universal was stung by the test screening and they shifted the film's release from December 1973—when *The Sting* (George Roy Hill) and *The Exorcist* (William Friedkin) were both released—to April 1974.

A few days before the release, Ila Fae Dent and two relatives drove into LA from Texas, and they were furious that they had not been told that a film had been made from their story. An agreement was finally reached to avoid another postponement of the film's release, and the trio left with a check for $1,200 (about $6,700 today)—and a color television set.

An Award at Cannes

On May 24, 1974, the jury of the Cannes Film Festival awarded the prize for Best Screenplay to Steven Spielberg, Hal Barwood, and Matthew Robbins for *The Sugarland Express*. But no one was there to pick it up: The director was stuck on the set of *Jaws*. As for the screenwriters, they did not know that the film had been entered into competition at the festival! Film editor Walter Murch (*Apocalypse Now, The English Patient*) was in attendance and collected the award on their behalf.

The Howard Hawks of a New Generation

Released in 250 theaters across the United States, *The Sugarland Express* received a disappointing reception. However, the film was praised by many critics, including the often caustic Pauline Kael of

the *New Yorker* (who would turn in some scathing reviews of some of Spielberg's later productions): "[He] could be that rarity among directors, a born entertainer—perhaps a new generation's Howard Hawks. In terms of the pleasure that technical assurance gives an audience, this film is one of the most phenomenal debut films in the history of movies."[5] Among the few negative reviews, the one in the *New York Times* foreshadowed the criticisms that would regularly be leveled at the filmmaker's work in later years: "*The Sugarland Express* is a prime example of the new-style factory movie: slick, cynical, mechanical, empty...," wrote Stephen Farber. "Everything is underlined," he continued. "Spielberg sacrifices narrative logic and character consistency for quick thrills and easy laughs."[6]

Based on his first full-length feature, Spielberg would learn lessons that he applied to his future work: Pay close attention to changes in mood, guide the viewer in their perception of the complete product, and do this work during the promotional stage as well. In retrospect, *The Sugarland Express* remains one of the filmmaker's most personal films. It's a work where fathers are weak (when they are not absent), and where women have difficulty inhabiting the role of motherhood.

⏸ Freeze Frame

In the foreground, a sniper shown from behind is braced at the window of baby Poplin's foster home. The man is aiming at the road when a car appears, moving slowly across the landscape. The Poplins have come to get their child, and they are about to fall into a trap set by the police. Spielberg suggests this trap with a compensated tracking shot, the effect of a zoom and a reverse tracking shot, which seems to draw the car and its passengers inexorably toward their terrible fate. This effect was invented by Alfred Hitchcock in *Vertigo*, and Spielberg used it again in his next film, *Jaws* (see page 79).

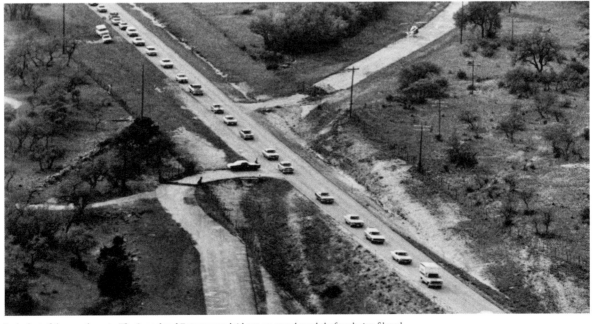

Each shot of the car chase in *The Sugarland Express* was laid out on storyboards before being filmed.

The terrifying motion picture from the terrifying No.1 best seller.

JAWS

ROY SCHEIDER · ROBERT SHAW · RICHARD DREYFUSS

JAWS

Co-starring LORRAINE GARY · MURRAY HAMILTON · A ZANUCK/BROWN PRODUCTION

Screenplay by PETER BENCHLEY and CARL GOTTLIEB · Based on the novel by PETER BENCHLEY · Music by JOHN WILLIAMS

Directed by STEVEN SPIELBERG · Produced by RICHARD D. ZANUCK and DAVID BROWN · A UNIVERSAL PICTURE ·

TECHNICOLOR® PANAVISION®

PG PARENTAL GUIDANCE SUGGESTED
SOME MATERIAL MAY NOT BE
SUITABLE FOR PRE-TEENAGERS

ORIGINAL SOUNDTRACK AVAILABLE ON MCA RECORDS & TAPES
...MAY BE TOO INTENSE FOR YOUNGER CHILDREN

Jaws

United States 2 hrs 4 **Color** **Mono** 2.39:1
(Technicolor) (Westrex Recording System)

Production Dates: May 2–October 3, 1974
United States Release Date: June 20, 1975

Worldwide Box Office: $471 million (equivalent to $2.6 billion in 2023)

Production Company: Zanuck/Brown Company, Universal Pictures
Producer: Richard D. Zanuck, David Brown, William S. Gilmore Jr.
Unit Production Manager: James Fargo

Based on the eponymous novel by Peter Benchley (1974)
Screenplay: Peter Benchley, Carl Gottlieb
Director of Photography: Bill Butler
Underwater Photography: Rexford Metz
Camera Operators: Michael Chapman, Lou Barlia
Underwater Camera Operator: Ronald Vidor
Shark shots in their natural habitat: Valerie and Ron Taylor
Film Editing: Verna Fields
Music: John Williams
Sound: John Carter, Robert Hoyt, Roger Heman, Earl Madery
Production Design: Joe Alves
Set Decoration: John M. Dwyer
Wardrobe: Robert Ellsworth, Irwin Rose, Louise Clark
Special Effects: Robert A. Mattey
Mechanical Special Effects: Roy Arbogast
Shark Models: Grant McCune, Bill Shourt
Technical Adviser: Fred Zendar

Starring: Roy Scheider (Chief Martin Brody), Richard Dreyfuss (Matt Hooper),
Robert Shaw (Quint), Lorraine Gary (Ellen Brody), Murray Hamilton (Mayor
Larry Vaughn), Jeffrey C. Kramer (Assistant Hendricks), Susan Backlinie
(Chrissie Watkins), Chris Rebello (Michael Brody), Jay Mello (Sean Brody),
Lee Fierro (Mrs. Kintner), Jeffrey Voorhees (Alex Kintner), Carl Gottlieb (Harry
Meadows), Peter Benchley (reporter on the beach)

> **"For a movie that became awesomely successful and gave me complete personal creative freedom, I still look back at it and even now say it was the most unhappy time in my life as a filmmaker."**[1]
>
> —Steven Spielberg, on the filming of *Jaws*

SYNOPSIS

———

Chrissie Watkins and a young man leave a night party on the beach in the small New England resort town of Amity. The young woman enters the ocean, but the boy is too drunk and he collapses on the sand. Suddenly, Chrissie is attacked and dragged to the bottom. The next day, her remains are found in the dunes by the local police. According to the analysis of the body, Chrissie Watkins was killed by a shark. The chief of police, Martin Brody, wants to close the beaches, but he encounters resistance from the mayor and local shopkeepers who don't want to lose business during tourist season, which is about to begin. Martin Brody gives in until a few days later, when a teenager falls prey to another shark attack and panic grips Amity. A shark hunt is quickly organized but Matt Hooper, an oceanographer hired by the town, warns that the animal responsible for these deaths is probably gigantic. Brody and Hooper enlist the help of a local shark hunter named Quint and together the three men set out to hunt the shark down.

GENESIS

Author Peter Benchley was a freelance writer and journalist in addition to working as a speechwriter for President Lyndon B. Johnson. Eventually he was let go from his speechwriting position when Richard Nixon was elected president.

A Shark and a Moral Dilemma

In 1971, Peter Benchley was trying to sell book ideas between articles. After a lunch with an editor, he said, "I want to tell the story of a great white shark that marauds the beaches of a resort town and provokes a moral crisis."[2] The idea came from a small article in the *New York Daily News* in 1964 about a two-ton, five-and-a-half-meter-long great white shark that had been speared off Montauk, Long Island. The editor was enthusiastic.

The writing of the book took a year and a half. The title was chosen at the last moment: *Jaws.* When it was published in February 1974, producers Richard D. Zanuck and David Brown already had the rights to adapt the novel into a feature film. The rights had been acquired the previous year on the basis of early proofs of the book that had been sent by the author's agent. The contract stipulated that the first script would be written by Peter Benchley.

Formerly of Fox and Warner Bros., Zanuck and Brown founded the Zanuck/Brown Company in 1972 and signed a deal with Universal Pictures. The duo had a hit with *The Sting* (George Roy Hill, 1973), which became a critical and public success almost immediately upon release. In *Jaws,* they saw a good thriller that was likely to stoke the primal fears of the moviegoing audience, but they did not consider how to portray a twenty-five-foot shark.

A Director with a Fresh Perspective

In addition to their work on *The Sting,* Zanuck and Brown had also produced *The Sugarland Express,* Steven Spielberg's first full-length feature film. It was while passing through their office one day in the summer of 1973, during postproduction on *Sugarland,* that the director spotted the *Jaws* proofs. The subject of a danger lurking in the depths of the sea immediately attracted him, as did the story of ordinary men who are forced to confront an extraordinary creature. For Richard D. Zanuck, Steven Spielberg was the perfect man for the job: He had a fresh perspective on how to make movies, as demonstrated with his made-for-television movie, *Duel,* in 1971; and despite being twenty-six years old, he

Roy Scheider (left), Steven Spielberg, and Verna Fields (right) examining raw footage—also known as "rushes"—on the beach.

already knew all the ins and outs of the business. However, Spielberg had some reservations. First, he did not like the characters in the novel. He was also apprehensive about the similarities with *Duel* (which was about a malevolent truck driver hunting down his prey): Spielberg was concerned about being stereotyped as a certain sort of filmmaker.

In the end, two other directors were initially approached about the film. The illustrious John Sturges, director of *The Magnificent Seven* (1960) and *The Great Escape* (1963), was an "old hand," and general opinion was that he would probably make an efficient but traditional film. Dick Williams was chosen instead. His first feature film, 1972's *The Culpepper Cattle Co.*, was a Western that demystified the West, in keeping with the style of the time. But during a lunch that should have sealed his involvement in the picture, Williams kept confusing a "shark" and a "whale." Williams was immediately dropped.

Filming in Real-Life Settings

As Brown and Zanuck continued their search for a director, Spielberg had time to do some thinking. *The Sugarland Express* was due to land in cinemas in March of 1974. What if it was a failure? What if no one gave him any more feature films to direct? *Jaws* would be a way to keep a foot in the door. In June of 1973, Steven Spielberg was hired to direct *Jaws*.

Zanuck and Brown planned on using models and miniatures filmed in studio water tanks for most of

Cameraman Michael Chapman looking into a camera alongside cinematographer Bill Butler (behind, left) as Spielberg (right) looks on.

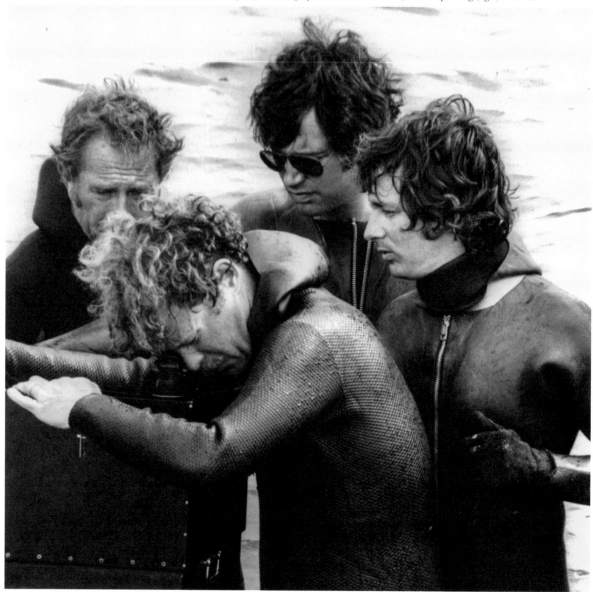

the ocean-centric scenes in the film. For a while, they even thought they could shoot the movie using trained sharks, but this plan was quickly dropped. Steven Spielberg had another idea: He wanted to film on the ocean (a first for a Hollywood film) in order to give the film a sense of realism.

Preproduction for the film took place during the winter of 1973–1974, without a finished script. Art director Joe Alves created the design for the shark and the production team then brought Robert A. Mattey, a famous specialist known for creating model creatures, out of retirement to work on the project. He had the idea of attaching the model to a mechanical arm mounted on a submersible platform that would roll on a rail in the water. Once built, this machinery weighed twelve tons!

From *The Warlock* to the *Orca*

For the film's location shoots, Joe Alves was looking for an area without big tides, without too much current, and with a sheltered bay; it also had to be picturesque and touristy. Nowhere on Long Island, where the action of the book took place, proved suitable. Joe Alves planned on exploring the island of Nantucket, but bad weather on his trip to the island forced his ferry to turn back. He settled on the island of Martha's Vineyard, and the location proved perfect. In the process, he also found an old lobster fishing boat that was forty-two feet long. It was named *The Warlock*, and he found it in a shipyard in Boston. Once it was redecorated, it became Quint's boat, *Orca*, and a fiberglass copy was made and destroyed for the final scene of the film.

When Peter Benchley handed in his script, the film team was less than thrilled. Steven Spielberg took it over and removed some of the subplots, which focused on the links between the mayor of Amity and the mafia, and on an affair between Matt Hooper and Chief Brody's wife. At the suggestion of producer David Brown, Spielberg also called on screenwriter and playwright Howard Sackler (who asked not to be credited), before turning to his old TV writer friend Carl Gottlieb, who was also hired to play the small role of a local journalist.

A Little-Known Story

The credit-shy playwright Howard Sackler was responsible for one of the film's crucial scenes: Quint's monologue recounting the torpedoing of the *USS Indianapolis* on its way back to an American base after delivering parts used in the atomic bomb. The ship's crew was subsequently decimated by sharks. This true story was unknown at the time,

Freeze Frame

When the shark attacks while Chief Brody is posted on the beach, Spielberg used a tracking shot to convey the horror that grips the character. The camera effect gives the impression that the background is slipping away while simultaneously zooming in on actor Roy Scheider's face. This discombobulating effect is achieved by the opposing movements of a dolly and a reverse zoom.

even to Steven Spielberg. Gottlieb reworked the dialogue and the characters, injecting a dose of comedy and satire into the scene and creating one of the most famous monologues in film history.

When the book was released in bookstores, it quickly climbed to the top of the sales charts. To capitalize on its success, Richard D. Zanuck, David Brown, and the executives at Universal wanted to start shooting as soon as possible, especially since an actors' strike was looming. But Steven Spielberg was not ready, and the budget had barely been set. The pressure mounted and the director cracked. By the end of March, he wanted to leave *Jaws* for another project, *Lucky Lady*. Called to order by Sid Sheinberg, thus far his faithful protector at Universal, Spielberg really had no choice: His contract precluded him from abandoning a production in progress. Meanwhile, far from the studio, Robert A. Mattey's teams were making three giant model sharks.

CASTING

One of the first actors hired was Lorraine Gary, who played Ellen Brody, the wife of Amity's police chief. In real life, Gary was Sid Sheinberg's wife, but in spite of the possible politics at play, Spielberg always believed that she was capable of creating a

The mechanical shark used in *Jaws* was ironically very sensitive to seawater.

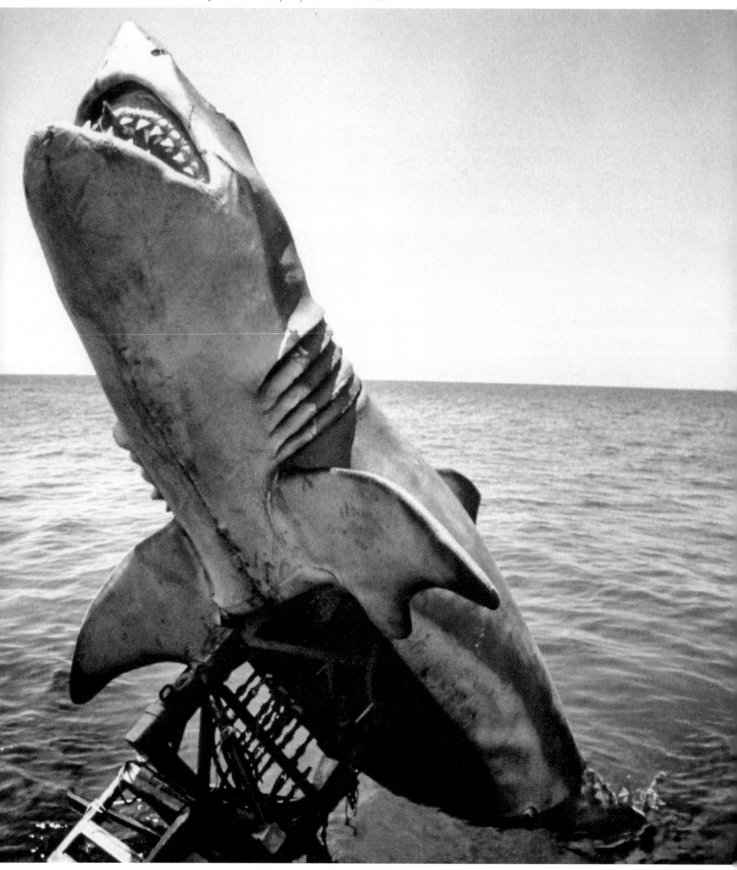

Swimmers in Amity, framed at the water's edge, as if being watched by the shark.

believable family life for the film that would allow the public to recognize itself. (The actress's last film was *Jaws: The Revenge*, in 1987.)

Charlton Heston Takes Offense

Murray Hamilton played the key role of Mayor Larry Vaughn. At the time, he was known for playing Mr. Robinson in *The Graduate* (Mike Nichols, 1967). The three lead roles were more difficult to cast. Spielberg did not want superstars who might upstage the shark. He therefore said no to Charlton Heston when he asked to play Brody. Vexed, the *Ben-Hur* star (1959) swore never to act for Spielberg. When approached, Robert Duvall said he was not interested in the part. Later, while attending a party, Spielberg met the actor Roy Scheider by chance. As Spielberg opened up about his current worries, the actor naturally put himself forward for the role. In spite of his past roles as tough guys (*The French Connection*, 1971), he knew how to allow doubt and vulnerability to shine through in his performances. For the oceanographer Matt Hooper, Richard Dreyfuss was recommended to Spielberg by George Lucas, who had worked with him previously on *American Graffiti* (1973).

The Birth of an Alter Ego

When Carl Gottlieb and Steven Spielberg met him, Richard Dreyfuss was casually dressed with a stubbly beard and glasses: an ideal Matt Hooper. But the actor declined the offer, believing that *Jaws* was doomed to failure and that the scientist character was not very interesting. Dreyfuss had recently played the lead role in *The Apprenticeship of Duddy Kravitz* (Ted Kotcheff, 1974), a Canadian film that had not yet been released in the United States. When he saw

it, he felt that his performance was so catastrophic that it would put an end to his career. Dreyfuss then promptly asked to play Matt Hooper. As the script continued to be tinkered with, the character evolved to become a kind of alter ego for Steven Spielberg.

Holidays, Takes, and a Visa

For the shady Quint, the director wanted actor Lee Marvin. But Marvin was on vacation fishing, and he didn't want to interrupt everything to *pretend* to be a fisherman. Sterling Hayden also refused the role: He was in arrears to the IRS and he knew that his salary would go directly into the state coffers, so he had no interest in being hired. Producer David Brown then thought of the British actor Robert Shaw, who had recently been in *The Sting*. He was currently appearing on Broadway and the expiration date of his work visa gave him just enough time to work on *Jaws*. If he overstayed his visa, however, the production would be forced to pay the legal penalties. Shaw was hired only a few days before everyone left for Martha's Vineyard in late April 1974.

FILMING AND PRODUCTION

The filming of *Jaws* actually began during preproduction. In January 1974, Zanuck and Brown still had the intention of filming with real great white sharks. A crew went to Port Lincoln, Australia, to film underwater shots that were going to be used for Matt Hooper's attack sequence set inside a shark cage.

Great White Shark vs. Stuntman

The plan for filming was to use two cages: A scaled-down model cage containing a mannequin would be filmed on a soundstage, and another, larger cage would be submerged in the ocean with a

five-foot-tall former jockey turned stuntman named Carl Rizzo locked inside. The thinking was that onscreen, a shark would appear oversized next to Rizzo. A couple of industry experts, Ron and Valerie Taylor, operated the cameras. They had worked on the documentary *Blue Water, White Death* (1971), which Peter Benchley had seen when he was writing his novel. But the operation almost turned into a drama when a great white shark attacked the crew and smashed their equipment. Rizzo narrowly escaped and the crew returned home not knowing if what they had filmed was usable.

Meanwhile, Steven Spielberg started filming on Martha's Vineyard on May 2. Principal photography on *Jaws* was supposed to last fifty-five days. The welcome of the island's residents, who were disturbed in their tranquility, was not the warmest, and the authorities piled on the red tape. Nevertheless, the shooting of the scenes set on the mainland went well. Spielberg fueled the tension of the film by using shots with the camera partially submerged in water or set just below the surface, which allowed the water line to float across the frame. This effect came from a trick by cinematographer Bill Butler: A camera was enclosed in a glass box before being manipulated in the water.

The Secrets of Shark City

To preserve the element of surprise ahead of the film's release, the shark was manufactured by a company called Rolly Harper, a supplier of equipment and restoration services for the studios, well outside of Hollywood in Sun Valley, California. The work site, nicknamed Shark City, was used to create one complete shark and two halves, right and left. Harper mobilized about forty technicians between November 1973 and April 1974. The body of the shark was made in neoprene foam mounted on a steel frame, and the skin was done in polyurethane and nylon. Once complete, the shark wasn't painted until it reached Martha's Vineyard. The shark's animatronic framework was based on a pneumatic system composed of about thirty flexible tubes. The shark was nicknamed Bruce, in reference to Spielberg's lawyer (who was anything but a shark!), Bruce Ramer.

A Screenplay in the Making

While filming, Spielberg stayed with Carl Gottlieb in a cottage that served as a meeting place for the crew. Film editor Verna Fields was there, and the actors often came for dinner to discuss the scenes and their characters. Carl Gottlieb was also there sorting out the script that was still a work in progress.

On June 11, scene #188 was one of the last items shot before the crew went to sea with their mechanical shark. This was Quint's account of the *USS Indianapolis* tragedy. On the night of the shoot, actor Robert Shaw was reportedly too drunk to finish the scene. Ashamed of his behavior, and after apologizing to Spielberg, Shaw delivered a model performance the next night. The final scene combines shots from both nights, and it would go on to become of the greatest moments in the film.

"Steven Spielberg's Garage Sale"

By all accounts, filming at sea was a nightmare. Stabilizing the cameras proved impossible on the

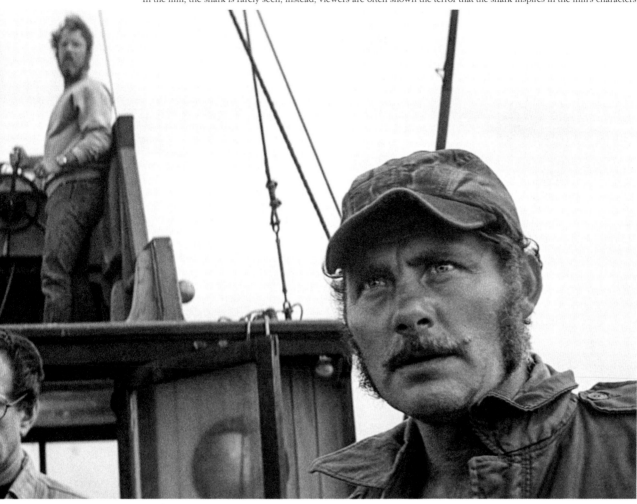

In the film, the shark is rarely seen; instead, viewers are often shown the terror that the shark inspires in the film's characters.

boat, so the cameramen were forced to film with the camera on their shoulder and without a tripod. Equipment fell into the water, the *Orca* accidentally sank, and Carl Gottlieb fell overboard. A huge barge was used to house all the equipment and controls needed for the shark animatronics. It was so heavily loaded that it earned the nickname of "Steven Spielberg's Garage Sale," or SS Garage Sale. Wide shots are also taken from the barge, but because of the constant movement of the ocean, the crew struggled to keep a steady alignment of boats, actors, sharks, light, and horizon from one shot to the next. To make matters worse, Robert Shaw made life difficult for Richard Dreyfuss between takes, often criticizing his acting and launching into personal attacks, mostly while under the influence of alcohol.

From *Jaws* to Flaws

The biggest problems, however, came from the central element of *Jaws*: the shark itself. Transported from Los Angeles to Martha's Vineyard and then reassembled on the island, the shark was never tested at sea before being put into use. Once it was put into the Atlantic, the water pressure and the force of the currents, mixed with the cold and salty water, made the machine malfunction almost constantly. *Jaws* was renamed "Flaws" by the team. Over the course of the shooting schedule, Steven Spielberg was forced to eliminate shots showing the shark, and he replaced them with subjective, often slightly murky views of the creature. Without anyone realizing it, these shots that had been born out of unfortunate necessity would turn out to be the strength of the film. The budget on the film exploded, as did the schedule. Back on the Universal lot in California, studio execs considered taking the film away from Spielberg or even canceling the project altogether, but Sid Sheinberg prevented this from happening.

The very last shot of the film—the explosion of the shark—was completed in September without the director in attendance. Spielberg was already on his way to Boston. Exhausted from the shoot, he also

The enormous model of the shark was perfected in every detail, down to the color and shape of its teeth.

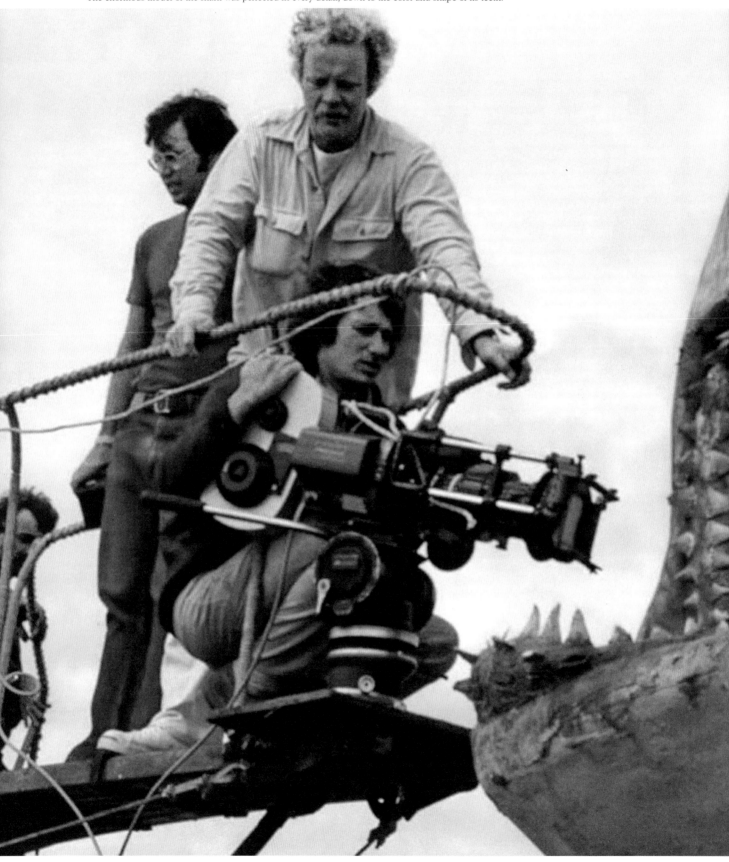

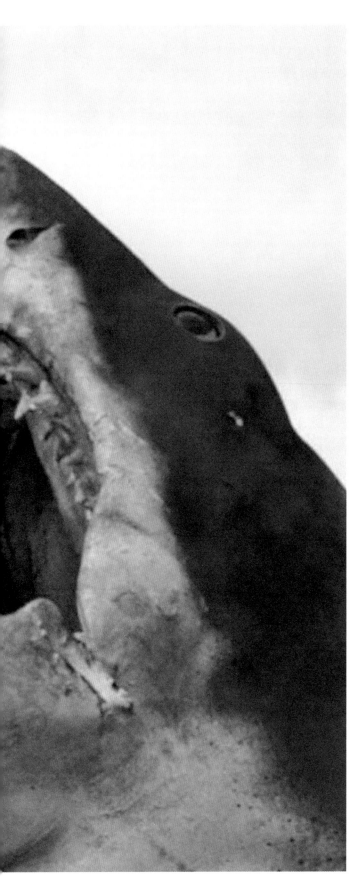

refused to attend the customary film "wrap party." Yet even after all the shoot-related pain, the film was still not quite finished. When footage of the great whites came back from Australia, it proved impossible to stage Hooper's death. The story was then modified to let the scientist live, which required additional footage to be shot.

A Body in the Swimming Pool

While dealing with the additional Hooper shoots, Spielberg also found the energy to add a shocking sequence: the appearance of a decomposing corpse with a missing eyeball. Shots were taken off Catalina Island and along the docks of MGM's and Universal's studios. During the editing of the film with Verna Fields, the director reworked the underwater sequence showing the corpse, adding powdered milk to the water to make the image cloudier.

Completed in early October 1974, Jaws took 159 days of shooting instead of fifty-five and it doubled its budget. If the film was a failure, Steven Spielberg's career would be over.

RECEPTION

For a long time in the United States, film releases had been spread over several weeks. In 1972, *The Godfather* changed this when it was shown in five New York City cinemas in its first week before being rolled out simultaneously in 316 theaters across the country. After a test screening of *Jaws* in Long Beach, California, Universal executives decided to push the same logic to its natural conclusion: The film would be released simultaneously in 409 theaters to maximize revenue in a short period of time. This strategy would result in the first so-called blockbuster (a term originally used to describe an aerial bomb). Another novelty: In the three days before the film's release, Universal orchestrated a TV advertising campaign with thirty-second spots that cost the equivalent of $3.5 million in today's money. The studio would not regret their investment: *Jaws* topped the box office all summer long, and it reached $260 million in total ticket sales by the end of the year ($1.325 billion today). *Jaws* was the first film in history to earn more than $100 million for a movie studio.

A Rare Win with Audiences *and* Critics

The film was also a critical success.[3] "[An] artistic and commercial smash," according to *Variety.* "[C]leverly directed by Steven Spielberg [...] for maximum shock impact," according to the *New York Times. Newsweek,* the *Hollywood Reporter*, and the *New Yorker* praised the suspense as well as the editing, the photography,

and the music; and all noted that the film was all the more frightening because the shark was rarely seen. Still, in the face of all the adoration, there were a few dissenting voices. The *Los Angeles Times* was unconvinced by the scenes set on dry land in Amity, and the *Village Voice* felt that *Jaws* was a mechanical film that put the audience in the position of a laboratory rat—subjected to a shock treatment, without anything to "disturb your summer with thoughts." This is a reproach that Steven Spielberg's films have often faced, from *Raiders of the Lost Ark* (1981) to *Jurassic Park* (1993).

Those Two Famous Notes

Jaws won three Academy Awards (for music, sound, and editing) out of four nominations, but Steven Spielberg was unhappy not to receive a nomination for Best Director. However, with wins for sound and editing, it was the very essence of the film that was honored. The fact that shots of the shark were replaced by murky indications of its presence was largely due to editor Verna Fields, but the effect would not have been so effective without John Williams's haunting score. This two-note pulse (double bass, then cello and tuba) associated with the animal's point of view was not just film music: It was the shark itself (the irony being that when the composer first played it on the piano for the director, Spielberg thought it was a joke).

With the triumph of *Jaws*, Steven Spielberg was through with being a director for hire. He now had all the freedom he wanted, including the freedom not

FOR SPIELBERG ADDICTS

The *Jaws* poster is based on the cover of the book by Peter Benchley. It represents the opening scene...but not a great white shark. Artist Roger Kastel created an oil painting inspired by photos of a stuffed mako shark that he took at the American Museum of Natural History in New York.

to shoot any of the three mediocre *Jaws* sequels that were released between 1978 and 1987. The experience of making *Jaws* has become so legendary that it inspired a play, *The Shark Is Broken* (2019), co-written by Ian Shaw, son of Robert. In spite of all the awards and accolades, filming *Jaws* has always remained one of Spielberg's worst memories as a filmmaker.

The End of the 1970s

It's not an exaggeration to say that *Jaws* changed the way the film industry operated. Whether purposefully or not, the movie's success ushered in the era of the summer blockbuster, and of aggressive and often shortsighted commercial strategy on the part of the Hollywood studios. Major players in the industry decided to focus on shock value and special effects rather than offering audiences more of the complex and often dark, cynical films that had been released earlier in the decade. The 1970s were officially over.

Spielberg deployed all his mastery as a director to film scenes of panicked crowds at the beach.

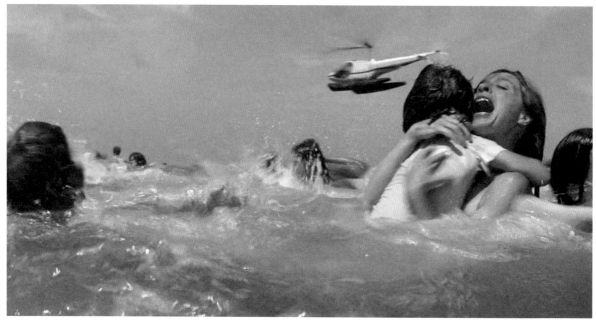

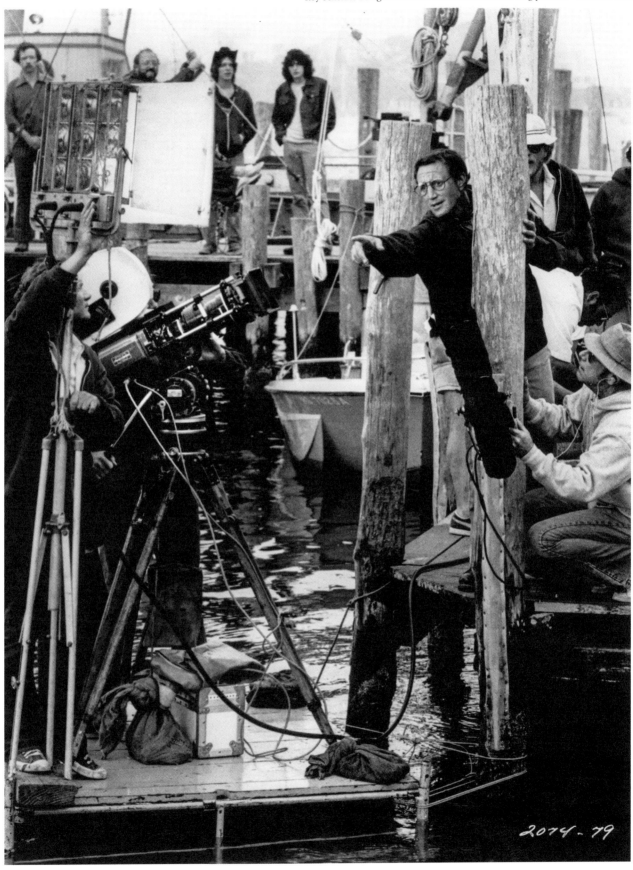

Jaws
Cult Sequence

This is the most famous moment in *Jaws*: the first attack of the killer shark, when an idyllic midnight swim (1, 2, and 4) turns to pure horror. The point of view of the shark sets up the threat (3), and things turn menacing when John Williams's musical theme starts to build as the invisible shark approaches Chrissie, the swimmer (5 and 6). Caught in the grip of the predator (7), Chrissie is shaken from one edge of the frame to the other, trapped in fixed shots and in the teeth of the shark. Different angles of shots alternate (8, 9, 10, and 11), bringing the victim closer to and farther away from the viewer, until she is finally engulfed by the sea (12). Back on the shore, the young man who accompanied Chrissie to the beach is too drunk to realize what has happened (13). The sea grows calm once again, its murky depths concealing all manner of secrets (14).

Richard Dreyfuss
The Alter Ego

"When I first met Steven, he was the uncrowned king of Hollywood,"[1] Richard Dreyfuss recalled in 2020. At the time, Dreyfuss himself was also waiting for his moment to come. Both men would achieve fame, together and separately (Dreyfuss was the youngest actor to win an Oscar with *The Goodbye Girl* in 1977). Over the course of three films, a kind of fusion took place between the actor and the filmmaker.

Watching Films at Night

Spielberg and Dreyfuss were born less than a year apart, and they are both products of their generation. Born in New York in 1947, Richard Dreyfuss arrived in Beverly Hills when he was eight years old. At twelve, he discovered acting and improvisation classes at the Westside Jewish Community Center and began watching movies on television almost every night. He continued his acting training at San Fernando Valley State College (now California State University, Northridge), but by the mid-1960s he had already made his television acting debut.

"I [...] Begged for the Part"

In the summer of 1972, Richard Dreyfuss filmed *American Graffiti* (1973) under the direction of George Lucas, but it was with a film called *The Apprenticeship of Duddy Kravitz* (1974) that he thought his career would officially take off. After filming wrapped on *American Graffiti*, Lucas recommended Dreyfuss to Steven Spielberg for the role of Matt Hooper, the oceanographer in *Jaws* (1975). For the director and his screenwriter, Carl Gottlieb, Richard Dreyfuss was the perfect fit, but the actor declined the offer...twice. Dreyfuss was convinced

When the quest for wonder turns into an obsession: Dreyfuss as Roy Neary in *Close Encounters of the Third Kind* (1977).

that this shark story would flop with audiences; however, when he saw the final cut of *The Apprenticeship of Duddy Kravitz*, he was so horrified that he worried his career would not survive. Officially in survival mode, Dreyfuss made a life-changing decision: "I called Steven and begged for the part."[2]

The Ordeal of Matt Hooper

Matt Hooper is a kind of sarcastic and passionate big kid. He is an expert in his field, but unable to hold his own against the local elites in Amity. In short, he is an ersatz Steven Spielberg from the days when Universal Television was impervious to his filmmaking aspirations. Richard Dreyfuss injects life into a character who could have been little more than a plot device in human form, there only to provide occasional pseudoscientific exposition. By turns fascinated, blasé, excited, and angry, Dreyfuss's version of Hooper has an adolescent penchant for exaggerated reactions. On the set of *Jaws*, the actor developed a difficult working relationship with the actor Robert Shaw, who appeared in the film as Quint, the shark hunter. Shaw insisted on humiliating Dreyfuss about his acting, his physical abilities, and his weight just as in the film Quint humiliates Hooper, through whom Steven Spielberg seems to re-create his experience as a bullied high school student. It was during the shooting of *Jaws* that Richard Dreyfuss got wind of the filmmaker's next project, "Watch the Skies," which would eventually become *Close Encounters of the Third Kind* (1977). From the start, the actor wanted to play Roy Neary, a man who gives up everything to travel with aliens. "I swore an oath to myself that I would badmouth every actor in Hollywood.

I would walk by [Steven's] office and say, 'Pacino's crazy. De Niro has no sense of humor.'"[3]

A Man with a Taste for What Lies Beyond

Like Spielberg, Roy Neary was a character driven by a childlike sense of wonder. Dreyfuss gave Neary all the banality of a Midwestern electric company employee worn down by family life. In the course of the film, Neary finds himself with toothpaste in his mouth or schlubbing around the house while daydreaming about what else might be out there in the universe.

During this same time period, Dreyfuss and Spielberg discovered a mutual affection for Victor Fleming's film *A Guy Named Joe* (1943). The idea of a remake became a reality in 1989 when the pair worked together for a third time on *Always*.

A Transitional Film

Always stars Richard Dreyfuss as a reckless water bomber pilot who kills himself on a mission. Back among the living, but in the form of a ghost, he can only watch helplessly as his girlfriend moves on. *Always* marks a sea change in Spielberg's career (at the time, he was in the midst of separating from his first wife, Amy Irving). Dreyfuss plays a character type that recurs throughout much of the director's work, that of a big, irresponsible, and boastful man. As if finally understanding the limits of this character trait, *Always* depicts a man brushing up against the limits of childlike wonder; it seems sometimes life demands a different approach. Steven Spielberg's career was about to change register, and he needed Richard Dreyfuss to help propel him into adulthood.

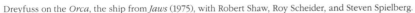

Dreyfuss on the *Orca*, the ship from *Jaws* (1975), with Robert Shaw, Roy Scheider, and Steven Spielberg.

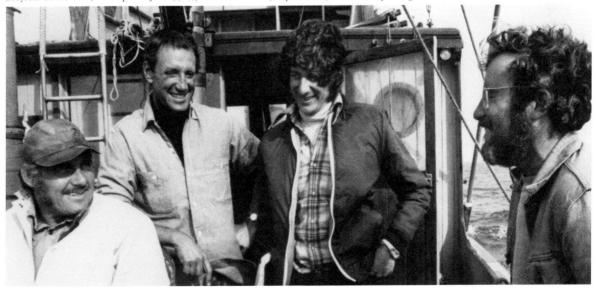

CLOSE ENCOUNTER
OF THE FIRST KIND
Sighting of a UFO

CLOSE ENCOUNTER
OF THE SECOND KIND
Physical Evidence

CLOSE ENCOUNTER
OF THE THIRD KIND
Contact

CLOSE ENCOUNTERS
OF THE THIRD KIND

A COLUMBIA/EMI Presentation
CLOSE ENCOUNTERS OF THE THIRD KIND A PHILLIPS Production A STEVEN SPIELBERG Film
Starring RICHARD DREYFUSS Also Starring TERI GARR, MELINDA DILLON with FRANCOIS TRUFFAUT as Lacombe
Music by JOHN WILLIAMS Visual Effects by DOUGLAS TRUMBULL Director of Photography VILMOS ZSIGMOND, A.S.C.
Produced by JULIA PHILLIPS and MICHAEL PHILLIPS Written and Directed by STEVEN SPIELBERG
Read the Dell Book Panavision®

Close Encounters of the Third Kind

United States **2 hrs 15** **Color** **Stereo** 2.39:1

(special edition: 2 hrs 12 director's cut: 2 hrs 18) (Metrocolor) (Dolby/6-Track)

Production Dates: May 1976–February 1977
United States Release Date: November 16, 1977 (New York); November 18, 1977 (Los Angeles); December 14, 1977 (rest of the country)

Worldwide Box Office: $288 million ($1.3 billion in 2023)

Production Company: Columbia Pictures, EMI, Julia Phillips & Michael Phillips Productions
Producers: Julia and Michael Phillips
Associate Producer: Clark Paylow

Screenplay: Steven Spielberg
Director of Photography: Vilmos Zsigmond
Film Editing: Michael Kahn
Music: John Williams
Sound: Gene Cantamessa, Steve Katz
Sound Effects: Frank Warner
Production Design: Joe Alves
Art Direction: Dan Lomino
Set Decoration: Phil Abramson
Makeup: Bob Westmoreland
Wardrobe: Jim Linn
Special Effects: Douglas Trumbull
Creator of the Extra-Terrestrial (puppet): Carlo Rambaldi
Casting: Shari Rhodes, Juliet Taylor

Starring: Richard Dreyfuss (Roy Neary), François Truffaut (Claude Lacombe), Teri Garr (Ronnie Neary), Melinda Dillon (Jillian Guiler), Cary Guffey (Barry Guiler), Bob Balaban (David Laughlin), Roberts Blossom (farmer), J. Patrick McNamara (project manager), Lance Henriksen (Robert), Shawn Bishop (Brad Neary), Justin Dreyfuss (Toby Neary), Adrienne Campbell (Silvia Neary), Carl Weathers (soldier), Hal Barwood (pilot returned from space), Matthew Robbins (pilot returned from space)

> "Science is no more than an investigation of a miracle we can never explain, and art is an interpretation of that miracle."
>
> —Ray Bradbury, *The Martian Chronicles,* 1954

SYNOPSIS

I n the Sonoran Desert along the Mexico–US border, a team of scientists led by Frenchman Claude Lacombe discovers planes that were reported missing during World War II but somehow remain intact. In an Indianapolis air traffic control station, air traffic controllers detect an unidentified presence. In Muncie, Indiana, four-year-old Barry is awakened in the middle of the night when his toys start turning on by themselves; then he is lured out of his home by mysterious beams of light. Nearby, Roy Neary, a power plant employee and a father in crisis, is called to fix a widespread power outage. Surprised on his way by an intense white light, an invisible power briefly magnetizes his car, and he sees a colossal machine pass over his head. Once he's back home, Neary compulsively starts to sculpt the same monolithic shape with anything he can get his hands on (shaving cream, mashed potatoes…): This is Devils Tower butte, in Wyoming, where a team of scientists and the US Army are getting ready to secretly make contact with planetary visitors of unknown origin. Warlike or peaceful, what are their intentions?

GENESIS

Following the historic triumph of *Jaws*, Steven Spielberg had Hollywood at his feet. He felt that the time had come to work on his first personal feature film, one he had dreamed of and nurtured since childhood.

A Popular Obsession

One night, a five-year-old Steven Spielberg was awakened by his father, Arnold, who put him in the family car and drove him to a field where a crowd of people had parked their cars so they could watch the sky. What the young Spielberg saw—a shower of meteors—marked him forever: Space became a source of endless possibilities. Amazed, young Steven wondered if there was life elsewhere in the cosmos. This original scene from Spielberg's imagination is repeated almost exactly as it happened in *Close Encounters of the Third Kind*, except that the meteor shower has been replaced by unidentified flying objects. Spielberg makes no secret of this fact: "I've always believed that there was a truth to it all. There were just too many similarities in the accounting of UFO sightings."[1]

A fan of science fiction films, books, and comics, Spielberg was born a few months before the incident in Roswell, a New Mexico town where several witnesses identified UFO debris. He grew up in an America where fantasies and fears about aliens were fueled by the Cold War, the space race, and popular legend. When he was sixteen, he made *Firelight*, which was the same length as *Close Encounters* (2 hours, 15 minutes!) and contained the beginnings of the film: scientists investigating the traces of spacecraft, a couple in crisis and a husband who is possessed by an indefatigable hunger for knowledge, spaceships with colorful and dazzling lights, etc. The amateur film was shot during weekends in Super 8, and Spielberg cast his friends and relatives as his actors. The early film was honored with a screening on March 24, 1964, at the Phoenix Little Theatre, with tickets going for $1. An audience of five hundred people gave Spielberg his very first success, but this did not satisfy him: In his humble opinion, it was one of the worst films ever made. His great work on the subject still remained to be done.

A Script and Off He Goes

In 1973, Spielberg met with Julia and Michael Phillips, a couple of young producers who had just had a great success with George Roy Hill's *The Sting*,

Working with a different sort of camera operator: Spielberg and one of his aliens.

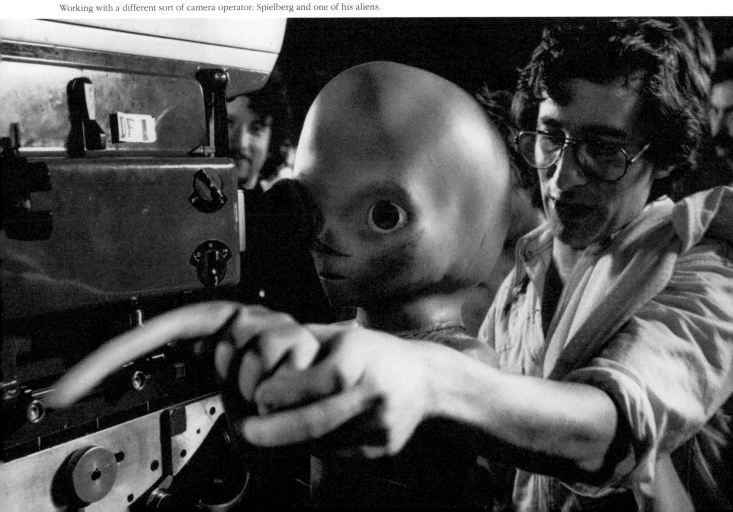

Initially, "When You Wish Upon a Star" from Disney's *Pinocchio* was played over the film's final moments, but this concept was dropped after a few initial test screenings.

and who were also preparing *Taxi Driver*, written by Paul Schrader. Spielberg needed a screenwriter, so the Phillips couple put Schrader on the job. But no two men could have been further apart than Spielberg—the average American with popular tastes—and Schrader, the Calvinist intellectual haunted by questions of guilt and redemption. Spielberg spoke to Schrader about his nostalgia for 1950s sci-fi B movies, especially Jack Arnold's *It Came from Outer Space*, which had been written by Ray Bradbury and featured a government plot to keep the discovery of aliens quiet in keeping with the post-Watergate mood. The plot even had a title: Project Blue Book, named after the US Air Force's UFO investigation commission. Schrader soon after proposed the story of an army veteran searching for traces of extraterrestrial life who is transformed by his encounter with a flying saucer. Entitled *Kingdom Come*, his script included multiple biblical reminiscences and was full of dialogue but thin on spectacle. Spielberg was disappointed. He retained some elements from Schrader's script (the notion of a spiritual quest, the finale that takes place at a monumental site); however, having a soldier as the protagonist was out of the question. According to Spielberg, the main character had to be a guy that every viewer could identify with, an ordinary man plunged into extraordinary circumstances. This was a lesson he had learned from the films of Alfred Hitchcock and Frank Capra.

A Universal Language

Taken over by Spielberg, the script now revolved around Roy Neary, a character that was a mixture of traits taken from the filmmaker himself and from his father, Arnold, an electrical engineer and absent head of the family. Against this very personal backdrop, set inside a dysfunctional home in a typical American suburb, Spielberg intended to juxtapose the amazing story of first contact with extraterrestrial life. In another example of the simple and ingenious construct of the film, Spielberg's aliens are benevolent, contrary to most popular imagery, and their arrival on Earth is the occasion of a mystical reunion...even though Roy Neary (the apparent chosen one) joins many Spielbergian heroes and abandons wife and children in order to go into space. "I would never [have] made *Close Encounters of the Third Kind* the way I've made it in 1977." Spielberg remarked two decades later, "Because I have a family that I would never leave [...] It's the one film

The Man Who Searched Elsewhere

Initially called *Watch the Skies*, *Close Encounters of the Third Kind* owes its title to the classification of the different stages of contact with extraterrestrials established by ufologist J. Allen Hynek. A close encounter of the first kind involves a sighting of a UFO from less than five hundred feet. A close encounter of the second kind requires material proof of a UFO, such as imprints on the ground, animal reactions, or electronic interference. A close encounter of the third kind requires direct contact with a UFO and/or one of its occupants. Hynek is credited as a consultant on the film and he appears among the scientists in the final sequence.

Two of Spielberg's mentors: on the left, François Truffaut, and below, the ufologist J. Allen Hynek.

I see that dates me, I really look back and see who I was twenty years ago."[2]

Spielberg knew that this project was too close to his heart to be written by someone else. For the first time in his career, he put his name on a script with no other writers—Paul Schrader agreed not to be credited. A man of images more than words, Spielberg nevertheless invited a few people he trusted to polish his script, including the writers of *The Sugarland Express*, Hal Barwood and Matthew Robbins, who added in the kidnapping of the child (which also happens in *Firelight*), and the authors of *Fun with Dick and Jane* (1977), David Giler and Jerry Belson, who were tasked with injecting some humor into the film.

The script was constantly being reworked, hence the crude evocation of the military plot, which does little to mar the magic of the film and even helps to contribute to its childlike charm. The music, however, was completed before the movie began filming, with Spielberg asking his composer, John Williams, to write the score. The music is a character in its own right: A universal language in essence, it is through the music that the film's aliens communicate with their human counterparts via a combination of

Freeze Frame

In Spielberg's own opinion, the image of little Barry facing the blinding orange light of the UFOs in the doorway is the one that best sums up his cinema, between a childish attraction to the unknown and the threat of the outside world, supernatural danger, and heavenly promise. According to him, it has its source in a vision he had, in his early childhood, of red beams lighting up the entrance to the synagogue near his home in Cincinnati, creating a backlit effect. It also reveals his love for Cecil B. DeMille's cinema, its colorful chromos and its divine lights.

five precise notes (G, A, F, low F, C), a heady leitmotif that has become part of the cultural zeitgeist in the years since the film was released. The rest of Williams's score, like the film, presages another Spielberg classic: *E.T.*

Monkeys on Rollerblades?

Steven Spielberg was very aware that tackling the vastness of space from a realistic perspective less than a decade after Stanley Kubrick's *2001: A Space Odyssey* was a bold undertaking. So, he asked NASA to collaborate, but he was refused. Then he hired Douglas Trumbull, the person in charge of the visual effects of Kubrick's classic film. The design of the UFOs was the subject of much debate and numerous attempts (including models based on famous logos, such as the McDonald's *M*) that resulted in fairly classic shapes topped with impressive multicolored neon lights. Spielberg nicknamed the mother ship "the ice cream cone." Kubrick had not depicted any aliens in his film, but Spielberg now ventured to do so...with a fair amount of difficulty. In an attempt to avoid a stand-in wearing an alien costume, which would betray its all too human form, Spielberg tried out apes perched on rollerblades. A disaster! Puppets were also considered, but how to camouflage the strings when digital retouching did not yet exist? The puppet option was eventually utilized for one creature, a whitish dragonfly of human size that was created by Carlo Rambaldi. The other creatures, small threadlike beings that looked half-tadpole and half-humanoid, were reminiscent of Roswell, and they were portrayed by little girls wearing masks and overalls. The child actors were filmed against the light to blur their appearance and accentuate the mystery of the film.

CASTING

Ever since Spielberg whispered a few words to him about the film on the set of *Jaws*, Richard Dreyfuss had been following the evolution of the *Close Encounters* project closely. But he was now facing a number of lucrative acting offers, and the choice for his next project was no longer clear.

The Unacknowledged Alter Ego

Spielberg, for his part, was convinced that Steve McQueen would make a formidable and unexpected Roy Neary. The *Bullitt* star arranged to meet Spielberg at a bar where he was a regular. Spielberg, who never touched a drop of alcohol, made an exception to his rule. The actor, although charmed by the screenplay, declined the role under the

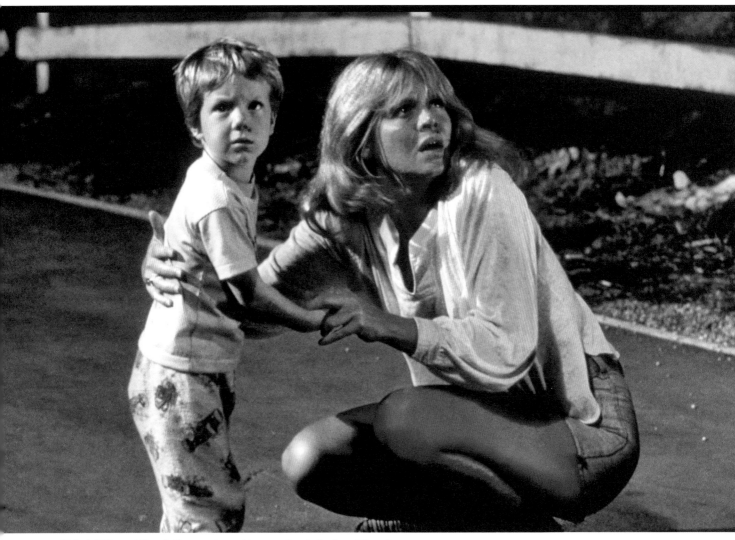

Melinda Dillon and Cary Guffey: a mother and her son, alone in the face of the unknown.

pretext that he did not know how to cry onscreen. "I'll cut out the cry," retorted the director. "No, no, the crying broke my heart,"[3] answered McQueen. Dustin Hoffman, Al Pacino, and Gene Hackman were subsequently approached and all refused. Jack Nicholson was willing, but he was busy shooting his first film, *Goin' South*. Meanwhile, Dreyfuss realized that the role was slipping away from him, and he found himself denigrating all his colleagues to Spielberg. "You need a child [for Roy Neary], that's what you need for this part,"[4] he told the director. Since completing work on *Jaws*, the two men had become friends of a sort, an obvious fact that they were both oddly reluctant to admit.

A Genius in Our Midst

Eager to internationalize his film, Spielberg insisted that the character of the scientist, Claude Lacombe,

should be played by someone French. Some stories attest that Spielberg always wanted François Truffaut for the part, but never dared to believe it was possible. Spielberg loved Truffaut's work as a director, and he was impressed by his "human and compassionate" portrayal in *L'enfant sauvage* (*The Wild Child*). Whatever the stories may claim, Spielberg first contacted actors Lino Ventura, Yves Montand, Jean-Louis Trintignant, and Philippe Noiret, but to no avail. When he approached Truffaut, the most famous French director in the United States after his film *La nuit Américaine* (*Day for Night*) won the 1974 Oscar for Best Foreign Language Film, agreed to play Dr. Claude Lacombe. Truffaut admired *Duel* and he apparently had a few months free before he had to start working on his next picture, *L'homme qui aimait les femmes* (*The Man Who Loved Women*). Acting in a Hollywood production was a unique experience that Truffaut felt

Roy Neary (Richard Dreyfuss) discovers the origin of the shape that obsesses him: the Devils Tower in Wyoming.

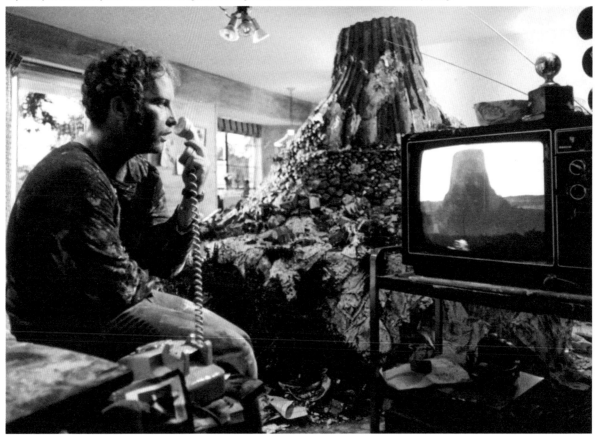

would enrich his own career, as well as informing a book project he was working on about actors. At the end of the shoot, Truffaut advised Spielberg to make a film about children because he felt Spielberg himself was a child, thereby helping pave the way for the filmmaker to make *E.T.*

The Art of Childhood

Chosen to portray little Barry Guiler after a casting session in Alabama, Cary Guffey was four years old when he shot *Close Encounters of the Third Kind*. He was the first of many children Steven Spielberg would immortalize onscreen, and he had already proved his genius for directing them (see page 96). The naturalness of Guffey's looks and reactions is a big part of the emotional beauty of the film. In order to obtain them, Spielberg used various tricks and subterfuges. He opened a gift in front of the child, who, upon understanding what was inside, smiled broadly and said, "A toy!"—the facial expressions and comment which, in the film, we attribute to his first vision of a flying saucer.

And for the scene where Barry discovers the aliens, off-camera, in the kitchen, Spielberg placed an extra disguised as a clown who surprised the child before

the appearance of a simulated gorilla, at the other end of the room, frightens the kid, then reassures and amuses him, the gorilla removing its mask and revealing the face of the person who prepped him every day, makeup artist Bob Westmoreland. A charming anecdote: Before appearing in the film, Cary Guffey had never seen a movie before.

Reassuring Blondes

Spielberg said he had the idea of casting Teri Garr as Ronnie Neary after noticing her in several commercials and being impressed by her ability to bring stereotypical housewives to life in a few seconds. The actress had just made her mark in Francis Ford Coppola's *The Conversation* and Mel Brooks's *Young Frankenstein*. Her character of a neglected partner on the verge of a nervous breakdown foreshadowed her most memorable roles in Coppola's *One from the Heart* and Sydney Pollack's *Tootsie*.

Five days before shooting began, Spielberg still had no one to play Barry's single mother, a key role that was paralyzing his decision-making process. The breakthrough came when Hal Ashby showed Spielberg footage from *Bound for Glory*, a biopic of folk singer Woody Guthrie in which Guthrie's wife

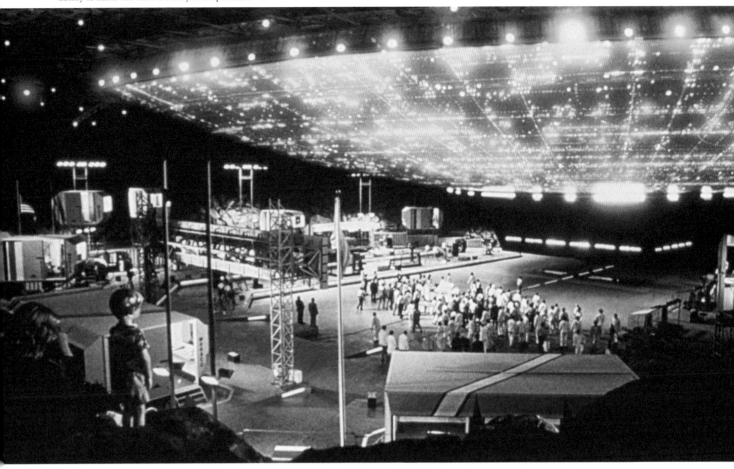

During filming, François Truffaut was said to have been impressed by Spielberg's ability to make the extraordinary seem possible.[5]

was played by Melinda Dillon. The actress joined the long line of blond WASPs with a round and maternal face that populate the filmmaker's filmography. She eventually became the only performer in the film nominated for an Oscar, for Best Supporting Actress.

FILMING AND PRODUCTION

To avoid a replay of the technical and budgetary hell of the filming of *Jaws*, Spielberg carried out numerous tests beforehand and had a gigantic studio built to protect the open-air set of the last half hour of the film and avoid being dependent on the whims of nature. But this was without taking into account a cocaine-addicted producer and a studio in a financial slump.

Defense Secret

After two days of shooting in an air traffic control center in Palmdale at the end of December 1975, the production moved to Mobile, Alabama, in March 1976. There, in a 26,000-square-foot military hangar tall enough to house airships, Joe Alves and his team spent four months building a studio four times larger

FOR SPIELBERG ADDICTS

Close Encounters of the Third Kind marks the first collaboration between Spielberg and Michael Kahn, who edited all of his films after this, except *E.T.* and *The Fabelmans*. The character of the US Air Force major was named Benchley after the author of *Jaws*, Peter Benchley. The dog that comes out of the spacecraft was Elmer, Spielberg's cocker spaniel. Finally, a quick pause of the film as the mother ship flies over the base of Devils Tower will allow eagle-eyed viewers to spot an R2-D2 robot fixed onto its side, a nod to *Star Wars*, which was released six months before *Close Encounters*.

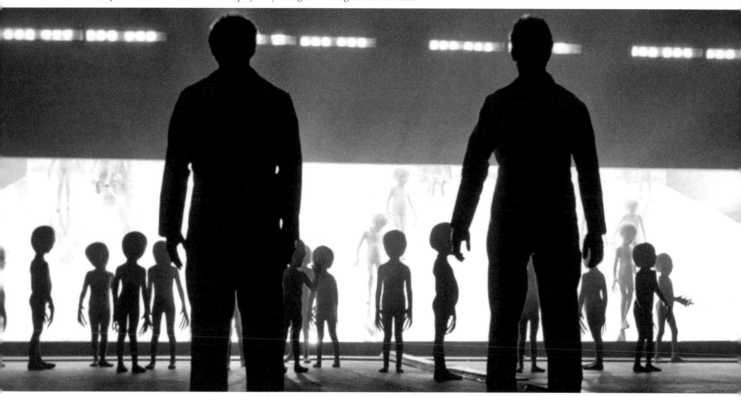

The peaceful aliens in the film were played by little girls wearing masks and suits.

than the largest MGM sets at a cost of $700,000 (more than $3 million today).

On May 16, filming began in earnest. The press was kept at a distance, the script was kept secret, and each copy was numbered for tracking purposes. The set was so secure that one day when he forgot his badge, Spielberg was reprimanded by security guards. As protected as the set was, violent storms damaged the structure, which threatened to flood. Inside, the heat was suffocating despite an air-conditioning system powerful enough to cool an entire village. Indeed, Spielberg's ambition to make his film a kind of nocturnal symphony of sound and light obliged the cinematographer Vilmos Zsigmond to flood the studio with spotlights, which created a great deal of heat.

A Revolutionary Technology

In addition to the requirements of photographic composition, special effects (shot in 70 mm for optimal rendering), UFOs, light effects, and cloud formations were added in postproduction by Douglas Trumbull's team using a new technology called *motion control*. Now frequently used, it consists of recording the exact movements of the camera on a digital medium in order to reproduce them identically, and to harmonize the visual effects added to the image. The process was then in its infancy and each shot involved

was laborious to prepare, which had the tendency of annoying Julia Phillips. Eventually, the producer took Vilmos Zsigmond to task for the delays he was causing. It would take the support of Spielberg to keep Zsigmond on the project. A similar concern was brewing with the executives at Columbia Pictures, which was then on the verge of bankruptcy. *Close Encounters* had an estimated budget of $4 million at the time the screenplay was written (just under $20 million today), which then ballooned to $12 million before finally coming in at $19 million!

The Studio on His Heels

Following stopovers in Los Angeles and on the outskirts of Devils Tower butte in Wyoming—a national monument whose laborious ascent by Richard Dreyfuss and Melinda Dillon was filmed by Spielberg in homage to the Mount Rushmore sequence from Alfred Hitchcock's *North by Northwest*—a first cut of the film was shown to studio executives. They were ecstatic and put some money back into the film to enable Spielberg to film six additional scenes that would prove crucial, including the opening set in Mexico (filmed in the Mojave Desert in California) and a scene in India (filmed in situ). With Julia Phillips keeping Vilmos Zsigmond out of the picture, the shooting was done by different directors of photography from amongst the most prestigious

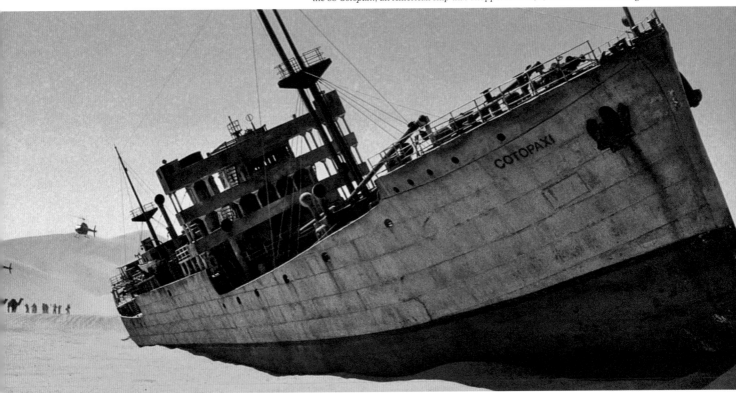

A scene in the Gobi Desert was shot and photographed for a special edition of the film. It resurrected the SS *Cotopaxi*, an American ship that disappeared in 1925 in the Bermuda Triangle.

available (Douglas Slocombe, László Kovács, William Fraker, John Alonzo). In February 1977, Spielberg could finally devote himself to postproduction, from which he emerged nine months later, exhausted and disgruntled. The leaders of Columbia, whose shares were falling precipitously, had pressed him to release the film by mid-November.

RECEPTION

Science fiction writer Ray Bradbury called the movie "the most important film of our time"[6] and the influential *New Yorker* critic Pauline Kael was charmed by what she called a "children's film in the best sense of the word."[7] Meanwhile, *Time* magazine, in the words of Frank Rich, hit the nail on the head: "What lifts this film into orbit—and what saves it from being a shaggy flying-saucer story—is the breathless wonder that the director brings to every frame. [...] Spielberg seems to be looking at everything onscreen as if for the first time."[8]

Another Triumph

Although enthusiastic, the critical reception included its share of detractors, such as Molly Haskel of *New York* magazine, who called the film "the dumbest story ever told," foreshadowing the snobbery that would long plague Spielberg's idealistic, deeply American, and universally entertaining films.

Nominated for eight Oscars, most of them technical (Vilmos Zsigmond won for Best Cinematography), the film earned Spielberg his first nomination as director. At the box office it was another triumph, although it fell short of the record set by *Jaws*, which had been broken six months earlier by *Star Wars*. Along with that film, *Encounters* would popularize science fiction as never before, leading to a plethora of fans and a growing cult following.

From One Version to Another

In exchange for being able to complete the film as he wanted, Spielberg conceded to Columbia and added a sequence where Roy Neary sees the interior of the mother ship; the studio felt this would satisfy the audience's expectations. The scene was an aberrant addition, and Spielberg removed it from the director's cut that was released on video in 1998. In this version, Neary insists on taking his children to see *Pinocchio* at the movies when they would rather watch *The Ten Commandments* on TV. He is also caught crying in the bathtub, which angers his eldest son, who calls him a crybaby—two very autobiographical moments from the director's life. At once pragmatic and chimeric, *Close Encounters* lays the foundations of Spielberg's cinematic oeuvre and his primary aspiration as a director: to make dreams and reality coexist.

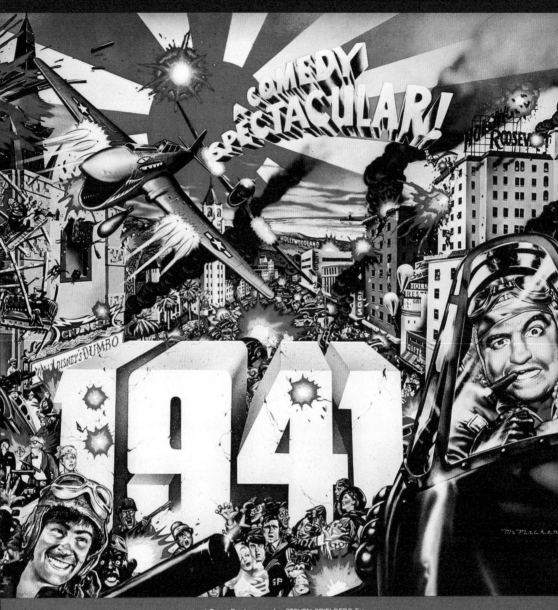

An A-Team Production of a STEVEN SPIELBERG Film

DAN AYKROYD · NED BEATTY · JOHN BELUSHI · LORRAINE GARY
MURRAY HAMILTON · CHRISTOPHER LEE · TIM MATHESON · TOSHIRO MIFUNE
WARREN OATES · ROBERT STACK · TREAT WILLIAMS

A UNIVERSAL PICTURES and COLUMBIA PICTURES Presentation

NANCY ALLEN · EDDIE DEEZEN · BOBBY DiCICCO · DIANNE KAY · SLIM PICKENS · WENDIE JO SPERBER · LIONEL STANDER

Director of Photography WILLIAM A. FRAKER, A.S.C. · Screenplay by ROBERT ZEMECKIS & BOB GALE · Story by ROBERT ZEMECKIS & BOB GALE and JOHN MILIUS · Music by JOHN WILLIAMS · Produced by BUZZ FEITSHANS · Executive Producer JOHN MILIUS · Directed by STEVEN SPIELBERG

Original Soundtrack Album on ARISTA Records and Tapes. | Read the Ballantine Book

PG PARENTAL GUIDANCE SUGGESTED ⊕
SOME MATERIAL MAY NOT BE SUITABLE FOR CHILDREN

1941

United States **1 hr 58**
(director's cut: 2 hrs 26) **Color**
(Metrocolor) **Stereo**
(4-Track/6-Track) **2.35:1**

Production Dates: October 23, 1978–May 16, 1979
United States Release Date: December 14, 1979

Worldwide Box Office: $90 million (equivalent to $368 million in 2023)

Production Company: A-Team, Universal Pictures, Columbia Pictures
Producer: Buzz Feitshans
Associate Producers: Janet Ealy, Michael Kahn
Executive Producer: John Milius
Unit Production Managers: Chuck Myers, Herb Willis

Based on a story by Robert Zemeckis, Bob Gale, and John Milius
Screenplay: Robert Zemeckis, Bob Gale
Director of Photography: William A. Fraker
Camera Operator: Dick Colean
Assistant Directors: Jerry Ziesmer, Steve Perry

Film Editing: Michael Kahn
Music: John Williams
Sound: Robert Knudson, Robert Glass, Don MacDougall, Gene S. Cantamessa

Production Design: Dean Edward Mitzner
Art Direction: William F. O'Brien
Set Decoration: John Austin
Hair Stylist: Susan Germaine
Special Effects: A. D. Flowers, Gregory Jein

Starring: Dan Aykroyd (Sergeant Frank Tree), Ned Beatty (Ward Herbert Douglas), John Belushi (Captain Wild Bill Kelso), Lorraine Gary (Joan Douglas), Murray Hamilton (Claude Crumn), Christopher Lee (Captain Wolfgang von Kleinschmidt), Tim Matheson (Captain Loomis Birkhead), Toshirô Mifune (Commander Akiro Mitamura), Warren Oates (Colonel Maddox), Robert Stack (Major General Joseph W. Stilwell), Treat Williams (Corporal Chuck Sitarski), Nancy Allen (Donna Stratton), Bobby Di Cicco (Wally Stephens), Dianne Kay (Betty Douglas), Slim Pickens (Hollis P. Wood)

> **"I didn't really know what I was doing on this movie. One of the reasons the movie came out so chaotic is that I didn't really have a vision."**[1]
>
> ——
>
> —Steven Spielberg, in 1996

SYNOPSIS

——

On December 13, 1941, a Japanese submarine approaches Los Angeles with the ambition of destroying a powerful symbol of the American empire: Hollywood. In town, Wally wants to take his girlfriend Betty to a dance contest, but a brawling soldier has set his sights on Betty and takes it upon himself to eliminate his rival. A few miles away, General Joseph W. Stilwell tries to reassure the population, frightened by the prospect of a Japanese attack one week after the attack on Pearl Harbor. This is a threat that does not frighten Captain Wild Bill Kelso. Visibly unbalanced, Kelso sets out to pursue Japanese planes in the California sky with his Curtiss P-40 fighter.

GENESIS

When Bob Gale and Robert Zemeckis met on the benches of the film department of the University of Southern California, their mutual understanding was immediate. Their age, first of all, was the same, and they were born within a few days of each other. They also shared a passion for American popular cinema, while other students swore by European and New Wave film. One day in 1973 when their class was invited to a screening of *The Sugarland Express*, Zemeckis took the opportunity to approach Spielberg and present him with a short film of his own, *A Field of Honor*. The director was impressed by the mood of this comedy—which was very dark, in the style of *Mad* magazine—and by its spectacular visuals, which were captured in spite of a lack of resources.

Blackout in Los Angeles

Fresh after graduation, the Gale/Zemeckis duo contacted John Milius: a USC alumnus who had the triple advantage of being a prominent director (*Dillinger*, *The Wind and the Lion*), a noted screenwriter (*Dirty Harry*, *Magnum Force*, and *Jeremiah Johnson*), and a close friend of Spielberg. Gale and Zemeckis had

Playing the clarinet, Spielberg gives an extra a run for their money.

two projects in mind: One, *Bordello of Blood*, was a vampire horror-comedy with strong sexual overtones; the other, *Tank*, was set in World War II. Passionate about military history, Milius did not like the first project, and he had enormous reservations about the second. He nevertheless sensed a very audacious spirit that won him over. The third project Zemeckis and Gale proposed was the right one. Retitled *The Night the Japs Attacked* by Milius himself, the script evoked the night of panic into which Los Angeles was plunged in February of 1942 after a false alarm for a supposed Japanese air raid went out across the city. After six hours of blackout and thousands of rounds fired into the sky, there was never a trace of any Japanese planes. The director took the opportunity to incorporate the true story of General Stilwell, who was in charge of defending the West Coast from a possible invasion after the attack on Pearl Harbor in December 1941. In the course of their research, Zemeckis and Gale added a riot reminiscent of the June 1943 race riot between white soldiers and young Mexicans (the Zoot Suit Riots) and the real-life attack by a Japanese submarine that sent a pair of torpedoes into a California refinery in February 1942.

A Palpable Energy

Milius was delighted. MGM, with whom he was under contract, was less impressed. The screenplay was increasingly subversive and represented a huge risk. The influential producer then had the idea of entrusting the direction to his friend Spielberg. The "transaction" took place at the shooting club that both directors liked to attend. In the middle of preproduction for *Close Encounters of the Third Kind*, Spielberg was convinced when he discovered a script full of sentences written in capitals and lines filled with exclamation marks: The energy was palpable. He agreed to be part of it, with the impression of being in touch with his own *Doctor Strangelove* (Stanley Kubrick, 1964), which he particularly loved.

Zemeckis and Gale visited Spielberg on the set of *Close Encounters* and the project that was to become *1941* was refined in one evening; or, rather, it exploded in all directions. Impressed by the duo's verve and very adolescent imagination, the filmmaker joined in their delirium, forgetting his promise not to exceed the budget he had set for himself: "I will not make this film if it costs one penny over $11 million."[2] In today's money, that translates to $50 million.

CASTING

To play the role of General Stilwell, Spielberg dreamt of casting John Wayne, who had become a friend since they met at a tribute to Joan Crawford. The legend of the Western read the script but refused the role, horrified by a film that he considered anti-American. He even advised the director not to make the film. Charlton Heston also declined for similar reasons. Finally, Robert Stack, the icon of the series *The Untouchables*, was suggested for the part. Stack, Spielberg, and Milius all frequented the same shooting club in California (Oak Tree Gun Club), and he also physically resembled the general. The role was his.

A Cult Duo

The characters in the film are countless and Spielberg continued to have fun with his new project. By poaching the cult duo Dan Aykroyd and John Belushi from the satirical TV show *Saturday Night Live*, he pulled the film toward an even more "crazy" universe, and he was ready to encourage their improvisations on set. In the Japanese submarine, we find the legendary interpreter of *Dracula*, Christopher Lee, as a Nazi

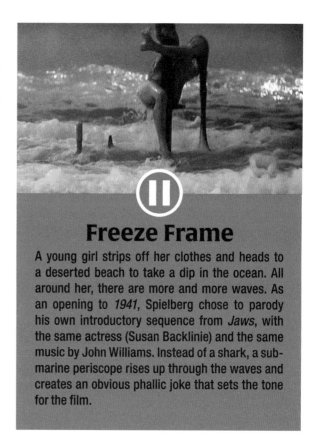

Freeze Frame

A young girl strips off her clothes and heads to a deserted beach to take a dip in the ocean. All around her, there are more and more waves. As an opening to *1941*, Spielberg chose to parody his own introductory sequence from *Jaws*, with the same actress (Susan Backlinie) and the same music by John Williams. Instead of a shark, a submarine periscope rises up through the waves and creates an obvious phallic joke that sets the tone for the film.

Birkhead (Tim Matheson) and Donna Stratton (Nancy Allen) having fun on set.

The filmmaker makes a stand between a famous vampire (Christopher Lee) and a famous samurai (Toshirô Mifune).

For a time, Spielberg wanted to turn *1941* into a musical; only one sequence from this plan remains in the film.

officer, as well as Toshirô Mifune, Akira Kurosawa's favorite actor, as a Japanese commander. Mifune also intervened in the script by changing some details in the Japanese sequences. As for the rest of the roles, it was a free-for-all! There were various appearances by veteran actors as well as some of the director's relatives, and *1941* seemingly turned into one big party.

FILMING AND PRODUCTION

Filming began in October 1978, and Spielberg had not lost his sense of fun. Belushi made him laugh so much that the director made the actor's stupid aviator one of the main characters of the film. Belushi, with his notorious excesses (he died of an overdose in 1982, at the age of thirty), was absolutely unpredictable. During a scene in which he had to get back into his plane, he slipped on the wing and fell onto some of the extras, an accidental stunt that made it into the film.

The Temptation of Musical Comedy

"On about the hundred and forty-fifth day of shooting, I realized that the film was directing me, I wasn't directing it."[3] As the weeks went by, the situation became more and more intolerable; the political incorrectness asserted by "the two Bobs" (Zemeckis and Gale) alarmed him. So, instead of a cynical black comedy, *1941* gradually became a screwball comedy, a burlesque genre popular in the United States in the 1940s and 1950s. Is there anything to be pleased about? Not really. For a while, Spielberg even considered turning the whole thing into a musical.

An aerial pursuit shot against a pasteboard background.

John Williams warned him that the exercise would require a lot of time to set up. From this idea, only the dance hall sequence remains, a piece of bravura directing whose fluidity is due to the use—unheard of in Hollywood—of the Louma, a crane to which a camera is attached, which Spielberg was one of the first to use in America.

An Aerial Pursuit on Hollywood Boulevard

Spectacular is how one might describe the aerial pursuit on Hollywood Boulevard, where the special effects team reconstructed the Los Angeles strip in the studio using cardboard and small cars. Also spectacular are the destruction of the Ferris wheel on the Santa Monica pier, which rolls before sinking into the ocean, and the house that collapses off the cliff in the final scene. Finally, and similarly spectacular, was the balance sheet at the end of the shooting: budgeted at $11 million, then revised up to $26 million, the budget ended up at $31.5 million ($128 million today), which makes it at that time one of the most expensive films ever made.

RECEPTION

In the editing room, Spielberg was dejected: He had shot the equivalent of 186 miles of film! A first version running to 2 hours and 26 minutes was presented on October 19, 1979, at the Medallion Theatre in Dallas, where the director's two previous films had been well received. After the hilarious opening of the film, embarrassment set in. Worse, some spectators plugged their ears, so aggressive was the soundtrack. At the exit, the president of Universal, Sid Sheinberg, tried to reassure him: "There's a movie somewhere in this mess. There's a really good movie, and we should go off and find it."[5]

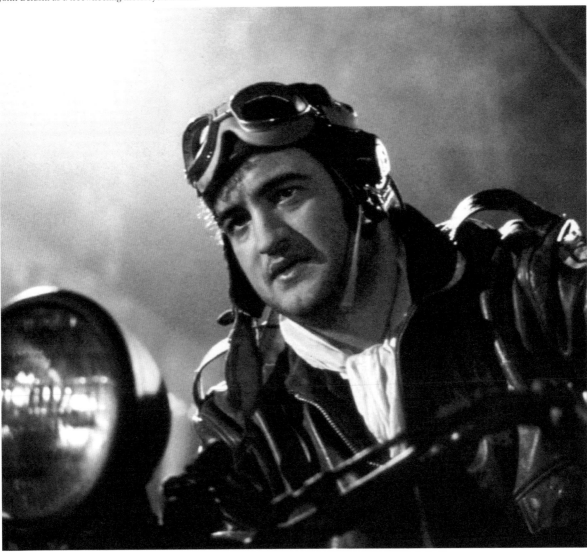

John Belushi as a freewheeling motorcycle aviator.

"Spielberg's Pearl Harbor"

Spielberg cut seventeen minutes of film to help the pace, without realizing that the result was even less intelligible to audiences. After another disastrous preview in Los Angeles on December 13, 1979, the day before the film's national release, the press shot the film down completely. The *Los Angeles Times* even spoke of "Spielberg's Pearl Harbor."[5] However, *1941* was not a commercial failure and even made some money. But although it ended up being somewhat reappraised fifteen years later with the release of the director's cut, Spielberg had no illusions about the project: This comedy was not for him. At the helm, the two "Bobs" would have remained faithful to the original spirit of the script. Spielberg, on the other hand, had aspirations of making something rather more raucous and naughty.

An Army of Cameos

Among many notable appearances in the film, we find Hollywood legends such as Warren Oates, Samuel Fuller, Murray Hamilton, and Slim Pickens. Among younger cast, there are appearances from James Caan, Mickey Rourke, *Spinal Tap*'s Michael McKean, John Landis, and Penny Marshall. John Milius, who plays an armed Santa Claus, was cut in the editing room. Even a set had a cameo: The gas station from *Duel* makes an appearance in *1941*, with the same actress playing the owner.

Spielberg flanked by Brian De Palma and Martin Scorsese in 1984.

Spielberg and the New Hollywood
The Family You Create

Steven Spielberg was both an emblematic figure of the New Hollywood era and also one of its final inhabitants. An emblematic figure in the sense that, along with Martin Scorsese, Francis Ford Coppola, and Brian De Palma, he embodied that generation of "bearded kids" who were mocked by Billy Wilder in *Fedora* (1978) and nicknamed "the movie brats." They buried the old studio system and, assisted by their success, imposed a new era in which the film-maker was king. Spielberg was viewed as a human wrecking ball by some because he participated, along with George Lucas, in building the reign of entertainment for young audiences.

An American Revolution in Cinema

When Steven Spielberg started out in the late 1960s, Hollywood was an aging industry in the midst of a major upheaval. Gone were the big features that

consistently drew crowds, and gone were the cavalcades of stars and directors kept under exclusive contracts by all-powerful movie moguls: The golden age of the studios was over. When television entered the home in the mid-1950s, it supplanted cinema as the primary form of popular entertainment. Worried by this new competition, the majors saw bigger and bigger budgets until the commercial flops of monumental blockbusters such as Joseph L. Mankiewicz's *Cleopatra* (1963) or Joshua Logan's *Paint Your Wagon* (1969) made them permanently vulnerable. Society itself also changed. The Vietnam War, as well as the assassinations of President John F. Kennedy in 1963 and of Martin Luther King Jr. and Bobby Kennedy in 1968, plunged America into an era of disillusionment and paranoia. The utopia of the American way of life, promoted since the postwar period, was thrown out the window: It was time for the country to take a

A virtuoso in search of meaning.

look at itself, to look its violence and its evils straight in the eye. It was time for the civil rights movement, the liberation of morals, and flower power.

Overwhelmed by these changes and faced with the unprecedented success of the films that echoed them, like *Bonnie and Clyde* (Arthur Penn, 1967), *The Graduate* (Mike Nichols, 1967), and *Easy Rider* (Dennis Hopper, 1969), the leaders of Hollywood opened up to a new generation of filmmakers determined to take advantage of this opportunity. These were mavericks trained onstage (Mike Nichols, Bob Fosse, etc.) and on television (Robert Altman, John Cassavetes, William Friedkin, Sidney Lumet, Arthur Penn, etc.), but also, and above all, they were aspiring directors from film schools: Francis Ford Coppola and George Lucas came from the University of Southern California, Martin Scorsese from New York University, and Brian De Palma from Columbia University.

"Previously, film crews were under the sovereign control of the unions," explained writer-director Matthew Robbins, who graduated from the University of Southern California. "For outsiders like us, strangers to the business, it was strictly impossible to make it in Hollywood without starting at the bottom and working your way up. But that's when everything changed."[1]

A Child of the System

Like his contemporaries, Spielberg was a child of the "glorious thirty years," fed on films gleaned from the small and the big screens alike. He had ambition and an unquenchable thirst for filming...but he did not graduate from any school. Galvanized by films coming out of Europe (in particular the French, and their policy of authorship theorized in the film magazine *Cahiers du Cinéma*) and influenced by the authenticity of Italian neorealism and English free cinema, Spielberg's peers sought to import this freedom to Hollywood and, for the most ambitious such as Coppola, to reinvent the system. Spielberg, on the other hand, did not care about being an auteur and instead looked to the B movies and blockbuster films that had enthralled his youth. As for the system, he had not complained about it since 1969, when Sid Sheinberg, the head of Universal, took him on as a contract director. Counterculture meant very little to him. Steven was more innocent-minded and less complicated than Brian de Palma or Marty Scorsese, and this was reflected in his films. As actress Margot Kidder commented, "He was much more normal than we were, in the sense of having our neuroses get in the way of our professional lives."[2] The house at Nicholas Beach, near Malibu, where Kidder lived with her friend and colleague Jennifer Salt in the mid-1970s became the haunt of young "bearded" Hollywood. Amid an ambiance of sex and drugs, Spielberg would often sit in front of the television while the others tested the latest fashionable substances.

Spielberg's Quest for Steven

"It was the hippie era, everyone drove Volkswagens except Steven, who was already very Hollywood, with his 'crypto-adult' style," noted Matthew Robbins. "He drove a little Mercedes convertible, gave to

(left to right) Steven Spielberg with Martin Scorsese, Brian De Palma, George Lucas, and Francis Ford Coppola in 1990.

charity because that's what he thought a mature man was supposed to do. We were twenty-seven and he acted like he was fifty. He had learned to live through the movies and, outside of them, didn't really know how to do it. John Milius collected guns; sometimes we would go shooting with him and Steven would think, 'Here's a hobby I could do.' Another day, someone would introduce him to great French wines and his interest would be piqued. Steven, in the 1970s, embodied a strange mix of enthusiasm, curiosity about things, and a search for who he was. On a movie set, however, he never doubted his authority for a moment, and had complete confidence in his filmmaking instincts. He had already made films for television, and in that, too, he stood out among the group."[3]

It is ironic in retrospect, but at the time, Spielberg was considered the ugly duckling of the group and a kind of traitor to the cause. His friend George Lucas introduced him in glowing terms to his mentor Francis Ford Coppola, but Coppola did not invite Spielberg to join American Zoetrope, the studio he created to compete with the majors. In the eyes of the director of *The Godfather* (1972), this little protégé of Universal, who was a maker of TV movies and TV episodes, embodied the establishment against which he intended to make a stand.

Inventor of the Blockbuster

Spielberg thus went through the 1970s a little lost. He was searching for himself while his colleagues plunged headlong into the troubled decade and embraced the ambient pessimism with their films

populated with antiheroes. Certainly, *Duel* (1971) maintains a frightening suspense that can be seen as a parable of the individual facing the system, and *The Sugarland Express* (1974), inspired by a tragic news item, is not kind to the American police. Meanwhile, *Jaws* (1975), apart from its violence, evokes the trauma of war through the character of Quint, and offers a critical portrayal of the authorities of the small seaside resort town who send holidaymakers to the slaughter for commercial and electoral reasons (a possible metaphor for the attitude of the American government with regard to the conscripts in the Vietnam War).

Added to this is the realistic grounding of these films (and of *Close Encounters of the Third Kind*) due to the fact that they were shot on real sets and not in the studio, as had long been the tradition. But these elements, which were characteristic of the time, were a source of inspiration for Spielberg for cinematic rather than political reasons. When Martin Scorsese, William Friedkin, and Michael Cimino led their protagonists into a dead end, and when Robert Altman, Bob Rafelson, and John Cassavetes broke the rules of scriptwriting by tying their stories into the vagaries of the characters, it was meant to convey a certain reality of America and society at large.

Spielberg, on the other hand, always seemed to be interested in creating spectacle. His focus was always on the story, and the human adventure. His heroes are ordinary men and women, John and Jane Does who overcome adversity or open themselves up to the extraordinary. The historic box-office hits of *Jaws* in 1975 and *Star Wars* in 1977 radically changed the face of Hollywood. Combined with the costly failures of Scorsese's *New York, New York* (1977), Friedkin's *Sorcerer* (1977), and Cimino's *Heaven's Gate* (1980), they signaled the end of the New Hollywood, and of the adult ambitions of an industry that was now aiming for a young, and more family-oriented audience. "*Star Wars* was in, Spielberg was in, and we were finished,"[4] said Martin Scorsese. Much more than the New Hollywood, it was the popcorn cinema of the 1980s that Spielberg embodied as both a director and as a producer of such films as *Back to the Future*, *The Goonies*, *Gremlins*, and *Who Framed Roger Rabbit*.

Did the spirit of the New Hollywood ever reach him? Certainly in the 2000s, when he made *Minority Report*, *War of the Worlds*, and *Munich*, three films that seem to be haunted by the attacks of 9/11, terrorism, and issues of security. Twenty years later, it seems Spielberg decided to take a slightly darker approach to film.

Spielberg reclines on a makeshift Hollywood throne.

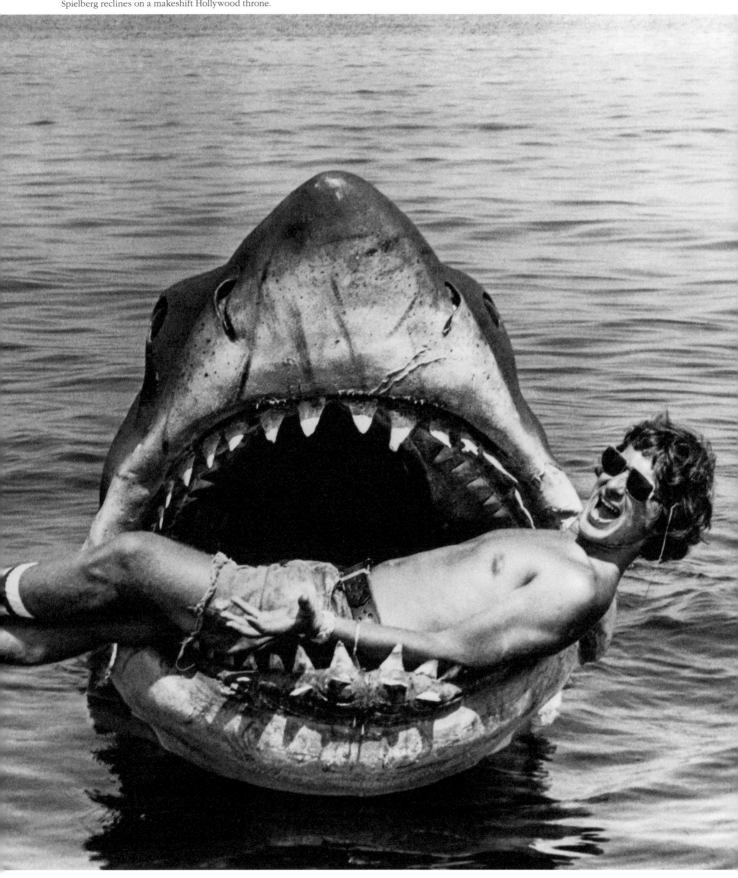

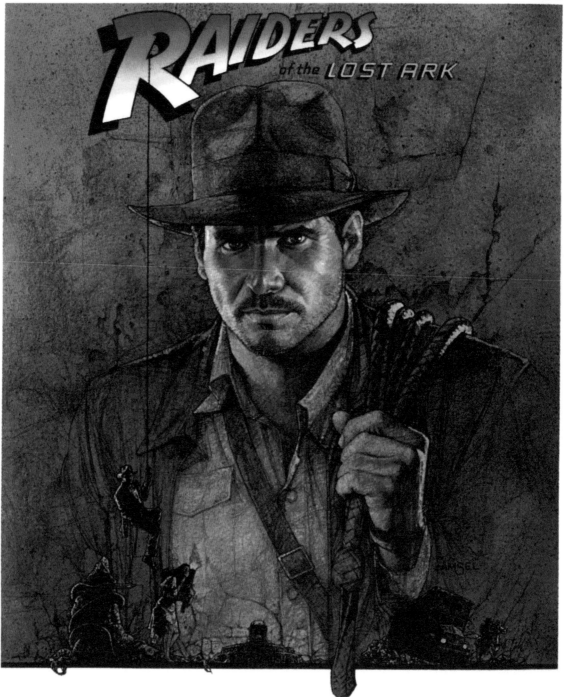

Raiders of the Lost Ark

United States 1 hr 55 Color (Metrocolor) Stereo (Dolby/6-Track) 2.39:1

Production Dates: June–October 1980
United States Release Date: June 12, 1981

Worldwide Box Office: $351 million (equivalent to $1.15 billion in 2023)

Production Company: Paramount Pictures, Lucasfilm
Producers: Frank Marshall
Associate Producer: Robert Watts
Executive Producers: George Lucas, Howard Kazanjian
Unit Production Manager: Douglas Twiddy

Based on a story by George Lucas and Philip Kaufman
Screenplay: Lawrence Kasdan
Director of Photography: Douglas Slocombe
Visual Effects: Richard Edlund, Bruce Nicholson, Joe Johnston, Kit West
Film Editing: Michael Kahn, George Lucas (uncredited)
Music: John Williams
Sound: Roy Charman
Production Design: Norman Reynolds
Art Direction: Leslie Dilley
Set Decoration: Michael Ford
Costume Design: Deborah Nadoolman
Casting: Jane Feinberg, Mary Selway, Mike Fenton
Second Unit Directors: Michael D. Moore, Frank Marshall (uncredited)

Starring: Harrison Ford (Indiana Jones), Karen Allen (Marion Ravenwood), John Rhys-Davies (Sallah), Paul Freeman (René Belloq), Ronald Lacey (Toht), Denholm Elliott (Brody), Wolf Kahler (Dietrich), Anthony Higgins (Gobler), Alfred Molina (Satipo), Don Fellows (Colonel Musgrove), William Hootkins (Major Eaton), Pat Roach (German 1st mechanic), Christopher Frederick (Otto), George Harris (Katanga), Fred Sorenson (Jock)

"Now I just wanted to make a movie where people would say he's a responsible director who came in under budget and under schedule."[1]

—Steven Spielberg

SYNOPSIS

In 1936, just back from an expedition to Peru, the American archaeologist and university professor Indiana Jones is approached by intelligence agents who tell him that the Nazis are looking for the Ark of the Covenant, a chest containing the tablets on which the Ten Commandments are inscribed. They must be stopped because the so-called Ark of the Covenant is supposed to confer great power on those who possess it, and this would allow Hitler's armies to dominate the world. The person who knows the most about the Ark is Indiana Jones's mentor, Abner Ravenwood. The last time anyone had any information about him, he was in Nepal. Indiana Jones goes off to find his mentor.

GENESIS

The anecdote is now part of the annals of the industry. At the end of May 1977, when *Star Wars* was released in American theaters, George Lucas was on vacation in Maui, Hawaii. Exhausted by a demanding shoot and at loggerheads with 20th Century Fox, who did not believe in the film, the filmmaker fled Hollywood to escape the pressure.

Star Wars was an incredible triumph. Steven Spielberg joined George Lucas on vacation and while building a sand castle on the beach, the two men discussed their future. Spielberg, who was finishing *Close Encounters of the Third Kind*, could see himself at the helm of a James Bond film. Lucas had another idea. Since 1973, he had been working on an adventure film inspired by the productions of the 1930s and 1940s, B series, comic books, and serials seen on television when he was a child. The tentative title was *The Adventures of Indiana Smith*—Indiana being the name of his wife Marcia's dog, a large Alaskan malamute that inspired the hairy character of Chewbacca in *Star Wars*.

A MacGuffin to Get Things Going

In 1975, George Lucas and filmmaker Philip Kaufman worked for three weeks on a draft script. Indiana Smith was a university archaeologist, and Kaufman had the idea of sending him on a quest for the Ark of the Covenant, a sacred relic mentioned in the New Testament. It thus serves as a MacGuffin, a screenplay trick popularized by Alfred Hitchcock in which a story focuses on the search for a specific object, which drives the action of the film. By including the Nazis as villains in the film, Kaufman also explored the genuine attraction for the occult possessed by certain leading figures of Hitler's regime, who had tried to use archaeology for ideological purposes. In fact, Heinrich Himmler had created in 1935 the Ahnenerbe (meaning "ancestral heritage"), an institute devoted to research on the culture and origins of the Germanic race.

Cliffhangers to Keep Things Intersecting

Busy shooting *The Outlaw Josey Wales* (Clint Eastwood, 1976), Philip Kaufman was unable to direct *The Adventures of Indiana Smith*. George Lucas, who intended to produce the film, was therefore free to offer the project to Steven Spielberg. At the same time, the two filmmakers were attracted by a script circulating in Hollywood called *Continental Divide*. They agreed that its author, Lawrence Kasdan, would participate in the project. In the end,

Lucas and Spielberg on set in the Tunisian desert.

Continental Divide was directed by Michael Apted in 1981 and produced by Spielberg.

During five days at the end of January 1978, the three men exchanged ideas. Recording their brainstorming sessions on tape, they drew from the films of Michael Curtiz, John Huston, and Howard Hawks, as well as from thrillers, Westerns, spy films, and samurai films. From the outset, the discussion revolved around the essence of the film and its sequels: the cliffhanger, that is, a critical situation that should keep audiences on the edge of their seats. The process came directly from episodic films, designed to keep the audience coming back to the cinema to see the sequel. Several scenes of this type would follow one another in the film, with a constraint, stipulated by Steven Spielberg, that: "each cliffhanger is better than the one before."[2]

On the Importance of the University Hero

For the hero, Spielberg had a manly and gruff character like Humphrey Bogart or Clark Gable in mind. George Lucas insisted on the importance of making him a university man as a way of creating a comic contrast with the insane adventures he was going to experience.

Indiana Jones teaching a class of students. George Lucas was keen on including this kind of scene.

He thus envisaged, in the film's opening, an action scene located in the jungle followed without transition by a scene "back in Washington or New York, back in the museum." (This is exactly how the film begins.) For Lucas, again, Indiana Smith was a troubled hero, a kind of "grave robber for hire" and "outlaw archaeologist" for private collectors or museums. Spielberg would do everything he could to water down this dimension of the film, but there are still traces of it in the final product and its sequels.

Several authentic archaeologists are supposed to have served as models for Indiana Smith—for example, the Briton Percy Fawcett, who disappeared in 1925 in his quest to find the "lost city of Z," and the American Roy Chapman Andrews, who recounted his wild adventures in several books. But Spielberg and Lucas never directly quoted anyone. Quite simply, the figure of the adventurer archaeologist existed in the popular culture, fed by accounts of expeditions published in newspapers, magazines, and various biographies. Just as Arthur Conan Doyle wrote *The Lost World* (1912) by extrapolating upon what his friend, Percy Fawcett, told him, Spielberg and Lucas used generally available information to build the character of Indiana Smith.

The Killer Deal

In spite of ongoing debates of character, the essence of the film was already in place during these sessions

in early 1978. The only hitch: Steven Spielberg hated the name Indiana Smith, which was too reminiscent of the Western *Nevada Smith* (Henry Hathaway, 1966). So it was changed to Indiana Jones.

Lawrence Kasdan began to write a screenplay based on all of these elements, while George Lucas began work on *The Empire Strikes Back* (again with Kasdan as co-writer) and Steven Spielberg shot *1941*. In the end, Lucasfilm, George Lucas's production company, could not finance the project alone. However, while the big Hollywood studios could sense the potential of Indiana Jones, the proposed contract scared them: Not only did Lucas need a $20 million budget (equivalent to $72 million today), but also, true to the spirit of serials, Lucas required a commitment for five films focused on the adventures of Indiana Jones. And that was not all: The producer was asking to be paid 80 percent of the film's profits before the studio began to recoup its investment, and to keep the rights to any spin-offs and sequels, as well as keeping artistic control of the project as a whole. This kind of deal was unheard of, and the studios called it a "killer deal."

A Problem Called Spielberg

As negotiations for Indiana Jones were taking place, Spielberg had a major failure with *1941*. Despite his previous success, the studios remembered that he had exceeded deadlines and budgets on all three of

his feature films to date: *Jaws, Close Encounters of the Third Kind*, and *1941*. They quite simply wanted someone else. Lucas refused to budge on Spielberg, but he did agree to adjust his own contractual demands, and an agreement was finally reached with Paramount Pictures. An interesting clause was added to the contract: Penalties would have to be paid to the studio if the picture went over budget.

Once the deal was in place, Steven Spielberg suggested bringing on Frank Marshall as a producer, while Lucas would serve as an executive producer. Spielberg didn't know Marshall, but he had seen him at work on a visit to his friend Peter Bogdanovich's set. Marshall made a strong impression on him through his commitment, not even bothering to sit down for lunch because he was so obsessed with the work. If Steven had to work under supervision, then it might as well be under Frank Marshall's supervision. In the end, this relationship of convenience would go on to become a serious partnership, and the two men, along with Kathleen Kennedy, co-founded the production company Amblin in 1981.

CASTING

To play Indiana Jones, George Lucas wanted an unknown face, a blank page that would be conducive

❚❚ Freeze Frame

Indiana Jones appears in the very first seconds of the film, during the credits, in a nonspeaking scene. Seen from behind, his silhouette takes the place of a mountain literally stamped with the director's name. During the whole scene, we see his hands, his torso, his hat, but never his face. He remains silent; his gestures speak for themselves. Indiana Jones does not have to become an icon—he is one already.

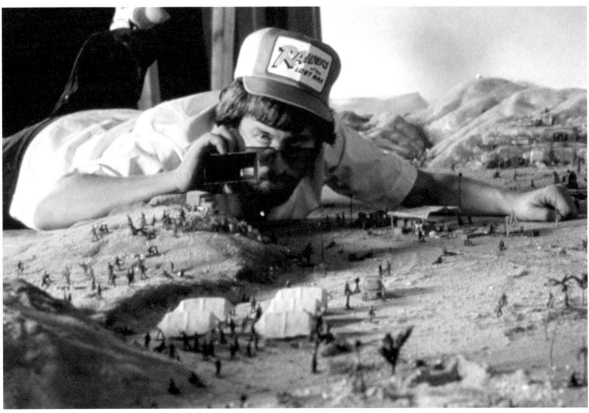

Steven Spielberg tested his camera framing on model sets. In this case, he's considering how to frame the excavation site.

Indiana Jones finds a rare treasure in a booby-trapped cave.

to the emergence of a new movie icon. He did not want Harrison Ford: The actor had appeared in three of his productions and was now inseparable from the character of Han Solo in *Star Wars*. Tom Selleck was chosen for the role after testing the scene set in the Nepalese tavern. Karen Allen was cast in the role of Marion Ravenwood.

A Series of Missed Opportunities

It turned out that just before his audition, Selleck had shot the pilot of a TV series for CBS called *Magnum P.I.*, for which he had signed an exclusive contract. For a month, Spielberg and Lucas tried to convince the network to allow the actor to work for them, but they were unsuccessful. Harrison Ford was called in at the last minute to take over the role. Other actors that had been approached would also end up needing to be replaced, including French actor Jacques Dutronc, who was meant to play the role of René Belloq. British actor Paul Freeman was chosen for the part after Spielberg saw him in a 1980 television docudrama about a Saudi princess who had been executed for adultery three years earlier. At the last moment, however, the director began to have doubts and brought Freeman in to hear him imitate a French accent. With Spielberg apparently convinced, Freeman kept his part. Danny DeVito was Spielberg's first choice to play Sallah, but DeVito couldn't make the scheduling work and he was replaced by the actor John

Rhys-Davies, who had been spotted by Spielberg in the series *Shogun* (1980).

FILMING AND PRODUCTION

The filming was organized in a rigorous manner right from the start. Shooting began on location in La Rochelle, France, on June 23, 1980. The location was used as a stand-in for the scenes from the film that took place in the port of Cairo. The production managed to rent an old Egyptian steamer brought from Ireland as well as a U-boat made for the film *Das Boot* (*The Boat*) that Wolfgang Petersen was shooting at the same time, also in La Rochelle.

Fire at Elstree

After shooting in France, everyone met at EMI's Elstree Studios, in Borehamwood, on the northwest outskirts of London. This is where all the interiors were shot and where various other sets were built—the map room, the secret military base in the final scenes, the tavern, and the Peruvian cave full of traps. Unfortunately, Spielberg had to postpone his arrival at Elstree because of a fire on set No. 3, which was being used by Stanley Kubrick for *The Shining* (1980). In the end, Spielberg benefited from the fire: After restoration, the set was enlarged, thereby allowing him to erect ancient jackal-headed statues more than thirty-three feet high.

George Lucas chose these premises because he knew them well and would thus be better able to

The final climax of the film was shot on a studio set located on the outskirts of London.

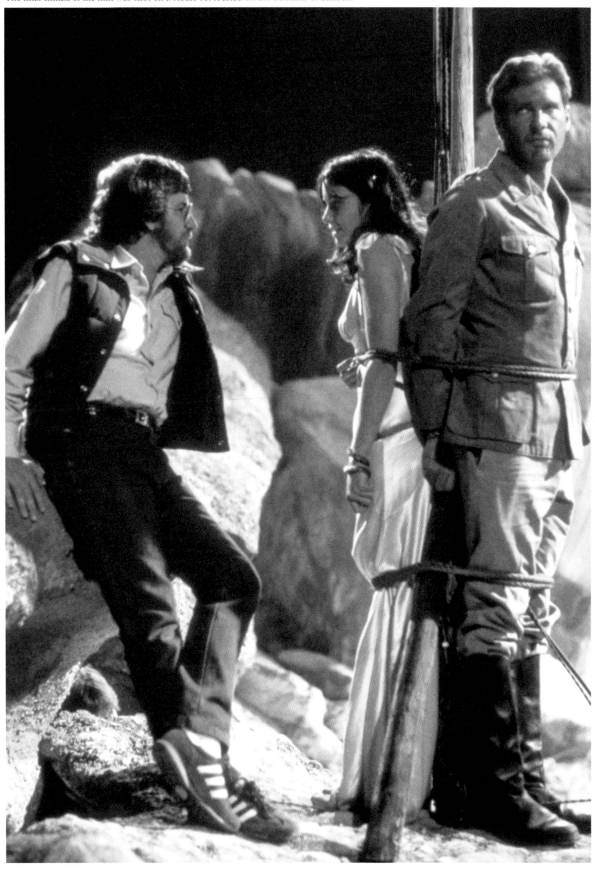

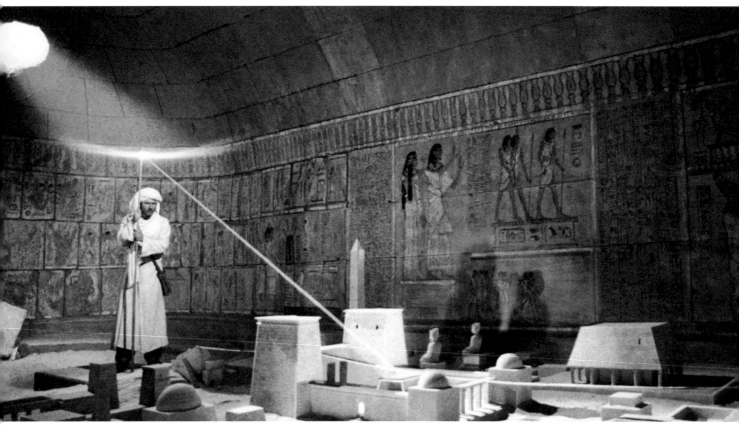

control the film's production. He had been there for *Star Wars* and *The Empire Strikes Back*. The same rule of thumb was applied to the Egyptian outdoor scenes: Lucas took Spielberg to Tunisia, and to the sites he had used to represent the planet Tatooine, near the cities of Nefta and Tozeur. In addition, Lucas's own special effects company, Industrial Light & Magic (ILM), would be handling all the effects in the film.

Planning a Secret, Seventy-Three-Day Schedule

The streets of Cairo that appear in the film can actually be found in Kairouan, in the north of Tunisia, where the film's production team had hundreds of television antennas removed for wide shots spanning over the roofs of the city.

For his part, Steven Spielberg refrained from filming multiple takes, guided by his desire to stick to the schedule. The official schedule agreed to with Paramount was for eighty-five days, but the director's secret goal was seventy-three days. To this end, Spielberg took on a second team director for the first time on *Indiana Jones*, opting to work with a man named Michael D. Moore. Filming on the famous chase sequence began in the Tunisian desert one

week before the entire crew arrived. Once Spielberg was on site, all he had to do was film the shots involving Harrison Ford. In total, the sequence took five weeks of filming.

Overwhelming the Viewer with Action

This process became emblematic of the way Steven Spielberg treated climactic action sequences in his films. He was willing to put in the work required to exploit every possible ounce of action he could from a given sequence. In the case of *Raiders*, vehicles were racing along a track and every element of their makeup was exploited to electrify the confrontation between the hero and his enemies, including taps, doors, windshields, and even the chassis and the Mercedes logo. The goal was to prevent the audience from seeing the potential outcome of the confrontation and to leave them as exhausted as the characters.

The director also has a gift for applying multiple sources of tension within a scene. On a German airfield, Indiana Jones fights with a mechanic while avoiding a spinning plane in which Marion, who is trapped in a machine-gun turret, fires randomly and triggers an explosion on the ground while a wing of the plane causes a leak in a gas tank. Spielberg thus makes multi-layered action sequences a trademark of

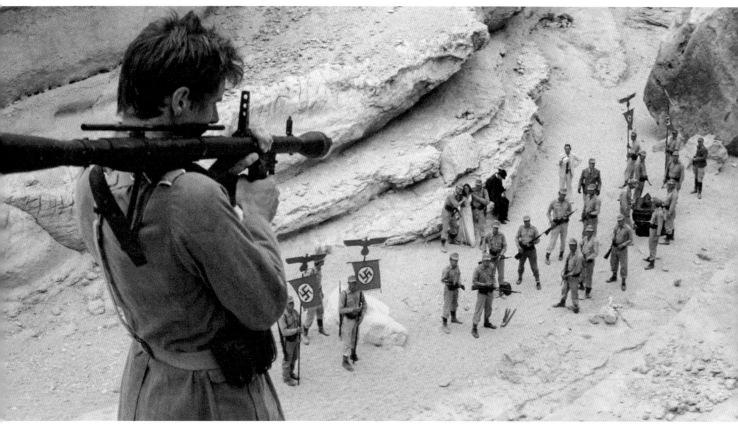

A confrontation in a canyon combines popular tropes from movie Westerns and adventure films.

his films, and one that would only be amplified in later films.

The Ravages of *La Turista*

Most of the people involved in the filming of *Raiders of the Lost Ark* recall a conscientious but relaxed work atmosphere. George Lucas enjoyed shooting second unit shots and Steven Spielberg learned to be efficient with his time. The reality was less idyllic: After some weather-related delays, the team faced hellish heat in Tunisia and a stomach bug (*la turista*, traveler's diarrhea) took its toll on the cast and crew, leaving the film's star, Harrison Ford, in bad shape. This health issue became the origin of another strong moment in the film: Challenged by a warrior armed with a sword, Indiana Jones is forced to face him with his whip. Ford begged the director to make the scene shorter because he wasn't feeling well, and in the end Indiana Jones shoots his opponent with a pistol. Skeptical at first, George Lucas agreed to the change, and the reaction of audiences made it clear that the change was a good one.

Mistreatment of Snakes

Steven Spielberg had not completely lost his spendthrift reflexes. Short of extras for the scene with the

Fun facts

The seaplane that awaits Indiana Jones at the beginning of the film is registered with the name OB-CPO, a reference to Obi-Wan Kenobi and the robot C-3PO from *Star Wars*. In the Well of Souls, C-3PO, his buddy R2-D2, and Princess Leia all appear as hieroglyphs. Later, we hear a German on a loudspeaker count out "Eins, eins, drei, acht," which translates to "one, one, three, eight" an allusion to Lucas's first feature film, *THX 1138* (1971).

German plane, he asked producer Frank Marshall to play the pilot, promising him that one morning's work would suffice. In the end, the scene took three days to shoot. At Elstree, the director was so excited about the moment when Indiana Jones runs away from a huge rock (an idea inspired by a 1954 *Uncle Scrooge* comic book!) that he decided to stretch the sequence. He then made the ramp on which the 500-pound fiberglass ball rolled fifty feet

longer. On the other hand, Spielberg was unhappy with the number of swarming snakes at the bottom of the Well of Souls, so he had several thousand more brought in from Denmark, but the mistreatment of the reptiles led to the intervention of the British animal protection authorities. Filming had to be interrupted for a day to ensure the safety of the animals on set.

The last week of filming was spent in Hawaii, and the film's opening scene was shot. The three-and-a-half-minute walk through the jungle required multiple shooting locations. While in Hawaii, Spielberg, at the last moment, had the idea to do a cross-fade between the Paramount logo and the first image of the film. The effect became the signature of Indiana Jones. When shooting wrapped on *Indiana Jones and the Raiders of the Lost Ark*, filming was completed in seventy-three days and without any additional costs, proving that Spielberg could stick to a schedule and to a budget.

RECEPTION

When the film was released in cinemas, critics understood perfectly what Lucas and Spielberg wanted to do, but reviews were mixed. Richard Schickel of *Time*[3] and Vincent Canby of the *New York Times*[4] were ecstatic. Meanwhile, Dave Kehr of the *Chicago Reader*[5] did not like the main character or the pace of the film, and the *New Yorker*'s[6] influential critic, Pauline Kael, was distressed by what she saw as a regression in Spielberg's career.

As for the general public, the film's success exceeded all expectations. In one month, the film grossed $50 million (the equivalent of $150 million in 2022). It was the most successful film in the world in 1981, surpassing the latest James Bond film, *For Your Eyes Only* (John Glen) and *Superman II* (Richard Lester and Richard Donner). In spite of its success, the film's consecration at the Oscars was a touch ambiguous: With nine nominations, *Raiders* won five technical statuettes (for sets, sound effects editing, sound, editing, and special effects) but nothing for the director.

A Hybrid Product

With *Raiders of the Lost Ark*, Spielberg was not just reviving the adventure film, but he was also creating a hybrid object where multiple genres mixed, sometimes within the same scene. A fedora-wearing hero investigates a mystery just like in a classic film noir; then he flees from a huge ball of stone like something out of a Chuck Jones cartoon and attacks a military convoy in the spirit of a Western

outlaw mounting a stagecoach. The annihilation of the Germans by the ark is in itself an amalgamation of genres: Nazis that look as though they are in the middle of a Black Mass are transformed into liquefied puppets straight out of classic horror, while Indiana Jones and Marion Ravenwood are tied to a post reminiscent of *King Kong*.

Taking inspiration from classic film is a common pastime in Hollywood, and in *Raiders* the director paid particular homage to *Secret of the Incas* (Jerry Hopper, 1954). Spielberg nevertheless applies all the best technology that early 1980s filmmaking had to offer, along with real settings and realistic-looking violence featured in often brutal fights. The final shot of the film shows the interior of a vast warehouse. Sealed inside a wooden box, the Ark of the Covenant is stored alongside other wooden boxes. The coveted relic becomes just that—a relic. Spielberg's MacGuffin can now be laid to rest; it has served its purpose well.

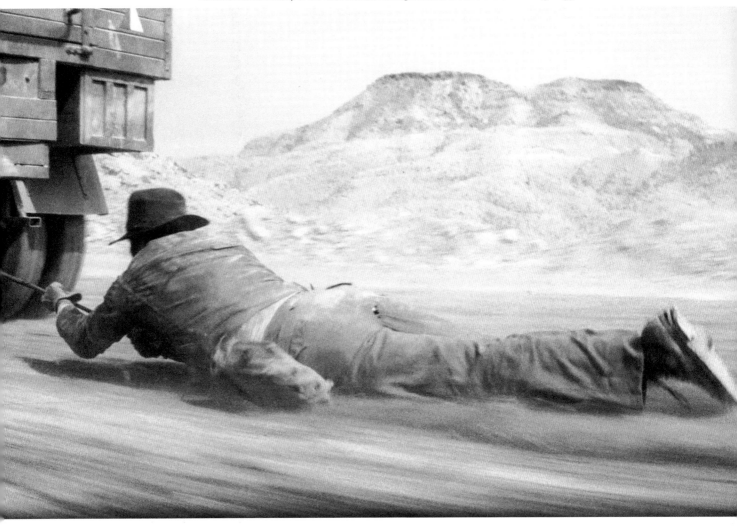

A Whip, a Fedora, a Hero

With his worn leather jacket, whip, and fedora, Indiana Jones is an almost perfect copy of Harry Steele, the hero of the *Secret of the Incas* played by Charlton Heston. The costume designer on *Raiders*, Deborah Nadoolman, recognized this herself. The look was inspired by photos published in *National Geographic* that were taken by Hiram Bingham III, professor of South American history at Yale and the first Westerner to discover the Incan city of Machu Picchu in 1911. In 1989, a leading archaeologist named Walter Fairservis talked about being consulted by the film's production team regarding attire worn by archaeologists in the field. He said he described his own attire.

A Fallible and Passive Tough Guy

The greatest success of *Raiders of the Lost Ark* remains its main character. Far from being infallible, Indiana Jones has doubts, gets hurt, grumbles, and even makes a fool of himself. We sometimes forget that he has nothing to do with the resolution of the story: He is indeed a prisoner and is not involved when the Nazis cause their own destruction. Harrison Ford's acting has a lot to do with the film's success. He brings to "Indy" the air of an everyman dropped into the jungle and forced to survive on his wits alone, even if it means chasing trucks on the back of a white horse. Lucas and Spielberg had invented a new, iconic cinema hero.

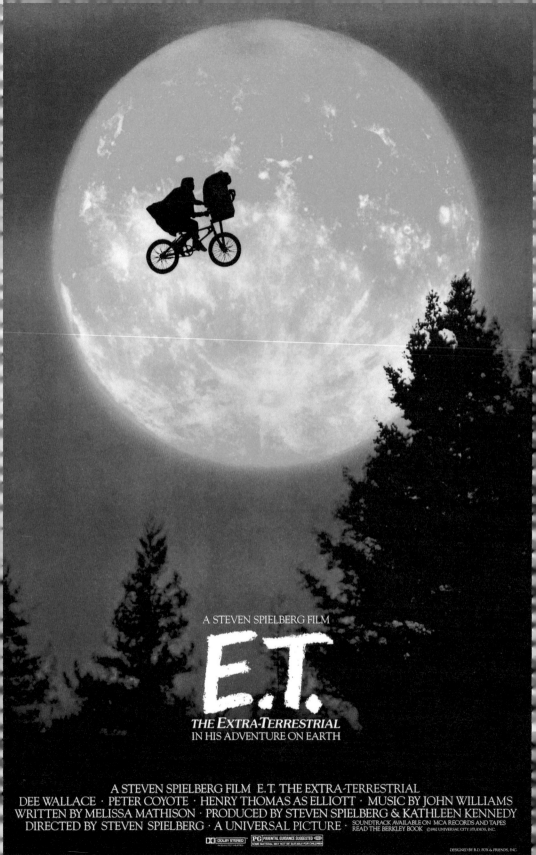

E.T. the Extra-Terrestrial

| United States | 1 hr 55 | Color (DeLuxe) | Stereo (Dolby) | 1.85:1 |

Production Dates: September–December 1981 and February 1982
United States Release Date: June 11, 1982

Worldwide Box Office: $717 million (equivalent to $2 billion in 2023)

Production: Universal Pictures, Amblin Entertainment
Producers: Steven Spielberg, Kathleen Kennedy
Associate Producer: Melissa Mathison
Unit Production Manager: Wallace Worsley Jr.

Screenplay: Melissa Mathison
Director of Photography: Allen Daviau
Film Editing: Carol Littleton
Music: John Williams
Sound: Gene Cantamessa, Robert Knudson, Robert Glass, Don Digirolamo
Sound Effects: Charles L. Campbell
Sound Editor for E.T.'s Voice: Ben Burtt
Production Design: James D. Bissell
Set Decoration: Jackie Carr
Special Effects: Dale Martin
Creators of E.T.: Carlo Rambaldi, Beverly Hoffman (design of the eyes)
Illustrators: Ed Verreaux (E.T.), Ralph McQuarrie (spacecraft)
Coordination of E.T.'s movements: Caprice Rothe
Visual Effects: Dennis Muren

Starring: Henry Thomas (Elliott), Dee Wallace (Mary), Robert MacNaughton (Michael), Drew Barrymore (Gertie), Peter Coyote (Keys), K.C. Martel (Greg), Sean Frye (Steve), C. Thomas Howell (Tyler), Richard Swingler (science professor), Tamara De Treaux, Pat Bilon, and Matthew DeMerritt (E.T.), Debra Winger (zombie with a poodle in the Halloween parade, uncredited)

"Five years ago, I think I would probably have been too embarrassed about what people might think of me to make *E.T.* or even respond to an idea like this. I had essentially [to] get over my fear of running through the world naked and say, 'Take me or leave me.'"[1]

—

—Steven Spielberg, just before the release of *E.T.*

SYNOPSIS

——

One night, in a forest on the outskirts of Los Angeles, a spaceship lands and a group of aliens scatter in the grass. Faced with the arrival of government agents, the foreign beings hurry to leave. One member of their crew does not have time to make it back to the ship and gets left behind. Left all alone, the lost refugee finds sanctuary in the Taylor family's suburban home. He befriends ten-year-old Elliott, who lives with his mother, Mary; his older brother, Michael; and his younger sister, Gertie, in a home disrupted by the divorce of Elliott's parents and the departure of his father.

GENESIS

In 1978, after *Close Encounters of the Third Kind*, Steven Spielberg wanted to follow up on an old idea that was more personal than his previous productions. Originally titled *Growing Up*, the film was inspired by his parents' divorce, and it would tell the story of the breakup of a home from the viewpoint of the children in the house and their relationships with each other.

A Violent Confrontation

The success of *Close Encounters of the Third Kind* had galvanized Columbia Pictures. The studio wanted a sequel, but the director was reluctant. Nevertheless, fearing that someone else would sign on to the sequel and mar his original creation, Spielberg proposed a sort of negative counterpoint to *Close Encounters of the Third Kind*. While the first film told a story of peaceful contact between earthlings and aliens, the new film would depict a decidedly less friendly confrontation.

The original for *E.T.* idea goes back to the days when Spielberg was prepping to begin work on *Close Encounters*. Astrophysics professor and ufologist Josef Allen Hynek told Steven Spielberg the story of a Kentucky farm that was besieged by humanoid creatures that were less than three feet tall for four hours on August 21, 1955. The terrorized residents had to defend themselves with guns. Spielberg used this story to inspire a project he called *Night Skies*. When his Amblin co-founder Kathleen Kennedy saw *The Return of the Secaucus Seven* (1980), she asked the film's director and screenwriter, John Sayles, to write a script for *Night Skies*. At the same time, Rick Baker was hired to design the aliens.

The Desire for a Peaceful Story

In 1980, Spielberg was shooting *Raiders of the Lost Ark* in Tunisia when he received the *Night Skies* script from John Sayles. Suddenly, he realized that his mindset was not at all focused on the themes of terror and violence that were originally driving the plot of the new film. He could not convince himself that aliens would cross galaxies just to fight. "I thought they would come here to either observe at a distance or to interact in some kind of healthy way."[2] Furthermore, after the dizzying adventures of *Indiana Jones*, he was looking forward to working

Steven Spielberg performed the voice of E.T. on the set during filming.

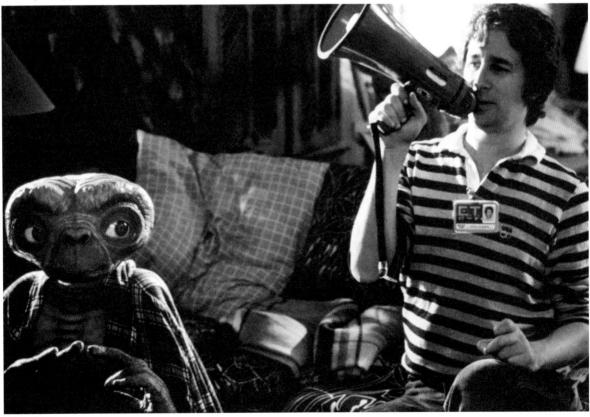

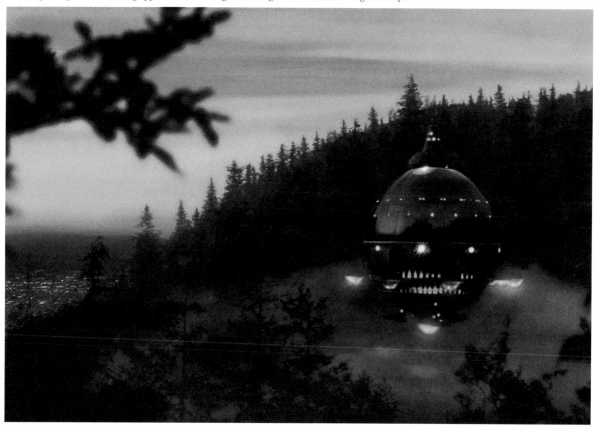
E.T.'s ship was given a reassuring appearance, reflecting ambient light and the surrounding landscape.

on a quieter story. The fact that he was far from home may also have contributed to his desire to film a story more concerned with domestic life. In his head, *Growing Up*, the project about his parents' separation, slowly resurfaced.

It was in this state of mind that the director had a decisive encounter with a young woman who was looking at crustacean fossils in the Tunisian Sahara. This thirty-year-old woman was Melissa Mathison, the girlfriend (and future wife) of Harrison Ford. Mathison had worked as an assistant on the sets of *The Godfather Part II* (1974) and *Apocalypse Now* (1979), and she knew her way around a Hollywood film shoot.

A Child and a Horse
Melissa Mathison had tried to break into screenwriting, but she had planned to give it up by the time she crossed paths with Steven Spielberg. "She said she had written a number of scripts that she wasn't really happy with, and only one got made,"[3] Spielberg recalled in 2015. Immediately, Spielberg suggested that Melissa Mathison should work with him. She declined at first; then, when pressed by Harrison Ford (at the request of the director), she changed her mind.

When she was invited to read the script of *Night Skies*, Mathison pointed out what she considered to be John Sayles's strongest idea: Among the horde of hostile aliens, there is one being who forms a benevolent bond with an autistic child. This would be the central theme of the film that would become *E.T.*

Once the shooting of *Raiders of the Lost Ark* was over, the final decision was made: Steven Spielberg abandoned *Night Skies*. He would allocate elements of the script to various future films, including *Poltergeist* (1982), *Gremlins* (1984), and another new film, soon to be titled *E.T. and Me*. That new film would be devoted to a child of divorced parents who fills the emotional gap created by the absence of his father through a friendship with an extraterrestrial that has been left behind on Earth.

The Powers of an Extra-Terrestrial
Melissa Mathison started working in October 1980. She wrote four or five days in a row on her own, and then she submitted the results to Spielberg while he was editing *Raiders of the Lost Ark*. They discussed his notes and then she went back to work four or five days. This continued for eight weeks. Mathison put herself in the shoes of a child, asking Harrison Ford's sons and their friends about what powers they

In this shot, Steven Spielberg harkened back to his childhood while also instilling a sense of mystery in a small suburban bungalow.

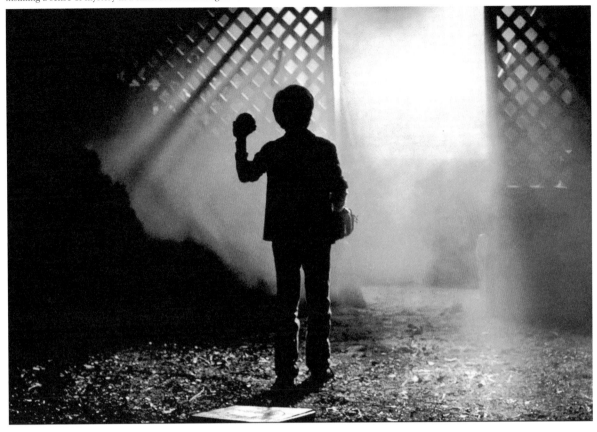

thought an alien would have. Telepathy and telekinesis came up a lot, as did the ability to heal bumps and cuts, which were the daily wounds in the life of a typical child.

Spielberg and Mathison agreed not to involve adults until the final act of the film. The alien would spend most of his time interacting with human beings that were as small as himself. "So when he went back to his planet he would basically [be] reporting on a planet populated by children," explained Melissa Mathison, "which we thought was a kind of poetic idea."[4] From the point of view of the narrative, the absence of adults also offered a way for Elliott, the film's main character, to exercise power over the story—to make it feel like he is a child who acts and makes decisions for himself. When Melissa Mathison turned in her 107-page script, Steven Spielberg was ecstatic.

A Furious Rick Baker

John Sayles apparently took no offense when *Night Skies* was scrapped, but Rick Baker was furious: Not only would all of his work now amount to nothing, but this new project did not interest him in the slightest. Refusing to take part, he was replaced by illustrator Ed Verreaux, who drew the first outlines

of the character, and Carlo Rambaldi, the creator of the creatures in *Close Encounters of the Third Kind*. The two men produced multiple sketches and clay sculptures, guided by Steven Spielberg's desire to reproduce the faces and eyes of Albert Einstein, Ernest Hemingway, and the poet Carl Sandburg, which were all combined and then given baby chins and mouths. Columbia Pictures also felt cheated. They had been deprived of the science fiction film they originally agreed to finance. On the other hand, the studio had the rights to another script about an alien lost on Earth, which was called *Starman*. The tone of that feature was more serious, more adult, and Columbia was not comfortable with Spielberg's childish approach. At the beginning of 1981, the studio kept *Starman* and cut the director loose to shop his film around town. Convinced by the script and the first drawings of the alien, Sid Sheinberg, the president of Universal, acquired the rights to the movie for one million dollars. Spielberg's contract with Columbia entitled the studio to a "special edition" of *Close Encounters of the Third Kind* in 1980, and they also negotiated a 5 percent cut of the net profits from *E.T. and Me*. At this point, no one—not even Steven Spielberg—was banking on a big hit.

CASTING

This was the first Steven Spielberg production to feature so many children and teenagers, and Drew Barrymore was the first to be cast.

A Troupe of Child Actors

Drew Barrymore initially auditioned for *Poltergeist*, but Steven Spielberg saw her more as Gertie in *E.T.* Born in 1975, she came from a famous line of actors dating back to the 1920s, and her first film, Ken Russell's *Altered States*, was completed 1980. During one of their early conversations, Barrymore impressed Spielberg by inventing a life as a punk rocker who was touring the United States. At the age of fifteen, Robert MacNaughton got the role of the older brother, Michael, after failing an audition for *The Entity* (Sidney J. Furie, 1982). He was a New York stage actor, and Spielberg felt that his experience could serve as a strong foundation for the rest of the child actor cast. It took six months to find the right person to play Elliott. Film director Jack Fisk suggested Henry Thomas after casting him in a feature titled *Raggedy Man* (1981). Thomas was only ten years old. Surrendering to his penchant for secrecy, Steven Spielberg did not give Henry the script. He asked him to improvise a scene where government agents take E.T. away, and to act as if they were taking his pet. The boy delivered a heart-breaking performance that moved everyone in the room. One of Elliott's friends, Tyler, was played by C. Thomas Howell, who would go on to appear in many other films.

Some Essential Adults

For the mother, Mary, Steven Spielberg chose Dee Wallace after seeing her in an episode of the canceled series *Skag* (1980). For the director, Mary Taylor was really just an overgrown child who was weakened by her divorce. On the other hand, the character played by Peter Coyote represented the world of grownups, which was a little disturbing. In the end Coyote's character, Keys, was a benevolent adult and a kind of de facto big brother who taught Elliott that one day he had to grow up. Coyote had failed his audition to play Indiana Jones by getting his feet tangled up in some equipment. When Spielberg ran into him again at a professional event in 1981, he remembered his clumsiness and offered him a role as a scientist in *E.T.* For the sake of authenticity, Steven Spielberg asked real doctors to play the team of researchers who invaded the Taylor home.

FILMING AND PRODUCTION

Filming began in early September 1981 under a veil of secrecy. The script was given a false title, *A Boy's Life*, and it could only be accessed by the actors from behind closed doors. Most of the film took place in the vast residential area of the San Fernando Valley, just to the north of Los Angeles.

A Clearing in a Studio

The dreary streets lined with individual homes radiated boredom and routine, and they are reminiscent of Spielberg's own childhood spent growing up in Scottsdale, Arizona. Elliott's house is located in Tujunga, literally wedged between a bend in Lonzo Street and the base of the San Gabriel Mountains—a symbol of a trapped life. For the forest scenes, Spielberg opted for the fairy-tale atmosphere of the coastal redwoods in Northern California, but the clearing where the aliens' spacecraft lands was created on a set built at Laird International Studios in Culver City, as were all interiors of the Taylors' home as well as their backyard.

A Screenplay Written on a Pack of Cards

For the first time, Kathleen Kennedy, who co-founded Amblin Entertainment with Steven Spielberg and Frank Marshall in 1981, was working as a producer. Writer Melissa Mathison was also on board as an associate producer. On the set, Mathison supported the children, talking with them and helping them rehearse without interfering with the director's work. She did, however, provide the director with a useful trick: She transferred the entire script onto a series of pocket-size cards, each summarizing the day's shooting with the dialogue and actors involved. Less cumbersome than a full, annotated script, the method also left more room for improvisation. When Elliott presents E.T. with his toys spread out on a table,

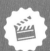

FOR SPIELBERG ADDICTS

Steven Spielberg praised Rick Baker's work on *Night Skies*, but Baker was resentful of the way his preparatory drawings and sculptures were confiscated when *Night Skies* was scrapped. Baker always suspected that Carlo Rambaldi was "inspired" by them. In 2014, he posted photos of the (unfinished) aliens from *Night Skies* on Twitter, and although the creatures are more threatening in appearance, the likeness to *E.T.* is easy to see.

Carlo Rambaldi was inspired by his own painting, *Donne del Delta* (*Women of Delta*), when he created the alien in *E.T.*

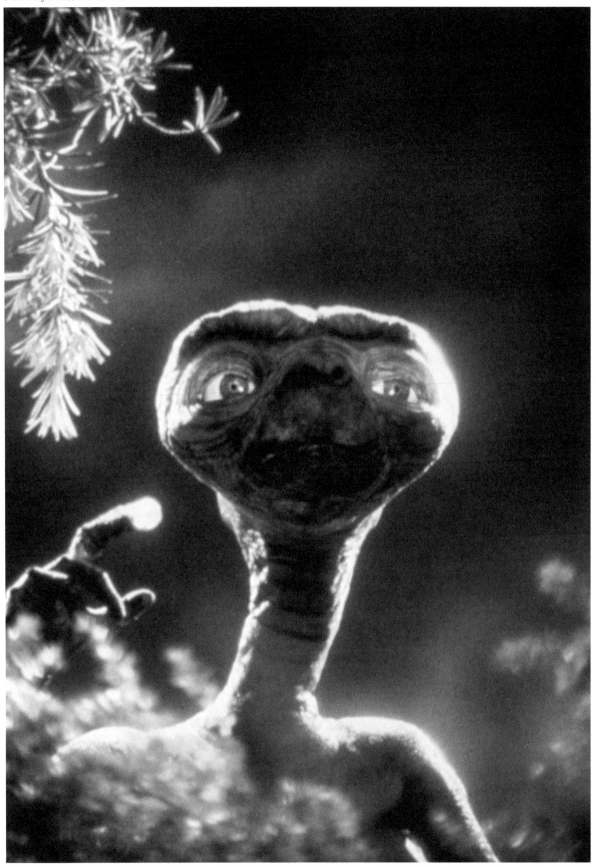

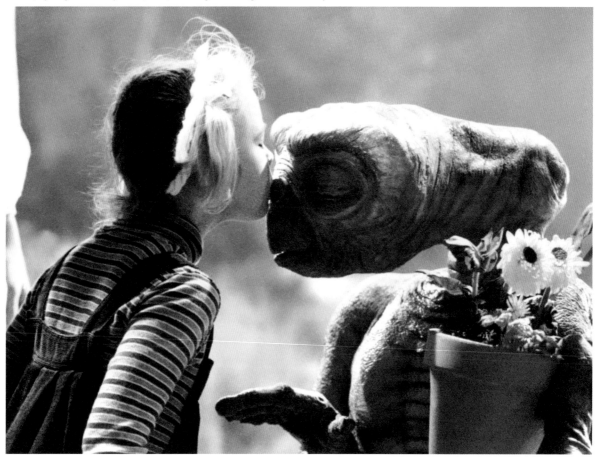

Henry Thomas speaks in his own words. When Gertie says, "I don't like his feet!" about the alien, this is Drew Barrymore's actual opinion—the line was never written in the script.

As expected, adults are almost completely absent in *E.T.* When they did appear, they were often shown from behind, depicted as menacing silhouettes, or only shown from the waist down. He further limited their screen time by cutting out an entire passage with the school principal (played from behind by Harrison Ford). Mounted on a dolly, the camera usually filmed from roughly five feet above the ground, always pointing upward to simulate the viewpoint of the children or the alien.

Realism and Mystery

Cinematographer Allen Daviau had a difficult task to accomplish: Spielberg wanted realistic lighting while also creating a sense of mystery around E.T., who had to remain an ill-defined shape for the first twenty-five minutes of the film. "For that scene in the bedroom where Elliott entices E.T. out of the closet, I had to make E.T. as near a silhouette as possible and still show his eyes!"[5] recounted Daviau.

Spielberg also insisted on using simple special effects that were never ostentatious or too over-the-top. E.T.'s spacecraft, designed by illustrator Ralph McQuarrie, looks like a mix between a toy, a Christmas tree, and a contraption straight out of a Jules Verne novel, which has the interesting effect of feeling slightly familiar to the viewer. Spielberg thought the ship looked like E.T. himself! For the same reason, the children's bicycle flight against the backdrop of a full moon was done via a very simple trick. After days of scouting for the perfect location, the night sky was captured on film over the course of two evenings, and then tiny models of bicycles topped with puppets were filmed against this filmed background. The scene became instantly iconic, straddling the threshold between enchantment and a childlike sense of innocence and wonder. It would also become the logo of Amblin Entertainment.

In the original script, Elliott and E.T. were to be taken to a medical center. But at the last minute, Spielberg followed the advice of his friend Matthew Robbins not to leave the boy's house. Remembering that he had seen a work zone at the Los Angeles International Airport with partitions and plastic-coated cylindrical corridors,

he imagined that the scientists who had come to take E.T. away would deploy this kind of temporary installation at the Taylors' home. In passing, he found the spirit of *Night Skies* with the attack on a home by hostile creatures…except that this time, the "attackers" are adult earthlings.

Twelve Operators for One Alien

The production of *E.T.* still had one more major hurdle to overcome: bringing the alien to life. As with the shark in *Jaws*, Steven Spielberg was obsessed with providing a necessary sense of realism in the creature and its interactions with the actors; nothing could betray the artifice going on behind the scenes. The alien was animated by a dozen different people on the set. Operators activated controls for movements of the face, the mouth, the eyes, and the pulsating organs. Two actors of short stature, Tamara De Treaux (30 inches) and Pat Bilon (32 inches), slipped into the *E.T.* costume, and a twelve-year-old child named Matthew DeMerritt, who had been born without legs, performed the scenes where the alien walks or falls—DeMerritt put his hands through the feet of the costume. Not only that, the finger gestures and object manipulations were performed by

A Heavy Smoker, a Burp, and Animal Noises

On the set, Steven Spielberg performed the voice of E.T., and then actress Debra Winger tried her hand at it for the film's first cut. But the final result was a work of craftsmanship completed by sound editor Ben Burtt, who distinguished himself on *Star Wars*. When E.T. speaks, it is with the voice of heavy smoker Pat Welsh, a former radio actress. This is mixed with animal breathing noises. For the myriad versions of the alien's little sounds, Ben Burtt used the sounds of raccoons, otters, and horses, as well as a burp from his former film teacher, and the breathing sounds of his sleeping wife, who had a cold when he recorded her. In total, eighteen different sound sources make up the "voice" of E.T.

Two lost and hooded beings: E.T. and Elliott are both trying to make sense of new experiences.

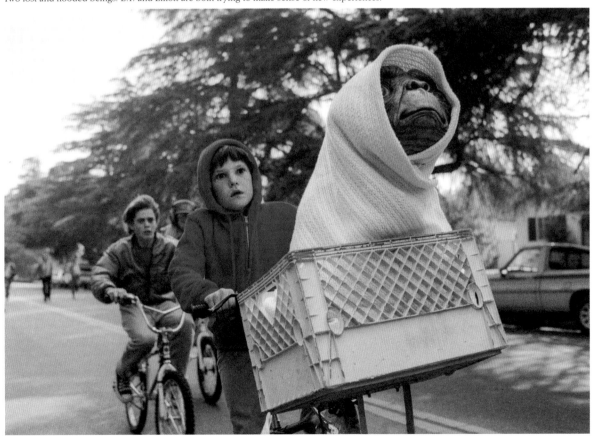

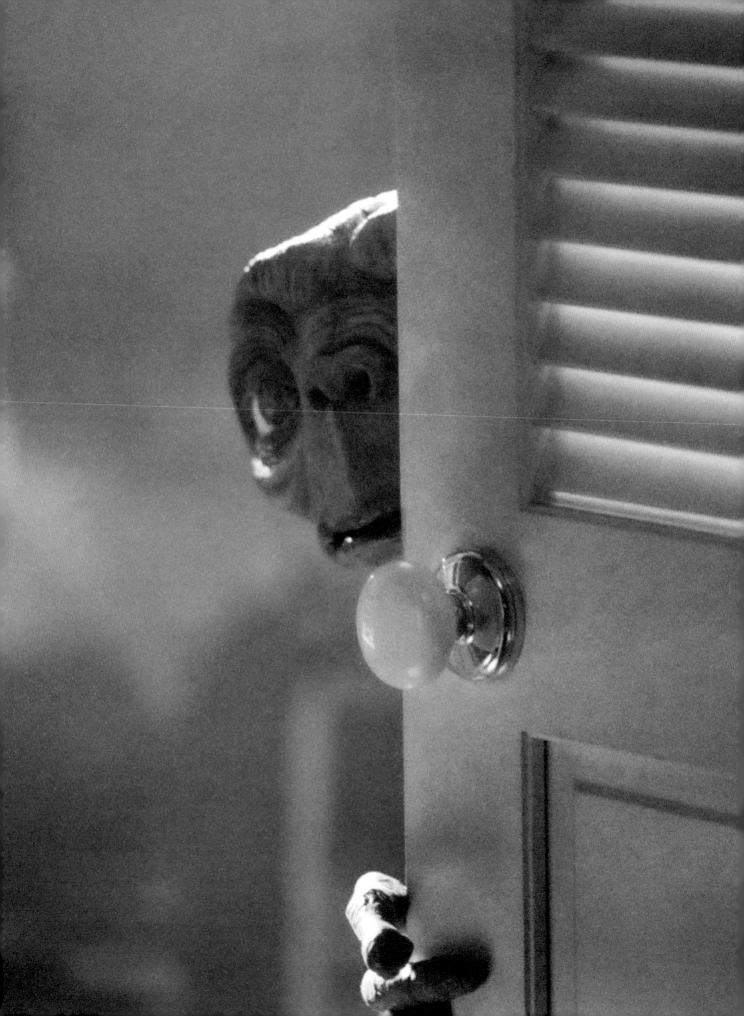

the mime artist Caprice Rothe. She wore prosthetics independent of the creature, and she regulated her movements by watching a monitor that showed her the scene taking place while she lay at the foot of the animatronic creature. According to Carlo Rambaldi, filming took an "average of three takes per human and 15 takes per E.T."[6] In spite of all these logistics, the filming of *E.T.* was completed in sixty-one days, five days ahead of schedule.

RECEPTION

Steven Spielberg did not imagine that *E.T. the Extra-Terrestrial* would reach many people other than children. He quickly realized just how wrong he was.

Tears and Records

After the film's first screening for Universal executives, the audience was left in tears. The film was also shown at the closing ceremony of the Cannes Film Festival in France at the end of May 1982, and it received a protracted standing ovation. Released in more than eleven hundred theaters in the United States on June 11, 1982, *E.T.* topped the box office for six weeks in a row, breaking the previous record of three weeks held by *Superman II* (Richard Lester and Richard Donner, 1980). After that, the film bounced between first and second place, spending a total of twenty-four weekends at the top of the charts before the end of November.

A Suspicion of Plagiarism

The critical success was almost unanimous. Everyone seemed to be taken aback by Steven Spielberg's ability to create serious emotions in the hearts of adults. Because, obviously, *E.T. the Extra-Terrestrial* was not only a film for children. It transported adults back to their lost, and subsequently idealized, childhoods, and to their abandonment of a world of fantasy and imaginary friends. *E.T.*'s final line was even directly addressed to them: "I'll be right here," he says, pointing to Elliott's forehead. We never forget the child in us. Straddling the line between realism and fantasy—and even a certain sense of mysticism, with this little miracle worker–like being from above, hooded like a messiah—*E.T.* appealed to everyone.

Indian filmmaker Satyajit Ray was less enthusiastic. According to him, this film plagiarized one of his projects, *The Alien*. Written in English, the script had been offered to Columbia Pictures, and then abandoned in 1968. Steven Spielberg has always denied being aware of the competing script, arguing that at the time he was just out of high school. Supported

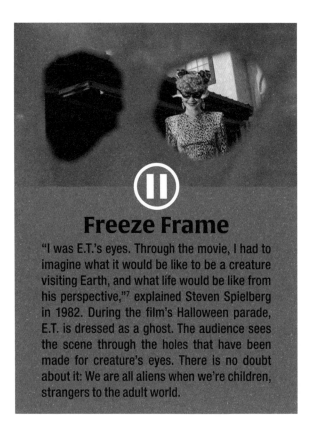

Freeze Frame

"I was E.T.'s eyes. Through the movie, I had to imagine what it would be like to be a creature visiting Earth, and what life would be like from his perspective,"[7] explained Steven Spielberg in 1982. During the film's Halloween parade, E.T. is dressed as a ghost. The audience sees the scene through the holes that have been made for creature's eyes. There is no doubt about it: We are all aliens when we're children, strangers to the adult world.

by the science fiction writer Arthur C. Clarke, who advised him to contact Spielberg, Satyajit Ray never made a legal claim against the director.

Ballet Music

The Oscars would once again be a source of semi-frustration for the director. The film was nominated for Best Picture, Best Director, and Best Screenplay, but all three statuettes went to *Gandhi*, directed by Richard Attenborough. *E.T. the Extra-Terrestrial* won Oscars for sound, sound effects, visual effects (including the work of Carlo Rambaldi), and music, which was once again hauntingly written by John Williams with ballet in mind.

For Steven Spielberg, the success of the film offered him a feeling of liberation: He now had the courage to expose his own sensitivity more frankly than he had done in the past. He reflected for a while with Melissa Mathison on making a sequel, but they quickly gave up the idea. The strength of *E.T. the Extra-Terrestrial* would only be diminished.

For the film's twentieth anniversary in 2002, the director released a digitally retouched version of the now classic movie. Walkie-talkies replaced the weapons of the policemen and the movements of E.T. were "improved." The outcry was universal, and this version is no longer available.

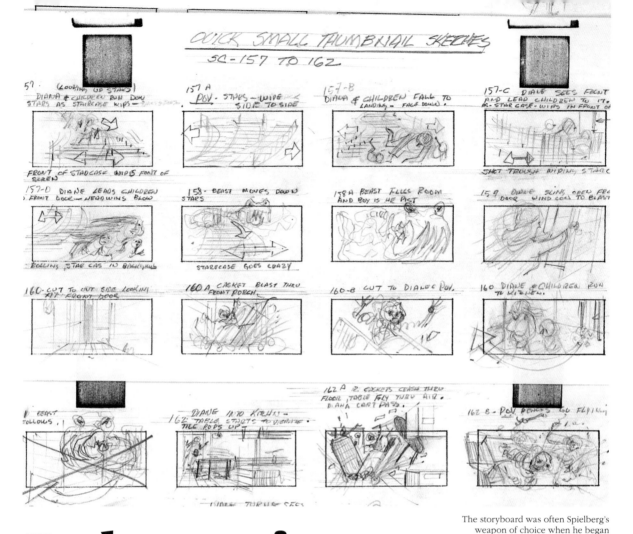

The storyboard was often Spielberg's weapon of choice when he began production on a new project.

Poltergeist
Duel in the Suburbs

The impressive creative team assembled on *Poltergeist* promised to captivate the whole of Hollywood: On the one hand, there was Spielberg, a creative genius capable of making audiences all over the world squirm in the face of a killer shark and cheer for the adventures of a daring archaeologist; on the other hand, Tobe Hooper had created one of the most traumatic films in cinema history, which was banned in a dozen countries at the time of its release.

A Disturbing Spirit

Like everyone who had seen it, Steven Spielberg was shocked when he discovered *The Texas Chain Saw Massacre*. Released in 1974, the film was directed by Tobe Hooper, and it redefined the horror film genre by anchoring it in a contemporary social reality, and also by questioning the formal codes inherent to that

genre. Hooper shoots "dirty": The grain in the film is large, and the colors are saturated.

The whole feature was made using handheld cameras in a spirit of cinema verité, which makes the final product feel even more immediate and disturbing. So, when MGM announced that the two thirty-somethings were combining their talents on a new project, there was much interest. No one had any idea that filming the movie would turn into such a nightmare.

A Ghost Story

The story of *Poltergeist* begins with a beautiful agreement. In 1980, Spielberg wanted to produce a project that he had had in mind for quite some time. *Night Skies* would tell the story of the intrusion of belligerent aliens into the daily life of a suburban family. At that time, Spielberg offered Hooper the chance

to direct the film, but Hooper wasn't interested—he wanted to make a ghost story. In the midst of preparing his next film, the future creator of *E.T.* jumped at Hooper's idea and hired two young screenwriters, Michael Grais and Mark Victor, to whom he gave the basic concept: A suburban family is attacked by ghosts. With this change made, Hooper joined in the adventure with total conviction since his career was floundering. After *The Texas Chain Saw Massacre*, he went on to make *Eaten Alive* (1977), from which he eventually withdrew after an argument with the producer. He also made the television adaptation of a Stephen King novel (*Salem's Lot*, 1979), and then a film called *The Funhouse*, which was released in March 1981 and received a mixed reception from both critics and the public. Perhaps *Poltergeist* would be the project that would finally open up the doors of Hollywood for Hooper.

A Progressive Assumption of Control

Alas, this was not to be. While Spielberg, who was credited as the author of the story and a co-writer, supervised the writing of the script from afar, he was nonetheless determined to play his role of producer to the full. This resulted in a gradual takeover that

Hooper, either out of confidence or naïveté, did not see coming. Spielberg was present on the set almost every day, and he did not hesitate to give orders that encroached on the director's own prerogatives. Soon, a rumor relayed by the press spread through Hollywood: Hooper was only acting as a front man for Spielberg, who was contractually bound by Universal not to direct another film before shooting *E.T.,* which was scheduled to be filmed in August (though it was eventually postponed by one month). Coincidentally or not, the filming of *Poltergeist* began on May 11, 1981, and it was scheduled to conclude in August. In addition to being hemmed in by his contract with Universal, the Directors Guild of America (the professional union of directors) barred producers from taking over shooting responsibilities from a director; Spielberg therefore could not take control behind the camera, no matter what the rumor mill claimed.

Public Apologies

Once the film reached postproduction, Hooper was removed from the project and the film was edited under the sole supervision of Spielberg. Hooper also became angry when he discovered that the trailer for the film had the producer's name written twice as big

Poltergeist has the hallmarks of many Spielberg films, but the man behind the camera was actually Tobe Hooper.

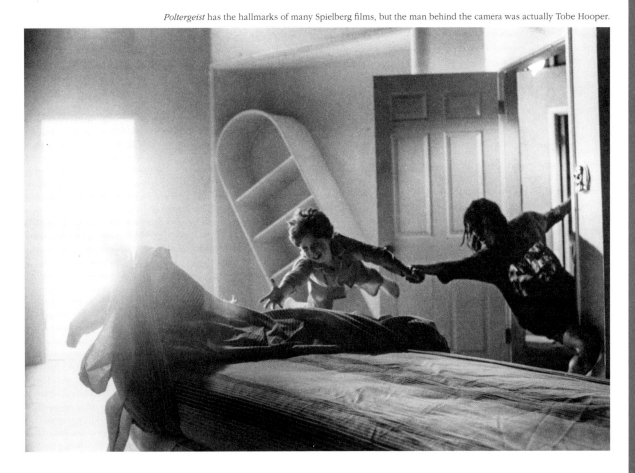

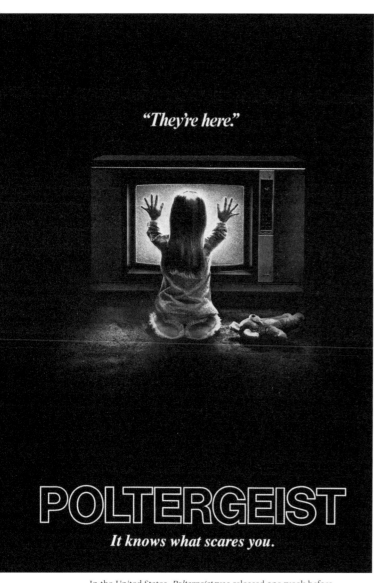

"*They're here.*"

POLTERGEIST

It knows what scares you.

In the United States, *Poltergeist* was released one week before *E.T. the Extra-Terrestrial*.

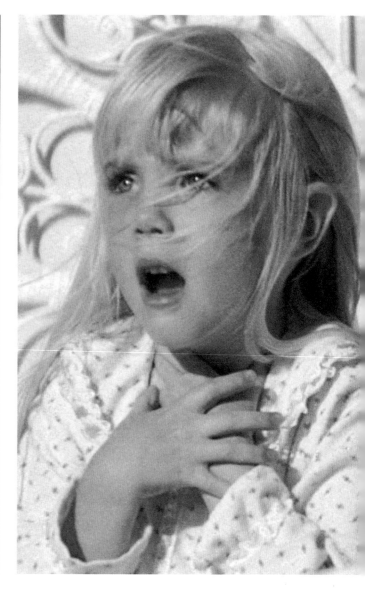

as his own. Following legal arbitration, Hooper won financial compensation and the sizing of his directorial credit was changed. He also received a public apology from MGM, as well as from Spielberg, who thanked his former collaborator in carefully chosen words: "I enjoyed your openness in allowing me, as a producer and a writer, a wide berth for creative involvement, just as I know you were happy with the freedom you had to direct *Poltergeist* so wonderfully. Through the screenplay you accepted a vision of this very intense movie from the start, and as the director, you delivered the goods."[1]

A Diptych on Childhood

"If I write it myself, I'll direct it myself," Spielberg said when the film was released. "I won't put someone else through what I put Tobe through, and I'll be more honest in my contributions to a film."[2] Released in cinemas on June 4, 1982, *Poltergeist* was the perfect counterpoint to *E.T. the Extra-Terrestrial*, which was released the following month. By giving the two stories a common setting, that of an ordinary suburb, and by questioning the foundations of the nuclear family, Spielberg created an interesting conversation on childhood. In *Poltergeist*, little Carol Anne is chosen by the spirits as the point of passage between their world and the corporeal world: The youngest child thus becomes the epicenter of a family whose unity is undermined by the ghosts' attack. As a child, Spielberg spent hours watching the snow on the television screen, convinced that he could detect messages in it: "*Poltergeist* is the darker side of my

Sadly, the young actress Heather O'Rourke (shown here) met a tragic fate when she died during an operation at the age of twelve.

nature—it's me when I was scaring my younger sisters half to death when we were growing up—and *E.T.* is my optimism about the future and my optimism about what it was like to grow up in Arizona and New Jersey."[3]

A Scientific Response

When it was released, *Poltergeist* was a great success all over the world, giving rise to three Oscar nominations and some inconsequential sequels. Ominously, the film garnered a reputation for being cursed after the deaths of four of its actors: Dominique Dunne, who played Carol Anne's older sister, was killed by her boyfriend in October 1982; Julian Beck died of cancer after the end of the shooting of the film's sequel. Will Sampson died on the operating table shortly before

shooting the third film in the franchise, and the same thing happened to Heather O'Rourke, who played little Carol Anne, and who died of septic shock following an operation...for what turned out to be a misdiagnosed disease. But the real *"Poltergeist* curse" afflicted the unfortunate Tobe Hooper. The imbroglio around the film closed the doors of Hollywood for him, and they would never reopen. At the time of his death in 2017, in addition to *The Texas Chain Saw Massacre*, there was still talk of his involvement in *Poltergeist*. It must be said that over time, opinions have varied widely about who was finally responsible for the film. In 2009, researcher Warren Buckland analyzed the film shot by shot, based on the style of each director.[4] The result? According to Buckland, and contrary to what he expected, *Poltergeist* was indeed directed by Hooper.

You're travelling through another dimension into a wondrous land
whose only boundaries are that of the imagination.
Next stop, the Twilight Zone.

THE TWILIGHT ZONE

"THE TWILIGHT ZONE" • DAN AYKROYD • ALBERT BROOKS • SCATMAN CROTHERS
JOHN LITHGOW • VIC MORROW • KATHLEEN QUINLAN

Produced by STEVEN SPIELBERG and JOHN LANDIS		Music by JERRY GOLDSMITH	Executive Producer FRANK MARSHALL
	Story by GEORGE CLAYTON JOHNSON	Based on a story by JEROME BIXBY	Based on a story by RICHARD MATHESON
Written by JOHN LANDIS	Screenplay by GEORGE CLAYTON JOHNSON and RICHARD MATHESON and JOSH ROGAN	Screenplay by RICHARD MATHESON	Screenplay by RICHARD MATHESON
Directed by JOHN LANDIS	Directed by STEVEN SPIELBERG	Directed by JOE DANTE	Directed by GEORGE MILLER

The Twilight Zone: the movie

"Kick the Can" • Segment 2

United States	1 hr 41	Color (Technicolor)	Stereo (Dolby)	1.85:1

Production Dates: November 26–December 2, 1982
United States Release Date: June 24, 1983

Worldwide Box Office: $29.45 million ($87.8 million in 2023 dollars)

Production Company: Warner Bros.
Producers: Steven Spielberg, John Landis
Associate Producer: Kathleen Kennedy
Executive Producer: Frank Marshall
Unit Production Manager: Dennis E. Jones

Based on a story by George Clayton Johnson (1962)
Screenplay: George Clayton Johnson, Richard Matheson, Melissa Mathison
(under the pseudonym Josh Rogan)
Director of Photography: Allen Daviau
Camera Operators: John Toll, Jamie Anderson
Assistant Directors: Pat Kehoe, Daniel Attias
Film Editing: Michael Kahn
Music: Jerry Goldsmith
Sound: Tommy Causey
Production Design: James D. Bissell
Set Decoration: Jackie Carr
Special Effects: Mike Wood
Casting: Mike Fenton, Jane Feinberg, Marci Liroff

Starring: Scatman Crothers (Mr. Bloom), Bill Quinn (Mr. Leo Conroy), Martin Garner (Mr. Weinstein), Selma Diamond (Mrs. Weinstein), Helen Shaw (Mrs. Dempsey), Murray Matheson (Mr. Agee), Peter Brocco (Mr. Mute), Priscilla Pointer (Miss. Cox), Scott Nemes (young Mr. Weinstein), Tanya Fenmore (young Mrs. Weinstein), Evan Richards (young Mr. Agee), Laura Mooney (young Mrs. Dempsey), Christopher Eisenmann (young Mr. Mute), Burgess Meredith (narrator)

"No movie is worth dying for."[1]

—
—Steven Spielberg, in an interview with Dale Pollock

SYNOPSIS

—

In a retirement home, the daily routine of a group of elderly people is disrupted by the arrival of a new resident, Mr. Bloom. After surveying each of the elderly residents, Mr. Bloom suggests that they become children again at night. All they have to do is play a game and kick a can. When the time comes, most of the residents decide to sneak out and play. Only Mr. Conroy, who considers it childish to believe in all this, refuses to join, and then he reports them to the manager of the retirement home.

GENESIS

This was a small-scale project—a diversion, almost. Still, when Warner Bros. contacted him about *The Twilight Zone*, Steven Spielberg was enthusiastic from the start.

John Landis, an Old Acquaintance

Ted Ashley, the studio boss at Warner Bros., had the idea of producing a film grouping together several stories in the spirit of *The Twilight Zone*, the famous series created by Rod Serling that terrorized audiences between 1959 and 1964. As a child, Spielberg loved this program; paying homage to it therefore seemed like a natural and even enjoyable prospect, especially since the project would allow him finally to work with John Landis, who, since his first film in 1973, *Schlock*, had established himself as one of the troublemakers of Hollywood. His college comedy *National Lampoon's Animal House* (1978) was a great success in the United States, and although *The Blues Brothers* (1980) and *An American Werewolf in London* (1981) were less successful, they left a mark on the popular culture. Michael Jackson also famously chose Landis to shoot the music video for his song "Thriller," which, when it was first broadcast on December 2, 1983, revolutionized the pop music industry.

Landis and Spielberg met during the shooting of *Jaws*. At the time, Landis was responsible for reworking a script that had originally been written by Paul Schrader. That script was originally titled *Project Blue Book*, but it would eventually become *Close Encounters of the Third Kind*.

One Film, Four Directors

Warner Bros. was delighted to have Spielberg on board, especially since Ashley's successor, Terry Semel, had hoped to start a long collaboration between the studio and Spielberg. Spielberg and

In Joe Dante's segment of *The Twilight Zone* movie, little Anthony (Jeremy Licht) gives his family a hard time.

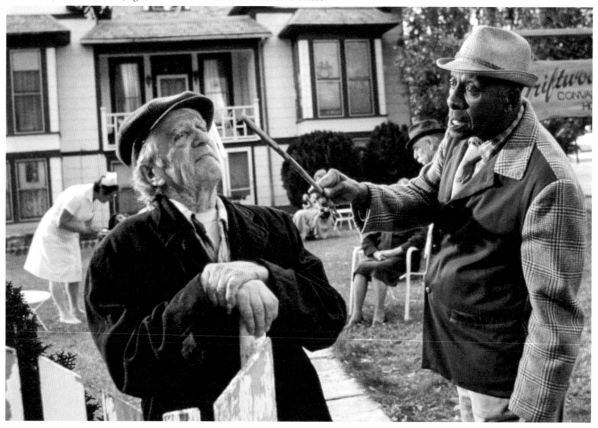

Mr. Bloom (Scatman Crothers, right) is about to lead his cohorts on an adventure.

Landis agreed to produce the film in exchange for a percentage of the profits.

The producers and the studio also agreed on the structure of the film, which Spielberg felt should include an introduction, four short standalone stories, and a conclusion. Landis would be in charge of the introduction and the first segment; Spielberg would shoot the second. He also suggested Joe Dante for the third: The director of *The Howling* (1981) had caught Spielberg's eye to such an extent that he sent him the script for *Gremlins*. As for the fourth segment, it went to George Miller almost by chance. Visiting the studio to prepare for the American release of *Mad Max 2* in May 1982, the Australian filmmaker stopped by the office where Spielberg and Landis were working. Spielberg had been a fan of the first *Mad Max*, and they offered Miller a segment. Each director worked with their own technical team to film their portions of the movie.

Nothing Original, Just Adaptations

Curiously, the four stories chosen for the film were not original; they were remakes of episodes from the series. "Time Out" (Landis) tells the story of a racist American who finds himself successively in the shoes of a Jew in Vichy France, a Black man hunted by the Ku Klux Klan, and a Vietnamese man attacked by the US Army. Landis's segment drew themes from "A Quality of Mercy," a third-season episode of *The Twilight Zone* that aired in 1961, in which a young, zealous US Army officer found himself in the shoes of a Japanese soldier he was about to execute. Spielberg chose "The Monsters Are Due on Maple Street" from the show's first season, in which an ordinary man is harassed by his neighbors, who are convinced that he is an alien. Dante took over "It's a Good Life," which originally aired in the show's third season. It was a delightful episode about a child with special powers who takes over his family and community. Finally, Miller took on "Nightmare at 20,000 Feet" from the show's fifth season, which follows an airplane passenger who is convinced that a monster is attacking the engines mid-flight. For a while, the plan was to link the film's disparate segments through shared characters, but that idea was eventually abandoned. In the end, only the introduction and the conclusion formed a continuity between the four mini-films, with the same character from the beginning of the film reappearing at the very end.

Like the *Alfred Hitchcock Presents* series, each episode of *The Twilight Zone* was introduced and concluded by a narrator—Rod Serling, in the case of the

The Twilight Zone. Spielberg thought of bringing Rod Serling back as a narrator via special effects (Serling died in 1975), but the idea was quickly abandoned. To stick to the spirit of the original series, Spielberg entrusted the writing of his segment, as well as those of Dante and Miller, to Richard Matheson, who had worked alongside Serling. It was Matheson's job to make the stories more contemporary.

A Terrible Accident

Landis filmed first, and the project quickly turned into a nightmare. On the night of July 22–23, 1982, while the crew was working on a sequence where the racist hero of "Time Out" flees a Vietnamese village that's under attack by the US Army, poor preparation on set led to a horrific catastrophe. As lead actor Vic Morrow attempted to cross a river carrying two Vietnamese children, a poorly controlled explosion set off by the special effects team hit a helicopter flying overhead at very low altitude. The helicopter crashed into the actor and the children, killing them instantly. The horrifying event quickly led to an investigation, and fingers were pointed: Landis allegedly asked the helicopter to fly lower than expected to make the scene more spectacular. Worse still, it was soon discovered that the child actors, who should not have been allowed to work at such a late hour, had been hired illegally.

Spielberg in the Spotlight

As the film's producer, was Spielberg aware of what was happening on the set? Whatever the truth may have been, the American press placed him front and center in the tragedy. Moreover, he and the executive producer, Frank Marshall (who was supposedly present on the set the night of the accident), were never interviewed by the authorities when an eventual trial took place in 1986 and 1987. They both claimed to have insane schedules that required them to live abroad on a regular basis. Landis was accused of manslaughter by the families of the deceased, and he was eventually acquitted.

Bruised by the whole affair, Spielberg contemplated canceling the film. Dissuaded from this by Warner Bros. and by his lawyers, he decided not to adapt "Monsters Are Due on Maple Street," which required children to work at night near special effects. Instead, he began work on "Kick the Can," an episode from the third season of the show. Matheson modified the original script, written by George Clayton Johnson, and Johnson suggested that after becoming children again, the residents of the old people's home could choose to return to their old

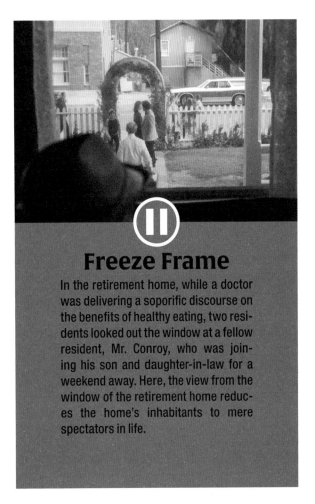

Freeze Frame

In the retirement home, while a doctor was delivering a soporific discourse on the benefits of healthy eating, two residents looked out the window at a fellow resident, Mr. Conroy, who was joining his son and daughter-in-law for a weekend away. Here, the view from the window of the retirement home reduces the home's inhabitants to mere spectators in life.

age. In the original 1962 episode, the kids ran away for good. Spielberg agreed and asked *E.T.*'s screenwriter, Melissa Mathison, to become more involved in the project. She agreed to come on and was eventually credited as "Josh Rogan." She was also one of the few people involved in the preproduction of the film; the director, meanwhile, no longer seemed to be interested in the project at all.

CASTING

Spielberg met Scatman Crothers while visiting Stanley Kubrick on the set of *The Shining* at Elstree Studios in England (which is also where parts of the first *Indiana Jones* were filmed). This seventy-two-year-old former jazz singer had made regular appearances in television series and films, including *One Flew Over the Cuckoo's Nest* (Miloš Forman, 1975). Like him, the rest of the "Kick the Can" cast consisted of well-known actors like Bill Quinn, who had appeared in Alfred Hitchcock's *The Birds* (1963) and in Spielberg's own TV movie, *Savage*. Murray Matheson and Peter Brocco were also cast, and they had both previously appeared in episodes of *The Twilight Zone*.

FILMING AND PRODUCTION

On November 26, 1982, when Joe Dante and George Miller had finished shooting their segments for the film, Spielberg began work on his own contribution. He only took six days to complete the film, almost as though he felt a need to dispose of this burden as quickly as possible. On location, every precaution was taken for the child actors on set. The segment was shot entirely in the studio, and night scenes were filmed during the daytime to make sure the production complied with the law. Spielberg refused to attend the end of shooting wrap party, saying that he had to go to London.

RECEPTION

His near absence from the postproduction process confirmed that Steven Spielberg wanted to move on. When it was released, *The Twilight Zone* suffered the usual fate of anthology films: Each segment was compared to the others.

Some Often Violent Criticism

When reviews came in for *The Twilight Zone: The Movie*, Miller and Dante were mostly acclaimed while Landis and Spielberg were often violently criticized. After describing Spielberg's work as "inept," the critic Vincent Canby asserted that "a lot of money and several lives might have been saved if the producers had just rereleased the original programs."[2]

The film has been regularly maligned in the years since its initial release, but "Kick the Can" is fully in keeping with the filmmaker's career spent analyzing and celebrating childhood nostalgia, which is underlined by Scatman Crothers's line in the film: "I've found out a long, long time ago I wanted to be my own true age and try to keep a young mind."

The elderly become children again in Spielberg's contribution to *The Twilight Zone*.

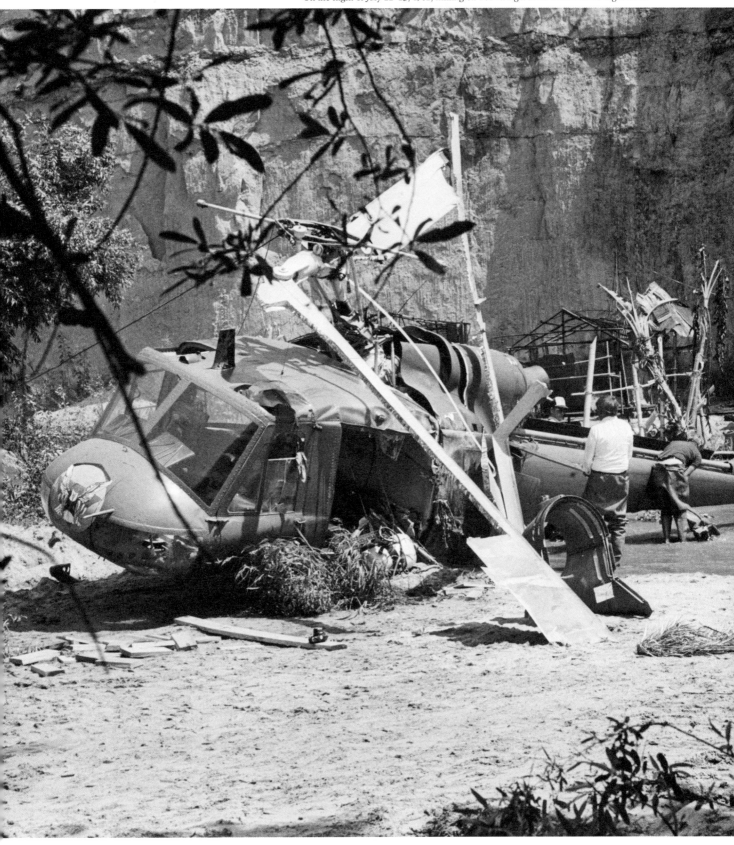

On the night of July 22–23, 1982, filming on *The Twilight Zone* turned into a nightmare.

Indiana Jones and the Temple of Doom

United States **1 hr 58** **Color** (DeLuxe) **Stereo** (Dolby/6-Track) **2.39:1**

Production Dates: April 18–September 8, 1983
United States Release Date: May 23, 1984

Worldwide Box Office: $333 million ($951 million in 2023 dollars)

Production Company: Lucasfilm, Paramount Pictures
Producer: Robert Watts
Associate Producer: Kathleen Kennedy
Executive Producers: George Lucas, Frank Marshall

Based on a story by George Lucas
Screenplay: Willard Huyck, Gloria Katz
Director of Photography: Douglas Slocombe
Film Editing: Michael Kahn
Music: John Williams
Sound: Simon Kaye
Sound Effects: Ben Burtt
Art Direction: Alan Cassie
Choreography for the Musical Number: Danny Daniels
Set Decoration: Elliot Scott
Makeup: Peter Robb-King
Wardrobe: Anthony Powell
Special Effects: Dennis Muren
Mechanical Special Effects: George Gibbs
Stunt Coordinators: Vic Armstrong and Glenn Randall

Starring: Harrison Ford (Indiana Jones), Kate Capshaw (Willie Scott), Ke Huy
Quan (Short Round), Amrish Puri (Mola Ram), Roshan Seth (Chattar Lal),
Philip Stone (Captain Blumburtt), Roy Chiao (Lao Che), David Yip (Wu Han), Ric
Young (Kao Kan), Dan Aykroyd (Weber)

"With the exception of these first ten minutes, this is a completely ridiculous and incredibly poor film."[1]

—Satyajit Ray, Indian filmmaker
(*The World of Apu, Charulata...*)

SYNOPSIS

I n a Shanghai cabaret, in 1935, Indiana Jones meets Lao Che, a local underworld baron with whom he makes a deal. The exchange goes wrong, and Jones is poisoned. While trying to recover the antidote, the archaeologist provokes a gunfight that forces him to flee in the company of his young sidekick, Short Round, and the club's singer, Willie Scott. Pursued by Che's henchmen, the trio escape by car, then by plane, before ending up in India in a village ravaged by poverty. The local inhabitants welcome Indiana Jones as a messiah sent by the goddess Shiva to recover a protective stone and save their children, who have been enslaved by the satanic guru Mola Ram.

GENESIS

From the outset, Steven Spielberg and George Lucas had always thought of the adventures of Indiana Jones as a trilogy. The phenomenal success of *Raiders of the Lost Ark* paved the way for them to make a sequel.

A Darker Adventure Story

Is it possible that the success of *The Empire Strikes Back* (Irvin Kershner, 1980) led the creators to give the second *Indiana Jones* movie a darker character? Did George Lucas's divorce from Marcia Lucas add an extra layer of anguish to the proceedings? Whatever the cause, George Lucas wanted to make a darker and more intense film, while once again harkening back to the serials of the 1930s–1940s and their B-movie exoticism. To do this, he and Spielberg used a host of ideas that had been discarded during the writing of the first *Indiana Jones* film, including a jump from a plane using an inflatable raft, and a roller coaster–like wagon chase set inside of a mine.

A Return to India

Several plots were considered for the movie: One version was set in China and based on the legend

of the Monkey King, where, after a motorcycle ride over the Great Wall of China, Indy stumbles upon a lost valley inhabited by dinosaurs. Another idea was based on a haunted castle in Scotland. The first concept was abandoned because of the crew's inability to get clearance from the Chinese authorities to shoot on location. The second concept was dropped because it felt too close to *Poltergeist* (1982), which Spielberg had just produced. Spielberg pivoted and began plotting a return to India, where he had gone for a sequence in *Close Encounters of the Third Kind*. He decided to anchor the story around magic and the murderous sect of the Thuggee, worshippers of the goddess Kali, who enforced a reign of terror during the British colonial period. Passionate about Hinduism, writers Willard Huyck and Gloria Katz

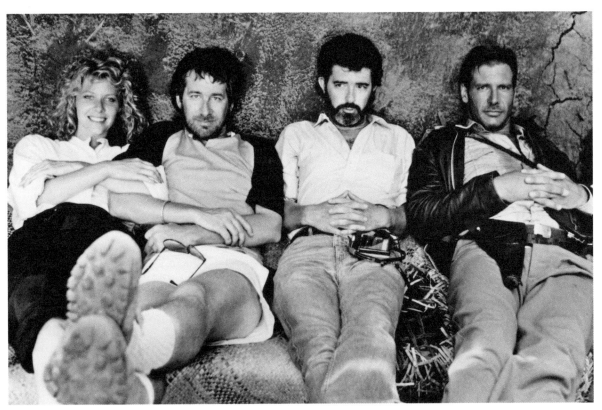

Kate Capshaw, Steven Spielberg, George Lucas, and Harrison Ford.

(who had previously written *American Graffiti* for Lucas) took on the script.

A Trio of Hounds

To make the plot less dependent on the previous film, the action was set in 1935, a year before the original movie took place. *Indiana Jones and the Temple of Death* (the original working title) was therefore a prequel, which allowed for a new adventure that was independent from the original film. Although Indiana Jones first appears in the new film wearing a tuxedo with a rose in his lapel, purists need not wait more than fifteen minutes for Indy to put on his famous leather jacket and fedora. Sadly, Marion, played by Karen Allen in *Raiders*, does not make an appearance here. Spielberg would have gladly brought her back, but Lucas was adamant that a new opus would require

a new leading lady. Instead, writers created a blond cabaret singer named Willie after Spielberg's cocker spaniel. As for the sidekick character, writers introduced a Chinese boy whom the archaeologist saved from poverty (an idea of Spielberg's). The character was named Short Round after Hyuck and Katz's Shetland shepherd. Indiana, it should be remembered, got his name from Lucas's Alaskan malamute. Three dogs' names for three protagonists—a comic trio indeed. This penchant for humor also extended to the film itself. Spielberg wanted to balance out the movie's gloomier moments with more gags, more spectacle, and about 20,000 insects (as opposed to the 4,500 snakes he used in *Raiders*).

Sri Lanka Stands in for India

Planned scenes for *Indiana Jones and the Temple of Doom* included a sequence of meals at the

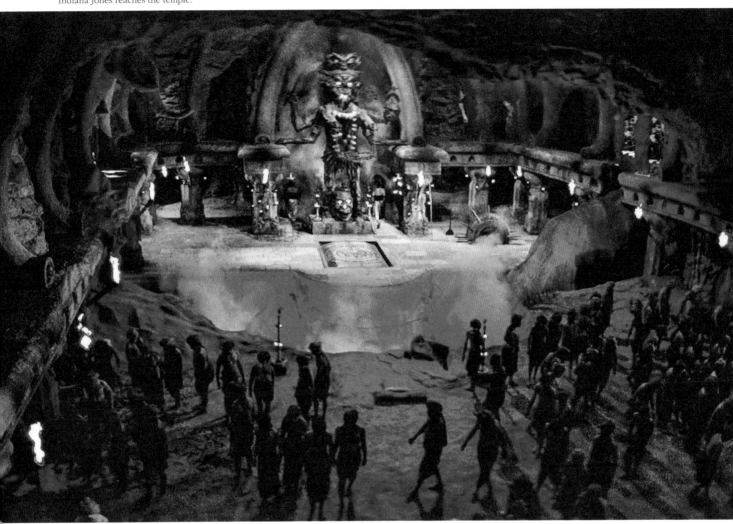

Indiana Jones reaches the temple.

maharaja's house where each dish turns out to be more repulsive than the last (giant beetles, snake stuffed with eels, eyeball soup, monkey brains in sorbet); an immersion into the hell of a Thuggee temple where hordes of kids are used as slaves; and human sacrifices involving ripping out hearts with bare hands. India did not look kindly on these ideas, which grossly caricatured local beliefs. When the production asked for permission to film in the Hotel Rose Palace in Jaipur, the Indian government balked and demanded numerous changes to the script. This was too much for the production team, who moved to Sri Lanka, near the city of Kandy (where David Lean shot *The Bridge on the River Kwai*), to shoot the films' exteriors. Interior sets were built on a studio lot in Great Britain. The rare views of the Pankot palace shown in the film were captured via painted canvases.

CASTING

After the commercial failure of *Blade Runner* (Ridley Scott, 1982) and the success of *Return of the Jedi* (Richard Marquand, 1983), Harrison Ford returned to the role that made him a worldwide star.

Love at First Sight…on Set

Spielberg was looking for a new face to play Willie Scott. One hundred and twenty actresses went through the casting process, and Sharon Stone was considered for a while, but Kate Capshaw eventually prevailed and won the role. Capshaw's real name was Kate Sue Nail. The thirty-year-old actress was originally from Texas and had trained as an actor in New York. She had made a few films for television and was destined for a career in independent cinema. But she fell in love with Spielberg at first sight: "It all started with his smell. It was familiar

to me, he smelled like my family [...] I smelled him like I was blindfolded and thought, 'He's the one.'"[2] Somewhat inconveniently, Steven Spielberg and Amy Irving got married during filming and had their first child, Max, in June 1985. Capshaw had to wait until 1991 to marry the man of her dreams after converting to Judaism. The couple now have seven children.

The Perfect Child Actor

Finding an actor to play the part of Short Round proved to be more complicated. After seeing six thousand child actors and amateurs, casting director Mike Fenton placed ads in several Los Angeles schools. Twelve-year-old Ke Huy Quan, of Chinese-Vietnamese descent, accompanied his older brother to the audition and caught the eye of producers Kathleen Kennedy and Frank Marshall. Spielberg thought he was so good that he summoned Harrison Ford to provide him with someone to act

opposite during an improvised audition set around a card game where Short Round suspected Indy of cheating. The scene ended up in the film. Spielberg liked Quan so much that the actor was brought back in the cast of *The Goonies* (Richard Donner, 1985), which was produced by Amblin the following year. Later in life, Quan moved on to a career as a stuntman and martial arts choreographer. To interpret the demonic Mola Ram, Spielberg insisted on casting Amrish Puri, a Bollywood star with a packed schedule that obliged the production to adjust their shooting dates around his limited availability: In 1983 and 1984, the actor appeared in twenty-five films!

FILMING AND PRODUCTION

On April 18, 1983, a week after the Academy Awards ceremony where *E.T.* was shunted aside by Richard Attenborough's *Gandhi*, Spielberg went to Kandy to start shooting.

Indiana Jones gets manhandled in the darkest, but also most jubilant, entry in the *Indiana Jones* film saga.

Harrison Ford, Ke Huy Quan, and Kate Capshaw get carried away in a memorable action scene.

Bravura Set Pieces

With a comfortable budget of $28 million (the equivalent of $68 million today), the filmmaker approached the film as recreation, but workmanlike recreation. In terms of direction, *The Temple of Doom* consisted of a succession of impressive bravura pieces, which the filmmaker planned for with the help of miniature sets and figures, as well as referential nods. Thus the opening musical number, set to a Chinese-language version of George Gershwin and Cole Porter's *Anything Goes*, was done as a tribute to Busby Berkeley's ballets. Kate Capshaw learned to sing in Mandarin for the scene, and she also took up tap dancing…in vain. Once she reached the set, she realized that the pencil dress costume created for her by costume designer Anthony Powell would considerably limit her movements, and so her dance was abandoned.

The First PG-13 Movie Rating

Prior to the release of *Indiana Jones and the Temple of Doom*, the Motion Picture Association of America (MPAA) limited their ratings of films to four categories: G (General Audiences), all audiences; PG (Parental Guidance Suggested), not recommended for children; R (Restricted), unaccompanied minors under 17 not allowed; and NC-17 (Adults Only), not for minors under 17. Fearing that the film's performance with teenage audiences would be hampered by its violence, Spielberg suggested that a PG-13 rating should be created. The MPAA agreed, and the PG-13 (Parents Strongly Cautioned) rating has been in use ever since.

Ke Huy Quan dangles from a bridge as part of a sequence that was filmed in three different countries.

A Leap without a Net

Many exteriors were filmed in Kandy (the car chase in Shanghai was shot in the streets of Macau), including the suspension bridge sequence. Taking advantage of the presence of a separate company that was in the middle of building a dam in town, set designer Elliot Scott commissioned them to build a life-size bridge over a river. Spielberg and Steadicam operator Garrett Brown were afraid of heights. To destroy the bridge when Indiana Jones cuts the ropes (which were actually steel cables) and thereby take Willie, Short Round, Mola Ram, and his men down with him, explosives were placed along its length. In place of the actors, fourteen battery-operated mannequins performed the gesticulations of frantic limbs tumbling downward. Only one take was possible for the

shoot, and it was covered by eight cameras. The final moments of the scene, when the characters try to save themselves by clinging to what is left of the ropes, were re-created in a London studio on a mocked-up wall set in front of a trompe l'oeil cliff. Finally, the shots of hungry alligators swirling in the river below were filmed by a separate team on location in Florida.

Master of Illusion

Three-quarters of the film was shot at London's Elstree Film Studios. Elliot Scott built the interiors of the palace, the temple, and the mine on a gigantic set that Douglas Slocombe, director of photography, saturated with menacing shadows and hellish red lights. The scene of the wall of spikes closing in on Indiana Jones and Short Round—a classic of

suspenseful buildup—is purportedly Spielberg's favorite. As for the Dante-esque wagon chase, the scene required the fabrication of rails that were only a few meters long. The play of lighting and camera angles, as well as the subsequent addition of shots animated with models and accelerated with stop-motion (designed by Industrial Light & Magic), all worked together to create the illusion of a frantic race through a labyrinthine pathway.

Emergency Surgery

While shooting a fight scene, Harrison Ford, who was suffering from a herniated disc, injured his back. Sent back to Los Angeles, Ford was quickly operated on and underwent a treatment that kept him away for six weeks. Spielberg took the opportunity to rework some dialogue with John Milius. Forced to adapt, the director filmed the meal scene without Ford, and the fight on the conveyor belt with Ford's understudy, Vic Armstrong. When the actor returned, Spielberg only had to shoot a few continuity shots to make sure Indy's face was visible. Production on the film wrapped with only one week's delay.

RECEPTION

During promotion for the movie, Spielberg and Lucas made their mark in front of the mythical Mann's Chinese Theater on Hollywood Boulevard in Los Angeles. This appearance at a sacred Hollywood institution contrasted greatly with the film's mixed reception from the press.

Sadism and Catharsis

While some critics admired the film's dizzying spectacle ("It's brilliance racing down narrow tracks [...] You can't blame a theme park for not being a cathedral,"[3] wrote Richard Corliss in *Time*, others deplored the problematic portrayal of India as a country, and the stereotypical characters Spielberg and Lucas chose to populate their film, especially the hysterical Willie Scott, who was reduced to simpering and screaming in the face of danger. The film was accused of sexism and even racism. Nobody expected, moreover, for the film to depict so many casual cruelties (torture, killing, beaten or dying children), which felt more worthy of horror movies. Nevertheless, the movie was a success. At the peak of his popularity, and hidden behind the creation of his friend Lucas, Spielberg let loose: He let his bad-kid tendencies take over and transformed his family blockbuster into a semi-scandalous romp. The filmmaker never endorsed the cruelty of

Indiana Jones and the Temple of Doom, and always repeated in interviews that it was his least favorite episode of the saga. Yet this cruelty regularly resurfaced in his work. Perhaps its appearance here was a form of catharsis? It is possible to see the scene where an evil Indiana Jones, who has been bewitched by Mola Ram, is about to torture Willie and Short Round as a projection of Spielberg's surrounding his guilt as a producer in the aftermath of the tragic accident that occurred on the set of *The Twilight Zone*. Similarly, one can link the child slaves of Mola Ram to the controversy surrounding the suspected illegal exploitation of the two young actors who perished in that same accident. When Indy, who has returned from the abyss, saves the village children from their fate, it is childhood writ large that he saves. And Spielberg redeems his conscience through fiction...while at the same time invoking the macabre humor of the tricks he used to play on his little sisters when they were growing up.

Posterity: Better Late Than Never

While *Raiders of the Lost Ark* was filled with light, *The Temple of Doom* is like a claustrophobic visit to a sadistic theme park, and its last half hour is like an extreme ride on a ghostly train. It's pure "cinematic pleasure," driven by a drumbeat that plays on the audience's primal fears. The film also serves as a model of what movies could do before digital special effects took over the movie business. As such, *The Temple of Doom* has become the favorite *Indiana Jones* film of many fans of the saga.

A Raft of References

The Paramount logo shown on the gong in the opening scene is a nod to the credits of *Gunga Din* (George Stevens, 1939), which was a main influence for the film. The Chinese cabaret is called Obi Wan Club, after the character from *Star Wars* (George Lucas, 1977). The leap that's taken out of the window of that same nightclub, which is cushioned by blinds, is based on a stunt performed by Buster Keaton in *Three Ages* (Edward F. Cline and Buster Keaton, 1923), which was also used by Jackie Chan in *Project A* (Jackie Chan, 1983).

Will Smith and Tommy Lee Jones as alien hunters in *Men in Black* (Barry Sonnenfeld, 1997).

Amblin Entertainment
The Fantasy Factory

Steven Spielberg always seemed to underestimate his 1968 short film *Amblin'*, which was made specifically to impress studio executives. Nevertheless, since the film did give him a start in his career at Universal Television, it is only fitting that Amblin (without the apostrophe) was taken up as the name of the filmmaker's first production company.

A Bicycle with a Moon in the Background...As a Logo

Amblin Entertainment was established in 1981, initially under the name Amblin Productions, with producer Frank Marshall and Spielberg's collaborator Kathleen Kennedy serving as partners alongside Spielberg. Marshall had been working with filmmaker Peter Bogdanovich for a long time when Spielberg

first called on him to produce *Raiders of the Lost Ark* (1981). Meanwhile, Kennedy was John Milius's assistant when he produced *1941* (1979).

When Steven Spielberg and George Lucas were looking for a screenwriter for *Raiders of the Lost Ark*, they set their sights on Lawrence Kasdan, who had written the script for another movie that they both admired called *Continental Divide* (Michael Apted, 1981). This was the first film made under the Amblin label. This was followed by two projects close to Spielberg's heart: *Poltergeist* (1982), directed by Tobe Hooper, and *E.T. the Extra-Terrestrial*. Two years later, the iconic image from *E.T.* of the bicycle crossing in front of a giant, full moon became the official logo of Amblin Entertainment.

Happy Endings and Groups of Friends

Amblin typically works in co-productions with Hollywood studios. Amblin's offices reside within Bungalow 477, which is located on the Universal backlot, between a New York City street set and an alleyway called Amblin Drive. The company's television division was born in 1984, and Spielberg's other production company, DreamWorks, would eventually also be based there.

From *Back to the Future* (Robert Zemeckis, 1985) to *Who Framed Roger Rabbit* (Robert Zemeckis, 1988), *Gremlins* (Joe Dante, 1984), *Harry and the Hendersons* (William Dear, 1987), and *The Goonies* (Richard Donner, 1985), Amblin Entertainment became the emblem of a certain kind of cinema that was distinct to the 1980s; mainly, cinema consisting of adventure, fantasy, and reassuringly happy endings, and mostly led by children and adolescents. Amblin is indeed the cinema of the buddy gang, as in *The Goonies* and *Fandango* (Kevin Reynolds, 1985), with Kevin Costner in his first leading role. High school rivalries are at the heart of *Back to the Future*, and in *Young Sherlock Holmes* (Barry Levinson, 1985), Sherlock Holmes and Dr. Watson meet at school.

A Sense of Entertainment and Narrative Efficiency

Some of Amblin's productions would go on to have a lasting impact on popular culture, starting with the *Back to the Future* trilogy and *Gremlins*. Science fiction, in the case of the former, and horror, in the case of the latter, moved away from the sociopolitical commentary of the previous decade, instead giving priority to a strong sense of entertainment and narrative fun. This tone would become a standard for a whole generation of filmmakers, from J. J. Abrams to the Duffer brothers, who created the *Stranger Things* series for Netflix (2016).

In an Amblin feature, the audience reconnects with figures that had been abandoned to childhood—pirates, monsters, mad scientists—almost like they're dipping into a long-forgotten toy chest. *The Mask of Zorro* (Martin Campbell, 1998) was originally developed by and for Spielberg, and it revives an old folk hero. *Twister* (Jan de Bont, 1996) recalls classic disaster films, and *Innerspace* (Joe Dante, 1987) revisits Richard Fleischer's 1966 *Fantastic Voyage*. The special effects in these films are legion, and they're provided by the ubiquitous Industrial Light & Magic studio that was created by Spielberg's friend George Lucas. In fact, *Young Sherlock Holmes* has ILM to thank for giving it the distinction of being the first film to include a character created using photorealistic computer graphics (a knight emerging from a stained-glass window).

Ordinary Americans in Ordinary Towns

Many of the themes and motifs that are typical to Spielberg's films can be found in Amblin's creations, such as unreliable or absent fathers, characters living in ordinary American towns, and the often-disturbing world of adults. Characters are constantly tinkering with newfangled inventions, which evoke the filmmaker's father, Arnold, who was an electronics enthusiast. Spielberg's childhood fascination with television (the content, but also the device itself) is the source of *Poltergeist*, and the title character of *An American Tail* (1986), a cartoon by Don Bluth, is named after Spielberg's maternal grandfather, Fievel Posner. Born in Odessa, Ukraine, in 1883, he left his home for America, like the mouse in the film. It is also difficult not to see *The Goonies* as a kid-friendly version of Indiana Jones.

Amblin Entertainment Grows and Multiplies

While Spielberg had free rein to let his inspirations run wild, there were certain risks he wasn't willing to take in his own films, which do show up in some of Amblin's slate of movies. These include moments and scenes like the macabre visions of *Poltergeist*, the hypersexual Jessica of *Who Framed Roger Rabbit*, and the semi-incestuous impulses lurking inside the otherwise fun and straightforward *Back to the Future*. *Gremlins* is a real ransacking of the Christmas spirit. Directed by Joe Dante, the irreverent filmmaker who helmed a parody of *Jaws* called *Piranha* (1978), *Gremlins* is once again about a group of friends, except this time they're little furry monsters!

The successes were often huge, and they came one after another (*E.T., Back to the Future, Gremlins, Who Framed Roger Rabbit, Jurassic Park, Twister*), though there were some films that disappointed at the box office (*Young Sherlock Holmes, Fandango, Hook*). Savaged by the critics, *The Flintstones* (Brian Levant, 1994) was Elizabeth Taylor's last feature film, and it earned the actress a Worst Supporting Actress nomination at the Razzie Awards!

While Amblin's television division had its ups and downs, the animation division, Amblimation, was a conspicuous failure. Created in 1989, it produced only three feature films before being merged into DreamWorks Animation in 1997. As for their special effects arm, Amblin Imaging only lasted from 1992 to 1995.

Back to the Future was written and directed by two Steven Spielberg postulates, Robert Zemeckis and Bob Gale.

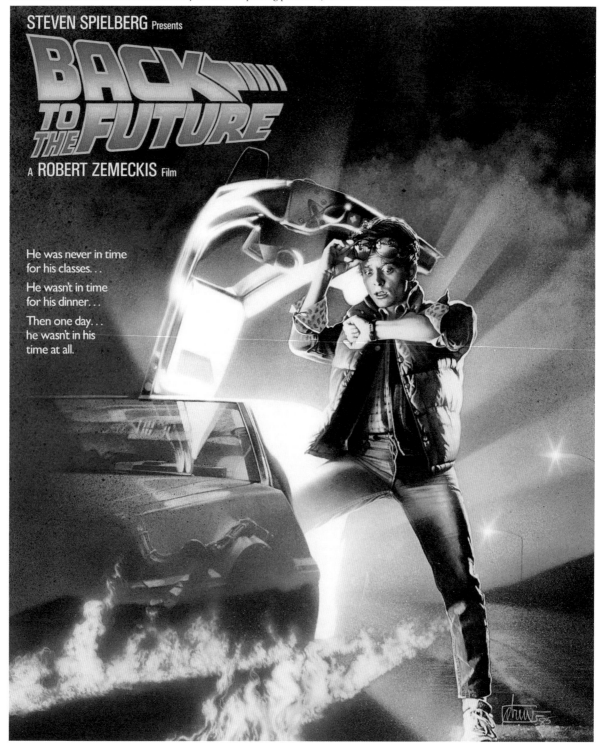

A Breeding Ground for Talent

Steven Spielberg took Robert Zemeckis and Bob Gale under his wing in the late 1970s when they graduated from the University of Southern California. "No studio wanted *Back to the Future* until Bob [Zemeckis] found success with *Romancing the Stone*," Gale recalled in 2014. "Suddenly, everyone wanted our movie, but we took it to Steven."[1] Zemeckis worked on *Who Framed Roger Rabbit* at Bungalow 477 on the Universal lot, and his director of photography, Dean Cundey, would eventually go on to make two films with Spielberg.

Gremlins was directed by Joe Dante (1984) and includes many typical Spielberg themes.

In 1984, illustrator David Wiesner made the drawings for a book called *E.T., The Book of the Green Planet* (1985), with a story written by the filmmaker. Screenwriter Chris Columbus joined Amblin with *Gremlins* (which Spielberg pushed into being more of a comedy). After *Jurassic Park*, David Koepp was a writer on other Spielberg films, and he directed *The Trigger Effect* (1996) for Amblin before working on the second team of *The Lost World: Jurassic Park* (1997). The co-founder of the company, Frank Marshall, also went behind the camera with *Arachnophobia* (1990), after working in the second unit team on some of his producing partner's features.

Pioneering Marketing Strategies

Amblin distinguished itself in another area: marketing. Brad Globe, head of merchandising, was the man behind some revolutionary cross-merchandising strategies. McDonald's offered *Back to the Future, An American Tail*, and *Who Framed Roger Rabbit* merchandise in their restaurants, and in 1988, figurines from *The Land Before Time* (Don Bluth, 1988) could be found at Pizza Hut. A year later, videocassettes of the film were sold with a voucher for the pizza chain. When *Back to the Future Part III* (Robert Zemeckis) was released in May 1990, Amblin and Universal set up a contest with Western Union. The prize was a visit to the Universal theme park that the studio was opening that June in Orlando, Florida.

These merchandizing opportunities were nothing compared to the *Jurassic Park* craze. The film was released in 1993, but the promotional operations orchestrated with Universal began in 1991 and they took place without ever revealing a single image of a dinosaur from the film. This time, the innovative marketing strategy consisted of placing spin-off products that would eventually be sold in stores directly into the film. The Amblin team also wisely made the Jurassic Park logo an official and real brand. Kellogg's, Coca-Cola, McDonald's, Pepsi-Cola, Kenner toys…everyone wanted to sink their claws into Spielberg's dinosaurs.

Tending Toward a Certain Withdrawal

Despite all the success and innovation at Amblin, some dissatisfactions were emerging at the company. Spielberg himself was tired of the role of producer, which could sometimes be thankless and was inherently a source of conflict. His name was also increasingly associated with some mediocre films and, as a director, he moved away from the "spirit" of Amblin after *The Lost World* so that he could begin to make more "serious" and sometimes dark films. He only returned occasionally to the thrilling adventure genre. As for Frank Marshall and Kathleen Kennedy, they had their own ambitions: They left Amblin to form The Kennedy/Marshall Company in 1992.

Constant evolution within the film industry led Amblin to start alternating between producing films from Spielberg and massive franchise movies like *Men in Black, Jurassic Park, The Flintstones*, and *Zorro*. In 2015, the company was integrated into a new entity overseeing all of Spielberg's activities called Amblin Partners. This new outfit benefited from a distribution partnership with Universal, but its future may lie elsewhere. In June 2021, Amblin Partners signed with Netflix to provide the platform with several feature films per year.

Amazing Stories

"Ghost Train" • *Season 1, Episode 1*

United States • 25 mins • Color • Mono • 1.33:1

Production Dates: Unknown
Date of Broadcast in the United States: September 29, 1985, on NBC

Production Company: Amblin Entertainment, Universal Television
Producers: Joshua Brand, John Falsey, David E. Vogel
Associate Producers: Skip Lusk, Steve Starkey
Executive Producers: Steven Spielberg, Kathleen Kennedy, Frank Marshall

From the television series *Amazing Stories*, created by Steven Spielberg, Joshua Brand, and John Falsey (1985)
Screenplay: Frank Deese, based on an idea by Steven Spielberg

Director of Photography: Allen Daviau
Film Editing: Steven Kemper
Music: John Williams
Sound: Michael C. Moore
Art Direction: Richard B. Lewis
Set Decoration: Gregory Garrison
Wardrobe: Carol Hybi, Sanford Slepak
Visual Effects: William Reilly, Dream Quest Images
Casting: Jane Feinberg, Mike Fenton, Valorie Massalas
Assistant Directors: David L. Beanes, Jerry Ketcham

Starring: Roberts Blossom (Opa Clyde Globe), Scott Paulin (Fenton Globe), Gail Edwards (Joleen Globe), Lukas Haas (Brian Globe), Renny Roker (Dr. Steele)

SYNOPSIS

Fenton Globe is excited to show his father, Clyde, the new house he has had built, where Clyde will live. Upon arriving at the property, "Opa" Clyde is stunned: The building is located on the exact spot where, in 1901, as a child, he accidentally caused a train to derail, killing all the passengers. Opa is certain that the next night, the train will come back to pick him up for his final journey. He shares his distress with his grandson, Brian, who is the only one who believes his story.

GENESIS

It was the television event of the year in 1985: Steven Spielberg was back on the small screen with an anthology series he created and produced. NBC had no hesitation in accommodating his requirements for the series, and they were enormous: forty-four episodes spread out over two seasons, regardless of audience figures.

Childhood Memories

Each segment of *Amazing Stories* lasted for about thirty minutes, and they had a budget of between $800,000 and $1 million (between $2 million and $2.5 million today). Universal suggested that the filmmaker should present the series, as Rod Serling did by introducing and concluding the episodes of *The Twilight Zone* (1959–1964) or include his name in the title as Hitchcock did for *Alfred Hitchcock Presents* (1955–1962), but Spielberg refused to put himself forward in this way.

Nevertheless, *Amazing Stories* benefited from his involvement, especially since the project was particularly close to his heart. The series took him back to a time when, as a child, he would climb onto his father's lap for a very special reading session from the latest issue of *Amazing Stories*.

A Notebook Filled with Ideas

To find the plots that would make up *Amazing Stories*, Spielberg drew on a notebook where he regularly jotted down ideas whenever they came to him; it was up to the scriptwriters to develop them. To find directors for the series, Spielberg reached out to filmmakers he admired (Martin Scorsese, Clint Eastwood, Joe Dante, Robert Zemeckis, Irvin Kershner), as well as to those he wanted to launch (Phil Joanou, Kevin Reynolds, Brad Bird). He also offered episodes to his faithful colleagues (Matthew Robbins, Michael D. Moore, Joan Darling, Norman Reynolds) while reserving two episodes for himself, including the pilot, "Ghost Train." Here again, Spielberg opened his personal box of memories: When he lived in New Jersey, he often heard the sound of an express train running at full speed near his house at night; and the close relationship between a grandfather and his grandson, as well as the lack of understanding spanning generations, are also autobiographical motifs.

CASTING

For the role of the eighty-four-year-old Opa Clyde, the filmmaker chose Roberts Blossom, who was then only sixty-one years old. The two men had already worked together on *Close Encounters of the Third Kind*. Scott Paulin and Gail Edwards were both experienced TV series actors, but the real star of the show was nine-year-old Lukas Haas, whose performance in Peter Weir's *Witness* impressed Spielberg when it was released in February 1985. In the show's final scene, Drew Barrymore and Spielberg's mother-in-law, Priscilla Pointer, both make brief appearances.

FILMING AND PRODUCTION

Like every director in the series, Spielberg had one week to shoot his episode. Almost entirely filmed on soundstages at Universal Studios, "Ghost Train" also marked the beginning of the director's long collaboration with set designer Rick Carter. During shooting, Spielberg received a visit from David Lean, a renowned filmmaker who he admired, and to whom he suggested shooting his own episode of *Amazing Stories*. When he learned that each director had to complete his segment in six to eight days, the director of *Lawrence of Arabia* (1962) politely promised to think about it…if a zero was added after the six or eight.

RECEPTION

As the episode entered postproduction, Spielberg forbade the network to show it to journalists before broadcast. This was a way, in his opinion, of preserving the mystery and the suspense of the series. Director of NBC Entertainment Brandon Tartikoff subsequently recognized this as a strategic error after the very disappointing ratings of the first season: "If I could do it all over, I would have taken the first five or six episodes and trotted them out on the press tour and gotten off on a better foot with the people who write about television."[1]

The Magic of the Big Screen

Too much mystery has a way of killing the mystery. The media had nothing to go on when *Amazing Stories* premiered, and viewers had a hard time making their minds up about the show. Broadcast during prime time on September 29, 1985, "Ghost Train" saw a sizable portion of its viewers tune out or change the channel in the middle of the show. For producer David E. Vogel, it was not just a story about journalists: "'Ghost Train' works wonderfully on a big screen. In a theater, you can create magic. On television, when sight and sound are limited, the visual leaps of faith are limited."[2]

Amazing Stories

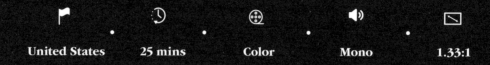

"The Mission" • *Season 1, Episode 5*

🏳	🕐	🎞	🔊	▱
United States	**25 mins**	**Color**	**Mono**	**1.33:1**

Production Dates: Unknown
Date of Broadcast in the United States: November 3, 1985, on NBC

Production Company: Amblin Entertainment, Universal Television
Producers: Joshua Brand, John Falsey, David E. Vogel
Associate Producer: Steve Starkey
Executive Producers: Steven Spielberg, Kathleen Kennedy, Frank Marshall
From the television series *Amazing Stories*, **created by Steven Spielberg, Joshua Brand, and John Falsey (1985)**
Screenplay: Menno Meyjes, based on an idea by Steven Spielberg
Director of Photography: John McPherson
Film Editing: Steven Kemper

Music: John Williams
Sound: Michael C. Moore
Art Direction: Richard B. Lewis
Set Decoration: Richard B. Goddard
Special Effects: Wayne Rose
Visual Effects: William Reilly, Dream Quest
Starring: Kevin Costner (captain), Casey Siemaszko (Jonathan), Kiefer Sutherland (Static), Jeffrey Jay Cohen (Jake), John Philbin (Bullseye), Gary Mauro (Sam), Glen Mauro (Dave), Peter Jason (commander), Karen Kopins (Liz), Anthony LaPaglia (mechanic), Gary Riley (gunner), Ken Stovitz (Lamar), Nelson Welch (Father McKay)

SYNOPSIS

D uring the Second World War, the crew of an Allied bomber goes on a night mission in enemy territory. During the mission, the crew engages in aerial combat with German fighters. At the end of the encounter, as the plane returns to its base, the damage it has sustained—two out of four engines are out of order, the landing gear has been destroyed, and, above all, the machine gunner under the belly of the plane is stuck in his turret—makes landing safely almost impossible.

GENESIS

For "The Mission," the second episode of *Amazing Stories* that he directed, Steven Spielberg picked a tailor-made story for himself, bringing together two of his many pet interests: planes and World War II.

Saved by the CGI

The interior of an Allied bomber is virtually the only location of the plot, which hurtles toward a perilous conclusion. Indeed, Jonathan (played by Casey Siemaszko) is trapped in the machine gun turret, and he is facing certain death upon landing before drawing on a pair of wheels that materialize as if by magic. To do this, Spielberg uses CGI (computer-generated imagery) for the first time. Interestingly, Allen Daviau, who worked on "Ghost Train," was replaced by John McPherson, a cinematographer who worked on fourteen episodes of the series. This choice matched the much darker atmosphere of "The Mission." On the other hand, production designer Rick Carter, who also worked on "Ghost Train," was again part of the adventure. For the music, Spielberg turned to his accomplice John Williams. Another "returnee," writer-scriptwriter Richard Matheson, acted as a consultant for the script, three years after having collaborating with the director on *The Twilight Zone*.

CASTING

At just thirty years old, Kevin Costner had yet to make a major splash on the big screen. Released in January 1985, *Fandango* (produced by Amblin) was a minor hit and, at the time "The Mission" was shot, *Silverado* (Lawrence Kasdan, 1985) had not yet been released. By his side, the young Kiefer Sutherland, nineteen at the time, was just beginning to follow in the footsteps of his father, Donald. Meanwhile, Casey Siemaszko, who plays the central character of the episode, was also at the beginning of his career. He had just met Kiefer the previous summer on the set of *Stand by Me* (1986), directed by Rob Reiner.

FILMING AND PRODUCTION

"The Mission" was shot entirely at Universal studios. The interior of a B-17 bomber was re-created there, and it was decorated with a few period objects found in order to accentuate the authenticity of the proceedings. For the rest of the production, a few well-placed smoke bombs, some clever lighting effects, and tight framing accentuated the feeling of confinement. As work began, Spielberg just kept on filming, and "The Mission" did not fit into the twenty-five minutes planned for each episode. To fit into a regular television episode slot, the segment had to be "expanded" to fifty-two minutes.

RECEPTION

The fifth episode of the series, "The Mission" suffered, as was the case with the previous episodes, from direct competition with the series *Murder, She Wrote*, which had major audience success on CBS.

An "Amazing" Weakness

The lukewarm critical reception for the series did not help matters. Even worse, the two episodes helmed by Spielberg were the worst received by the media, who considered their weakness as the most "amazing" aspect of the entire enterprise. The most scathing criticism, and probably the most realistic, came from the filmmaker's own camp: "Steven never could make up his mind what the show was going to be, whether it was going to be scary or whether it was going to be fantasy," as Bob Gale later summarized. "Every month Steven would change his mind about what direction we should go. Television is not a director's medium, and it's great that Steven got all these directors in there to do these shows, but the scripts weren't any good. He should have spent more time getting the best writers in the world to contribute and then worrying about the directors."[1] The second season of the show began on September 22, 1986, and it met a similar fate as the first. Spielberg, who was supposed to direct at least one more episode, finally gave the project up.

An Experimental Series

Disparaged at the time of its broadcast, *Amazing Stories* resembles a giant laboratory from which ideas, talents, and even a film emerged: Ideas, like the integration of animated images at the end of "The Mission," which foreshadows *Who Framed Roger Rabbit*. Talents, such as Brad Bird, who wrote and directed "Family Dog," a cartoon episode that six years later became a full-fledged series produced by Amblin. Finally, a film called **batteries not included* (Matthew Robbins, 1987), which was initially intended to be an episode of the anthology. In 1986, "The Mission" won two of the five Emmy Awards won by *Amazing Stories* as a series: one for McPherson, the other for the sound editing. Spielberg was already back on the movie set. He would not be involved in a series again until *Band of Brothers* in 2001.

The original cast of *E.R.*, with George Clooney (third from left).

Amblin Television
Back to the Small Screen

The announcement, in the summer of 1984, of a television series developed by Steven Spielberg felt like a return to his roots. With the title *Amazing Stories*, the program was co-produced by the director's company, Amblin Entertainment, and by Universal Television for broadcast on NBC starting in the fall of 1985.

A Familiar Context

Steven Spielberg started his career at Universal Television, and his first production was a segment of the pilot for the series *Night Gallery* (1969), which was intended for NBC. The official presentation of *Amazing Stories* was made by Sid Sheinberg, the president of MCA, Universal's parent company. This was the man who offered Spielberg his first contract in 1968.

In this familiar context, Amblin Entertainment was endowed with a television division called Amblin Television, which was initially dedicated to

Amazing Stories. After filming *The Color Purple* in 1985, Steven Spielberg put his film projects on hold for a year to devote himself to this new activity. It was now an entity in its own right, alongside Amblin Entertainment and DreamWorks.

A Family Audience

Amblin Television generally worked on co-productions alongside a studio (Universal, Warner, Paramount…) that would eventually air on NBC, ABC, CBS, or on pay-TV channels and, later, on streaming services.

As a television medium, the productions were originally aimed at a family audience and children—hence several animated series, including *Tiny Toon Adventures* (1990) and *The Plucky Duck Show* (1992), in which Steven Spielberg teamed up with animator and scriptwriter Tom Ruegger. Amblin Television also siphoned off of Amblin Entertainment productions. The world of the films *Back to the Future* (Robert Zemeckis, 1985 to 1990),

Men in Black (Barry Sonnenfeld, 1997 to 2012), and *Gremlins* (Joe Dante, 1984 to 1990) gave rise to animated series, and the comedy *Harry and the Hendersons* (William Dear, 1987) became a sitcom in 1991. Co-produced with Spielberg's friend George Lucas, two seasons of *The Adventures of Young Indiana Jones* were derived from the films about the famous archaeologist and broadcast between 1992 and 1993. This ambitious program benefited from large resources, but it was not as successful as many had hoped. In 2020, the development of a new series based on the *Jurassic Park* universe was launched.

Big Ambitions

Amblin Television produced shows relating to science fiction, such as the series *SeaQuest 2032* (1993–1996), for which Steven Spielberg had great ambitions and mobilized significant resources, *Earth 2* (1994), and the 2013 adaption of the 2009 Stephen King novel *Under the Dome*. In 2012, Spielberg hoped to innovate with *The River*. "There's nothing like this, something very raw and visceral, on TV,"[1] he assured the creator of the series, Oren Peli, who had previously directed *Paranormal Activity* (2007), and who initially thought of making *The River* as a low-budget film.

However, Amblin Television had to deal with the harsh reality of television ratings. *Amazing Stories* was a disappointment for NBC, who did not extend the series beyond two seasons. The third season of *SeaQuest* did not go all the way, and *The River* (2012) and *The Whispers* (2015) were canceled by ABC after only one season. In 2013, *Lucky 7*, an adaptation of a British series whose creator had been personally contacted by an enthusiastic Steven Spielberg, proved to be an abysmal failure from the first episode. A TV adaptation of *Minority Report* performed so poorly on Fox that the series was reduced from thirteen to ten episodes.

ER, or the Renewal of the Series

Amblin's master stroke in television came with *ER* in 1994. A critical, artistic, and ratings success, the medical series ran for fifteen seasons and won twenty-three Emmy Awards out of 126 nominations. *ER* was an old project brought to Steven Spielberg by a former Harvard medical student turned best-selling author, Michael Crichton. The script had long scared the studios, who felt it was too technical, too realistic, and too willing to let

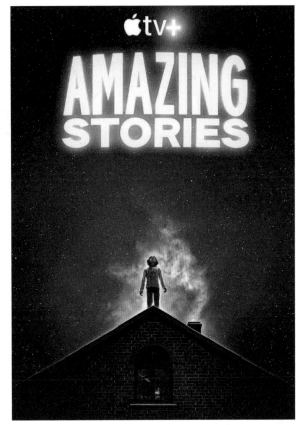

The *Amazing Stories* series was relaunched on March 6, 2020.

patients die. Spielberg was attracted by this authenticity, which was far from the calm of past medical series he'd worked on, such as *Marcus Welby, M.D.* He was very involved in the first few seasons of the show, watching the rushes in the middle of making his own films. *ER* laid the foundation for a new generation of television series.

Meanwhile, the television division of Dream-Works—the production company founded by Steven Spielberg, Jeffrey Katzenberg, and David Geffen in 1994—was struggling to find its way. In 2013, it was merged into Amblin Television. The latter took over the expensive series *The Borgias* (2011), which was canceled after its fourth season, but *Falling Skies* (2011) and *The Americans* (2013) were successful.

The Age of the Streaming Platform

Amblin Television co-produced two seasons of the anthology *The Haunting* (2018) for Netflix before launching a new version of *Amazing Stories* for Apple TV+. The new series launched in March of 2020 in co-production with Universal Television.

A STEVEN SPIELBERG
FILM

The Color Purple

Alice Walker's Pulitzer Prize Winning Story

It's about life. It's about love. It's about us.

WARNER BROS. Presents A STEVEN SPIELBERG Film THE COLOR PURPLE Starring DANNY GLOVER
ADOLPH CAESAR · MARGARET AVERY · RAE DAWN CHONG and Introducing WHOOPI GOLDBERG as Celie
Director of Photography ALLEN DAVIAU Production Designer J. MICHAEL RIVA Film Editor MICHAEL KAHN, A.C.E. Music QUINCY JONES
Based upon the novel by ALICE WALKER Screenplay by MENNO MEYJES Executive Producers JON PETERS and PETER GUBER
Produced by STEVEN SPIELBERG · KATHLEEN KENNEDY · FRANK MARSHALL · QUINCY JONES Directed by STEVEN SPIELBERG

The Color Purple

United States · 2 hrs 34 · Color (DeLuxe) · Stereo (Dolby) · 1.85:1

Production Dates: June to August 1985
United States Release Date: December 18, 1985

Worldwide Box Office: $142 million (equivalent to $384.5 million in 2023)

Production: Amblin Entertainment, Guber-Peters Company
Producers: Quincy Jones, Kathleen Kennedy, Frank Marshall,
Steven Spielberg
Associate Producer: Carole Isenberg
Executive Producers: Peter Guber, Jon Peters
Unit Production Manager: Gerald R. Molen, Vincent Winter (Kenya)

Based on the eponymous novel by Alice Walker (1982)
Screenplay: Menno Meyjes
Second Unit Director (Kenya): Frank Marshall
Director of Photography: Allen Daviau
Film Editing: Michael Kahn
Music: Quincy Jones
Sound: Willie Burton, Richard L. Anderson
Art Direction: J. Michael Riva
Set Decoration: Robert Welsh
Costume Design: Aggie Guerard Rodgers
Special Effects: Matt Sweeney
Casting: Reuben Cannon

Starring: Whoopi Goldberg (Celie Johnson), Margaret Avery (Shug Avery),
Oprah Winfrey (Sofia), Danny Glover (Albert Johnson), Akosua Busia (Nettie
Harris), Adolph Caesar (M. Johnson, father), Willard Pugh (Harpo), Desreta
Jackson (young Celie), Rae Dawn Chong (Squeak), Dana Ivey (Miss Millie),
Leonard Jackson (Pa Harris), James Tillis (Buster), Carl Anderson (Reverend
Samuel), Bennet Guillory (Grady), Susan Beaubian (Corrine), Laurence
Fishburne (Swain), Howard Starr (young Harpo), Táta Vega
(singing voice of Shug Avery)

> **"Spielberg would direct me in terms of movies we'd both seen. 'Whoopi, this scene, it's Claude Rains and Bogart at the end of *Casablanca*.'"**[1]

—
—Whoopi Goldberg on her role in
The Color Purple

SYNOPSIS

——

In 1909, in rural Georgia, fourteen-year-old Celie and twelve-year-old Nettie Harris live under the iron fist of an incestuous father. When Albert Johnson, a widower, asks to marry Nettie, the girls' father prefers to give him Celie instead. The teenager quickly understands that she has passed from one brute to another. Unloved by Albert's children, and humiliated and beaten by her husband, Celie does what she is told. One day, Albert tries unsuccessfully to rape Nettie and when she retaliates, he drives her out of town and away from her sister. The years pass, and the indignities that befall Celie continue to mount. Will the sisters ever be reunited?

GENESIS

Can a white, male filmmaker tell the story of Black women set in the segregated South of the early twentieth century? Alice Walker thought not, and so she decided not to give up the rights to adapt her 1983 Pulitzer Prize–winning novel, *The Color Purple*, believing that Hollywood producers would be unable to do it justice.

A Book that Received Some Criticism

Alice Walker was born in February 1944 in Eatonton, Georgia (where *The Color Purple* is set), to share-cropper parents. She became a civil rights activist in the 1960s, but rather than focusing on the domination of white people over Black people, her novel documents the domination of Black men over Black women, drawing in part on stories from her own family. The book received criticism for its portrayal of brutal Black men, but its defenders praised its ability to give voice to women and to provide an alternative view of the condition of African Americans in the southern United States.

When Alice Walker was approached by Peter Guber and Jon Peters about making a film, she was doubtful. They had produced *Flashdance* (Adrian Lyne, 1983), whose heroine is a young working-class woman, but that film wasn't exactly celebrated for

its social realism. Walker consulted with a group of friends and finally decided that improving Hollywood's representation of Black people, and Black women in particular, would only happen if she interacted with the Hollywood system. So, she ceded the rights to her novel while guaranteeing a consulting role for herself, as well as the right to review casting decisions. She was also adamant that the actors cast in the film not be major stars but rather talents in the making, much like the characters in her book, who would eventually reveal their true selves over the course of many years. Walker's contract also stipulated that half of the production (apart from the actors, all of whom were Black) had to be made up of people of color, or women, or from third-world populations.

A Salary of Forty Thousand Dollars

In this context, Guber and Peters asked composer Quincy Jones to write the music for the film. At the time, Jones had already won fifteen Grammy Awards, including one for the audiobook version of *E.T. the Extra-Terrestrial*. In spite of all his well-deserved accolades, Jones was searching for a new challenge. "Alice Walker wanted me involved in the production," said Quincy Jones. "She trusted my

Alice Walker, author of the novel *The Color Purple*, at home in San Francisco in 1985.

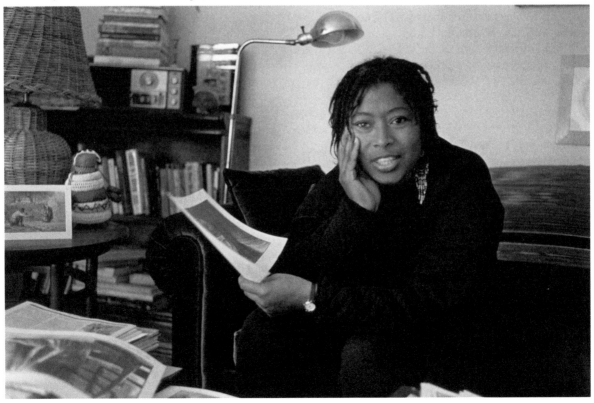

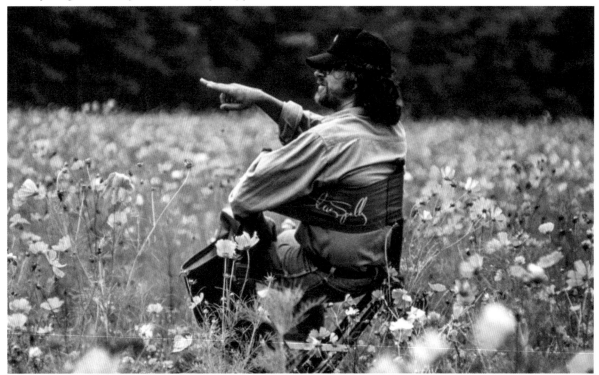

Steven Spielberg surrounded by flowers that were specially planted for the film.

creative input. So I asked Peter [Gruber] to let me run with the whole thing and I ran straight to Spielberg. Everybody thought I was nuts."[2]

Despite her role as a consultant, Alice Walker was still skeptical about the project. Spielberg himself was also concerned about signing on to direct. After all, what did he know about the conditions of Black people in the United States? But Quincy Jones did not want anyone else for the project, and he pointed out that Spielberg did not have to be an alien to make *E.T.*! In the end, the director not only accepted the project, but he also reduced his salary to the minimum required by the Directors Guild of America: forty thousand dollars.

The Color Purple Filmed in Black and White?

The writing of the screenplay was entrusted to Menno Meyjes, who worked on Spielberg's *Amazing Stories* series. *The Color Purple* was his first feature film. He was so concerned about receiving Alice Walker's approval that when she okayed his first draft, he became ill! Walker and Meyjes then worked together to refine the dialogue, helping the actors to restore the phrasing and vocabulary that was particular to the Black population of the rural South at the turn of the twentieth century. Walker also advised the costume designer and the set designers.

Spielberg called upon the services of a cinematographer who specialized in creating rich atmospheres, Gordon Willis, who had worked on the first two *Godfather* films (1972 and 1974). He even considered shooting in black and white, but he ended up finding it strange to remove the colors from a film called *The Color Purple*. In the end, Spielberg opted to work with his regular associate, Allen Daviau, who had served as director of photography on *Amblin'* and *E.T. the Extra-Terrestrial.*

CASTING

The vast majority of the actors appearing in *The Color Purple* were Black, which was (and is) a rare occurrence for a Hollywood film of this magnitude. Getting her start on the stage, Whoopi Goldberg made a name for herself with her one-woman show *The Spook Show* in 1983, which was later adapted for Broadway. She discovered the book after listening to Alice Walker reading *The Color Purple* on the radio. Goldberg immediately wrote to Alice Walker, enclosing a résumé and asking for a role if the book was ever adapted into a movie.

Two Stars in the Making

The writer had in fact already seen the actress perform, and she thought Whoopi was perfect for the character of Celie. She passed the word to Steven

Albert Johnson (Danny Glover) was a constant threat to Celie (played by Desreta Jackson in early scenes) and Nettie (Akosua Busia).

Spielberg. As an audition, he brought Whoopi Goldberg to his offices in Los Angeles and had her perform her show onstage in front of an audience, including Michael Jackson and Quincy Jones. The director was won over. He then convinced Goldberg that she could be Celie, because he could sense in her demeanor the strength and fighting spirit of the character.

In 1984, Oprah Winfrey was not the famous talk show host she is today. She hosted a morning show in Chicago, *AM Chicago*. Quincy Jones discovered her on television, and it was a revelation: She had to be Sofia. The host had an obsession with *The Color Purple* and she knew that an adaptation was in preparation. At first, she was disappointed to be contacted for a film called *Moonsong*, but when she saw the

text of her audition, she quickly understood what she was really auditioning for. After she read for the part, she spent two months without hearing any news. Convinced that she had failed, she tried to forget her disappointment, until she finally learned that she had been selected for the film. But beware, she was told: "If you lose a pound, you could lose the part."[3] Oprah Winfrey immediately stopped working out.

Casting Shug Avery

Actress and singer Margaret Avery had been pestering casting director Reuben Cannon to play Shug Avery, although Cannon dreamt of hiring Tina Turner for the part. For her part, Turner grew up in the South and had suffered through an abusive relationship with her husband Ike Turner; she

Casting the Villain...and a Guitarist

Danny Glover had not yet appeared in some of his most famous roles (*Silverado* by Lawrence Kasdan, in 1985; *Lethal Weapon* by Richard Donner, in 1987) when Steven Spielberg saw him in *Places in the Heart* (Robert Benton, 1984). The director did not want anyone else to interpret the loathsome character of Albert Johnson. The actor, he believed, would be able to show his character's awfulness, while also drawing a line between his own behavior and the way his father treated him.

After *Apocalypse Now* (Francis Ford Coppola, 1979), Laurence Fishburne's film career had begun to stagnate. Here he plays Swaim, the guitarist friend of Harpo (Albert's son). Renowned musicians Sonny Terry (blues harmonica), Greg Phillinganes (keyboards), and Roy Gaines (guitar) also make appearances.

had no desire to relive all that. Margaret Avery was called in and Steven Spielberg realized that she had played a singer in his 1972 TV movie *The Thing*. She was eventually cast as Shug Avery; however, in *The Color Purple*, her vocal performances are provided by Táta Vega.

Reuben Cannon suggested that Akosua Busia, a stage actress, audition for the role of Nettie. She discovered the novel, read it in one sitting, begged to be hired, and auditioned without having slept the night before. Although risky, her method worked and the part was hers.

FILMING AND PRODUCTION

Shooting took place during the summer of 1985. The first three weeks were devoted to filming interior scenes on sets built at Universal Studios. For the next eight weeks, the production had hoped to work on location in Georgia, but location scouting couldn't find anywhere suitable, and eventually

Childhood games became a source of respite and refuge for Nettie and Celie.

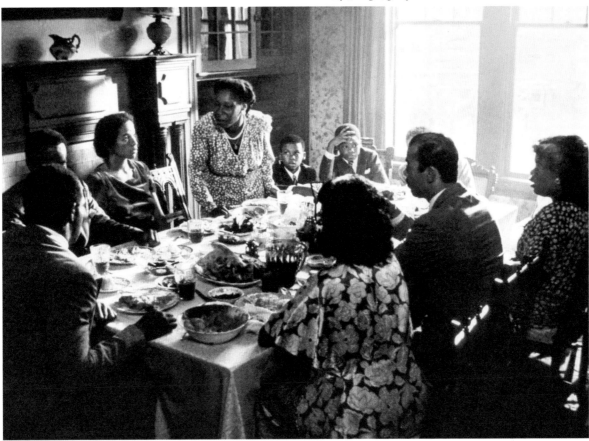

filming was moved to North Carolina, in rural towns east of Charlotte.

Flowers That Were Too Pink

The streets of Marshville, North Carolina, and a former cotton plantation in the vicinity of Wadesboro became the central locations for filming.

The set designers aged a house in town and planted tobacco, millet, and sunflowers. The local church was scheduled for demolition, so the production was able to dismantle it and reassemble it on the plantation. Harpo's bar and Celie's house were built from scratch. A field of purple flowers was also planted, but the color was a little too pink, so the set designers dyed the plants artificially for close-up shots. Toward the end of the shoot, the flowers were removed and fake snow was spread to film the winter scenes.

The weather is very changeable in the South, going from bright sunshine to clouds and thunderstorms in the same day. These vagaries complicated the work of cinematographer Allen Daviau, but they also enabled him to obtain a range of moods that, when edited, gives viewers a sense of the passage of time. The atmospheric dampness generated a diffuse light and pastel tones that some criticized in the film.

Bringing Words to Life

Many in Hollywood did not (and still do not) know how to properly film the faces of Black actors. As Allen Daviau explained: "It is easier to deal with dark faces against a mid-tone or darker background than it is against a light background. The lighting on the faces can be much more subtle, and it is an awful lot easier to keep control of your walls."[4] In addition to issues with lighting, Steven Spielberg also had a few tricky scenes to direct. Oprah Winfrey was terrified of not being up to the task, but she improvised her famous dinner tirade scene. Also, according to those who were there, the scene where Albert chased Nettie was excruciating to play. The director's only instruction to Akosua Busia on the day was to prevent Danny Glover from separating her from Whoopi Goldberg by any means. She cried, she clung, she screamed, "Why?" which was not in the script, while the actor actually pounded her hands with his fists.

The interior of Harpo's cabaret.

The Voice of Max Spielberg

The Color Purple was meant to be its director's first "adult" film. Coincidentally, while shooting the birth scene that opens the film, Spielberg's first son, Max, was born. Spielberg left the set and asked producer Frank Marshall to finish. He then recorded the cries of his own child and included them in the finished scene. In addition to this scene, Marshall also directed the shots in Kenya, which illustrate Nettie's letters sent to her sister from Rhodesia. By this time, editing on the film had already begun.

RECEPTION

One month before the release of *The Color Purple*, the Coalition Against Blaxploitation denounced the film and demonstrated in front of Quincy Jones's offices. Once the film was released, the association protested in front of the Motion Picture Academy in Los

Angeles while a screening took place for the Black Women's Forum. The National Association for the Advancement of Colored People (NAACP) expressed similar criticisms of the movie, deeming the portrayal of Black male characters to be, "very stereotypical."[5]

An Immediate Controversy

Among historians, columnists, and writers, the controversy over the film was immediate, but opinions were divided within the Black community. Women were much more accepting of the film than men.

On the other hand, film critics were generally not very kind. For many, the film was too beautifully shot to make sense for the story it told. Some denounced the movie's fairy-tale aesthetic and reproached Steven Spielberg for removing the lesbian attraction between Celie and Shug that existed in the novel. Critics also spoke out against the elimination of a character named

Squeak, and against the use of Harpo for a recurrent gag where he falls off a roof. The scenes set in Africa did not pass muster either: "[W]henever Spielberg has trouble interpreting the text, he slips into the trademark Raidersesque exoticism,"[6] the *Harvard Crimson* wrote. The *New York Times* found Quincy Jones's music intrusive and pointed out the film's tonal discontinuities. The *New Yorker*'s Pauline Kael, however, was the most ferocious: "Spielberg's *The Color Purple* is probably the least authentic in feeling of any of his full-length films."[7]

Eleven Oscar Nominations but No Wins

In spite of varied opinions among critics and audiences, the film was a success. At the end of 1985, it finished fourth in terms of overall tickets sold, coming in behind *Rocky IV* (Sylvester Stallone, 1985) but ahead of *Out of Africa* (Sydney Pollack, 1985). That year's Oscar ceremony triggered another controversy. The film was nominated in eleven categories, but not for Best Director, which was seen as a slight by some. The affront became even more difficult to ignore when *The Color Purple* did not win any statuettes at the ceremony. The NAACP, which had criticized the film, now accused the Academy of refusing to honor Black artists and of ignoring films about African Americans. Since its release, *The Color Purple* has been commented on, criticized, and occasionally reevaluated, but it remains controversial.

From Page to Screen to Stage... to Screen

In 2005, *The Color Purple* was adapted into a Broadway musical. Produced by Quincy Jones and Oprah Winfrey through her production company Harpo Productions (the name of a character in *The Color Purple*, and also Oprah in reverse), it was based on both the original book and the movie script. In 2022, a feature film adaptation of the musical was announced with Steven Spielberg tagged as a producer.

Oprah Winfrey at the Broadway premiere of *The Color Purple* in December 2005.

A STEVEN SPIELBERG Film

EMPIRE OF THE SUN

To survive in a world at war,
he must find a strength greater
than all the events that surround him.

WARNER BROS. Presents A STEVEN SPIELBERG Film "EMPIRE OF THE SUN" Starring JOHN MALKOVICH
MIRANDA RICHARDSON · NIGEL HAVERS and Introducing CHRISTIAN BALE
Music by JOHN WILLIAMS Director of Photography ALLEN DAVIAU, A.S.C. Executive Producer ROBERT SHAPIRO
Produced by STEVEN SPIELBERG · KATHLEEN KENNEDY · FRANK MARSHALL
Screenplay by TOM STOPPARD Based on the novel by J. G. BALLARD
Directed by STEVEN SPIELBERG

AMBLIN ENTERTAINMENT · DOLBY STEREO IN SELECTED THEATRES · READ THE POCKET BOOK · SOUNDTRACK AVAILABLE ON WARNER BROS. RECORDS, CASSETTES AND CD's · WARNER BROS A WARNER COMMUNICATIONS COMPANY © 1987 Warner Bros., Inc. All Rights Reserved ADVANCE 1 SHEET PRINTED IN U.S.A.

Empire of the Sun

United States 2 hrs 33 Color
(Technicolor) Stereo
(Dolby/6-Track) 1.85:1

Production Dates: March 1–June 20, 1987
United States Release Dates: December 9, 1987 (New York and Los Angeles);
December 25, 1987 (nationwide)

Worldwide Box Office: $66 million ($156.6 million in 2023 dollars)

Production Company: Amblin Entertainment, Warner Bros.
Producers: Steven Spielberg, Kathleen Kennedy, Frank Marshall
Associate Producer: Chris Kenny
Executive Producer: Robert Shapiro

Based on the novel of the same name by J. G. Ballard (1984)
Screenplay: Tom Stoppard
Director of Photography: Allen Daviau
Film Editing: Michael Kahn
Music: John Williams
Sound: Charles L. Campbell, Colin Charles, and Tony Dawe
Production Design: Norman Reynolds
Art Direction: Charles Bishop
Hair Stylist: Vera Mitchell
Makeup: Paul Engelen
Costume Design: Bob Ringwood
Special Effects: Kit West
Model Aircraft: Peter Aston
Lead Stuntman: Vic Armstrong
Second Unit Director: Frank Marshall
Casting: Maggie Cartier, Mike Fenton, Jane Feinberg,
Judy Taylor, and Yuriko Matsubara

Starring: Christian Bale (Jim Graham), John Malkovich (Basie),
Miranda Richardson (Mrs. Victor), Nigel Havers (Dr. Rawlins),
Joe Pantoliano (Frank Demarest), Leslie Phillips (Maxton),
Masatō Ibu (Sergeant Nagata), Emily Richard (Jim's mom),
Rupert Frazer (Jim's dad), Peter Gale (Mr. Victor),
Takatorō Kataoka (young kamikaze), Ben Stiller (Dainty)

> "The loveliest
> things in life [...]
> are but shadows;
> and they come
> and go and
> change and
> fade away [...]."
> ——
> —Charles Dickens, *Martin Chuzzlewit*
> (1844)

SYNOPSIS
———

In 1941, eleven-year-old Jim Graham is growing up in Shanghai as the only son of an English expat couple. He's shielded from the tensions of the country, which has been under Japanese occupation for four years. From his opulent home, the aviation-obsessed youngster dreams of flying as he watches the air raids. The day after the attack on Pearl Harbor, the Japanese army enters the city. The Grahams try to flee the country, but they're caught in the general panic and Jim loses sight of his parents. Left to his own devices, he returns home to find nobody waiting for him, and then he experiences a series of risky encounters before joining forces with an American sailor named Basie. Along with his sidekick, Frank, Basie is well versed in the ins and outs of trafficking and the black market. All three of them end up in the Soochow Creek internment camp in Longhua. Four years later, Jim has adapted and learned how to survive life in the camp. He's Basie's right-hand man, helps out Dr. Rawlins, and befriends a teenage Japanese trainee pilot.

A young Christian Bale played the role of Jim. To play opposite Bale during the audition process, Spielberg cast a then little-known Irish actor, Liam Neeson.

GENESIS

Sir David Lean's historic images played a decisive role in Steven Spielberg's ambitions for this movie. Spielberg had always been candid about the impact that *Bridge on the River Kwai* (1957) and *Lawrence of Arabia* (1962) had on him when he saw them in movie theaters as a kid, and the extent to which they had influenced his filmmaking. It seemed inevitable that his path would cross with that of the English maestro one day.

From Maestro to Disciple

When *Duel* was released, David Lean expressed his admiration for Spielberg's direction. When Spielberg invited his idol onto the set of *Amazing Stories*, his mind was already on his next production. Lean, who had taken a break from directing for thirteen years after the bitter flop of *Ryan's Daughter* (1970), had finished *A Passage to India* (1984) and, approaching the age of eighty, seemed determined to get back in the saddle—why not with his younger admirer? Lean was interested in adapting J. G. Ballard's 1984 novel *Empire of the Sun*, so Spielberg approached Warner Bros., who held the movie rights. The plan had been for the book to be adapted by Harold Becker (*Taps*, 1981) into a screenplay with playwright Tom Stoppard, but the Spielberg/Lean partnership changed everything, particularly because Spielberg

had just filmed *The Color Purple* for the studio and was now on extremely good terms with Steve Ross, the flamboyant CEO, whom he saw as a new father figure. So, David Lean embarked on his own project, which he abandoned after a year because he couldn't find a suitable "dramatic form."[1] On his recommendation, Spielberg took over the role of director, confessing "From the moment I read the novel, I secretly wanted to do it myself."[2]

War Through the Eyes of a Young Boy

J. G. Ballard's semi-autobiographical story is based on his memory of being a young British adolescent whose privileged childhood in the British enclave of Shanghai was turned completely upside down by World War II, when he was interned with his family in a prisoner-of-war camp. "Many of the adventures that Jim goes through are invented. But I think his psychology is very true to mine."[3] As for Jim, in the film he survives alone, without his parents. He faces death, famine, and illness, and discovers solitude as well as the cruelty and violence of man, but gets excited at the sight of a pilot or an air raid, be it Japanese or American. Spielberg was evidently drawn to the horrors of war seen through the impartial, at times helpless, at times mesmerized eyes of a young boy.

A Personal Story

In *1941* Spielberg articulated his fascination with aviation and WWII, during which his father, Arnold, fought in the US Air Force, but his handling of the topic was farcical and didn't quite sit well with audiences. With *Empire of the Sun*, Spielberg was aiming for a more serious register, as he had done in *The Color Purple*. "Hitting forty, I really had to come to terms with what I've been tenaciously clinging to, which was a celebration of a kind of naïveté that has been reconfirmed countless times in the amount of people who have gone to see *E.T.*, *Back to the Future* and *Goonies*. [...] I thought *Empire* was a great way of performing an exorcism on that period."[4] In addition, there was a historical connection between his family story and that of J. G. Ballard. In 1897, to flee the persecution of the Jews in their native Russia and Ukraine, some of Spielberg's ancestors on the side of his paternal grandmother, Rebecca Chechik Spielberg, emigrated to Shanghai.

Dickensian Influences

Having commissioned *The Color Purple* screenplay writer Menno Meyjes to rework the script, Spielberg called Tom Stoppard back in to add the finishing touches. Stoppard, the son of an Ashkenazi Jewish family from Czechoslovakia who fled the Nazis, had spent some of his youth in Singapore during the Japanese occupation. The two men became firm friends and their differing sensibilities—one cerebral, one sentimental—helped illuminate and create the exceptional beauty of the movie. One of the challenges they faced was how to condense the second half of the book (which took place at Longhua internment camp) and its plethora of characters. Spielberg focused on the relationship between Jim and Basie, the American sailor the young boy latched onto as a kind of makeshift father figure. He erased some of the book's underlying sexual ambiguity between Basie and his sidekick Frank, but retained the troubling scene where Jim catches a glimpse of the tired

Drama during the exodus: Jim's mom (Emily Richard) is carried off by the crowd and separated from her son (Christian Bale, in the background).

"Jim was delighted that the Mustangs were so close" even though the camp was bombarded, wrote J. G. Ballard in his novel.

embrace of the Victors, a couple who share his dorm, while American bombs rain down in the distance. He accentuated the Dickensian characteristics of Basie, who is to Jim what Fagin was to Oliver Twist: a crooked mentor who exploits and corrupts him but teaches him the law of the jungle. This brings Spielberg's affiliation with David Lean full circle, since Lean was also influenced by Dickens: He adapted *Great Expectations* (1946) and *Oliver Twist* (1948).

DISTRIBUTION

It took the casting team nine months to find the right young actor who was to play Jim. Thirteen-year-old Christian Bale stood out among more than four thousand hopefuls who auditioned.

Christian Bale: A Rising Star

"A little Steve McQueen, this kid!"[5] Spielberg exclaimed as he watched in admiration while Bale crawled about in the mud during a scene. Many of their exchanges on set appear in the documentary *The China Odyssey*: Spielberg is pensive but all smiles, seemingly proud to project himself onto the young actor, as he closely observes his every expression and astonishing calm. For his part, Bale was no novice. He'd had already acted alongside Rowan "Mr. Bean" Atkinson in *The

A Landmark Movie

Would Steven Spielberg have tackled *Schindler's List* if he hadn't made this film first? Aside from their common themes (WWII, life in a concentration camp, finding hope in the midst of horror), *Empire of the Sun* was Spielberg's first mature historical drama.

Nerd (1984) and appeared in the miniseries *Anastasia* (1986) with Amy Irving, Spielberg's wife, and Omar Sharif (who had appeared in David Lean's famous adaption of *Doctor Zhivago*). His acting in *Empire of the Sun* is unforgettable because it's so difficult to define. Somewhere between dreamy determination and fiery despair, the resilience of the child and the anger of the adolescent, Bale's Jim never seeks to be loved, unless for his own ends. "The curious thing is that Christian does look like the little boy I was,"[6] J. G. Ballard remarked.

Jim (Christian Bale) reaches out to touch his childhood dream as the struggle for survival and the violence of war stand in his way.

The Walking Dead

John Malkovich, who played Basie, was still fairly unknown at the time of filming. He'd just completed *The Killing Fields* (Roland Joffé, 1984) and *Places in the Heart* (Robert Benton, 1984), for which he was nominated for a Best Supporting Actor Oscar. Simultaneously repulsive and elusive in his appearance opposite Christian Bale, Malkovich didn't yet have the magnetism that would earn him such high acclaim one year later, in his role as Valmont in Stephen Frears's *Dangerous Liaisons*. Among the actors cast as American good-for-nothings who hang with Basie were Joe Pantoliano, who became an acclaimed supporting actor (*The Matrix*, Lana Wachowski and Lilly Wachowski, 1999), and Ben Stiller, in one of his first appearances in a major motion picture. Around Christian Bale, the adults appeared as fleeting presences, the walking dead: British actor Nigel Havers (*Chariots of Fire*, Hugh Hudson, 1981) appeared as the doctor, and Miranda Richardson (*The Crying Game*, Neil Jordan, 1992) was cast in the almost silent role of the deathly pale Mrs. Victor. There are no heroes and no heroism in this film—the only glimmers of life in *Empire of the Sun* come from a small, awkward English boy who loses his childhood illusions, and his Japanese alter ego (the young kamikaze pilot played by Takatarō Kataoka), who was destined for an early grave.

FILMING AND PRODUCTION

Producers Frank Marshall and Kathleen Kennedy were unable to find an alternative to filming in Shanghai, so they approached the Chinese government. Bolstered by Spielberg's popularity and the theme of the movie (the Chinese were not ready to forget the trauma of the war with Japan), intense negotiations ensued, and an agreement was eventually reached. The marketing campaign would sell *Empire of the Sun* as the first Western production filmed in the People's Republic of China—failing to mention Bernardo Bertolucci's *The Last Emperor*, which was filmed several months ahead of *Empire of the Sun*.

Twenty-One Days in Shanghai

The crew had three weeks in Shanghai, and local extras and police security were provided by the China Film Corporation, the country's official movie organization. Rickshaws were banned at the time because they had been considered a symbol of capitalist oppression by Mao Zedong, so production had around a hundred rickshaws manufactured. Several Boeing 747s were chartered to transport them all to

China, along with tanks and period cars that would be used during filming. Once he was on location, Spielberg took advantage of the remains of European architecture left behind from previous international exploits in the country. His team began filming on the Bund, a riverfront historical area, on March 1, 1987. In the space of one day, the crew obtained permission to close off seven housing blocks to film the scenes of panic and gunfire that ensued after the invasion of the Japanese army and the flight of the Westerners. Ten thousand extras were dressed in period costume, many recruited from the Chinese army, and they created an impressive crowd surge in these pivotal scenes. Among them, several bodyguards were given the job of protecting the actors if things got out of hand. Spielberg's inner sense of epic scope did the rest. "He told me that he had first drawn all the plans and that at the last minute, he had imagined something else. [...] Who else can do that?"[7] his friend and colleague Martin Scorsese said with admiration in an interview with *Cahiers du Cinéma*. But it didn't all go smoothly. While filming the scene where Jim is separated from his parents, actress Emily Richard (who played Jim's mother) was carried along by the crowd and thrown to the ground during one of the takes. Not only that, but also the production was hit with a

$13,500 fine for pollution after setting fire to piles of tires to fill the scenes with smoke.

Model Aircraft

After passing through Los Angeles for the Oscars ceremony, where he received the prestigious Irving G.

A Friend with Benefits

Spielberg's encounter with the playwright Tom Stoppard on *Empire of the Sun* gave rise to a collaboration that was both unexpected and low-key: The author of *Rosencrantz and Guildenstern Are Dead* (both the 1966 play and the 1990 film) was for several years the designated script doctor of Amblin Entertainment and would even pen an adaptation of *Hook*. Spielberg's friendship with Stoppard and, later, Tony Kushner, opened his eyes to new levels of screenwriting and marked his progression as an artist.

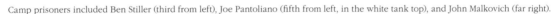

Camp prisoners included Ben Stiller (third from left), Joe Pantoliano (fifth from left, in the white tank top), and John Malkovich (far right).

Thalberg Memorial Award, which is given to "creative producers whose bodies of work reflect a consistently high quality of motion picture production,"[8] Spielberg rejoined his team at Elstree Studios in England. This is where they filmed the indoor scenes that took place at the Grahams' home, the outdoor shots of the British sector of Shanghai (J. G. Ballard makes an appearance at the costume ball), and the final bombardment of the city.

Next, he headed to a place near Trebujena, Spain, where production designer Norman Reynolds had had a prisoner-of-war camp built on a piece of land bordering the Guadalquivir marshes. Although torrential rain and an invasion

FOR SPIELBERG ADDICTS

After taking over for David Lean, Steven Spielberg launched and co-financed a restoration of *Lawrence of Arabia*, which was released in 1989. He also embarked on a production of *Nostromo*, an adaptation of Joseph Conrad's novel to which Lean was attached. But a combination of the old maestro's failing health, the scope of his ambition, and his unwillingness to accept Spielberg's many suggestions led Spielberg to withdraw from the project. *Nostromo* would never see the light of day because Lean died at the age of eighty-three in April 1991, a few weeks before filming was due to begin.

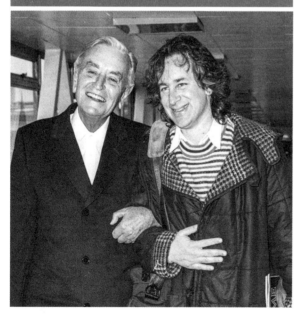

David Lean and Steven Spielberg at Heathrow airport in March 1985.

of mosquitoes held up construction for five weeks and hurt the final budget, Spielberg finished filming slightly ahead of schedule. So, Andalusian sunsets mimicked those of the Middle Kingdom in the shots of Jim being blinded by the planes flying over the camp; a Japanese kamikaze Mitsubishi A6M "Zero" here, a US Air Force P-51 Mustang (nicknamed "Cadillac of the Sky") there. Some were real (costing $500,000 each at the time), but most were remote-controlled small-scale models (one-third the size) with moped engines.

RECEPTION

J. G. Ballard loved the movie and played an active part in the film's marketing campaign. The

After escaping from a costume ball, a little English boy comes face-to-face with a Japanese army battalion.

press reaction, on the other hand, was lukewarm and fairly baffling, showing a preference for John Boorman's *Hope and Glory,* which was released at the same time and was also about children living during war.

Innocence Lost

Some leading critics did, however, see *Empire of the Sun* as a major leap forward for Spielberg. It was described as "unforgettable" by Janet Maslin in the *New York Times,*[9] and Andrew Sarris of the *Village Voice* called it the best movie of the year. The impressive tone of this epic production was always honed in the service of following Jim's personal journey, and it was achieved via the powerful symbolism of the film's images, which are evidence that Spielberg must have assimilated some of David Lean's cinematic style. But all this did not garner favor with the American public, who were seemingly disconcerted by the realistic war drama that displayed a bitter lyricism they hadn't really expected from the director of *E.T.* This was "a movie with grown up themes and values, although spoken through a voice that hadn't changed through puberty as yet,"[10] and it remains one of Spielberg's biggest box-office flops.

Empire of the Sun
Hallucinatory Sequence

There's a sequence in *Empire of the Sun* that's one of the most devastating Spielberg has ever shot. The arid, lyrical hallucinatory effect was created by a series of cross-fades that give it the trappings of a (bad) dream, and the sickly sentimentality that follows is not without fault. It occurs after the liberation of the camp where Jim and dozens of Westerners had been held. Spielberg films them fleeing in the style of a biblical exodus, a diaspora (1 and 3). Distraught, his face waxen (2), Jim reaches the riverbank to throw his suitcase into the water, and with it, his innocence is swept away by the current (4). Against the light, the child is nothing more than a shadow, his silhouette merging with those of the vagrant adults (5). His overlarge shoes, taken from a corpse, underline this early death (6). The abandoned stadium where the escapees take refuge is piled with precious belongings stolen by the Japanese army—Biedermeier furniture, cars, crystalware, etc.—a surreal vision of the wealth of a civilization in an old set that relegates them to a distant past (7 and 8). Jim makes his way through this strange cemetery, passing close to a piano a woman is playing. The notes ring loud, bringing back memories of his mother, who (like Spielberg's) played the piano in the family living room. In the morning he discovers a lifeless Mrs. Victor among the inert objects (9 and 10). When an intense light floods the sky and lights up his face, an almost delirious Jim sees it as a mystical sign: Mrs. Victor's spirit passing over into the afterlife (11 and 12). It's only when he returns to the sad reality of the men that he realizes this flash of divine light has come from the atomic bomb that has just hit Nagasaki.

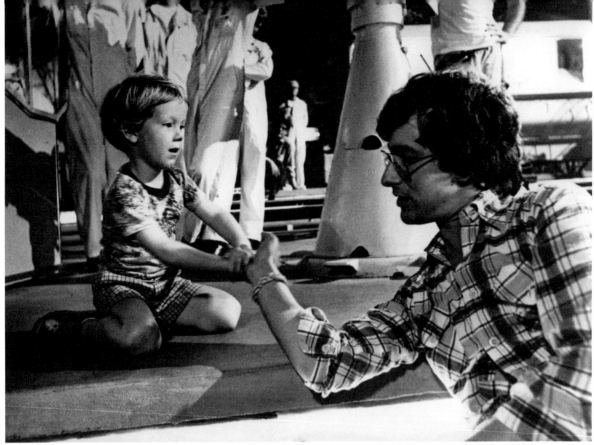

Cary Guffey was only four years old when he roamed the set of *Close Encounters of the Third Kind*.

Where Are They Now?
Spielberg's Child Actors

From *Close Encounters of the Third Kind* to *The BFG*, children are part of the Spielberg legend. Many talk of the great lengths he went to in order to look after his young actors—especially his constant ability to arouse their genuine emotions, which were never faked and which helped his films capture the public's heart. Cary Guffey was the first of many in a great tradition of children in Spielberg's movies. Before him, there had of course been fleeting appearances—the infant Harrison Zanuck in *Sugarland Express*, or children as shark food in *Jaws*—but it all began with a little blond kid scarcely four years old, taking tentative steps onto the set of *Close Encounters of the Third Kind* while trying hard to hit his mark and not look directly into the camera. Off camera, when the lights went out and the markers disappeared, it was Spielberg who guided

and looked after him. Some of these young actors have tried to pursue careers in acting, with varying degrees of success. Others have thrown in the towel to follow new dreams. Here are updates on some of Spielberg's most memorable child actors:

Cary Guffey (Barry Guiler in *Close Encounters of the Third Kind*)

Little Cary was seven when he returned to the cinema in 1979 alongside Bud Spencer, this time as an extra-terrestrial in Michele Lupo's Italian comedy *The Sheriff and the Satellite Kid*. He was also in the sequel, *Everything Happens to Me,* the following year. His short career ended five years later after *North and South* (Richard T. Heffron), a miniseries about the American Civil War. Little Cary then focused on his studies and he now works in finance.

Henry Thomas (Elliott in *E.T.*)

At the age of eleven, Henry Thomas shot to global stardom, which he didn't find easy to handle. After the film, the preteen kept a low profile, preferring to quietly appear in smaller movies. There were many that didn't cause much of a stir, but *Misunderstood* (Jerry Schatzberg, 1984) and *Valmont* (Milos Forman, 1989) were exceptions. As an adult, Thomas persevered in second, sometimes third, supporting roles on both the big screen (*Gangs of New York*, Martin Scorsese, 2002) and the small screen, with numerous appearances on TV (*The Experts*, *FBI: Most Wanted*,...). Since the late 2000s, the actor has appeared most notably in a spate of horror productions, primarily via regular collaborations with director Mike Flanagan (*Doctor Sleep* in 2019, *The Haunting of Bly Manor* in 2020).

Drew Barrymore (Gertie in *E.T.*)

After *E.T.*, everything moved fast for the young Hollywood scion. An alcoholic at the age of nine and cocaine addict at twelve, the young girl's youth consisted of an endless round of parties. Her teenage years were punctuated by rehab, suicide attempts, and stints in psychiatric hospitals. At the age of fifteen she published her autobiography, in which she exposed every detail of her descent into addiction hell. Her road to redemption came via financial independence (at the age of fourteen she distanced herself from her possessive mother) and work; she took on more and more roles and (slowly) got back on the straight and narrow. With roles in many different kinds of movies—*Batman Forever* (Joel Schumacher, 1995), *Scream* (Wes Craven, 1996)—she showed the movie world that she was back. Since then, she's been juggling her career as an actress (with a fondness for romantic comedies) with her roles as producer, director, and talk show host.

Christian Bale (James "Jim" Graham in *Empire of the Sun*)

Bale has won an Oscar (for *The Fighter*, by David O. Russell, 2010), two Golden Globes, and two Screen Actors Guild Awards. Christian Bale has marked his career with strong roles and exacting performances. From a Victorian scalawag (*The Portrait of a Lady*, Jane Campion, 1996) to a deranged New York yuppie (*American Psycho*, Mary Harron, 2000), not to mention glam bodysuits (*Velvet Goldmine*, Todd

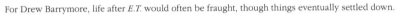

For Drew Barrymore, life after *E.T.* would often be fraught, though things eventually settled down.

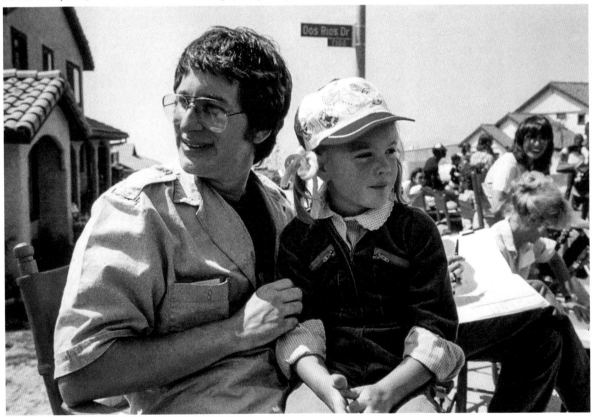

Christian Bale and Steven Spielberg on the set of *Empire of the Sun*.

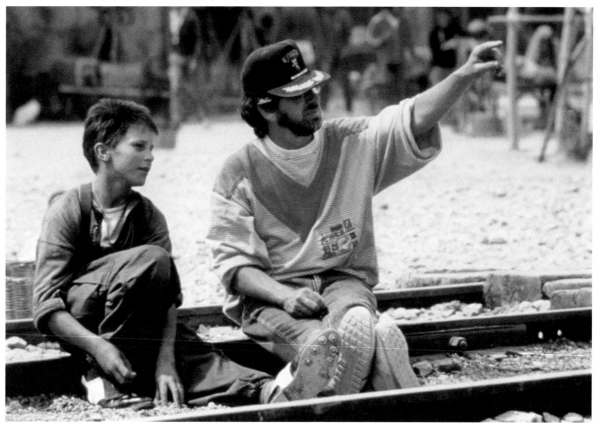

Haynes, 1998), he can carry off any look. Acting is as natural as breathing for the adult Christian Bale, who lost nearly sixty-two pounds in three months for *The Machinist* (Brad Anderson, 2004) just as easily as he gained forty-five to take on the role of Dick Cheney in *Vice* (Adam McKay, 2018). He may be a physical actor, but his talents don't stop there. His Batman is one of the most moving ever filmed (*The Dark Knight* trilogy, from 2005 to 2012) and his stubborn racing car driver in *Ford v Ferrari* (James Mangold, 2019) is both exasperating and funny. In *The Big Short* (Adam McKay, 2015), he types on his computer keyboard as if his life depended on every stroke. In other words, he's an intense actor.

Charlie Korsmo (Jack Banning in *Hook*)

Although it was his sixth movie, *Hook* marked the end of an era for the thirteen-year-old Korsmo. In fact, he wasn't seen on the screen again until 1998 in the teen comedy *Can't Hardly Wait* by Deborah Kaplan and Harry Elfont. In the meantime, Charles discovered a passion for studying. He graduated from the Massachusetts Institute of Technology (MIT) in 2000,

went into politics, and then obtained a doctor of law from Yale in 2006. He went on to work in a number of law firms before taking a job teaching business law at Case Western Reserve University in Cleveland.

Joseph Mazzello (Tim Murphy in *Jurassic Park*)

Spielberg made Mazzello a promise. Having been unsuccessful in the *Hook* auditions, Joseph Mazzello would get a second chance, and that opportunity was *Jurassic Park*. After Jurassic Park was released, many other roles would follow, including in *Shadowlands* (1993), which was directed by his *Jurassic Park* co-star, Sir Richard Attenborough. After garnering acclaim for his appearance in *The Lost World: Jurassic Park*, he went on to study at the USC School of Cinematic Arts, backed by a letter of recommendation from Spielberg himself. Since then, he's been spotted in a number of series (*The Pacific*, produced by Spielberg) and movies, including David Fincher's *The Social Network* (2010) and Bryan Singer's *Bohemian Rhapsody* (2018), in which he plays bassist John Deacon.

Ariana Richards (Lex Murphy in *Jurassic Park*)

The blond teen made a comeback in *The Lost World: Jurassic Park*, but her career didn't really survive a second dinosaur attack. After roles in B horror and fantasy series, she began to study art. She now has a career as an artist, carrying on a family tradition that includes Carlo Crivelli, a master of the Italian Renaissance.

Celine Buckens (Emilie in *War Horse*)

War Horse was not the last time the Belgian youngster came into contact with horses. Between 2017 and 2019, she was part of the cast of *Free Rein*, a three-season equine series in which teens shared their passion for the animals. With the horses finally back in the stables, she won a recurring role in the second season of *Warrior* in 2020, which she followed up with the British series *Showtrial* in 2021. That same year, she wrote and directed her first short film, *Prangover*.

On the set of *The BFG*, Steven Spielberg was instrumental in launching the career of newcomer Ruby Barnhill.

Indiana Jones and the Last Crusade

United States **2 hrs 7** **Color** **Stereo** **2.35:1**

(DeLuxe) (Dolby SR/6-Track)

Production Dates: May 16–September 30, 1988
United States Release Date: May 24, 1989

Worldwide Box Office: $474 million ($1.13 billion in 2023 dollars)

Production Company: Lucasfilm, Paramount Pictures
Producer: Robert Watts
Associate Producer: Arthur Repola
Executive Producers: George Lucas, Frank Marshall

Based on a story by George Lucas and Menno Meyjes
Screenplay: Jeffrey Boam
Director of Photography: Douglas Slocombe
Film Editing: Michael Kahn
Music: John Williams
Sound: Richard Hymns
Sound Effects: Ben Burtt
Production Design: Elliot Scott
Art Direction: Stephen Scott
Makeup: Peter Robb-King
Costume Design: Anthony Powell, Joanna Johnston
Special Effects: Michael Lantieri
Mechanical Special Effects: George Gibbs
Visual Special Effects: Michael J. McAlister
Lead Stuntman: Vic Armstrong
Second Unit Directors: Michael D. Moore, Frank Marshall

Starring: Harrison Ford (Indiana Jones), Sean Connery (Henry Jones),
Denholm Elliott (Marcus Brody), Alison Doody (Elsa Schneider), John Rhys-
Davies (Sallah), Julian Glover (Walter Donovan), River Phoenix (young Indiana
Jones), Michael Byrne (Vogel), Kevork Malikyan (Kazim),
Robert Eddison (Grail Knight), Richard Young
(Fedora), Vernon Dobtcheff (the butler)

"I wasn't happy with the second film at all. It was too dark, too subterranean, and much too horrific."[1]

—Steven Spielberg

SYNOPSIS

In 1912 Utah, a Boy Scout on a horseback ride with his troop distances himself from the group to spy on tomb raiders who've gotten their hands on a precious relic, the Cross of Coronado, which he steals from them. Following a pursuit on horseback, then on circus train, the leader of the group of raiders gives the teen his hat in recognition of his courage. The hat is a fedora, and twenty-six years later, Indiana Jones appears wearing it on a boat in the height of a storm, still at loggerheads with some brutes in possession of the famous cross. Back among his students at university, Indiana Jones is approached by Walter Donovan, an art collector, who asks if Indy can get hold of the Holy Grail before giving him his father's notebook. Indiana's father had been chasing the Holy Chalice before being taken prisoner by the Nazis. In a quest to find the Holy Grail and his father, Indiana arrives in Venice with his associate, museum curator Marcus Brody, and together they meet Professor Elsa Schneider, who is waiting for them...

GENESIS

Disappointed at the critical disinterest in *The Color Purple* and the commercial flop of *Empire of the Sun*, Steven Spielberg decided to press pause on his "adult" ambitions. The obvious move was for him to fall back on what he knew he could do, so he made an Indiana Jones movie. Since *Indiana Jones and the Temple of Doom*, which was disliked by the public and even more so by himself, the saga had left a bitter taste in his mouth.

Script After Script

George Lucas had several topics in mind. Keen on the concept of the haunted Scottish castle, already rejected for the previous episode, he commissioned a screenplay from scriptwriter Diane Thomas, who penned *Romancing the Stone* (Robert Zemeckis, 1984) before her fatal accident in 1985. But Spielberg rejected it once again. Lucas had another bee in his bonnet. He was obsessed with the quest for the Holy Grail, which legend links to the cup Christ drank from at the last supper and which was also supposedly used to collect his blood at the crucifixion. This idea didn't find favor with Spielberg either and was rejected because of the overly esoteric biblical

reference, which, incidentally, had closer connections to Christianity than the Ark of the Covenant of *Raiders of the Lost Ark*, an important symbol in Judaism.

These angles were dismissed and a script was commissioned from Christopher Columbus, an Amblin protegé who had written the screenplays for *Gremlins* and *The Goonies*. He brought in the Chinese legend of the half-man/half-primate Monkey King. Although this encapsulated the spirit of the first film in the franchise, Spielberg and Lucas weren't comfortable with the context after the severe criticism they'd received for their depiction of Indian culture in *The Temple of Doom*. So it was decided they'd revert to the most universal bad guys of them all: Nazis.

Holy Grail, Blasted Father!

Straightaway, Lucas put the Holy Grail back on the table, giving it the power of immortality. Anyone who drank from the Holy Chalice was rewarded with eternal life. Spielberg associated the object with the lunacy of *Monty Python and the Holy Grail* (Terry Gilliam and Terry Jones, 1975), so he needed more convincing and sought another layer of interpretation that felt

Spielberg with Harrison Ford and Sean Connery.

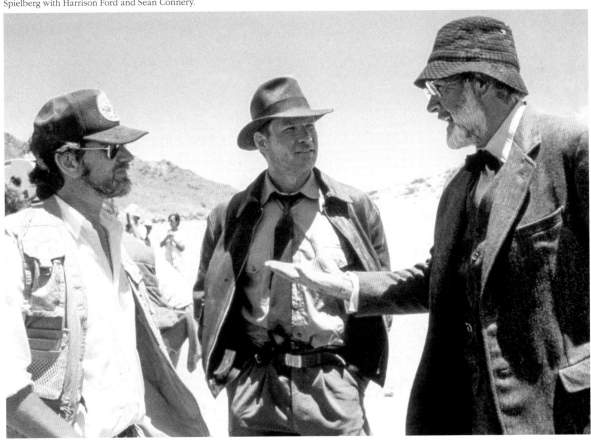

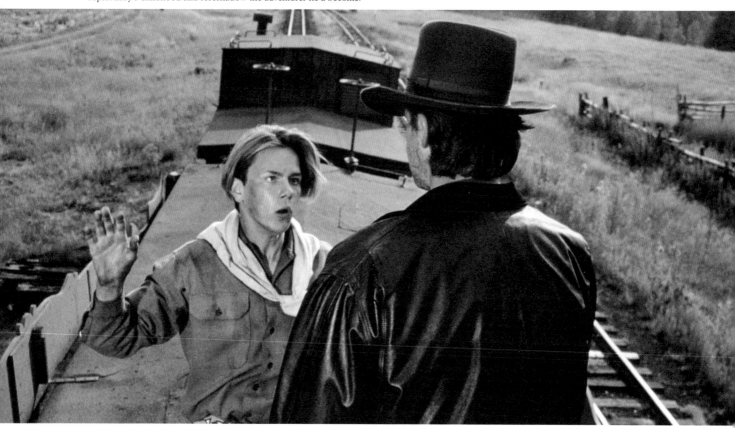
Young Indiana Jones (River Phoenix) in the film's opening moments, which depict Indy's childhood and foreshadow the adventurer he'd become.

more akin to him and his hero, and thus his audience. It all fell into place when Indiana Jones's father came into the picture. The film was given the seal of approval, but they couldn't agree on who should write the script. The quest for the Holy Grail, tied into the search for the father, Professor Henry Jones—also an archaeologist, and a workaholic whose obsession with his career had damaged his relationship with his son—now, Spielberg *did* like that idea! It was all the more appealing because he himself had gotten closer to his progenitor after eleven years of estrangement— the time it took for him to discover that his parents' divorce and the departure of his father, Arnold, whom he'd never forgiven, had been the result of an affair between his mother and the family's best friend. The reunion of Henry and Indiana is therefore a metaphor for Arnold and Steven's reconciliation. What's more, the fact that in getting his hands on the Holy Grail, Indiana had succeeded in doing what his father had failed to do—and that, with the help of the grail's supernatural powers, Indiana had rescued Henry from the throes of death—tied in with mythologist Joseph Campbell's theory of the hero figure. Campbell developed his so-called monomyth concept in the book *The Hero with a Thousand Faces* (1949), which George Lucas used as one of his writing models. This is also where he found inspiration for the relationship between Darth Vader and Luke Skywalker in the *Star Wars* saga.

A Playwright Comes to the Rescue

Script drafts arrived one after another, first from Menno Meyjes (*The Color Purple*, 1985), then from Jeffrey Boam (*Innerspace*, Joe Dante, 1987). Spielberg called upon his friend and *Empire of the Sun* scriptwriter, the playwright Tom Stoppard (uncredited), to add a final polish. His contribution proved vital; he cut out superfluous elements and scenes and changed the character of Kazim from a crook at the beck and call of the Nazis to a member of the Brotherhood of the Cruciform Sword, protector of the Holy Grail. He also added rhythm to the story and sharpened the gags and dialogues, specifically the exchanges between Indiana and his father, which were particularly important to Spielberg. These are standout moments in the movie. They portray with humor the relationship between the two (the father plays down everything his son does and insists on calling him "Junior," much to Indiana's annoyance), but are also at times emotionally charged (when the deceased wife and mother is mentioned at the end of the sidecar

chase, or when Henry finally calls his son "Indiana" to save him from death when the temple collapses). In fact, Indiana's name is not Indiana at all: Jones is named Henry like his father, but took the name of his beloved dog, Indiana, as his own.

Back to Their Roots

In the plethora of things left unsaid, and the bonds of familial affection, we find a father and son duo that has a Howard Hawks–like feeling to it, which was already present in *Raiders of the Lost Ark*. This marks a return to their roots, further confirmed by the presence of Indy's two sidekicks: the nonexistent Sallah (John Rhys-Davies) and Marcus Brody (Denholm Elliott), whose comical senility isn't one of the most inspired moments of the movie, unlike the opening sequence. Mimicking a Western pastiche, the opening scene was initially intended as a simple action scene that would be unrelated to the plot—the epilogue of the previous Indiana Jones adventure, in fact. As a result, the opening moments of the film were shot as an homage to John Ford, and the scene takes place in the beloved, arid landscapes of Utah that appear in many of Ford's most famous films, coupled with Indiana's backstory of having been captured as a teen when he wandered

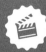
off from his Boy Scout camp to challenge a band of mercenaries who'd uncovered a historical treasure. In ten minutes flat we're told not only about Indy's early vocation, but also about the origins of his uniform (leather jacket and fedora), his favorite weapon (the whip), the scar on his chin, his fear of snakes, his mantra ("This piece belongs in a museum"), and his relationship with his father. The latter appears off camera as a ghostlike figure engrossed in his books, present but absent, and heralding the spectacular entrance of Sean Connery thirty minutes later.

The Last Crusade features the most universal bad guys there are: the Nazis.

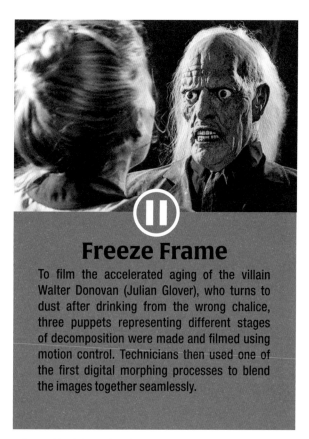

⏸ Freeze Frame

To film the accelerated aging of the villain Walter Donovan (Julian Glover), who turns to dust after drinking from the wrong chalice, three puppets representing different stages of decomposition were made and filmed using motion control. Technicians then used one of the first digital morphing processes to blend the images together seamlessly.

DISTRIBUTION

The stroke of genius of *The Last Crusade* was casting the legendary James Bond actor Sean Connery as Indiana Jones's father. Having based their archaeologist hero on the most famous spy in Her Majesty's Secret Service, Lucas and Spielberg had come full circle.

His Name Is Jones, Henry Jones

Spielberg rejected Lucas's suggestion of casting Gregory Peck or the Shakespearean actor John Houseman. For Steven, Sean Connery was Henry Jones and too bad if there was only a twelve-year age difference between him and Harrison Ford. What's more, at the time, Connery's popularity was growing thanks to the success of *The Name of the Rose* (Jean-Jacques Annaud, 1986) and *The Untouchables* (Brian De Palma, 1987), which had just earned him an Oscar for Best Supporting Actor. After his initial enthusiasm, Connery became disillusioned when he read the script because he didn't appear until page seventy and he wasn't particularly enamored by the character's sage-like wisdom, which reminded him of Yoda from *Star Wars*. Tom Stoppard's intervention changed things, and Connery also made his own suggestions. He based the character on Richard F. Burton, an iconic explorer of the Victorian era, added in some little

Indy saved his father's life earlier in the film, and now it's the father's turn to save his son from the temptation of the Holy Grail.

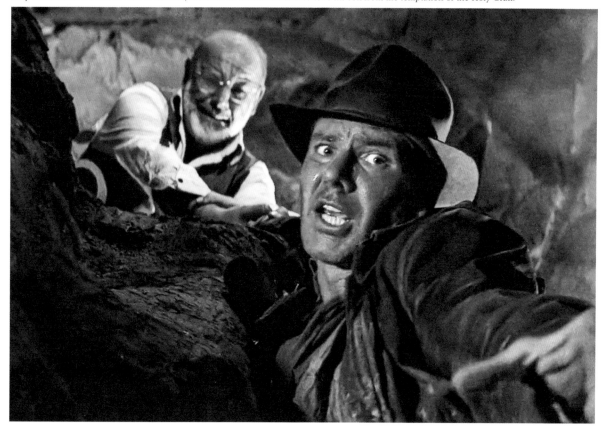

eccentricities, and supported Jeffrey Boam's idea of having father and son discover that they've both slept with Elsa Schneider. Despite reticence on the part of the prudish Spielberg, the oedipal rivalry spiced up the movie and also provided its best one-liner when Harrison Ford/Indiana Jones asks Connery how he knew that Elsa was a Nazi and, off the cuff, Connery replies, "She talks in her sleep."

A Short-Lived Career
The film has another link with the world of 007 in the form of the actress who plays Elsa Schneider, Alison Doody. The twenty-one-year-old Irish model had just appeared as a secondary Bond girl (answering to the name of Jenny Flex) in *A View to a Kill* (John Glen, 1985) when she auditioned to take over from Karen Allen and Kate Capshaw. The role of this cold, "Hitchcock blonde" Austrian art historian currying favor with the Nazis was the peak of a rather sparse career, other highlights including her stint along-side Patrick Swayze in the miniseries *King Solomon's Mines*, a lowbrow take on the Indiana Jones movies.

From James Bond to James Dean
To play the adolescent Indiana Jones in the pro-logue, Harrison Ford suggested River Phoenix, who'd recently appeared as his son in the wonderful film *The Mosquito Coast* (Peter Weir, 1986). Just like the casting of Sean Connery, the young actor was a nat-ural choice for Spielberg. At the age of seventeen, Phoenix was already an acclaimed actor and had

become a teen idol thanks to his roles in Rob Reiner's *Stand by Me* (1986) and Sidney Lumet's *Running on Empty* (1988). The producers even felt the need to cir-culate a false rumor about the up-and-coming star's moral character to dispel any hope among his fans that Phoenix might eventually take over the role from Harrison Ford. Nobody knew then that he would become the James Dean of his generation when he died of an overdose five years later.

FILMING AND PRODUCTION
Producing *The Last Crusade* meant Spielberg had to abandon *Rain Man*, a project he'd been working on for several months with Dustin Hoffman and Tom Cruise (Barry Levinson would take it over). This must have burned, since *Rain Man* won big at the 1989 Oscars and could have earned Spielberg the statuette that he still had yet to receive. By opting for the crowd-pleaser over a drama about the rela-tionship between an arrogant yuppie and his autistic brother, Spielberg was clearly looking to garner favor at the box office after a pair of box-office disappoint-ments. Luckily, he was about to have one of his most enjoyable filming experiences.

White Doves and Sewer Rats
When the loyal *Indiana Jones* crew got together to start shooting in Almería, Spain, on May 16, 1988, it was like one big happy family reunion: producers Robert Watts and Frank Marshall, director of photogra-phy Douglas Slocombe, lead stuntman Vic Armstrong,

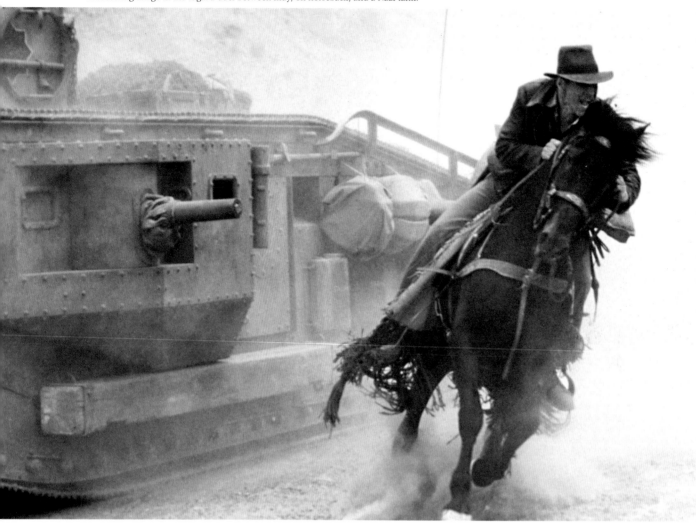

A recurring image in the saga: a duel between Indy, on horseback, and a Nazi tank.

The Indy Series Adaptation

The prologue of *The Last Crusade* was the inspiration behind George Lucas's planned series *The Young Indiana Jones Chronicles,* in which the hero (played by Sean Patrick Flanery) encounters a character from history in each episode. The show flopped, but it was followed by four TV films between 1994 and 1996.

and, of course, Harrison Ford, who got along well with Sean Connery. A true bond developed between the two during filming. The Andalusian desert, the location for many classic spaghetti Westerns, provided the backdrop for most of the action sequences: the tank chase, the Messerschmitt plane chase, and the scene on the beach where, to stop them being dive-bombed by a fighter plane, Henry Jones disperses a flock of seagulls with his umbrella and sends the aircraft exploding into a cliff. On paper this was straightforward for Spielberg and his crew. They may have been action scene experts, but they didn't know that you can't train seagulls. Take after take, despite their efforts, not a single gull deigned to take flight, so they were replaced by doves, which are more docile by nature.

In *The Last Crusade,* rats also joined the vast line-up of gross-out animals that have made appearances in the Indiana Jones movies. After snakes (*Raiders*) and insects (*The Temple of Doom*), they were the latest shiver-inducing creatures. But only disease-free rats that were bred in captivity were permitted on the shoot, so, to be able to release ten thousand rats as Harrison Ford and Alison Doody made their way through a sewer, the production had to sign up breeders beforehand and ask them to produce thousands of rats for an appearance that lasted a mere two minutes!

Meeting Audience Expectations

After a short stint in Venice, the team took up residence at Elstree Studios in London, as they had done for the two previous installments in the franchise. This is where they filmed the indoor scenes and some segments of the boat chase on the city's Grand Union Canal. One final trip to Petra, the archaeological site in Jordan where the entrance to the temple (carved into the pink sandstone cliff) was used as the entrance to the chamber that held the Grail, and the movie (with a budget of close to $50 million at the time) was in the bag. Well, almost. After watching it end to end for the first time, Spielberg and his editor, Michael Kahn, feared there was less action than the public would expect. Ford and Connery were called back to Lucas Valley, near San Francisco (and George Lucas's home), to film the scene where the Jones men are chased in their sidecar by Nazi motorbikes.

RECEPTION

The press was kind to the film, and audience numbers made it the highest-grossing movie of the trilogy. Spielberg made it quite clear in the marketing campaign that he was going to stop making new films in the series—a claim he'd go back on nineteen years later.

A Return to Success

Often the third film in a series is one too many, but *Indiana Jones and the Last Crusade* didn't disappoint thanks to the Ford/Connery duo, the great mix of humor and adventure, and Spielberg's expert filming. But, as Pauline Kael wrote in *New Yorker*, it "simply doesn't have the exhilarating, leaping precision that Spielberg gave us in the past."[2] Technique had replaced spectacle, some of the sets looked like cardboard cutouts, and some transparencies and digital overlays were quite jarring. *The Last Crusade* marked the beginning of a strange period for Spielberg, who went back to longstanding projects that were linked to works he'd enjoyed as a youth: *Always*, a remake of a cult movie from his childhood (Victor Fleming's *A Guy Named Joe*), and *Hook*, a variation on Peter Pan. Spielberg immersed himself in his youth at a time when he himself was being forced to grow up. As a young father, he divorced Amy Irving in June of 1989, following in the footsteps of his parents, who divorced when he was nineteen. It seems that Spielberg was lost and trying to find himself, which might explain some of the misjudgments in his next spate of films. He would eventually move past this creatively fallow period after his marriage to Kate Capshaw in 1991 and his meeting with Janusz Kamiński.

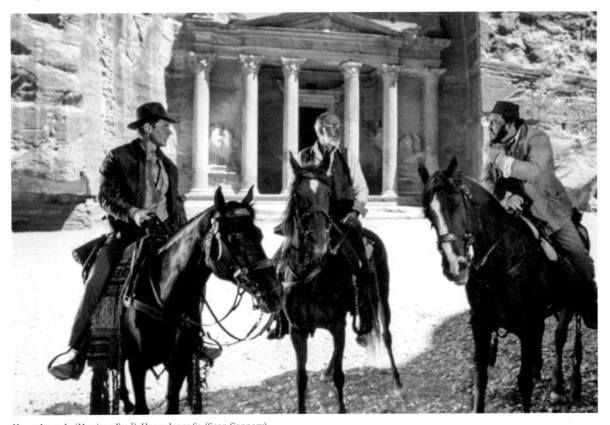

Henry Jones Jr. (Harrison Ford), Henry Jones Sr. (Sean Connery), and Sallah (John Rhys-Davies) at the Petra site, in Jordan.

A STEVEN SPIELBERG FILM

RICHARD
DREYFUSS

HOLLY
HUNTER

JOHN
GOODMAN

They couldn't hear him.
They couldn't see him.
But he was
there when they needed him...
Even after he was gone.

Always

UNIVERSAL PICTURES and UNITED ARTISTS present 'ALWAYS' Introducing BRAD JOHNSON Special Appearance by AUDREY HEPBURN

Music by JOHN WILLIAMS Film Editor MICHAEL KAHN A.C.E. Production Design by JAMES BISSELL Director of Photography MIKAEL SALOMON Co-producer RICHARD VANE

Screenplay by JERRY BELSON Produced by STEVEN SPIELBERG · FRANK MARSHALL · KATHLEEN KENNEDY

AMBLIN
ENTERTAINMENT

PG PARENTAL GUIDANCE SUGGESTED
SOME MATERIAL MAY NOT BE SUITABLE FOR CHILDREN

DOLBY STEREO
IN SELECTED THEATRES

Directed by STEVEN SPIELBERG

SOUNDTRACK ON MCA RECORDS, CASSETTES AND CDs

A UNIVERSAL·UNITED ARTISTS PICTURE
©1989 UNIVERSAL CITY STUDIOS, INC.

PRINTED IN U.S.A.

NSS¥ 890155

Always

United States	2 hrs 2	Color (DeLuxe)	Stereo (Dolby/6-Track)	1.85:1

Production Dates: May 15, 1989–August 1989
United States Release Date: December 22, 1989

Worldwide Box Office: $74 million ($168 million in 2023 dollars)

Production Company: Universal Pictures, Amblin Entertainment, United Artists
Producers: Steven Spielberg, Kathleen Kennedy, Frank Marshall
Co-Producer: Richard Vane
Unit Production Manager: Gary Daigler

Based on the Victor Fleming movie *A Guy Named Joe* (1944), written by Dalton Trumbo
Screenplay: Jerry Belson
Second Unit Directors: Frank Marshall (Montana sequences), James W. Gavin (additional aerial sequences)
Director of Photography: Mikael Salomon
Directors of Photography, Aerial Shots:
Frank Holgate, Alexander Witt
Camera Operator: Paul Babin
Assistant Directors: Pat Kehoe, Bruce Cohen, Linda Brachman
Film Editing: Michael Kahn
Music: John Williams
Sound: Ben Burtt
Film Editing Sound Effects: Richard Hymns, Gary Rydstrom
Production Design: James D. Bissell
Art Direction: Christopher Burian-Mohr, Richard Reynolds, Richard Fernandez
Costume Design: Ellen Mirojnick
Special Effects: Michael Wood
Visual Effects: Bruce Nicholson
Aerial Sequence Designer: Joe Johnston
Casting: Lora Kennedy

Starring: Richard Dreyfuss (Pete Sandich), Holly Hunter (Dorinda Durston), John Goodman (Al Yackey), Brad Johnson (Ted Baker), Audrey Hepburn (Hap), Roberts Blossom (Dave), Keith David (Powerhouse), Ed Van Nuys (Nails), Marg Helgenberger (Rachel), Dale Dye (Don), Brian Haley (Alex), James Lashly (Charlie), Michael Steve Jones (Grey), Kim Robillard (air traffic controller), Jim Sparkman (dispatcher)

> "I could have made *Always* in 1981; I could have made it in '83, '85, '87. I just never quite had the courage to step up to the mark."[1]
>
> —Steven Spielberg

SYNOPSIS

Pete Sandich is an aerial firefighter whose girlfriend, air traffic controller Dorinda, is increasingly unhappy at his lack of humility and love of danger. While out on a mission, he risks himself to save his best friend Al's plane, waking up in a clearing in the middle of a group of burned-out trees. Then a woman dressed in white, Hap, tells him that he died when his plane crashed and assigns him a new mission. He's to become the conscience of a clumsy young pilot, Ted Baker. Initially, Pete is highly amused by this new role, especially because he's invisible to those who are still in the land of the living. Even better, he can see Dorinda again and watch out for her. But the mission gets complicated when Ted makes a move on Dorinda.

GENESIS

Legend has it that when Steven Spielberg was a teenager, he allegedly showed *A Guy Named Joe* to one of his girlfriends. Because she wasn't a fan of the film, he immediately stopped going out with her.

A Cult Movie

You don't mess with a filmmaker's iconic movie. Spielberg came upon Victor Fleming's 1944 movie when it aired on TV when he was a child living in Phoenix. The original film tells the strange story of Pete (Spencer Tracy), an aerial firefighter who died during a dangerous mission in World War II and found himself in pilot heaven. A heavenly superior gave him one last mission, to become the invisible conscience of shy young pilot Ted (Van Johnson). The problem is that the novice pilot falls for the deceased pilot's girlfriend, Dorinda (Irene Dunne). It then becomes Pete's job to reluctantly bring them together in a way that ensures Dorinda lets go of the memory of her lost love.

A Guy Named Joe (1944) was one of Spielberg's favorite films when he was growing up.

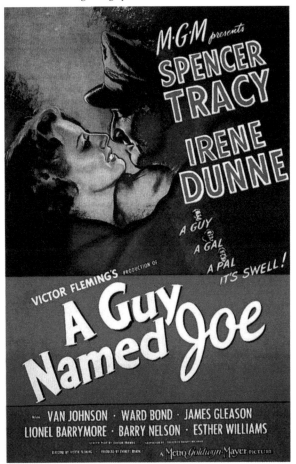

There is no doubt that the future filmmaker saw in this fantasy drama similarities with another, more personal turmoil: the story of a family on a steady path toward breaking up. Not to mention the fact that his father, Arnold, had been part of a bomber crew during the war. In *A Guy Named Joe*, the dead pilot learns that life goes on even if you lose a loved one, and that the dead live on in the memories of their nearest and dearest. Divorce is no longer the end, but rather a stepping-stone to the land of memory.

A Slow Gestation

The idea of doing a remake went back to 1974 and a discussion with Richard Dreyfuss on the set of *Jaws*. But it was a long time in the making. Spielberg didn't really launch the project until 1980. A dozen or so screenplay writers were involved; one of them was Jerry Belson, who would pen the final version. First and foremost, Spielberg made sure he didn't watch it again, for fear of stunting his creativity. He rejected the idea of staying true to the original, set in 1943, because he didn't want to lose his young audience, for whom the historical and emotional references specific to that period were no longer really relevant. It was his director friend Penny Marshall who came up with the idea of transposing *Always* into the world of volunteer firefighters and water bomber pilots.

An Outlet for His Anxieties

Always took other liberties from the original. Both movies end with the same line by Pete, addressing the two lovers who, in the great Hollywood tradition, are heading into the sunset (*That's my girl... and that's my boy*), but Dorinda and Pete's love story is much more central to the plot in the remake. Doubtless one of the reasons for this shift was Spielberg's personal life at the time; in the late 1980s his marriage to Amy Irving was breaking down and their divorce was announced on April 24, 1989. *Always* became an outlet for his anxieties about death, the end of one story and the beginning of another, and transition (especially at a time when parents are aging and before children fly the nest). When promoting the movie, he was elusive about his intentions, saying he wanted to tell a story about inspiration, the little inner voice that seems to guide artists in their creativity—which, in any event, actually makes *Always* all the more personal.

Always was Audrey Hepburn's final film role.

DISTRIBUTION

As a fan of *A Guy Named Joe* and a good friend of Spielberg, Richard Dreyfuss might have seemed like the perfect man for the role of Pete, but he apparently wasn't at the top of the filmmaker's list when the project took shape in the early 1980s. At the time, Spielberg's dream was to cast Paul Newman and Robert Redford in the respective roles of Pete and Ted, but that didn't happen. In the end, Dreyfuss secured the role.

Tom Cruise Says No

At one point, Spielberg was hoping that Tom Cruise would play Ted, but Cruise turned him down. The role went to newcomer Brad Johnson, who was mostly known as an advertising model at the time. The decision was made when the handsome rodeo fan met Spielberg and clumsily spilled his coffee on him. For a short while, Debra Winger was first in line to play Dorinda, but Holly Hunter got the role in the end. Alongside her, John Goodman plays the couple's best friend. The two actors had just appeared together in Joel Coen's *Raising Arizona* (1987): "I wanted real people that we could relate to. People about whom we could say, 'Gee, I'm like her,' [...] that kind of thing. [...] Everybody has a best friend like John Goodman in life or should."[2]

Roberts Blossom, a regular on Spielberg sets, was back after *Close Encounters of the Third Kind* and the

"Ghost Train" episode of the *Amazing Stories* anthology. This time he plays a preacher-like, deranged old man whom Pete and Ted meet in an abandoned hangar during a totally incongruous sequence.

Audrey Hepburn's Last Role

The casting coup of the film was the choice of Audrey Hepburn to play Hap, the angel who welcomes Pete into the other world. Spielberg initially wanted Sean Connery for the role but the actor wasn't available, so Spielberg decided to bring Hepburn out of retirement. The sixty-year-old actress, whose last cinema appearance had been in Peter Bogdanovich's *They All Laughed* in 1981, agreed to appear in return for a fee of $1 million ($2.5 million in 2023 dollars), which she donated in its entirety to UNICEF, the United Nations Children's Fund.

FILMING AND PRODUCTION

Two and a half years before shooting started, when preparations were being made for the movie, massive fires ravaged Yellowstone Park. Production immediately took advantage of the spectacle and sent two aircraft to take aerial shots.

A New Director of Photography

Always was the first time that Spielberg worked with Mikael Salomon. The young upstart came highly recommended by James Cameron, who worked with

Lighting the fire: The crew filmed in a controlled fire re-created by the special effects team.

Salomon on *The Abyss*. Spielberg was intrigued by the suggestion, so he invited Salomon over to his place and watched Cameron's movie with him. After a mere twenty minutes Salomon was hired.

On May 15, 1989, the crew began work in Montana, close to the Kootenai National Forest. Five hundred inhabitants of the small town of Libby were brought in to play volunteer firefighters. The fire scenes were filmed on already burned land in Yellowstone Park.

Immaculate Conception
The stretch of water that appears at the beginning and the end of the movie is Bull Lake in Montana. The scenes supposedly taking place in Colorado were actually shot in Washington State. And it was in this same state, near Spokane, that Audrey Hepburn filmed the final shots of her career. She wore an outfit from her own wardrobe, and for two weeks the crew transported her around the set on a stretcher so she could keep it looking immaculate.

RECEPTION
Always was released a mere five months after *Indiana Jones and the Last Crusade*. It was no surprise that the public generally favored the archaeologist's latest adventures over those of the dead pilot,

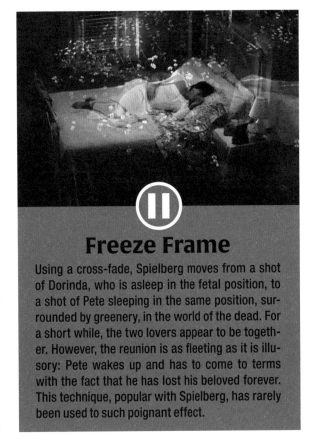

Freeze Frame
Using a cross-fade, Spielberg moves from a shot of Dorinda, who is asleep in the fetal position, to a shot of Pete sleeping in the same position, surrounded by greenery, in the world of the dead. For a short while, the two lovers appear to be together. However, the reunion is as fleeting as it is illusory: Pete wakes up and has to come to terms with the fact that he has lost his beloved forever. This technique, popular with Spielberg, has rarely been used to such poignant effect.

A time to live, a time to die: Pete and Dorinda enjoy one last moment together.

Invisible to the lovebirds, Pete watches as their relationship blossoms.

but the movie wasn't a flop. Far from it, especially outside the United States.

An Old-Fashioned Charm

Critics were divided. If some thought the film had a simple charm, others highlighted Spielberg's inability to dramatize the love story between the two main characters, or to create even a glimmer of sexual tension. Famed film critic Roger Ebert even said, "This is Spielberg's weakest film since *1941*."[3]

This remark was all the more pertinent because *Always* was aiming to be thought of as a typical Hollywood period piece. The blunt comedy of *1941* was replaced by the comedy of morals in *Always*, at least in the beginning. After a span of ten years, the result was basically the same: The comedy and emotion were forced, just like the acting. Most reviews claimed the film was stuck between "old-fashioned" writing and an attempt at creating a contemporary fairy tale; they described the film as clumsy in

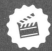

FOR SPIELBERG ADDICTS

Spielberg suggested that Tobe Hooper should include a clip from *A Guy Named Joe* in a scene from *Poltergeist* where the parents are watching the movie in bed. In the clip that appears in *Poltergeist*, Pete (Spencer Tracy) arrives in aviator heaven and learns that he's dead. A few seconds later, the spirits of *Poltergeist* make themselves known.

its handling of fantasy. Constantly pulled between true-to-life fire sequences and overbaked scenes of passion, *Always* very much mirrored the life of its creator in the late 1980s.

E.T., a friend from another planet, makes up for a lack of fatherly affection.

Bad Dads
Home Life in the Eye of the Storm

Steven Spielberg was nineteen when his parents, Leah (1920–2017) and Arnold (1917–2020), divorced. His personal trauma left him feeling lost, but also full of acrimony toward a father he held responsible for his family's dissolution. This father-related pain would become a central tenet of much of Spielberg's work.

A Mother Who Wouldn't Grow Up

Spielberg learned many years later that it was Leah's affair with a family friend that was behind the separation of his parents, but he couldn't bring himself to be angry at his mother. In 2012, in an interview for CBS that was done in his parents' presence, Spielberg admitted that he had placed Leah on a pedestal when he was younger, and that he'd taken his anger out on his father. "My mom didn't parent us as much as she sort of 'big-sistered' us. She was Peter Pan. She refused to grow up."[1] He chastised Arnold for having done nothing to prevent the divorce and for having been absent for many years

because he was always occupied elsewhere, traveling and working all the time.

The topic came up early on, during Spielberg's second production for Universal Television, in the episode "The Daredevil Gesture" from the series *Marcus Welby, M.D.* (1970). High school student Larry Bellows is relating a childhood memory about his father when, almost unwittingly, he starts to talk about his parents' divorce. In a moment of palpable tension, the boy, who is full of resentment for a father he no longer sees, seems to be voicing the feelings of the then twenty-three-year-old director.

Children of Divorce

The episode "The Private World of Martin Dalton" (1971) from *The Psychiatrist* also dealt with the issue of an imminent divorce. Then there's little Barry, living alone with his mother in *Close Encounters of the Third Kind* (1977), and Elliott in *E.T.* (1982), who's growing up in a home permeated with sadness since his parents' separation. Elliott seeks escape through

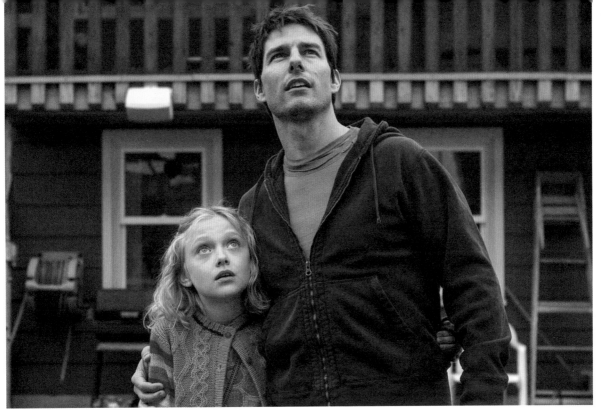

In *War of the Worlds*, Tom Cruise plays a dad who initially seems aloof and even unkind.

his close friendship with a being from another planet, one who is just as lost as he is. Even when fathers are present in Spielberg films, they are often woefully inadequate or mostly absent from their family.

Empty Homes

Paul Worden (*Something Evil*, 1972), Peter Banning (*Hook*, 1991), and Henry Jones Sr. (*Indiana Jones and the Last Crusade*, 1989, where the quest for the Holy Grail merges with the search for a missing father) live for their work, letting their home lives crumble around them in the process. In *Indiana Jones and the Kingdom of the Crystal Skull* (2008), we learn that Indy has repeated the same paternal pattern with his own son. In *Ready Player One* (2018), Art3mis's father is killed when trying to pay back the debts he ran up in a virtual reality universe. Throughout *The Lost World: Jurassic Park* (1997), Ian Malcolm brushes off his daughter's reproaches, gives endless useless or awkward advice, and when he makes a promise, he hears in reply: "But you never keep your word!" And then there's Steve Freeling in *Poltergeist* (which was written by Spielberg), who comes across like a big, jocular teenager. When his daughter is abducted by malevolent forces, he's struck by a mute impotence and an inability to react.

Dads Who Don't Come Back?

The most extreme case of inadequate fathers is undoubtedly Roy Neary in *Close Encounters of the Third Kind* (1977). Spielberg used this character to try to understand how a man can get to the point of no longer having any interest at all in his family, so much so that he would choose to leave Earth rather than staying with them. In *War of the Worlds* (2005), the father figure becomes even more distressed, if not disturbing. Divorcé Ray Ferrier obviously doesn't know what to do with his two children when he's looking after them. In the midst of the film's growing chaos, he spends his time seemingly trying to get rid of his kids before he gradually accepts his responsibilities. Because Steven Spielberg got closer to his father from the mid-eighties onward, following his own divorce and remarriage, his attitude on fatherhood has softened over time.

Reconciliation

In 2002, *Catch Me If You Can* made an attempt to put things right. Although the dad in the film is likable, if not totally reliable, it's the mother's affair with someone close to the family that leads to the parents' divorce, and to Frank Abagnale's descent into a world of illegal activity and make-believe. At the end of the day, however, the movie showing the clearest signs of improved relations between the director and his father is *Lincoln*, which was released ten years after *Catch Me If You Can*. Lincoln is a portrait of the father of a nation that has been ripped apart and is seeking reconciliation. Spielberg will doubtless close the loop in the 2022 release of *The Fabelmans*, which will tell the story of his youth in Arizona.

STEVEN SPIELBERG ALL THE FILMS

FOCUS

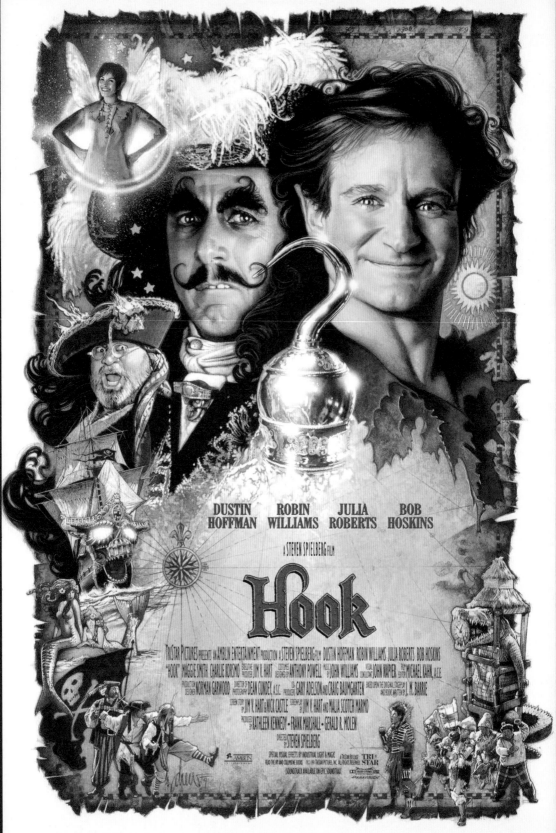

Hook

🏳 • 🕐 • ⚫ • 🔊 • ◺

United States **2 hrs 22** **Color** **Stereo** **2.35:1**
(DeLuxe) (Dolby SR/SDDS/6-Track)

Production Dates: February 19–August 1, 1991
United States Release Date: December 11, 1991

Worldwide Box Office: $301 million ($636 million in 2023 dollars)

Production Company: Amblin Entertainment, TriStar Pictures
Producers: Steven Spielberg, Kathleen Kennedy, Frank Marshall, Gerald R. Molen
Co-Producers: Gary Adelson, Craig Baumgarten
Associate Producers: Bruce Cohen, Malia Scotch Marmo
Executive Producers: Jim V. Hart, Dodi Fayed
Unit Production Manager: Gerald R. Molen

Screen Story: Jim V. Hart, Nick Castle, based on the work by J. M. Barrie
Screenplay: Jim V. Hart, Malia Scotch Marmo, Carrie Fisher (not credited)
Director of Photography: Dean Cundey
Camera Operator: Raymond Stella
Assistant Directors: Bruce Cohen, Carla McClosky
Film Editing: Michael Kahn
Music: John Williams
Sound: Ron Judkins
Production Design: Norman Garwood
Set Decoration: Garrett Lewis
Hair Stylist: Judith A. Cory
Makeup: Christina Smith, Monty Westmore, Greg Cannom
Costume Design: Anthony Powell
Special Effects: Michael Lantieri
Visual Effects: Eric Brevig, Harley Jessup, Mark Sullivan
Visual Effects Consultant: John Napier

Starring: Robin Williams (Peter Banning/Peter Pan), Dustin Hoffman (Captain James Hook), Julia Roberts (Tinkerbell), Bob Hoskins (Smee), Maggie Smith (Granny Wendy), Caroline Goodall (Moira Banning), Charlie Korsmo (Jack Banning), Amber Scott (Maggie Banning), Dante Basco (Rufio), Laurel Cronin (Liza), Arthur Malet (Tootles), Gwyneth Paltrow (Young Wendy)

> "I was afraid because I didn't want to grow up, because everybody who grows up has to die someday."
>
> —Peter Banning to Tinkerbell

SYNOPSIS

—

Peter Pan has grown up. In *Hook*, Pan grows up and goes by the name of Peter Banning. He lives an exhausting life as an overworked corporate lawyer. He has little time for his children, Jack and Maggie, or for his wife, Moira, who is Wendy's grand-daughter—the same Wendy he meets up with in London for a charity dinner held in her honor. During a family reunion, Wendy tries to reconnect Peter with his child-hood, but to no avail. When Captain Hook takes advan-tage of the dinner to kidnap Jack and Maggie, Peter receives a visit from Tinkerbell, who reveals that Hook has taken the two children prisoner as a means to force their father to return to Neverland so that he can kill him as payback for their previous duel, in which Hook lost a hand. Once he arrives in Neverland, Peter has to face facts: He has become a shadow of his former heroic self.

GENESIS

The original idea for the film came from a child. In 1982, screenwriter Jim V. Hart came across a drawing by his three-year-old son, Jake. In a few rough strokes, the little boy fantasized that Captain Hook had survived the crocodile attack and had managed to escape. The timing couldn't have been better, as Hart was thinking about adapting *Peter Pan* but didn't want to simply do a remake. Jake asked his father what would have happened if Peter Pan had grown up…and right there and then, Jim had his concept.

A Modern-Day Peter Pan

Hook took shape gradually. For the purposes of the film, J. M. Barrie's hero would now be in his forties and he would be transposed to Wall Street, a hotbed of modern piracy (according to the screenwriter), peopled by ruthless traders. Delighted with this new vision, TriStar Pictures (a subsidiary of Columbia Pictures) decided to develop it and, in 1984, they appointed a director: Nick Castle, who had previously directed the acclaimed science fiction film *The Last Starfighter*.

In 1989 Columbia was acquired by Sony and this caused a major shakeup at the studio. In the game of C-suite musical chairs that followed, Mike Medavoy, who was one of the most influential agents in Hollywood at the time, found himself heading TriStar. Medavoy knew that Sony wanted to make a splash with a blockbuster, so the ambitions for *Hook* were kicked up a notch. Medavoy got out his address book and recruited two major movie stars for the film: Robin Williams and Dustin Hoffman. With these two giants of the silver screen on board, the film now needed a major director. Medavoy had been Spielberg's first agent in the 1960s, so he wasted no time in contacting his old client.

Michael Jackson Gets Slighted

The character of Peter Pan had obsessed Spielberg since childhood, so much so that his influence can be seen in many of Spielberg's movies: the fear of growing old, the mad desire for eternal youth, the fear of losing your way as an adult. Many of the director's characters have harbored these anxieties, in movies as varied as *The Sugarland Express* (1974) and *Always* (1989). In the early 1980s, the filmmaker very nearly adapted Barrie's work with Michael Jackson in the lead role. The singer was so invested in the idea

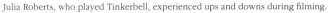

Julia Roberts, who played Tinkerbell, experienced ups and downs during filming.

Ever the perfectionist, Dustin Hoffman wanted to try multiple takes for each scene.

that he took it very badly and actually fell out with Spielberg when he finally withdrew from the project.

The fact is that Spielberg had grown up. He became a father in 1985 and looked at childhood differently, as reflected in *Empire of the Sun* in 1987. During this time he passed on making *Big* (Penny Marshall, 1988), the story of a child in an adult's body, which was written by his sister Anne. The character that interested him was Peter Banning in *Hook*, a man who works so much that he sacrifices his role as a father. He saw parallels not only with his own father, who used to spend days at a time at work to the neglect of his family, but also with himself.

Spielberg accepted an offer to direct *Hook*, but he refused to take Castle's place. When Castle was dropped from the project (he was compensated with a writing credit and a handsome payoff), *Hook* was finally ready to sail. Hart was also replaced (by Malia Scotch Marmo) because Spielberg thought that his approach to Captain Hook wasn't sufficiently developed. Although her role was uncredited, actor (and occasional script doctor) Carrie Fisher rewrote Tinkerbell's dialogue.

DISTRIBUTION

Mike Medavoy knew that with Spielberg, Hoffman, and Williams on board, he was on the way to making a surefire hit.

Four Aces

When he learned that he would be playing opposite Hoffman, Robin Williams had some misgivings, specifically about whether his character would be a match for his fellow actor's performance. It was celebrated actor Bob Hoskins, who had been cast as Smee, who persuaded him to accept.

Three of a kind then became four aces with the arrival of Julia Roberts in the role of Tinkerbell. Roberts had risen to global stardom on the success of *Pretty Woman* (Garry Marshall, 1990) the previous year. The British actor Maggie Smith, then aged fifty-six, was chosen to play ninety-two-year-old Wendy on the recommendation of costume designer Anthony Powell. For the teenage version of Wendy, Spielberg brought in his teenaged goddaughter, Gwyneth Paltrow.

FILMING AND PRODUCTION

Hook was no longer just a movie—it had become a major spectacle. Sony went overboard for its flagship movie, which had an initial budget of $48 million (equivalent to $194 million in 2023) but would eventually end up costing almost twice that. The sets took six months to build and occupied nine sound stages at the Culver Studios in Los Angeles, including the massive Stage 27, where *The Wizard of Oz* (Victor Fleming, 1939) had been shot. Here, the team reconstructed the pirates' lair and a full-sized version of Captain Hook's galleon, measuring 170 feet long, 35 feet wide, and 70 feet high. Stage 30 housed the Lost Boys' playground, again built to actual size. Production design was entirely in the hands of Norman Garwood, who also created the memorable sets for Terry Gilliam's *Brazil* (1985).

An Impossible Schedule

Filming began on February 19, 1991, and it took place almost entirely in the studio, except for some baseball scenes that were shot on location in a local park. It quickly became apparent that it was going to be impossible to keep to the seventy-six-day schedule that had been initially settled on for the shoot. Spielberg took his time, not so much out of choice but because he had no clear vision of what he wanted to do with the film. "Every day I came on the set, I thought: Is this flying out of control?"[1]

The relentless perfectionism of Hoffman, who constantly wanted to try different approaches and always asked for multiple takes, didn't help matters. Julia Roberts had her own issues to deal with: Struggling to cope with her skyrocketing fame and a troubled private life, she started calling in sick. Meanwhile, the young actors playing the Lost Boys were becoming more and more unmanageable. Although it was closed to the press, the set attracted visits from a host of celebrities, who came to hang out on the hottest set in Hollywood. When an exhausted Spielberg finally completed shooting, he came in forty days behind schedule.

RECEPTION

When *Hook* landed in theaters, it felt as if it had been blown in by an ill wind. The film was lambasted by the press, getting possibly the worst reviews Spielberg had seen in his career to date. Criticism mainly centered on the weak script, let down by its inability to truly transcend the gimmick of its premise. The inner conflict between Banning and Pan was merely a pretext for allowing history to repeat itself, since the film ended with a showdown between Pan and Hook. For most of the media, Spielberg's film was anesthetized by a lack of dramatic tension. According to Kenneth Turan in the *Los Angeles Times*, the filmmaker seemed to be so aware of his failure that he dragged his feet before shifting the action to Neverland, which was undoubtedly the most unsuccessful part of the movie: "For very much like Peter, it has clearly gotten harder for this director to break free of the lure of material things and believe in simple magic."[2] Of all the actors, only Bob Hoskins escaped the shipwreck. The others, especially Robin Williams, were deemed incapable of bringing even a hint of empathy to their characters.

A Lucrative Deal

Hook was released in the United States just before Christmas, but it did not bomb as expected. Although rumor had it that Sony would have trouble breaking even on the picture, things turned out very differently: After a slow first weekend, the movie started making headway. The studio made its money back once the film was released in foreign territories, and sales of VHS cassettes ensured a comfortable bottom line,

Freeze Frame

Back in London after saving his children, Peter wakes up in a park under a statue of Peter Pan. His fetal position echoes Pete Sandich in *Always* and the concept is the same: to indicate the transition from dream to reality. But whereas Sandich returns to the hereafter, Banning remains in the human world...with the ghost of his childhood inside him.

especially as many younger viewers had plunged headlong into the film's adventure plot; they were seemingly unburdened by the aesthetic qualms of adult film critics. The film proved to be quite lucrative for Spielberg, Williams, and Hoffman, who all opted not to take salaries on the film. Instead, they split 40 percent of TriStar Pictures' gross revenues ($20 million) from the first $50 million that the film made. TriStar then kept the next $70 million that the movie earned, and the trio shared 40 percent of the profits that were earned thereafter.

Insecurity and Colorful Sets

Despite creating a financial windfall for the director, the experience left Spielberg with a bitter taste in his mouth. "I felt like a fish out of water," he would admit almost thirty years later. "I didn't have confidence in the script. [...] I didn't even know what I was doing and I tried to paint over my insecurity with production value. The more insecure I felt about it, the bigger and more colorful the sets became."[3]

Each new achievement from Spielberg seemed to lead him toward making *Hook*. But, in the end, instead of becoming his crowning achievement, the film feels like a point of no return. For Spielberg, there was nothing redeeming about the experience: "I still don't like that movie. I'm hoping someday I'll see it again and perhaps like some of it."[4]

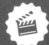

FOR SPIELBERG ADDICTS

One way to appreciate *Hook* is to focus on the film's many cameo appearances. The most famous faces in the film, and the hardest to spot, are George Lucas and Carrie Fisher, who can be seen as a couple kissing in silhouette on a London bridge before floating away when Tinkerbell spills some fairy dust on them. Other cameos include singer David Crosby as a bearded pirate whose privates take a bashing by the Lost Boys, a cross-dressing Glenn Close as a cowardly pirate who ends up getting thrown into a chest with scorpions, Phil Collins as a Scotland Yard police inspector, singer Jimmy Buffett as a shoe thief—and Dustin Hoffman's three children.

The final attack was set on a full-sized pirate ship, and it was all shot on a soundstage inside a film studio.

Father and son are reunited (Robin Williams and Charlie Korsmo).

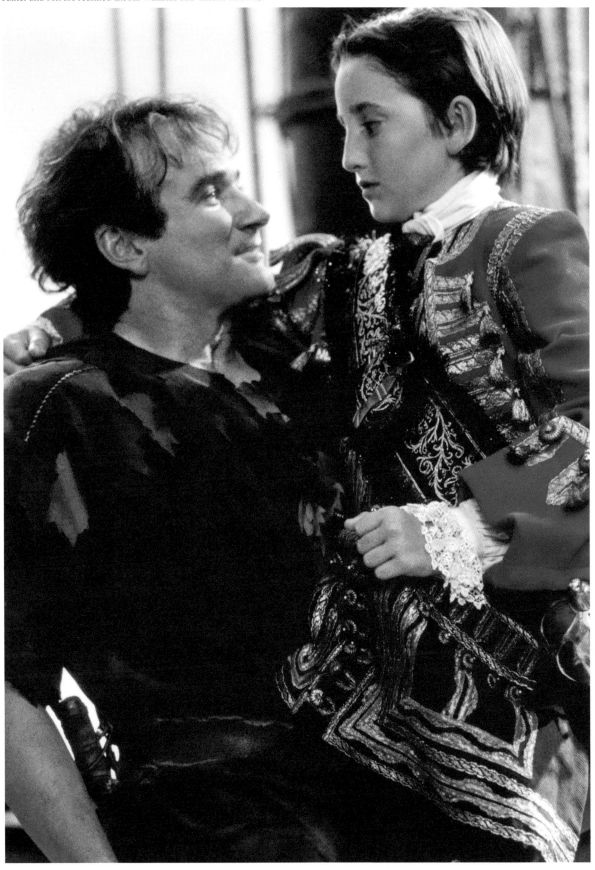

A STEVEN SPIELBERG FILM

An Adventure
65 Million Years In The Making.

UNIVERSAL PICTURES PRESENTS AN AMBLIN ENTERTAINMENT PRODUCTION SAM NEILL · LAURA DERN · JEFF GOLDBLUM
AND RICHARD ATTENBOROUGH "JURASSIC PARK" BOB PECK · MARTIN FERRERO · B.D. WONG · SAMUEL L. JACKSON · WAYNE KNIGHT
JOSEPH MAZZELLO · ARIANA RICHARDS LIVE ACTION DINOSAURS STAN WINSTON FULL MOTION DINOSAURS BY DENNIS MUREN, A.S.C. DINOSAUR SUPERVISOR PHIL TIPPETT
SPECIAL DINOSAUR EFFECTS MICHAEL LANTIERI MUSIC BY JOHN WILLIAMS FILM EDITED BY MICHAEL KAHN, A.C.E. PRODUCTION DESIGNER RICK CARTER DIRECTOR OF PHOTOGRAPHY DEAN CUNDEY, A.S.C.
BASED ON THE NOVEL BY MICHAEL CRICHTON SCREENPLAY BY MICHAEL CRICHTON AND DAVID KOEPP PRODUCED BY KATHLEEN KENNEDY AND GERALD R. MOLEN
DIRECTED BY STEVEN SPIELBERG SPECIAL VISUAL EFFECTS BY INDUSTRIAL LIGHT & MAGIC A UNIVERSAL PICTURE

Jurassic Park

United States 2 hrs 7 **Color** **Stereo** 1.85:1
(Eastmancolor) (Dolby Digital SR/ DTS)

Production Dates: August 24–November 30, 1992
United States Release Date: June 11, 1993

Worldwide Box Office: $914.6 million ($1.88 billion in 2023 dollars)

Production Company: Universal Pictures, Amblin Entertainment
Producers: Kathleen Kennedy, Gerald R. Molen
Associate Producers: Lata Ryan, Colin Wilson
Unit Production Manager: Paul Deason

Based on the eponymous novel by Michael Crichton (1990)
Adaptation: Michael Crichton, Malia Scotch Marmo
Screenplay: Michael Crichton, David Koepp
Director of Photography: Dean Cundey
Camera Operator: Raymond Stella
Film Editing: Michael Kahn
Music: John Williams
Sound: Ron Judkins
Sound Effects Editing: Richard Hymns, Gary Rydstrom
Production Design: Rick Carter
Art Direction: John Bell, William James Teegarden
Mechanical Special Effects: Michael Lantieri
Dinosaur Models: Stan Winston
Visual Effects: Phil Tippett, Dennis Muren
Second Unit Director: Gary Hymes (uncredited)

Starring: Sam Neill (Alan Grant), Laura Dern (Ellie Sattler), Jeff Goldblum (Ian Malcolm), Richard Attenborough (John Hammond), Bob Peck (Robert Muldoon), Martin Ferrero (Donald Gennaro), Samuel L. Jackson (Ray Arnold), Wayne Knight (Dennis Nedry), Ariana Richards (Lex), Joseph Mazzello (Tim), Jerry Molen (Harding), Cameron Thor (Dodgson), Miguel Sandoval (Rostagno)

"When Steven asked whether I would work on the movie, I said, 'As long as I don't get eaten, that will be just fine.'"[1]

—Jack Horner, paleontologist and consultant on *Jurassic Park*

SYNOPSIS

———

As the head of his genetic engineering company InGen, John Hammond has succeeded in cloning dinosaurs. His researchers used DNA samples contained in blood, itself taken from prehistoric mosquitoes preserved in amber. Brachiosaurs, dilophosaurs, gallimimus, triceratops, and even a tyrannosaurus now populate an animal reserve called Jurassic Park, which the businessman is preparing to open on Isla Nublar, off the coast of Costa Rica. But when an employee is killed by a velociraptor, the investors want to make sure that everything is under control before the place welcomes visitors. Scientists are dispatched to analyze the situation: paleontologist Alan Grant, paleobotanist Ellie Sattler, and chaos theory mathematician Ian Malcolm. John Hammond organizes a tour of the park and the scientific facilities for the team, and his two grandchildren, Tim and Lex, join the expedition.

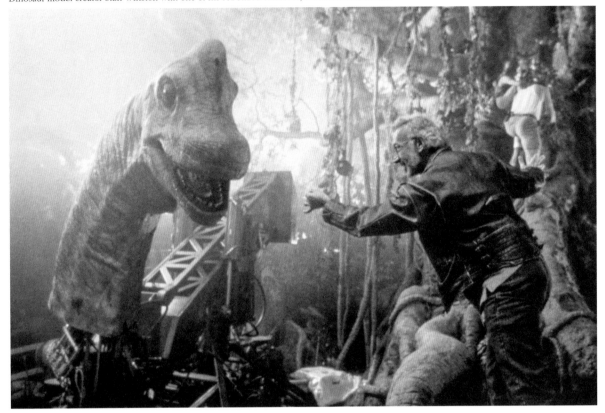

Dinosaur model creator Stan Winston with one of his robotized creatures, a brachiosaurus head.

GENESIS

Writer Michael Crichton and Steven Spielberg met in the late 1960s. Crichton was twenty-seven years old and he had just sold Universal the rights to adapt *The Andromeda Strain* (1971), his first bestseller. Spielberg was twenty-three and just beginning his career as a director at Universal Television. Spielberg was assigned to show Crichton around the studio and the two men became friends.

From a Medical Series to Dinosaurs

Twenty years after their first meeting, when the writer, a former medical student, failed to convince Hollywood to pursue *Code Blue*, a 150-page script set in a Chicago hospital emergency room, he turned to Spielberg—who loved it. This was the beginning of the series that would become *ER*. But during one of their conversations, Michael Crichton was pressed by a curious Spielberg, and he revealed one of his other projects: a novel about dinosaurs re-created from strands of DNA. Forget the medical series (for now…)! Spielberg had only one desire: to bring this story to the screen. The filmmaker said that he and Crichton agreed right away to make the film together. In fact, things were more formal than a simple verbal agreement: The writer's agent sent the manuscript of *Jurassic Park* to various studios in May 1990 (the

book was to be published in October) and considered four offers from Columbia Pictures/TriStar, Warner Bros., 20th Century Fox, and Universal Pictures. All of them proposed a director, a production company, and a sum of $1.5 million for the rights of the novel. Universal won, with Amblin Entertainment producing and Steven Spielberg directing (Richard Donner, Tim Burton, and Joe Dante would have to look for their next projects elsewhere).

Three Consultants with a Challenge

The writer also received $500,000 to write the screen adaptation of his novel. His first draft was rewritten by Malia Scotch Marmo, author of the screenplay for *Hook*, but her version did not satisfy Steven Spielberg, who turned to a screenwriter then under contract with Universal named David Koepp. Koepp, who was not yet thirty, had co-written a script in 1989 that Spielberg liked for a movie called *Death Becomes Her* (the film was released in 1992 under the direction of Robert Zemeckis).

Koepp and Spielberg respected the general plot of the novel and also opted for an open-ended ending, but the character of John Hammond became much more sympathetic in the script (he was a new avatar of the Spielbergian adult: childlike but endowed with

The laboratory at Jurassic Park. Steven Spielberg was hyper-focused on ensuring the scientific realism of his film, sometimes at the expense of the film's schedule.

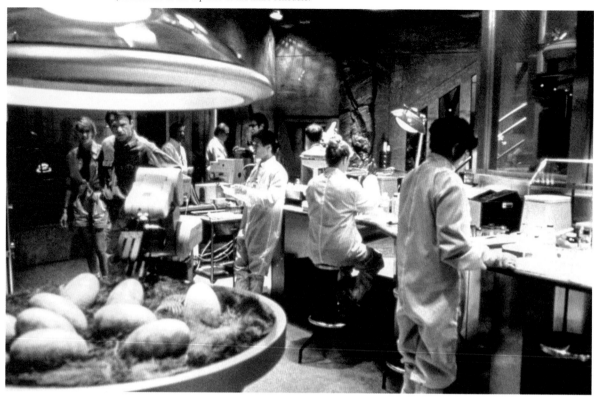

the means to satisfy his whims). Another important difference was that Hammond and Ian Malcolm did not perish as they had in Crichton's book. The main challenge of *Jurassic Park* was not its writing, but its creatures. Three consultants were brought in: paleontologists Jack Horner and Robert Bakker,

Dinosaurs with the Latest Sound

A graduate of the California Institute of Technology in Pasadena, Terry Beard had been working in film sound technology for twenty years when he founded DTS (Dolby Theater Systems) in October 1990. Through his network, he organized a demonstration of his six-channel digital sound process for Steven Spielberg, applying it to scenes from *Close Encounters of the Third Kind*. The filmmaker was more than enthusiastic: He convinced Universal Pictures to invest $4 million to equip a thousand theaters with DTS equipment in preparation for *Jurassic Park*. In July 1993, he even bought shares in the company. DTS became the sound for Amblin productions going forward.

and dinosaur science popularizer Don Lessem. They advised the director and the special effects team. Horner, a native of Montana who discovered the *Maiasaura* in 1979, theorized about the social behavior of dinosaurs and how they were closer to birds than to reptiles. He is the model for Alan Grant's character in both the novel and the film adaptation. The film also includes allusions to his scientific disagreements with Robert Bakker.

The Lost World and King Kong

In spite of the consultants, there are many factual errors in the film, starting with the recovery of DNA from millions of years ago, which is technically impossible without movie magic. The color of the animals and their cries do not correspond to the conclusions of scientific research, the tyrannosaurus probably did not run very fast, the ruff and the venom of the dilophosaurus are cinematic inventions. The consultants were aware that they were taking part in the creation of a fictional universe, which required a few doses of shock effects. "Basically I was there to make sure that sixth graders didn't send him [Steven Spielberg] nasty letters about something being wrong!"[2] summarized Jack Horner in 2014.

Having been fascinated by dinosaurs since childhood, Steven Spielberg's references for the film were

The Lost World (Harry O. Hoyt, 1925), with its dozens of prehistoric animals shot in stop motion (frame-by-frame animation), and *King Kong* (Merian C. Cooper and Ernest B. Shoedsack, 1933), where the famous giant gorilla fights with a tyrannosaurus. But he intended to go further: As he had done with *E.T.* and *Jaws*, he wanted dinosaurs that would be capable of cohabiting with the actors as if they actually existed.

Old School Special Effects

In the early 1990s, computer-generated special effects were still in their infancy, and their most breathtaking applications—the polymorphic robot in *Terminator 2* (James Cameron, 1991) and scenes from *The Abyss* (James Cameron, 1989)—focused on imaginary creatures, not animals that required respect for the laws of anatomy and physics. Old-fashioned special effects were therefore chosen for *Jurassic Park*, and they were produced by experts in the field. Stan Winston made animatronic dinosaurs and velociraptor costumes that were worn by stuntmen. Phil Tippett and Dennis Muren worked at Industrial Light & Magic (ILM), George Lucas's company that was founded at the time of *Star Wars* (1977). The former built clay miniatures animated in go motion, an improved version of stop motion; the latter handled the computerized postproduction. And Michael Lantieri (*Indiana Jones and the*

Last Crusade, Hook, Back to the Future II and *III*) coordinated the entire process. Phil Tippett began by staging storyboarded sequences with his sculptures and models, in order to evaluate the work that would be required on the set. The result was impressive, but not enough for Steven Spielberg. Spielberg asked Dennis Muren to show him what ILM's computers could do.

"I think I'm extinct."

The very first demonstration by ILM's computer scientists took place in November 1991, and it included a striking cavalcade of gallimimus dinosaur skeletons. Then there were complete gallimimuses, with the reflection of light on their skin and almost perfect muscular movements. Then a whole *T. rex*, then a *T. rex* attacking gallimimuses… Spielberg was stunned. Phil Tippett too. He understood that the era of miniatures and stop motion was over—and that he was no longer useful on the film! "I think I'm extinct,"[3] and he said. Spielberg sympathized, but he liked the formula so much that he used it in the film, in an exchange between Alan Grant and Ian Malcolm.

Phil Tippett joined Dennis Muren's team. His clay dinosaurs served as a reference for the computer graphics designers, who also observed rhinoceroses, giraffes, crocodiles, and elephants to re-create the way they move. Tippett also designed a key

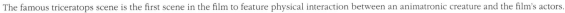

The famous triceratops scene is the first scene in the film to feature physical interaction between an animatronic creature and the film's actors.

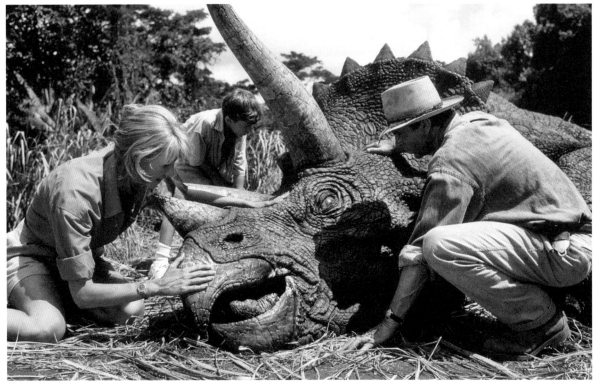

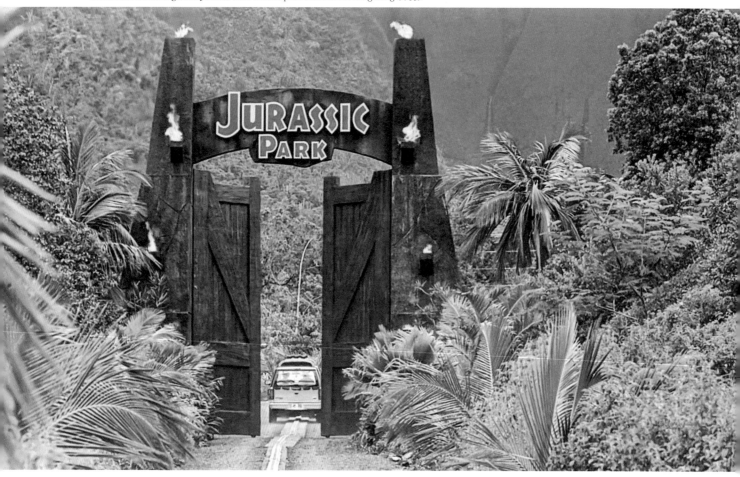

The iconic entrance gate to Jurassic Park is an explicit reference to *King Kong* (1933).

tool, the "Dinosaur Input Device." This was a miniature *T. rex* robot whose programmable movements could be transferred to its synthetic counterpart in the computer. This machine alone sums up the transition taking place at that time in the world of special effects.

CASTING

As was often the case on his films, Steven Spielberg did not want big stars for *Jurassic Park*. The characters had to remain accessible to the audience, which meant they couldn't be played by major celebrities.

A Poor American Accent

John Hurt and Tim Robbins were considered for the role of Alan Grant, but Sam Neill eventually claimed the part. Born in Ireland, he grew up in New Zealand. His career in Hollywood was just beginning to take shape; he had just appeared in *The Hunt for Red October* (John McTiernan, 1990). In preparation for *Jurassic Park*, he spent time with Jack Horner, in his everyday life, to immerse himself in the character and his work. He also developed an American

accent, but the result left so much to be desired that Spielberg let him to retain his New Zealand diction. Nominated for an Oscar for *Rambling Rose* (Martha Coolidge, 1991), Laura Dern was discovered by David Lynch and appeared in *Blue Velvet* in 1986 and *Wild at Heart* in 1990. Nevertheless, she had not yet appeared in a major production. It was the actor Nicolas Cage, her acting partner in *Wild at Heart*, who pushed her to take the role of Ellie Sattler, which had been offered to, among others, Gwyneth Paltrow, Helen Hunt, and Juliette Binoche.

The Return of Richard Attenborough

Jim Carrey wanted to the part of Ian Malcolm and asked to audition, but the production stuck with the actor envisioned from the beginning, Jeff Goldblum. The latter nevertheless had to battle with Spielberg, who was ready, at one point, to cut the character. As for the British actor Richard Attenborough, he became John Hammond despite having suspended his acting career in 1979 to focus on directing. He had a special bond with Spielberg. In March 1983, the Directors Guild of America named him

best director for *Gandhi* (1982). However, he was so convinced that the honor would go to Spielberg for *E.T.* that he told him so even before receiving his award! Richard Attenborough was then asked to direct *Hook*, but he was working on *Chaplin* (1992). With the character of chief engineer Ray Arnold, Samuel L. Jackson landed one of those amazing supporting roles that his career has frequently been peppered with; even more than *Jurassic Park*, it was *Pulp Fiction* (Quentin Tarantino, 1994) that would be a game changer for Jackson.

The Clothes of the Goonies

Nefarious computer scientist Dennis Nedry, who betrays John Hammond, was played by Wayne Knight. In *Basic Instinct* (Paul Verhoeven, 1992), Knight played one of the policemen who was transfixed by Sharon Stone's leg crossing during the famous interrogation scene. This is where Spielberg spotted him. From the outset, the character wears the same clothes as the boys in another Amblin Entertainment production: *The Goonies*. The similar looks included a floral-pattern shirt, a yellow raincoat, and a gray windbreaker.

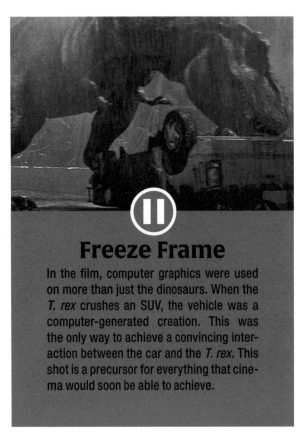

⏸ Freeze Frame

In the film, computer graphics were used on more than just the dinosaurs. When the *T. rex* crushes an SUV, the vehicle was a computer-generated creation. This was the only way to achieve a convincing interaction between the car and the *T. rex*. This shot is a precursor for everything that cinema would soon be able to achieve.

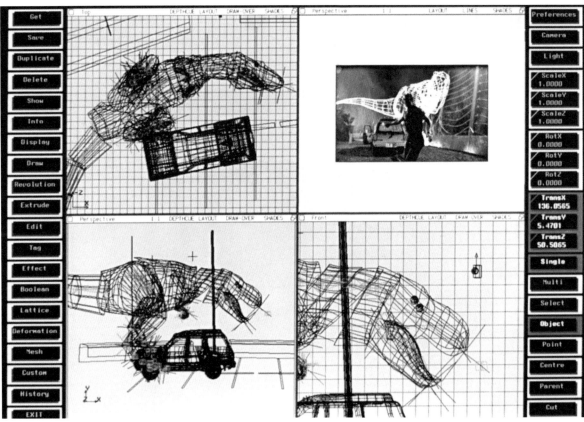

In 1992–1993, computer-generated imagery (CGI) was still in its infancy.

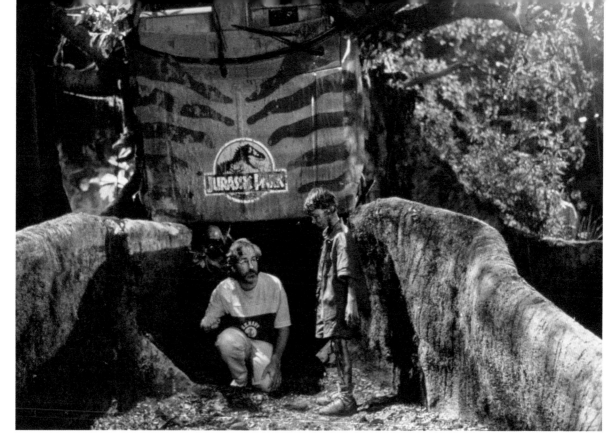

Steven Spielberg and Joseph Mazzello (Tim). At its heart, *Jurassic Park* is a film about children who are forced to deal with the chaos that's created by the adults around them.

FILMING AND PRODUCTION

The Costa Rican island at the center of the action in *Jurassic Park* was actually filmed in Hawaii. Steven Spielberg spent three weeks there working on outdoor and daylight shots.

Fifteen Minutes of Dinosaur Shots

The sets for the park's huge gate, which is so reminiscent of Ian Malcolm's *King Kong*, as well as the electrified tyrannosaurus fence and the amber mine that was supposedly located in the Dominican Republic were all built on the island of Kauai. The velociraptor enclosure was built in the Limahuli nature preserve.

Just to be sure, the team quickly created the scene of the collapsed and unwell triceratops, to evaluate the effect produced by Stan Winston's robotic creatures. The result is near perfection. When Sam Neill lies down on the animal, whose breath lifts him up and down, it is almost a demonstration of strength: CGI would never have been able to reproduce such physical and tactile interaction.

In total, *Jurassic Park* has only fifteen minutes worth of dinosaur shots, of which four minutes are computer-generated. The latter involve dinosaurs on foot and in motion. In these cases, empty landscapes had to be filmed with actors marveling at invisible brachiosaurs or fleeing from an equally nonexistent

herd of gallimimus (a sequence filmed on the island of Oahu). Stan Winston's robotic creatures, on the other hand, were used when the animals came to life on location.

Montana in the Mojave Desert

In the film, a storm hits Isla Nublar. In reality, the hurricane Iniki swept the island of Kauai on September 11, 1992, washing away the film's sets and preventing the completion of certain scenes, such as the death of Ray Arnold, which had to take place off camera. Steven Spielberg therefore returned to California much earlier than expected. Once he was on the mainland, Alan Grant's excavation site in Montana was filmed in the Mojave Desert, and then the director moved on to filming the interiors and the jungle night scenes on the lots at Universal and Warner Bros.

One of the biggest moments of the film, the tyrannosaurus attack on a deserted road inside the park, mixed the use of a robotized creature (weighing over nine thousand pounds) for close-up shots, and computer-generated images of the *T. rex* whenever it was shown in motion. The computer-generated imagery was added in postproduction after the film was shot. The scenes at the end of the film with the velociraptors required the same mixture of old-fashioned effects and digital wizardry, except that instead of

robotic dinosaurs, Spielberg put two stuntmen in velociraptor costumes, and their head and tail movements were controlled from inside the costumes.

At this point, the director decided to modify the final action sequence, which took place on the Visitors Center set, where the banner "When Dinosaurs Ruled the Earth" is featured in an ironic nod to the film of the same name (*When Dinosaurs Ruled the Earth*, Val Guest, 1970). Indeed, Spielberg found the *T. rex* so impressive that he knew he had to bring it back. So he orchestrated a fight between the velociraptors and the tyrannosaurus without putting any creatures in front of the cameras. The movements were much too complex to be executed by machines or by actors in costumes; everything had to be done on computers. Phil Tippett actually waved cardboard images of this or that animal around in front of the cameras in order to give them a sense of direction in the otherwise empty set. At this point in the shooting process, the crew was more comfortable with filming imaginary creatures. "After a while we shot those things as if we'd been into CGI for ten years,"[4] Spielberg said later.

On a Human Level

Not everything in the film was focused on special effects. First of all, the framing of the film is done at the height of the (human) characters. A brachiosaurus is seen from a vertiginously low angle, corresponding to the points of view of the two paleontologists in the film. The triceratops is gradually revealed through the grass, at the level of the children's eyes, which reinforces the terrifying feeling of the beasts' presence. Steven Spielberg also insisted on using typical camera movements, even though this complicated the responsibility of the computer graphics artists (such as the tracking shot that was done in the gallimimus race). Apart from preserving the director's creativity, this was a way of avoiding a break in his directorial style that might highlight

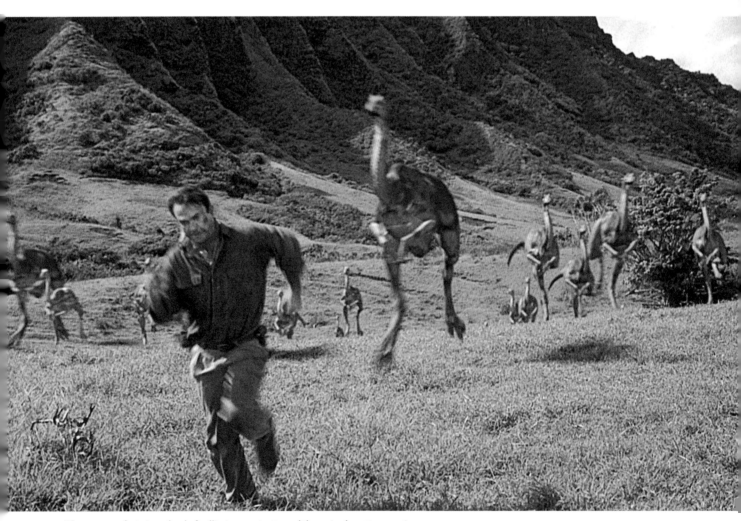

The sequence featuring a herd of gallimimus racing toward the main characters remains an iconic moment in the history of cinema, and of computer graphics in motion pictures.

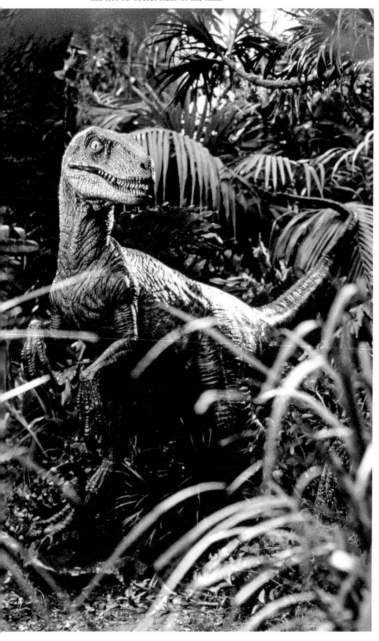

Along with the *T. rex*, velociraptors became the not-so-secret stars of the film.

three rooms full of computer servers to store all of their data. It took four months to animate the *T. rex* SUV chase scene, and the moment when the massive dinosaur smashes a tree trunk. The sound editors combined the sounds of owls, rattlesnakes, swans, cows, geese, walruses, and dolphins to bring the terrifying creature's piercing scream to life.

Spielberg in Poland

Starting in January of 1993, all this postproduction work was carried out without Steven Spielberg. The director was in Poland shooting *Schindler's List*. He had a hard time approving sequences of dinosaurs sent by satellite connection in the middle of filming a movie about the Holocaust. His mind was no longer on dinosaurs. To this day, critics and commentators continue to have difficulty explaining the massive swing between Spielberg's next two films following *Hook*, which were both destined to leave their mark on the world of cinema, but for very different reasons.

RECEPTION

On June 11, 1993, *Jurassic Park* was released in 2,404 cinemas across the United States; one thousand of those cinemas were equipped with the brand-new DTS (Digital Theater Systems) sound system that Spielberg had asked the studio to support.

A Hundred Million Dollars in Nine Days

The film quickly climbed to the top of the box office, grossing $50 million on its opening weekend and remaining number one for the next two weekends thereafter. It took only nine days for the film to exceed $100 million in revenue, a major feat at the time. Once again, a Steven Spielberg film was the top draw in the year of its release, coming in ahead of *Mrs. Doubtfire* (Chris Columbus, 1993) and *The Fugitive* (Andrew Davis, 1993). In Asia, Europe, and Australia, *Jurassic Park* broke previous box-office records. When box office tallies from all countries were combined, including the United States, the film's receipts totaled $914.6 million ($1.88 billion in 2023 dollars). The critics were unanimous on at least one point: The special effects were stunning. For *Rolling Stone*, they were works of art in and of themselves, and Stan Winston, Dennis Muren, Phil Tippett, and Michael Lantieri were the real stars of the film. "You won't believe your eyes,"[5] concluded the film's review. The English magazine *Empire* called it a miracle. The comments on the characters were also more or less the same everywhere: Alan Grant, John Hammond, and the others were only

the artificiality of the dinosaurs. Finally, many scenes were set at night, or in the rain, as a means of providing some cover for the computer graphics team. The darker scenes helped them mask any visual defects and prevented the spectator from distinguishing between computer images and real models. In the end, filming on *Jurassic Park* was completed twelve days ahead of schedule.

After filming ended, editor Michael Kahn got to work finishing a final cut of the film so that the ILM teams could place their computer-generated creatures into the empty shots. CGI generation can be an interminable process, and the ILM teams relied on

The first dinosaur that viewers see in *Jurassic Park* appears in broad daylight, and next to the actors. This was a major challenge for the production team!

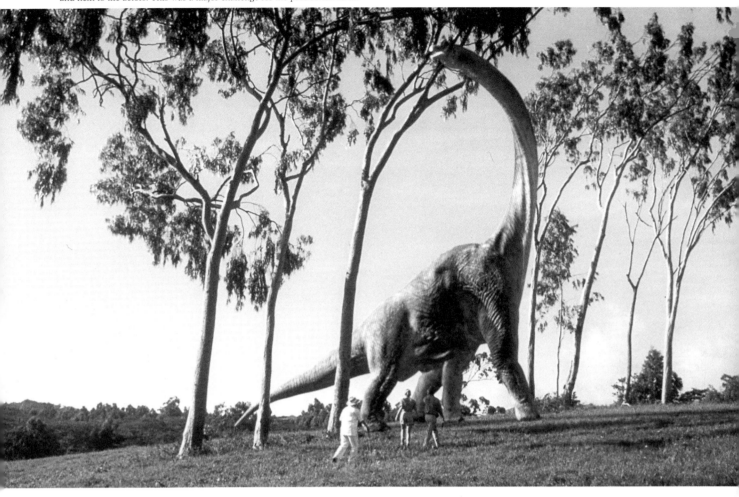

rough sketches characterized in broad strokes. "In fact, the monsters are far more convincing than the humans,"[5] *Variety* said in an otherwise enthusiastic review. Others noted the closeness of *Jurassic Park*'s structure to *Jaws,* and the resemblance of the velociraptors' stalking of the characters to *Aliens* (James Cameron, 1986). Among the most severe takes, the *Chicago Tribune* said that Michael Crichton's novel was already a recycling of the film *Westworld*, a movie he had written in 1973. That film focused on a theme park of Wild West robots that descends into chaos. In short: *Jurassic Park* lacked originality.

Intrigue Worthy of a Sitcom

The *New York Times* criticized Spielberg for watering down the tone of the book, and Roger Ebert of the *Chicago Sun-Times,* typically an inveterate defender of Steven Spielberg, was quite harsh. The plot around the theft of dinosaur embryos was, according to him, worthy of a sitcom, and he did not feel the same sense of wonder and amazement that usually permeates Spielberg's oeuvre.

The 1994 Oscars, in any case, affirmed the film's critical reception. The movie was nominated in three technical categories: Best Sound, Best Sound Editing, and Best Visual Effects. *Jurassic Park* won all three awards, but the film's director was not nominated.

FOR SPIELBERG ADDICTS

During preproduction on the film, a team went to New York to scope out the laboratory of renowned AIDS researcher Jeffrey Laurence. Hoping to get inspiration for *Jurassic Park*, the visitors were disappointed to find the lab contained no buttons, diodes, or other suitably scientific-looking devices. The film's laboratory was therefore built on a Universal soundstage in accordance with Hollywood's heightened sense of scientific realism.

Monster Movies
from the Monster Movie Emporium

Dracula, *Frankenstein*, *The Mummy*, and *Creature from the Black Lagoon* all brought glory to Universal Studios beginning in the 1930s. Steven Spielberg could not have found a better studio to start his career, as he had always been interested in classic monster movies. His most famous monster, the giant shark in *Jaws* (1975), was shown via underwater views reminiscent of *Creature from the Black Lagoon* (Jack Arnold, 1954). In *Ready Player One* (2018), everyone plays at being a monster, but this time in avatar form. But it is perhaps the child-sized world of *E.T. the Extra-Terrestrial* (1982) that features most terrible monsters of all: adults.

Jaws, 1975.

(above) *The Lost World: Jurassic Park*, 1997.
(right) *Poltergeist*, 1982.

Schindler's List

🏳 • 🕐 • 🎞 • 🔊 • ▭

United States 3 hrs 10 Black and Surround 1.85:1
white / Color (DTS)

Production Dates: March 1–May 11, 1993
United States Release Date: December 15, 1993
Release Date in France: March 2, 1994

Worldwide Box Office: $322 million ($645 million in 2023 dollars)

Production Company: Amblin Entertainment, Universal Pictures
Producers: Steven Spielberg, Branko Lustig, Gerald R. Molen, Lew Rywin
Co-Producer: Irving Glovin
Associate Producer: Robert Raymond
Executive Producer: Kathleen Kennedy
Unit Production Manager: Branko Lustig

Based on the book *Schindler's List* by Thomas Keneally (1982)
Screenplay: Steven Zaillian
Director of Photography: Janusz Kamiński
Assistant Directors: Sergio Mimica-Gezzan, Marek Brodzki
Film Editing: Michael Kahn
Music: John Williams
Sound: Andy Nelson, Steve Pederson, Scott Millan, Ron Judkins
Production Design: Allan Starski
Set Decoration: Ewa Braun
Hair Stylist: Judy Alexander Cory
Makeup: Christina Smith, Matthew Mungle
Costume Design: Anna B. Sheppard
Visual Effects: Gail Currey, Steve Price
Special Effects: Bruce Minkus

Starring: Liam Neeson (Oskar Schindler), Ben Kingsley (Itzhak Stern),
Ralph Fiennes (Amon Göth), Caroline Goodall (Emilie Schindler), Jonathan
Sagall (Poldek Pfefferberg), Embeth Davidtz (Helen Hirsh), Malgorzata
Gebel (Wiktoria Klonowska), Shmuel Levy (Wilek Chilowicz), Mark Ivanir
(Marcel Goldberg)

> ## "The list is an absolute good. The list is life. All around its margins lies the gulf."
>
> ___
>
> —Itzhak Stern to Oskar Schindler, in
> *Schindler's List*

SYNOPSIS

In 1940, the Polish town of Krakow was under German occupation and the Jewish community saw their living conditions becoming worse with each passing week. Oskar Schindler, a businessman of Sudeten origin and a member of the Nazi party, arrives in the town with the intention of deriving the maximum amount of profit from his new acquisition: the town's enamel factory. To this end, he presents himself to the local Wehrmacht and SS officers and is quite prepared to bribe them to advance his interests. He also engages a Jewish accountant, Itzhak Stern, who is influential within the community. He then explains his project to Itzhak: to find Jewish financiers and employees to start the factory. The financiers would have their money protected because it would be invested in the factory instead of being recovered by the army, and the employees would be granted the status of protected persons.

GENESIS

"I have your next movie. I'll send a messenger to your house." It was more or less with these words that the president of MCA, Sid Sheinberg, called Steven Spielberg on the phone in the fall of 1982. Intrigued, a few days later the filmmaker received a *New York Times* review of a book by an Australian author, Thomas Keneally, entitled *Schindler's List*.[1] The filmmaker, who at that time was relishing the triumph of *E.T.* at the American box office, was immediately stunned by the story of Oskar Schindler, a German businessman who, in the middle of the Second World War, succeeded in saving more than a thousand Polish Jews from the death camps by employing them in his factories after numerous negotiations with the Nazis. Spielberg was won over by the book. Almost as soon as the book had been awarded the prestigious Booker Prize, Universal had bought the rights.

"Buying Back" Jews

In August 1983, Spielberg met Poldek Pfefferberg, now Leopold Page after his postwar migration to California, where he opened a luggage store. It was Page who told Keneally—while selling him a case for his socks—about the horror of the Krakow ghetto and the murderous insanity of the commandant of the Plaszow labor camp, Amon Göth, who killed Jewish prisoners for making simple eye contact. Page also told the author about Schindler's famous list, which consisted of more than a thousand names typed on several sheets of paper, an unexpected insurance policy against almost certain death. Schindler "bought his Jews" on the grounds that they were indispensable to him as workers in his factories, and he spent every last mark he had to save as many people as possible. Ruined after the war, he was supported financially by the *Schindlerjuden*, the "Schindler Jews." In 1963, Pfefferberg even gave him $37,500 (about $342,000 today) after selling the story to MGM, though the film was never made. Schindler died in 1974 at the age of sixty-six and was buried on Mount Zion in Jerusalem. When Pfefferberg finished telling the story to Spielberg, he asked when filming would begin. "Ten years from now," Spielberg replied with a big smile.

Confront the Holocaust

The filmmaker knew that he was not ready to deal with such a serious subject, which stirred up so many feelings within him. Although Spielberg is Jewish, it is an understatement to say that he found it difficult to come to terms with this fact. It was an intimate conflict that began in childhood. In 1950s America, the trauma of the Holocaust was terribly alive within the Jewish community—the *Shoah*, or rather "great murders," in the words of the director's grandmother, who refused to use the Hebrew term or the word "holocaust." It was on her wrist that Spielberg discovered a strange succession of tattooed numbers without knowing what this terrifying mark signified. His father estimated that between sixteen and twenty members of their family had lost their lives in the camps of Ukraine and Poland. During his childhood and adolescence, the young Steven experienced his Jewishness as something that separated him from other people. He wanted to be like the other boys of his age—to celebrate Christmas, to blend in with the masses—but religion regularly reminded him that he was different. Slowly, a reconciliation between the director and his faith took place in the middle of the 1980s. After the birth of his first child, Max, the typical religious rites were followed, and when his future wife, Kate Capshaw, insisted on converting to Judaism before their wedding in 1991, Spielberg was deeply touched.

The real Oskar Schindler (1908–1974).

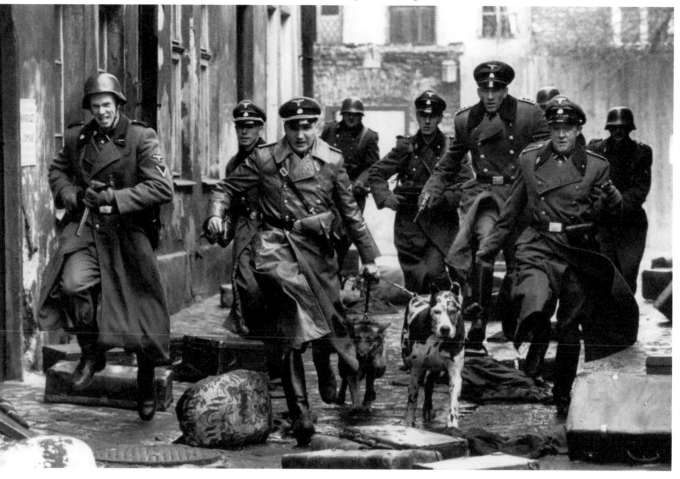

With a terrifying exuberance, Amon Göth took the lead in "cleansing" the Krakow ghetto.

Ten Years of Hesitation

Over the course of ten years, *Schindler's List* passed from hand to hand while waiting for Spielberg to develop the idea into a feature film. Thomas Keneally was asked to write the first script. The 220-page copy he handed in was judged harshly by the filmmaker; too much prominence was given to secondary characters. Keneally was succeeded by journalist Kurt Luedtke, who had just won the Oscar for Best Adapted Screenplay for *Out of Africa* (Sydney Pollack) in 1986. Luedtke spent three and a half years trying to make Schindler's "conversion" to the Jewish cause credible—without success, according to Spielberg, who in the meantime submitted the project to Roman Polanski. As a child, the Polish filmmaker lived in the Warsaw ghetto, and lost his mother and grandmother at Auschwitz. For him, the wounds were still raw and he declined. Billy Wilder offered his services: The older director had lost most of his family at Auschwitz and considered it his duty to make this project his last film. However, Spielberg had another person in mind. According to him, the ideal filmmaker for *Schindler* was his friend Martin

Scorsese. Scorsese would be able to take on such a heavy subject without any mawkishness or watering down. But almost as soon as "Marty" accepted, Spielberg regretted letting go of the film; he felt he was failing in his duty. He then offered Scorsese a remake of *Cape Fear*, which he was about to produce, and so Spielberg got *Schindler* back.

Scorsese had commissioned a new script from Steven Zaillian. Spielberg took a look at the 115-page script and pointed out a problem of perspective: Zaillian had made Schindler the central character of the film while forgetting the others. Another problem: The script only gave two pages to the liquidation of the Krakow ghetto. Zaillian and Spielberg went to Poland for a few days to give more soul to Zaillian's work. When he turned in his revised script, it was 195 pages long. While the plot was becoming clearer, the director was still hesitating about moving forward. His decision was made one evening in 1991 on the set of *Hook*. He was rereading Zaillian's script, which he had not looked at in a year, and he announced to his wife that *Schindler's List* would be his next film.

Begged to Film in Color

While Kate Capshaw was delighted that Steven was taking on the film, Universal was a little less encouraging. One of the studio's executives even tried to dissuade Spielberg by offering to make a donation to the future Holocaust Memorial Museum in Washington (which opened in 1993). When Tom Pollock, the studio's then boss, learned that Spielberg wanted to shoot the film in black and white, and that he wanted to use a young, almost unknown Polish director of photography named Janusz Kamiński, he begged him to film in color and then to transfer the film to black and white so that a color version could be shown on television and released on video cassettes. Pollock also criticized the lack of a single cathartic moment in the script, a scene that would clearly mark Schindler's realization of the awful fate of the Jews. The director stood his ground. In return, he accepted a reduced budget of $22 million ($46 million in 2023 dollars) and refused to accept a salary; he felt that being paid to make such a film was inappropriate. As a supporter of the project, MCA president Sheinberg went along with the plan, adding his own small condition: that Spielberg would first shoot *Jurassic Park*, with its monstrous economic potential.

CASTING

From the beginning of the casting process, Spielberg focused on finding Itzhak Stern. In the script, this character is a Jewish accountant who instigated the list and became central to the story. For the director and the screenwriter, he was the most difficult character to write, to the point of modifying the historical reality somewhat in order to make him the one who opens the eyes of the industrialist and sets the rescue plan in motion. Ben Kingsley, an English

actor who won an Oscar in 1983 for his portrayal of Gandhi in Richard Attenborough's film of the same name, was the director's second choice. He first offered the role to Dustin Hoffman and was turned down, which the actor would later regret.

Another English actor was chosen for the role of Amon Göth. The director spotted Ralph Fiennes in a TV movie about Lawrence of Arabia and decided to test him for the part: "Ralph did three takes," he recalled in an interview with Richard Corliss. "I still, to this day, haven't seen Take 2 or 3. He was absolutely brilliant. After seeing Take 1, I knew he was Amon. [In Fiennes's eyes] I saw sexual evil. It is all about subtlety: there were moments of kindness that would move across his eyes and then instantly run cold."[2] Fiennes gained thirty pounds for the part to help make him look even more like the real-life monster.

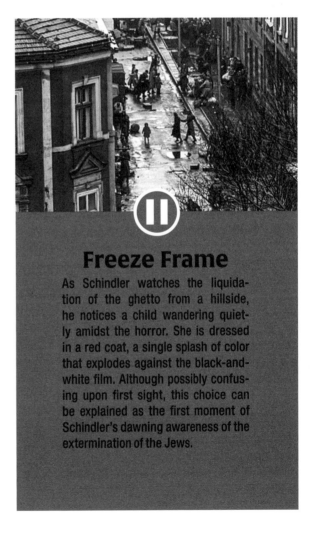

Freeze Frame

As Schindler watches the liquidation of the ghetto from a hillside, he notices a child wandering quietly amidst the horror. She is dressed in a red coat, a single splash of color that explodes against the black-and-white film. Although possibly confusing upon first sight, this choice can be explained as the first moment of Schindler's dawning awareness of the extermination of the Jews.

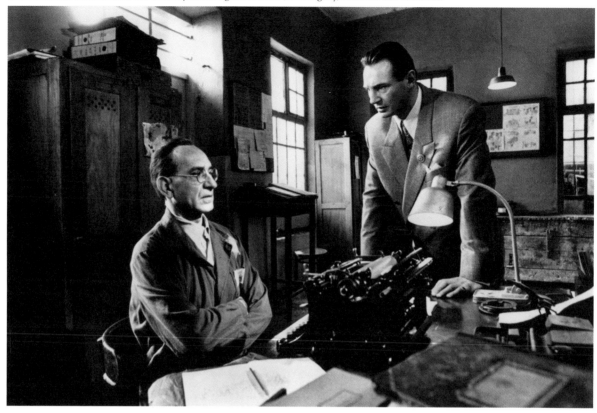

Oskar Schindler (Liam Neeson) had difficulty reassuring Itzhak Stern (Ben Kingsley) about his true intentions.

Costner, Gibson, and Beatty

When the information circulated around Hollywood that Spielberg was finally taking on the adaptation of Keneally's book, many actors expressed their desire to play the main character. Rumors suggested Kevin Costner or Mel Gibson were up for the part, as was Warren Beatty. However, Spielberg had a clear idea of what he wanted: a solid but not too well-known actor, whose fame would not interfere with the project. He had a model in mind, a bit incongruous: his good friend Steve Ross, the head of the Warner studio—a matter of physical presence, a man of stature. When Spielberg chose Liam Neeson for the role, he gave him a lot of photos and personal videos to help him get a feeling of who Ross was. Neeson's casting was the happy conclusion to a relationship that began during *Empire of the Sun*. At that time, the Northern Irish actor was struggling to establish a career in Hollywood despite bit parts in *Excalibur* (John Boorman, 1981) and *The Mission* (Roland Joffé, 1986). He was hired to read opposite actors during auditions for the role of Jim Graham on *Empire of the Sun* but was not cast himself. A few years later, the actor passed several tests for Schindler, and he finally convinced the director during an evening at the theater, when

Spielberg was attending a performance of *Anna Christie* on Broadway with his wife and mother-in-law in December 1992. Backstage, Neeson gave Spielberg's mother-in-law a long hug, and she was full of praise for his performance. On the way out, Kate remarked to her husband that Neeson had behaved exactly as Schindler would have if he had been in that situation. Steven had found his Oskar.

FILMING AND PRODUCTION

The day after the last performance of *Anna Christie*, Liam Neeson took the plane to Krakow. After two days of fittings, he arrived in Auschwitz and discovered the set established right next to the camp. Branko Lustig, one of the producers, approached him and pointed to the barracks in which he himself was imprisoned. Shocked to the point of forgetting his lines, Neeson understood that this production would not be like any other.

Robin Williams' Jokes

As for Spielberg, he thought he was prepared for the shock of filming. He had already been to Auschwitz during preproduction, where he was surprised to find that he did not cry; instead he just felt immense anger. Along with Kamiński, they agreed on a film style that would look slightly like a

documentary, with the most natural lighting possible, a handheld camera, and the deliberate nonuse of cranes and dollies. Before shooting, preparation was reduced to a minimum, and the filmmaker did not create storyboards. He filmed quickly, as if in a hurry; sometimes the team would produce about forty shots in a day. And in the evening, he broke down. He broke down in front of Kate, who had moved to Krakow with him and their five children during the production. His parents and his rabbi came to see him regularly. Every week, his friend Robin Williams called him and gave him a "survival pack" of jokes. He also received videotapes of *Saturday Night Live* episodes to keep his spirits up. Three nights a week, Spielberg isolated himself and worked on the postproduction of *Jurassic Park*, which finished shooting on November 30, 1992. Since the beginning of shooting *Schindler* on March 1, 1993, George Lucas had managed the finalization of *Jurassic Park*, but everything still had to be approved by Spielberg. John Williams also made him listen to the progress on the dinosaur film's soundtrack as it was being completed.

A Not-So-Distant Past

Feeling discombobulated from all the toggling back and forth between *Jurassic Park* and *Schindler's List*, the filmmaker felt an increasingly enormous weight on his shoulders: a technical weight (*Schindler's List* had 126 speaking roles and thirty thousand extras, a team of 210 people and 148 sets spread over thirty-five locations, all of which was happening in the middle of winter), but above all a psychological weight. Spielberg wanted to film as much as possible at the scene of the tragedy. In the streets of Krakow and Plaszow, the ghosts of a not-so-distant past wandered around: In the morning, it was not unusual for the crew to come across freshly painted swastikas on the walls of the city, and Ralph Fiennes would long remember the lady who, from her balcony, called out to him to tell him what a fine uniform he was wearing. One night, a German businessman mimed putting a rope around his neck in front of a Jewish actor in a hotel bar and Kingsley read him the riot act. It was an emotionally charged set, and some scenes were harder to shoot than others. After the so-called shower scene, when the employees

Making a deal with the devil: To get what he wants, Schindler shares a drink with Göth.

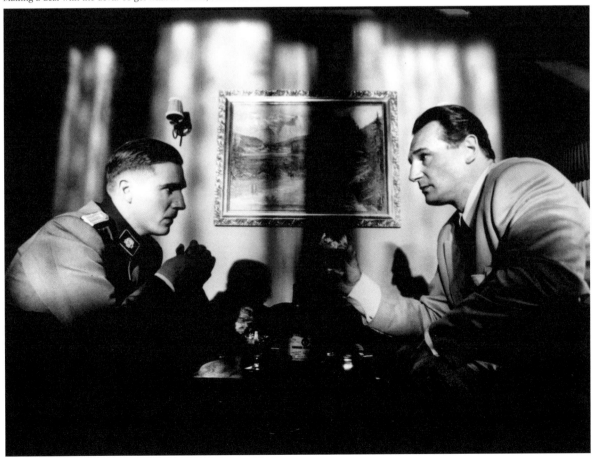

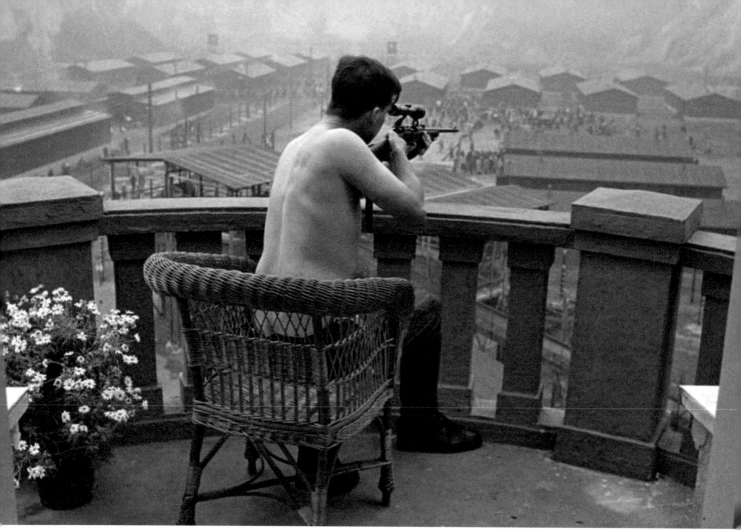

On the terrace of his house, a bored Göth entertains himself by killing prisoners at random.

believed they were being gassed at Auschwitz only to discover water coming out of the showerheads, two young Israeli actresses had to take three days off before they could work again. The scene of the selection process, where the prisoners of Plaszow are stripped and sorted according to their physical ability, was also difficult to contemplate, let alone film. The vision of bodies running in the mud while soldiers laughed was unbearable for the director, who had to look away. For many years, Spielberg spoke of this as the most traumatic moment of his entire career.

Problems with the Uniform

From the beginning of filming, Spielberg had difficulty with the German uniform, especially since the soldiers were played by German and Austrian actors. When the actors spoke to him between takes about *E.T.* or *Jaws*, the filmmaker found it difficult to suspend his own disbelief. The turning point came during the celebration of Passover. Cast in Israel, the Jewish actors and extras (some of whom had actually lived through Schindler's story) were surprised to

see the German-speaking actors arrive to celebrate, mingling with them to read the *Haggadah*. Three-quarters of the way through the film, Spielberg was plagued by a new anxiety: that of not being believed by an audience accustomed to his fantastical stories. He came up with the idea of ending the film with a parade of actors accompanied by survivors in front of Schindler's tomb in Jerusalem, a scene that was not in the script: "It was a desperate attempt from me to find validation from the survivor's community itself. To be able to certify that what we have done was credible."[3]

RECEPTION

Schindler's List was released in the United States on December 15, 1993, almost six months to the day after *Jurassic Park*. It received a rave reception from the press: "This is the film to win over Spielberg's skeptics,"[4] Todd McCarthy wrote in *Variety*.

Lanzmann's Judgment

Nevertheless, some dissenting voices could not fail to be heard. Many criticized the director's bias in certain scenes (the little girl in the ghetto whose

The mechanics of horror: Göth needs a servant, whom he selects from among the female prisoners.

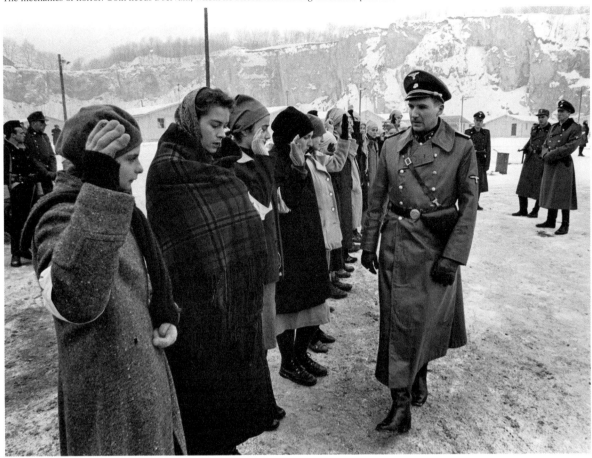

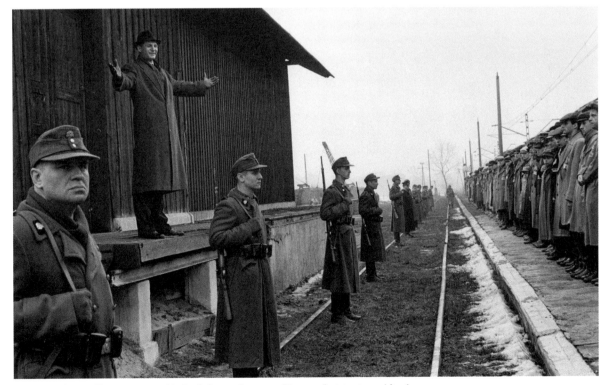

Schindler welcomes "his" prisoners to his Czech factory. For many, this was a first step toward freedom.

red coat bursts against the black and white of the rest of the film, the shower scene, the final meditation on Schindler's grave), considering them to be in bad taste in such a grim context. In Europe, the critical debate was intense. The most vociferous was a filmmaker, Claude Lanzmann. A journalist and member of the Resistance at the age of eighteen, Lanzmann authored the landmark documentary on the Holocaust, *Shoah*: It took twelve years of work for him to create a nine-hour film made up

of testimonies without archival footage—just the accounts of survivors, their descendants, or their executioners. In a scathing article published in *Le Monde,* he attacked Spielberg's film. As the author of a "kitsch melodrama," the American director had, according to Lanzmann, "trivialized" the Holocaust. "What I criticize Spielberg for fundamentally, is showing the Holocaust through a German. Even if he saved Jews, it completely changes the approach to history. It is the world upside down. [...] I have a sense that he made an illustrated *Shoah,* he put in images where there are none in the *Shoah,* and images kill the imagination. [...] I thought that after the *Shoah,* a certain number of things could no longer be done. But Spielberg did it."[5] In the pages of *Cahiers du Cinéma,* Camille Nevers responded to "the vexed and dogmatic discourse of Claude Lanzmann": "*Schindler's List* is the image of the survivors' stories; what we do not forgive Spielberg for is precisely putting them into images. Just as he did not make a film about Auschwitz, at no time does the filmmaker put images on the Holocaust. [...] *Schindler's List* has much more to do with the parable, or the tale, a biblical parable in many ways identical to that of Noah's Ark. [...] Rather than the images of the Apocalypse, Spielberg gives us the story of a

FOR SPIELBERG ADDICTS

During the preparation of the film, the World Jewish Congress, obviously apprehensive about the potential "Hollywood" character of the project, forbade the production team from filming at Auschwitz itself. Nevertheless, Spielberg found a solution by building a replica of the camp attached to the real one.

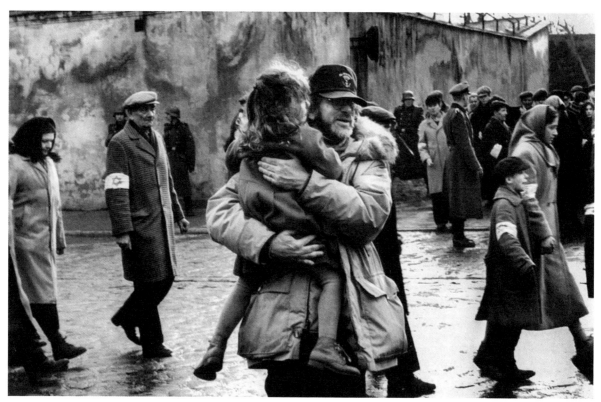

For Spielberg, filming *Schindler's List* was the most demanding experience of his entire career.

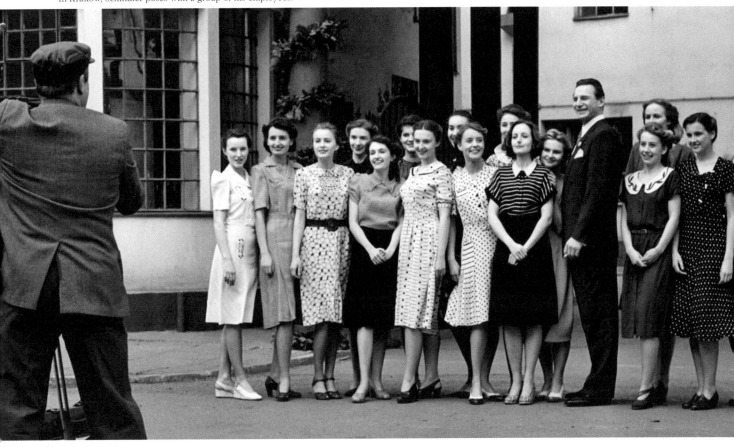
In Krakow, Schindler poses with a group of his employees.

genesis."[6] Far from these critical debates, the film's reception by the public surpassed all expectations. In the North American market, it earned $96 million ($192 million in 2023). Worldwide, it earned $322 million ($646 million today). *Schindler's List* was endorsed by most political leaders, and President Bill Clinton encouraged Americans to see the film.

Consecration at the Oscars

On March 21, 1994, another form of recognition crowned Spielberg's career as a director thus far—twenty years after the release of his first feature film. That evening, after years of disappointment, Spielberg finally received the Oscar for Best Director. The film won six other statuettes (Best Film, Adapted Screenplay, Music, Artistic Direction, Editing, and Photography) out of twelve total nominations. Onstage accepting his award while on the verge of tears, he particularly thanked his wife "for rescuing me ninety-two days in a row in Krakow, Poland, last winter, when things just got too unbearable."[7]

Ninety-Two Days to Transform a Man

For Spielberg, there is before *Schindler* and there is after *Schindler*. In *Empire of the Sun*, the filmmaker looked at the chaos of the world through the eyes of a child. The character of Oskar Schindler now made him look at the state of the world as an adult: There was no longer a question of turning his head away, but of taking responsibility as a man and also as a filmmaker. It is true that Spielberg did not live through the Shoah as Polanski did, but he felt its horror. In the film, it is mostly lurking off-screen: The work says as much about the survivors as it does about the dead who haunt them. A few months after the film's release, with the money he earned from his percentage of the film's profits, Spielberg created the Survivors of the Shoah Visual History Foundation. The institution interviews and preserves the stories of survivors and witnesses of the Holocaust and genocides from around the world. In the first three years of its existence, nearly fifty thousand testimonies were collected. "I was so ashamed of being a Jew, and now I'm filled with pride. [...] This film has kind of come along with me on this journey from shame to honor. My mother said to me one day, 'I really want people to see a movie that you make someday that's about us and about who we are, not as a people but as people.' So this is it. This is for her."

Schindler's List
A Controversial Sequence

This sequence, which depicts the arrival of Schindler's employees at Auschwitz, is the most controversial moment in Spielberg's work. Shaved (1), then stripped naked, these women know that Jews are gassed in the camps. Fear and terror can be seen on the faces of the actors, whom the camera captures as closely as possible (2). When the doors of the "disinfection" room open, the camera rushes in with the prisoners, as if caught in the crush (3). A brief moment of respite before the doors close (4). The camera is then positioned at the peephole to observe the fate of the captives held inside (5): The shot places the viewer in the role of a voyeur. From this point on, the setting of the scene is cut in such a way as to generate an unbearable feeling of suspense. The camera is again inside the shower room. The light goes out for a moment, eliciting frightened cries. The editing alternates between close-ups of the victims and the showerheads (6 and 7) before returning to a general wide shot. After a tense few moments, water flows from the showerheads, one after the other (8), causing cries and shouts of joy (9). The viewer is both relieved and circumspect, for even though the anecdote is authentic (Schindler's employees were not gassed), one has the feeling of having been fooled, or forced into expecting a deadly conclusion. Did the filmmaker play with our expectations, or decline to show that which could not be shown? Outside, after the shower, a prisoner watches new arrivals entering the building (10 and 11). The camera rises to the chimney above, which is spewing thick smoke as ashes mingle with the snow (12). It's another scene of suggestive horror.

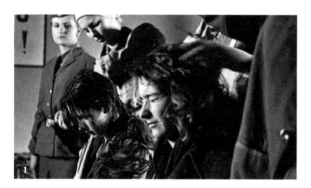

A STEVEN SPIELBERG FILM

THE LOST WORLD
JURASSIC PARK

SOMETHING

HAS

SURVIVED

UNIVERSAL PICTURES PRESENTS AN AMBLIN ENTERTAINMENT PRODUCTION "THE LOST WORLD: JURASSIC PARK" JEFF GOLDBLUM JULIANNE MOORE PETE POSTLETHWAITE
ARLISS HOWARD LIVE ACTION DINOSAURS STAN WINSTON FULL MOTION DINOSAURS DENNIS MUREN A.S.C. SPECIAL DINOSAUR EFFECTS MICHAEL LANTIERI MUSIC BY JOHN WILLIAMS FILM EDITOR MICHAEL KAHN A.C.E. PRODUCTION DESIGNER RICK CARTER
DIRECTOR OF PHOTOGRAPHY JANUSZ KAMINSKI A.S.C. EXECUTIVE PRODUCER KATHLEEN KENNEDY BASED ON THE NOVEL "THE LOST WORLD" BY MICHAEL CRICHTON SCREENPLAY BY DAVID KOEPP PRODUCED BY GERALD R. MOLEN AND COLIN WILSON

 PLAY THE PLAYSTATION GAME FROM DREAMWORKS INTERACTIVE www.lost-world.com DIRECTED BY STEVEN SPIELBERG A UNIVERSAL PICTURE

TM & © 1996 UNIVERSAL CITY STUDIOS, INC. AND AMBLIN ENTERTAINMENT, INC.

The Lost World: Jurassic Park

United States **2 hrs 9** **Color** (DeLuxe) **Surround** (DTS) **1.85:1**

Production Dates: September 4–December 11, 1996
United States Release Date: May 23, 1997

Worldwide Box Office: $618.6 million ($1.14 billion in 2023 dollars)

Production Company: Universal Pictures, Amblin Entertainment,
Digital Image Associates
Producers: Gerald R. Molen, Colin Wilson
Associate Producer: Bonnie Curtis
Executive Producer: Kathleen Kennedy
Production Supervisor: Peter M. Tobyansen

Based on the novel *The Lost World* by Michael Crichton (1995)
Screenplay: David Koepp
Director of Photography: Janusz Kamiński
Film Editing: Michael Kahn
Music: John Williams
Sound: Ron Judkins, Robert Jackson
Sound Effects: Richard Hymns
Production Design: Rick Carter
Art Direction: Lauren E. Polizzi, Paul Sonski, William James Teegarden
Mechanical Special Effects: Stan Winston (animatronics), Michael Lantieri,
Miguel A. Fuertes (animation)
Visual Effects: Dennis Muren, Randal M. Dutra
Second Unit Directors: David Koepp, David B. Nowell (aerial team)

Starring: Jeff Goldblum (Ian Malcolm), Julianne Moore (Sarah Harding),
Pete Postlethwaite (Roland Tembo), Arliss Howard (Peter Ludlow), Vince
Vaughn (Nick Van Owen), Richard Schiff (Eddie Carr), Peter Stormare
(Dieter Stark), Harvey Jason (Ajay Sidhu), Vanessa Chester (Kelly Curtis),
Richard Attenborough (John Hammond), Thomas F. Duffy (Dr. Robert Burke),
David Koepp (customer in video store eaten by *T. rex*)

> "This is magnificent!— Oh yeah. 'Ooh,' 'ahh'... That's how it always starts. But then later, there's running and then screaming."
>
> —

—Dialogue between Eddie Carr and Ian Malcolm in front of a herd of stegosaurus, in *The Lost World: Jurassic Park*

SYNOPSIS

———

Four years after Isla Nublar was ravaged by genetically re-created dinosaurs, the Bowman family arrive on a beach on nearby Isla Sorna. Their daughter wanders off and is attacked by small prehistoric creatures that have sprung from the bushes: Compsognathidae. She is rescued just in time. Thousands of miles away, researcher Ian Malcolm visits John Hammond, the creator of Jurassic Park and founder of the company InGen. He reveals that Sorna Island was used as "Site B," the place where dinosaurs were made and raised before being placed inside Jurassic Park. The animals live there in the wild, in an ecosystem that has found its balance, without human intervention. John Hammond wants to preserve this place as it is, but his nephew Peter Ludlow has taken control of InGen. Ludlow's ambition is to exploit the monetary value of the dinosaurs. Ian Malcolm is invited to go to Sorna to report on the situation and support John Hammond. He agrees when he learns that Sarah Harding, his paleontologist companion, is already there. Convinced that the situation on the island will inevitably get out of hand, Malcolm travels with another scientist, Eddie Carr, and a photographer, Nick Van Owen, in the hopes of convincing Sarah to return home.

GENESIS

Michael Crichton had no intention of writing a sequel to *Jurassic Park*, but under pressure from his readers, the idea gained traction. On his side, Steven Spielberg wanted to produce a second film, but not without the support of a book written by the writer.

Dinosaurs in the Wild

Michael Crichton gave his book *The Lost World* the same title as Arthur Conan Doyle's 1912 novel about dinosaurs living on a high plateau in South America. While Crichton's prehistoric animals were re-created by genetics, they were also evolving in the wild and no longer living in a theme park under human control…and this idea delighted Steven Spielberg. The filmmaker started working on the film even before the book was published, in September 1995. He had no intention of following the plot. Moreover, he drew a number of events from the first novel (the attacks of Compsognathidae, for example). The plot relating to the ambitions of John Hammond's nephew is also entirely unique to the film. Spielberg again entrusted the script to David Koepp, explaining that it should focus on the conflict between "hunters" (Peter Ludlow's expedition to capture animals) and "gatherers" (the scientists). *The Lost World: Jurassic Park* is therefore immediately characterized as an action film, with more violence and more dinosaurs than its predecessor.

A Robotized Baby *T. rex*

Most of the *Jurassic Park* team signed on for the sequel. Paleontologist Jack Horner was a consultant, Industrial Light & Magic (ILM) did the CGI, and Stan Winston built the animatronic beasts. Winston even made two elaborate eight-ton *T. rex*es, a baby stegosaurus, and a new technical feat: a robotic baby *T. rex* that was totally autonomous and operated without any external mechanism. It could be carried by the actors like a real animal. Visually, the new dinosaurs had to remain consistent with the original *Jurassic Park*, to create continuity (the *T. rex*es were cast from the same molds), but in many ways, the two films are at odds with each other.

CASTING

The Lost World: Jurassic Park had many more characters than its predecessor, and the climax involved lots of large crowd movement. The cast can be divided into two distinct groups.

The "Gatherers"

Richard Attenborough reprised his role as John Hammond for two scenes, and Jeff Goldblum once again played Ian Malcolm. The jaded scientist offers brief moments of humor in a film that is otherwise quite sinister. Additionally, Malcolm joins the long list of bad Spielbergian fathers owing to his complicated relationship with Kelly, his daughter. The

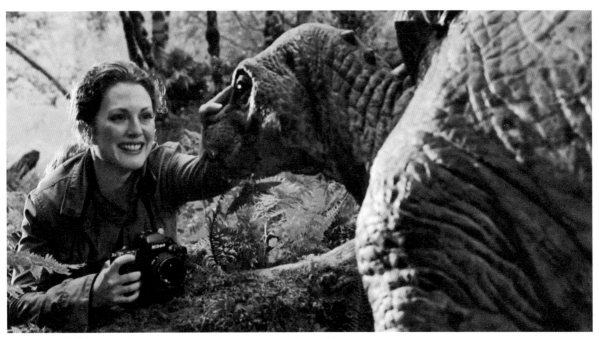

Sarah Harding (Julianne Moore) meets a stegosaurus in a moment reminiscent of the children interacting with brachiosauruses during the first film, *Jurassic Park*.

The Shaving Cream Mystery

In the original *Jurassic Park*, a can of shaving cream containing dinosaur embryos is lost in the jungle. However, neither *The Lost World* nor the following films exploit this plot element. It is only ever found in the video game *Jurassic Park: The Game* (2011). This apparent oversight has become a fan obsession. In June 2020,[1] an astonished David Koepp clarified things: The can of shaving cream was permanently lost. Neither he nor Spielberg ever considered resurrecting it.

twelve-year-old actress who played her, Vanessa Lee Chester, was spotted by the director at the premiere of *A Little Princess* (Alfonso Cuarón, 1995), in which she played a supporting role. "As I was signing an autograph for him [sic], he told me one day he'd put me in a film,"[2] the actress said in 2017. Already approached for *Jurassic Park*, French actress Juliette Binoche declined the role of paleontologist Sarah Harding. She explained in 2016 that she lamented the absence of strong female characters in Spielberg films.

Julianne Moore then accepted the role; meanwhile, Steven Spielberg also discovered Vince Vaughn in *Swingers* (Doug Liman, 1996), where he played his first leading role. The filmmaker saw this comedy before its release to approve the use of the *Jaws* theme in a scene where a character played by Vaughn stalks a girl at a party. In *The Lost World*, Vaughn's character (Nick Van Owen) explains that he wrote a story for Greenpeace for the sole purpose of meeting women.

The "Hunters"

Jurassic Park lacked traditional "villains": Peter Ludlow fulfills this function in *The Lost World*. Gary Oldman was not available for the part, so Arliss Howard played the character with a startling coldness. The actor also appeared in *Amistad* seven months later. The hunter, Roland Tembo, was played by dry and enigmatic Englishman Pete Postlethwaite. Postlethwaite worked extensively in British television before making his mark via *In the Name of the Father* (Jim Sheridan, 1993) and *The Usual Suspects* (Bryan Singer, 1995). The Swedish actor Peter Stormare had just appeared as a psychopathic brute in *Fargo* (Joel and Ethan Coen, 1996) and here he plays the scarcely more likable Dieter Stark, Roland Tembo's right-hand man. The hunters also have their paleontologist: Robert Burke. With his beard and cowboy

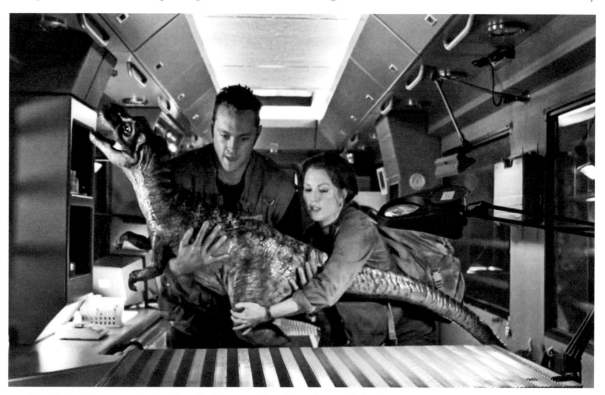

Somehow, Sam Winston managed to top himself in the construction of the animatronic baby *T. rex*.

In the grand tradition of sequels, *The Lost World: Jurassic Park* tried to outdo its predecessor with two tyrannosaurs instead of one.

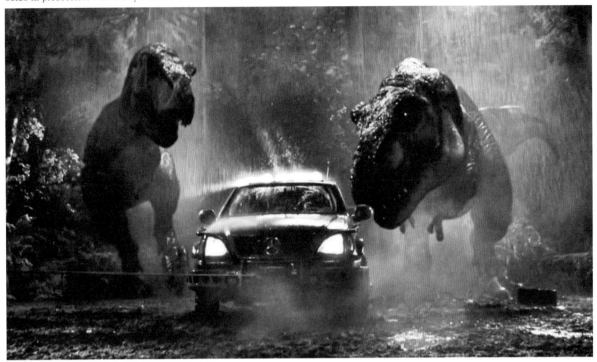

hat, he is a replica of Robert T. Bakker, the famous dinosaur specialist who was also a consultant on *Jurassic Park* alongside Jack Horner.

FILMING AND PRODUCTION

The atmosphere of *The Lost World* is that of a world that has gone back to nature, and it's very different from the original *Jurassic Park*. While some passages were filmed in Hawaii as in the first film, the natural settings were mostly shot in the redwood forests on the Pacific coast of Northern California.

The Look of a War Film

As director of photography, Janusz Kamiński created a "moody feeling"[3] based on fog, night, and humidity. *The Lost World* even looks like a war film (the InGen expedition, the abandoned buildings of Site B, etc.). The team used Stan Winston's robotic dinosaurs as much as possible as a way of adding authenticity to the creatures and their interactions with the actors. As in *Jurassic Park*, CGI was used for more complex movements. The herd of stegosaurus, the large pack of creatures that are stalked by the hunters, and the *T. rex* roaming San Diego were all added in post-production. Stan Winston's two tyrannosaurs, however, were so heavy that they remained at Universal Studios. The sets were built around them, dismantled, and then replaced by other sets according to whatever scene was being shot! In one scene, the *T. rex* memorably shoves its snout through a waterfall

in pursuit of its prey. To capture this shot, special effects supervisor Michael Lantieri created a mobile waterfall. It could be filmed from different angles and moved as needed. In any case, the new tyrannosaurs proved to be much more powerful than the original creations from *Jurassic Park*: They could demolish a vehicle and catch fleeing stuntmen for real, without any CGI.

Rampage

For the film's climactic scene, set inside a mobile laboratory that's suspended perilously above a steep drop-off, the lab was hooked up to a crane on Universal's set 27. It was also filmed outside, against the studio's parking lot, which had been redecorated as a cliff to capture the overall background views. Steven Spielberg always wanted to end the film by dropping a *T. rex* into a city, as a nod to *King Kong* (Merian C. Cooper and Ernest B. Shoedsack, 1933), *Godzilla* (Ishirô Honda, 1954), and *Gorgo* (Eugène Lourié, 1961), in which a huge monster in search of its offspring ravages London. To differentiate *The Lost World* from movies of the past, the idea was eventually discarded during preproduction in favor of a finale set back on the island and featuring flying dinosaurs. In the end, however, the director eventually returned to his original concept and orchestrated a real rampage scene set in the streets of Burbank and Granada Hills, in the northern suburbs of Los Angeles, which stood in for San Diego. In December

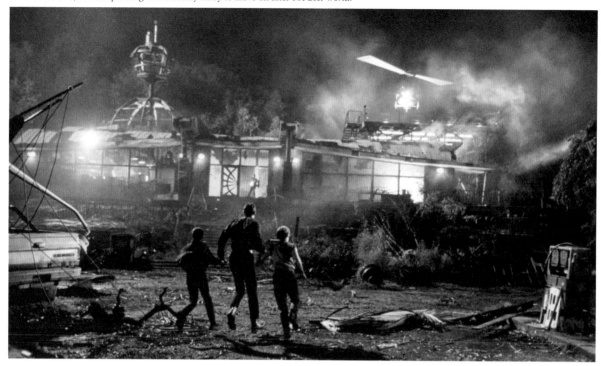

Darker and more violent, this second *Jurassic Park* presents apocalyptic visions (here, the old buildings of site B from the original film). *On the right*: Having been fascinated by dinosaurs since childhood, Steven Spielberg was officially ready to move on after *The Lost World*.

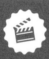

FOR SPIELBERG ADDICTS

A year before filming began, seven acres of sugarcane were planted so the sugarcane could be used in a velociraptor attack sequence.

1995, the shooting of *The Lost World* was completed nine days ahead of schedule.

RECEPTION

The Lost World: Jurassic Park was released in over three thousand cinemas worldwide, and it generated $72 million in its first weekend. In 2001 it was only topped by *Harry Potter and the Sorcerer's Stone* (Chris Columbus). On its seventh day of release, *The Lost World* passed the symbolic $100 million mark. However, the film has never quite reached the heights that were achieved in the original *Jurassic Park*.

The Temptation of a Lucrative Sequel

As for the reviews, they were similar to those from the first film: The dinosaurs were amazing, but the characters were just stereotypes, "scripted to do stupid things so that they can be chased and sometimes eaten by the dinosaurs,"[4] argued the *Chicago Sun-Times*. The sequence in San Diego impressed nobody.

Some even suspected that the director shot it to pull the rug from under the feet of the American remake of *Godzilla*, which was scheduled to be released in 1998. *Empire* magazine conceded the "genius"[5] of the velociraptor attack scene in the tall grass, but for the rest of the film, the critics did not mince their words. They were disappointed that Spielberg gave in to the temptation to create a lucrative sequel.

A More Serious Problem

The critics also pointed out the total lack of fascination and surprise on the faces of the actors in the sequel. Steven Spielberg himself felt that this was the film's greatest mistake—all the characters knew what to expect and why they were there. In fact, there was an even more serious problem to contend with: The director realized while shooting that this kind of spectacular film did not suit him anymore. He didn't hide his growing sense of boredom, if not downright cynicism: At the beginning of the film, a scene cuts away from the screams of a terrified mother who has just discovered her daughter being attacked by dinosaurs. The camera quickly shifts focus to the yawning mouth of Ian Malcolm. In doing so, Spielberg mocked the suffering of a child—and this was coming from a director who had always been fascinated by the innocence of children! *The Lost World: Jurassic Park* is, in short, the work of a filmmaker who was in the process of moving to a new stage in his career.

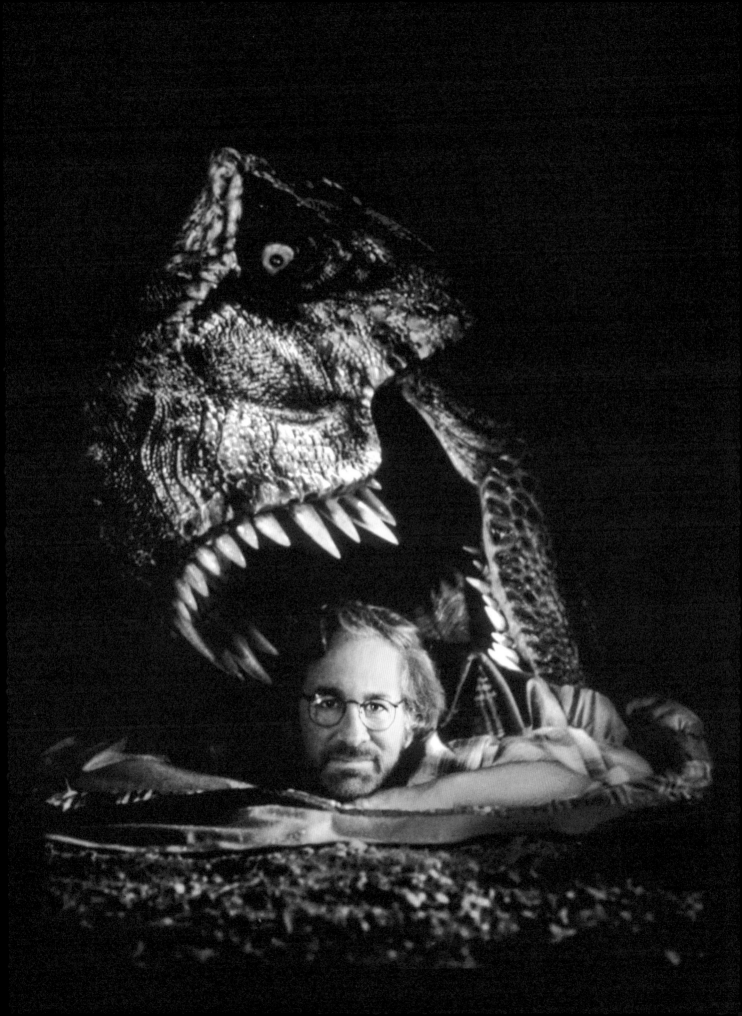

MORGAN **FREEMAN** ANTHONY **HOPKINS** DJIMON **HOUNSOU** MATTHEW **McCONAUGHEY**

"ABSOLUTELY
UNFORGETTABLE."
- Jeffrey Lyons, WNBC-TV

A STEVEN SPIELBERG FILM

AMISTAD

DREAMWORKS
HOME ENTERTAINMENT

Amistad

United States 2 hrs 9 Color (Technicolor) Surround (DTS) 1.85:1

Production Dates: February 18–April 30, 1997
United States Release Date: December 25, 1997

Worldwide Box Office: $67.5 million ($123 million in 2023 dollars)

Production: DreamWorks Pictures, HBO
Producers: Debbie Allen, Steven Spielberg, Colin Wilson
Co-Producer: Tim Shriver
Associate Producers: Bonnie Curtis, Paul Deason
Executive Producers: Walter Parkes, Laurie MacDonald
Executive Co-Producer: Robert Cooper
Production Managers: Paul Deason, Nannette Rosa Collazo

Screenplay: David Franzoni, Steven Zaillian (uncredited)
Director of Photography: Janusz Kamiński
Camera Operator: Mitch Dubin
Assistant Directors: Sergio Mimica Gezzan, Sean Hobin, Eric Jones
Film Editing: Michael Kahn
Music: John Williams
Sound: Charles L. Campbell, Louis L. Edemann, Doug Jackson, Ron Judkins
Production Design: Rick Carter
Set Decoration: Rosemary Brandenburg, Trish Luberti
Costume Design: Ruth E. Carter
Special Effects: Tom Ryba
Casting: Victoria Thomas

Starring: Morgan Freeman (Theodore Joadson), Nigel Hawthorne (Martin Van Buren), Anthony Hopkins (John Quincy Adams), Djimon Hounsou (Cinqué), Matthew McConaughey (Roger Sherman Baldwin), David Paymer (John Forsyth), Pete Postlethwaite (Holabird), Stellan Skarsgård (Lewis Tappan), Razaaq Adoti (Yamba), Abu Bakaar Fofanah (Fala), Anna Paquin (Queen Isabella), Tomas Milian (Calderon), Chiwetel Ejiofor (James Covey), Arliss Howard (John C. Calhoun), Jeremy Northam (Judge Coglin)

SYNOPSIS

—

With bleeding fingers, the slave Cinqué manages to tear off the nail that holds his chains. Freed, he unties his comrades and distributes makeshift weapons. The mutineers, who have been kidnapped and taken from their native Sierra Leone, leave the ship's hold and surprise the sleeping Spanish crew on deck. As sudden as it is violent, the slaves' revolt ends in carnage. Cinqué nevertheless spares the commander and his second in command, who are given the responsibility of taking them back to Africa. Without any knowledge of navigation, Cinqué realizes too late that he has been fooled by the navigators. While the ship is sailing off the American coast, it is boarded by the local navy. Now captured, the slaves are the object of much attention: The Queen of Spain claims ownership of them, while the American justice system wants to charge them with mutiny and murder. A white abolitionist named Lewis Tappan and his black associate, Theodore Joadson, are contacted by an ambitious young lawyer named Roger Sherman Baldwin, who believes he can get Cinqué and his friends acquitted.

GENESIS

The journey to making *Amistad* was a long one. After ten years of being turned down, actress, dancer, singer, and choreographer Debbie Allen was finally able to get the movie made with Steven Spielberg as the director.

A Mutiny and an Acquittal

Written by John Alfred Williams and Charles F. Harris, *Amistad 1: Writings on Black History and Culture* brings to light a completely forgotten event in the history of civil rights in the United States: In 1839, slaves shipped from Africa to America aboard the Spanish slave ship called *Amistad* revolted and killed most of the crew. Captured off the coast of Connecticut, they were the subject of a landmark trial in 1841, resulting in an acquittal and the affirmation of their right to justice and freedom. This was a first in a country that would eventually be torn apart by the Civil War twenty years later. Famed actress Debbie Allen quickly realized that this major event had been forgotten by history, even among members of the Black community. In 1984, she acquired the rights to another book, *Black Mutiny: The Revolt on the Schooner Amistad*, by William A. Owens (published in 1953) and decided to bring it to the screen. Unfortunately, Allen struggled to find a director willing to bring the project to life. Emerging African

American filmmakers like Spike Lee and John Singleton knew about the story but didn't believe they'd be able to get the financing required to make the film. What studio would be willing to spend millions of dollars on a movie made by Black people about Black people?

Twenty-Five Minutes, and Not a Moment Longer

Undeterred, Allen shifted gears. In 1993, *Schindler's List* was a revelation: Only Spielberg could make such a high-risk film with the right balance of sensitivity. Moreover, he had just set up his own studio, DreamWorks, in partnership with David Geffen and Jeffrey Katzenberg. The trio had promised to dust off the Hollywood business by putting art back at the center of major movie projects. Best known for her role in the series *Fame*, Allen discussed her fledgling project with Laurie MacDonald and Walter Parkes, both Spielberg loyalists who were in charge of development at his brand-new studio. The duo wrangled her a twenty-five-minute meeting on the filmmaker's busy schedule, but their discussion ended up lasting for more than an hour. "She had me after ten minutes, really," recalled the director. "She impressed upon me the importance of the African culture. And this film industry does not make movies about

The *Amistad* prisoners were considered to be a threat from the moment they were captured.

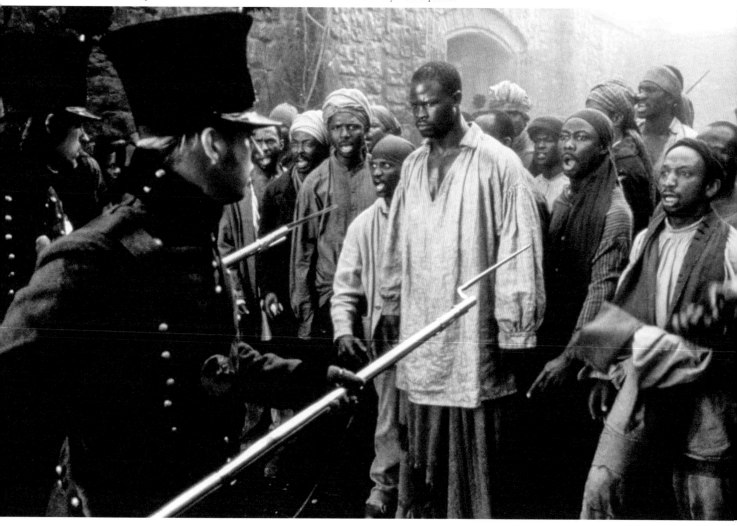

African subjects, and Debbie was passionate, "Why can't Hollywood change?"[2]

Spielberg Walking on Eggshells

Spielberg had never heard of the *Amistad* mutiny. The story touched him all the more because he and Kate Capshaw had just adopted two black children: Theo, born in 1988, and Mikaela, born in 1996.

Amistad would therefore be his first project for DreamWorks. And Spielberg was walking on eggshells: The criticisms of *The Color Purple* had been difficult to take, and he knew that he would still be criticized for putting a white perspective on the history of the slave trade and Black Americans. In an attempt to circumvent some of these criticisms, an armada of historians was called in to make the film irreproachable. The future screenwriter of *Gladiator* (Ridley Scott, 2000), David Franzoni wrote one of the first treatments of *Amistad*. The story was fairly accurate, but Spielberg was not completely satisfied and

asked Steven Zaillian, his associate from *Schindler's List*, to rework the text. Legal wrangling prevented Zaillian from appearing in the credits.

CASTING

Initially approached to play John Quincy Adams, Dustin Hoffman eventually refused the part and it went to Anthony Hopkins, who earned an Oscar nomination for his performance. As the lawyer Roger Sherman Baldwin, a then up-and-coming Matthew McConaughey was finally offered the opportunity to play a major role in a popular film—and too bad if the real Baldwin was much older than the actor who played him. Unlike Adams and Baldwin, the character of Theodore Joadson (played by Morgan Freeman) was completely fictitious.

The real casting struggle came while searching for the right actor to play Cinqué. Having just won an Oscar for *Jerry Maguire* (Cameron Crowe, 1996), Cuba Gooding Jr. turned down the part. The actor

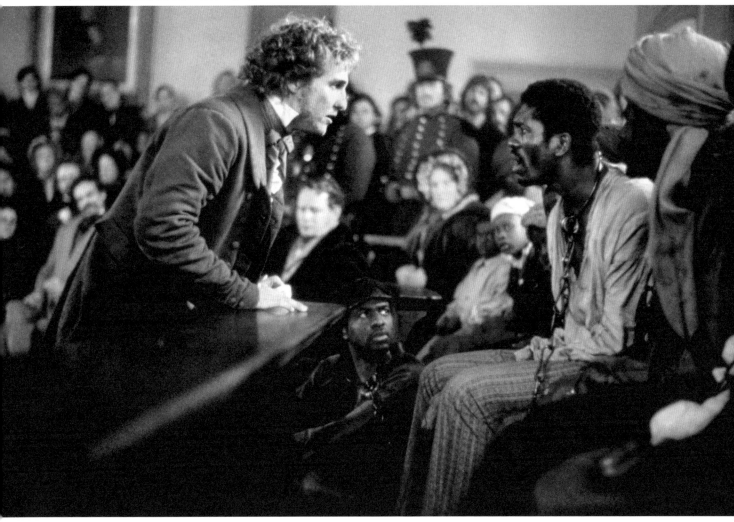

later admitted that saying no was one of the biggest mistakes of his career.

Finding the Right Actor for a Difficult Role

Nine weeks before the start of shooting, the role of Cinqué had still not been cast in spite of auditions held in London, Paris, and West Africa. Spielberg was impatient; he knew that he had to move quickly on *Amistad* if he wanted to keep momentum going on his next project, *Saving Private Ryan*. *Amistad* was about to be postponed when a thirty-three-year-old model from Benin, Djimon Hounsou, arrived on the scene. It didn't matter that his career in front of the camera was limited to a few appearances in music videos and B movies: Spielberg was charmed: "Djimon has an inner peace and an outer strength that made him perfect for the role."

The casting of the actors who would play the slaves was equally complicated. The filmmaker demanded that everyone who was cast had to have been born in Africa, and able to express themselves in one of the hundreds of languages used on the continent. The casting team had to coordinate work visas and some actors lost out on parts simply because they couldn't meet the production's schedule.

FILMING AND PRODUCTION

Filming took place in Puerto Rico, Rhode Island, Massachusetts, and California. The replica of the *Amistad* was built in Mystic, Connecticut.

"Force of Habit"

After a few days of filming, Debbie Allen pointed out to Spielberg the almost total absence of African Americans on the technical crew: "And then the next day there were people," she reported years later. "It wasn't intentional. You get a group of people you're used to working with and you use them all the time." For the film, the Black actors had to learn Mende, a language commonly spoken in Sierra Leone. For

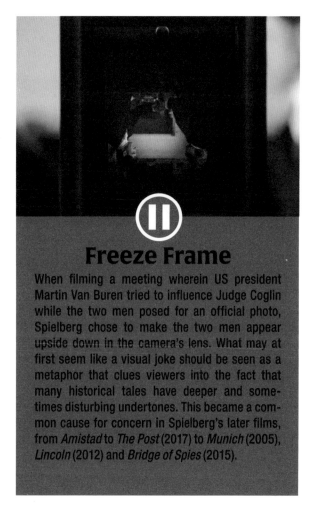

Freeze Frame

When filming a meeting wherein US president Martin Van Buren tried to influence Judge Coglin while the two men posed for an official photo, Spielberg chose to make the two men appear upside down in the camera's lens. What may at first seem like a visual joke should be seen as a metaphor that clues viewers into the fact that many historical tales have deeper and sometimes disturbing undertones. This became a common cause for concern in Spielberg's later films, from *Amistad* to *The Post* (2017) to *Munich* (2005), *Lincoln* (2012) and *Bridge of Spies* (2015).

Spielberg, it was out of the question to let them express themselves in English with an accent. An expert in linguistics, Dr. Arthur Abraham, ensured that the actors spoke comprehensible Mende, not hesitating to intervene between takes.

"Sir" Anthony Hopkins

Anthony Hopkins had to deliver a long speech (seven pages of script) at the end of the film's pivotal trial. The actor did it in one take, much to the astonishment of the director, who from then on referred to him as "Sir" as a mark of his respect. When the filming was completed (on time), Spielberg began preproduction on *Saving Private Ryan* while supervising the editing and postproduction of *Amistad*.

RECEPTION

Since the announcement of the project, *Amistad* had been shadowed by an accusation of plagiarism made by the author Barbara Chase-Riboud. In 1989, she published the novel *Echo of Lions*, which her editor was quick to pitch to Amblin Entertainment.

The Plagiarism Case

According to Barbara Chase-Riboud, Amblin had declined to do an adaptation of her novel, which also told the story of Cinqué, on the grounds that the subject was too big for a film…without returning either the manuscript or the novel they were sent after the book had been printed. In 1996 she discovered Spielberg's project, and her blood ran cold. After an attempt at reaching an amicable settlement was rejected by DreamWorks, she decided to sue. The studio argued that the film was based on historical facts that did not belong to any one party, and that the project had been carried by Debbie Allen since 1978. The author, on the other hand, claimed that the film plagiarized the fictional part of her book, including the depiction of the friendly relationship between Cinqué and Adams, as well as the totally invented character of the Black printer, Theodore Joadson. After investigating further, Chase-Riboud also found that an initial version of the script was entitled *The Other Lion,* and that the ending of the film was changed during shooting because it was too close to her novel. Two days before the release of *Amistad* in theaters, the complaint was deemed inadmissible by a judge on the grounds that the act of plagiarism was not clearly established. In February 1998, a few days before the Oscar nominations were announced, a settlement was reached between the two parties for a confidential amount. From then on, Barbara Chase-Riboud never ceased to praise the film.

"Who Are the Heroes of the Film?"

The case was closed, but it weighed on the film's release and box office receipts were below expectations. The same was true at the Oscars, where *Amistad* received only four nominations and nothing for the director. The reviews were, on the whole, mixed: Although many considered the film to be important, they were just as likely to judge it as being weighed down by its message. Spielberg seemed to have failed in making people forget that a film about Black people was being made by a white man. Director Spike Lee derided the release of yet another film where the Black people were yet again saved by heroic white men. As for Steve McQueen, director of *12 Years a Slave* (2013), another film about slavery in the United States, McQueen delivered a resounding thumbs-down in 2014: "Who are the heroes of the film? Anthony Hopkins and Matthew McConaughey. For me, maybe because I'm black, a story with slaves has to be told from their point of view."

On set, putting actors in chains so they could be filmed was always a painful moment.

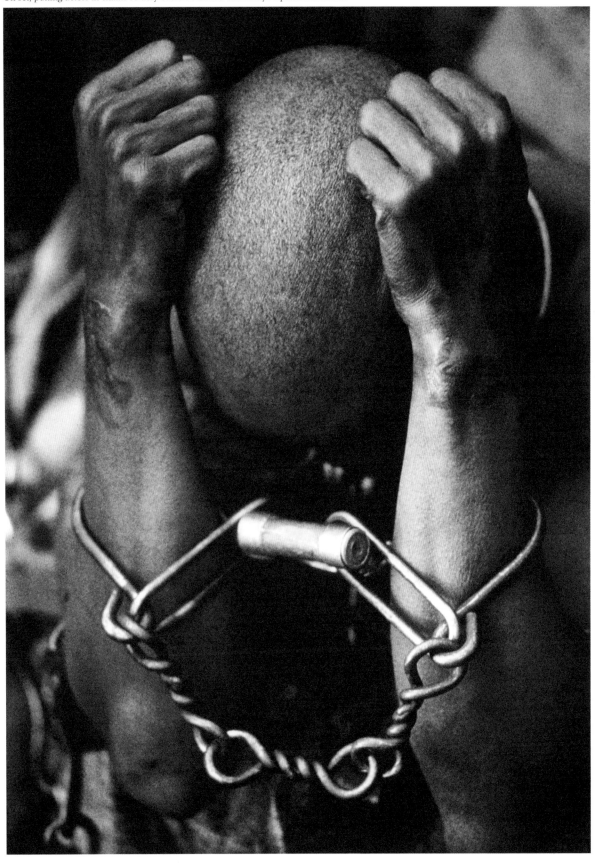

The DreamWorks SKG founding trio: David Geffen, Steven Spielberg, and Jeffrey Katzenberg in October 1996.

DreamWorks
The Ups and Downs of Independence

To free himself from the influence of the big Hollywood studios, Steven Spielberg created DreamWorks SKG in October 1994, following in the footsteps of Francis Ford Coppola and George Lucas, who had both started their own studios (American Zoetrope and Lucasfilm, respectively) in a bid to have greater control over their artistic output.

An Underemployed Billionaire

The creation of a new studio was big enough news to make the cover of *Time* on March 27, 1995. But where American Zoetrope, in 1969, and Lucasfilm, in 1971, represented the hopes of young idealists, this new production company was the product of three perhaps overconfident moguls.

At forty-six, Steven Spielberg embarked on this new business venture with Jeffrey Katzenberg (forty-three) and David Geffen (fifty-one). Katzenberg had just left the presidency of Walt Disney Pictures after internal power struggles. The name DreamWorks came from the fact that he called the trio a "dream team." As for Geffen, he sold his record company, Geffen Records (Cher, Joni Mitchell, Guns N' Roses, Aerosmith…), in 1990 to MCA Records. He had been producing films since the 1980s via the Geffen Film Company (*Risky Business, Beetlejuice*). In 1994, he was "the most under-employed billionaire in showbiz,"[1] according to *Entertainment Weekly*.

High Standards and a Need for Prestige

As both a producer and a distributor, DreamWorks (SKG comprised the initials of the company's three founders, but it eventually disappeared from the name) saw itself as a herald of strong subjects, of high aesthetic standards, of prestigious filmmakers and those destined to become so. Like Spielberg's production company, Amblin Entertainment, DreamWorks was based out of offices at Universal Studios, but filming on location was always preferred to the fake sets found on the backlots and soundstages at Universal. Cinema was just one facet of their new project, which was intended to touch other areas of the entertainment business. DreamWorks Interactive would be their video game branch, and it was conceived as a joint venture with Microsoft. The branch started by releasing *Director's Chair* with Steven Spielberg (1996), then film adaptations, but nothing that excited the video game world. In 1998, *Jurassic Park: Trespasser* was even considered one of the worst games in history. Redemption came with *Medal of Honor* (1999). Based on an idea Steven Spielberg had after *Saving Private Ryan* (1998), this title was unanimously acclaimed and renewed the genre of historical war games. DreamWorks sold their video game business to Electronic Arts in 2000.

DreamWorks Gets Its Feet Wet

On the music side of things, DreamWorks Records launched with the release of *Older* by George Michael. The album was a success in Europe, but not in the United States. The label then created a sensation by signing the group Eels, as well as Elliott Smith and Randy Newman. In spite of some interesting releases, the music division was sold to Universal Music in 2003. The big screen was where DreamWorks was expected to stand out. It took three years for DreamWorks to release its first production, *The Peacemaker* (Mimi Leder, 1997), a post–Cold War action film starring George Clooney and Nicole Kidman. The film inaugurated the company's logo, created by painter Robert Hunt and depicting a child fishing in the hollow of a crescent moon set to music by John Williams. In the same year, *Amistad* was released and it became the first DreamWorks Pictures feature film directed by Steven Spielberg. The huge success of *Deep Impact* (Mimi Leder, 1998) did little to hide the film's lack of substance, but it put the company on the map, especially since it rivaled Michael Bay's *Armageddon*. It was followed two and a half months later by *Saving Private Ryan*, also directed by Spielberg. The more political

American Beauty won five Academy Awards in 2000, including Best Picture.

direction the filmmaker took in the 1990s fit perfectly with the DreamWorks project. *American Beauty* (1999) and its five Oscars launched Sam Mendes's career and solidified the studio's imprimatur of prestige. Then came the surprise success of Ridley Scott's *Gladiator* (2000) in July 1999. In spite of these successes, financial problems forced DreamWorks to abandon an ambitious studio project, spanning a hundred acres and eighteen soundstages, that was meant to be in Los Angeles. In February 2005, David Geffen revealed that DreamWorks had come close to bankruptcy twice.

The Evolution of a Studio

Artistically, the studio endeavored to fulfill its initial promise. Robert Zemeckis moved away from his usual fantasies to try his hand at a survival film with *Cast Away* (2000). Originally developed by Spielberg, but directed by Clint Eastwood, *Flags of Our Fathers* (October 2006) was a complex story about the battle of Iwo Jima. It was Eastwood who brought DreamWorks the idea of making a film about the Japanese counterpoint to the same events, *Letters from Iwo Jima* (December 2006). More austere in tone, this second film was also handled with a greater sense of ease. In a changing industry, pragmatism gradually took over. Director Joe Dante saw the audacity of his film *Small Soldiers*

(1998) sacrificed on the altar of a partnership with a toy manufacturer. DreamWorks also joined forces with the man *Deep Impact* had challenged in 1998: Michael Bay. As the undisputed king of formulaic blockbusters, the director made pyrotechnic overkill the cornerstone of his films. He was seemingly the antithesis of the original aspirations of DreamWorks.

A Different Kind of Disaster Movie

The first third of *The Island* saw Michael Bay step out of his comfort zone to deliver a dystopian thriller focused on social issues…before explosions and outrageous stunts take over. The production costs on the film were so high that DreamWorks had to join forces with Warner, handing over their rights to international distribution. The film was a commercial and critical disaster: It debuted in fourth place in its opening weekend at the American box office before plunging to tenth place just three weeks later. It performed better outside of the United States, but Warner reaped the benefits. DreamWorks was unable to orchestrate an appropriate marketing campaign for the project, seemingly because they were confused by this hybrid film. The company was also accused of plagiarism by the authors and producers of *The Clonus Horror* (Robert S. Fiveson, 1979). The

lawsuit ended in a financial settlement that avoided a trial. DreamWorks and Michael Bay then found themselves on safer ground with two *Transformers* films (2007 and 2009) that capitalized on the popularity of the Hasbro toys and became major performers at the box office.

The Television Division Stumbles

Like Amblin, DreamWorks Pictures also had a television division. In January 1997, the *New York Times* estimated that out of the three series that the studio had in progress, two would not last (*Ink* and *High Voltage*). The paper was right, and both shows ended in May of that year. The last three episodes of a sitcom called *Champs* were not even broadcast, nor were the final episodes of the second season of *It's Like, You Know…* (1999). DreamWorks Television nevertheless made a name for itself with *Spin City* (1996), *Rescue Me* (2004), and *Band of Brothers* (2001), which was created by Spielberg and Tom Hanks on the heels of *Saving Private Ryan*. This did not prevent the business from disappearing, and it was eventually merged into Amblin Television in 2013.

A Not-So-Secret Strength

DreamWorks quickly realized that their animation division was their stealth performer. The company ultimately hoped to generate 40 to 50 percent of its profits from animated films; for Jeffrey Katzenberg, head of DreamWorks Animation, this was his revenge on Disney after being ousted from the company. The studio's first animated feature film, *Antz* (Eric Darnell and Tim Johnson, 1998), caused a controversy when, two months later, another animated film about ants, *A Bug's Life* (John Lasseter and Andrew Stanton), was released by Pixar for Disney. Lasseter and Stanton were furious, and accused Katzenberg of exploiting an idea dating from his Disney years. Next came *The Prince of Egypt* (Brenda Chapman, Steve Hickner, and Simon Wells, 1998), a $60 million production gambling on traditional animation; *Chicken Run* (Peter Lord and Nick Park, 2000), from the British studio Aardman (creators of *Wallace & Gromit*); and most importantly, *Shrek* (Andrew Adamson and Vicky Jenson, 2001). The family film about everyone's favorite ogre was selected for competition at the Cannes Film Festival and it won the first ever Oscar for Best Animated Feature. It also did massive numbers at the box office. During this period, DreamWorks Animation acquired Pacific Data Images, a computer animation company. In spite of all its success, the studio's release of *Sinbad: Legend of the Seven Seas* (Patrick Gilmore and Tim Johnson, 2003) was a major failure. The film's losses amounted to the current equivalent of $186 million.

The Split

After *Sinbad*, the studio abandoned traditional animation to concentrate on computer-generated animation...and it took off: *Shrek 2* (Andrew Adamson, Kelly Asbury, and Conrad Vernon, 2004), then *Shrek the Third* (Chris Miller and Raman Hui, 2007), *Madagascar* (Eric Darnell and Tom McGrath, 2005), and *How to Train Your Dragon* (Dean DeBlois and Chris Sanders, 2010) all did so well that DreamWorks Animation eventually split from its parent company and went public. The dream of independence for DreamWorks faded after a spate of successive financial maneuvers, including acquisition by Paramount, a distribution agreement with Walt Disney, entry into the fold of an India-based company called Reliance, and joint ventures with Hasbro and Alibaba. By 2015, DreamWorks Pictures was just a brand name for films distributed by Universal (*Green Book* in 2018, *First Man* in 2018, *1917* in 2019).

Shrek (2001) was the first film to win an Academy Award for Best Animated Feature.

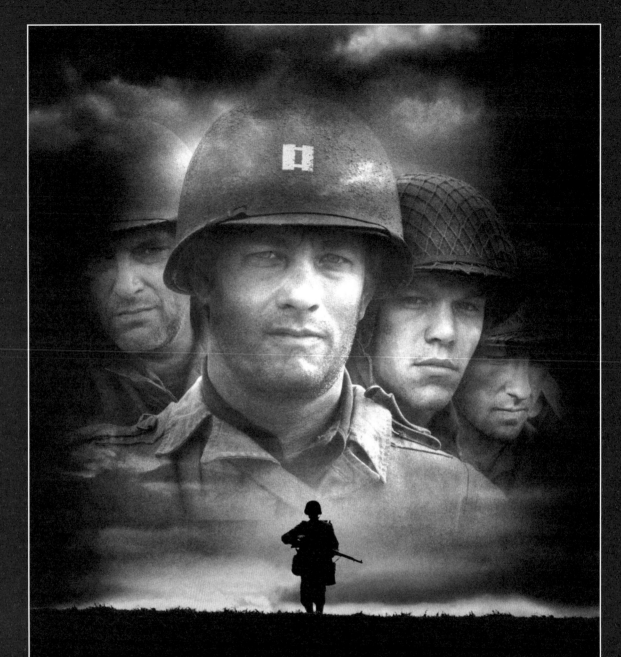

A STEVEN SPIELBERG FILM

tom hanks

saving private ryan

the mission is a man.

DREAMWORKS PICTURES and PARAMOUNT PICTURES PRESENT
AN AMBLIN PRODUCTION IN ASSOCIATION WITH MARK GORDON and GARY LEVINSOHN TOM HANKS "SAVING PRIVATE RYAN"
EDWARD BURNS MATT DAMON TOM SIZEMORE MUSIC BY JOHN WILLIAMS COSTUME DESIGNER JOANNA JOHNSTON EDITED BY MICHAEL KAHN, A.C.E.
PRODUCTION DESIGNER TOM SANDERS DIRECTOR OF PHOTOGRAPHY JANUSZ KAMINSKI, A.S.C. PRODUCED BY STEVEN SPIELBERG & IAN BRYCE and MARK GORDON & GARY LEVINSOHN
WRITTEN BY ROBERT RODAT DIRECTED BY STEVEN SPIELBERG

DREAMWORKS
PICTURES

Saving Private Ryan

United States	2 hrs 49	Color	Surround (Dolby Digital/ DTS/ SDDS)	1.85:1

Production Dates: June 25–beginning of September 1997
United States Release Date: July 24, 1998

Worldwide Box Office: $482 million ($877.6 million in 2023 dollars)

Production Company: Amblin Entertainment, Mutual Film Company,
Paramount Pictures, DreamWorks
Producers: Steven Spielberg, Ian Bryce, Mark Gordon, Gary Levinsohn
Co-producers: Bonnie Curtis, Allison Lyon Segan
Associate Producers: Mark Huffam, Kevin de la Noy

Screenplay: Robert Rodat
Director of Photography: Janusz Kamiński
Camera Operators: Seamus Corcoran, Cian de Buitléar, Mitch Dubin,
Chris Haarhoff
Assistant Director: Sergio Mimica-Gezzan
Film Editing: Michael Kahn
Music: John Williams
Sound: Andy Nelson, Ron Judkins, Gary Rydstrom, Gary Summers
Production Design: Thomas E. Sanders
Set Decoration: Lisa Dean
Makeup: Lois Burwell, Conor O'Sullivan, Daniel C. Striepeke
Special Effects: Neil Corbould
Stunt Coordinator: Simon Crane
Casting: Denise Chamian
Historical Consultant: Stephen E. Ambrose
Military Consultant: Dale Dye

Starring: Tom Hanks (Captain Miller), Edward Burns (Private Reiben), Tom
Sizemore (Sergeant Horvath), Matt Damon (Private Ryan), Barry Pepper
(Private Jackson), Adam Goldberg (Private Mellish), Vin Diesel (Private
Caparzo), Giovanni Ribisi (T), Jeremy Davies (Corporal Upham), Leland Orser
(Lieutenant DeWindt), Ted Danson (Captain Hamill), Dennis Farina (Lieutenant
Colonel Anderson), Paul Giamatti (Sergeant Hill)

"No one knows who they are until they have been severely tested."[1]

—Steven Spielberg

SYNOPSIS

——

Accompanied by his family, a World War II veteran visits the American military cemetery in Colleville-sur-Mer, Normandy. On the morning of June 6, 1944, Allied soldiers landed on Omaha Beach. Their operation quickly turned into carnage, but Captain Miller's squad managed to climb a hill and destroy part of the German fortifications. Meanwhile, in the United States, military staff realizes that one family has lost three children on different fronts. Their fourth son, James Ryan, was parachuted into the Cotentin region, current location unknown. Captain Miller is charged with finding the last surviving Ryan and bringing him home to spare his family from further grief.

Accompanied by his relatives, a veteran remembers his fallen friends.

GENESIS

It all began with a war memorial in the town square of a small New Hampshire town. As screenwriter Robert Rodat walked his newborn son around town, he paused in front of the memorial. The list of the fallen was a long one, including the Revolutionary War, the Civil War, World War I, World War II, and Vietnam. Rodat noticed that the last names of some fallen soldiers reoccurred regularly. He discovered that one family had lost three members during the Revolutionary War, and five during the Civil War.

An Almost True Story

The idea of families decimated by successive conflicts continued to haunt Rodat. It should be said that this was happening around the time of celebration of the fiftieth anniversary of D-Day, when the Allied landing on the beaches of Normandy dealt a decisive blow to the German occupiers. In 1994, the anniversary of this large-scale operation attracted significant media and literary coverage. Among the books published, one in particular fascinated the scriptwriter: *D-Day, June 6, 1944: The Climactic Battle of World War II*, by historian Stephen E. Ambrose, a leading scholar on the major world conflict. In another book by the same author, *Band of Brothers*, he recounts the story of Sergeant Frederick Niland, who learned that two of his brothers had died within a day of each other on the German front, where he was also serving. Discovering that a fourth brother had just been killed in the Pacific

(which was later refuted), the American army chief of staff had the only presumed survivor of the siblings repatriated as quickly as possible. The issue of families dealing with multiple deaths had become a sensitive one among officers after the destruction of a warship in 1942 that resulted in the death of five brothers. After this event, every effort was made to avoid having members of the same family serve in the same unit.

A Spielberg-Hanks package

Rodat wanted to focus on an expeditionary force responsible for recovering a soldier named Ryan in the aftermath of D-Day, after his brothers had been killed at the front. He pitched the idea to producer Mark Gordon, who commissioned him to write a screenplay and quickly told Paramount about the project, who expressed great interest. However, a few weeks later, the studio acquired two scripts set during World War II: *Combat*, with Bruce Willis as a potential star, and *With Wings as Eagles*, written for Arnold Schwarzenegger. Gordon was concerned about his project, which was now associated with Gary Levinsohn. A young agent at Creative Artists Agency (CAA) named Carin Sage took it upon herself to reassure him of his project's potential. After reading the script, she arranged for two of the agency's clients, Tom Hanks and Steven Spielberg, to take a look. Gordon called the actor and met him and Levinsohn a few days later. Hanks was passionate

The sound and the fury: Captain Miller gets caught up in the madness of war.

about World War II and found the story fascinating. Moreover, the idea of working with his friend Spielberg was exciting for him. A collaboration had come close to happening with *Big* in 1988, which was based on a script by one of Spielberg's sisters, but Spielberg withdrew from the project. When Spielberg discovered Rodat's script, he was struck by the moral question it posed: Should eight soldiers be sent to save one? In *Schindler's List*, a sentence from the Talmud is quoted: "He who saves one life saves the whole world entire." Once again, *Saving Private Ryan* questions the notion of sacrifice and its value, as well as the conduct to be maintained in such extraordinary circumstances that a civilized man can be transformed into a barbarian.

In the Name of the Father

For Spielberg, "World War II was the crossroads of the twentieth century. Its consequences still affect us today and will still crucially affect the coming millennium."[2] In addition to the world history, there was another, much more personal one at play: While reading the script, the filmmaker immediately thought of his own father, Arnold, who was a World War II veteran. Arnold was engaged on the Indian front as a radio operator in a US Air Force

bomber, flying dangerous missions. Spielberg's obsession with war, from an early age, undoubtedly originated from his dad and, perhaps, from his silence on the subject. Born in December 1946, Spielberg was saddled with a father who drowned himself in work. When he did come home, often late in the evening, he didn't say much. However quiet he may have been, Arnold supported his son by financing his early films. At the age of fourteen, Spielberg and some of his school friends made two short films, *Fighter Squad* and *Escape to Nowhere*, both set in the Second World War. In 1964, his parents' divorce loosened the ties between father and son, who were not reconciled until the mid-1980s. And while Spielberg felt that he had made *Schindler's List* for his mother, he did not disguise the fact that he made *Saving Private Ryan* as a tribute to his father. The decision to shoot *Saving Private Ryan* was not without consequences for an already busy schedule. The director had just directed *The Lost World: Jurassic Park* and had begun production on *Amistad*. But this did not matter: "I'm only fifty years old, and I'm not ready to retire," he explained to Peter Biskind in 1997. "The minute I feel I have achieved my goals, then I'll probably stop. But I don't know what my

goals are."[3] Paramount and DreamWorks produced the film with Amblin Entertainment and the Mutual Film Company. DreamWorks dealt with casting in the United States, and Paramount dealt with casting abroad.

Robert Capa's Photos

Spielberg now had control over the project. He dissected Rodat's script and, with the help of Hanks and Frank Darabont (who was not credited), accentuated the documentarian aspects of the film. Thus, in the battle scene that opens the film, all the jokes that the soldiers originally exchanged (in the tradition of contemporary action films) were removed. The filmmaker also watched a huge number of films focused on the Second World War, including documentaries and fictional accounts. He also listened to many testimonies of veterans, including his friend Samuel Fuller: They had met on the set of *1941*; the veteran filmmaker had been in the landing at Omaha Beach and had made a film about it, *The Big Red One* (1980). He told Spielberg mostly about the fear he felt and the noise. The major influence on Spielberg was actually eight photographs taken by Robert Capa on the morning of D-Day, in the first minutes of the landing. These images, captured in the heat of the

moment and often blurred, are the only ones that survived a laboratory accident during their development (there would have been three hundred of them in all), and they convinced the filmmaker to use handheld cameras and thus infuse the film with an atmosphere of chaos.

CASTING

Tom Hanks could not help but be excited when the project was officially announced. The actor was then a major Hollywood star following a run of hits with *Sleepless in Seattle* (Nora Ephron, 1993), *Philadelphia* (Jonathan Demme, 1993), *Forrest Gump* (Robert Zemeckis, 1994), and *Apollo 13* (Ron Howard, 1995), not to mention his voice work as Sheriff Woody in *Toy Story* (John Lasseter, 1995).

The Faces of Ordinary Americans

Tom Hanks fit perfectly into Spielberg's vision: to find "faces" of ordinary Americans, the antithesis of the muscular warriors that action movies often featured. "I was trying very hard to imagine what actor would not immediately want to use his teeth to pull out a pin from a hand grenade. And Tom Hanks just sprung to mind,"[4] confirmed the director. In fact, all of the actors chosen met this criterion. In his desire

The photographs taken by Robert Capa on June 6, 1944, are a unique testament to the D-Day landings.

to stick as closely as possible to the reality of the time, he noticed a major difference while viewing a number of archives: "Today boys 17 or 18 years old look like children, but back then, the 16-, 17-, 18-year-old face actually looked sometimes like a 29- to 35-year-old face."[5] Whether or not by chance, some of the actors chosen had already appeared in other films. Boston-born Edward Burns had been known as an independent writer and director since the success of his first feature film, *The Brothers McMullen* (1995), in which he played the lead role. Upon discovering the film, Spielberg immediately thought of Burns to play the strong New Yorker, Private Reiben. Chosen to play the soldier Caparzo, the then unknown Vin Diesel had also previously written and directed an independent feature film, *Strays* (1997). Giovanni Ribisi, Adam Goldberg, Barry Pepper, and Jeremy Davies were at the beginning of their acting careers. Chosen after Billy Bob Thornton refused the role of Sergeant Horvath because of a fear of water, Tom Sizemore was the best-known member of the team charged with bringing Private Ryan safely home. Sizemore had previously given notable performances in *True Romance* (Tony Scott, 1993), *Natural Born Killers* (Oliver Stone, 1994), and *Heat* (Michael Mann,

1995). His commitment to Spielberg led him to turn down a role in *The Thin Red Line*, which was then in production with Terrence Malick directing. This quest for more or less anonymous faces was challenged by the casting of Matt Damon. The actor, who had not yet really made his mark, was introduced to Spielberg by Robin Williams, who had just shot *Good Will Hunting* (1997) with him. The film was directed by Gus Van Sant and based on a script written by Damon and Ben Affleck. Damon became a star a few months after the shooting of *Saving Private Ryan* when *Good Will Hunting* was released. Later that year, he and his writing partner won an Oscar for best screenplay.

Threats to Revolt During Boot Camp

Damon was not part of the boot camp that took place a few days before filming began on the movie. The idea was to reinforce the bonds between the actors who had been hired to play soldiers. For six days, military advisor Dale Dye roughed up his "recruits." After three days of mud and rain, the winds of revolt blew through the team. "Some of the actors started vomiting, coughing. [...] We voted," recalls Tom Hanks. "In the first round, they all wanted to quit, except me. On the second, everyone chose to stay.

When droplets of fake blood splashed onto the camera lens, Spielberg opted to leave them in the final film.

Should eight men sacrifice themselves in order to save one? This is the dilemma posed by Spielberg.

We got a few extra blankets, warm clothes, and everything worked out."[6]

FILMING AND PRODUCTION

Once *Amistad* was in postproduction, General Spielberg prepared for battle. This time, once more, there were no storyboards. For the first time since *E.T. the Extra-Terrestrial*, the film was also shot in chronological order, so that the actors were placed in the same psychological conditions as the soldiers they were portraying.

Desaturated Colors

Having considered and then abandoned the idea of filming in black and white, the filmmaker did not settle for using traditional color technical processes. The goal was to achieve the desaturated colors of the archive images filmed during the period. "We did not want this to look like a technicolor extravaganza about World War II," explained cinematographer Janusz Kamiński, who had the idea of removing the protective coating from the lenses: "The whole image was softer without being out of focus." The effect was further enhanced by applying a process to the negative that neutralized much of the color. To film the battle scenes, shutters at 90 or even 45 degrees were used instead of the traditional

180: "we used a different shadow degree to achieve a certain staccato in the actors' movement. We got a crispness of explosions, everything we shot became slightly, just slightly, more realistic."[7] Spielberg did not want to leave anything to chance, especially not the opening of the film, which depicted the landing on Omaha Beach in the early morning of June 6, 1944. "Here I wanted to bring the audience onto the stage with me and demand them to be participants with those kids who had never seen combat before in real life, and get to the top of Omaha Beach together,"[8] he said. The real beach was no longer usable because of subsequent construction; the production found the near-ideal location at Curracloe Beach, near Wexford in southeastern Ireland. The sequence, which lasted twenty-four minutes in the final cut, required eleven weeks of preparation. When the team arrived on June 25, 1997, Spielberg already had a problem: The beach chosen was not as large as the one in Omaha. So he played with the depth of field to reinforce the illusion of it being a long way to go to reach the cliff dominated by German bunkers.

Bullets Fired into Carcasses

The shooting of the film's opening sequence lasted fifteen days. Strangely, most of the landing craft

Upham (Jeremy Davies) tries to survive during the final battle.

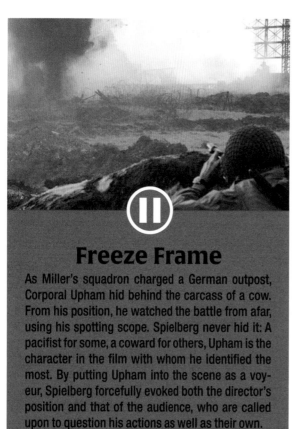

Freeze Frame

As Miller's squadron charged a German outpost, Corporal Upham hid behind the carcass of a cow. From his position, he watched the battle from afar, using his spotting scope. Spielberg never hid it: A pacifist for some, a coward for others, Upham is the character in the film with whom he identified the most. By putting Upham into the scene as a voyeur, Spielberg forcefully evoked both the director's position and that of the audience, who are called upon to question his actions as well as their own.

were sourced from Palm Springs, in the middle of the desert! The Irish army provided 750 soldiers—some of whom were already accustomed to film sets, having appeared in Mel Gibson's *Braveheart* (1995) three years earlier. By instinct, the camera wanders between the thousand or so fake corpses and the twenty or so real amputees. There was screaming, crying, and blood spurting everywhere, even onto the camera lens. In addition, the weather during filming was quite bad, as it was on June 6, 1944, which made the filmmaker very happy. Dale Dye intervened when the explosions looked a little too much like pyrotechnic displays (at the time of the film's release, many specialists still identified a number of errors in the use of military equipment). Particular care was taken with the sound: Instead of using electronic simulators, real bullets were fired near microphones. The sounds of bullets hitting all kinds of materials were also recorded; for the sound of bullets hitting flesh, ammunition was fired into beef carcasses in a slaughterhouse. The production team took almost a month to return the location to its original appearance.

Terrifying News from Home

Filming continued, mainly in England. In fact, only the cemetery scene was filmed in the real military cemetery of Colleville-sur-Mer, a few minutes away

from Omaha Beach. A fake farmhouse was built in Wiltshire to represent the Ryan farmhouse, which was supposed to be in Iowa. The attack on the German outpost was filmed near Oxford. As for the final battle, set in the fictitious village of Ramelle, it was filmed on sets built at the old Hatfield airfield, north of London. The pace of filming was fast (an average of four takes filmed per shot), so much so that Spielberg completed his film a few days ahead of schedule: "War doesn't give you a break, and I didn't want the production of *Private Ryan* to give them [the actors] one either."[9] The filming was no picnic for the director. During filming on the beach, he learned from the police that a man named Jonathan Norman had been arrested when he tried to enter Spielberg's home in the Pacific Palisades neighborhood of Los Angeles. Authorities found a knife, tape, handcuffs, and razor blades on Norman, and materials found in his car indicated an extreme obsession with Spielberg and a desire to take him and his wife hostage. The thirty-year-old man—an apprentice scriptwriter—was sentenced to twenty-five years in prison in June 1998.

RECEPTION

Saving Private Ryan was released on July 24, 1998, in the United States and Canada, fewer than seven months after *Amistad*. Unlike its predecessor, the film met with a dazzling success that stunned its director. The film earned about $482 million worldwide (more than $877 million in 2023 dollars), 45 percent of which was earned in the United States. National critics universally beat the drums to bring the audiences into the cinema. "The greatest war movie ever made, and one of the great American movies,"[10] swooned Stephen Hunter of the *Washington Post*. "No further commentary is needed when the raw brutality of combat is presented as indelibly as it is here,"[11] agreed Todd McCarthy in *Variety*.

In the time between the filming and release of *Saving Private Ryan*, Matt Damon became a star thanks to *Good Will Hunting*.

From the "Never seen before" to the "Déjà-vu"

In England and France, the film was received with reticence. At the top of the list of recriminations: the crudely portrayed characters. Nell Norman, for the *Evening Standard*, described the film as follows: "(*Ryan*) seems almost banal in its achievement, a film that sacrifices humanity for technical wizardry."[12] In *Libération*, Gérard Lefort deplored the filmmaker's inability to transcend his subject, as the opening sequence had led one to hope: "Foot by foot, shot by shot, the 'never seen before' gives way to the 'déjà-vu' [...]. In the course of this acknowledgement, attention wanes, enjoyment melts away and, consequently, also the famous fund of emotion of which Spielberg is the chief banker."[13] On the other hand, for Samuel Blumenfeld of *Le Monde*, the film portrayed "the mourning of a certain America, in the style of Frank Capra, a filmmaker with whom he is obsessed, that is to say, a country united, supportive, preserved in the respect of certain values, of which the family is the cornerstone. *Saving Private Ryan* is the first film in which Spielberg yields and draws the line between what he can and cannot film."[14]

Leaving the critics on their battlefield, the filmmaker surveyed the results of his work. Like Hanks, he refused a basic salary but allowed himself a share of the profit: Both were to receive 17.5 percent of each dollar earned by the studio. Meanwhile, Spielberg was also honored by the Department of Defense, the Smithsonian, and various other American institutions. His friend Bill Clinton even gave him the National Medal of Humanities in 1999. He was also made a Commander of the Order of the British Empire in 2001. *Saving Private Ryan* was nominated for eleven Oscars and won five statuettes, for Best Cinematography, Best Sound, Best Sound Mixing, Best Editing, and Best Director for Spielberg—his second after *Schindler's List*. In the "Best Picture" category, to everyone's surprise, he lost to John Madden's *Shakespeare in Love*, propelled by the

Featuring desaturated colors and cameras set close to bodies, *Saving Private Ryan* is one of the finest achievements in the career of its director of photography, Janusz Kamiński.

A mother learns of the death of her sons (seen in a photo set atop a dresser on the right) in a memorable shot inspired by the films of John Ford.

intense lobbying of the much-reviled producer Harvey Weinstein.

"Dad, you're the greatest," said Spielberg from the Oscar's stage, addressing his father in the audience. "Thank you for showing me that there is honor in looking back and respecting the past. I love you very much. This is for you."[15] One Oscar for Mom (*Schindler's List*), the other for Dad. As Spielberg entered his fifties, he thanked his parents in his own way by creating films that honored their memories, often at the cost of enormous and grueling work. The filmmaker did not return to a movie set until August of 2000 when he began work on *A.I. Artificial Intelligence*. This time, he would be creating a tribute to an artistic father: Stanley Kubrick.

FOR SPIELBERG ADDICTS

When *Saving Private Ryan* was released, a rumor was circulating on a new medium called the Internet that the German sniper who aims at the squad from the top of a bell tower was played by Kevin Costner. When asked, Spielberg always gave the same answer: The actor had never been near the set. And even if he had, the director would never have dared to ask him to play such a small role.

In all the chaos of battle, mud makes it impossible to distinguish the color of army uniforms (*Lincoln*).

A Child of War
From Fantasy to Reality

"There is no greater drama, no greater crime, than war. I am obsessed with World War II, because America, which had already lost its innocence many times, abandoned it forever in that conflict."[1]

Good Guys and Bad Guys

In Spielberg's work, everyone who is subjected to the vagaries of history must be changed forever. The theorem works as much for the characters filmed by the filmmaker as it does for the filmmaker himself. Of course, he never went to the front, having avoided the draft during the Vietnam War. But he was a child of war, without a doubt: "This fascination was passed on to me by my father. He fought in the Second World War. When I was a kid, every year when his comrades-in-arms gathered at home, I listened to their stories."[2] From this came stories of growing up where soldiers become heroes, borne on the winds of justice. There are good guys, bad guys, and little reason to question the rightness of things. This vision can be found in *Escape to Nowhere*, a forty-minute film he made at the age of fourteen, recounting a battle between the Allies and the Germans in North Africa, as well as later in *1941* (1979) or *Raiders of the Lost Ark* (1981), marked by a schoolboyish spirit in which everything in uniform is doomed to be mired in ridicule. In "The Mission," an episode made in 1985 for the *Amazing Stories* series, the fatal outcome for one of the crew members of a bomber on a mission is avoided by the intrusion of a fantastic element, a cartoon. Here again, it was the child who spoke.

Empire of the Sun Changes His Outlook

An initial shift occurred in 1987 with *Empire of the Sun*. At the time, Spielberg was forty years old and had recently become a father: enough to change some perspectives. By following the itinerary of an English boy caught up in the tumult of a conflict (the capture of Shanghai by the Japanese army in 1941) whose implications were beyond him, the filmmaker structured his relationship with the war. This was the case in *Empire of the Sun* as in the films that follow: The global drama is studied through the prism of constrained individual experience; it destroys reference points, separates families, and tests the resilience of each individual. In the middle of an internment camp full of adults, young Jim learns to find his place and to become a man. Six years later, Spielberg set up his camera in another camp. The perspective is much darker. *Schindler's List* is intimately linked to his mother, but it also resonates particularly with the times. The filmmaker has never hidden it: The urgency of the project was born out of the ethnic cleansing initiated by the Serbs in the former Yugoslavia, as well as the platform that was then given to Holocaust deniers on American television.

The Duty of Memory

In 1989, a chance meeting between Indiana Jones and Adolf Hitler could be played on in *Indiana Jones and the Last Crusade*. In 1993, it was no longer a time for laughter, and Amon Göth, the SS leader of the concentration camp, represented a major evil. *Schindler's List* was the second shift after *Empire of the Sun*. It was now a duty of the director to make people remember. The war is shown in all its horror and, above all, by what it says about men. Even Oskar Schindler, at the beginning of the film, is a person who takes advantage of a dramatic situation to make money off the Jewish people. By eventually becoming aware of the horrors they faced, and doing something to help them, Schindler asked himself the moral question that every Spielbergian hero faces: What kind of person am I? It is then up to each character to create an environment conducive to the fulfillment of their noble goals. Schindler chooses to play the role of surrogate father to his Jewish employees. It is a role much like the one played by Captain Miller (Tom Hanks) in *Saving Private Ryan* five years later. For his men, Miller is both an emotional and moral beacon. He is the one who shows them which lines cannot be crossed, and he is the

A soldier loses a friend and his innocence in *Battleground*, directed by William A. Wellman in 1949.

The English cavalry gallops toward its destiny with swords drawn in *War Horse*.

one who keeps them from turning into monsters. The soldiers sent to the butchery of D-Day were young; many were not even twenty years old. Spielberg shows combat in all its crude terribleness. At one point, a bayonet is slowly and sadistically thrust into the heart of an American ranger; at another, German artillerymen are left to burn alive so as not to shorten their suffering. "I think Vietnam pushed people from my generation to tell the truth about war without glorifying it,"[3] the director explained to journalist Stephen Pizzello after the film's release. In order to prepare the famous opening sequence, Spielberg rewatched the war films that had impressed him as a child—*Battleground* (William A. Wellman, 1949), *The Steel Helmet* (Samuel Fuller, 1951), *Hell Is for Heroes* (Don Siegel, 1962)—with the objective of distancing himself from them as much as possible. In response to the spectacle portrayed in those films,

he sought realism and turned to the documentaries of John Huston (*The Battle of San Pietro*, 1945) and William Wyler (*The Memphis Belle: A Story of a Flying Fortress*, 1944).

Reacting to September 11

This duty of remembrance was continued by the filmmaker, who created the series *Band of Brothers* with Tom Hanks in 2001. Based on a true story and punctuated by the testimonies of veterans, it follows the progress of a group of American paratroopers from France to Germany. The duo also co-produced a sequel called *Hell in the Pacific*, which was broadcast nine years later. Spielberg alone produced *Flags of Our Fathers* (October 2006) and *Letters from Iwo Jima* (December 2006), which depicted the battle of Iwo Jima from both sides. He had planned to film the first, but Clint Eastwood directed both.

In the meantime, America found itself at war after the attacks of September 11, 2001. Spielberg never addressed the event head-on, but the conflict permeated many of his films, from *Minority Report* (2002) to *War of the Worlds* (2005), in which he turned Herbert George Wells's novel into a film depicting real life. *War of the Worlds* is as much about the stupefaction of the attack as about the occupation of a country by an overly armed alien power and the devastating effects on the population. Here again, salvation comes through a recasting of roles within the family nucleus. In *Munich* (2005) as in *Bridge of Spies* (2015), an underground struggle is waged by secret agents, also echoed in *Lincoln* (2012)—a political battle waged against the backdrop of physical conflict (the Civil War). Spielberg now questioned war as well as peace, and the price that must be paid to preserve it.

An Ambiguous Flag

Ambiguity is everywhere in Spielberg's work. As he grew older, Spielberg's films took on a much more layered view of adult life—and they grappled with the idea that good guys can sometimes behave badly. Thus, Corporal Upham, a devout pacifist in *Saving Private Ryan*, refuses to kill a German, which leads to the death of two others…and leads him to finally kill the criminal in an almost lyrical scene where the filmmaker seems to approve of his decision. Does war in cinema also reflect on the directors who film it? The same film opens and closes with an American flag flying in the wind. At the time of the film's release, this was considered to be emblematic of a strong sense of patriotism. Thirteen years after *Saving Private Ryan*, Spielberg put the German and Allied sides up against each other on the 1917 front in *War Horse*. Both have their share of heroes and bloodthirsty fools, inflated egos, and good men; only the uniforms differentiate the two sides, a distinction that the horse is incapable of making. The horse is a dove of peace, galloping from one trench to another and saved from certain death by a soldier on each side. The film is based on a children's story, much like *The BFG* (2016), where the world trembles at the impending attack of some not-so-wonderful creatures that devour children and humans. Two allegorical films reach the same conclusion: War is filled with literal death, but also the death of innocence.

"The Mission" (episode from *Amazing Stories*).

David is 11 years old.

He weighs 60 pounds.

He is 4 feet, 6 inches tall.

He has brown hair.

His love is real.

But he is not.

A STEVEN SPIELBERG FILM
ARTIFICIAL INTELLIGENCE

WARNER BROS. PICTURES and DREAMWORKS PICTURES Present
An AMBLIN/STANLEY KUBRICK Production A STEVEN SPIELBERG Film A.I. ARTIFICIAL INTELLIGENCE HALEY JOEL OSMENT
JUDE LAW FRANCES O'CONNOR BRENDAN GLEESON and WILLIAM HURT Robot Characters Designed By STAN WINSTON STUDIO
Special Visual Effects & Animation By INDUSTRIAL LIGHT & MAGIC Costume Designer BOB RINGWOOD Music By JOHN WILLIAMS
Film Editor MICHAEL KAHN, A.C.E. Production Designer RICK CARTER Director of Photography JANUSZ KAMINSKI, A.S.C.
Executive Producers JAN HARLAN WALTER F. PARKES Screenplay By STEVEN SPIELBERG Based on a Screen Story By IAN WATSON
Based on the Short Story By BRIAN ALDISS Produced By KATHLEEN KENNEDY STEVEN SPIELBERG BONNIE CURTIS
Directed By STEVEN SPIELBERG

DREAMWORKS
PICTURES

AMBLIN
ENTERTAINMENT

WARNER BROS. PICTURES
A TIME WARNER ENTERTAINMENT COMPANY
©2000 Warner Bros. All Rights Reserved

SUMMER 2001

AOL Keyword: A.I. www.AImovie.com

A.I. Artificial Intelligence

United States 2 hrs 26 Color Surround 1.85:1
(Technicolor) (Dolby Digital EX/
DTS/SDDS)

Production Dates: August 17–November 18, 2000
United State Release Date: June 29, 2001

Worldwide Box Office: $236 million ($395.5 million in 2023 dollars)

Production Company: Amblin Entertainment, Warner Bros., DreamWorks
Pictures, Stanley Kubrick Productions
Producers: Steven Spielberg, Kathleen Kennedy, Bonnie Curtis
Executive Producers: Jan Harlan, Walter F. Parkes

Based on the short story "Supertoys Last All Summer Long" by Brian Aldiss
(1969) and on a story by Stanley Kubrick and Ian Watson
Screenplay: Steven Spielberg
Director of Photography: Janusz Kamiński
Film Editing: Michael Kahn
Music: John Williams
Sound: Gary Rydstrom, Richard Hymns
Production Design: Rick Carter
Art Direction: Richard Johnson, William James Teegarden, Thomas Valentine
Conceptual Artist: Chris Baker
Hair Stylist: Candace Neal
Makeup: Ve Neill
Costume Design: Bob Ringwood
Special Effects: Michael Lantieri
Visual Effects: Dennis Muren, Scott Farrar, Henry LaBounta
Design of Robots and Animatronics: Stan Winston

Starring: Haley Joel Osment (David), Jude Law (Gigolo Joe), Frances O'Connor
(Monica Swinton), Sam Robards (Henry Swinton), William Hurt (professor
Hobby), Brendan Gleeson (Lord Johnson Johnson), Jake Thomas (Martin
Swinton), Clara Bellar (FemMecha nanny), Jack Angel (voice of Teddy)

SYNOPSIS

———

A s the ice caps melt, oceans wipe out coastal cities and overpopulation leads to famine. Rich countries have remained stable by means of strict birth control laws and the proliferation of "mechas," androids designed to perform human tasks. Professor Hobby of Cybertronics goes one step further and creates a mecha capable of love, in the form of a ten-year-old child named David. David is adopted by Monica and Henry Swinton, whose son Martin is seriously ill. In search of maternal affection, David faces Monica's apprehension, then Martin's animosity. Abandoned by his "mother" in the middle of the forest, David, accompanied by his teddy bear, Teddy, who is also a robot, is captured as fodder at the Flesh Fair, where downgraded mechas are destroyed to entertain humans. He escapes and runs away with Gigolo Joe, a mecha-lover wrongly accused of the murder of one of his clients. David tells him that he is looking for the Blue Fairy, who will make him a real boy, like Pinocchio. He ends up in Rouge City, a site of much debauchery, and then in sunken Manhattan at the home of Professor Hobby, who enlightens him about his origins. Devastated, David throws himself into the ocean, where the remains of an amusement park and a statue of the Blue Fairy lie. "Make me real," he begs her again and again. Two thousand years later, humanity has perished. Beings from the future extract David from the ice and see in him the last trace of earthly life. The child begs them to grant his wish: to win his mother's love.

"Will robots inherit the Earth? Yes, but they will be our children."[1]

———

—Marvin Minsky, American scientist, pioneer of artificial intelligence

GENESIS

This was no coincidence: In 1982, the year of the historic triumph of *E.T.,* filmmaker Stanley Kubrick took an option on the rights to adapt a short story by science fiction writer Brian Aldiss, "Supertoys Last All Summer Long," published in 1969 in *Harper's Bazaar* magazine. The elliptical story revolves around David, a little boy, who questions Teddy, his talking teddy bear: How can he express his love for his unaffectionate mother Monica? And how to distinguish what is real from what is not? When Henry, the boy's father and a designer of intelligent robots, comes home and tells Monica that they have been granted permission to have a child, David feels his future is in jeopardy.

Kubrick's Odyssey

Kubrick's interest in the subject of artificial intelligence had been growing ever since he offered the most striking cinematic representation of the subject to date with HAL, the shipboard computer in *2001: A Space Odyssey* (1968). The filmmaker even had discussions with one of the pioneers in the field, the scientist Marvin Minsky. "One of the fascinating questions that arise in envisioning computers more intelligent than men is at what point machine intelligence deserves the same consideration as biological intelligence. [...] You could be tempted to ask

yourself in what way is machine intelligence any less sacrosanct than biological intelligence, and it might be difficult to arrive at an answer flattering to biological intelligence."[2] An avid reader of *Scientific American* magazine, Kubrick contacted Brian Aldiss to work on adapting his work into a film. But when the director told him of his intention to mix the story of *Pinocchio*, by Carlo Collodi (1883), with the repercussions of global warming, Aldiss gave up: Crossing his futurist story with a fairy tale was not to the author's taste. But this was precisely Kubrick's ambition—and one of the reasons why, in 1985, he talked to Steven Spielberg about taking it on.

Underperforming Special Effects

Spielberg and Kubrick maintained an ongoing correspondence after meeting six years earlier. In a perpetual search for information, the director of *Barry Lyndon* assumed the habit of grilling his illustrious junior colleague on his job, his life, his projects, without ever giving out any details about his own life… until a fateful day in 1985. "This is best story you've ever had to tell,"[3] enthused Spielberg, who served as his sparring partner from a distance. Kubrick was aware that the film taking shape in his head was full of Spielbergian elements—a lost child in search of love,

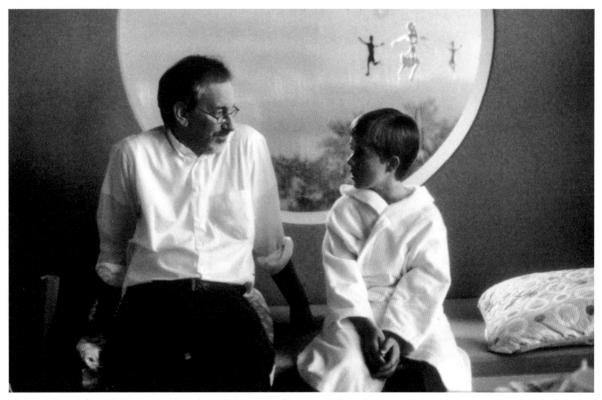

While he admired the performance given by Haley Joel Osment, Spielberg regretted that the technology was not yet advanced enough to create a robot boy entirely from special effects.

Freeze Frame

A.I. is populated with mirror effects and circular or oblong shapes that evoke maternal and uterine curves. During David's first meal with his family, shot from a bird's-eye view, the glow of a wall light forms a halo over his head, emphasizing the angelic purity of the child robot. At the end of his journey, a similar shot shows him looking furious, topped by a broken halo after having met and destroyed his double in the office of his creator. A chilling observation: David is not unique. Worse still: His apprenticeship with humans has given rise to frustration, anger, and destructive impulses.

the feeling of exclusion, and references to Pinocchio (to which *Close Encounters of the Third Kind* and *E.T.* also allude). Kubrick also struggled to come up with a script despite the successive collaborations of several science fiction authors: Arthur C. Clarke, Bob Shaw, Sara Maitland, and Ian Watson, among others. The contribution of Watson, who was behind the character of Gigolo Joe, was the most substantial. At the same time, Kubrick put illustrators on the job, including the British artist Chris Baker, aka Fangorn, who

provided nearly two thousand drawings. This was a big step for the film but a small one for Kubrick, who was still skeptical about embarking on the adventure. According to him, special effects technology was not yet advanced enough, and it couldn't be counted on to make the character of David come to life.

Passing the Baton

The discovery of *Jurassic Park* gave Kubrick faith... for a while. In 1993, Warner Bros. announced that *A.I.* would be its next feature film. The following year, Kubrick drafted a script of eighty-seven pages. With the idea of creating the mechas, the androids that cohabit with humans, using the digital imagery that was used for the dinosaurs in Spielberg's film, he consulted their designer, Dennis Muren, as well as ILM, Digital Domain (filmmaker James Cameron's special effects company), and Chris Cunningham, who had directed the music video *All Is Full of Love*, featuring a robotic Bjork. He came to the conclusion that the technology was not yet up to the task of convincingly reproducing the human appearance, movements, and gaze that are essential to the realism of robots. After having ordered the manufacture of an animatronic, modeled on one of his nephews, and obtained a catastrophic result, Kubrick considered entrusting the role of David to Joseph Mazzello, the young actor in *Jurassic Park*, but he understood that his obsessive perfectionism and the inherent length of his shoots were incompatible with the growth of a child, whose age must appear identical throughout the film. Spielberg, who, once invested, had a habit of working fast, would not have this problem. Ten years after having unofficially associated him with its genesis, Kubrick then suggested to Spielberg that he direct *A.I.*, under the pretext that "this is much closer to your sensibilities than my own,"[4] though Kubrick was happy to produce it. The idea remained unfulfilled, as Spielberg preferred to concentrate on his own projects, and Kubrick launched *Eyes Wide Shut* (1999), which was to be his last film. Kubrick's sudden death on March 7, 1999, convinced Spielberg to work on *A.I.*, supported by the widow of the deceased filmmaker and his brother-in-law and producer, Jan Harlan.

A Posthumous Collaboration

The stakes were high for Spielberg, who, by appropriating a work that had been fantasized about for so long, was paying homage to a cinematic master, while at the same time measuring himself against a personal hero. In every respect, his position was ambivalent. He wrote the final screenplay alone—which he had not done since *Close Encounters of*

Gigolo Joe (Jude Law), David, and Teddy discover Rouge City, Spielberg's version of the city of debauchery.

the *Third Kind*, and which he has not done again since—mostly out of a concern for remaining faithful to Kubrick's vision. Or was it out of a desire to put his own stamp on the project? Both, one would be tempted to answer. "The whole last twenty minutes of the movie was completely Stanley's. The whole first thirty-five, forty minutes of the film— all the stuff in the house—was word for word from Stanley's screenplay,"[5] Spielberg argued, suggesting that the most Spielbergian parts of the film are not the ones one might assume. Thus, the segment around the Flesh Fair, absent from Kubrick's first script, came from Spielberg; the images of roundups and mass graves evoke the Shoah (*Schindler's List*) and the gothic-futuristic circus games, slavery (*Amistad*), all of which translate his fascination for the spectacle of our most base and derogatory instincts (*Indiana Jones and the Temple of Doom*). According to Chris Baker, whom Spielberg naturally included in his team, this segment of the film corresponds to the illustrations commissioned by Kubrick. Another significant development was that Spielberg's depiction of Rouge City had less to do with Kubrick's likely replica of Sodom and Gomorrah, and more to do with a mixture of Las Vegas and the Land of Oz.

CASTING

Convinced that the success of the film lay in the viewer's faith in David's possible humanity, Spielberg saw no other solution than to have him played by a real boy. There was no question of hiring a unknown actor, as he was used to doing. Spielberg needed a pro, and he had only one name in mind: Haley Joel Osment.

A Very Gifted Twelve-Year-Old

At the age of twelve, Osment was already a film veteran: At five, he played Forrest Gump's son in Robert Zemeckis's eponymous film (1994) with Tom Hanks; at seven, he was paired with Whoopi Goldberg and Gérard Depardieu in the forgettable *Bogus* (Norman Jewison, 1996); at ten, he traumatized audiences worldwide and earned an Oscar nomination for his role as a child psychic who "sees dead people" in

David and Specialist, a being from the future voiced by Ben Kingsley.

M. Night Shyamalan's *The Sixth Sense* (1999). A gifted young boy with "Tintin-like" features, the Californian spent half an hour every day in makeup in order to play a credible mecha. His face and hands were coated with wax, thereby adjusting the mechanical aspect of his movements to the character's evolution, and, cool as a cucumber, he refrained from blinking during each take. All this was done while carrying Teddy, David's Jiminy Cricket, an animatronic animal that weighed thirty pounds!

Half Elvis, Half Dracula

In the role of Gigolo Joe, Jude Law, at the height of his fame following *The Talented Mr. Ripley* (Anthony Minghella, 1999), played the sex symbol with style. To develop the character, the English actor rehearsed for three months with the choreographer Francesca Jaynes and borrowed from the gigolos of the 1930s as well as from the elegance of Fred Astaire and the flexibility of Gene Kelly, which he reinvented in a robotic way. As for the clothes, costume designer Bob Ringwood blended the style of Dracula, Elvis Presley,

and the romantic heroes of the Victorian era. The slicked-back hair, a latex-foam chin prosthesis, and layers of makeup completed the synthetic look. For the Swinton couple, Spielberg chose two lesser-known actors: the Englishwoman Frances O'Connor and the American Sam Robards, son of Jason Robards and Lauren Bacall. On the other hand, he invited a host of stars to lend their voices to the mythological figures, including Meryl Streep (the robot Blue Fairy), his friend Robin Williams (the oracle Dr. Know), and Ben Kingsley (a Specialist being of the future).

FILMING AND PRODUCTION

Although science fiction was familiar to him, Steven Spielberg had always approached it in contemporary contexts. With *A.I.,* a film of pure futurism, he created a completely different world for the first time in his career.

Disparate Atmosphere

The shooting of the film monopolized five sound stages at Warner Bros. Studios in Burbank, where the

majority of the sets were built, from the Swintons' house to the outskirts of Rouge City. The crew only ventured outside for the forest scenes, which were filmed in Oxbow Regional Park (Oregon) and Guerneville (California), and to take advantage of the geodesic ceiling of the *Queen Mary* dome in Long Beach. A fairly picaresque adventure, David's journey takes him to worlds far removed from one another, a disparity of atmospheres that director of photography Janusz Kamiński supported with his lighting: padded and sanitized in the first act (the Swintons' house), nocturnal and colorful in the second (the Flesh Fair, Rouge City), intense and contrasting in the last (Manhattan, the ocean floor).

Using Robots in Order to Be Real

"A quest for love using all the tools that special effects offer us"[6]: This is how Spielberg presented *A.I.* to his faithful collaborators, Michael Lantieri and Dennis Muren. Indeed, handcrafted tools were used to create the underwater amusement park, which was built in miniature and filmed in a smoke-filled room to give the illusion of being underwater. Digital tools were used to create the beings of the future, which were entirely generated by computer. The life-size set of Rouge City was filmed in front of a blue background so that the perspective could be extended in postproduction.

The film combined all the most technologically advanced techniques available at the time. The same applied to the robots, designed by Stan Winston. Animatronics and puppets were used, as were actors outfitted with prostheses, some of whom were retouched with a graphic palette. Spielberg's watchword: that there should be an element of humanity in each actor, real or computer generated.

RECEPTION

With the Spielberg-Kubrick combo being taken as a guarantee of success at the box office, the promotional campaign played the mystery card. But the secrecy surrounding the film backfired, first with the critics, who were confused and inclined to crudely oppose Kubrick's proverbial pessimism and Spielberg's sentimentality.

Who Was Responsible for What?

Many articles focused on the differentiation between the supposed share of one and the other. "*A.I.* winds up with Kubrick's empathy and Spielberg's intellectual muscle. It's a lethal combination,"[7] wrote Peter Bradshaw in the British newspaper the *Guardian*.

The film's final image depicts a chimerical mother as fantasized by a child-robot.

Manhattan underwater. In the foreground, the sunken Statue of Liberty.

David's freedom vanishes after he discovers his mechanical condition. Through
the pain of a robot, Spielberg dared to film the symbolic suicide of a child.

Animatronics, made-up extras, and real amputees: A room of robots surround Spielberg on the set of the film's Flesh Fair sequence.

"Spielberg bogs down Kubrick's project in his humanist mush,"[8] commented Didier Péron for *Libération*—about a heart-rending fable that traces nothing less than the genesis of a robot's consciousness! The success of *A.I.*, its singular accomplishment, relied precisely on the complex balance between Spielberg's poetic, emotional force and Kubrick's conceptual, analytical foundation. "Spielberg reaches [...] what only he would never have dared to face, the morbid truth of his cinema, regression to the point of nausea which, suddenly, by an excess of candor and sadness is brutally affecting, as a Spielberg film had never before been so affecting," noted Stéphane Delorme in *Cahiers du Cinéma*. "*A.I.* ends with a stunning image: [...] a small child in the bed of his dead mother, two corpses side by side for eternity. Two remnants of humanity, a robot and a fantasy."[9] "The film needs Spielberg's warmth in order not to be intolerably cruel,"[10] as Richard Schickel quite rightly remarked. It was not surprising, then, that the public, especially the American public, did not give it the expected triumph ($78.6 million in receipts in the United States for a production budget of $100 million). *A.I.* may have drawn on universal myths, from biblical episodes (Cain and Abel, the flood,

etc.) to fairy tales (Thumbelina, Goldilocks, Sleeping Beauty, etc.), but it did not become one in its own right. Since then, the tide has turned and the film has been reconsidered for its true value: as an ode to belief and the virtues of the imagination in a shroud for humanity.

FOR SPIELBERG ADDICTS

Two and a half months after the release of *A.I.*, the September 11 attacks occurred in New York City. When the film was released on video, Steven Spielberg refused to remove the World Trade Center towers from the film, which appeared submerged in water. Four years later, he concluded *Munich* with an eloquent shot of New York in the 1970s, where the newly built twin towers are visible in the distance. Darker and more critical, focused on state violence and the history of American democracy, Spielberg's cinema entered a new era.

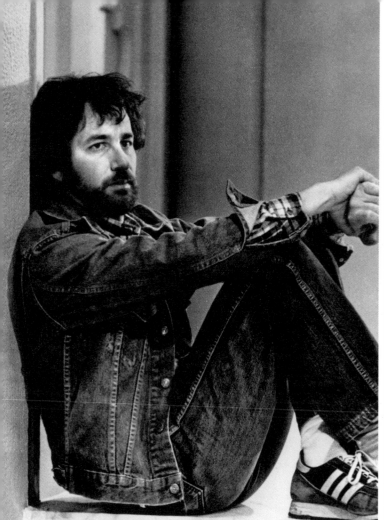

Steven and Stanley
A Secret Relationship

The day after Stanley Kubrick's death, on March 7, 1999, Steven Spielberg revealed the hitherto confidential friendship that bound him to the director of *Barry Lyndon*—a relationship that would be translated artistically in a posthumous way after the release of *A.I.*, two years later. The fact that Spielberg—the idealistic entertainer, the Hollywood mogul—was appreciated by Kubrick—the pragmatic intellectual, the reclusive genius—surprised many. Their correspondence, between two of the most popular and most respected American filmmakers of their time, was not as surprising as one might have supposed.

A Twenty-Year Dialogue

The two men met for the first time at the end of the 1970s at Elstree Studios, where Spielberg was

scouting for *Raiders of the Lost Ark* (1981) and where Kubrick was working on *The Shining* (1980). The master invited his younger colleague to dinner at his Childwickbury mansion, and relations were cordial; they became tense a few months later, when Kubrick's daughter, Vivian, poked her head in on the set of *Raiders of the Lost Ark*. She was shocked by the treatment of the snakes on set, and she alerted the British Animal Health Service. The incident was soon forgotten and a dialogue of nearly twenty years ensued in the form of long telephone conversations and a dozen interviews. At Kubrick's request, Spielberg went so far as to install a fax machine in his room reserved for their exchanges, which was soon relocated to another room at the request of Spielberg's wife, Kate Capshaw, who was

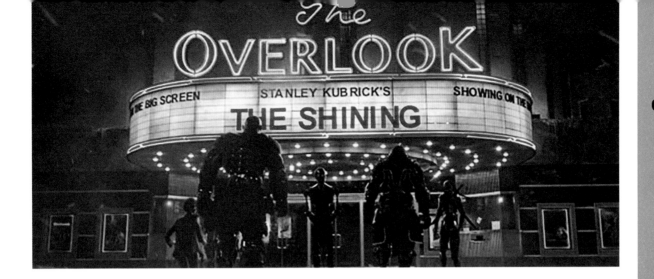

tired of being woken up in the middle of the night by the numerous missives they received. This was typical of Kubrick's consistent desire for secrecy, from which Spielberg drew inspiration in the promotional management of his own films.

A "Master Standard"

The discovery of *Doctor Strangelove* when it was released in 1964 marked Spielberg's first decisive encounter with Kubrick's work. Aged just eighteen, the future filmmaker was captivated by this farce about the Cold War and nuclear deterrence. In his eyes, "no film has ever better mixed the 'docu-drama' and the crazy comedy."[1] He aimed for a similar achievement with *1941* (1979), even casting actor Slim Pickens as a Yankee pilot, in line with the character he played in *Doctor Strangelove*. Among the other actors Spielberg lifted from his illustrious predecessor were Philip Stone, Kubrick's favorite supporting actor, who appeared in *Indiana Jones and the Temple of Doom* (1984); and Scatman Crothers, the telepath in *The Shining,* in Spielberg's segment of the *Twilight Zone* (1984). Spielberg was an avid fan of *The Shining* (which he "remixed" a sequence of in *Ready Player One,* 2018) and considered *Paths of Glory* (1957) to be the greatest anti-militarist film—Kubrick's sparing use of close-ups taught him the emotional power of the process. But it was *2001: A Space Odyssey* (1968) that he listed among his twenty favorite feature films. On the set of *Close Encounters of the Third Kind* (1977), Spielberg regularly replayed it, both as a model (for its conceptual mastery) and as a counterexample (he targets the heart more than the brain of the viewer). He even hired his visual effects supervisor Douglas Trumbull, whose innovative touch forever links the two films.

Techno-Pioneers

2001: A Space Odyssey and *Close Encounters of the Third Kind* are united by both filmmakers' fascination with space, extraterrestrial life, and technological advancement. In the vanguard of the latter, Kubrick, a devotee of scientific literature, owned early computers long before their domestic versions were widely available, and he converted to virtual editing as early as 1986, using a workstation imported for him to England from the United States. Attuned to the miracles of electronics by his father, Arnold, a pioneer in computer engineering, Spielberg was always on the lookout for the latest gadgets and video games, even decorating his first home with arcade terminals. A geek but also a filmmaker, he was at the forefront of special effects, as if he had made it his duty to put his stamp on every milestone in their evolution: CGI with *Jurassic Park*, motion-capture with *The Adventures of Tintin*, virtual reality with *Ready Player One*. Kubrick understood this very early on, following closely the career of the directing prodigy who had the ear of the public: He considered hiring the child actor in *Close Encounters of the Third Kind*, Cary Guffey, to play Danny Thomas in *The Shining*; and he abandoned his project *Aryan Papers*, an adaptation of Louis Begley's novel *A Polish Education*, after the success of *Schindler's List* (1993). War was another shared obsession (*Full Metal Jacket, Saving Private Ryan*), along with state violence (*A Clockwork Orange, Minority Report, Spartacus, Amistad*). Essentially, each director admired in the other what they each personally lacked. Kubrick, often criticized for the coldness of his films, envied Spielberg's ability to reach the masses. And Spielberg, long eschewed by the intelligentsia, looked up to the analytical rigor and authorial vigor of his "friend Stanley."

TOM CRUISE

PRECRIME

A STEVEN SPIELBERG FILM

MINORITY
REPORT

TWENTIETH CENTURY FOX AND DREAMWORKS PICTURES PRESENT A CRUISE/WAGNER/
BLUE TULIP/RONALD SHUSETT/GARY GOLDMAN PRODUCTION A STEVEN SPIELBERG FILM
TOM CRUISE "MINORITY REPORT" COLIN FARRELL SAMANTHA MORTON
AND MAX VON SYDOW MUSIC JOHN WILLIAMS SPECIAL ANIMATION AND VISUAL EFFECTS INDUSTRIAL LIGHT & MAGIC
COSTUME DESIGNER DEBORAH L. SCOTT FILM EDITOR MICHAEL KAHN, A.C.E. PRODUCTION DESIGNED BY ALEX McDOWELL
DIRECTOR OF PHOTOGRAPHY JANUSZ KAMINSKI, ASC EXECUTIVE PRODUCER GARY GOLDMAN RONALD SHUSETT
PRODUCED BY GERALD R. MOLEN BONNIE CURTIS WALTER F. PARKES JAN DE BONT
BASED UPON THE SHORT STORY BY PHILIP K. DICK SCREENPLAY BY SCOTT FRANK AND JON COHEN DIRECTED BY STEVEN SPIELBERG

DREAMWORKS
PICTURES

SOUNDTRACK AVAILABLE ON DREAMWORKS RECORDS

www.minorityreport.com

Minority Report

United States 2 hrs 20 **Color** **Surround** 2.35:1
(Technicolor) **sound**
(Dolby Digital/DTS/
SDDS)

Production Dates: March 22–July 19, 2001
United States Release Date: June 21, 2002

Worldwide Box Office: $358.4 million ($591 million in 2023 dollars)

Production Company: DreamWorks Pictures, 20th Century Fox, Amblin
Entertainment, Cruise/Wagner Productions, Blue Tulip Productions
Producers: Gerald R. Molen, Bonnie Curtis, Walter F. Parkes, Jan De Bont
Associate Producers: Sergio Mimica-Gezzan, Michael Doven
Executive Producers: Gary Goldman, Ronald Shusett

Based on the novella *Minority Report* by Philip K. Dick (1956)
Screenplay: Jon Cohen, Scott Frank
Director of Photography: Janusz Kamiński
Camera Operators: Mitch Dubin, Gregory Lundsgaard
Assistant Directors: Sergio Mimica-Gezzan, Robert Rooy
Film Editing: Michael Kahn
Music: John Williams
Sound: Andy Nelson, Ron Judkins, Gary Rydstrom
Production Design: Alex McDowell
Set Decoration: Anne Kuljian
Costume Design: Deborah L. Scott
Visual Effects: Scott Farrar, Mark Russell, Michael Lantieri
Casting: Denise Chamian

Starring: Tom Cruise (John Anderton), Max von Sydow (Lamar Burgess), Colin
Farrell (Danny Witwer), Samantha Morton (Agatha), Neal McDonough (Gordon
"Fletch" Fletcher), Steve Harris (Jad), Patrick Kilpatrick (Jeff Knott), Jessica
Capshaw (Evanna), Lois Smith (Dr. Iris Hineman), Kathryn Morris (Lara Clarke
Anderton), Peter Stormare (Eddie Solomon), Tim Blake Nelson (Gideon),
Jessica Harper (Anne Lively)

"I wanted to make the ugliest, dirtiest movie I've ever made. I wanted this movie to be dark and grainy and to be very cold. This is not a warm adventure the way *A.I.* was."[1]

—Steven Spielberg

SYNOPSIS

———

I n Washington in 2054, the Precrime program has been invented by Lamar Burgess and aims to prevent murders before they're committed. To do this, the program uses precogs—three almost-humanlike creatures who are plied with synthetic drugs and kept in a permanent state of stasis— who have visions that are used by the police to arrest future perpetrators of murder before they commit their crimes. Behind his wall of computer screens, John Anderton works for the authorities, tracking down every little detail of the predictions. He believes the program is beyond reproach and predicts better days ahead for society, especially when it's rolled out countrywide, despite the misgivings of national security agent Danny Witwer. One day, however, when he is analyzing a new vision from the program, the police officer makes an astonishing discovery: In thirty-six hours he will kill a man he doesn't know named Leo Crow. Knowing that he'll soon be arrested, Anderton goes on the run with Witwer on his heels.

GENESIS

On March 2, 1982, the life support machine that had been keeping Philip K. Dick alive for the five days following his second heart attack was turned off. And so, one of the most original and prolific US science fiction writers, with forty-four novels and over one hundred novellas to his name, died in a California hospital room at the age of fifty-three. He missed the cinematic release of the first adaptation of one of his books, *Blade Runner* (directed by Ridley Scott), by only a few weeks. His masterpiece helped put the genre back on the map and shone the spotlight on the author's paranoiac vision of the world.

Cruise Out in Front

Eight years later, *Total Recall*, which was based on a Philip K. Dick novella, was released with Arnold Schwarzenegger at the peak of his career. Encouraged by the movie's success, in 1992 Gary Goldman, who produced and co-wrote *Total Recall* with Ronald Shusett, bought the rights to one of the author's other novellas, *Minority Report*. He wanted to make this a sequel in which Douglas Quaid, the hero of *Total Recall*, would replace John Anderton. After several attempts at making the project work,

FOR SPIELBERG ADDICTS

Spielberg may have claimed that the inspiration for his movie came from the films of John Huston, but there are more than a few nods to Alfred Hitchcock. The ultimate homage: The famed English "Master of Suspense" had once had the idea of shooting a scene with two men chatting on a car assembly line in a factory; the conversation would flow as the car moved along the construction line, and at the end of the scene a door would open to reveal a body. In *Minority Report*, Anderton hides in a car that's under construction in order to escape his pursuers.

Shusett and Goldman commissioned novelist Jon Cohen to write the adaptation. For the production, they hoped to hire Jan de Bont, a renowned director of photography (*Die Hard*, *Basic Instinct*) whose first movie as director, *Speed* (1994), had taken everyone by surprise, not only because it was exceptionally good but also because of its commercial success.

Tom Cruise was excited by the project, and he sent the script to Spielberg to get his opinion.

Agatha (Samantha Morton) is the most talented of the three precogs, and her visions are valuable to the authorities.

John Anderton, a one-man band in front of his computer.

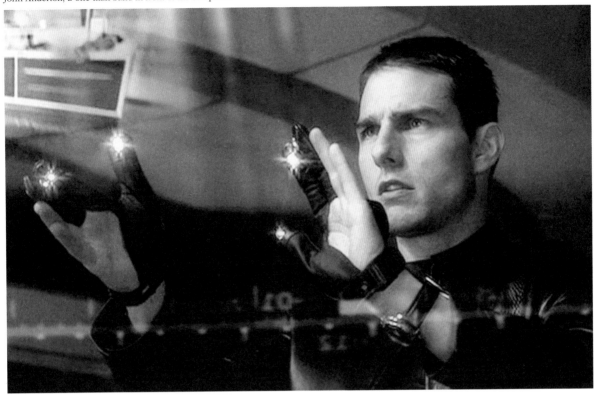

Cohen arranged for the script to be sent to Tom Cruise. The star, who had just finished filming Stanley Kubrick's *Eyes Wide Shut*, was so intrigued that he sent it to Steven Spielberg to ask his opinion. The two had been buddies since they'd met on the set of *Risky Business* (Paul Brickman, 1983). They had already tried several times to work together, but various projects never got off the ground, including an adaptation of the Francis Scott Fitzgerald novella *The Curious Case of Benjamin Button*, which David Fincher would make in 2008. In 1988, Spielberg was supposed to direct *Rain Man* but subsequently chose to work on *Indiana Jones and the Last Crusade*. This time it looked like the two men would finally work together. Spielberg asked Cohen to rework the script before confirming to Cruise that he would be involved, with a view to shooting the movie in February 2000 for a November release.

Brainstorming the Future

The problem was that Cruise was no longer available. Kubrick was behind schedule, delaying the filming of *Mission: Impossible II*. And after the latter died in March 1999, Spielberg embarked on *A.I. Artificial Intelligence*, which he filmed in early September 2000 without actually putting *Minority Report* on hold. Taking Cohen's work as his basis, in late 1998 Spielberg hired another screenwriter,

Scott Frank, whose repertoire included *Get Shorty* (Barry Sonnenfeld, 1995) and *Out of Sight* (Steven Soderbergh, 1998) and who had rewritten the script of *Saving Private Ryan*. He was tasked with including Spielberg's brainwaves and flashes of inspiration as and when they happened, because the filmmaker was not short on ideas. In 1999, he formed a think tank of fifteen or so specialists in the future who brainstormed for three days in a hotel in Venice, Los Angeles. The group—which included an architect, a writer, a journalist, and researchers in biomechanics, biomedicine, and computer engineering—was tasked with evaluating the credibility of *Minority Report*, which is supposed to take place in 2054. They produced a report of some eighty pages that would prove to be worth its weight in gold for the artistic director Alex McDowell, whose work on the very recent *Fight Club* by David Fincher (1999) and aborted plan to adapt *Fahrenheit 451* by Mel Gibson had impressed Spielberg.

Logic and realism were the order of the day. Spielberg designed his new movie to counterbalance the poetry of *A.I.* Scott Frank spent almost two years on the screenplay that had now moved quite a way from the original novella. Dick's precogs predicted all crimes, but those in the film only prevented murders. Anderton, the lead, was no longer a potbellied fifty-something but an athletic guy in his thirties

Cruise was adamant that he wanted to do as many stunts as he could.

who had experienced a trauma that wasn't in the original—the disappearance of his child, thought to have been kidnapped—which had turned him into a depressed drug-addict. While Cohen's plot had police officer Witwer as the main bad guy in the story (unlike in the novella), Scott Frank came up with this own bad guy, the character of Lamar Burgess, the creator of the Precrime program. To get a feel for the movie, he watched *The French Connection* (1971), a William Friedkin move with a shady character for its protagonist. Most importantly, he listened to the wise words of the director, who encouraged him not to feel "trapped" by the future. In other words, he was free to describe normal situations. If a character had to answer the phone or get into his car, then that's what they should do.

Orwell Was Right

Dick set his story in New York. But Spielberg felt the city wasn't right for what he had in mind, so the action was moved to Washington, DC. He chose the capital city for two reasons: aesthetics and symbolism. Aesthetics because it has beautiful iconic monuments that should still be standing in 2054, and symbolism

because this is where all the political decisions are taken—and the filmmaker had an idea in the back of his mind. He was not at all happy with the world as it looked at the dawn of the twenty-first century. He, the image man, didn't feel particularly at ease anymore in a society where technological innovations were increasingly being used to step up the surveillance of people and the collection of their data: "George Orwell's prophecy really comes true. Big Brother is watching us now. The little privacy we have now will be completely evaporated in twenty or thirty years. Because technology will be able to see through walls, through rooftops, into the very privacy of our personal lives and in the sanctuary of our families. These violations will be to the detriment of society."[2]

But philosophy was far from the mind of 20th Century Fox chairman Tom Rothman, who was already rubbing his hands with glee: "How are we marketing it? It's Cruise and Spielberg. What else do we need to do?"[3]

DISTRIBUTION

Rothman's optimism was understandable. At the time, Spielberg's movies had made almost $3 billion

A newcomer appears opposite Colin Farrell: Jessica Capshaw, the director's stepdaughter.

($5 billion in 2023 dollars) in the States alone, and those of Tom Cruise had raked in $2 billion ($3.3 billion in 2023 dollars). As Tom Hanks had done for *Saving Private Ryan*, Cruise agreed not to take a salary in return for a share of the proceeds of around 15 percent, the same percentage as the director.

Cast Changes

As things altered during preproduction, there were considerable changes made to the remainder of the cast. Matt Damon, Ian McKellen, Meryl Streep, Cate Blanchett, and Jenna Elfman were approached for the roles of the agent Witwer, Director Burgess, Dr. Iris Hineman, Agatha the precog, and Lara, Anderton's ex-wife. However, successive postponements forced Spielberg to change tack. For Witwer, he hired the Irish actor Colin Farrell, whose career had only just started to take off thanks to his roles in action-packed B movies. Burgess was played by famed Swedish actor Max von Sydow, who was an iconic lead in Ingmar Bergman movies before he built a solid career for himself in supporting roles in Hollywood. Kathryn Morris (Lara Anderton) appeared in *A.I.* but her scenes ended up on the

cutting room floor, so Spielberg included her in the cast of *Minority Report* by way of apology.

Who's Tom Cruise?

The role of Agatha went to a young English actress, Samantha Morton, who was basking in the very recent glory of Oscar and Golden Globes nominations for her performance—as a mute, no less—in 1999's *Sweet and Lowdown*. In *Minority Report*, Agatha says very little, but the actress has an imposing, almost divine, presence. If the precogs have an otherworldly appearance, Spielberg must have thought that Morton had also arrived from another planet when she confessed to him that she'd only seen one movie with Tom Cruise, the recently released *Magnolia* (Paul Thomas Anderson, 1999): "It's not that I'm ignorant or rude. I didn't go to the pictures that much as a kid. I didn't have the money. I didn't even have a TV until a while back. I'm weird like that."[4] Amused, the filmmaker then showed her Cameron Crowe's *Jerry Maguire* (1996), so that she could size up her future acting buddy. Incidentally, Crowe makes a cameo in the film's metro scene alongside Cameron Diaz and Paul Thomas Anderson.

Other than a role he gave to Jessica Capshaw, Kate's oldest daughter, Spielberg paid particular attention to the casting of the "mugshots" who'd only appear at a specific point in the film, but would move the story along (Peter Stormare, Tim Blake Nelson, and William Mapother, Tom Cruise's real-life cousin). This decision wasn't random; behind its high-tech veneer, Spielberg was convinced that *Minority Report* had the makings of a great old-fashioned film noir.

FILMING AND PRODUCTION

"I'm telling the audience you definitely need to pee and buy your popcorn before you come in to this one. It's a ride you need to be in from beginning to end."[5] Spielberg issued these instructions when promoting the movie and it spoke volumes about his intentions. He wanted to set the rules when he delivered his vision of society. This meant that the audience had fifteen minutes to understand the Precrime concept, how it worked, and how it was organized. It was this same method that made *Jurassic Park* so successful: wrapping a madcap idea in a layer of science to make it more credible.

An Eighty-Page Bible

For it to really work, the process had to be as authentic as possible, and Spielberg had several tricks up his sleeve. He had the eighty-page "2054 bible" used by Alex McDowell and his crew, as well as his own insatiable curiosity for all things new. So when he discovered digital preview, it revolutionized his production method. This time, there was no longer any need to rely on the storyboard drawings to understand the shots because you could use them to digitally model the scene and incorporate the characters' movements, which enabled you to plan the camera movements on a simulated set. The technology was still in its infancy for *The Lost World,* but now the filmmaker could exploit it to the fullest. Photoshop replaced the pencil and Spielberg entered the twenty-first century.

But credibility was still uppermost on his mind, so he entrusted the visual aspect of the precogs' premonitions to the creative agency Imaginary Forces, having been impressed by their work on the credits of David Fincher's *Se7en* in 1995. Spielberg made one demand: He wanted circular images

In the film, spider robots scan people's eyes to obtain their identity, a metaphor for the security state.

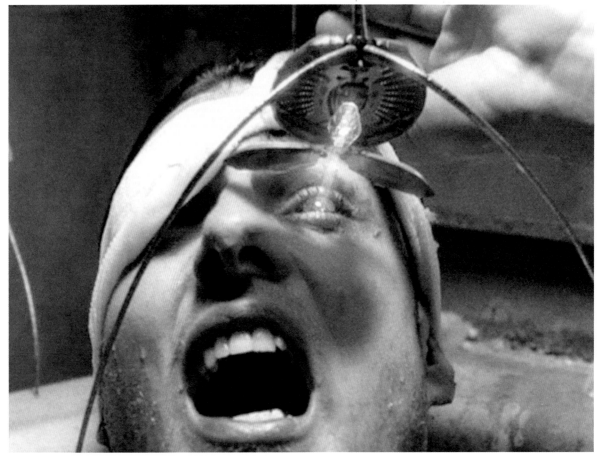

One runs, the other doesn't. Anderton and Agatha, an odd couple united in flight.

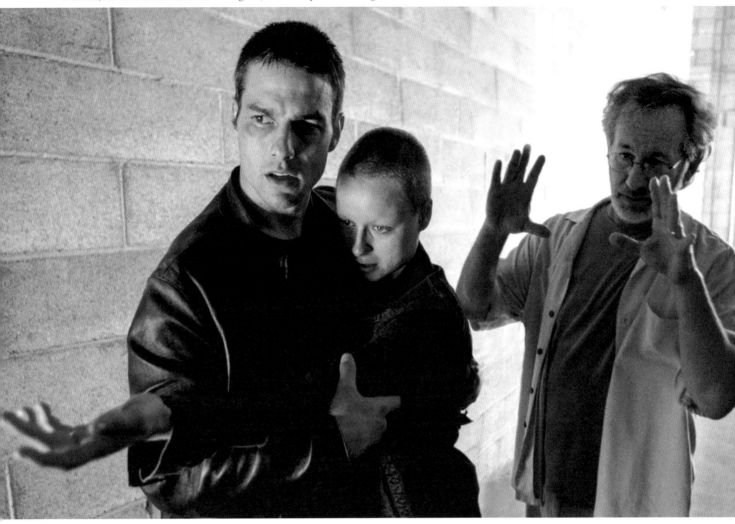

because humans don't see things in a rectangle like a cinema screen; how they handled the rest was up to them. The designers took advice from cognitive science specialists and delivered their version of the visions: images in almost perpetual movement that jumped back and forward through time. The shots were then processed by another company, Asylum VFX, which linked them to the preview screens and incorporated them into the scenes filmed by Spielberg.

The Feeling of a Film Noir

Minority Report contains some 450 shots with digital special effects. Among the most famous are those where Anderton is at the control panel wearing special gloves, viewing the murder premonitions and trying to put things right by tracking down the slightest detail on the motion-activated screens. The interface was designed by John Underkoffler after

Spielberg asked him to come up with the computer of the future with neither keyboard nor mouse. The researcher taught Tom Cruise how to manipulate the device using hand movements that gave him the air of an orchestra conductor. Spielberg, on the other hand, thought of him as a "human Avid," Avid being the digital editing software that was revolutionizing traditional practices at the time—and which Spielberg didn't use until *The Adventures of Tintin* ten years later!

Using this new technology, Janusz Kamiński was commissioned to set the tone of the movie. He suggested a special calibration process, bleach bypass, which fades the color and whitens the faces to give a colder feel and create a bluish, almost metallic, ambiance. But above all he played about with film noir codes such as shadows and high-angle and low-angle shots...on the same page as his director, who had described to him the type of ambiance found in

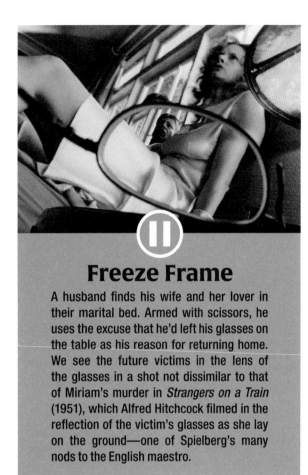

Freeze Frame

A husband finds his wife and her lover in their marital bed. Armed with scissors, he uses the excuse that he'd left his glasses on the table as his reason for returning home. We see the future victims in the lens of the glasses in a shot not dissimilar to that of Miriam's murder in *Strangers on a Train* (1951), which Alfred Hitchcock filmed in the reflection of the victim's glasses as she lay on the ground—one of Spielberg's many nods to the English maestro.

Key Largo (1948), *The Maltese Falcon* (1941), and *The Asphalt Jungle* (1950), three John Huston masterpieces of the genre. Spielberg even made a tongue-in-cheek tribute to three great crime writers by naming his precogs after them: Dashiell (Hammett), Arthur (Conan Doyle), and Agatha (Christie).

Reining in Cruise

Filming began on March 22, 2001, and lasted until July 19, four months during which Spielberg had to negotiate every single stunt with his star. Tom Cruise is the type who wants to do everything himself, sometimes with no heed for the risk involved, as Spielberg discovered when he visited him on the set of *Mission: Impossible II*. For *Minority Report*, the two reached an agreement. Spielberg would let him do as many stunts as possible, but when he said no, the actor was not to question his decision. Cruise also readily let actor Neal McDonough shave his head, even though he'd been offered a prosthetic. Once an adrenaline junky, always an adrenaline junky.

Most of the movie was shot in the studio, with a few outside scenes in Los Angeles, Virginia, and

Washington, DC. Shooting had barely wrapped when Goldman and Shusett were reminding production that Frank and Cohen's script included a number of their initial ideas. Their claim was dismissed by the Writers Guild of America, but they did at least get a mention in the credits as executive producers. This was but an inconsequential hitch because Spielberg did manage to stick to schedule. He was starting on postproduction, with one eye on the preparations for *Catch Me If You Can,* when, on September 11, 2001, two planes crashed into the World Trade Center in New York.

RECEPTION

Nine months passed between the attacks on the World Trade Center and the release of *Minority Report* in the States—nine months that completely shook America's convictions and its relationship with the very concept of freedom. At the end of October 2001, the Patriot Act was passed. It was intended to help US intelligence services combat terrorism, by authorizing the arrest and detention without charge of men suspected of wanting to involve themselves in a terrorist operation, and the collection of personal information about the whole population.

"Where do you draw the line?"

In June 2002, while Spielberg was in full swing promoting *Minority Report*, he told the *New York Times*: "Right now, people are willing to give away a lot of their freedoms in order to feel safe. They're willing to give the FBI and the CIA far-reaching powers to, as George W. Bush often says, root out those individuals who are a danger to our way of living. I am on the president's side in this instance. I am willing to give up some of my personal freedoms in order to stop 9/11 from ever happening again. But the question is where do you draw the line? How much freedom are you willing to give up? That is what this movie is about."[6] "My movie, which was more fiction a year ago, is suddenly becoming less fiction,"[7] he commented a few days later in the British daily broadsheet the *Daily Telegraph*.

And his movie is what was being judged by the critics. Most of the reviews were very positive, focusing on the cast and the infernal rhythm that the filmmaker managed to keep up for over two hours—even if some believed it had a tendency to lose a little of its substance along the way. In France, *Positif* even called it "Spielberg's best film."[10] For others, however, by attempting to do too much and say too

September 11, the Patriot Act, and Guantanamo: Suddenly the distant future didn't feel so far away.

much, Spielberg had spread himself too thin. Some critics also felt that the brands that appeared in the film (Lexus, Nokia, Gap, etc.) were a crass example of product placement that detracted from the film-maker's artistic intentions. The film's production team remained tight-lipped when asked to reveal if the brands that were featured in the film paid money to be included.

The Impact of September 11

The fact remains that *Minority Report*, like all the masterpieces of the sci-fi genre, has withstood the test of time. As a movie with a visionary approach to the future, it also offers a pertinent insight into society at the time, questioning the notions of free will and determinism—without, again, going into any great depth for fear of interrupting the flow in the action. Because Spielberg never forgot that his main aim was to entertain. And *Minority Report* did not disappoint on that front. But he does seem to have been gripped by one anxiety, which he shared during an interview with the *Independent*: "9/11 changed a lot for me. And my films did grow darker after 9/11. So I think the world has a great impact

on how it colours my movies. I think that's a good sign. It just means I'm changing by being aware of what's happening."[11]

Spiders and Wizards

In the early 2000s, Steven Spielberg's name was linked to two major adaptations: first the *Spiderman* comic book adaptation that was happening at Sony, and then the J. K. Rowling bestseller *Harry Potter and the Sorcerer's Stone*, which was coming from Warner Bros. It didn't take him long to refuse the first, but he considered the second for a while. His idea was to make an animated film that would combine several of the books, but the bosses at Warner categorically refused both suggestions and Spielberg moved on to other things.

dicaprio hanks

A STEVEN SPIELBERG FILM The true story of a real fake.

catch me ◄ if you can

DREAMWORKS PICTURES PRESENTS A KEMP COMPANY AND SPLENDID PICTURES PRODUCTION A PARKES / MacDONALD PRODUCTION A STEVEN SPIELBERG FILM
LEONARDO DiCAPRIO TOM HANKS "CATCH ME IF YOU CAN" CHRISTOPHER WALKEN MARTIN SHEEN NATHALIE BAYE CASTING DEBRA ZANE, CSA CO- PRODUCER DEVORAH MOOS-HANKIN
BASED UPON THE BOOK BY FRANK W. ABAGNALE WITH STAN REDDING MUSIC BY JOHN WILLIAMS COSTUME DESIGNER MARY ZOPHRES FILM EDITOR MICHAEL KAHN, A.C.E. PRODUCTION DESIGNER JEANNINE OPPEWALL DIRECTOR OF PHOTOGRAPHY JANUSZ KAMINSKI, ASC
CO-EXECUTIVE PRODUCERS DANIEL LUPI EXECUTIVE PRODUCERS BARRY KEMP LAURIE MacDONALD MICHEL SHANE AND TONY ROMANO PRODUCED BY STEVEN SPIELBERG WALTER F. PARKES SCREENPLAY BY JEFF NATHANSON
AMBLIN ENTERTAINMENT SOUNDTRACK AVAILABLE ON DREAMWORKS RECORDS SDDS Catch them this Christmas DIRECTED BY STEVEN SPIELBERG DREAMWORKS PICTURES
www.dreamworks.com/catchthem

Catch Me If You Can

United States · 2 hrs 20 · Color · Surround (Dolby Digital/DTS/ SDDS) · 1.85:1

Production Dates: February 11–May 4, 2002
United States Release Date: December 25, 2002

Worldwide Box Office: $352 million ($567.8 million in 2023 dollars)

Production Company: DreamWorks Pictures, Splendid Pictures, Kemp Company, Parkes/MacDonald Productions
Producers: Steven Spielberg, Walter F. Parkes
Co-Producer: Devorah Moos Hankin
Executive Producers: Barry Kemp, Laurie MacDonald, Michel Shane, Tony Romano
Executive Co-Producer: Daniel Lupi
Associate Producer: Sergio Mimica-Gezzan

Based on the autobiography *Catch Me If You Can*, by Frank W. Abagnale and Stan Redding (1980)
Screenplay: Jeff Nathanson
Director of Photography: Janusz Kamiński
Film Editing: Michael Kahn
Music: John Williams
Sound: Charles L. Campbell, John A. Larsen, John Murray
Art Direction: Sarah Knowles
Production Design: Jeannine Oppewall
Hair Stylist: Kim Santantonio
Costume Design: Mary Zophres
Casting: Debra Zane, Terri Taylor

Starring: Leonardo DiCaprio (Frank Abagnale Jr.), Tom Hanks (Carl Hanratty), Christopher Walken (Frank Abagnale), Martin Sheen (Roger Strong), Nathalie Baye (Paula Abagnale), Amy Adams (Brenda Strong), James Brolin (Jack Barnes), Brian Howe (Earl Amdursky), Frank John Hughes (Tom Fox), Chris Ellis (Special Agent Witkins), Jennifer Garner (Cheryl Ann), Ellen Pompeo (Marci), Elizabeth Banks (Lucy), Frank Abagnale Jr. (a French police officer)

> # "*Catch Me…* is really like a bonbon, if you like. It's light, it's amusing, entertaining, oddly enough about a serious subject."[1]
>
> —John Williams in 2002

SYNOPSIS

<div style="border-bottom: 3px solid"></div>

In the 1960s, Frank Abagnale Jr. took flight in a mad chase across the United States. Between the ages of sixteen and twenty-one, he'd written several million dollars' worth of bad checks and lived the high life posing as first an airline pilot, then an attorney, and then a physician…right under the nose of FBI agent Carl Hanratty, who'd been put in charge of finding him. Arrested and imprisoned in Montrichard, France, the village where his divorced parents met, he was extradited and served a sentence on American soil before joining the FBI to help combat fraud and forgery.

In order to go unnoticed, Frank Abagnale Jr. (Leonardo DiCaprio) had to blend in by standing out.

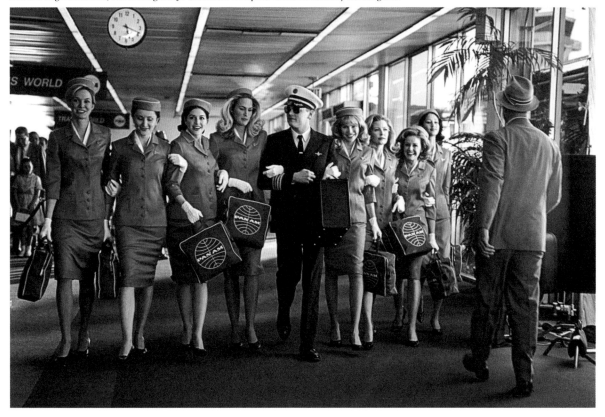

GENESIS

"When the legend becomes fact, print the legend."[2] This famous quote from *The Man Who Shot Liberty Valance* (John Ford, 1962), a movie that summarizes America's pioneering spirit and its shady side, finds a powerful resonance in Steven Spielberg's work. Before he began to question them, Spielberg had long believed in the great founding stories of his nation and the American way of life that he had been sold as an ideal in the 1960s. And the story of Frank Abagnale Jr. seems to be an absurd celebration of this American dream.

The Habit Makes the Monk

In 1977, Frank Abagnale Jr. appeared on the TV game show *To Tell the Truth*, where the players had to pick out which of the three mystery contenders had done something extraordinary. On the show, the host Joe Garagiola described Abagnale as follows: "I'm known as the world's greatest imposter and no wonder. In the course of my nefarious career, I've passed myself off as a doctor, a lawyer, a college instructor, a stockbroker, and an airline pilot… For six years, I also cashed 2.5 million dollars in bad checks in 26 countries. Ultimately, I was sentenced to 72 years in prison. I served one year in France, one in Sweden, I then served four years in a federal prison in this country. Paroled, I now devote my life to the prevention and detection of crime." The program brought him into the spotlight and led to his appearance on talk shows and, in 1980, the publication of his autobiography *Catch Me If You Can*, which he wrote with the help of journalist Stan Redding. And the staggering epic tale of an underage crook very quickly caught the attention of Hollywood. The adaption rights passed from person to person; the projects from one studio to the next. In 1981, Dustin Hoffman even came very close to playing Abagnale.

An Unseen Character

In the late 1990s, screenwriter Jeff Nathanson (*Twister*, *Speed 2*) discovered a recording of one of the seminars given by Abagnale, who had set up a fraud detection consultancy. Hearing him talk about his life reminded Nathanson of George Roy Hill's movies about likable swindlers such as *The Sting* (1973) and *Butch Cassidy and the Sundance Kid* (1969). He and producer Barry Kemp, who held the rights to the book at the time, approached DreamWorks studio and they were extremely interested. Director David Fincher got in on the act but decided to focus on *Panic Room* (2002) in the end. Leonardo DiCaprio got wind of the project, read

Frank Abagnale (Christopher Walken) and his son trapped behind a metal shutter, an image predicting his son's time behind bars.

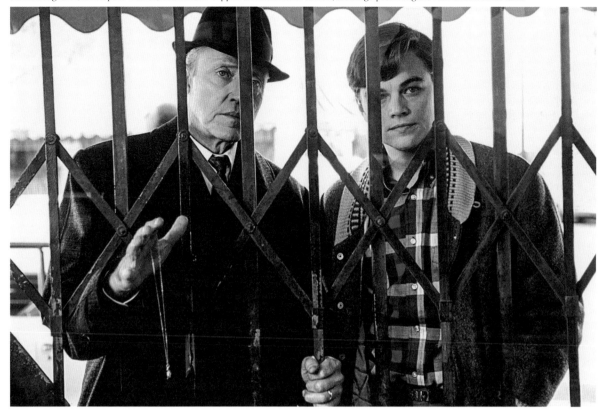

Paula Abagnale (Nathalie Baye) was an unfulfilled stay-at-home mom who was attracted to life outside the home.

the book on the set of *Gangs of New York* (Martin Scorsese, 2002), and, fascinated by the character, put his name in the ring. A deal was reached: *Catch Me If You Can* would be directed by Gore Verbinski (*Pirates of the Caribbean*), starring DiCaprio and with James Gandolfini as the FBI agent Carl Hanratty. But alas, the filming of *Gangs of New York* was complicated, and DiCaprio had been detained on the set, so the shooting of *Catch Me If You Can* was postponed. Exit Verbinski. Lasse Hallström (*Chocolat*, 2000), Milos Forman (*Amadeus*, 1984), and Cameron Crowe (*Jerry Maguire*, 1996) were approached to replace him without success. Spielberg, who had been following developments as the producer, then decided to take the reins.

Looking for Levity

At the time, Spielberg was working on the adaptation of Arthur Golden's novel *Memoirs of a Geisha*, which he passed on to Rob Marshall. After four movies with heavy subject matter (*Amistad, Saving Private Ryan, A.I., Minority Report*), he felt the need for something light. He'd actually tried to end a three-year sabbatical in 1999 to direct the comedy *Meet the Parents* (Jay Roach, 2000), but his wife, Kate Capshaw, had vetoed it. It was after he watched his family and some friends improvise reading the *Catch*

Me If You Can script that he signed up. The portrait of America and the father-son relationship told through Abagnale's story really spoke to him.

Children of Divorce

Frank Abagnale Jr. claims that his flight from the law began on the day the divorce lawyers asked him to choose which of his parents he wanted to live with. In admiration of his father—a charismatic failed businessman sought by the tax authorities for fraud—Abagnale constantly wanted to succeed where Frank Sr. had failed. How did he do it? By charming anything on legs, particularly women and his future victims—capturing their gaze to manipulate them, disguising himself, inventing identities, faking checks and papers, and, when found out, fleeing to another state or country. In other words, he treated the world like a vast playground, refused to grow up despite his adult means, and took refuge in a world of artifice: Were there not similarities between the impostor and the director? Did Spielberg, as a teenager, not take advantage of a coach tour of Universal studios to sneak his way in, and, if we are to believe him, pass himself off as an employee, with suit and briefcase, during his summer vacation—for several months, according to some versions of the story?

FOR SPIELBERG ADDICTS

In 2003, in an enlightening article entitled "Steven Spielberg, A Jew in America: Deconstructing *Catch Me If You Can*,"[4] author Alan Vanneman interpreted the movie (and Abagnale's journey) as an allegory of Jewish identity in America: living on the fringes of society, changing identity to escape social determinism, chasing success, integrating into the WASP family model—evident in, for example, the recurrent Christmas scenes when Abagnale feels isolated.

One Father After Another

Spielberg will not be the last person who has rewritten his life story in the course of interviews. For a long time, his age was under discussion because his obsession with making his first professional movie before the age of majority had led him to lie about his year of birth on several occasions. The parallel with Abagnale is all the more disconcerting when we learn the latter began his career as a forger at the time when Spielberg was starting out as an apprentice at Universal. They were driven by ambition, of course, but were also fleeing the

Abagnale Jr. and one of his conquests in the heady 1960s.

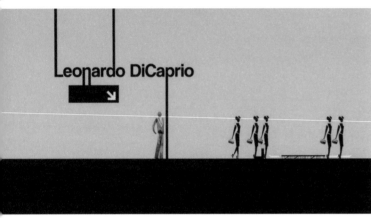

pain of being children of divorce; *Catch Me If You Can* functions as a declaration of each man's love for his father. Abagnale's father died during one of his son's stretches in prison; Spielberg's father disappeared from his life. Convinced that Arnold was responsible for breaking up their home, Steven cut all contact with him for nearly twenty years, the time it took for him to realize that his mother was mostly to blame, as she had fallen in love with the family's best friend…just like in the movie.

DISTRIBUTION

Playing Frank Abagnale Jr. for ten years from the age of sixteen posed no problem for Leonardo DiCaprio, who was twenty-six at the time. The actor had been a global star since the triumphant success of *Titanic* (James Cameron, 1997) and had just begun his long-term collaboration with Martin Scorsese. He was seeking out the great filmmakers to put his career on a firmer footing. To hone the character, he spent three days with the real Abagnale, aged fifty-three at the time, equipped with his tape recorder. His verdict: "You don't think he would steal a postage stamp. He looks as innocent as a school teacher. […] A lot of his way of seducing people was very unconscious."[5]

The Paradox of Choice

Having been left in the lurch by James Gandolfini, who went off to film the new season of *The Sopranos*, Spielberg wasn't sure about asking his friend Tom Hanks to play Carl Hanratty, fearing he would hardly

Eye-Catching Credits

With vanishing silhouettes, geometric lines, and vibrant colors, the opening credits of *Catch Me If You Can* immediately establish the swinging sixties mood of the movie. The sixties feel is further enhanced by John Williams's jazz fugue on the vibraphone, a nod to the music of Henry Mancini. They are the work of French duo Florence Deygas and Olivier Kuntzel, alias Kuntzel+Deygas, tasked with creating a graphic animation in the manner of Saul Bass and Maurice Binder. Bass was known for the credits of Hitchcock's *North by Northwest* (1959); Binder for those of Stanley Donen's *Charade* (1963)—movies mirroring and modeling the spy entertainment genre. Two games of cat and mouse…like *Catch Me If You Can*.

Stay on the straight and narrow, or follow his vocation? Abagnale Jr. hesitates when he encounters FBI agent Carl Hanratty (Tom Hanks).

be interested in a supporting role. This was far from the case. The character of Hanratty combines several FBI agents who'd tracked down Abagnale but is based mainly on Joseph Shea, who remained close to Abagnale and encouraged him to put his talents to good use assisting the government. On set, another FBI veteran, William Rehder, acted as a technical adviser and coach for Hanks, who was back in uniform (the black hat and suit of the FBI) for the first time since *Saving Private Ryan*. Once again he embodied the moral guardian of American authority, but with a certain irony this time.

On the other hand, it was the first time Spielberg had filmed with Christopher Walken, who played Abagnale's father, and Nathalie Baye, his mother, who was French like the actress herself. Baye was signed up after tryouts filmed in Paris by the director Brian De Palma, who lived in the French capital at the time. Spielberg never hid the fact that his memory of Baye's interpretation of a young script girl in François Truffaut's *Day for Night* had influenced his choice.

FILMING AND PRODUCTION

Spielberg approached *Catch Me If You Can* as a nostalgic trip back in time to pop art and the charm of 1960s movies about swindlers and spy comedies such as *The Flim-Flam Man* (Irvin Kershner, 1967). It also provided him with the opportunity to re-create the America of his teenage years with all that was great about it (family values, booming capitalism), which he now knew had turned sour.

Stepping on the Gas

It was filmed in real-life sets (with a budget of $52 million in today's terms) at lightning speed, matching the rhythm of the movie itself. There were 52 days of shoots in 147 different places from New York (the Abagnale's apartment, Chase Bank, JFK airport) to Alcatraz prison in San Francisco, and from all four corners of California to Montreal and Quebec (for the scenes that were supposed to take place in France)… "It reminded me of the best times I used to have in television, when I first got started and cut my teeth on Marcus Welby. We had to really move

fast and quickly."[6] Remembering what he'd learned about comedy from Frank Capra, Spielberg pushed his actors to speed up their game and improvise… and Christopher Walken didn't hold back. In a scene where father and son meet again, without any warning the actor burst into tears when mention was made of him meeting his ex-wife during WWII. Walken thought he might have taken it too far and asked for a retake. No need, Spielberg insisted, I

got it. It was as though he could see in Walken's misty eyes the things that were left unsaid with his own father.

The America of *Playboy* and Edgar J. Hoover

DiCaprio worked at a feverish pace throughout the filming. The actor wore over a hundred different costumes, including a Pan Am pilot's uniform, a James Bond–style three-piece suit and a cardigan and sailor's pants in Beach Boys fashion. As production designer Jeannine Oppewall explained, "I've talked to Mary, the costume designer, for a long time, and we've talked about a color arc of emotions in the movie in which he would start in a kind of ordinary, slightly monochromatic environment and, as he got better and better, things are getting wilder and wilder in terms of color."[7] The director of photography, Janusz Kamiński, had the paved streets constantly sprayed with water to improve reflections and add luster to the images, in contrast to the austere interiors of the FBI offices. With the heady pace of Abagnale's life and the inertia of Hanratty's, the feigned insouciance of one and the conservative rigidity of the other, it's the two

⏸ Freeze Frame

When Frank (Leonardo DiCaprio) is arrested by the French police, a shot captures his helpless glance as he turns back to look at Carl Hanratty, his substitute father, through the back windscreen of the car that is taking him away. A nod to the unforgettable scene in *A.I.*, when little David is abandoned by his mother in the forest. Spielberg shows the petrified little boy in the rear-view mirror as it moves away from him. Two heartbreaking still frames in which the inevitable internal movement of the vehicle (symbolizing the adult authority) tears a little boy away from the ties he has with his childhood to project him into the hostile reality of the world.

Spielberg and Leonardo DiCaprio take a time-out during a filming schedule that moved at lightning speed.

Hanratty does his laundry between assignments, in juxtaposition with his target, Abagnale, who is constantly jet-setting.

sides of America—*Playboy* on one side and J. Edgar Hoover on the other—that the movie depicts, as well as the encounter between two lone figures united through family trauma: Abagnale, the lonely child of divorced parents, ends up looking to Hanratty, a single divorcé, as a substitute father.

RECEPTION

On May 31, 2002, after he had wrapped up filming, Spielberg received his degree in film and electronic arts from California State University, Long Beach, at the age of fifty-six. This was a moment of celebration and reflection for the much-honored director.

Speed and Fluidity

There were signs that the critics were changing their minds about Spielberg when *Catch Me If You Can* was met with a certain degree of enthusiasm. "That rarity of rarities, a mainstream American feel-good movie with both charm and intelligence,"[9] Andrew Sarris wrote in *The Observer*. *Variety* praised

"DiCaprio's winning performance goes a long way toward encouraging the viewer to forgive the film its indulgences and missteps."[10]

A Last Hurrah?

The movie was represented at the Oscars by Christopher Walken, who was nominated for Best Supporting Actor, and John Williams, who was cited for his jazz heavy score. Its box-office success led to a musical comedy on Broadway nine years later, shining the spotlight on Abagnale and delivering a fatal blow. In his 2020 book *The Greatest Hoax on Earth: Catching Truth While We Can*, journalist Alan Logan investigated and discredited many of Abagnale's claims—his luxurious lifestyle, numerous feats, his job with the FBI—and portrayed him instead as a small-time huckster who spent most of his time behind bars. Whatever the case, by filming the legend of Abagnale, Spielberg laid himself bare in one of his liveliest and most personal movies to date.

John Williams records the score
for *Saving Private Ryan* (1998) at
Boston Symphony Hall.

John Williams
A Musician Who Can Make Bicycles Fly

It was the score for the movie *The Reivers* (Mark Rydell, 1969) that was the deciding factor in Steven Spielberg's requesting John Williams for *Sugarland Express* (1974). The two men met in a restaurant in Beverly Hills in the very early 1970s. "I met what looked to be this seventeen-year-old kid, this very sweet boy, who knew more about film music than I did,"[1] the musician recalled in 2020.

A Collaboration and Three Oscars
And so began a collaboration of rare longevity. For many years, *The Color Purple* (1985) was the only Spielberg movie without a John Williams score, though the latter began to take a step back with *Bridge of Spies* in 2015. But in 2022 he made a comeback with *The Fabelmans*, a work so personal that Spielberg could not do it without him. Spielberg also famously recommended the composer to George Lucas, who was looking for an epic score for *Star Wars* (1977).

In 2012, Spielberg said John Williams was the person who had played the biggest part in his success. It must be said that the man could adapt anything he turned his hand to, from the infamous dissonances of Igor Stravinsky's *The Rite of Spring* for *Jaws* (1975) to the typewriter-mimicking mechanical rhythms of *The Post* (2017), not to forget the heartrending sobriety of Itzhak Perlman's violin for *Schindler's List* (1993). In total, Steven Spielberg's movies earned Williams three Oscars.

328 *John Williams*

Bernard Herrmann Was Incensed

John Williams was born in New York in 1932. When he was fifteen, his family moved to Los Angeles, where his percussionist father worked for the movie studios. John himself formed a jazz group. A pianist for seven years, he attended UCLA and the Juilliard School in New York, and began composing for the cinema in 1958 with Lou Place's comedy *Daddy-O*. As a member of the Henry Mancini orchestra, he played on the scores for *Days of Wine and Roses* (Blake Edwards, 1962), *Hatari!* (Howard Hawks, 1962), *Charade* (Stanley Donen, 1963), and the famous theme for the *Peter Gunn* series (Blake Edwards, 1958). Already before his Spielberg years he had been nominated eight times for Oscars and received one for *Fiddler on the Roof* (Norman Jewison, 1971). But this adaptation of an existing piece of music managed to exasperate Bernard Herrmann, his mentor: "Write your own music,"[2] he said.

Sitar and Johnny Mercer

Williams's music for *The Poseidon Adventure* (Ronald Neame, 1972) helped to bring back orchestral scores, a comeback further reinforced by the success of disaster movies like *Earthquake* (Mark Robson) and *The Towering Inferno* (John Guillermin) in 1974. Williams was responsible for their scores, at a time when New Hollywood favored pop, rock, or no music at all for its movies.

For *The Long Goodbye* (Robert Altman, 1973), John Williams proved himself as capable as anyone of the experimentation that was so popular at the time. He created a dozen versions of the same piece (jazz trio, song to lyrics by Johnny Mercer, supermarket music, sitar, etc.) that were heard by the protagonists of the movie in different situations.

Jurassic Park versus *Schindler's List*

John Williams's special bond with Steven Spielberg was unassailable. He created scores carried by the woodwind section, with the French horn also taking pride of place, in which the mix of enthusiasm and melancholy fitted the movies "like a glove" (in the director's own words). And yet, the composer had a jazz background and said he was drawn to the abstract style of Edgar Varèse. But with the cinema he quickly understood that he had to set his personal preferences aside to work in someone else's world.

It was the same ritual for each project. Williams would shut himself away to watch a rough cut of the movie and then would put forward his initial ideas. "Sometimes when I hear his music, I'll run to the editing room and make adjustments to better fit the

Williams and Spielberg in 2016, at an event given in the composer's honor by the American Film Institute.

music,"[3] Spielberg confirmed. In 1993, for *Jurassic Park*, the process was more chaotic. Spielberg was shooting *Schindler's List* in Poland and, for the first time, couldn't attend the recording. He had to make do with piano demonstrations he'd taken with him. It was a completely different story for *The Post*, which was composed in such a rush, in the middle of *Ready Player One* (2018), that Spielberg discovered the music for the first time during recording.

The Ultimate Five Notes

John Williams made his mark primarily as a master of the leitmotif: musical phrases that define a character or a situation and that are often short, to meet the constraints of a movie and so they can still be heard even in the midst of the action. It is a real art. The theme "The Raiders March" in *Raiders of the Lost Ark* took him several weeks. The *Jaws* ostinato is so radical (two notes on cello and tuba) that Spielberg initially thought he wasn't being serious. But he quickly came to understand that this theme, destined for posterity, was not only a piece of music but also personified the shark itself, which no longer needed to appear on-screen to inflict terror.

The process perhaps reached its apogee with *Close Encounters of the Third Kind,* where a sequence of five notes is the very theme of the movie—proof, if it were ever needed, of the director's trust in the composer, without whom, he said in 2016 in reference to *E.T.*, "without John Williams, bikes don't really fly."[4]

Tom Hanks
Catherine Zeta-Jones

A STEVEN SPIELBERG Film

The Terminal

Life is waiting.

DREAMWORKS PICTURES presents a PARKES/MacDONALD Production A STEVEN SPIELBERG Film

TOM HANKS CATHERINE ZETA-JONES "THE TERMINAL" STANLEY TUCCI CHI McBRIDE DIEGO LUNA

DEBRA ZANE, CSA SERGIO MIMICA-GEZZAN JOHN WILLIAMS MARY ZOPHRES MICHAEL KAHN, A.C.E.

ALEX McDOWELL JANUSZ KAMINSKI, ASC PATRICIA WHITCHER JASON HOFFS ANDREW NICCOL

WALTER F. PARKES LAURIE MacDONALD STEVEN SPIELBERG ANDREW NICCOL and SACHA GERVASI SACHA GERVASI and JEFF NATHANSON

STEVEN SPIELBERG

DREAMWORKS PICTURES

The Terminal

| United States | 2 hrs 8 | Color (Technicolor) | Surround sound (Dolby Digital/DTS/ SDDS) | 1.85:1 |

Production Dates: October 1–December 12, 2003
United States Release Date: June 18, 2004

Worldwide Box Office: $218 million ($342.5 million in 2023 dollars)

Production Company: DreamWorks Pictures, Amblin Entertainment, Parkes/ MacDonald Productions
Producers: Laurie MacDonald, Walter F. Parkes, Steven Spielberg
Co-Producer: Sergio Mimica-Gezzan
Executive Producers: Jason Hoffs, Patricia Whitcher, Andrew Niccol
Unit Production Managers: Leeann Stonebreaker, Don J. Hug (Palmdale), Irene Litinsky (Montreal), Steve Rose (New York)

Based on a story by Andrew Niccol and Sacha Gervasi, loosely inspired by the situation of Mehran Karimi Nasseri (uncredited)
Screenplay: Sacha Gervasi, Jeff Nathanson
Director of Photography: Janusz Kamiński
Film Editing: Michael Kahn
Music: John Williams
Sound: Ron Judkins
Sound Effects: Charles L. Campbell
Scripts: Ana Maria Quintana, Neale De Silva (uncredited)
Production Design: Alex McDowell
Art Direction: Christopher Burian-Mohr, Brad Ricker
Hairstylist: Kim Santantonio
Makeup: Edouard F. Henriques
Costume Design: Mary Zophres
Special Effects Supervisor: Michael Lantieri
Casting: Debra Zane

Starring: Tom Hanks (Viktor Navorski), Catherine Zeta-Jones (Amelia Warren), Stanley Tucci (Frank Dixon), Chi McBride (Mulroy), Diego Luna (Enrique Cruz), Kumar Pallana (Gupta Rajan), Zoe Saldana (Dolores Torres), Eddie Jones (Salchak), Corey Reynolds (Waylin), Jude Ciccolella (Karl Iverson), Guillermo Díaz (Bobby Alima), Michael Nouri (Max), Sasha Spielberg (Lucy, the young lady with the broken suitcase), Benny Golson (himself)

> **"He's also endlessly imaginative, almost to a fault. He just can't stop inventing things. He has everything accessible to him. He'll ask for something that hasn't been invented yet, and just say: 'go invent it.'"**[1]
>
> —Stanley Tucci, talking about Steven Spielberg after the release of *The Terminal*

SYNOPSIS

—

At John F. Kennedy International airport in New York, a tourist is refused entry to America. His name is Viktor Navorski and he has traveled from the (fictional) country of Krakozhia in Eastern Europe. In the time it has taken him to make the flight, a revolution has taken place and overthrown his government. All visas have been canceled. In a nutshell, he is now a "citizen of nowhere," Frank Dixon, the head of Customs and Border Protection at JFK, informs him. Until the new Krakozhian government is recognized by Washington, Viktor Navorski can neither enter nor leave the United States—meaning he can neither leave the airport nor fly elsewhere. Frank Dixon does, however, permit him to remain in the international transit zone, but the stranger's presence disrupts his own career plans (he was about to be appointed airport commissioner). Frank Dixon tries one underhanded trick after another to get rid of Navorski, who is in the process of making a life for himself in the terminal: He learns the language, improvises a place to stay in an area undergoing work, and befriends the employees.

The airport set built for the film was fully functional.

GENESIS

After *Catch Me If You Can*, Steven Spielberg wanted to continue in a (not entirely) lighter vein, believing that laughter was good for both him and his audience. So, for his next movie, he chose a bittersweet comedy in which, he summarized, a man "discovers that life is about waiting, and that the best answers, the ones that will move you forward, come to those who have patience,"[2] set against a backdrop of a high-security post-9/11 America.

Inspired by the Story of an Iranian Refugee

Although it was never mentioned during promotion of the movie, there is not a shadow of a doubt that *The Terminal* was based on the case of Iranian refugee Mehran Karimi Nasseri, who had been stuck at Terminal 1 of Paris Charles de Gaulle Airport in France since August 1988 (he would leave in late July 2006). It was only Nasseri's situation they used, not his life; the fact remains that Steven Spielberg's production company, DreamWorks, paid him a considerable sum of money (the check was deposited at the airport branch of the postal bank). It was only later, though, that Spielberg heard about the French movie based on the same story, *Tombés du ciel* [*Lost in Transit*, literally "Fallen from the Sky"] (Philippe Lioret, 1993).

The story was initially scripted by Andrew Niccol and Sacha Gervasi. Niccol made a name for himself as writer of *The Truman Show* (Peter Weir, 1998), which is also about a man living in a closed world. Gervasi co-wrote the comedy *The Big Tease* (Kevin Allen) in 1999. He spent two days at Charles de Gaulle with Mehran Karimi Nasseri, observing his routines, how he got hold of food and showered. He also watched him direct lost travelers and scrounge meals and books, perfectly at one with the terminal employees. Sacha Gervasi also obtained permission to live at JFK airport in New York for five days, where he focused on the day-to-day life of such a place, everything the average traveler never has time to notice.

Prison Movie Strategies

Steven Spielberg felt the first version of the script was too static, so he called upon the services of the *Catch Me If You Can* screenwriter Jeff Nathanson. And the latter found the solution. Because for Viktor Navorski the terminal was like a prison, they needed to include some narrative strategies from prison movies. The head customs officer became the

Catherine Zeta-Jones plays a flight attendant oscillating between funny and chaotic, a new type of role for the actress.

equivalent of a prison warden, and Navorski had to get around or adapt the rules to his own advantage.

It quickly became apparent that filming in a real airport would not be possible. There were too many factors outside their control, and since September 11, the security regulations complicated everything—so the decision was made to build a life-size terminal.

A Colossal Building Site

For almost six months, the production designer Alex McDowell oversaw a colossal building site in Hangar 703 of Palmdale Airport in the Mojave Desert. The site was part of a US Air Force complex where bombers were built and modified. The ground was covered with polished granite and an escalator installed. United Airlines provided a departure gate. A mechanical Solari (split flap) board was salvaged from Milan airport and an electronic information panel made specially for the movie. And there was more: Thirty-five stores bearing the names of real-life brands (Starbucks, Borders, Hugo Boss, La Perla, etc.) were set up with the help of representatives from each of them. A massive window measuring over a hundred thousand square feet overlooked the runways, which were in fact a huge painted fresco forty feet from the wall.

Work was completed on October 16, 2003. Alex McDowell was a little tense when he arrived there on the day Steven Spielberg and Tom Hanks would see his work for the first time, but he'd scarcely had time to enter the hangar before he was met with cheering and applause.

DISTRIBUTION

This was the third time Steven Spielberg called upon Tom Hanks, an actor who practically specialized in characters who achieved hero status precisely because of their insignificance. Viktor Navorski also had that slightly disorientated side (he understands neither the language nor the rules), likening him to a child in a complicated adult world. Krakozhia might be a fictional country, but the character speaks Bulgarian. For eight months prior to filming, Tom Hanks took lessons from a translator who then helped him on set.

A Flight Attendant Who Lost Her Way and an Ambitious Director

Catherine Zeta-Jones's career took off via an Amblin Entertainment production, *The Mask of Zorro* (Martin Campbell, 1998), before she received an Oscar for the musical comedy *Chicago* (Rob Marshall, 2002). Used to playing the femme fatale, she finally finds in flight attendant Amelia Warren a character who's slightly lost and—because it's Spielberg—sensual in a truly sterile way.

Stanley Tucci, known for playing not particularly likable characters (even Adolf Eichmann in a TV movie), plays the deceitful and ambitious Frank Dixon. He represents a certain failing on the part of America. He imagines that Viktor Navorski is fascinated by the country, though the latter has absolutely no intention of staying there. But Stanley Tucci doesn't make his character all bad, injecting a certain doubt and frustration into his motivations. When Viktor Navorski escapes him in the end, Frank Dixon suddenly relaxes, aware of the futility of his attitude.

Menials of the Melting Pot

As the terminal in the movie represents America in miniature, with its false promises and paranoia, there are a handful of actors who play menial workers from different cultural backgrounds. Mexican Diego Luna plays a catering services employee, Zoe Saldana (of Dominican and Puerto Rican descent) is an immigration assistant, and Indian actor Kumar Pallana is a member of the cleaning staff. Having once appeared as an acrobat and actor in the early Wes Anderson movies, he adds a touch of acerbic, slapstick humor.

The reason Viktor Navorski came to New York was to get the autograph of the jazz saxophonist Benny Golson. The musician appears as himself but

Freeze Frame

This shot captures the drama of Viktor Navorski, who, like a hobo, has taken up residence in a wing undergoing work. The sense of imprisonment is accentuated by signs of the outside world (flashing lights, silhouettes, computer-generated images of planes) behind the walls, and when an aircraft's headlights suddenly light up the room, the character has become so inundated by the paranoia around him that he immediately thinks he's being arrested.

Actor Stanley Tucci appears as Frank Dixon, the arrogant head of Customs.

only as a shadow in the spotlights, a touch of the otherworldly in a country that's gone mad.

FILMING AND PRODUCTION

Filming began on the set of an immigration office in the vicinity of Los Angeles International Airport in early October 2003. Next, everyone arrived in Palmdale (in another hangar) for the scenes at Gate 67, where Viktor Navorski takes up residence.

Six Hundred Extras Add Movement

With the initial scenes in the bag, it was time to enter the terminal. Filming in a single place really does simplify the logistics. "If someone has a good idea, or Steven sees something or Tom Hanks has a suggestion, it really can be 30 minutes between the idea and when you shoot it,"[3] producer Walter F. Parkes said.

Spielberg injected life into the closed world with movement from around six hundred extras playing travelers in transit, and highly mobile framings. One of the tools he used was the Spydercam (not to be confused with the Spidercam, a competitor's equivalent), a remote-controlled camera that moves on a cable from high above the action. This allowed

Spielberg to follow Viktor Navorski from afar as he moves about the airport.

In a Virtually Empty Airport

For his part, the director of photography Janusz Kamiński abandoned his usual style of contrasts and chiaroscuro to use realistic lighting that simulated all the hours of the day and night in every season, as the story spans a period of eleven months. Because the terminal was an atrium, most of the lighting came from a lightbox on the ceiling.

In early December the crew turned up at the virtually empty Montréal-Mirabel International Airport in Canada for the immigration hall scenes at the start of the film and those in front of the exterior facade at the end. In postproduction, digital animation was used to enhance the background fresco, but it took much less than originally anticipated thanks to the quality of the painted picture. This is one of Alex McDowell's proudest achievements.

RECEPTION

Taking $72.2 million at the box office in the States, the movie did not come anywhere near the staggering

An abstract portrayal of saxophonist Benny Golson, a symbol of the bond between Viktor Navorski and his father.

performances of Spielberg's blockbusters. It started out in the number two slot on the first weekend of release but fell to fifth place the following weekend.

Between Enthusiasm, Skepticism, and Boredom

Critics did not hide their surprise at the extent that the movie, as summarized in *Première* magazine in France, "destabilized those who see [Spielberg] only as a director of spectacle and bombast."[4] There were repeated mentions of Franz Kafka, but opinions on *The Terminal* oscillated between enthusiasm, skepticism, and boredom. Roger Ebert, in the *Chicago Sun-Times*, was touched by the humanity of the movie and the sympathy inspired by all the characters.[5] *Entertainment Weekly* felt that "it's hard to shake the feeling that Spielberg, in essence, is doing what you do when you sit around an airport. He's killing time."[7] Given the state in which America found itself in 2004, perhaps the filmmaker didn't know how to laugh about it.

Paul Berczeller, screenwriter and actor on the movie *Here to Where* (Glen Luchford, 2001), about a director's obsession with Mehran Karimi Nasseri stuck at Charles de Gaulle airport, befriended the Iranian for a year. What did Berczeller think of *The Terminal*? A "load of puerile crap," he wrote in the *Guardian*.

A Great Day in Harlem

The photo of the fifty-seven jazz musicians that Viktor kept in his iron box is a famous picture of the group (Count Basie, Dizzy Gillespie, Lester Young, Charles Mingus, Thelonius Monk, etc.) taken by Art Kane in Harlem, New York, on August 12, 1958. Entitled *A Great Day in Harlem*, it appeared in *Esquire* magazine in January 1959. The headline "The Golden Age of Jazz," which, in the movie, is seen in the context of Viktor Navorski's close relationship with his late father, mirrors Spielberg's less rocky relationship with his own.

TOM CRUISE

A STEVEN SPIELBERG FILM

WAR
OF THE
WORLDS

War of the Worlds

2005

United States 1 hr 56 Color Surround 1.85:1
(Dolby/DTS/ SDDS)

Production Dates: November 8, 2004–March 7, 2005
United States Release Date: June 29, 2005
Worldwide Box Office: $604 million ($918 million in 2023 dollars)

Production Companies: Amblin Entertainment, Cruise/Wagner Productions,
Paramount Pictures, DreamWorks Pictures
Producers: Kathleen Kennedy, Colin Wilson
Executive Producers: Paula Wagner, Damian Collier

Based on the eponymous novel by H. G. Wells (1898)
Screenplay: Josh Friedman, David Koepp
Director of Photography: Janusz Kamiński
Film Editing: Michael Kahn
Music: John Williams
Sound: Richard King, Andy Nelson, Anna Behlmer, Ron Judkins
Production Design: Rick Carter
Art Direction: Tony Fanning
Set Decoration: Anne Kuljian
Costume Design: Joanna Johnston
Special Effects: David Blitstein, Gintar Repecka, Daniel Sudick
Concept Artists, Spaceships and Aliens: Doug Chiang, Brian Flora,
Marc Gabbana, Randy Gaul, Kurt Kaufman
Visual Effects: Dennis Muren, Pablo Helman
Animation: Randal M. Dutra (ILM)
Second Unit Director and Stunt Coordinator: Vic Armstrong
First Assistant Director: Adam Somner
Casting: Debra Zane, Terri Taylor

Starring: Tom Cruise (Ray Ferrier), Dakota Fanning (Rachel), Miranda Otto
(MaryAnn), Justin Chatwin (Robbie), Tim Robbins (Harlan Ogilvy), Rick
Gonzalez (Vincent), Yul Vazquez (Julio), Lenny Venito (Manny the mechanic),
Lisa Ann Walter (barmaid), Ann Robinson (grandmother), Gene Barry
(grandfather), David Harbour (Ray's colleague), Amy Ryan (neighbor with
toddler), Morgan Freeman (narrator)

"Since September 11, 2001, I can no longer look at the sky in the same way."[1]

—

—Steven Spielberg

SYNOPSIS

—

In New Jersey, Ray Ferrier takes his children, Rachel, eleven, and Robbie, seventeen, for the weekend. Suddenly, the weather turns ominous. The news reports that an unexplained phenomenon has demagnetized Ukraine and plunged the country into darkness. In the northeastern United States, lightning strikes and rouses devices that emerge from the ground: Gigantic tripods invade the sky and begin to destroy everything. Like millions of Americans, Ferrier and his two children flee for safety.

GENESIS

Having been made aware of the classic science fiction literature by his father, Steven Spielberg read *War of the Worlds* in the late 1960s as part of his creative writing course at university in Long Beach. At the time, H. G. Wells's book had already been adapted into two seminal works.

A Reflection on the State of the World

War of the Worlds, the first story of an extra-terrestrial invasion, was published in 1898 as a serial in *Pearson's* magazine. In it, H. G. Wells imagines hostile Martians, driven by a colonizing ambition against our planet. His genius lies in presenting the human species from the point of view of a more technologically advanced conqueror, in the way we would view a colony of ants. Underpinned by Wells's scientific background, the work has a metaphorical dimension: It targets British imperialism and, more generally, the Western sense of omnipotence over people and nature. Ultimately, *War of the Worlds* reflects the state of the world and its fears, as confirmed by its most famous adaptations: In 1938, Orson Welles was inspired by the threat of Nazi Germany and produced a radio play so credible that it created panic among listeners. In 1953, after filmmakers as diverse as Sergei M. Eisenstein, Alfred Hitchcock, and Cecil B. DeMille had all taken an interest, Byron Haskin directed the first film version, a B-movie blockbuster that capitalized on the fear of communism and the nuclear bomb.

A Persistent Desire

Having been influenced by Byron Haskin's version and by other films about invasive aliens, allegories of the Cold War, such as *Earth vs. the Flying Saucers* (Fred F. Sears, 1956) or *Invaders from Mars* (William Cameron Menzies, 1953), Spielberg had never forgotten his reading of Wells's novel, even though he had until now been a proponent of peaceful extra-terrestrials, from whom we have more to learn than to fear. In 1994, he bought the script of Orson Welles's broadcast at auction and set his sights on adapting the almost century-old novel. But the worldwide triumph of Roland Emmerich's *Independence Day* (1996) took the wind out of his sails. It was out of the question that he should be left behind. The desire did not leave him for all that, reactivated by the attacks of September 11, 2001, in the United States. Spielberg spoke to Tom Cruise, who was enthusiastic about the idea, but the two men had other priorities. Cruise was filming *The Last Samurai* (Edward Zwick, 2003), *Collateral* (Michael

An illustration by Brazilian artist Alvim Corrêa, which appeared in the 1906 French-language publication of the novel.

In the film, images of chaos are accompanied by sound effects that are sometimes distorted and deafening, both unusual techniques for a mainstream blockbuster.

Mann, 2004), and then, in the summer of 2004, suddenly found himself available when production of *Mission: Impossible III* was delayed. Spielberg, then in the midst of preparing *Munich*, put the project on hold and seized the opportunity. Cruise and Spielberg together in the most famous alien attack story! Paramount, under contract with the actor, rubbed their hands with glee in anticipation and set the release date for June 29, 2005, a key date in the blockbuster season—a mere ten months later.

A Global Disaster and a Family Reunion

In the wake of the success of the film *Independence Day,* and as the year 2000 approached, disaster science fiction became fashionable again: *Deep Impact* (Mimi Leder, 1998), *Dante's Peak* (Roger Donaldson, 1997), and *Armageddon* (Michael Bay, 1998) dominated the screens to the point of overdose, while the satirical *Mars Attacks!* (Tim Burton, 1996) and *Starship Troopers* (Paul Verhoeven, 1997) brought a salutary disorder to these clichés. To distance himself from these, *Jurassic Park* screenwriter David

Koepp—who succeeded Josh Friedman, author of the first draft of the script—listed all the clichés of the genre to be avoided: no destruction of famous monuments, no shot of a devastated Manhattan or of the military discussing a map of the world, no team of journalists filming the peril live before succumbing in turn... While Koepp adopted the point of view of the protagonist, as in Wells, he substituted the scientist of the book for an ordinary man— an ordinary man who reacts instinctively to events so that each audience member can see themselves in him. Ray Ferrier (as he is called), a simple docker, is played by Tom Cruise, an archetype of the larger-than-life hero. Koepp therefore refined the characterization of the man by imagining the character from *Top Gun* (Tony Scott, 1986), fearless and predatory, who has gone wrong. "I approached him like one of those characters in Springsteen's song who got married too young, got a job he hated and just got stuck in this go-nowhere life that makes him miserable."[2] An unsympathetic aging teenager, Ferrier joins the long list of divorced, selfish,

immature fathers in Spielberg's oeuvre. The tipping point between his reunion with his two children, of whom he has custody for the weekend, and the chaos that is taking over the world will awaken his paternal moral fiber. *War of the Worlds*, according to Spielberg, teaches Ray his role as a father thanks to an alien invasion—in other words, he moves in the opposite direction of the father in *Close Encounters of the Third Kind*, in which Roy Neary left his family to go into space.

American Fear

The words "alien" and "extra-terrestrial" are never uttered in the film; characters only ever refer to "them." When little Rachel first realizes what is going on, her first instinct is to ask her father, "Is it the terrorists?" "These came from someplace else," he finally replies. "What do you mean—like, Europe?" his son Robbie asks as they drive through the devastated landscape of New Jersey. "I wanted to have this rust-belt America look," said David Koepp. "So I made him a dockworker so we could end up in these really industrial environment[s] that would contrast our technological primitivism with the invaders' incredible technological advancement."[3]

FOR SPIELBERG ADDICTS

The prologue and epilogue, narrated by Morgan Freeman, are taken directly from the novel by H. G. Wells. The film is peppered with reminiscences of other contemporary blockbusters—from James Cameron's *Titanic* (1997) (the ferry wreck) to M. Night Shyamalan's *Signs* (2002) (the sequence in the cellar)—as if Spielberg was having fun measuring himself against his emulators. In the last scene, the grandparents are played by the main actors from the first film, Ann Robinson and Gene Barry...who had already been directed by Spielberg in the episode "LA 2017" from the series *The Name of the Game*.

An image of a mass exodus that evokes stills from many contemporary wars.

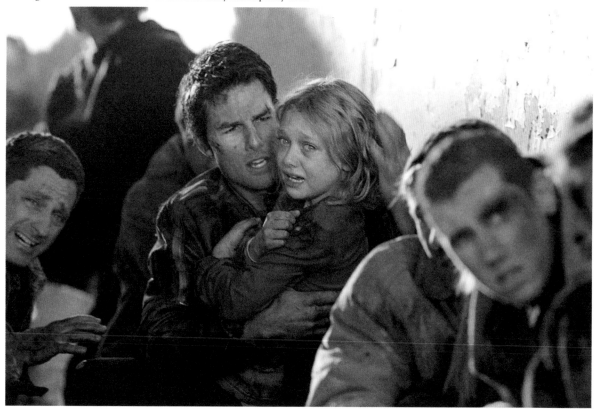

The Ferrier family is overcome by the fear, the withdrawal reflex, and the patriotism (Robbie, suddenly obsessed with the idea of joining the army) that took hold of Americans when, on September 11, 2001, for the first time since the Civil War, their soil once again became a theater of destruction. "For me, it became about what would really happen if we were invaded, and everything we thought made us invulnerable to invasion was all wrong?"[5] This is where the most important change from the novel makes sense: In the film, the aliens do not come from the sky. Their ships were already there, buried underground for thousands of years, ready to be activated at the right moment—a way of suggesting that evil, like terrorism, never comes completely from the outside, and finds its source in part within us, among the corpses and rubble on which our history has been built.

CASTING

In order to avoid overburdening the production budget ($132 million), Tom Cruise agreed once again, as he had done for *Minority Report*, not to take a salary, this time in exchange for 20 percent of the revenue. The arrangement brought him no less than $100 million.

Fear and Anger

For the roles of the Ferrier children, Spielberg brought together two young actors, Dakota Fanning and Justin Chatwin, who had been spotted in other DreamWorks productions, notably the series *Disappearance* (2002), where they had worked together. Dakota Fanning, then ten years old and six years into her professional career, immediately stood out in the mind of the filmmaker, who was impressed by her acting instincts. In her wide-open blue eyes, one can see fear, and in the increasingly faded colors of her rainbow sweater and pink camouflage jacket, the innocence that war erases. Her piercing screams of terror are no match for Kate Capshaw's in *Indiana Jones and the Temple of Doom*, except that these are justified by her youth. Spielberg cast a wide net before casting the twenty-two-year-old Canadian Justin Chatwin as the warmongering older brother; it was Chatwin's "very American" side that finally convinced him.

The Choice of Arms

Around this single-parent family unit, hundreds of extras swarmed, playing panicked crowds all trying to get out of harm's way. This is the other threat that the film interrogates: "That kind of

collective fear is a dangerous animal. What will we do as a society that becomes a mob fleeing for our collective lives, possibly at the expense of the lives of others?" Twice, Spielberg places a gun in the midst of these beleaguered humans and, inevitably, tragedy strikes in the character of Harlan Ogilvy, a bewildered farmer ready to fight the invaders after having seen his family die in front of his eyes, a conspiracy theorist recluse with his gun and his hooch in his cellar, where he shelters Ray and Rachel. An amalgam of three characters from the Wells novel, Ogilvy is played by Tim Robbins—who had previously appeared with Tom Cruise in *Top Gun*—in a twenty-five minute sequence, a high-tension, claustrophobic scene that marks a break in the film's central action. Faced with the madness of Ogilvy, who starts digging a tunnel and purposefully drawing the attention of the attackers, Ferrier kills Ogilvy in order to save his own life, and his daughter's.

FILMING AND PRODUCTION
Five days after the re-election of George W. Bush, filming on *War of the Worlds* began. A coincidence, it might seem, but one that echoed Spielberg's recent ambition to be in direct discussion with the political evolution of his country.

A Production Challenge
Spielberg was given less than ten months to develop, shoot, and finalize a production of this magnitude, a challenge that few filmmakers would be able to handle. To achieve this, Spielberg and his loyal collaborators took full advantage of the techniques at their disposal, mixing live action, live effects, and computer-generated images. First of all, digital previsualization, the technique of creating electronic storyboards, enabled Spielberg to anticipate the entirety of his film; and the people in charge of special effects were able to simulate the integration of their work in the sets, spotted by Rick Carter. For

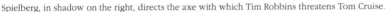

Spielberg, in shadow on the right, directs the axe with which Tim Robbins threatens Tom Cruise.

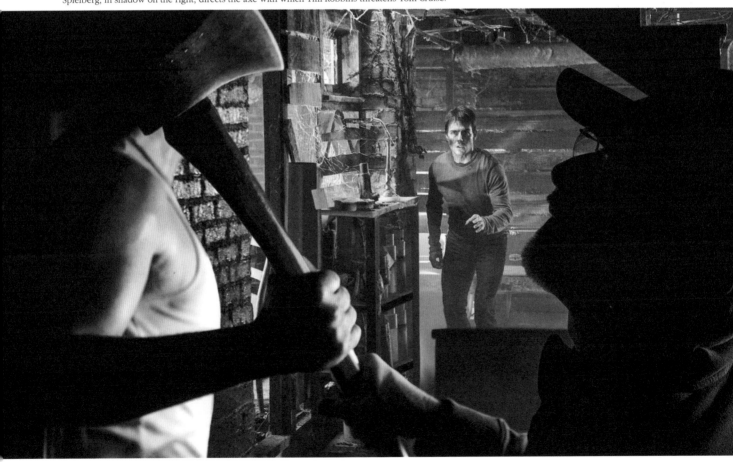

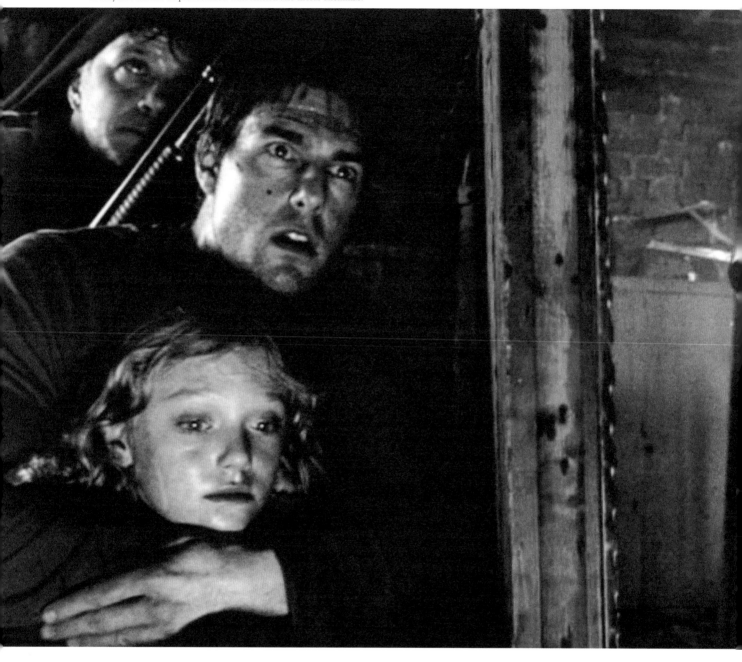

three months, Spielberg prepared for filming with the engineers of Industrial Light & Magic (ILM), who reflected his directorial choices with Zeno 3D modeling software. Once on the set, the director could show his actors and technicians an "animated" version of each shot before shooting it—an invaluable timesaver, especially since the choice was made to shoot most of the film on natural sets for greater realism. The only exceptions were the water attack and the wreck of the Boeing 747, created at Universal Studios, as well as the lock-in in the basement, filmed on a 20th Century Fox set.

The Highlight of the Film...Improvised!

From Bayonne, New Jersey (the first attack of the tripods, the escape on the roads), to Lexington, Virginia (the military front, the burned valley), via Athens, New York (the exodus, the wreck of the ferry), the film's scouting team canvassed the northeastern part of the United States, a region steeped in history. The scenes requiring the most digital special effects were wrapped up first, to give the ILM teams time to finalize them. To bridge the gap between filming and postproduction, the faithful Dennis Muren and Pablo Helman, who were in

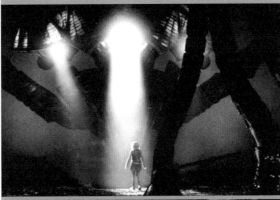

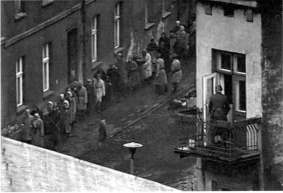

charge of visual effects, took turns dealing with Spielberg's last-minute intuitions.

"Taking their cues from *Saving Private Ryan* and Spielberg's directive that the entire movie be told from Cruise's point of view, the vfx crew was also limited in its reliance on blue- or greenscreen work," noted Dennis Muren. "This meant the camera setups and the feel were much more organic than the futuristic trappings associated with the genre. This was a combat situation and we were trying to give it a feeling of dirt and chaos."[6] While

shooting one of the highlights of the film, which was also a distant nod to *The Sugarland Express*— the Ferrier family's minivan escape, captured in a two-and-a-half-minute sequence shot by an all-seeing camera, entering, exiting, and circling the vehicle—Spielberg discovered a bridge and houses located on the side of the road. He then had the idea to orchestrate their destruction in order to make the scene more impressive.

Even better, with his producer Kathleen Kennedy, the filmmaker thought that it would make an ideal

teaser to launch the promotion of the film during the halftime show at the Super Bowl, which took place only one month later. The ILM team rose to the challenge and got the final shots done in time.

Bad Aliens

In *War of the Worlds*, Spielberg reiterates the motifs of the 1953 film, which he reorganizes and updates. In his film, the church is no longer the place where the survivors find refuge, but the first building destroyed. The military response is relegated to the background, but for the sake of credibility, the troops are represented by real soldiers—some of whom are between tours of duty in the Middle East. As for the aliens, they are derived from the originals, with their tentacled probes topped by a camera eye, probing for humans to liquidate. "One of the things that Steven wanted was to have the tripods have three legs...and to make sure that these creatures were 150 feet tall," said Pablo Helman. Every time you have a scale that is so huge, 150 feet against a 6-foot man or woman or whatever, it's kind of a very difficult thing [to do]...Steven wanted something that wasn't completely mechanical, so we did put [in] some natural and fluid movements."[7] With CGI, Spielberg dared to do what Byron Haskin had very clumsily tried to do in the same basement setting: show the aliens. Spielberg's goal: to make them like "lyrical jellyfish," with a morphology close to the shape of their ships. "I told the animators to think of them as amphibious and I used the red-eyed tree frog as a model," explained their supervisor, Randal M. Dutra, "how slowly they walk and stay close to the ground and have a stealth that was almost creepy."[8]

RECEPTION

War of the Worlds was one of the filmmaker's five biggest hits. Given the subject matter and the Spielberg/Cruise association, this public triumph would seem to be a foregone conclusion. However, Spielberg has never reached such depths of darkness.

A Classic of the 2000s?

While the press on the whole was enthusiastic, some reviewers seemed confused, especially in the United States. The *New Yorker* asked: "Who are the aliens? [...] What does the attack mean? Nobody raises any of these issues"[9]; and Roger Ebert, of the *Chicago Sun-Times*, regretted that it was "lacking the zest and joyous energy we expect from Spielberg."[10] The French critics were generally more sensitive to the filmmaker's ambition. "The film's plot is loose and sketchy, alternately incoherent and concerned with marketing. Spielberg does not care. His business here is to pile up nightmares," noted *Le Monde*, which called the film "an apocalypse without divine intervention."[11] Nominated for three technical Oscars (visual effects, sound editing, and sound mixing categories), *War of the Worlds* was ranked the eighth-best film of the 2000s by *Les Cahiers du Cinéma*.

Apocalypse Now

Under the guise of creating a roller-coaster spectacle, Spielberg filmed the eruption of total war, evoking most of the conflicts and genocides that have

Freeze Frame

E.T. was already inspired by *War of the Worlds*: The shot where the creature puts its hand on little Elliott's shoulder is copied from Byron Haskin's film (1953), but Spielberg transformed a threatening moment into a gesture of comfort. In Spielberg's *War of the Worlds*, a nod to *E.T.* is given when a bicycle, hanging on a wall, falls on one of the belligerent aliens.

Rachel (Dakota Fanning) watching in horror as her father (Tom Cruise) discovers roots nourished by the blood of victims.

marked the twentieth and twenty-first centuries. Dust and ash fall on Tom Cruise's face, reminding us of the survivors around the World Trade Center; a dazzling vision is made out of a train on fire, as if coming out of the hell of the Nazi death camps; a horizon eaten by flames awakens memories of napalm in Vietnam...Spielberg is a master in his field, and the symbolism of his images has rarely been as powerful as in this film, in which he seems to want to review the atrocities of recent human history. In the space of his film, Hiroshima and even the colonization of Algeria are invoked, while a rather crude "Sophie's choice" is imposed on Ray Ferrier when, caught under the bombardments, he must decide whether to abandon his son, who has gone to the front, or his daughter. "It's the ones that keep their eyes open. That keep looking at you. Keep thinking. They're the ones that survive," asserts Harlan Ogilvy, who has gone mad. Ferrier, for his part, spends his time shielding his youngest daughter's gaze to protect her from the horrors they're experiencing. To see or not to see? Spielberg's staging can be summed up with this question: vision (the film's field of vision), or imagination (what's left off-screen)? In this respect, *War of the Worlds* is a textbook case: Under a barrage of spectacular images with effects that are more anxiety-provoking than repulsive, Spielberg exposes the extent of human horror without actually depicting much actual violence. The only victims we see are disintegrated by lasers, victims bodies' are shown from afar, and the carcass of a Boeing 747, empty of passengers, is enough to suggest the tragedy that occurred. The blood we see in the film does not come out of bodies; instead, it is spread like fertilizer across the land by the colonizing invaders.

No More Cruise

A few years after the release of *War of the Worlds*, Spielberg admitted that he was unhappy with the film's ending. The resolution of the film, while faithful to Wells's novel, is anchored in the environmentalist tradition of the genre, but the reunion of the Ferrier family seems tenuous at best. As for the return of the son, who was thought to have died at the front, this family reunion seems out of place. Although Spielberg never expressed overt displeasure with his star, Tom Cruise, the two have not worked together since *War of the Worlds*. Interestingly, during the promotional run-up to the film's release, the famous actor turned the movie's marketing campaign into a one-man show—jumping for joy over the love he'd found with his new girlfriend, Katie Holmes on Oprah Winfrey's couch, and lecturing actress Brooke Shields about taking medication to treat her postpartum depression.

Tom Cruise in *War of the Worlds*, and Tom Hanks in *The Post*.

The Two Toms
Two Faces of America

There are several volumes in the history of Steven Spielberg working with actors.

Volume I: Spielberg's beginnings in television, where he directed celebrities aging out of mainstream Hollywood films, as well as rising stars on the small screen.

Volume II: The first half of his career as a filmmaker, where he assiduously avoided stars—even if it meant creating them himself (Richard Dreyfuss, Harrison Ford, Liam Neeson).

Volume III: Resorting, finally, to working with big screen idols, who were often longtime friends. These include Robin Williams, Dustin Hoffman, Daniel Day-Lewis, Meryl Streep, and, above all, the two Toms, Hanks and Cruise, who personify two facets of America: One is its Everyman, the other its G.I. Joe.

Hanks: The Everyday Hero

Tom Hanks met Spielberg in 1985 on the set of the comedy *The Money Pit* (1986), produced by Amblin. Invited to dinner at Spielberg's office with the director of the film, Richard Benjamin, and the screenwriter David Giler, Hanks met Robert Zemeckis, his future director for *Forrest Gump* and *Cast Away*. This was a key date for him, which he remembers as an embarrassing moment: "I didn't know what to say. I didn't put together two cohesive sentences. I sat there and laughed like a guy visiting his girlfriend's parents for the first time."[1] Spielberg and Hanks were made for each other. The son of divorced parents, Hanks, from the age of five, followed his father, a traveling cook, on his travels. From this solitary childhood, he drew on the ambition to found a solid family—like Spielberg—with his wife, the actress

Tom Hanks and Spielberg on the set of *Bridge of Spies*.

and producer Rita Wilson. As an actor, he first broke out by playing big kids: such as in *Big*, where he played a twelve-year-old projected into a thirty-year-old's body, which made him a star. The film, written by Anne Spielberg, was inspired by the childlike spirit of her brother Steven (who almost directed it). The Hanks and Spielberg families, who lived in the same neighborhood, became friends long before Tom and Steven made *Saving Private Ryan* together in 1998, motivated by their shared passion for history and World War II: Hanks's father, Amos, served as a Navy mechanic in the Pacific.

For Spielberg, Hanks "is remarkably facile, like Spencer Tracy or Henry Fonda or Jimmy Stewart, with whom he's so often compared. And that's a compliment, because those actors had a kind of everyday naturalism that made you feel the dialogue wasn't written for them but they were, in fact, improvising the lines as they went through the movie."[2] Hanks, in Spielberg's work, embodies the best side of America: its unifying patriotism. Hanks is an actor with whom viewers can easily identify; he is the man in the street who spreads the good word, and even acts as a hero. In *Saving Private Ryan*, Hanks plays a squadron captain plunged into the horror of the D-Day landings; he reminds his troops of their values and their humanity. After September 11, 2001, Spielberg asked Hanks to portray a new kind of everyman: a stateless foreigner stuck in the purgatory of JFK airport (*The Terminal*). As portrayed by Spielberg, Hanks is the citizen who doubts (*Bridge of Spies*, *Catch Me If You Can*) and does not give in when the nation becomes blind and its institutions are threatened (*The Post*). Hanks is, after all, directly related to Abraham Lincoln via Nancy Hanks, Lincoln's mother.

Cruise: The Man on the Run

Tom Cruise was introduced to Spielberg by producer David Geffen in 1982 on the set of *Risky Business* (written and directed by Paul Brickman). It took nineteen years and a dozen aborted projects for these two Hollywood figures with the Midas touch to collaborate on *Minority Report* and *War of the Worlds*. The star was then at the peak of his career, and Spielberg was at the peak of his. In both films, the filmmaker takes the opposite view of Cruise's white-toothed playboy image, filming him playing an arrogant guy, overwhelmed by events: a representative, and then a victim, of the aberrations of the criminal justice system (*Minority Report*); and a failing father faced with an invasion of genocidal aliens (*War of the Worlds*). In Spielberg's films, Cruise is a citizen driven by anxiety and fear, and put in harm's way after the headlong rush of a post–September 11 America has lost all its safeguards. A physical actor with an intense performance style, Cruise blends in wonderfully with Spielberg's ever-changing direction. Unfortunately, Spielberg and Cruise haven't worked together since *War of the Worlds*. If Hanks is an actor who edifies, Cruise is an actor who believes, against all odds. According to Thomas Aquinas—the third Tom?—the combination of belief and edification leads to wisdom.

THE WORLD WAS WATCHING IN 1972
AS 11 ISRAELI ATHLETES WERE
MURDERED AT THE MUNICH OLYMPICS.

THIS IS THE STORY OF
WHAT HAPPENED NEXT.

A STEVEN SPIELBERG FILM

MUNICH

UNIVERSAL PICTURES AND DREAMWORKS PICTURES PRESENT AN AMBLIN ENTERTAINMENT·KENNEDY/MARSHALL·BARRY MENDEL PRODUCTION
IN ASSOCIATION WITH ALLIANCE ATLANTIS COMMUNICATIONS "MUNICH" ERIC BANA DANIEL CRAIG CIARAN HINDS MATHIEU KASSOVITZ HANNS ZISCHLER
AND GEOFFREY RUSH MUSIC BY JOHN WILLIAMS COSTUME DESIGNER JOANNA JOHNSTON EDITOR MICHAEL KAHN ACE PRODUCTION DESIGNER RICK CARTER DIRECTOR OF PHOTOGRAPHY JANUSZ KAMINSKI ASC
BASED ON THE BOOK "VENGEANCE" BY GEORGE JONAS PRODUCED BY KATHLEEN KENNEDY STEVEN SPIELBERG BARRY MENDEL COLIN WILSON SCREENPLAY BY TONY KUSHNER DIRECTED BY STEVEN SPIELBERG

DreamWorks PICTURES AMBLIN THIS FILM IS NOT YET RATED DECEMBER 23 A UNIVERSAL PICTURE UNIVERSAL
www.munichmovie.com

Munich

United States/
Canada/
France

2 hrs 44

Color

Surround
(Dolby Digital EX/
DTS-ES/SDDS)

2.39:1

Production Dates: June 29–September 29, 2005
United States Release Date: December 23, 2005

Worldwide Box Office: $131 million ($198 million in 2023 dollars)

Production Companies: Amblin Entertainment, Alliance Atlantis
Communications, DreamWorks Pictures, Universal Pictures, The Kennedy/
Marshall Company, Barry Mendel Production, Peninsula Films
Producers: Kathleen Kennedy, Steven Spielberg, Barry Mendel, Colin Wilson

Based on the book *Vengeance* by George Jonas (1984)
Screenplay: Tony Kushner, Eric Roth
Director of Photography: Janusz Kamiński
Film Editing: Michael Kahn
Music: John Williams
Sound: Richard Hymns, Ben Burtt
Production Design: Rick Carter
Art Direction: Rod McLean
Hair Stylist: Jeremy Woodhead, Alain Luzy, Kenneth Walker
Makeup: Paul Engelen, Florence Roumieu, Carl Fullerton
Costume Design: Joanna Johnston
Special Effects: Joss Williams
Stunt Coordinator: Paul Jennings
First Assistant Director: Adam Somner
Casting: Jina Jay, Lucky Englander, Fritz Fleischhacker

Starring: Eric Bana (Avner), Daniel Craig (Steve), Ciarán Hinds (Carl), Mathieu
Kassovitz (Robert), Hanns Zischler (Hans), Geoffrey Rush (Ephraim), Ayelet
Zurer (Daphna), Mathieu Amalric (Louis), Michael Lonsdale (Papa), Gila
Almagor (Avner's mother), Lynn Cohen (Golda Meir), Marie-Josée Croze
(Jeanette), Yvan Attal (Tony), Moritz Bleibtreu (Andreas), Ami Weinberg
(General Zamir), Amos Lavi (General Yariv), Makram Khoury (Wael Zwaiter),
Igal Naor (Mahmoud Hamshari), Hiam Abbass (Marie Claude Hamshari),
Valeria Bruni Tedeschi (Sylvie)

> "Violence always serves as a counter-violence, that is, as a response to the violence of the other."

—Jean-Paul Sartre, *Critique of Dialectical Reason* (1960)

SYNOPSIS

On September 5, 1972, at the Munich Olympic Games, eight Palestinian terrorists from the Black September group took eleven Israeli athletes hostage and demanded the release of 238 of their imprisoned militants. None of the athletes survived. In response, and in great secrecy, Israel, under the authority of prime minister Golda Meir, sent five men recruited by Mossad across Europe to eliminate eleven Palestinian leaders. Heading the operation, Avner, son of an Israeli Defense Force veteran, is forced to stay away from his wife, who has just given birth to their first child. As assassinations, mistakes, and collateral damage start to pile up, Avner is plagued by paranoia and begins to doubt the validity of his mission.

Spielberg directs Lynn Cohen, the actress who plays Golda Meir, in a scene of light and shadow.

GENESIS

The impact of the September 11, 2001, attacks was a determining factor for Steven Spielberg. Embracing Stanley Kubrick's legacy by taking up the baton on *A.I.* after his death must also have played a role, as did the removal of a cancerous lesion in his kidney that he underwent in 2000. Thus, at the beginning of the twenty-first century, as if his time was running out and his posterity was at stake, Spielberg combined a frenzy of work with an all-encompassing inspiration and a political awareness of unprecedented boldness. *Munich*, the culmination of this phase, appears to be the most risky film of his career.

A *Vengeance* with Troubled Faces

On September 5, 1972, eight fedayeen infiltrated the village of the Munich Olympic Games, killing two athletes from the Israeli team during the assault and taking the other nine hostage. Spielberg was in front of his television: "I don't think I ever heard the word 'terrorism' before September of '72."[1] Covered by the world's TV channels, the drama ended in bloodshed (seventeen dead, including the eleven athletes and a German policeman) and precipitated the Israeli-Palestinian conflict into a new spiral of violence. One of its developments would not be revealed until 1984 with the publication of *Vengeance*, a book by

Canadian journalist George Jonas: A group of five men was sent by Israel across Europe to kill eleven Palestinian leaders presumed responsible. Jonas's main source and the book's protagonist, under the pseudonym Avner—the agent in charge of the operation, called "Wrath of God"—eventually quit the Israeli secret service. Although *Vengeance*, described by Israel as a tissue of lies, caused a lot of ink to flow when it was released, former Mossad agents officially acknowledged the mission in 1993.

A Minefield

In the late 1990s, producer Barry Mendel discovered Jonas's book and passed it on to Steven Spielberg's associate Kathleen Kennedy, with whom he had just produced *The Sixth Sense* (M. Night Shyamalan, 1999). The latter immediately turned to the filmmaker, who commissioned a script. Spielberg knew that he was on the edge of a minefield: the Israeli-Palestinian conflict, terrorism, the law of retaliation applied at the state level. For three years, screenwriters David and Janet Peoples (*12 Monkeys*), Charles Randolph (*The Interpreter*), and Eric Roth (*Forrest Gump*) worked on the adaptation. Of the people involved, Spielberg met only Avner, whose real name was Yuval Aviv. At the same time, he talked

to as many people as possible who could enlighten him on the situation in the Middle East, from Bill Clinton, to ex-diplomat Dennis Ross, to his rabbi, to whom he submitted the script. But he still hesitated. As with *Schindler's List*, which he offered to Martin Scorsese and Roman Polanski before daring to take on the project himself, the filmmaker was apprehensive about dealing with such a complex subject.

The "Good" and the "Bad" Jew

"After 9/11, Steven wanted to abandon the project," said Kathleen Kennedy. "He did not want to appear to be capitalizing on such a tragic event. Then, as he looked at the aftermath, he realized that it was even more important to get on with it."[2] In search of the

right person to successfully make a thriller out of such a political subject, Steven found his match in Tony Kushner. Author of the Pulitzer Prize–winning play *Angels in America* and *Homebody/Kabul*, the Jewish-American playwright had always questioned the Israeli-Palestinian conflict, notably through his anthology of progressive essays *Wrestling with Zion* (2003). The two men met in February 2004 and, in May, Kushner began rewriting the script. A radical leftist, he considered the creation of Israel "a mistake," unlike Spielberg. "Steven and I also had different views on counterterrorism," Kushner added. "Through the film, we found a common ground that our disagreements nourished. The script gained depth and complexity."[3]

The film's atmosphere of a cosmopolitan seventies thriller is reminiscent of William Friedkin's *Sorcerer* (1977).

Real footage from the hostage crisis and its reconstruction appear in the same shot.

Understanding Does Not Mean Forgiving

Doing their best to stay true to the facts, Spielberg and Kushner imagined details that were not known, to the extent that they could do so, namely the specific details of the missions, and most of the dialogue. They compressed time (the operation lasted five years; it only covers one in the film), confronted the characters with their scruples, and added Spielbergian figures (the little girl in the red coat, symbol of the murder of innocence) and a purely fictional scene, the one dearest to Spielberg, where the Mossad team and a PLO group have to coexist in the same safe house in Athens. The Israeli Avner and the Palestinian leader, who does not know the true identity of his interlocutor, discuss the respective interests of their camps. "*Munich* is a form of tragedy in which everyone has their reasons," said Kushner. "It is disrespectful to the victims of political violence not to try to reflect on the meaning of that violence. Acting without thinking will only make things worse. And understanding does not mean approval or forgiveness."[4]

Thanatos and Eros

Spielberg's most dialectical film is also his most sexual. "One day I called Steven and said, 'I'm writing your first sex scene, where Avner makes love to his pregnant wife,'" Kushner recalled. "Soon after, he asked me to imagine another scene where Avner, back from his mission, remembers the massacre of the athletes while he sleeps with his wife. At first I was puzzled by his request. In the end, I thought it was a very strong moment. Throughout the film, there is an unpleasant intimacy with the violence. Through this scene, Steven wanted to make the

killing even more disturbing. I talked about it a lot with the widows of the athletes who died in Munich. Some of them thought it was a good illustration of the idea of life beyond death."[5] From the milk that mixes with the blood during the first murder, to the ritual of meals, pillars of Jewish culture, during which the assassinations are planned, the whole film is based on this idea of proximity and confusion between the impetus for life, and the impetus for death. Between the celebration and morbidity of the fight for a "home"[6]—the notion of home dear to Spielberg, here constantly questioned.

CASTING

When, in June 2004, the film's preproduction was launched, Spielberg already knew who would play Avner. "I saw Eric Bana as Avner, funn[il]y enough when I saw *Hulk* (Ang Lee, 2003) with my kids...I saw a warmth and a strength and even a little tickle of fear behind his eyes which, I think, humanizes

FOR SPIELBERG ADDICTS

As a complement to *Munich*, *One Day in September* (Academy Award for Best Documentary in 2000) details the hostage-taking and sheds light on the responsibility of the German authorities (avoided by Spielberg) in the massacre. Its director, Kevin Macdonald, was consulted by producer Barry Mendel during the preparation of *Munich*.

During a meal prepared by Avner (Eric Bana, above right), assassinations are organized.

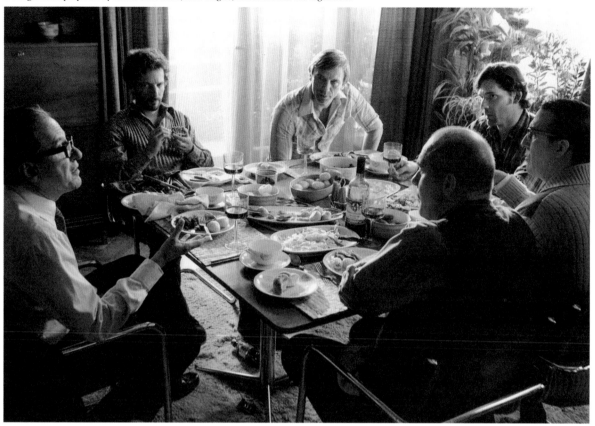

people no matter what their jobs." Now, humanizing each character was, for Spielberg, one of the major challenges in this film.

A Cosmopolitan Cast

Around Bana, an Australian actor of German-Croatian origin, four other actors who make up the commando unit had to be, beyond their functions, of different origins and temperaments. Just before being announced as the next James Bond, the Englishman Daniel Craig was cast as the South African Steve (driver), the warrior. Irishman Ciarán Hinds appeared as German Carl (the "cleaner"), the moral conscience. German actor Hanns Zischler played Hans (forger and accountant), the pragmatist. And French actor Mathieu Kassovitz played Robert (bomb-maker), the emotional one. In the most cosmopolitan cast Spielberg has ever assembled, the French include Yvan Attal, Michael Lonsdale, and Mathieu Amalric, the latter two playing a father and son, Avner's enigmatic informants, inspired by an organization of political agitators called "The Group." "Spielberg was very amused by the fact that he had cast Kassovitz, Attal and me," said Mathieu Amalric. "He told us, 'It's so nice to shoot with actor-directors.'"[7] As an echo of *Schindler's List*, Ben Kingsley was to play Ephraim, the Mossad liaison officer. When Spielberg

postponed production of *Munich* for a few months in favor of *War of the Worlds*, Kingsley, who in the end was unavailable, gave way to Geoffrey Rush.

FILMING AND PRODUCTION

With a budget of $70 million, the filming of *Munich* began on June 29, 2005. Except for a few days in Paris and New York, the filming did not take place at the actual locations, not so much for security reasons as because of the exchange rate. The Mediterranean settings (Israel, Beirut, Athens) were reconstituted in Malta, and those of Old Europe (Munich, Paris, Rome) in Budapest. The set was placed under strict surveillance, closed to the media, and the script was distributed in dribs and drabs to a few selected actors who had signed a confidentiality contract—a fairly common measure with Spielberg.

Actors: Emissaries of the People

Kushner was omnipresent and kept the script evolving day by day, attentive to the discussions taking place between actors on set. "The Arab actors were afraid that Spielberg would make an anti-Palestinian film, and the Jews were worried about my critical approach to the Israeli occupation," said Kushner. "They all felt a bit like emissaries of their own

Under the eye of Spielberg, Palestinian actress Hiam Abbass and daughter Mouna Soualem (on Abbass's lap) film a scene.

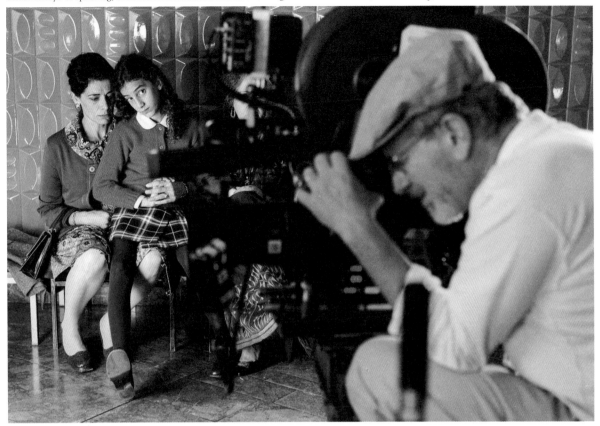

people." Hired for a small role, Palestinian Hiam Abbass was promoted to acting coach and consultant. "When we filmed the hostage crisis, the actors had a lot of trouble facing each other violently," she said. "They lived in the same hotel, they went out together, they were friends. Steven shot dialogue scenes between them knowing he wouldn't use them, just to get the mood right."[8]

Led by Inspiration

Aesthetically, Spielberg borrows from the political and espionage thrillers of the 1960s and 1970s—in particular *The Day of the Jackal* (Fred Zinnemann, 1973), *Z* (Costa-Gavras, 1969), and *The Battle of Algiers* (Gillo Pontecorvo, 1966), including their frequent use of zoom lenses. Without a storyboard or preconceived outline, he allowed himself to be carried by the inspiration of the moment and the location. While he was preparing the scene of the first murder in a Budapest street, the sound of musicians rehearsing drifted in from a window of the opera house. He immediately decided to include them in the film. To save time, his editor Michael Kahn was present on the set and edited (on film) daily, providing Spielberg with an evolving vision— hence the more organic, and often virtuoso, style

of direction. In the last shot, Avner and his superior Ephraim separate on the banks of the East River in Manhattan. In the distance are the two World Trade Center towers, just constructed. History repeats itself, Spielberg points out, linking these two days in September that were sadly marked by terrorism, and that both led to some highly questionable responses.

RECEPTION

Once shooting was completed at the end of September 2005, a postproduction marathon began, to enable the film to be presented to Oscar voters before December 8...and also because Spielberg wanted to get the film in front of audiences as quickly as possible, to cut short any rumors or controversies. This did not prevent voices from being raised beforehand, such as that of Abu Daoud, the only surviving terrorist of the hostage-taking, who, at the time of the filming, complained that he had not been consulted.

Let the Film Speak for Itself

The marketing strategy was simply to let the film speak for itself. No press conference, no hype: just screenings organized by a media crisis specialist,

After the death of Robert (Mathieu Kassovitz), Avner (Eric Bana) was supposed to threaten Louis (Mathieu Amalric), his informant. Spielberg and Tony Kushner changed the scene on the set to an ambiguous repentance of Louis in front of a kitchen store window, a mundane allegory of "home." When the reflection of Louis's face replaces Robert's in the shop window, it is the memory of the loved one that is eclipsed by the reality of a perverse world of illusions, where Avner loses his footing. The effect was created on the spot, at the time of shooting.

Allan Mayer, ex-journalist and political consultant. His role: to invite hand-picked political and intellectual luminaries so that public opinion would be informed by opinions from all sides. On the Arab side, Siwar Bandar, spokesman for the American-Arab Anti-Discrimination Committee (ADC), appreciated that Spielberg was showing both sides in their worst light. On the Jewish side, the criticisms were virulent against the director, causing him to lose, in the eyes of some, his status as the darling of Israel. David Kimche, one of the heads of Mossad at the time of the hostage-taking, considered that "it is a tragedy that a person of the stature of Steven Spielberg, who has made such fantastic films, should have based this film on a book that is a falsehood." Rabbi Marvin Hier, a consultant on *Schindler's List*, thought Spielberg was wrong. Israel's consul in Los Angeles, Ehud Danoch, called *Munich* "presumptuous," "pretentious," and "shallow." To calm the debate, Spielberg ended up giving rare interviews,

A naked woman (Marie-Josée Croze) shot at close range: Spielberg creates an unimaginable image to illuminate the vicious circle of violence.

including one to *Time* magazine where he described *Munich* as "a prayer for peace."[9]

A Rorschach Test

As for the press, while the fury of some critics rained down on the film, contrasting opinions were well summarized by Rachel Abramowitz in the *Los Angeles Times*: "Politically, the film is a Rorschach test—almost impossible to view except through the lens each individual audience member brings to the theater." Some criticized Spielberg for his bias, others for not choosing sides, where it was not the principle of "moral equivalence"[10]—weighing a terrorist action against the victim's retaliation—that was problematic.

In France, in *Le Nouvel Observateur*,[11] the Jewish intellectual and editorialist Jean Daniel spoke of a "political event," while the film critic Pascal Mérigeau found the film "disappointing" with "the most grotesque sequence ever, an alternating montage of killings and orgasms." *Positif* recognized "a real, honest

man's film" that has "the politeness of objectivity,"[12] and *Technikart* praised the "dialectical experience" unrolling "the thread of Mossad's targeted assassinations in thriller mode, but also as an ethical and spiritual journey."[13]

Adventurous and Stimulating

Released six months after *War of the Worlds*, *Munich* attracted five times fewer viewers, and its five Oscar nominations (film, direction, adaptation, editing, music) did not result in any awards. By teaming up with a personality contrary to his own (Tony Kushner), Spielberg succeeded in making a challenging film with an unstable balance, like *Empire of the Sun* (Spielberg vs. Tom Stoppard) and *A.I.* (Spielberg vs. Stanley Kubrick). Thus, *Munich* closes an exceptional cycle of six features in four years that reinvented Spielberg's approach and his relationship with the world: From the world's most popular filmmaker, he became one of the most adventurous and exciting.

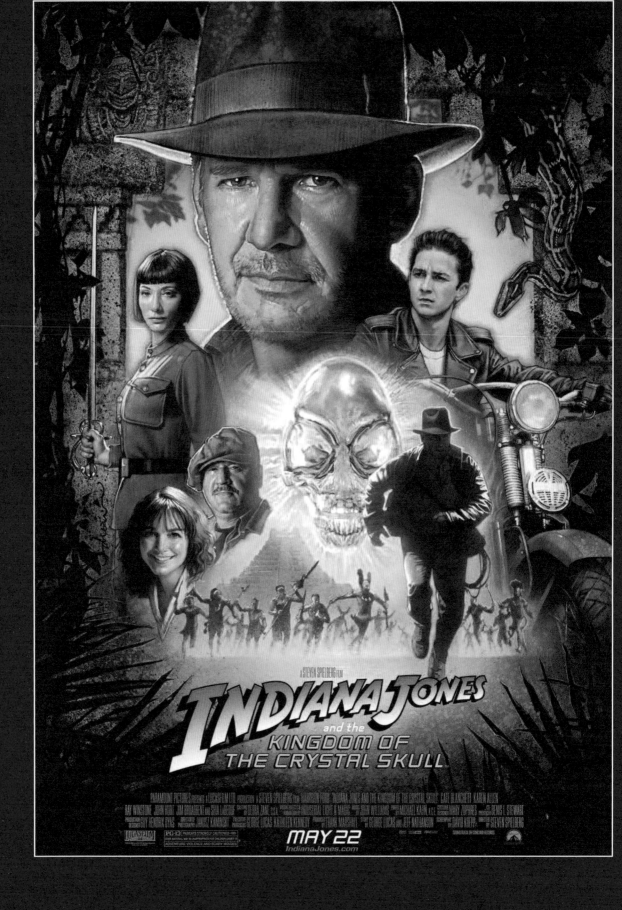

Indiana Jones and the Kingdom of the Crystal Skull

United States	2 hrs 2	Color	Surround (Dolby Digital/ DTS/ SDDS/Dolby Atmos)	2.39:1

Production Dates: June 18–October 11, 2007
United States Release Date: May 22, 2008

Worldwide Box Office: $790.6 million ($1.8 billion in 2023 dollars)

Production Companies: Paramount Pictures, Lucasfilm,
The Kennedy/Marshall Company
Producers: Frank Marshall,
Flávio Ramos Tambellini (aerial unit, Brazil)
Co-producer: Denis L. Stewart
Associate Producer: Kristie Macosko Krieger
Executive Producers: Kathleen Kennedy, George Lucas
Production Supervisor: Noelle Green

Based on a story by George Lucas and Jeff Nathanson and characters created
by George Lucas and Philip Kaufman
Screenplay: David Koepp
Director of Photography: Janusz Kamiński
Film Editing: Michael Kahn
Music: John Williams
Sound: Ron Judkins
Production Design: Guy Hendrix Dyas
Art Direction: Mark W. Mansbridge
Special Effects Coordinator: Daniel Sudick
Visual Effects: Pablo Helman

Starring: Harrison Ford (Indiana Jones), Karen Allen (Marion Ravenwood), Cate
Blanchett (Irina Spalko), Shia LaBeouf (Mutt Williams), Ray Winstone (Mac),
John Hurt (Harold Oxley), Jim Broadbent (Charles Stanforth), Igor Jijikine
(Dovchenko), Alan Dale (General Ross), Joel Stoffer (Taylor), Neil Flynn (Smith)

"Janusz had to approximate another cinematographer's look, and I had to approximate this younger director's look that I thought I had moved away from after almost two decades."[1]

—

—Steven Spielberg, on the filming and production of *Indiana Jones and the Kingdom of the Crystal Skull*

SYNOPSIS

In 1957, in the middle of the cold war, archaeologist Indiana Jones confronts Soviet agents led by Irina Spalko, an expert in parapsychology. They are looking for a crystal skull, a mysterious pre-Columbian artifact with supernatural powers. The Russians hope to use it to exert mental control over the American people. At the instigation of a young man named Mutt Williams, Indiana Jones does everything he can to get ahead of them. He is armed with clues from a letter that one of his former colleagues, Harold Oxley, sent to Mutt Williams's mother. But both of them have disappeared. Indiana Jones and his young companion fly to Peru in search of a crystal skull, a conquistador's tomb, and the lost city of Akator, on the banks of the Amazon River...

Indiana Jones is now a prisoner of the Soviets.

GENESIS

The gestation of *Indiana Jones and the Kingdom of the Crystal Skull* was long and painful. It goes back to the early 1990s, when George Lucas was working on the television series *The Adventures of Young Indiana Jones.*

Indy at 50

The hero in the television series was not played by Harrison Ford, except in a 1993 episode entitled "The Mystery of the Blues." In it, the actor plays a bearded, fifty-year-old Indy in 1950. Seeing him like this on the set, Lucas suddenly imagined an *Indiana Jones* with a more mature hero. Gone are the Nazis, replaced by East-West rivalry and nuclear testing in the Nevada desert. It is also the time of the "Roswell incident," in which an alien was allegedly recovered in secret by the US military after the crash of its flying saucer in 1947.

Problematically, neither Harrison Ford nor Steven Spielberg subscribed to the concept, especially since the latter was now oriented toward serious subjects (*Schindler's List, Amistad, A.I., Munich*) that distanced him from such childishness. But Lucas did not give up.

New Age Folklore

For years, scriptwriters followed one after the other. The release of *Independence Day* (Roland Emmerich) in 1996, about an alien invasion, put the project on hold for a while. For the "MacGuffin," an essential element of any *Indiana Jones* adventure, George Lucas also ended up dipping into *The Adventures of Young Indiana Jones*, and more precisely into an unfinished script where a crystal skull is mentioned. These objects exist; the most famous was found in 1924 in present-day Belize by the British traveler F. A. Mitchell-Hedges and his daughter. The pre-Columbian origin of these artifacts has never been attested, and all of them were "discovered" in ambiguous circumstances, but they were quickly associated with a whole New Age folklore. For Lucas, this was the ideal alien MacGuffin.

In the early 2000s, Spielberg was convinced, especially by his children, to return to Indiana Jones. He also saw it as a kind of recreation in the midst of the tougher films he was now making. Two big names are part of the adventure. The director Frank Darabont (*The Shawshank Redemption*—1994, *The Green Mile*—1999) had written several episodes of *Young Indiana Jones.* He believed he was following George Lucas's roadmap, but despite several rewrites, his work was rejected. However, the idea of giving the hero an offspring was retained (Darabont had however imagined a girl, which Spielberg found too close to *The Lost World*). M. Night Shyamalan

Irina Spalko is the villain of the film, played by Cate Blanchett, who had lobbied for the part via her agent.

A lorry chase in the jungle that recalls the previous movies.

Shia LaBeouf and Harrison Ford in the Temple of Akator, a set reminiscent of the original world of Indiana Jones.

(*Sixth Sense*, 1999), on the other hand, threw in the towel because of the difficulty of setting up working meetings with three overworked celebrities. The fact that Lucas was embarking on new episodes of the Star Wars saga (released between 1999 and 2005) did not simplify matters.

A Generational Conflict

The final adaptation was done by David Koepp, already a three-time screenwriter for Steven Spielberg. Koepp combined various elements from previous scripts and created the character of Colonel Irina Spalko. Of course, George Lucas became involved, insisting on making Indiana Jones's son a young rebel with a motorcycle and a leather jacket, typical of the pioneering days of rock 'n' roll…a means of injecting into the story some generational conflict and some perspective on his own youth as a hothead with a passion for motorsports.

CASTING

According to producer Frank Marshall, Harrison Ford followed a strict diet that allowed him to wear his outfit from *Indiana Jones and the Last Crusade* (1989) without any alterations. The return of Marion Ravenwood was decided upon by Spielberg and

Lucas without knowing if the original actress from 1981, Karen Allen, would agree to appear. Contacted only at the beginning of 2007, she accepted without hesitation, but had to keep her casting secret until the official announcement was made six months later. For the role of Mutt Williams, Steven Spielberg immediately thought of Shia LaBeouf, star of *Transformers* (Michael Bay, 2007), on which he was an executive producer. However, he failed to bring Sean Connery out of retirement to play Indy's father, as the actor considered the role too small. In the film, Henry Jones Sr. is referred to as deceased; his photo, contemplated by his emotional son, seems to express the director's regret.

The great idea of the film is Cate Blanchett: Unrecognizable, she slips into the uniform of Irina Spalko with just the right degree of caricature, imitating the character of Colonel Rosa Klebb, in *From Russia with Love* (Terence Young, 1963), the second James Bond film.

FILMING AND PRODUCTION

Conscious of the time that had elapsed since *The Last Crusade*, Steven Spielberg insisted that the direction, editing, and action scenes should keep to the spirit of the other three films.

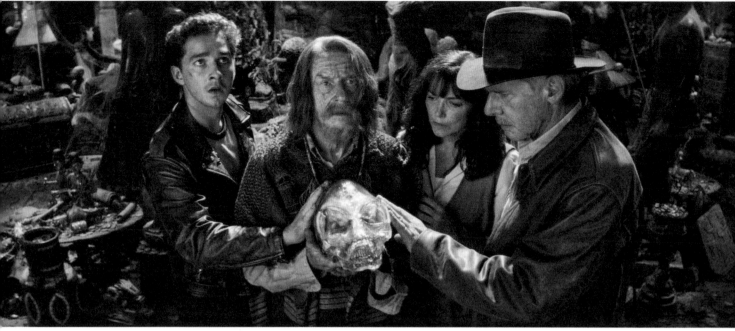

Both mysterious and of dubious archaeological authenticity, the crystal skull is the perfect "MacGuffin."

In the Warehouse of *Raiders*...

The beginning is a statement of intent: It takes place inside the warehouse from the end of *Raiders*—as if the two films were one after the other, albeit with a separation of twenty-seven years. And Spielberg specified to Lucas that he would keep digital special effects to a minimum.

So the director began by viewing the previous films with Janusz Kamiński, his director of photography since 1993, so that the latter could study the lighting work of his predecessor Douglas Slocombe, who had retired. Then the team went to film on location in New Mexico. A road one and a half kilometers long was built for the opening sequence. The setting of the fake town destroyed by a nuclear

explosion reproduced authentic sites of this type (the "Doom Towns"), built in 1955 for life-size study of the effects of an A-bomb. In this scene, we find Spielberg's ambiguous relationship with this suburban America, as perfect as it is dull—which was where he grew up, and which regularly traverses his films...but he had never gone this far before!

Disturbing Moments

The motorcycle chase with Mutt was filmed on the Yale campus in Connecticut and, as in *Raiders*..., Hawaii stood in for Peru. Various studios in Los Angeles were used for the interiors and exotic settings, such as the village and cemetery of Nazca or Akator. Despite the initial intentions, Janusz Kamiński's style remains noticeable: lots of penumbra, intense backlighting, faces sculpted by shadows and lights.

Filming was completed in eighty-four days. This does not include the eight months of postproduction at Industrial Light & Magic (ILM). George Lucas ultimately had a big input on the digital effects: From the traditional cross-fade between the mountain of the Paramount logo and the first shot of the film, we are treated to CGI images of a prairie dog.

A CGI Mushroom Cloud

The nine-minute jungle chase mixes scenes shot in Hawaii with rain forest footage brought back from Brazil and Argentina by the ILM teams. The movements of the leaves, vines, and branches were not set up in advance by the computer graphic designers, but generated automatically according to their

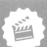

FOR SPIELBERG ADDICTS

While holding Indiana Jones prisoner, Irina Spalko plays him a recording of J. Robert Oppenheimer, designer of the first American atomic bomb, declaring: "Now I am become Death, the destroyer of worlds,"[2] a sentence taken from the Bhagavad Gita, a key text of Hinduism. A few moments later, doubting the extra-terrestrial origin of the crystal skulls, the archaeologist ironizes: "Saucermen from Mars?" *Indiana Jones and the Destroyer of Worlds* and *Indiana Jones and the Saucermen from Mars* are the titles of two discarded scripts.

Visually impressive, the film's CGI atomic explosion made the fans sit up and take notice.

interactions with other objects in the shot, according to the laws of physics and gravity. The mushroom cloud, the carnivorous ants, and the final apocalypse with the flying saucer are also computer creations. Even the Iguaçu Falls, on the Argentinean-Brazilian border, are modified on computer.

RECEPTION

The fourth *Indiana Jones* was the first of the internet era: As soon as it was released, the slightest rumor, the slightest hint in the media was relayed and echoed across the Web—so much so that the expectations were huge.

Predictable Mechanics

Presented out of competition at the Cannes Film Festival on May 18, 2008, the film received mixed reviews. Some were enthusiastic (*Chicago-Sun Times*[3] *Empire*[4]); others, such as the *New York Times*[5] and the *Los Angeles Times*,[6] commended the film while highlighting its predictable mechanics and ill-defined secondary characters, notably Mutt Williams. On the internet, columnists, bloggers, and fans were less kind. Many turned up their noses at this story of aliens; the sword duel in the middle of a jungle chase and the digital prairie dogs did not go down well. But it got worse: To protect himself from the nuclear explosion on Doom Town, Indiana Jones locks himself in a refrigerator… and the archaeologist, thrown miles away by the blast, comes out haggard but unharmed. Fans were willing to accept a lot, but not this. Two days after the release, a new expression, "nuking the fridge," appeared on the internet as a synthesis of the film's mistakes.

Out of Respect for George Lucas

Indiana Jones and the Kingdom of the Crystal Skull was, however, the third-biggest hit of 2008. Subsequently, Steven Spielberg admitted that he was never convinced by the MacGuffin, but he went along with it out of respect for George Lucas. He even admitted to being at the origin of the much-hated fridge scene, thereby endeavoring to protect his friend from reproach. For the fifth installment, in a development just as complicated, he eventually made the decision, in February 2020, to quit the direction.

Cannes Adventures

After *The Sugarland Express* (1974), which won an award for its screenplay, several of Steven Spielberg's films were presented out of competition at the Cannes Festival: *E.T.* in 1982, which elicited a standing ovation; *The Color Purple* in 1986; *Indiana Jones and the Kingdom of the Crystal Skull* in 2008; and *The BFG* in 2016. Spielberg made his mark on la Croisette as president of the jury in 2013: The Palme d'Or went to Abdellatif Kechiche's *La Vie d'Adèle* (*Blue Is the Warmest Color*), a source of various controversies, both political and artistic. With its raw love scenes and sensuality, it also represented everything that Spielberg never knew—or dared—to do in his own cinema.

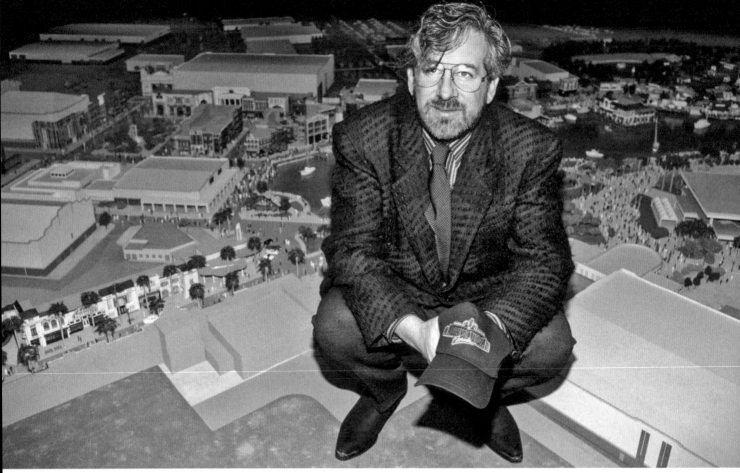

In February 1989, Spielberg poses in front of the model for Universal Studios in Florida, which opened the following year.

His Own Enterprise
Spielberg the Businessman

Impressed by his visit to the set of *Close Encounters of the Third Kind* at the beginning of 1977, George Lucas was convinced that his friend's next film would be a massive box-office success—much bigger than he himself hoped for with his movie *Star Wars*, which he was currently finishing. He proposed a small arrangement between friends: Each would receive 2.5 percent of the profits of the other's film. Spielberg accepted; the agreement would bring him some $50 million. Good luck? Not only that. A few weeks earlier, in February of the same year, he had attended, like many friends of Lucas, a screening of a working cut of *Star Wars*. "At the end of the screening, everybody was disappointed except me and Steven," recalled journalist and screenwriter Jay Cocks. "In the end, one of us

was smart enough to buy Twentieth Century [the film's producer] stock options the next day. And it wasn't me."[1]

A Colossal Fortune
Earnings of $50 million can mean the world to some, but are a small detail for others. Even today, Spielberg's fortune is difficult to quantify. In 2021, *Forbes* magazine estimated it at nearly $4 billion. The films he has made, however, have generated more than $10.5 billion in total revenue, far—very far—from the $275 per week ($2,300 in 2023 dollars) he earned in his early days at Universal. In comparison, the filmmaker would have received a fee of $20 million for *War Horse*. Like Lucas, Spielberg quickly understood that a film was not

necessarily enough on its own, especially where money was involved. His failures during the promotion of his first feature film, *The Sugarland Express*, served as a lesson to him: The role of a filmmaker does not stop at the end of the film. One has to follow through on the work, make the audience want to see it by telling stories and extending the experience—especially since the audience of the end of the 1970s consisted of 50 percent teenagers. Spielberg learned from the millions his friend had made on *Star Wars* merchandising and applied his lessons to the release of *E.T. the Extra-Terrestrial,* in 1982. Discs, dolls, board games, videos, books—everything was done to exploit the potential of films that had become brands. Cleverly, the director even postponed the release of the much-anticipated VHS version of the film until 1988, in order to take full advantage of the exponential sales of VCRs. In the meantime, the new king of Hollywood turned down several offers to become president of various studios, including Disney, preferring instead to create his own entity, Amblin Entertainment, which enabled him to control the production circuit.

Independence at All Costs

Spielberg was driven by a constant need to preserve his independence, whether creative or financial. Thus, for certain projects, he traded his salary for a share of the profits (usually 20 percent) and asked his stars (including Tom Hanks on *Saving Private Ryan* and Tom Cruise on *Minority Report*) to do the same. This system not only invested the people concerned in the success of the project, but it also limited the budget. And it was always the quest for independence that presided over Spielberg's permanent game with the studios, who wanted his projects at all costs: Amblin was thus able to make a deal with Netflix in 2021 while still being tied to Universal without either party finding fault with it. Born within the walls of the same Universal studios, Spielberg has worked with all the major Hollywood companies, even during the DreamWorks adventure.

During a legal battle between DreamWorks and Disney in 2009, another significant source of income for the director was revealed. At the beginning of the 1990s, when his contract with MCA/Universal was up for renewal, the studio, in the midst of a financial crisis, gave him 2 percent of the sale of each admission ticket to the Universal theme parks. Spielberg had been involved as a consultant in the attractions related to his films—and this applied worldwide.

Some Rockwells and a Yacht

The profits generated enabled the filmmaker to compensate for the few failures of this beautiful machine, such as when he had to inject $15 million into a dying DreamWorks (a sum that was largely recovered after the sale of the animation studio in 2016, for $3.8 billion), or bolster his Dive! chain of restaurants (whose principle was to create the sensation of eating in a submarine—a nice metaphor for a project that ended up dead in the water). Above all, they ensured him an affluent lifestyle. Spielberg's real estate holdings, including houses and land, are estimated at some $200 million (by way of comparison, *Jurassic Park* will have earned him a total of nearly $300 million). Among the works of art scattered in his houses or offices are a Modigliani, a Monet, and about fifty Norman Rockwells, his favorite painter. In 2021, he parted with his yacht, sold for $150 million.

Spielberg's business is not about to experience a crisis. And the devil is often in the details: When actors' agents are contacted by production, the filmmaker's name is never divulged, "otherwise the prices go up right away."[2] In Hollywood, too, there is no such thing as a small profit.

Jurassic Park led to numerous spin-off products.

Halos and Auras
Elsewhere, or the Great Beyond?

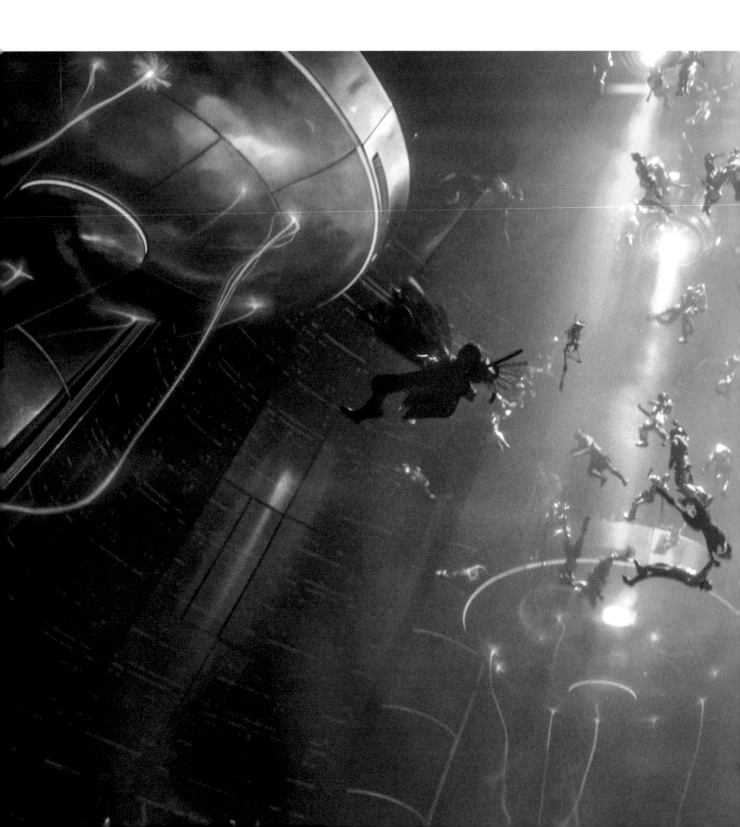

The halo is the divine halo. It is also the lamp in the cinema projector. Finally, it is Spielberg's first memory when, as a child (six months old, according to him!), he saw a powerful light emerge from behind a door in the synagogue in his neighborhood. This mystical vision imprinted on his retina and his imagination, translated into a passage to an afterlife or a promise of an "elsewhere," which, from being something marvelous in his first films, became darker, even funereal. Janusz Kamiński, his inseparable director of photography since *Schindler's List*, was no stranger to this mysticism either, with his penchant for auras, shrouded images, and intense sources of light. An anecdotal detail: *Halo* is also the title of a famous video game that Spielberg and his company Amblin adapted into a TV series in 2022.

Ready Player One, 2018.

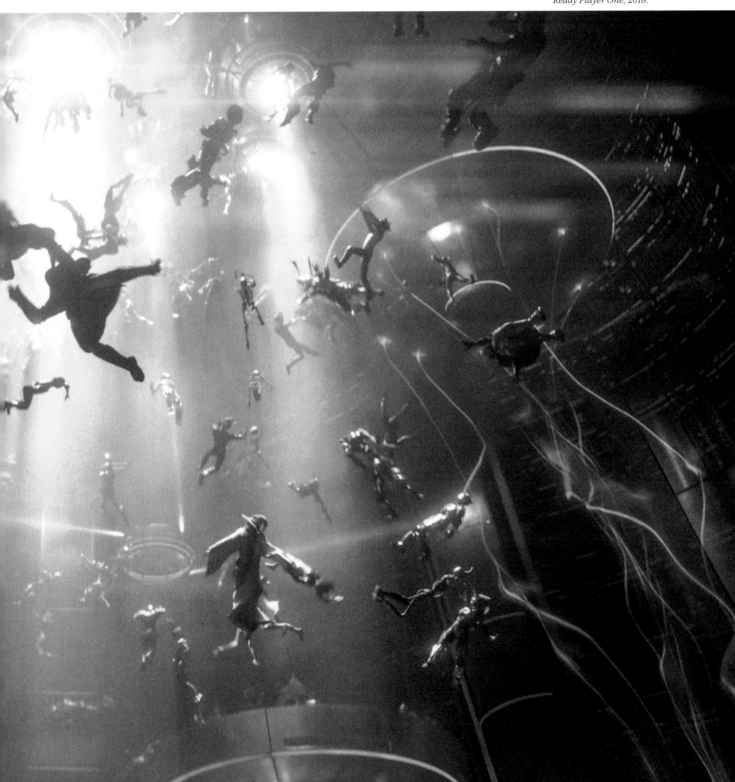

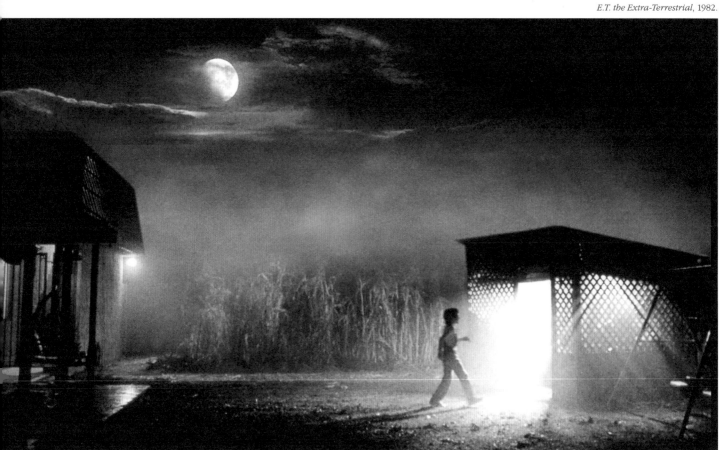

(above) *Close Encounters of the Third Kind*, 1977
(right) *War of the Worlds*, 2005.

FROM STEVEN SPIELBERG AND PETER JACKSON

THE ADVENTURES OF
TINTIN IN 3D
★ THE SECRET OF THE UNICORN ★

COLUMBIA PICTURES AND PARAMOUNT PICTURES PRESENT IN ASSOCIATION WITH HEMISPHERE MEDIA CAPITAL AN AMBLIN ENTERTAINMENT WINGNUT FILMS KENNEDY/MARSHALL PRODUCTION A STEVEN SPIELBERG FILM "THE ADVENTURES OF TINTIN: THE SECRET OF THE UNICORN" JAMIE BELL ANDY SERKIS DANIEL CRAIG MUSIC BY JOHN WILLIAMS VISUAL EFFECTS AND ANIMATION BY WETA DIGITAL LTD.
SENIOR VISUAL EFFECTS SUPERVISOR JOE LETTERI PRODUCERS CAROLYNNE CUNNINGHAM JASON McGATLIN EDITED BY MICHAEL KAHN, A.C.E. EXECUTIVE PRODUCERS KEN KAMINS NICK RODWELL STEPHANE SPERRY
PRODUCED BY STEVEN SPIELBERG PETER JACKSON KATHLEEN KENNEDY "THE ADVENTURES OF TINTIN" BASED ON "TINTIN" BY HERGÉ SCREENPLAY BY STEVEN MOFFAT AND EDGAR WRIGHT & JOE CORNISH

 COMING SOON
WWW.TINTIN-MOVIE.NET
DIRECTED BY STEVEN SPIELBERG SONY make.believe COLUMBIA PICTURES

The Adventures of Tintin

United States/
New Zealand/
United Kingdom/
France/Australia

1 hr 47

Color
(DeLuxe)

Surround
(Dolby Digital /
Datasat / SDDS)

2.39:1

Production Dates: End of January–Early March 2009
United States Release Date: December 21, 2011

Worldwide Box office: $374 million ($483.5 million in 2023 dollars)

Production Companies: Paramount Pictures, Columbia Pictures, Amblin
Entertainment, WingNut Films, Nickelodeon Movies,
The Kennedy/Marshall Company, Hemisphere Media Capital
Producers: Peter Jackson, Kathleen Kennedy, Steven Spielberg
Co-producers: Carolynne Cunningham, Jason McGatlin
Associate Producer: Adam Somner
Executive Producers: Ken Kamins, Nick Rodwell, Stephane Sperry

Based on the cartoon series *The Adventures of Tintin* by Hergé (1929–1983)
Screenplay: Steven Moffat, Edgar Wright, Joe Cornish
Cinematography Consultant: Janusz Kamiński (uncredited)
Virtual Camera Operators: Steven Meizler, David Paul,
Steven Spielberg (uncredited)
Film Editing: Michael Kahn, Jabez Olssen, Chris Plummer
Music: John Williams
Sound: John Neill
Sound Consultant: Gary Rydstrom
Sound Effects: Brent Burge, Chris Ward
Art Direction: Andrew L. Jones, Jeff Wisniewski
Motion Capture Supervisors: Philip Boltt, Kevin Cushing
(Giant Studios), Dejan Momcilovic (Weta Digital)
Motion Capture Coordinator: Fryderyk Kublikowski (Weta Digital)
Second Unit Director: Peter Jackson

Starring: Jamie Bell (Tintin), Andy Serkis (Captain Haddock/Sir Francis
Haddock), Daniel Craig (Sakharine / Red Rackham), Nick Frost (Thomson
[voice]), Simon Pegg (Thompson [voice]), Toby Jones (Aristide Filoselle),
Gad Elmaleh (Omar ben Salaad), Kim Stengel (Bianca Castafiore),
Nathan Meister (Hergé)

> **"At some point, Steven asked me if I wanted to be involved in the movie. Obviously I had to think very seriously about that, it took me, you know, two or three seconds."**[1]

> —Peter Jackson, on his collaboration with Steven Spielberg on *The Adventures of Tintin*

SYNOPSIS

A t a flea market in Brussels, Belgium, the reporter Tintin buys *The Unicorn*, a model of a three-masted ship from the time of Louis XIV. Two strangers, Barnaby Dawes and Ivan Ivanovitch Sakharine, try to buy it back, but in vain. At Tintin's house, the dog, Snowy, causes the ship model to fall and break. The broken mast releases a metal tube, which disappears under a piece of furniture. Later, Tintin is robbed of *The Unicorn*. Suspecting Sakharine, Tintin sneaks into the latter's residence, the castle of Moulinsart. While he's there, Sakharine tells him of the existence of three models of the ship. Tintin is then kidnapped and locked in the hold of the *Karaboudjan*, Captain Haddock's cargo ship, while the crew plots a mutiny. All these intrigues are the work of Sakharine. In the middle of the sea, in the desert, and in a North African port, he and Tintin compete to get their hands on a treasure for which the three *Unicorns* are the keys.

Peter Jackson helps Steven Spielberg discover the virtual camera.

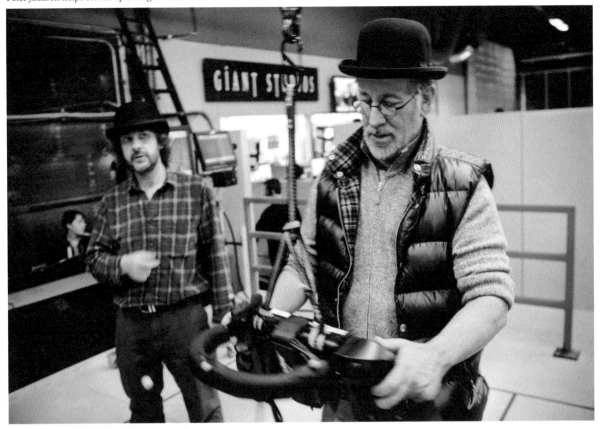

GENESIS

Steven Spielberg had never heard of *Tintin* before the early 1980s. It was while reading a press review of the French critics of *Raiders of the Lost Ark* (1981) that he noticed recurring references to the hero reporter of Hergé's comics.

A Relentless Narrative

Spielberg made his inquiries: Melissa Mathison, screenwriter of *E.T. the Extra-Terrestrial* (1982), whom Spielberg met during the shooting of *Raiders...*, had read *Tintin* in her youth, when she was an au pair in France. She offered Spielberg the French version of *The Crab with the Golden Claws* (*Le Crabe aux pinces d'or*) (1941). The filmmaker did not read the language, but he did not need to: Hergé's visual language won him over from the start, since the artist borrowed, consciously or not, so much from the cinema.[2] The relentless narrative, where even the moments of inaction are used as a relaunch of the adventures, was reminiscent of the pace of *Indiana Jones*, not to mention the exoticism and the "MacGuffin" process. The decision was made: Spielberg wanted to adapt *Tintin* for the cinema. Contact was made in November 1982 with Casterman, the publisher of the comic series; then

Hergé's secretary, Alain Baran, came to meet Steven Spielberg at Universal in early 1983.

Hergé had wanted to bring *Tintin* to the screen very early on. In 1948, he had even approached Walt Disney, without success. Several adaptations—for television and cinema, in cartoons, with stop-motion-animated dolls or with actors—produced uneven results. The designer was also very insistent on respect for his

FOR SPIELBERG ADDICTS

Among the plethora of inspirations for *Raiders of the Lost Ark* was a French film: *L'Homme de Rio* (*The Man from Rio*) (1964). Spielberg did not know it, but it is a *Tintin* adventure in disguise, brimming with borrowings from the series. Its director, Philippe de Broca, considered Hergé's character too iconic to be played by an actor. Later, Spielberg claimed that Short Round, in *The Temple of Doom* (1984), was his version of Chang, Tintin's Chinese friend, and he used the site of Petra, Jordan, in *The Last Crusade*, as Hergé did in *Coke en stock* (*The Red Sea Sharks*) (1958).

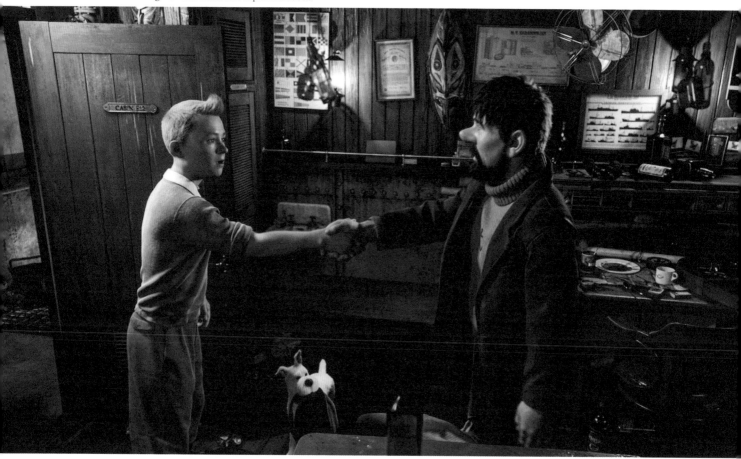

The first meeting between Tintin and Captain Haddock.

Freeze Frame

Tintin enters Sakharine's house, the castle of Moulinsart, at night. In this moment of suspense, Spielberg's style eclipses that of Hergé. The hero crosses a room in the dark without seeing that a man (Nestor, the butler, in the foreground) is following him at a distance. This shot is a replica of the final scene in Spielberg's 1973 TV movie *Savage*, where one figure stalks another in a darkened television studio.

world and, for this reason, distrusted Hollywood. However, he was enthusiastic about the idea of working with Steven Spielberg. The latter was no less enthusiastic, but he had his conditions: First, he would retain creative control; second, he planned to produce a trilogy. He would direct the first film and entrust the other two to Roman Polanski and François Truffaut. Henry Thomas, the young Elliott in *E.T.*, would play Tintin, and Jack Nicholson would be Captain Haddock. Melissa Mathison was entrusted with the script.

A Visit to the Hergé Studios

A meeting between Steven Spielberg and Hergé was set to take place in Belgium, but the cartoonist died on March 3, 1983, just before the meeting could take place. With his collaborator Kathleen Kennedy, Spielberg still went to Brussels, where he was received by Fanny Remi, Hergé's widow (Hergé's real name was Georges Remi); lingered in the artist's office; and visited the Hergé Studios—in short, he was immersed. The contract was signed in February 1984, and the project was formalized in June; then everything became bogged down. In 1985, Melissa Mathison proposed an adaptation of

After setting a film noir tone in the movie's opening act, *The Adventures of Tintin* becomes an action-adventure feature.

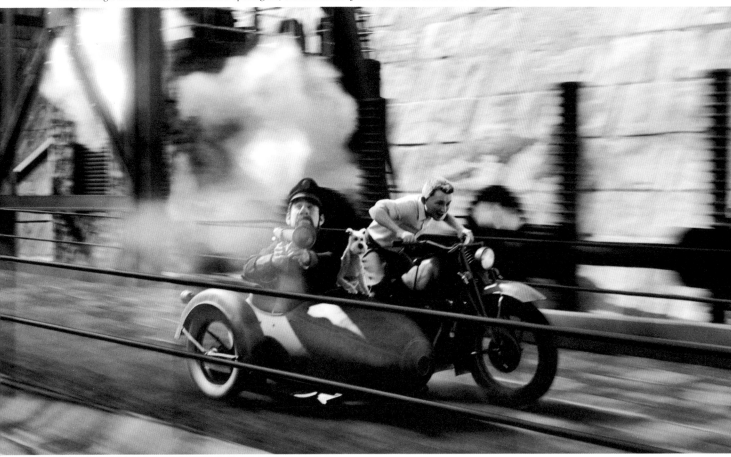

Tintin in the Congo (1931), but Spielberg did not like it. Roman Polanski drafted a screenplay for *Ottokar's Sceptre* (1939), but Spielberg got caught up in other films. In fact, *Tintin* offered so many possibilities that the filmmaker struggled to choose the best path forward. He also began to doubt the commercial potential of the project, as *Tintin* was still fairly unknown in the United States. Eventually, in 1990, Spielberg let his option lapse on the film rights.

In 2002, Kathleen Kennedy suggested going after the rights for a second time. "It took a long negotiation and a lot of convincing with the people of the Belgian foundation who manage the moral rights, and Nick Rodwell [his managing director]. They had never given up creative control over Hergé's work. But Spielberg wants absolute control over everything he does,"[3] said Stéphane Sperry, the executive producer of the future film and the driving force behind this reconciliation.

Leonardo DiCaprio as *Tintin*

Once the film rights were secured, there was still the question of casting. Leonardo DiCaprio

(twenty-eight years old at the time) was approached for Tintin, and Tom Hanks was approached to play Haddock. Again, the discussions dragged on, and Spielberg hesitated. A breakthrough came at the Academy Awards ceremony on February 29, 2004. That evening, Steven Spielberg gave the statuette for Best Picture to the New Zealander Peter Jackson and his team for *The Lord of the Rings: The Return of the King* (2003). It was the first time the two men had met, and they hit it off right away. Spielberg was also impressed by the work of the digital division of Jackson's special effects company, Weta. With *Tintin*, Spielberg was thinking of portraying the dog, Snowy, in CGI. To see what that would look like, he asked Weta Digital to produce a test animation. Jackson did him one better: He filmed himself dressed as Captain Haddock in front of a boat on the set of his 2005 film *King Kong*, with a digital Snowy that looked very lifelike jumping about around him.

Once he saw the result, Spielberg, who had been apprehensive about casting actors to portray comic book characters, reached a definitive decision: He would make the entire film using digital animation.

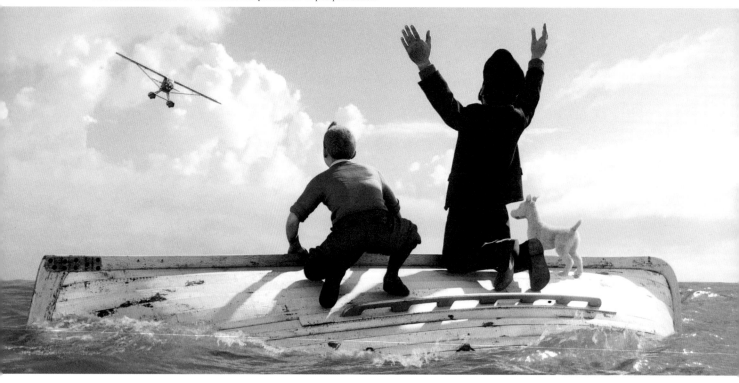

For this scene, actors wearing motion-capture outfits were filmed standing on a curved structure that was turned into a capsized boat in postproduction.

Therefore, he suggested that Peter Jackson should collaborate as a producer on the project and work as a director on one of the subsequent films planned in the series. The New Zealander seized the opportunity to work with Spielberg. Jackson had been a fan of *Tintin* since his childhood, and he even remembered his excitement when, in the 1980s, the original Spielberg adaptation was announced.

Surrounded by Europeans

Spielberg and Jackson decided to combine a few different *Tintin* stories: *The Secret of the Unicorn* (1943), *Red Rackham's Treasure* (1943), and *The Crab with the Golden Claws* (1940), because that was the story in which Captain Haddock first appeared. They also surrounded themselves with Europeans who were familiar with *Tintin*. The English screenwriter Steven Moffat was hired in the fall of 2007. He worked on *Tintin* while also writing on the British series *Doctor Who*, which was relaunched in 2005. Moffat eventually became the lead writer and executive producer on *Doctor Who*, but a writer's strike in the United States threw his scheduling into disarray and he could no longer manage to work on both projects. He opted to stay on *Doctor Who* and exited his duties on *Tintin*. Moffat was replaced by Edgar Wright and Joe Cornish.

The Adventures of Tintin had to be more than just another animated film. In order to achieve the best possible level of realism, the characters would be played by actors who were filmed in motion capture (MoCap). Peter Jackson took Steven Spielberg to Giant Studios in Los Angeles, the same motion capture studio used by James Cameron for *Avatar* (2009), another film in which Weta was involved. Cameron (who acquired Giant Studios in 2015) was there to explain things to Spielberg, who was a novice when it came to working with a "virtual camera": a controller with a small screen where digital avatars animated via motion capture would appear. In the motion capture process, the director is able to move around the studio, controller in hand, and they can virtually turn around the actor's avatars and execute camera movements that are immediately seen on the screen.

An Agreement Made in Extremis

In spite of the new abilities Spielberg was able to make use of via motion capture, the project seemed fated to suffer from other complications. Universal was supposed to produce a trilogy of *Tintin* movies, but they threw in the towel one month before the start of shooting when they became alarmed by the production costs ($130 million) and the 30 percent of gross revenues demanded by Spielberg and Jackson. An agreement was reached in extremis with Paramount and Sony, who agreed to release two films instead of three.

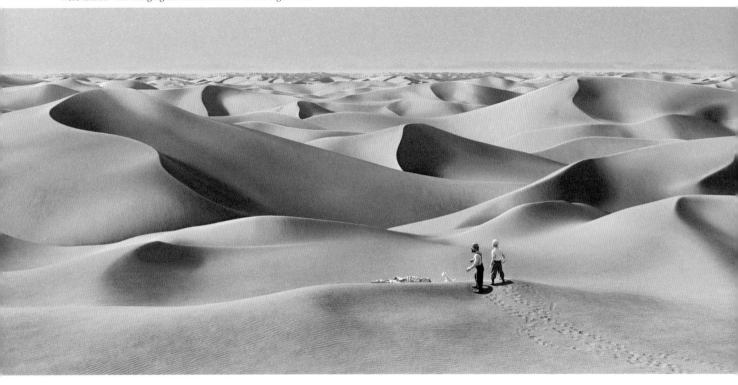

From comic book to film: Weta Digital's team of computer graphics artists were tasked with bringing the famous comics to the big screen.

CASTING

Given the nature of the digital production process, a resemblance between actors and Hergé's original characters was not required.

Two Actors from *King Kong*

For the title character, eighteen-year-old Thomas Brodie-Sangster (*Love Actually, The Queen's Gambit*) was cast in March 2008, but the delay caused by Universal's withdrawal from the project meant that he was no longer available. On Spielberg's suggestion, the actor was replaced by Jamie Bell, who had been discovered in *Billy Elliot* and also appeared in Jackon's remake of *King Kong*. Captain Haddock and his ancestor, Sir Francis Haddock, were brought to life by Andy Serkis, a veteran of motion capture. Serkis famously appeared as Gollum in *The Lord of the Rings* and as the gorilla in the 2005 *King Kong*. Sakharine, a secondary character from Hergé who would be the film's villain, was played by Daniel Craig. Craig worked with Spielberg on *Munich* and famously appeared in multiple James Bond films.

The Edgar Wright Crew

Originally, Simon Pegg was supposed to write the screenplay along with fellow actors Edgar Wright and Joe Cornish, but then Spielberg asked him to appear in the film instead.

Gad Elmaleh, who started out as a stand-up comedian and actor in France, was brought in to play Omar ben Salaad, a rich Arab living in Morocco. In the Hergé version, ben Salaad owes his fortune to drug trafficking, but the film made him a straightforward art lover. In the film, he attends a recital by the singer Bianca Castafiore.

A Soprano for Castafiore

Castafiore does not appear in the cartoons that were the feature film's inspiration, but she is so cinematic that she earned an appearance in the feature film. The "role" went to stage actress Kim Stengel, but her glass-shattering vocals were provided by world-renowned soprano Renée Fleming, who also appeared on the soundtrack of *The Lord of the Rings: Return of the King*.

FILMING AND PRODUCTION

The Adventures of Tintin was the most atypical filming experience in Steven Spielberg's storied career.

Thirty-Two Days in "the Volume"

For thirty-two days, at the beginning of 2009, actors played their scenes while wearing motion capture suits inside Giant Studios, in an empty room called the Volume. The actors were equipped with markers on their bodies and faces and mini-cameras attached to their heads to capture their facial expressions (in

Steven Spielberg (wearing a hat, center) in a studio without sets or props that was dedicated to motion capture.

this sense, this was more accurately *performance capture*). Rudimentary props were used (a frame simulating an overturned canoe, a motorcycle moved by hand by technicians), and Snowy the dog was portrayed by a tennis ball! Except for Andy Serkis, none of the other actors had ever worked like this. Daniel Craig admitted to some initial uneasiness, but with everyone in the same situation, things quickly started to flow. To guide the actors, monitors showed them what their performance looked like via digital characters placed in the middle of CGI sets already made by Weta.

Peter Jackson's company evolved the technology that was used on *Avatar* so that Steven Spielberg could intervene on set without disrupting the footage; dressed normally, Spielberg remained invisible to the MoCap cameras.

Respecting Hergé's Style

Peter Jackson was present during the first week of filming to help launch the operations, and then he returned to his projects in New Zealand. But every morning, he communicated by videoconference, supervised the set, and intervened in shooting as needed. In fact, he assumed the role of a co-director. After filming was completed, for the next year and a half, Weta Digital fine-tuned the images of the entire film as they had been provided by Spielberg. The exercise was a delicate one:

It was necessary to respect Hergé's style and not to modernize his universe, while adding photorealism, texture, and volume effects far from the "clear line" drawing style used by the artist. While the film took great pains to honor the artist's original intentions, we still find typical Spielberg framing, with the telltale play of shadows from his director of photography, Janusz Kamiński. The filmmakers knew there was some potential for viewers who had grown up with *Tintin* to be put off by their take on the classic story.

RECEPTION

As soon as the first posters, trailers, and excerpts from the film appeared in May 2011, Tintinophiles around the world expressed their reservations. At the end of October 2011, *The Adventures of Tintin* was released in cinemas.

World Premiere in Brussels

On October 22, in a gesture of deference to the homeland and the city of Hergé, the world premiere of the film took place in Brussels. The daily newspaper *Le Soir* was delighted: "Paced, colorful, full of relief, the film alternates the plot and the game of tracks with a background that is often lively, light, and sometimes even hilarious."[4] *La Libre Belgique* saluted the fact that Haddock's alcoholism had been retained but, as the title of its article suggests ("Les aventuriers de la Licorne

A nod to Tintin connoisseurs: Bianca Castafiore (above) and Hergé himself (below, left) both appear in the film.

perdue," or "Raiders of the Lost Unicorn"[5]), deplored the fact that *Tintin* played too much like *Indiana Jones*. This was a recurrent criticism of European critics who felt that the film had an excess of adventure and noise, and a frantic pace overall. As for the transposition of Hergé's refined drawings, opinions were mixed: For some, the challenge was successfully met; for others, the movement and texture of the film destroyed all fidelity to the original material.

"*Tintinizing* America"

The film appeared in the United States in December of 2011. Earlier that year, in July, Steven Spielberg and Peter Jackson presented an excerpt of the film at Comic-Con, the famous pop culture festival in San Diego. The plan was to "*Tintinize* America little by little."[8] Spielberg's decision to inject the spirit of *Indiana Jones* into *Tintin* was not lost on viewers, but no one seemed unduly offended, with the notable exception of the *New York Times*: "Relax, you think, as *Tintin* and the story rush off again, as if Mr. Spielberg were afraid of losing us [the American public] with European-style *longueurs*."[9]

Although the film was far from a flop—it generated $70.5 million at the box office in the United States—it did most of its business outside of the United States, earning $296 million from overseas territories.

War Horse

| United States/ India | 2 hrs 26 | Color | Surround (Dolby Digital / Datasat / SDDS) | 2.39:1 |

Production Dates: August 6–October 27, 2010
United States Release Date: December 25, 2011

Worldwide Box Office: $177.5 million ($219.3 million in 2023 dollars)

Production Companies: DreamWorks Pictures, Touchstone Pictures, Reliance Entertainment, Amblin Entertainment, The Kennedy/Marshall Company
Producers: Kathleen Kennedy, Steven Spielberg
Co-Producers: Adam Somner, Tracey Seaward
Associate Producer: Kristie Macosko Krieger
Executive Producers: Revel Guest, Frank Marshall
Production Manager: Nicholas Laws

Based on the eponymous novel by Michael Morpurgo (1982) and the eponymous play by Nick Stafford (2007)
Screenplay: Lee Hall, Richard Curtis

Director of Photography: Janusz Kamiński
Camera Operators: Mitch Dubin, George Richmond, Simon Baker
Film Editing: Michael Kahn
Music: John Williams
Sound: Stuart Wilson
Production Design: Rick Carter
Set Decoration: Lee Sandales
Hair Stylist: Jon Henry Gordon
Makeup: Lois Burwell
Costume Design: Joanna Johnston
Special Effects: Neil Corbould
Assistant Directors: Adam Somner, William Dodds, Emma Horton

Starring: Jeremy Irvine (Albert Narracott), Tom Hiddleston (Captain Nicholls), Benedict Cumberbatch (Major Stewart), Emily Watson (Rose Narracott), Peter Mullan (Ted Narracott), David Thewlis (Lyons), Niels Arestrup (grandfather), David Kross (Gunther), Celine Buckens (Emilie), Geoff Bell (Sergeant Perkins), Patrick Kennedy (Lieutenant Waverly), Toby Kebbell (English soldier), Robert Emms (David Lyons)

"It's an old fashioned narrative, much more old fashioned than any of the things I've done recently."[1]

—Steven Spielberg

SYNOPSIS

In the English countryside, on the eve of the First World War, a farmer buys a young horse at auction and entrusts the animal to his son, Albert. A deep friendship is born between the animal, named Joey, and the teenager. When war breaks out, Albert's father sells Joey to the British Army to pay off his debts. Albert enlists in the army and sets out on an odyssey across the battlefields of Europe, searching for his beloved horse.

GENESIS

In the late 1970s, a former schoolteacher turned farmer named Michael Morpurgo struck up a friendship with an old antique dealer that he met in a pub in the Devon area of the United Kingdom. One thing led to another, and Morpurgo's new friend shared his memories of the First World War, the horror of the trenches, and the loss of all humanity. The two were soon joined by another veteran, and then by a third individual, who, although too young to enlist, had nevertheless lived through conflict and witnessed the sale of local horses to the British Army.

A Classic of Children's Literature

Morpurgo began to look into some of the stories these men shared, and he discovered a story within a story: Four million horses had been killed on or near the battlefields of the First World War. At the end of the war, many of the surviving animals were bought by French butchers and ended up being sold as food. In 1982, Morpurgo published *War Horse*, the fictional tale of one of these horses, Joey, who was raised on a farm by a young boy named Albert, and then sold to the British Army by his father to pay off debts. Aimed at a young audience, the novel was written from the animal's point of view. Through

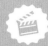

FOR SPIELBERG ADDICTS

The author of the original novel makes a cameo at the beginning of the film, when the village hosts the horse sale. He's wearing a top hat.

Joey's eyes, the war is shown in all of its absurdity, stultifying men and destroying all life. For Joey, uniforms do not distinguish the good from the bad. Wandering from camp to camp, he finds himself caught in the barbed wire of no-man's-land.

War Horse was a phenomenal success when it was published. Morpurgo tried several times to make a screenplay out of the book, without success. To his great surprise, the National Theatre submitted a rather daring stage adaptation to him, with the two main horses (Joey and his partner, Topthorn) represented by life-size animated puppets. The first performance of the play took place on October 17, 2007, and it quickly became a success. In the summer of 2009, Kathleen Kennedy and Frank Marshall attended a performance with their family. Their children's reactions (and their own emotions) convinced them of the potential for a film adaptation. Three months

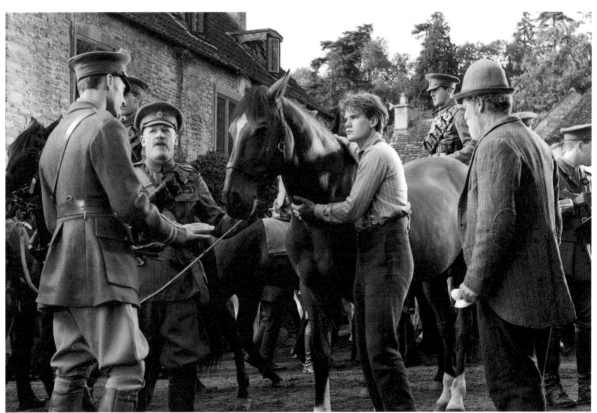

Albert (Jeremy Irvine) tries to prevent the sale of his horse, Joey, to the army under the gaze of his father (Peter Mullan).

Facing death: A spectacular assault on a German position ends in slaughter for the British cavalrymen.

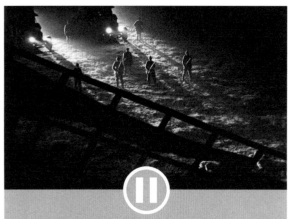

Freeze Frame

Caught by the enemy, Gunther and his brother Michael are to be executed at the first light of dawn near the mill where they had taken refuge. Placed at the top of the building, the camera captures the last moments of the two young deserters as they face the firing squad, caught between the movements of the rotating windmill sails. Shots ring out as one of the sails fills the image, a modest and poetic condemnation of blind justice in wartime.

later, DreamWorks acquired the rights to the book and play.

No Rest for Spielberg

Spielberg was in the middle of postproduction on *The Adventures of Tintin*. He had just completed additional shooting and he had to wait a year for the animation work to be completed, so he had some free time. Curious about the enthusiasm of his colleagues for this play about a horse, he discovered the novel and then attended a performance of the play in February 2010, from which he emerged just as moved as his associates. For a while, he thought he would limit himself to producing the adaptation…but in the end he decided to direct. Not quite satisfied with the script initially written by Lee Hall (*Billy Elliot*), he put the text into the hands of Richard Curtis, who was known for writing British sentimental comedies (*Four Weddings and a Funeral*, *Love Actually*), in order to stick more closely to the book. For three months, Curtis went through a series of drafts (more than a dozen) for Spielberg. Still centered on Joey, the script gave Albert, his young owner, a more prominent role. Spielberg hints that Albert was injured at the front, as does the idea of the war pennant brought back by Albert's father from the Boer War (1899–1902), which becomes a



common thread between the main characters of all nationalities. Also, the German and French roles were significantly modified (the two young deserters in the film do not exist in the novel) to increase the action. Given the scope of the screenplay, the film's budget of $70 million was deemed extremely tight.

CASTING

For Joey, the film's titular horse, no fewer than eleven different animals were brought on to shoot the film. For the actors in the film, Spielberg insisted on hiring people of the same nationality as the characters they played (although everyone would speak English) and, above all, he wanted an unknown face for the role of Albert, someone who was capable of playing the role at both fifteen and twenty-one years old. After months of searching and unsuccessful auditions, the director settled on Jeremy Irvine, a nineteen-year-old English actor with an almost blank résumé. The rest of the cast had a much more extensive pedigree. Albert's parents were played by Emily Watson and Peter Mullan. Benedict Cumberbatch, Tom Hiddleston, and Patrick Kennedy (who worked with Spielberg on *Munich*) played cavalry officers in the British army.

Playing Albert onstage, Robert Emms donned a tweed suit and played a local landlord's son in the

film. French actor Niels Arestrup was chosen to play the grandfather, and thirteen-year-old Belgian actress Céline Buckens was hired to play his granddaughter.

FILMING AND PRODUCTION

Dartmoor, in the southwest of England, hosted the film's first shot, which took place on August 6, 2010. Filming happened almost entirely in the countryside and was carried out at breakneck speed. To support this hellish pace, the filmmaker surrounded himself with his loyal crew: Janusz Kamiński, Rick Carter, Joanna Johnston, Mitch Dubin, and the two tireless technicians John Williams and Michael Kahn. The latter was responsible for editing the sequences as they came to him using Avid software, which Spielberg began to use for *The Adventures of Tintin*. This choice enabled him to "take the pulse of the film"[2] and to reuse a set if necessary, before it was destroyed.

A Helping Hand from Peter Jackson

Johnston scoured websites and museums (including the Imperial War Museum in London) to re-create as faithfully as possible the costumes of the period, both civilian and military. Peter Jackson, co-director of *The Adventures of Tintin,* is a collector of World War I artifacts and had three containers of props sent to

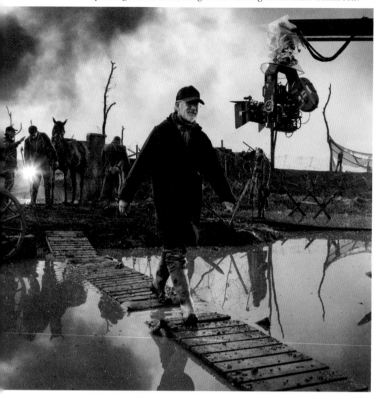

Spielberg almost broke a leg while working on the film's trench sets.

the production. Carter built the Narracott farm from a ruin in the middle of a protected landscape that had to be preserved with extensive netting. The forecast was often rainy, to the extent that Spielberg regularly changed the order of the shots while Kamiński watched for the slightest sign of a break in the weather. For the ultimately not-so-heroic charging sequence, thousands of reeds were pulled from a swamp and replanted one by one in Stratfield Saye Park, on the property of the Duke of Wellington.

Rats and Men

The most spectacular setting in the film was the no-man's-land that Carter's team built on an abandoned airfield in Surrey: Some 750 trenches were dug and consolidated during six weeks of work. Spielberg dropped men and rats into the set, and almost broke his leg in a shell hole that was filled with water. There was no time for him to take a break and recuperate because they were filming on a very precise schedule.

After five days spent in the studio shooting interiors, filming ended on October 27. In sixty-three days, Spielberg and his team had tamed the elements, nearly six thousand extras, and about thirty horses.

As soon as filming wrapped, Kamiński headed off to begin location scouting for *Lincoln* in Virginia.

RECEPTION

In the United States, *War Horse* was released four days after *The Adventures of Tintin* and took in nearly $80 million, with a worldwide gross of $177.5 million. This relatively paltry box office performance can be explained by a flawed positioning of the film, which viewers found difficult to categorize: Was it for children or adults? As Justin Chang, from *Variety*, pointed out, the film was "too long and intermittently too intense for small fry, but also too repetitive and simplistic to engage adults on more than an earnestly prosaic level."[3] The film was praised by a large proportion of American critics, who were seemingly caught under the spell of the film's pacifist message and carried away by the movie's formal splendor, which evoked the great Hollywood classics.

Not a Film About the War

In interviews, Spielberg claimed that war was not the film's main subject: "This is much more of a real story between the connections that sometimes animals achieve, the way animals can actually connect people together."[4] To support his point, he justified the near absence of blood in a film that illustrates the violence of a major world conflict: "*Saving Private Ryan* was carnage. In *War Horse*, I had to find the right balance between my desire to reach a young audience, the one in the book, and my responsibility not to betray the facts."[5] This intention sometimes results in moments that feel irremediably fake, especially in the English and French battle scenes, but also in moments of transcendence when the film depicts the ways in which war and violence can crush the spirit as well as the body. In the movie, furrows dug by a plow foreshadow the trenches of the Somme, and a tank surprises Joey, who struggles to escape. Spielberg paints an image of a changing world, where heroism no longer has a place. Awed by his settings, Spielberg seems to deliberately lose himself in the landscape. And although he strenuously refuted any overt reference to John Ford, the shadow of the master hovers over multiple shots where the earth seems to devour the men who trod upon it. *War Horse* is sometimes so beautiful that viewers could be excused for getting lost in the images and forgetting about the characters they're supposed to be following.

(right) Surprisingly, Joey's frantic gallop through the trenches required very little digital editing.

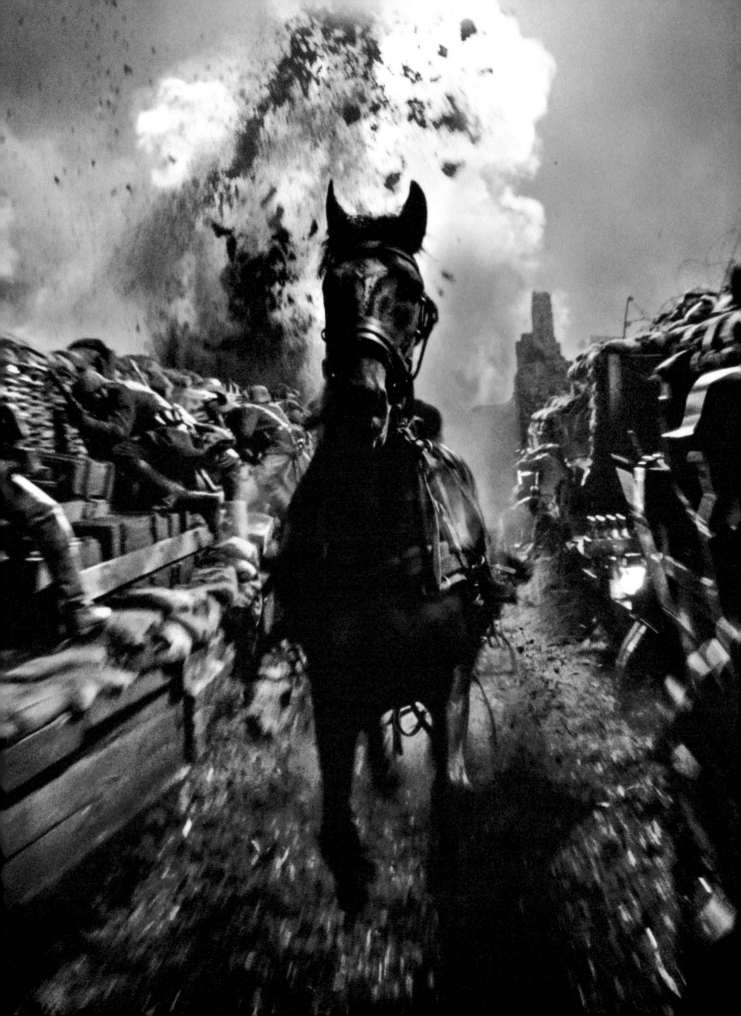

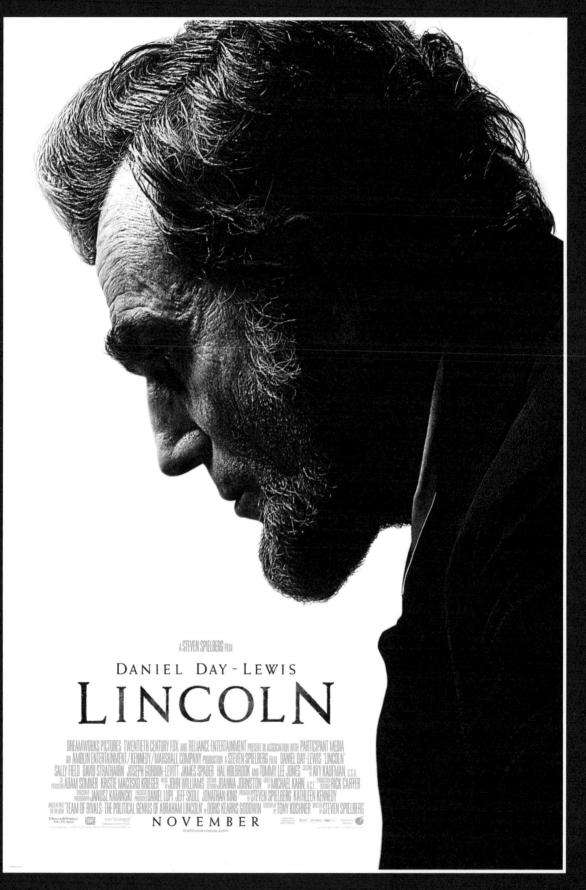

A STEVEN SPIELBERG FILM

DANIEL DAY~LEWIS

LINCOLN

DREAMWORKS PICTURES TWENTIETH CENTURY FOX AND RELIANCE ENTERTAINMENT PRESENT IN ASSOCIATION WITH PARTICIPANT MEDIA
AN AMBLIN ENTERTAINMENT/KENNEDY/MARSHALL COMPANY PRODUCTION A STEVEN SPIELBERG FILM DANIEL DAY-LEWIS "LINCOLN"
SALLY FIELD DAVID STRATHAIRN JOSEPH GORDON-LEVITT JAMES SPADER HAL HOLBROOK AND TOMMY LEE JONES CASTING AVY KAUFMAN, C.S.A.
CO-PRODUCERS ADAM SOMNER KRISTIE MACOSKO KRIEGER MUSIC BY JOHN WILLIAMS COSTUME DESIGNER JOANNA JOHNSTON EDITED BY MICHAEL KAHN, A.C.E. PRODUCTION DESIGNER RICK CARTER
DIRECTOR OF PHOTOGRAPHY JANUSZ KAMINSKI EXECUTIVE PRODUCERS DANIEL LUPI JEFF SKOLL JONATHAN KING PRODUCED BY STEVEN SPIELBERG KATHLEEN KENNEDY
BASED IN PART ON THE BOOK "TEAM OF RIVALS: THE POLITICAL GENIUS OF ABRAHAM LINCOLN" BY DORIS KEARNS GOODWIN SCREENPLAY BY TONY KUSHNER DIRECTED BY STEVEN SPIELBERG

NOVEMBER

thelincolnmovie.com

Lincoln

United States/ India	2 hrs 30	Color (Technicolor)	Surround (Dolby Digital / Datasat / SDDS)	2.39:1

Production Dates: October 17–December 19, 2011
United States Release Date: November 9, 2012

Worldwide Box Office: $275.3 million ($350.7 million in 2023 dollars)

Production Companies: DreamWorks Pictures, 20th Century Fox,
Amblin Entertainment, Reliance Entertainment, Participant Media,
Dune Entertainment, The Kennedy/Marshall Company, Touchstone Pictures
Producers: Steven Spielberg, Kathleen Kennedy
Co-producers: Adam Somner, Kristie Macosko Krieger
Executive Producers: Daniel Lupi, Jeff Skoll, Jonathan King

Based in part on the book *Team of Rivals: The Political Genius of Abraham
Lincoln* by Doris Kearns Goodwin (2005)
Screenplay: Tony Kushner

Director of Photography: Janusz Kamiński
Camera Operators: Mitch Dubin, George Billinger
Film Editing: Michael Kahn
Music: John Williams
Sound: Andy Nelson, Ron Judkins, Gary Rydstrom
Production Design: Rick Carter
Set Decoration: Jim Erickson
Makeup: Lois Burwell
Costume Design: Joanna Johnston
Assistant Directors: Adam Somner, Ian Stone
Casting: Avy Kaufman

Starring: Daniel Day-Lewis (Abraham Lincoln), Sally Field (Mary Todd
Lincoln), David Strathairn (William Seward), Joseph Gordon-Levitt (Robert
Lincoln), James Spader (W. N. Bilbo), Hal Holbrook (Preston Blair), Tommy Lee
Jones (Thaddeus Stevens), John Hawkes (Robert Latham), Jackie Earle Haley
(Alexander Stephens), Tim Blake Nelson (Richard Schell), Lee Pace (Fernando
Wood), Jared Harris (Ulysses Grant), Adam Driver (Samuel Beckwith),
Jeremy Strong (John Nicolay)

> **"So many of my movies have really been a kind of outpouring of imagery. I've made a lot of movies where I can tell the story through pictures, not words. In this case, the pictures took second position to the language. And so I took, in a sense, a backseat. I felt a little more like Sidney Lumet."**[1]
>
> —

—Steven Spielberg

SYNOPSIS

I n January 1865, with the Civil War turning in favor of the Union and the defeat of the Confederate Army seemingly a foregone conclusion, President Abraham Lincoln finds his political agenda in a state of disarray. After the Emancipation Proclamation of 1863, he seeks a vote in Congress to ratify a Thirteenth Amendment to the Constitution, which would abolish slavery. While the Senate has already voted in favor of the amendment, the House of Representatives has yet to vote. The rapid resolution of the Civil War, and the probable reintegration of slaveholding secessionists into the Union, threatens to prevent any adoption of the amendment.

For scenes set in the US House of Representatives, Spielberg deviated from his usual work uniform in favor of a suit and tie.

GENESIS

With Spielberg, his projects often begin with a story related to childhood or adolescence, as if he needed to search his youthful memories for a way to justify his fascination with, and enthusiasm for, great subjects. During the promotion of *Lincoln,* the filmmaker described a childhood trip he took with his father to the Lincoln Memorial in Washington, DC. This story was told multiple times, and Spielberg's age varied depending on the telling (from four to six years old); but when describing his feelings upon first seeing the gigantic marble statue of Lincoln sitting upon a throne-like chair, Spielberg's memory of his reaction stayed more or less the same: He felt amazement at the thirty-foot-high work of art, fascination with Lincoln's immense wrinkled hands, fear of looking up at the president's face, and eventually a sense of courage from the serenity emanating out of Lincoln's visage. The filmmaker swore that from that moment on, the great Abraham Lincoln became a constant source of fascination for him: "At school, when I was dyslexic without knowing it, I always listened more when people talked about him. He looked so 'un-Presidential': he was taller than everyone else, thinner, badly dressed, badly combed [...]. I liked the fact that this outsider, who was not destined for the job, managed to get to the top. It was

then that he discovered his own greatness: circumstances, the Civil War, and then the scourge of slavery enabled him to express the best of himself. Lincoln was lucky to be Lincoln."[2]

A Book That Had Only Just Been Written

In 1999, President Clinton commissioned Spielberg to make a twenty-minute film on the history of the United States during the twentieth century. *The*

FOR SPIELBERG ADDICTS

In August 2008, a short film helmed by Spielberg was screened at the Democratic National Convention. Produced especially for the occasion, and lasting for seven minutes, *A Timeless Call* was about the difficult return home for many American soldiers. It is an ode to veterans, consisting of short but intense testimonies and accompanied by voice-over from Tom Hanks, who makes an appearance at the end of film. Initially a supporter of Hillary Clinton, Spielberg subsequently endorsed Barack Obama.

As his troops advance to victory, Lincoln talks with General Grant.

Unfinished Journey was made to celebrate the turn of the millennium and to accompany music composed for the occasion by John Williams. In order to tell the story of the twentieth century in this short period of time, the director, who was then taking a break in his career, brought together a number of respected historians. Among them was biographer Doris Kearns Goodwin, who told Spielberg that she was in the middle of researching a book on America's sixteenth president. At the end of their conversation, the film legend decided to option the movie rights to Kearns Goodwin's book, which was still in early draft stages and far from being complete.

A Long Gestation

When *Team of Rivals: The Political Genius of Abraham Lincoln* was finally published in 2005, Spielberg's film adaptation was already underway. In 2001, screenwriter John Logan (*Any Given Sunday, Gladiator, Skyfall,* and many others) began work on the project before being replaced by playwright Paul Webb. In the end, another playwright, Tony Kushner, took over the project and produced a finished script. Kushner had been held in high regard by Spielberg ever since their collaboration on *Munich*. The first script Kushner delivered was a monumental draft that stretched on for 550 pages. Though there was some initial discussion of filming *Lincoln* as a miniseries and offering it to

HBO, the filmmaker eventually asked Kushner to tighten up his text, focusing on the seventy-page portion that covered the vote by Congress to ratify the Thirteenth Amendment to the Constitution, which would abolish slavery in the United States. In order to get the new amendment through Congress, Lincoln had to be diplomatic and shrewd with his opponents, engaging in a tactical war fought with a high degree of verbal sparring. The screenwriter was asked to revise his script, which he did for the next three years, with a view to releasing the completed film in 2009, the bicentennial year of Lincoln's birth.

CASTING

Spielberg was optimistic about casting when Liam Neeson, who played Oskar in *Schindler's List*, signed on for the titular role. Previously, the director had tried to approach Oscar-winning actor Daniel Day-Lewis for the part, but he was turned down in a letter in which the actor tactfully explained that he couldn't accept the role. Neeson signed on to the project in 2004 and threw himself into preparation for the role.

Neeson Backs Out

Liam Neeson began the work of preparing for the monumental role of Lincoln, but his life was turned upside down on March 14, 2009, when his wife,

The man of war: Abraham Lincoln (Daniel Day-Lewis) surveys the destruction after the battle.

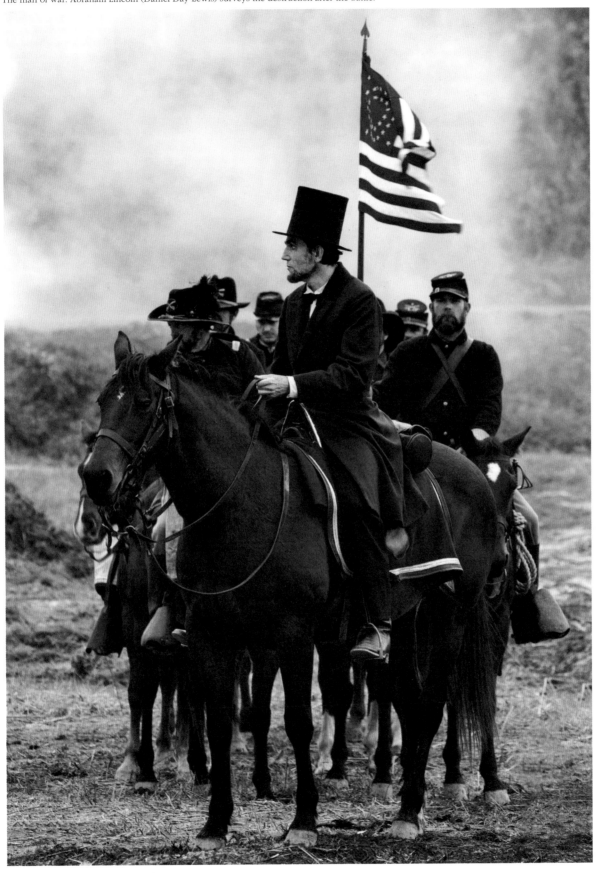

Through the looking glass: Even though she is his wife, Mary (Sally Field) finds it hard to see through all of Abraham's secrets.

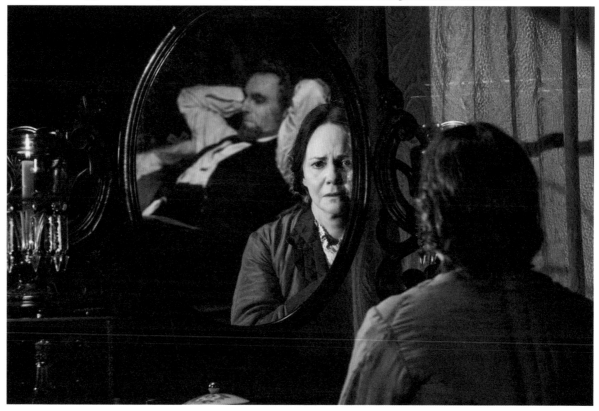

actress Natasha Richardson, died of complications from a skiing accident. A year later, when Spielberg reunited the actors for a reading of a new version of the script, Neeson found himself unable to access the role he had signed on for: "and there was an intro, and then I see 'Lincoln' where I have to start speaking, and I just—a thunderbolt moment. I thought, 'I'm not supposed to be here. This is gone. I've passed my sell-by date. I don't want to play this Lincoln. I can't be him.'"[3] That night he called the director and told him he was too old to play the character (he was fifty-eight, whereas Lincoln was fifty-five). Shaken, the director tried to get him to reconsider his decision but was unsuccessful. It took a few months before Neeson's successor was officially announced. The lucky man who finally took the part was a surprise, even for those who were following the project closely. Why did Daniel Day-Lewis change his mind? Timing, no doubt: "When I was very young, I made a promise to myself that I would only work when I felt a compelling need to," said the actor. "The work I do must be of great value to me. If not, it is not worth it and I can do something else. For that reason I can spend a year without working, then two others to invest myself completely on a project. If I worked all the time, I would exhaust my creativity, my desire."[4]

In Full Awareness

The actor had a year to prepare for his role: "The fear came from immersing myself in the life of this man. The characters I choose to play are the antithesis of my daily life. In the case of Lincoln, I first felt like I was hitting a wall. I was faced with a man whose life seemed entirely determined by politics. It was much later that I was able to grasp the human being behind the politician: a simple, accessible guy." Spielberg and Day-Lewis worked well together. The director never interfered in the work of the actor, except if the actor asked him for his opinion. It was the actor who created a voice that was much higher and less solemn than his predecessor's in the role, such as Henry Fonda in *Young Mr. Lincoln*. Spielberg was delighted by this change in tone.

While Daniel Day-Lewis was sought out by the director, Sally Field had to fight to convince Spielberg she was right for the part of Mary Todd Lincoln in spite of the ten-year age difference between Field and the president's wife. Field had already won two Oscars (in 1980 for *Norma Rae*, and in 1985 for *Places in the Heart*) but she was not willing to give up on the role.

Eventually, Spielberg was convinced (Day-Lewis even flew to Los Angeles to audition with Field in person) and Field won the part.

Among the other members of a predominantly male cast, Tommy Lee Jones (an Oscar winner for Best Supporting Actor in *The Fugitive*) played a strong-willed Thaddeus Stevens. Hal Holbrook played Preston Blair; Holbrook is a character actor who was used to playing supporting roles, but he had the distinction of playing Lincoln four times during his long career, with one of his performances earning him an Emmy. Young, up-and-coming actors Dane DeHaan and Adam Driver made some of their earliest screen appearances in the film. Also along for the ride was actor Lukas Haas, who had previously appeared in the Spielberg-directed "Ghost Train" segment of *Amazing Stories* and who appears in a small role in this film.

FILMING AND PRODUCTION

Filming took place in the fall of 2011, primarily in Richmond, Virginia. The city's capitol building,

which bears architectural similarities to the White House, was given a portico to reinforce the resemblance, and it stood in for the White House in the film. Production designer Rick Carter, who had been working on the project since 2002, was inspired by the rooms and architecture that were described by Doris Kearns Goodwin in her book.

Abraham's Watch

Spielberg demanded that his film be made with the utmost authenticity. Thus, Lincoln's office and living quarters were reproduced with great attention to detail, from the maps on the walls to the handwritten letters and the tapestries. A watch similar to the one owned by the president was loaned to the production by a museum so that the sound of the mechanism could be recorded. Director of photography Janusz Kamiński was the only person who was given some freedom in his choices. Respecting

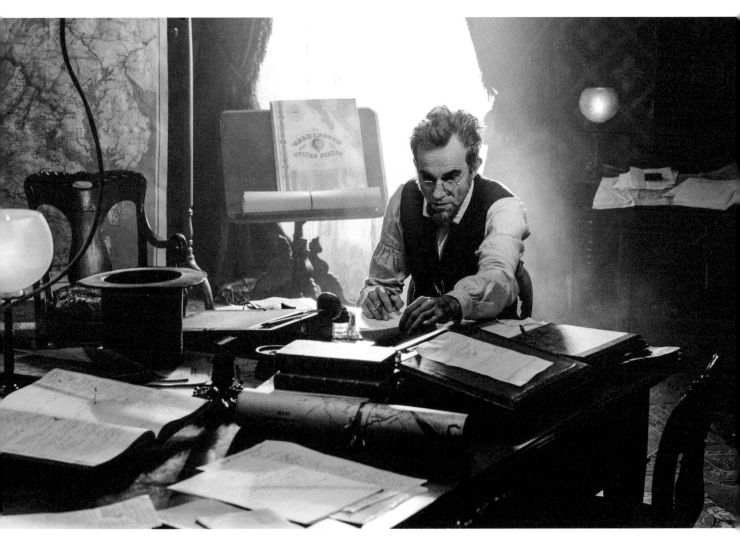

The film's technical team did a stunning job of re-creating Lincoln's office.

as much as possible the lighting of the time period, from the windows to the oil and kerosene lamps, the director allowed Kamiński to cheat a little (by accentuating some light sources, or adding "skylights"). For everyone else working on the production, the ability to play was kept to a minimum. The camera movements were reduced, which sometimes gives the film the cadence of a stage play—an impression reinforced by the quasi-unity of the film's locations, which are mostly set in the House of Representatives. Again, the Virginia House of Delegates in Richmond served as the setting for the crew. The scenes were filmed there over two weeks, in chronological order. On the set, Spielberg, who insisted on wearing a suit and tie during filming, forbade the 58 actors and more than 230 extras from engaging in idle chitchat between takes: No one was allowed to step out of character. Furthermore, everyone was called by the name of their role.

When Spielberg finished shooting *Lincoln* on December 19, he was in the news for two reasons. On the twenty-first of the same month, *The Adventures of Tintin* was released, followed four days later by *War Horse*! The last three years had been intense, and the projects had often overlapped. He also quickly had to get back to work in 2012 with *Robopocalypse*, a big-budget sci-fi thriller for which he had begun preparation. But script problems caused him to abandon the project, and he settled into a role as producer on the final film. He also embarked on adapting the autobiography of sniper Chris Kyle, *American Sniper*, before withdrawing in 2013, believing that he would not have a sufficient budget. The film was directed in 2014 by Clint Eastwood. In fact, Spielberg did not return to a movie set until September 2014 with *Bridge of Spies*.

RECEPTION

Lincoln was a great success when it was released, in spite of skepticism from some who worried that audiences wouldn't flock to a film with such a serious subject matter. With twelve nominations, the film was a heavy favorite going in to the 2013 Academy Awards, but it won only two statuettes: for Best Production Design and Best Actor. No stranger to the category (he already had two wins out of four previous nominations), Day-Lewis became the first actor to be awarded an Oscar for a Spielberg film.

"A Major Work"

While the Academy didn't shower the film with awards, it was alone in not doing so: The critics praised it. *Variety*[5] praised Kushner's ability to make the small theater of politics convincing, even when it revolves around a noble cause. In France, the film magazine *Cahiers du Cinéma* considered that "never before in his historical films has Steven Spielberg achieved a height of vision comparable to that which makes Lincoln a major work."[6]

In *Lincoln*, the filmmaker filmed the workings of a democracy as part of a complex institution that preserved freedom. But the gears of these workings are sometimes dirty, and the president, who became an icon, knew this better than anyone: The great story was also played out in rear courtyards and anterooms, with major propositions made that were not always entirely honest. In this, the film is the antithesis of *Amistad*, where the subject of slavery was approached without any benefit of hindsight, in an almost embarrassing display of naïveté. Without ever lapsing into cynicism, and in the image of Kamiński's photography, *Lincoln* operates in the realms of chiaroscuro in its heavy use of light and shadow. And also in terms of respect, characteristic of the filmmaker's work, he chooses not to film the assassination of his hero at the Ford Theater but

Freeze Frame

The bells are ringing, the guns are thundering. Lincoln leaves the darkness of his office to stand at the window, joined by his young son. Silhouettes cut into the frame, a hand resting on a shoulder: The sounds announce the vote on the amendment. Bathed in a bright sun, the country is no longer the same; it has passed from shadow into the light.

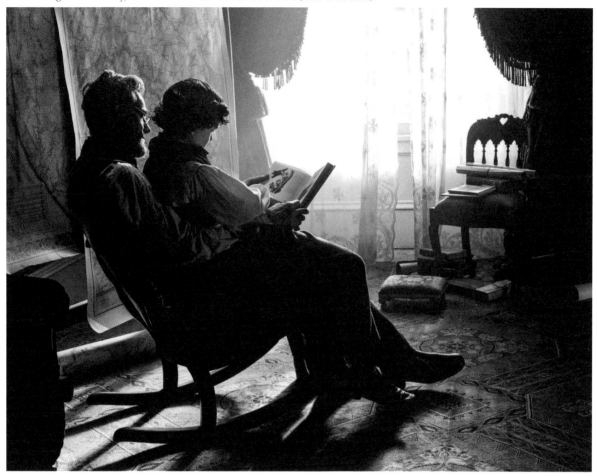

rather to take us to another theater, where Lincoln's son Robert was attending a performance of *The Arabian Nights*. It is there that, upon learning of his father's death, he begins to cry. As always, a child serves as the glue of Spielberg's work. "Spielberg may have matured," analyzed Frédéric Mercier in *Transfuge*, "but he continues to believe in superheroes, like a child—but his superhero is intended for adults: he is a super-politician. All Spielberg is there, in this refusal to decide between the adult and the child."[7]

The Unfinished Journey

On December 31, 1999, the Lincoln Memorial hosted a gala evening with a high-profile multimedia show. A never-before-seen short film by Spielberg, *The Unfinished Journey*, was projected onto one of the walls of the Lincoln Memorial, accompanied by music from a live orchestra conducted by John Williams. The documentary begins with the words of Abraham Lincoln and concludes with his famous marble statue. In about twenty minutes, the filmmaker draws the contours of a united America, rich in its differences, on a text spoken by luminaries, including President Bill Clinton. The film, which was rather ponderous, was never officially screened again.

Producers Kathleen Kennedy and Frank Marshall with Spielberg in 1981.

The Inner Circle
A Loyal Team

The concept of the family, which is at the heart of Steven Spielberg's work, is not an empty idea for the director. Having suffered from seeing his own family unravel during his youth, he never stopped building a large and lasting one as an adult, in both his personal and professional life. Composer John Williams, editor Michael Kahn, producers Kathleen Kennedy and Frank Marshall, first assistants Sergio Mimica-Gezzan and Adam Somner, production designer Rick Carter, costume designer Joanna Johnston, visual effects supervisor Dennis Muren, and sound designer Ben Burtt are among the filmmaker's faithful collaborators. If Spielberg was able to complete projects and film quickly and efficiently, it was in part because of his team's expertise and the trust he placed in them. Leonardo DiCaprio experienced this

on his first day on the set of *Catch Me If You Can*: A newcomer to the Spielberg galaxy, the actor was welcomed with a toast "to our family" before experiencing one of the fastest shoots of his career.

This "family" also serves as a protective barrier for Spielberg, one of the world's most sought-after and highly regarded filmmakers, whose every project and every move is scrutinized by the media. It is impossible, for example, to hand him a script or any other unsolicited document; it all has to go through his inner circle—a protocol born of the multiple lawsuits that have come his way since his name became synonymous with success and power in Hollywood.

This safeguard is also a way for him to concentrate on what he does best: filming. Here are a few memories[1] from some of his closest confidants:

Marshall, Kennedy, and Spielberg with young actor Ruby Barnhill on the set of 2016's *The BFG*.

Allen Daviau

American (1942–2020)

Role: Director of photography, cinematographer

Service Record: Daviau met Spielberg in 1967 through mutual friends. He was the assistant cameraman on the unfinished short film *Slipstream* and was also responsible for the cinematography of *Amblin'*, *E.T. the Extra-Terrestrial*, *The Color Purple*, *Empire of the Sun*, the scene in the Gobi Desert for the special edition of *Close Encounters of the Third Kind*, and the "Kick the Can" segment of *The Twilight Zone*. He died at the age of seventy-seven as a result of the effects of COVID-19.

Memories: "Steven plans things out, but is able to adapt or find the detail that makes the sequence magical. In *E.T.*, we were shooting the scene where E.T. and Elliott are discovered sick in the bathroom. Originally, the mother was going to take them to the hospital, but on set, Steven came up with a new idea: 'No, they can't leave the house like that' (from his friend and screenwriter Matthew Robbins, N.D.L.R.).

"Set designer Jim Bissell went to ask the people at NASA what they would do if they found an alien. They replied that they would isolate it, not knowing what this creature might emit. So what was supposed to be just a trip to the hospital became the scene where E.T. is wrapped in plastic and evacuated from the house through the aseptic tubes under the blinding lights of the task force."

Gerry Lewis

British (1928–2020)

Role: International press officer and international marketing consultant

Service Record: He worked on almost all of Spielberg's films, from *Duel* to *Ready Player One*, until his death at the age of ninety-one.

Memories: "We met at the time of *Duel*. I brought him to Paris; it was his first time outside the United States. He didn't even have a passport. He was claustrophobic and hated elevators. As we were on the sixth floor of the Plaza Athénée, his hands were black from going up and down the stairs, clutching the banister. It was also on this trip that he went to Normandy for the first time to see the D-Day landing beaches, which was very important to him. Otherwise, I will always remember the presentation of *E.T.* in Cannes: the standing ovation,

him in tears…To share that with him was incredible. We never talked about it."

Michael Lantieri

American (born 1954)

Role: Special effects supervisor

Service Record: After working on some Amblin productions (*Poltergeist*, *Back to the Future Part II*), he supervised the special effects for *Indiana Jones and the Last Crusade*, *Hook*, *Jurassic Park*, *Schindler's List*, *The Lost World*, *A.I.*, *Minority Report*, and *The Terminal*.

Memories: "When we were in preproduction on *Jurassic Park*, Steven called me from his car. He was listening to loud music and his rearview mirror was vibrating to the rhythm of the music. That gave him the idea for the scene where the characters feel the *T-rex* approaching as they watch the mirror and the glass of water shake with each step. That's how

Steven works: he interprets everything he sees in cinematic terms. He believes that if something affects him, then it will affect the audience. He's always looking for innovations to make what he's imagined possible, and he's always pushing you to do better. If you give him two different ideas, he manages to put them together to make one that you hadn't thought of."

Laurent Bouzereau

French (born 1962)

Role: Filmmaker and producer of *The Making of…* behind-the-scenes series

Service Record: He met Spielberg in 1995 for the documentary of the LaserDisc of *1941*. Since then, he has directed the "making of" documentaries on most of Spielberg's films.

Memories: "If you're dealing with him, for an interview or for anything else, he's with you 500 percent. He inoculates you with his power to succeed.

For *The Making of 'Jaws,'* it was the second time I had met him. I wondered what I should say to him to make him feel good, to make him understand that I loved his film. So I told him about the scene at the end, where the shark explodes. When it falls to the bottom of the sea, there is a very strange sound, identical to the one you hear in *Duel* when the truck falls. All of a sudden, his face lit up and he said, "Exactly. It's a dinosaur scream that I got from a 1950s movie that I love." As a result, we did the half-hour interview as scheduled, he left for an appointment, and then he came back to extend the interview."

Janusz Kamiński

Polish (born 1959)

Role: Director of photography

Service Record: Noticed by Spielberg for his work on the TV movie *Wildflower* (Diane Keaton,

1991) and hired as a test for *Class of '61* (Gregory Hoblit, 1993), a series pilot produced by Amblin, he collaborated with Spielberg for the first time on *Schindler's List.* Since then, he has been Spielberg's regular director of photography.

Memories: "I never know how I'm going to light the scene until I get to the set. I work fast and on instinct, which is what Steven likes about me. This gives him the freedom to improvise, not to be limited by storyboards. He himself encourages his whole team to come up with ideas, to take risks. And when something doesn't work, you can always turn the scene around. That's the advantage of working with someone so free from the studios. What we did visually on *Saving Private Ryan* was very bold. On *The Terminal,* I wanted to experiment with a new lens on a close-up of Catherine Zeta-Jones. It didn't work; we refilmed it a few days later."

Spielberg flanked by his two most consistent cinematographers, Janusz Kamiński (left) and Allen Daviau (right).

Bridge of Spies

 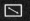

| United States/ Germany/ India | 2 hr 22 | Color (Technicolor) / Black and White (archives) | Surround (Dolby Digital / Datasat / SDDS) | 2.39:1 (Dolby Digital / Datasat) |

Production Dates: September 8–December 4, 2014
United States Release Date: October 16, 2015

Worldwide Box Office: $165.5 million ($207.4 million in 2023)

Production Companies: DreamWorks Pictures, Amblin Entertainment, Reliance Entertainment, Participant Media, Studio Babelsberg, Marc Platt Productions, Fox 2000 Pictures, TSG Entertainment
Producers: Steven Spielberg, Kristie Macosko Krieger, Marc Platt
Co-Producers: Christoph Fisser, Henning Molfenter, Charlie Woebcken
Executive Producers: Jeff Skoll, Adam Somner, Daniel Lupi, Jonathan King

Screenplay: Matt Charman, Ethan Coen, Joel Coen
Cinematography: Janusz Kamiński
Camera Operators: Mitch Dubin, Marcus Pohlus
Assistant Director: Adam Somner
Film Editing: Michael Kahn
Music: Thomas Newman
Sound: Drew Kunin, Andy Nelson, Gary Rydstrom
Production Design: Adam Stockhausen
Set Decoration: Bernhard Henrich, Rena DeAngelo
Costume Design: Kasia Walicka-Maimone
Casting: Ellen Lewis

Starring: Tom Hanks (James B. Donovan), Mark Rylance (Rudolf Abel), Scott Shepherd (Hoffman), Amy Ryan (Mary Donovan), Sebastian Koch (Wolfgang Vogel), Alan Alda (Thomas Watters Jr.), Austin Stowell (Francis Gary Powers), Billy Magnussen (Doug Forrester), Eve Hewson (Carol Donovan), Jesse Plemons (Joe Murphy), Michael Gaston (Agent Williams), Peter McRobbie (Allen Dulles), Will Rogers (Frederic Pryor), Domenick Lombardozzi (Agent Blasco)

"My dad always said, 'Don't worry about this, there's never going to be a war, nobody is that insane.' But I never believed it."[1]

—Steven Spielberg

SYNOPSIS

I n 1957, while the Cold War was straining diplomatic relations between the United States and the Soviet Union, an amateur painter, Rudolf Abel, is arrested in New York on charges of espionage. A law firm agrees to defend him and delegates the case to James B. Donovan, one of its best employees, who had previously worked as a legal assistant during the Nuremberg trials in 1945. Donovan soon finds flaws in the Abel case. But when he tells the judge and his employers, he realizes that no one is willing to give his client a chance. They all view Abel as an enemy of the United States who must be executed. Nevertheless, Donovan persuades the judge to spare Abel and keep him as a possible bargaining chip. A few months later, a US Army spy plane flying clandestinely over Russian territory is destroyed by the Red Army. The pilot, Francis Gary Powers, is recovered alive, and Donovan is recruited by the CIA to negotiate a potential prisoner swap of Abel for Powers and an American student.

Bridge of Spies marked the fourth collaboration between Spielberg and Hanks.

GENESIS

The Adventures of Tintin, War Horse, Lincoln: After a frenzy of projects at the beginning of 2010 (not counting *Robopocalypse*, which he eventually abandoned), Steven Spielberg was taking a break: "There are no rules or set patterns," he explained. "There are times when a project keeps me awake enough nights in a row that I end up making it just to get some sleep."[2]

The Remains of the U-2

The filmmaker also conceded that family life imposed some of these breaks: In order to be able to stay close to his wife and seven children, Spielberg had postponed or even canceled films. "But now, it's back on, I'm working like crazy. My youngest just started college. We find ourselves at home facing what we call an 'empty nest.' The perfect time to get back to work."[3] And this was an opportune moment, because a young English playwright, Matt Charman, had just pitched an idea for a film at the DreamWorks offices, the story of an exchange at the dawn of the 1960s, involving a Soviet spy flushed out in the United States, in return for two US citizens: an economics student arrested in East Berlin and the pilot of a U-2 spy plane captured after crashing in Russian territory.

At the center of the exchange is an insurance lawyer, a certain James B. Donovan. This true story appealed to Spielberg, who once again opened up his box of memories: During the Cold War, his father, Arnold, had been invited to the USSR as part of an exchange of engineers. Back in the United States, he told his son about the remains of the U-2 and the pilot's suit on display to the Moscow public, as well as the vindictiveness that Arnold and his colleagues had suffered at the hands of a local officer when it was discovered that they had American passports.

Fear of the Bomb

Born in 1946, Spielberg grew up under the threat of nuclear conflict between the world's two great powers. In 1957, he moved to the suburbs of Phoenix, Arizona, where his life was punctuated by the transit of bombers from the nearby military base. He was convinced that the Russians saw this base as a potential target for a nuclear attack. Young Steven made his calculations and knew that any bomb dropped on the site would destroy his house. He also knew that the electricity and water would be cut off. One night, his father was surprised to discover the bathtub and some containers filled up with water, just in case.

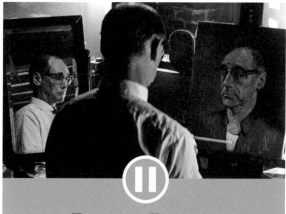

Freeze Frame

This is the opening shot of the film: An elderly man filmed from behind (Rudolf Abel) with, on his left, the reflection of his face in a mirror and, on his right, the self-portrait he is painting. The framing is not only a tribute to Norman Rockwell's *Triple Self-Portrait* (1960), an artist Spielberg loves and collects: It announces a film in trompe l'oeil. It is therefore less about telling a simple spy story than about probing people's complexity.

The scene (along with most of the filmmaker's anxieties) was added to the script by Charman. Once the script was completed, it was given to the Coen brothers, because they "write with a tone which is real, yet has a particular edge to it, which was perfect for this story,"[4] explained producer Marc Platt. Ethan and Joel Coen took on the task of energizing the dialogue-heavy sequences of the Berlin portion of the film, as well as adapting the character of Donovan to Tom Hanks's personality and style of acting.

CASTING

A decade after *The Terminal,* Tom Hanks and Steven Spielberg met again on a film set for a fourth collaboration. At no time did the filmmaker have anyone else in mind to play the role of a lawyer with the utmost integrity, capable of going all the way to ensure the triumph of morality despite threats and dangers. And furthermore, the actor was also passionate about contemporary history in general, and military history in particular.

Passing the Baton

Appearing opposite Tom Hanks was a newcomer to the Spielbergian universe. The director had been circling Mark Rylance for nearly thirty years.

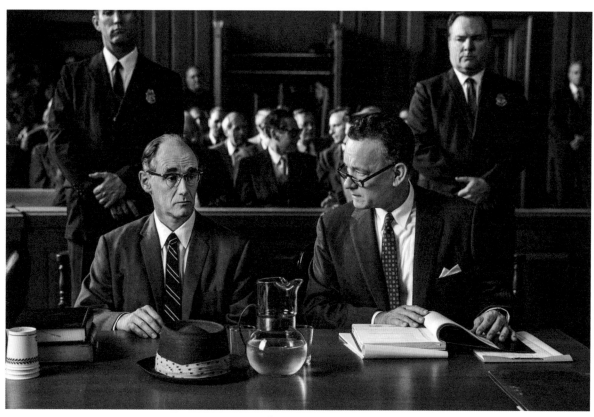

In 2016, Mark Rylance won a Best Supporting Actor Oscar for his role in *Bridge of Spies.*

Scenes set around the Berlin Wall were actually filmed in Wroclaw, Poland.

It was while attending a London performance of Shakespeare's *Twelfth Night*, in which Rylance appeared, that Spielberg was finally convinced. The British actor was the ideal man to play Rudolf Abel, a Soviet spy nevertheless born and raised in Scotland: "Mark played it with inscrutable ease," Spielberg remarked. "He invites you to look deeply into him to try to discover his secrets. And we get inexorably drawn into his character. Then we're left with a decision based on our own core or moral values: Do we want to like him, or will we prevent ourselves from liking him too much?"[5] The two actors did not know it yet, but *Bridge of Spies* feels like a passing of the baton: The penultimate film collaboration between Hanks and Spielberg up to then, this film also materialized the beginning of another. On the first day of shooting, the director offered Rylance the lead role in his next project, an adaptation of a children's literature classic,

The BFG, by Roald Dahl. *Bridge of Spies* also marks Spielberg's second collaboration with actress Amy Ryan, who played Tom Cruise's ex-wife in *War of the Worlds*. As for the son of the real American pilot Francis Gary Powers, he appears (furtively) in the role of a CIA agent.

FILMING AND PRODUCTION

On September 8, 2014, after a few months of preparation, the shooting of *Bridge of Spies* began in New York City, first in Brooklyn, then in the Astoria neighborhood of Queens and in Lower Manhattan. A month later, the team flew to Berlin, where a second team was already working. Scenes were shot in the former Tempelhof airport (converted into a park after 2010). The Friedrichstrasse subway station, with its now overly modern architecture, was re-created farther along, on a siding along a wall. *The* Wall, in fact: Donovan's adventures take place while the

German chancellor Angela Merkel visited the set during filming.

separation that was about to disfigure Berlin was being erected. The German capital has been completely transformed architecturally since the fall of the wall in 1989. It was in Poland, in Wroclaw, that the scenes set on the border between East and West Germany were shot. It is a city with "magnificent prewar architecture that has been neglected over the years," recalled cinematographer Janusz Kamiński, who grew up in these streets. "The air and quality of light were perfect, similar to East Berlin in the 1960s and at the time of the construction of the Wall. The image had to be in somewhat shabby grays and blues, devoid of color, it had to look polluted and oppressive."[6]

The Glienicke Bridge

Kamiński and Spielberg took particular care in managing the camera movements, finding a careful balance in the need to energize long dialogue sequences without losing the interaction between the actors: "There had to be a purpose—to emphasize a line, to play with a certain emotion or to make the audience understand that they should pay attention to this or that character and what he or she is saying, because what he or she is saying is important."[7] The team filmed for six nights on the Glienicke Bridge, the connecting point between East and West Germany, which links Berlin to Potsdam and was closed to civilian traffic until reunification. It was on this bridge that Abel and Powers were exchanged (the student, Pryor, having been retrieved at Checkpoint Charlie, in Berlin).

The filming was completed in early December. In the meantime, the team experienced with emotion the celebrations of the twenty-fifth anniversary of the fall of the Berlin Wall. Spielberg was also upset when John Williams told him that he was ill and could not compose the music for the film. For the first time since 1985 and *The Color Purple*, the director had to turn to another musician. He chose Thomas Newman, the composer of, among others, the soundtracks of *American Beauty* (Sam Mendes, 1999) and *Finding Nemo* (Andrew Stanton and Lee Unkrich, 2003).

A man facing his destiny: Donovan arrives in a new country.

RECEPTION

Bridge of Spies was released in the United States to critical acclaim in October 2015, almost three years to the day after *Lincoln*.

The One Who Stands Up to Be Counted

The break the filmmaker allowed himself did not distract him from his obsessions at the time: Both films illustrate Spielberg's questioning of democracy, the values it declares, and how to preserve it, even if it means getting one's hands dirty. Like Lincoln, Donovan is the man who stands up against all odds and justifies his actions by his moral values. Both adapted the "rules of the game" to fulfill their quests because they knew that the rules were rigged. In *Bridge of Spies*, a mistrial would set Abel free, but no one—from the judge to Donovan's colleagues—was willing to enforce this point of law and thereby aid an enemy of democracy. Spielberg continued these reflections two years later with *The Post*, after the *BFG* interlude.

FOR SPIELBERG ADDICTS

One night, Donovan and Agent Hoffman walk past a West Berlin cinema, whose slate of films warrants closer examination. *The Village of the Damned* (Wolf Rilla, 1960) is a science fiction film with a strong anti-communist slant. The comedy *One, Two, Three* (Billy Wilder, 1961) takes place in the German capital. Werner Klingler's *Das Gehimnis der swarzen Koffer* (The Secret of the Black Suitcase) is a West German thriller. As for Stanley Kubrick's *Spartacus* (1960), it was scripted by Dalton Trumbo, an author who was blacklisted in Hollywood during the communist witch-hunt.

From the human beans that created "E.T."
and the author of
"Charlie and the Chocolate Factory"
and "Matilda"

Disney

THE

BFG

The World
Is More Giant
Than You Can
Imagine

DISNEY, AMBLIN ENTERTAINMENT AND RELIANCE ENTERTAINMENT PRESENT IN ASSOCIATION WITH WALDEN MEDIA A KENNEDY/MARSHALL COMPANY PRODUCTION A STEVEN SPIELBERG FILM "THE BFG" MARK RYLANCE RUBY BARNHILL
PENELOPE WILTON JEMAINE CLEMENT REBECCA HALL RAFE SPALL BILL HADER CO-PRODUCER ADAM SOMNER MUSIC JOHN WILLIAMS COSTUME DESIGNER JOANNA JOHNSTON EDITED MICHAEL KAHN, A.C.E. PRODUCTION DESIGNERS RICK CARTER AND ROBERT STROMBERG
DIRECTOR OF PHOTOGRAPHY JANUSZ KAMINSKI EXECUTIVE PRODUCERS KATHLEEN KENNEDY JOHN MADDEN KRISTIE MACOSKO KRIEGER MICHAEL SIEGEL PRODUCED BY STEVEN SPIELBERG, p.g.a. FRANK MARSHALL, p.g.a. SAM MERCER, p.g.a. BASED ON THE BOOK BY ROALD DAHL

 PG IN 3D AND JULY 1st REAL D 3D
Disney.com/BFG
SCREENPLAY BY MELISSA MATHISON DIRECTED BY STEVEN SPIELBERG

The BFG

United States/
United Kingdom/
India

1 hr 57

Color
(Technicolor)

Dolby
Surround 7.1 /
Dolby Atmos

2.39:1

Production Dates: March 23–June 16, 2015
United States Release Date: July 1, 2016

Worldwide Box Office: $161.8 million ($200 million in 2023 dollars)

Production Companies: DreamWorks Pictures, Walt Disney Pictures, Amblin Entertainment, Reliance Entertainment, Walden Media, The Kennedy/Marshall Company
Producers: Steven Spielberg, Frank Marshall, Sam Mercer
Co-producer: Adam Somner
Associate Producers: Samantha Becker, Melissa Mathison
Executive Producers: Kristie Macosko Krieger, Michael Siegel, John Madden, Kathleen Kennedy

Based on the eponymous novel by Roald Dahl (1982)
Screenplay: Melissa Mathison
Director of Photography: Janusz Kamiński
Camera Operators: Mitch Dubin, Daniel Alexander Curtis (vfx camera), Oliver Loncraine
Assistant Directors: Adam Somner, Phil Booth
Film Editing: Michael Kahn
Music: John Williams
Sound: Andy Nelson, Gary Rydstrom
Production Design: Rick Carter, Robert Stromberg
Set Decoration: Melissa Spicer, Elizabeth Wilcox
Costume Design: Joanna Johnston
Visual Effects: Joe Letteri, Kevin Andrew Smith
Motion Capture Choreography: Terry Notary

Starring: Mark Rylance (the BFG), Ruby Barnhill (Sophie), Penelope Wilton (the Queen), Jemaine Clement (Fleshlumpeater), Rebecca Hall (Mary), Rafe Spall (Mr. Tibbs), Bill Hader (Bloodbottler), Adam Godley (Manhugger), Ólafur Darri Ólafsson (Maidmasher), Michael Adamthwaite (Butcher Boy), Daniel Bacon (Bonecruncher), Jonathan Holmes (Childchewer), Chris Gibbs (Gizzardgulper), Paul Moniz de Sa (Meatdripper)

SYNOPSIS

"**[Dream blowing],
it be as good
as I can do.**"

—

—The BFG to Sophie

Little orphan Sophie is languishing in a London orphanage. One night while she is awake at her window, she sees a giant man in the street. When he realizes he has been discovered, his response is to simply kidnap the curious little girl and take her to his faraway land. Once in his lair, the gentle vegetarian giant tells his hostage that he will never be able to free her again: There are other giants around who, unlike him, love the flesh of "human beans." Initially frightened, Sophie eventually realizes that the giant (Big Friendly Giant) is actually quite gentle and the two become friends. As their friendship grows, Sophie's presence draws the attention of other, less friendly giants.

GENESIS

Immersed in the Berlin mists of *Bridge of Spies* in autumn of 2014, Steven Spielberg knew he had no time to lose. In a few months, he would have to start shooting another film, the adaptation of *The BFG*, a children's novel written by British author Roald Dahl in 1982.

The Involvement of Robin Williams

As was often the case, it was Kathleen Kennedy who was at the origin of the project. As early as 1994, the producer and her husband Frank Marshall initiated the project by having Paramount buy the rights to the story. Screenwriters Robin Swicord and Nicholas Kazan, who had already worked on another Dahl adaptation (*Matilda*, by Danny DeVito, in 1996), set about translating the author's universe onto the screen…and above all its language. The story, already an unusual one (the friendship between an orphan girl and a giant vegetarian who kidnaps her to protect her from his companions, who are more interested in human flesh), is embellished with dialogues written in a language made of puns that will amuse young readers. Robin Williams was approached to play the main role after the idea of making an animated film had been rejected (an option preferred for an English TV film broadcast in 1989), but the tests were disastrous, with the actor failing to adapt

FOR SPIELBERG ADDICTS

In April 1943, Walt Disney and Roald Dahl considered several collaborations. Among them, *Gremlins*, the adaptation of a children's story in which little creatures mount a resistance against the British Army when it plans to destroy the forest where they live in order to build an airfield. The idea was finally abandoned and then fell into oblivion until 1984, when much nastier gremlins invaded the screens around the world in a Spielberg production. In this one, the gremlins attend a screening in a cinema. The film screened? *Snow White and the Seven Dwarfs*.

his improvisation-based acting to this very particular language.

"One of the Most Solitary Characters in Literature"

Gwyn Lurie, Ed Solomon, and even Monty Python member Terry Jones took turns writing the script, while the producers struggled to find a director; by the time Kathleen Kennedy convinced Melissa

The BFG was a family reunion of sorts for Melissa Mathison, Steven Spielberg, Kathleen Kennedy, and Frank Marshall, shown here around the time of *E.T. the Extra-Terrestrial,* in 1982.

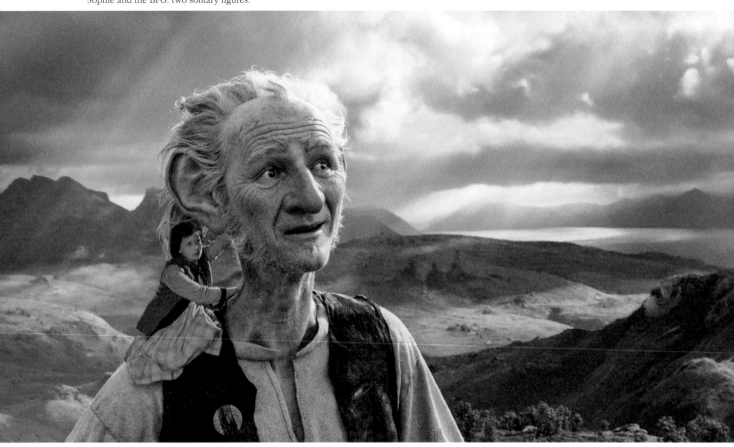
Sophie and the BFG: two solitary figures.

Mathison to take over the script, Paramount had even lost the rights. Mathison had written the screenplay for *The Black Stallion* (Carroll Ballard, 1979) and *Kundun* (Martin Scorsese, 1997), but her most notable work was writing *E.T. the Extra-Terrestrial* (1982) for Spielberg. Having retired from the business, but an ardent admirer of Dahl's work, she agreed to work without any advance or assurance that the project would be made.

Kennedy held out and won the interest of DreamWorks, which bought the rights to the story in 2011. Three years later, Spielberg entered the fray: "I have a special relationship with Roald Dahl's story," he later confessed. "I read it to all my children. He is one of the most solitary characters in literature, and this loneliness reminds me of the loneliness I experienced until I was a teenager. Although my parents loved me, I felt isolated from the outside world. We moved often and each time I lost the few friends I had. I felt that I was invisible to others and that there was nothing I could do to make it different."[1]

CASTING

The director had known it since the beginning of the shooting of *Bridge of Spies*: He had his "big friendly

giant" in Mark Rylance, especially since the English actor immediately accepted the role. For the role of the young orphan, Sophie, it was a different story. Six months of research and casting calls throughout England made it possible to find a nine-year-old schoolgirl, Ruby Barnhill, in Cheshire.

Penelope Wilton, loved by the filmmaker in the series *Downton Abbey* (2010–2015), had the honor of playing the Queen of England. At her side, as Her Majesty's lady-in-waiting, Mary, the Anglo-American Rebecca Hall was spotted as Scarlett Johansson's girlfriend in the truculent *Vicky Cristina Barcelona* by Woody Allen (2008).

FILMING AND PRODUCTION

A latecomer to the project, Spielberg nonetheless had very specific ideas about what he wanted: "I could have done it with actors dressed as giants, live and on location, in gigantic sets and using various tricks of photography and perspective. But I wanted my giants to be different, creatures from another world, characters from another medium. I didn't want the BFG to just look like Mark Rylance with big ears."[2] This other medium was refined during the summer of 2014, in the residence owned by the Spielbergs in

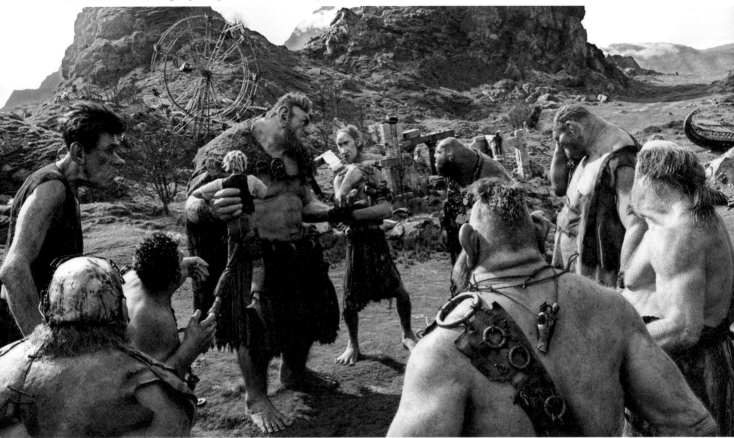

Themes from *The BFG* brought Spielberg back to moments he experienced as a teenager, when he had been harassed by his peers.

the Hamptons. This was where the filmmaker convened some of his technical team as well as Melissa Mathison to shape a draft of his future film using a virtual camera, a prototype where rudimentary 3D animations simulating the movements of the avatar-characters were integrated. Each sequence was then analyzed, enabling the filmmaker to adapt the story to the technology and vice versa.

Real Actors and Virtual Performances

Filming began in the spring of 2015 in a huge warehouse in the suburbs of Vancouver, Canada. Beyond the technology used for *The Adventures of Tintin*, it was no longer a matter of filming actors in MoCap suits on a green screen, then integrating them in postproduction into a virtual universe, but rather entailed bringing everything together in a way that was as close as possible to a "classic" shoot. Spielberg wanted to film real actors and virtual performances at the same time, and the Weta company, already called upon for *The Adventures of Tintin*, worked to meet his requirements.

In addition to the green backgrounds, real sets were built at different scales in order to facilitate the interactions between the cannibal giants, the BFG—much

smaller than his fellow creatures—and the tiny Sophie. Ruby Barnhill, who was filming for the first time, was also helped in her dialogue scenes with Mark Rylance, who climbed onto a platform to deliver his lines and provide a focal point for the debutante.

"The first day Steven showed up on set, he was completely clueless," recalled Rylance. "It was as if he had lost the manual. Whereas on *Bridge of Spies*, he blew me away with his total control."[3] It must be said that the filmmaker had to juggle between the sets, the green backgrounds, and the modeling—all centralized on a dozen monitors at his disposal. He was also assisted by the Simulcam used by James Cameron for *Avatar* (2009), which enabled the camera operators to film the actors with the virtual effects already integrated on their screen.

His Friend Melissa

On June 3, 2015, the team was celebrating Melissa Mathison's sixty-fifth birthday in the setting representing the Buckingham Palace banquet hall. She and Spielberg had met on the set of *Raiders of the Lost Ark*, when she was Harrison Ford's partner. She wrote *E.T. the Extra-Terrestrial* for Spielberg and saved his bacon by quickly cobbling together the

Characters sometimes appear in real settings, but shot on three different scales.

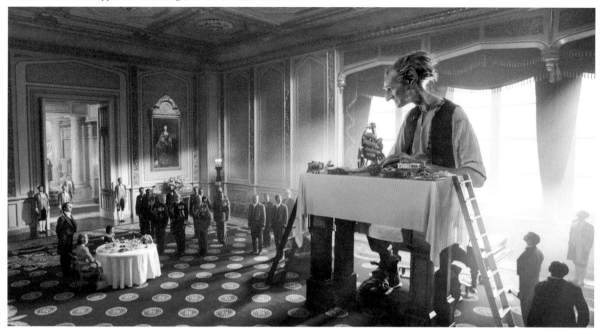

script for the "Kick the Can" segment of *The Twilight Zone* when the director, after the horrific death that happened on the John Landis set, no longer wanted to shoot the episode he had originally planned. Present every day, or almost, on *The BFG*, she was an anchor for Spielberg in this very virtual universe, never hesitating to modify his script. She barely absented herself for medical appointments, which she kept to a minimum. The following November 4, the news of her death from cancer was all the more shocking. "I have not had a chance to mourn Melissa," Spielberg said after the film was released, "because she's been so vibrant and real to me, in the cutting room, on the scoring stage—she's just always been there with me, so because of that, it's going to be hard when I have to let 'The BFG' go, because then I have to let Melissa go, too."[4]

RECEPTION

On May 14, 2016, *The BFG* premiered at the Cannes Film Festival. In the projection room, right next to Steven Spielberg, there was an empty seat: the one allocated in memory of Melissa Mathison. At the end of the screening, the filmmaker could not hold back his tears.

A Lukewarm Reception

The film was released in the United States a month and a half later. Many people compared it to *E.T.* (a doll with the effigy of the extra-terrestrial can be seen in the toys at the orphanage), a comparison that did not play favorably for the latest production:

a "conspicuously less captivating, magical and transporting experience than its classic forebear,"[5] according to the *Hollywood Reporter*. In France, the reception was similarly divided: "The film resembles the giant it portrays: a little clumsy, badly combed, but irresistible and ultra-endearing. Small, perhaps, but still strong."[6]

At the end of the summer of 2016, the bill was painful—both for the ego of the filmmaker and for his finances and those of Disney, the studio with which Spielberg collaborated on this film for the first time in his career. With a budget estimated at some $140 million (excluding ancillary costs such as promotion), *The BFG* became one of the creator's biggest (financial) failures on American territory.

Self-Portrait

As a young man, Spielberg was very much affected by the screening of *Snow White and the Seven Dwarfs* (David Hand, 1937), the first film he saw in a cinema. The porosity between the horrific and the marvelous is found in Disney productions, just as it is in Roald Dahl's works for children. By adapting *The BFG*, not only did the director return to elements of his childhood, but he also created a self-portrait. The giant who, with his long trumpet, blew the dreams he had collected to the youngest audiences is Spielberg himself. The slightly awkward, seemingly oafish character who finds himself at the table of the great and the good of this world without really knowing if he belongs there is always a stand-in for the director. Spielberg was seventy years old and still had the brain of his younger self.

The BFG introduces Sophie to a magical land.

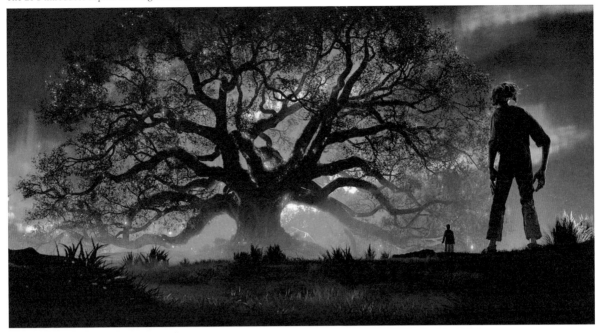

Spielberg and the young actor Ruby Barnhill.

Mark Rylance
The Close Friend

The first time was not the right time. In the mid-1980s, while preparing the adaptation of *Empire of the Sun*, Steven Spielberg met Mark Rylance. The young English actor came for an audition and left with an offer: "I was so impressed by the reading he had done, I offered him a major part," recalls Spielberg. "I was so excited until he called the next day and said he found a play he would rather do and turned me down."[1]

Theater and Nothing But

One does not trifle with the boards. Far removed from Gary Oldman and Daniel Day-Lewis, who surfed the wave of a new British cinema in the 1980s, carried by young filmmakers like Stephen Frears, Mike Newell, and Neil Jordan, Rylance had long

sworn by the theater in general, and Shakespeare in particular. Born in 1960 and a member of the Royal Shakespeare Company since 1982, he became the artistic director of Shakespeare's Globe in London in 1995, a role he held for ten years. Onstage, Rylance did not solely appear in Elizabethan dramas: He also excels in vaudeville, such as *Boeing Boeing*, in which he played in 2007 and 2008; and acerbic comedy, such as *Jerusalem*, performed from 2009 to 2012—performances that were acclaimed with two Tony Awards.

And the cinema in all this? This was somewhere the actor had rarely ventured. His first notable appearance was with Peter Greenaway in 1991 (*Prospero's Books*, after Shakespeare), though he had previously appeared with Bob Dylan in the 1987

film *Hearts of Fire* (Richard Marquand). In 2001, Patrice Chéreau offered him his first outstanding role in *Intimacy*, winning a Golden Bear at the Berlin International Film Festival. Subsequent projects were forgettable and forgotten. Only television offered him a few opportunities (the *Wolf Hall* series, Peter Kosminsky, 2015), but nothing comparable with the stage: "Theatre is so flexible and it's so different from being an actor in a film. It's a thousand times more enjoyable,"[2] he confessed again in 2022, at the age of sixty.

Since Rylance did not want to come to Spielberg, Spielberg came to him. Between 2013 and 2014, the actor played in *Farinelli and the King* at the Belasco Theatre in New York. One night, the filmmaker attended a performance with Daniel Day-Lewis, who, as a friend of both, facilitated their meeting backstage—a love at first sight, no less. A few weeks later, Rylance agreed to play Soviet spy Rudolf Abel in *Bridge of Spies*. No sooner had filming begun than Spielberg offered him the title role in *The BFG*, then the role of video game creator James Halliday in *Ready Player One*…

A Unique Intensity

Three films in four years. When it comes to actors, Spielberg had already experienced elective affinities (Richard Dreyfuss, Tom Hanks, Tom Cruise), but such intensity was unheard of. The duo found each other professionally, but also—and especially—humanly. "I think there's a real friendship," said Rylance. "We get along really well. And creatively… Let's just say that Steven is a very neat person. So he must be attracted to my lunar, non-rational side. I try to intellectualize my work as little as possible, to be in direct contact with my unconscious. It is my surrealist side. I like chaos."[3]

In Spielberg's films, Tom Hanks embodies a certain idea of America, that of the citizen with moral values challenged by the course of history. Rylance personifies a much more intimate reflection that resembles a self-portrait in which the filmmaker lays himself bare. The first shot of *Bridge of Spies*, where Rudolf Abel appears simultaneously from behind, in the reflection of the mirror and on the canvas he is painting, announces this *mise en abyme*, or metatheater. *The BFG* is a portrait of the artist as a giant who is misunderstood because he believes in magic and the power of dreams. In *Ready Player One*, James Halliday is a geek who has created a revolutionary new virtual world, but behind the genius lies a person with faults, engulfed in his loneliness: rich by the billions, revered the world over, but desperately

alone. "In talking with Mark, I discovered that we had had the same kind of childhood, that he had known this loneliness. That brought us together. On a film set, you form a family with a lot of love, passion, arguments…Then you leave each other and sometimes you never see each other again. It is rather hard to live. That's why I don't give my friendship easily anymore. I protect myself. Mark is one of my few friends in the movie business."[4]

Everyone Has Their Own "Rosebud"

In *Citizen Kane* (Orson Welles, 1941), a reporter tries to figure out why newspaper magnate Charles Foster Kane sighed "Rosebud" on his deathbed. It turns out that Rosebud was the trade name of the sled he had cherished as a child. So the key was there, buried in the depths of childhood. In June 1982, Spielberg acquired one of these famous sleds at auction, at the beginning of a decade in which the subject of the loss of innocence became an obsession in his work. While his cinema was moving toward an awareness of the world around him, the meeting with Rylance was like a trigger: His first obsession had never really left him. In Rylance, Spielberg found more than a friend; he found a companion in this quest.

Rylance played an avatar of sorts for Spielberg himself in *Ready Player One*.

Streep

Hanks

A Steven Spielberg Film

The Post

December 22

Music by John Williams Produced by Amy Pascal, p.g.a. Steven Spielberg, p.g.a. Kristie Macosko Krieger, p.g.a.
DreamWorks PICTURES Participant media #ThePost ThePostMovie.com Written by Liz Hannah and Josh Singer Directed by Steven Spielberg

The Post

United States/ India	1 hr 56	Color	Surround (Dolby Digital / SDDS / DTS)	1.85:1

Production Dates: May 31–July 26, 2017
United States Release Date: December 22, 2017

Worldwide Box Office: $180.4 million ($212 million in 2023 dollars)

Production Companies: 20th Century Fox, DreamWorks Pictures, Reliance Entertainment, TSG Entertainment, Participant Media, Amblin Entertainment, Pascal Pictures, Star Thrower Entertainment
Producers: Kristie Macosko Krieger, Amy Pascal, Steven Spielberg
Co-producers: Liz Hannah, Rachel O'Connor
Associate Producer: Ben Lusthaus
Executive Producers: Tom Karnowski, Josh Singer, Adam Somner, Tim White, Trevor White

Screenplay: Liz Hannah, Josh Singer
Director of Photography: Janusz Kamiński
Camera Operators: Mitch Dubin, John "Buzz" Moyer
Assistant Directors: Tudor Jones, Woodrow Travers
Film Editing: Michael Kahn, Sarah Broshar
Music: John Williams
Sound: Gary Rydstrom, Richard Hymns, Brian Chumney
Production Design: Rick Carter
Set Decoration: Rena DeAngelo, Kelly Solomon
Hair Stylists: Christine Fennell, Kay Georgiou
Makeup: Judy Chin
Costume Design: Ann Roth
Visual Effects Supervision: Jennifer Mizener
Casting: Ellen Lewis

Starring: Meryl Streep (Katharine "Kay" Graham), Tom Hanks (Ben Bradlee), Sarah Paulson (Tony Bradlee), Bob Odenkirk (Ben Bagdikian), Tracy Letts (Fritz Beebe), Bruce Greenwood (Robert McNamara), Matthew Rhys (Daniel Ellsberg), Alison Brie (Lally Graham), Bradley Whitford (Arthur Parsons), Carrie Coon (Meg Greenfield), Jesse Plemons (Roger Clark), Justin Swain (Neil Sheehan), David Cross (Howard Simons)

> "There is great anger in our Country caused in part by inaccurate, and even fraudulent, reporting of the news. The Fake News Media, the true Enemy of the People, must stop the open & obvious hostility & report the news accurately & fairly."[1]

—Donald Trump, 45th President of the United States, October 29, 2018

SYNOPSIS

In 1966, during the Vietnam War, Daniel Ellsberg, a military analyst on Secretary of Defense Robert McNamara's team, is on the scene to assess the situation. McNamara shares Ellsberg's observation: The United States is not making progress. However, in front of the media, he says the opposite. Shocked, Ellsberg copies and leaks a classified report detailing the involvement of the United States in Indochina since 1945. This document proved that all American presidents in power since then have known that a war in Vietnam was unwinnable and lied to Congress and the American people. What would soon be called the "Pentagon Papers" began to be published by the *New York Times* in June 1971, but President Nixon obtained a court order to stop the publication of the articles, in defiance of the First Amendment right to freedom of the press. Ben Bradlee, the editor of the *Washington Post*, a modest newspaper, seizes the opportunity for an editorial coup: He launches his reporter Ben Bagdikian on the trail of the Pentagon Papers. When the *Post* is about to go public with the story, the paper's owner, Kay Graham, surrounded by men who do not take her seriously, is faced with a dilemma: Defy the presidency in the name of freedom of information and democracy, at the risk of scaring off investors—or play it safe by staying out of the affair, at the risk of remaining a newspaper lacking ambition.

Tom Hanks is an avid collector of typewriters, and he tested all the machines that were used during filming on *The Post*.

GENESIS

After graduating from the American Film Institute's film school, Liz Hannah spent four and a half years producing films before she decided to start writing them.

Two Major Political Scandals

Liz Hannah was playing a game of chance with a subject that came to her while reading the life story of Katharine Graham in *The Georgetown Ladies' Social Club: Power, Passion and Politics in the Nation's Capital*.[2] Graham became editor and owner of the *Washington Post* at the age of forty-six after her husband's suicide in 1963. Katharine's father had bought the paper in 1933, but had entrusted its management to his son-in-law. Having arrived at the head of the newspaper without having wanted to do so, "Kay" Graham had to confront the White House in the context of two major political scandals: the Pentagon Papers (1971) and Watergate (1972), the second causing the resignation of President Richard Nixon. While searching for her place in a world of condescending men, Kay turned the *Washington Post* into a newspaper that matters. Although her autobiography[3] convinced Liz Hannah that this character deserved a feature film, it was the autobiography of *Post* editor Ben Bradlee[4] that gave her the key: "I realized the movie wasn't only about [Kay] finding her voice, and the Pentagon Papers and the

publishing of them, but it was the origin story of this superhero team that was Katharine Graham and Ben Bradlee."[5]

The script was written in the summer of 2016, and then everything came together. The production company Star Thrower Entertainment acquired the script in late October—ten days before the presidential election contest between Donald Trump and Hillary Clinton—and circulated it in Hollywood, where it quickly became a sensation.

"Alternative Facts"

Immediately after reading it, a heavyweight in the business obtained the rights: Amy Pascal, former boss of Sony Pictures, who left to set up Pascal Pictures after announcing her resignation from Sony in February 2015. The script spoke to her in more ways than one: Katharine Graham was a bit like her. Amy's husband was a reporter for the *New York Times*; her father worked in the same office as Daniel Ellsberg at the RAND Corporation, the consulting firm from which Ellsberg released the seven thousand pages of the Pentagon Papers[6] over a three-month period in 1969.

In February 2017, Amy Pascal sent *The Post* to Kristie Macosko Krieger, Steven Spielberg's collaborator at DreamWorks and Amblin. By this time, Spielberg had finished shooting *Ready Player One*, which had entered a lengthy postproduction phase.

His next project, *The Kidnapping of Edgardo Mortara*, was behind schedule. The filmmaker jumped on *The Post*. He even wanted to release it within the year: Its themes had become hotly debated in the context of the Trump presidency. A month earlier, White House spokesman Sean Spicer had claimed, in defiance of all evidence, that attendance at the inauguration had reached an all-time high. Donald Trump's communications adviser Kellyanne Conway was pushing back, telling the press that Spicer had given out "alternative facts."[7] As for Trump himself,

he had gone to war with the press, using lies, outrages, and threats. Among his obsessive targets were NBC, CNN, the *New York Times*, and the *Washington Post*. The defense of rigorous information and of a media ready to counter political power had never seemed so necessary in the United States.

Factual Accuracy

Three months before filming, the team was constituted and the actors were chosen. Josh Singer was hired to revise the script, renamed *The Papers* for a while,

For the look of the film, Director of Photography Janusz Kamiński was inspired by urban realist films like *The French Connection* (William Friedkin, 1971) and *The Parallax View* (Alan J. Pakula, 1974).

White House. Journalists from the *Washington Post* and the *New York Times* were consulted, as well as Kay Graham's son and grandson, Daniel Ellsberg, and people close to Ben Bradlee. The scriptwriters also wanted to distance themselves from *All the President's Men* (Alan J. Pakula, 1976), which described the work of the *Washington Post* on the Watergate scandal, and in which Ben Bradlee was played by Jason Robards. Kay Graham had refused to appear as a character in the earlier film, but later regretted it (she is merely cited). Putting her at the center of a new film about the *Post* was, according to Liz Hannah, a way to do her justice.

The Wrath of the *New York Times*

However, the enterprise was not to everyone's taste: As soon as the preproduction phase began, some staff members of the *New York Times* protested because the Pentagon Papers remained a scoop by their daily newspaper and only the name of the *Times* appeared in the decision of the Supreme Court on June 30, 1971,[8] to authorize their publication. In May 2017, in the *Columbia Journalism Review*, the interested parties called Spielberg's future film stupid, said they felt dispossessed, and took offense that Kay Graham and her newspaper were put on an equal footing with them.

Aware of the ambiguities, the scriptwriters insisted that the focus on the *Washington Post* was done to explain the paper's change in stature, which would lead it to tackle the Watergate scandal. "It's a prequel,"[9] as Liz Hannah humorously summarized the situation.

Meanwhile, the Trump fury continued to grow, giving the upcoming film more relevance with every passing day.

CASTING

The urgency was such that Steven Spielberg did not run any auditions. Miraculously, all the actors he approached were available.

An "Over-Rated Actress"

Meryl Streep (Graham) and Tom Hanks (Bradlee) were contacted the weekend after reading the script. The former, who had declined the role of Iris Hineman in *Minority Report* and lent her voice to the Blue Fairy in *A.I.*, had been interested in *The Post* since before the involvement of the director. At the Golden Globes ceremony in January 2017, she distinguished herself with a speech against Donald

with Liz Hannah. His résumé spoke for itself: He had worked on Aaron Sorkin's series *The West Wing* (1999–2006); wrote *The Fifth Estate* (Bill Condon, 2013) about another whistleblower, WikiLeaks founder Julian Assange; and won the Oscar for best screenplay for *Spotlight* (Tom McCarthy, 2015), about the journalistic investigation that revealed sexual abuse by Catholic priests in Boston.

As for Spielberg, he brought weight to the factual accuracy of the story, going so far as to use Richard Nixon's voice from conversations recorded in the

The first scene between Ben Bradlee and Kay Graham, two contrasting characters who are forced to collaborate.

Ben Bagdikian seeks information in a shot straight out of the paranoid cinema of the 1970s.

Linotype printing plates are shown in a quasi-documentary sequence.

Trump (without mentioning his name), that resulted in a raging tweet from the president: "Meryl Streep one of the most over-rated actresses in Hollywood."[10] Tom Hanks, on the other hand, had made four films with Spielberg. He was so relaxed that a week before shooting began, he invited all the actors who make up the *Post*'s editorial staff to his home to rehearse and arrive on the set perfectly prepared.

Camaraderie and Complicity

The casting favored above all a sense of camaraderie on set. Playwright and actor Tracy Letts (Fritz Beebe, Kay Graham's right-hand man) starred for the first time alongside his wife, Carrie Coon (editorial writer Meg Greenfield). Bob Odenkirk had established himself as the memorably crooked lawyer in the series *Breaking Bad* (2008–2013), and he appeared here alongside Jesse Plemons, previously seen in *Bridge of Spies*. A stand-up comedian and writer as well as television actor, Odenkirk formed a comedic duo with David Cross, the former appearing as reporter Ben Bagdikian and the latter as publishing executive Howard Simons.

Bruce Greenwood (Robert McNamara) and Matthew Rhys (Daniel Ellsberg) had appeared in Spielberg-produced series *The River* (2012) and *The Americans* (2013–2018), respectively. As a Welshman, Rhys knew nothing about Daniel Ellsberg, but when the two men met ahead of filming, the former whistleblower began to declaim Dylan Thomas: The actor had played the poet in *The Edge of Love* (John Maybury) in 2008. Like many in the cast of *The Post*, Sarah Paulson (Tony Bradlee, the journalist's wife) had a solid background in television. She had just played prosecutor Marcia Clark in *Inside Look: The People v. O.J. Simpson—American Crime Story* (2016), where Bruce Greenwood appeared as prosecutor Gil Garcetti.

FILMING AND PRODUCTION

The forty-four day filming of *The Post* was probably the most constrained schedule for Steven Spielberg since *Duel*, but this time, it was by choice.

An Exercise in Nostalgia

There are few exteriors in the film, which kept filming hazards to a minimum, and several sets were built in close proximity to each other. The *Washington Post* editorial office, Kay Graham's office, the RAND Corporation, and the Democratic National Committee offices were re-created in three abandoned floors of an AT&T building slated for conversion in White Plains, New York. The pay phones from which Bagdikian calls RAND are located at the foot of the building. The opening set in Vietnam was filmed not far away, on a field at the State University of New York at Purchase and in a nearby forest. The Bradlee residence was shot in New York City, in Brooklyn. A few blocks away, Steiner Studios subbed for the interiors of their home and the Grahams'. A

Freeze Frame

On the phone, Kay Graham has to make the decision of her life: to defy the White House by publishing the Pentagon Papers, or stop everything in extremis. For Spielberg, a suspenseful telephone call could only evoke Alfred Hitchcock (he had in mind *Dial M for Murder*). Alone and distraught, in a light dress, stalked by a camera that turns around her in a dive shot, Kay Graham experiences the vertigo of the English master's heroines, women for whom nothing had prepared them for a change in destiny.

A Scoop in Music

Although lacking the memorable melodies for which John Williams was renowned, the music of *The Post* demonstrates the debt the composer owes to Bernard Herrmann. All in cyclical movements and muffled pulsations, it refers as much to the tension of the story as to the rhythm of typewriters and rotary presses. "The Papers" and "Deciding to Publish" even use electric guitar and electronic sequences—a rarity in John Williams' work. "Setting the Type" nevertheless delivers an obsessive seven-note cello theme, a cousin of the *Jaws* motif.

block away, Spielberg had an unexpected opportunity to indulge in a nice exercise in nostalgia: filming the linotype printing process at the Woodside Press printing company, a technique made obsolete by computers. "Steven went crazy looking at the process, to see this molten lead go into the type and the pieces taken out by hand, and everything is set backwards,"[11] recalled art director Rick Carter. The presses from which the *Washington Post* issues came were those of the *New York Post* in the Bronx. In the digital age, with the pace of news made frantic by social networks and the flurry of tweets from the forty-fifth president of the United States, the director wanted to restore the value of journalistic information by literally showing how it is made.

The Distorted Reflection of Bob Odenkirk

The filmmaker was apprehensive about scenes with telephone conversations, which are difficult to make exciting on the big screen. He tried to find novel ways to reinvent the exercise—for example, filming Bob Odenkirk's distorted reflection in a metal dial, or multiplying the number of people involved in Kay Graham's final decision.

Meanwhile, some actors were also looking for their marks and dealing with stage fright—Meryl Streep felt sorry not to have a chance to rehearse, and Matthew Rhys and Bob Odenkirk were intimidated by Tom Hanks. "What made me feel better, was Tom trying stuff and then discarding it. And I'm like, 'Okay, if he can go down the wrong path once in a while, maybe I'll be alright,'"[12] Odenkirk said.

One of the reasons Spielberg was in such a hurry was to provide John Williams with an edit that he could use in time. As the composer was unable work on both of the director's films in progress, he left *Ready Player One* to Alan Silvestri to devote himself to *The Post*. He delivered the score three weeks after the shooting without Spielberg having been able to hear his piano demos, according to their time-honored procedure.

RECEPTION

Developed and produced after the shooting of *Ready Player One*, *The Post* was released in cinemas three months earlier. Critics—American, British, and French—did not hide their pleasure at what the website The Conversation described as "a love letter to the press and the journalistic profession."[13]

A Virtuosic Crew

Variety[14] reveled in the film's vision of hectic journalism, without computers or smartphones, and *Libération*[15] in France delighted in the scenes of linotype, rotary presses, and early-morning delivery of stacks of newspapers by truck. The same unanimity welcomed the film's lively pace and energy, which the *New York Times* said was due to the "virtuosic, veteran crew"[16] assembled by seventy-year-old Steven Spielberg. Others noted Spielberg's good instinct to avoid gravity and inject situational comedy. The *Guardian* pointed to the "chaotic, absurd moment"[17] when Kay Graham haltingly approves the publication of the *Washington Post* with its contentious articles.

The Truth: An Explosive Material

The Post fully embraced the legacy of *All The President's Men*: Its final shot, a view of the Watergate

In *The Post*, Steven Spielberg created a veritable homage to the traditional press and the newspaper medium in general.

façade from which the glow of flashlights filters through, copied the first shot of Pakula's film. But it suffers from the comparison: As Ben Bradlee, Tom Hanks was considered far too "smooth" compared to Jason Robards, and Spielberg too didactic. Some passages—such as when Tony Bradlee explains to her husband how much more Kay Graham has to lose than he does, or when the newspaper owner explains her feelings to her daughter—are veritable exercises in textual analysis.

The topicality of *The Post*'s subject matter obviously escaped no one, but for some, this relevance was not enough to make a film and only fed into a false suspense.

Steven Spielberg also faced factual criticism. He saw his film as a portrait of a woman emancipating herself from a phallocratic tutelage and was reproached for poorly narrating the Pentagon Papers scoop and for paying little attention to Daniel Ellsberg. On the Daily Beast[18] website, former *New York Times* vice president James Goodale, who was the paper's legal representative before the Supreme Court in 1971, once again put the *Washington Post* in its place. He explained that the paper's lawyer never mentioned the First Amendment before the Supreme Court and that the *Post*'s initial public offering was primarily to pay property taxes for shareholders (including Kay Graham)—not to hire journalists, as stated in the film. In 2017, more than ever, there was no fooling around with the facts.

Ready Player One

2018

| United States/ India | 2 hrs 20 | Color (Technicolor) | Surround (Dolby Digital/Dolby Atmos/DTS) | 2.39 :1 |

Production Dates: June–September 2016
United States Release Date: March 29, 2018

Worldwide Box Office: $583 million ($688 million in 2023 dollars)

Production Companies: Warner Bros., Amblin Entertainment, Village Roadshow Pictures, Dune Entertainment, De Line Pictures, Farah Films & Management (uncredited), Reliance Entertainment (uncredited)
Producers: Donald De Line, Dan Farah, Kristie Macosko Krieger, Steven Spielberg
Co-producers: Ernest Cline, Jennifer Meislohn
Associate Producer: Rick Carter
Executive Producers: Bruce Berman, Christopher DeFaria, Daniel Lupi, Adam Somner
Unit Production Manager: Steve Harding

Based on the eponymous novel by Ernest Cline (2011)
Adaptation: Ernest Cline, Eric Eason
Screenplay: Zak Penn, Ernest Cline

Director of Photography: Janusz Kamiński
Film Editing: Michael Kahn, Sarah Broshar
Music: Alan Silvestri
Sound: Chris Munro, Richard Hymns
Production Design: Adam Stockhausen
Art Direction: Mark Scruton, Claire Fleming (motion capture)
Set Decoration: Anna Pinnock
Visual Effects: Roger Guyett, Grady Cofer, Matthew E. Butler
Motion Capture: Heidi Hathaway, Gabriela Rios, Clint Spillers
Costume Design: Kasia Walicka-Maimone
Second Unit Director: Gary Powell (uncredited)
Assistant Directors: Adam Somner, Emma Horton, Fraser Fennell-Ball (crowd scenes), Rafael Sanz (uncredited)
Casting: Lucy Bevan, Ellen Lewis

Starring: Tye Sheridan (Wade Watts/Parzival), Olivia Cooke (Samantha Cook/ Art3mis), Mark Rylance (James Halliday/Anorak), Simon Pegg (Ogden Morrow/ curator), Ben Mendelsohn (Nolan Sorrento), T. J. Miller (i-R0k), Lena Waithe (Aech), Philip Zhao (Xo/Sho), Win Morisaki (Toshiro/Daito), Hannah John-Kamen (F'Nale Zandor), Susan Lynch (Aunt Alice), Ralph Ineson (Rick)

> "You can't stop Steven from improvising. That's what makes him a great director. But he doesn't want the seams to show, so he has moments of panic at the end of the day, where he says, 'Oh my God, I shot this, how are we going to link it into the next scene?'"
>
> —
>
> —Screenwriter Zak Penn, about his work with Steven Spielberg on *Ready Player One*

SYNOPSIS

—

In 2045, the majority of the population live in insalubrious slums called The Stacks. To escape their grim daily life, people immerse themselves as digital avatars in a virtual universe called the OASIS that is filled with references to 1980s pop culture. The OASIS is accessed via a virtual reality headset and various controllers that allow interaction with the environment and other avatars. Its creator, James Halliday, an asocial and mysterious genius, died leaving three riddles to be solved in this artificial world. The winner will inherit his fortune and control of the OASIS. Everyone has entered the race, but it is a young orphan, Wade Watts, who leads the way as his avatar Parzival, forming a small group of tightly knit players known as the High Five. In the virtual world, but also in the real world, they are pursued by the henchmen of the high tech firm IOI. Its CEO, Nolan Sorrento, is ready to do anything, including killing, to take over the OASIS and turn it into a profit-making machine.

Steven Spielberg insisted on showing the actual behavior of users of virtual reality props (here Wade Watts).

GENESIS

Ernest Cline wrote the novel *Ready Player One* after he had already sold the rights for its adaptation to Warner Bros. He started working on the screenplay in 2010, a year before the book was published. Producer Dan Farah, who brought the project to Warner Bros., even helped the author find a publisher.

An Invention That Took Over the World

Born in 1972 in Ohio, Ernest Cline quickly became an obsessive fan of *Star Wars* (George Lucas, 1977) and video games. In 2001, he worked at CompuServe, providing technical support to users of an invention that was taking over the world: the internet. Extrapolating from the power of this medium, Ernest Cline imagined a virtual environment with unlimited possibilities for escaping from a world without hope. Although he set his story in Oklahoma City, he was inspired by the winter grayness of Columbus, the capital of his native state (where the film takes place). He himself lived in a trailer park, those mobile home villages of which the destitute neighborhood of The Stacks, in the book, is the vertical version.

Ready Player One contains an avalanche of references to movies, TV series, role-playing games, music, and other cultural touchstones of the 1980s. Whole pages of the book are dedicated to video games, and the title itself refers to a formula displayed at the beginning of the game on arcade terminals. *Ready Player One* also struck a chord by showcasing young antiheroes who are fans of a widely deprecated subculture; over 1.7 million copies were sold. In passing, Ernest Cline describes accessories that, a few years later, were well and truly on the market: gaming headsets called head-mounted displays, or HMDs (including the Oculus Rift, HTC Vive, and PlayStation VR), haptic suits, and VR treadmills became operational between 2012 and 2015.

FOR SPIELBERG ADDICTS

Steven Spielberg did not want to quote his own films or Amblin productions, with the notable exceptions of the *T. rex* from *Jurassic Park* (1993), whose digital model created at the time was reused, and the DeLorean from *Back to the Future* (Robert Zemeckis, 1985). But in the final assault on Anorak Castle, ILM's mischievous computer graphics artists managed to slip in several gremlins (including one in a Santa hat), spotted too late by the director to have them removed.

In the book *Ready Player One*, the Stacks are inspired by the winter grayness of Columbus, Ohio. In the movie, they were created using a mixture of real sets and CGI.

A Superheroes Screenwriter

Known since the 2000s for his superhero movie scripts (*X2: X-Men United*, 2003; *Elektra*, 2005; *The Incredible Hulk*, 2008), Zak Penn started out co-writing the story of *Last Action Hero* (John McTiernan, 1993), where, already, it was a question of immersion in a fictional universe, in this case an action movie. Dissatisfied with the evolution of the original script, Zak Penn was dropped from the project—not without having advised, in vain, the Columbia studio not to release *Last Action Hero* a week after a film against which it would be impossible to compete, namely a certain *Jurassic Park*. The screenwriter met Ernest Cline while working on the documentary *Atari: Game Over* (2014), which Penn directed. From a shared chemistry rooted in common cultural references, Zak Penn found himself adapting *Ready Player One*.

Paradoxically, one of the problems of the book lay in what made it popular: the vast accumulation of branded cultural references. It was impossible to include everything in the script, so Zak Penn focused on what Warner Bros. had the rights to. Later on, Spielberg's involvement would help to obtain rights to others, but some would definitely be inaccessible, such as those for the Japanese superhero Ultraman. The screenwriter also replaced the video game parts, which were completely uncinematic, with action scenes, and Wade Watts's sidekicks were fleshed out, especially Samantha/Art3mis.

The whole quest of *Ready Player One* is based on clues in James Halliday's diary. Here again, Zak Penn, by agreement with Ernest Cline, opted for a more visual approach: The diary in the film consists of scenes from James Halliday's life, conceived as excerpts from films viewed by Parzival in the form of archives in the OASIS.

Toggling Between Worlds

As the book includes a reference to *Blade Runner* (Ridley Scott, 1982), Zak Penn and Ernest Cline imagined a scene involving a re-creation of the film in the OASIS. But Warner Bros., which owned the rights, vetoed the idea: It would interfere with *Blade Runner 2049* (Denis Villeneuve), scheduled for release in 2017. The two screenwriters ended up retaining Stanley Kubrick's two feature films from the 1980s: *The Shining* (1980) and *Full Metal Jacket* (1987). "Once Steven [Spielberg] saw *The Shining*, it was all over," Ernest Cline later told *Empire* magazine. "He got so excited and so did Janusz Kamiński, because they're the biggest Kubrick *Shining* fanboys I've ever met."[1]

The director entered the project via Warner Bros. in 2015. At his request, Zak Penn developed new tracks; in particular, he multiplied the switches between the virtual and real. "He really wanted to establish this physical link between what people are doing in the real world and what's happening in the OASIS,"[2] said the screenwriter. Spielberg's direction also kept Nolan Sorrento as a greedy CEO, but he

Samantha Cooke and Wade Watts: Two kids who grew up too fast in a world that was too hard.

is less cold and mechanical than in the book. Both menacing and pathetic, ruthless and ridiculous, he refrains from neutralizing Wade Watts/Parzival at the last moment, fascinated to see him succeed in the game. As for James Halliday, he acquires the dimension of a melancholic genius who has missed out on happiness, like *Citizen Kane* (Orson Welles, 1941). In short, instead of being satisfied with just an exercise in nostalgia, Spielberg irrigates *Ready Player One* with more emotion and bitterness.

CASTING

The early career of British actress Olivia Cooke had been marked by a few horror films and the *Bates Motel* series (2013–2017) when she was cast as Samatha/Art3mis, in a selection process that was once again shrouded in secrecy.

A Three-Month Wait for Ben Mendelsohn

To play the part of Wade Watts, Tye Sheridan, discovered in *Mud* (Jeff Nichols) in 2012, initially failed to convince the casting directors. It was on seeing him in a trailer that Steven Spielberg called him back to test with Olivia Cooke before choosing him.

The Australian Ben Mendelsohn, accustomed to the roles of ambiguous, even disturbing characters (*Animal Kingdom*, David Michôd, 2010; *The Dark Knight Rises*, Christopher Nolan, 2012), became Nolan Sorrento three months after his audition. James Halliday is played by Mark Rylance, who had

become a faithful friend of the director since *Bridge of Spies*.

A Long Break Gets Cut Short

As for Simon Pegg, he had filmed for Spielberg in *The Adventures of Tintin* (2011) and was about to take a long break after having been in a series of big productions. He changed his mind when he got the role of Ogden Morrow, the lost friend of James Halliday, guardian of the latter's memory and archives.

FILMING AND PRODUCTION

The filming of *Ready Player One* was unusual: It was divided between real shots and the eighty minutes in the virtual universe of the OASIS.

On Location in Birmingham and London

The first takes were during the summer of 2016 in the UK. Birmingham represents the American city of Columbus—augmented with a few London locations, including the street where Wade meets his friends in a US postal truck, and Holland Park School, which becomes IOI HQ. The former Sun Microsystems headquarters in Farnborough is home to the offices of the creators of OASIS, and Spielberg used Warner Studios in Leavesden, north of London. The Stacks were partially built there on the backlot before being completed by computer graphics.

The rest is a gigantic work of digital creation, 3D animation, and motion capture, so much so that

Three digital avatars from the film (top to bottom): i-R0k, Anorak, and Art3mis.

during postproduction, Steven Spielberg had time to direct and release *The Post* (2017) before *Ready Player One* reached the cinemas.

It was in Leavesden that the digital effects company Digital Domain set up a performance capture studio. As in *The Adventures of Tintin* (2011) and *The BFG* (2016), the actors shot the scenes involving their avatars, without sets and with pretextual props intended to be replaced by computer-generated images. When, in the film, the horrific doll Chucky was used as a projectile, in Leavesden, the actors were throwing a ball. The performances (movements, gestures, facial expressions) were used to animate the digital avatars; the actor T.J. Miller (i-R0k) never appears in his human form in the film. The final major battle is another technological feat: In order to animate half a million characters, digital extras in a sense, ILM developed a crowd management engine. Called

ARCADE, this was nothing less than an artificial intelligence system that generates coherent behaviors and interactions adapted to the situation.

ILM's Technical Prowess

The virtual characters thus created were then sent to Industrial Light & Magic (ILM) to be integrated into the OASIS. Because the entire virtual universe of *Ready Player One*—some sixty different environments— came out of the computers of George Lucas's special effects company (assisted by Territory Studio), including references galore: Batman, Superman, Freddy Krueger, the high school furniture from *The Breakfast Club* (John Hughes, 1985), the motorcycle from *Akira* (Katsuhiro Ôtomo, 1988), the van from *The A-Team* (1983–1987), the racing car from *Mad Max* (George Miller, 1979), *King Kong*…even the key scene, which Spielberg and his team kept secret until the very end,

Transformed into specialized workers in a virtual quest, IOI employees appear to be playing in a dystopian version of Charlie Chaplin's *Modern Times* (1936).

is in CGI: the breathtaking immersion of the characters in the sets of *The Shining*.

Steven Spielberg Immersed in the OASIS

While director of photography Janusz Kamiński later admitted that he was not always comfortable with his role sometimes being limited to overseeing lighting that had been determined upstream, Steven Spielberg extended his virtual camera experiments. This portable controller equipped with a screen made it possible to visualize the scenes in synthetic images and to apply camera movements to them according to the way the director manipulated it. But Spielberg was also learning about virtual reality: Wearing an HTC Vive headset, he immersed himself in the OASIS. And this simulated world became a "real" virtual film set, with the director taking a 360-degree walk around the environment to do

location scouting, test shots, and lights—just as he would have done on a real site.

RECEPTION

Palmer Luckey, the founder of Oculus VR, used to offer each new employee a copy of Ernest Cline's novel; this meant that virtual reality professionals were counting on the film to accelerate the growth of their market.

A Film Event at the South by Southwest (SXSW) Festival

HTC Vive was not shy about posting a video on the internet showing Steven Spielberg at work wearing a head-mounted display. The director himself was patting the high-tech community on the back by booking the film's premiere at Austin's SXSW festival, dedicated to interactive technology and media,

Freeze Frame

Nolan Sorrento finally gets his hands on Wade Watts as he is about to complete the quest. With a virtual reality helmet over his eyes, the teenager cannot see that the odious CEO of IOI is pointing a gun at him. But the purity of this vision of a child caught up in the game, the beauty of completing this treasure hunt, freezes Sorrento's gesture. It is his own lost innocence that he sees before him, and the man lowers his weapon with a naïve smile. All of Steven Spielberg in a single face.

on March 11, 2018. Two interruptions to the screening due to sound problems did not dampen the audience's enthusiasm: "When the sound came back on after five minutes," said the website Deadline, "the room exploded with a joy as deafening as if Van Halen were returning to the stage for an encore"[3] (the film opens with the California band's song "Jump").

Without breaking any records (it would be overtaken by Anthony and Joe Russo's *Avengers: Infinity War*, the following month), *Ready Player One* expunged the affront of three consecutive box-office failures for Steven Spielberg. And—surprisingly—it was quite an event in China, generating record receipts at the time for a Hollywood film, at $218.4 million (against $137.7 million in the United States).

A Renewed Sense of Fun

In the commentaries, virtual reality was relegated to the background; it was the nods and references that got everyone excited. There are countless online publications that have compiled lists of them. The prestigious *New York Times*[5] as well as the technophile magazine *Wired*[5] (a fake front page of which appears in the film) indulged in this exercise. As for the rest, the computer-generated images impressed everyone, as did Steven Spielberg's renewed sense of entertainment ("an atomic inventiveness," according to *Le Monde*[6] in France). But for some, these qualities masked the emptiness of the project and an outdated

...are followed by furious battles involving half a million digital characters appearing along the horizon.

dynamic between a hero and his stooges—the last straw, according to the *New York Times*,[7] for a film rooted in the culture of multiplayer video games.

It was specifically the video game media that were the hardest on the film, as a press review in *Le Monde*[8] pointed out. First, because the video game culture of the novel is largely supplanted by cinephile quotes, giving the impression that Spielberg has locked himself in his own OASIS. Second, because the film's message, far from being a positive one, seems to echo the clichés about disconnection from reality and loss of social ties—many scenes show characters waving their virtual reality helmets in the void, completely isolated from the world around them and somewhat ridiculous.

An Aged, Moralizing Father Figure

When, at the end, Wade Watts decides to close the OASIS on Tuesdays and Thursdays to force people back into real life, he explains that it is because "reality is the only thing that's real." In one line, Steven Spielberg seems to be speaking like an aged moralizing father figure, a world away from the fantasy world he had worked so hard to re-create for over two hours. But perhaps the subject of the film is its ambiguous relationship with nostalgia? Perhaps, suggested *New York Magazine* critic Matt Zoller Seitz in a series of tweets,[9] Steven Spielberg had not been given enough credit for making sad movies without the audience noticing.

A re-created sequence from *The Shining*.

Virtual Overlook Hotel

Under the supervision of ILM's Roger Guyett, the images of the Overlook Hotel in *The Shining* were scanned into the computer from a video transfer intended for television. From there, it became possible to invent angles and sequences that were not present in the original film. ILM went so far as to imitate the grain of the film, the light, and the texture of the fake snow; however, the Grady twins and the old woman in the bathroom are doubles for the original actors. In fact, the places where they appear are real sets—but the deluge of hemoglobin coming out of the elevator is still a digital miracle.

James Stewart in *Harvey* (1950). At one point, Spielberg wanted Tom Hanks to play the role of Harvey in a remake of the classic film.

Ghost Films
Unrealized Projects

Steven Spielberg is undeniably a tireless individual, to the point of abandoning many projects along the way because of lack of time, contractual problems, or simply because his interest was waning. There are the films eventually made by others (which he often simply produced, such as *Cape Fear*, Martin Scorsese, 1991; or *Memoirs of a Geisha*, Rob Marshall, 2005). And then there are those that have disappeared from the Hollywood radar. Here is a selection of them.

Snow White

1969–1970 Immediately after his very first filming for Universal Television, the episode "Eyes" from the series *Night Gallery* (1969), Steven Spielberg announced that he wanted to bring to the screen Donald Barthelme's first novel, *Snow White* (1967). Universal commissioned two screenwriters to adapt this perverse version of *Snow White and the Seven*

Dwarfs for a young audience. The project did not go any further than this.

Flushed with Pride: The Story of Thomas Crapper

EARLY 1970s Thomas Crapper, an English sanitary equipment entrepreneur, was the subject of a 1969 biography crediting him with the invention of the toilet flush. In the early 1970s, Steven Spielberg asked screenwriters Gloria Katz and Willard Huyck for an initial script, but Spielberg's agent warned that he would stop representing him if the filmmaker persisted with the idea.

Growing Up

1978 Spielberg had Robert Zemeckis and Bob Gale write a script inspired by his childhood and his parents' divorce. In February 1978, a twenty-eight-day

shooting plan in Phoenix, Arizona, was quoted in the press. Although *Growing Up* was finally supplanted by *E.T. the Extra-Terrestrial* (1982), its shadow hovers over *The Fabelmans* (2022) with a similar subject.

Reel to Reel

1980 Steven Spielberg recalls his own directorial debut via a fictional filmmaker, Stuart Moss, struggling with his first feature film, a musical remake of *Invaders from Mars* (William Cameron Menzies, 1953). The screenwriter Gary David Goldberg was up for it, before Spielberg fell back on *Indiana Jones and the Temple of Doom* (1984).

E.T. 2: Nocturnal Fears

1982 A few months after the release of *E.T. the Extra-Terrestrial*, Steven Spielberg and his screenwriter Melissa Mathison wrote the outline of a possible sequel. Albino aliens from a people hostile to those of E.T. arrive on Earth. They terrorize Elliott and his friends, but E.T. ends up saving them. Spielberg and Mathison finally decided that E.T. did not need a sequel. The filmmaker did, however, write a story for an illustrated book, *E.T.: The Book of the Green Planet* (1985), with William Kotzwinkle providing the text and David Wiesner providing the drawings.

The Mark

1998 In January 1998, Steven Spielberg was ready to shoot a script by comic book creator Rob Liefeld, *The Mark*, with actor Will Smith. But, as revealed by Liefeld in July 2015, the project was cancelled due to financial disagreements.

Lindbergh

1998 Spielberg purchased the rights to a biography of Charles Lindbergh that had only just been published, written by A. Scott Berg, without even having read it. While perusing the pages of the bestseller (winner of the Pulitzer Prize the following year), he discovered the anti-Semitism, isolationism, and pro-Nazi sympathies of the famous aviator. The project required an understanding of the ideological motivations of its subject, and the filmmaker was not sure he wanted to do it. Paul Attanasio and Menno Meyjes worked on an adaptation for a while before Spielberg put the film on hold.

Spares

2002 In 1996, DreamWorks acquired the rights to *Spares*, a science fiction novel by Michael Marshall Smith, when it was published. Spielberg planned to adapt it, with Tom Cruise in the role of a security guard at a clone breeding farm. The film never saw the light of day, but DreamWorks produced *The Island* (Michael Bay, 2005) with similar themes.

Ghost Soldiers

2002 At the end of January, just after the shooting of *Minority Report*, Tom Cruise, his producing partner Paula Wagner, and Steven Spielberg planned to adapt historian Hampton Sides's book *Ghost Soldiers: The Epic Account of World War II's Greatest Rescue Mission* (2001). It tells the story of the American raid in late January 1945 on a Japanese-held POW camp in the Philippines. But another film on these events was in preparation at the same time. Three years later, it was released under the title *The Great Raid* (John Dahl), stopping the Cruise/Spielberg project.

The Rivals

2003 Steven Spielberg was interested in a script by Robin Swicord (*Memoirs of a Geisha*, a DreamWorks production) about the authentic rivalry between two actresses, the French Sarah Bernhardt and the Italian Eleanora Duse. The producers of *American Beauty* (Sam Mendes, 1999) were involved, and actress Nicole Kidman was to play Sarah Bernhardt. *The Rivals* suffered from the consequences of the end of the agreement between DreamWorks and Paramount Pictures.

Harvey

2009 This play by Mary Chase (1944) was adapted in 1950 (by Henry Koster) as a film with James Stewart. It is the story of an alcoholic whose invisible friend is a six-foot white rabbit named Harvey. Spielberg hoped to film a remake of it in 2010. Tom Hanks, fearing comparisons with James Stewart, declined the role. Robert Downey Jr. was approached, but the actor and the director could not agree on the script. The project was officially abandoned in early December 2009.

Gershwin

2010 After the abandonment of *Harvey*, Spielberg turned to a biopic of the American composer and pianist George Gershwin. DreamWorks acquired the rights to this project (with no known title) in the fall of 2009, and the actor Zachary Quinto (the series *Heroes*, 2006 to 2010; *Star Trek* by J. J. Abrams, 2009) was chosen for the role. The press talked about filming in April 2010…then, nothing more.

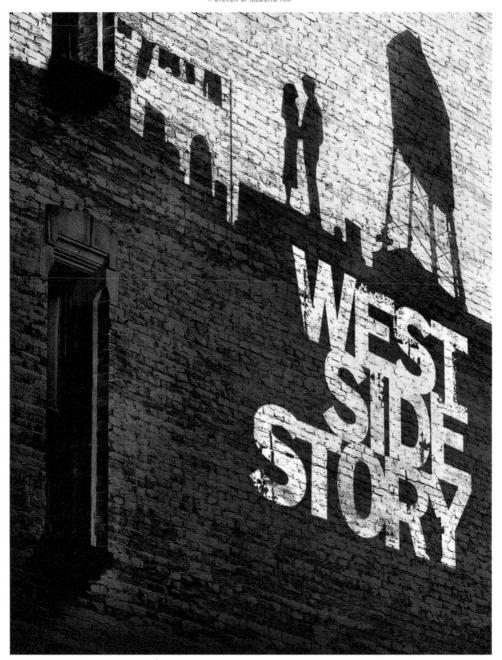

A STEVEN SPIELBERG FILM

WEST
SIDE
STORY

EXECUTIVE PRODUCERS RITA MORENO DANIEL LUPI ADAM SOMNER TONY KUSHNER PRODUCED BY STEVEN SPIELBERG, p.g.a. KRISTIE MACOSKO KRIEGER, p.g.a. KEVIN McCOLLUM

ORIGINAL CHOREOGRAPHY BY JEROME ROBBINS CHOREOGRAPHED BY JUSTIN PECK BASED ON THE STAGE PLAY BOOK BY ARTHUR LAURENTS MUSIC BY LEONARD BERNSTEIN LYRICS BY STEPHEN SONDHEIM

PLAY CONCEIVED, DIRECTED AND CHOREOGRAPHED BY JEROME ROBBINS LYRICS BY STEPHEN SONDHEIM MUSIC BY LEONARD BERNSTEIN SCREENPLAY BY TONY KUSHNER DIRECTED BY STEVEN SPIELBERG

 IN THEATERS
DEC 10

PG-13 PARENTS STRONGLY CAUTIONED SOME STRONG VIOLENCE, STRONG LANGUAGE, THEMATIC CONTENT, SUGGESTIVE MATERIAL AND BRIEF SMOKING.

West Side Story

United States	2 hrs 36	Color (Technicolor)	Surround (Dolby Digital / Atmos / Surround 7.1 / Imax 6-Track)	2.39:1

Production Dates: July 1–September 27, 2019
United States Release Date: December 10, 2021

Worldwide Box Office: $76 million ($89.8 million in 2023 dollars)

Production Companies: 20th Century Studios, Amblin Entertainment, TSG Entertainment
Producers: Kristie Macosko Krieger, Kevin McCollum, Steven Spielberg
Co-Producer: Carla Raij
Associate Producer: David Saint
Executive Producers: Tony Kushner, Daniel Lupi, Rita Moreno, Adam Somner

Based on the eponymous Broadway show created in 1957 by Leonard Bernstein, Stephen Sondheim, Arthur Laurents, and Jerome Robbins
Screenplay: Tony Kushner, based on the book by Arthur Laurents
Director of Photography: Janusz Kamiński
Film Editing: Michael Kahn, Sarah Broshar
Music: Leonard Bernstein
Arrangements: David Newman
Conductor: Gustavo Dudamel, with the New York Philharmonic
Lyrics: Stephen Sondheim
Vocal Producer: Jeanine Tesori
Music Producer: Matthew Rush Sullivan
Choreography: Justin Peck, based on the original choreography by Jerome Robbins
Production Design: Adam Stockhausen
Costume Design: Paul Tazewell
First Assistant Director: Adam Somner
Casting: Cindy Tolan

Starring: Ansel Elgort (Tony), Rachel Zegler (María), Ariana DeBose (Anita), David Alvarez (Bernardo), Mike Faist (Riff), Rita Moreno (Valentina), Brian d'Arcy James (Officer Krupke), Corey Stoll (Lieutenant Schrank), Josh Andrés Rivera (Chino), Iris Menas (Anybodys)

SYNOPSIS

New York City, 1957. In an Upper West Side neighborhood that is set to be demolished, the Jets gang, led by Riff, and the Sharks gang, led by Bernardo, fight over what is left of their territory. The Jets are third-generation European immigrants, and they resent the arrival of the Sharks, who are of Puerto Rican descent and looking for a place in America. Tony, an ex-member of the Jets on parole after a stint in prison, is behaving himself. He falls in love with María, Bernardo's sister, at a dance. Will their love survive the rivalries between the two clans?

GENESIS

Nothing was going well in Hollywood at the dawn of the 2020s. Cinemas were being overrun by superhero films and tentpoles—blockbusters that can be consumed by everyone around the world, calibrated to bring in a maximum profit in a minimum amount of time. A leader in this field, the Disney company was developing its monopoly at a rapid pace. Focused on the family and teenage audience, the majors were turning away from more adult projects, relegated for the most part to streaming platforms, which, led by Netflix, were picking up the great filmmakers (Martin Scorsese, David Fincher) and were experiencing a growing boom that, together with a global pandemic, threatened cinema attendance. In this context of market restructuring, Steven Spielberg was working on his most nostalgic, even anachronistic project: adapting *West Side Story*.

A Childhood Obsession

Spielberg was ten years old when, in 1957, his parents bought the vinyl of *West Side Story*, for a long time the only popular music record tolerated by his mother Leah, a classical pianist. Young Steven wore out the 33 rpm record, taken from the show staged on September 26 of the same year at the Winter Garden Theatre on Broadway, whose scenes he imagined as he played the soundtrack. Inspired by Shakespeare's *Romeo and Juliet*, the musical comedy, written by

Arthur Laurents and composed by Leonard Bernstein with lyrics by Stephen Sondheim and choreography by Jerome Robbins, revolutionized the genre with the modernity of its score and its representation of a certain New York reality: that of a youth on the margins, of an immigrant community struggling with endemic racism and the gang wars that ensued—subjects more often addressed in the news columns than on the stages of 42nd Street. Although the record was a triumph from the start with its gallery of hits ("Maria," "America," "Tonight") and the show was a growing success, it was thanks to the film (winner of ten Oscars in 1961) made of it by Robert Wise and Jerome Robbins that *West Side Story* became a cornerstone of twentieth-century American culture.

The Musical: A Long-Standing Fantasy

In 2014, theater producer Kevin McCollum, the holder of the rights to adapt *West Side Story*, was approached by 20th Century Fox at Spielberg's initiative. The filmmaker had long wanted to direct a musical, a genre he had touched on several times in various features, like *1941*, *Indiana Jones and the Temple of Doom*, *The Color Purple*, *Hook*, *Ready Player One*—and around which he had developed a few projects that never came to fruition. As a classic piece of Hollywood iconography, the musical

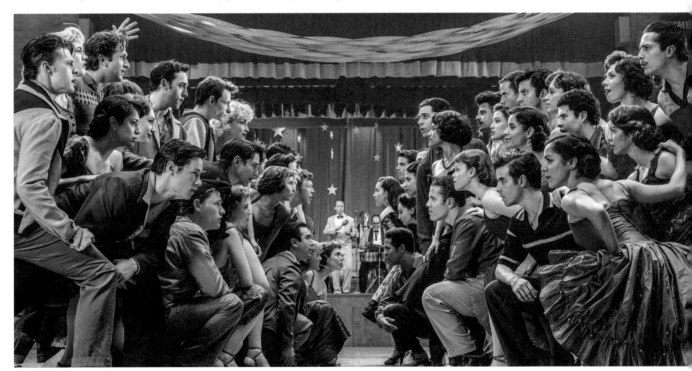

The Jets (on the left) and the Sharks (on the right) meet during a dance sequence set inside a gym.

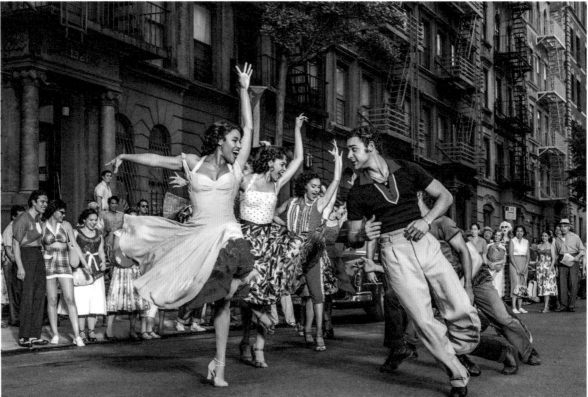

The famous "America" sequence from the original 1961 film (top) was transformed into a daytime ballet for the 2020 remake.

film genre has attracted many filmmakers whose audiences do not always follow suit. For every successful *Moulin Rouge!* (Baz Luhrmann, 2001) or *La La Land* (Damien Chazelle, 2016), there are also less successful productions like *Nine* (Rob Marshall, 2009) and *Cats* (Tom Hooper, 2019). At nearly seventy years old, Spielberg decided to fulfill this long-held fantasy and set his sights on the classic that had enchanted him in his youth. He met with Stephen Sondheim, then the only one of the four creators of *West Side Story* who was still alive; while he was allowed to change the dialogue, he was not to touch the story. As for the music and choreography, they would be reworked in the spirit of, and respectful to the work of, Leonard Bernstein and Jerome Robbins.

Then, As Now

Anxious to update the original while remaining faithful to it, Spielberg called on his screenwriter for *Munich* and *Lincoln*, so often assigned to stories of the past that echo the present time: his friend Tony Kushner. Kushner started not from the script of the first film, but from the libretto by Laurents—a nuance on which the marketing campaign would rely to reject the idea of a remake in favor of a new adaptation of the original work. When Kushner set out to write, during 2017, Donald Trump had just entered the White House in an unsettling climate of populism and racial tension. "The world of *West Side Story* is one of division, as in *Romeo and Juliet*," noted Spielberg. "The characters are wary of the unknown, in this case another culture. In the broader debate we have today, we see that there is a lack of dialogue between communities, as in the 1950s. In my version, the Sharks have jobs, they have families, they work hard, their parents left Puerto Rico in hopes of achieving the great American dream. The Jets, on the other hand, have been here for two or three generations, and they have nothing. I wanted to show the possibility of breaking down the barriers that separate these two communities."[2] In doing so, he reminds us that the xenophobes of today are sometimes the immigrants of yesterday. Kushner's work is therefore more realistic, in line with the political movements toward empowerment of women and minorities—Me Too, Black Lives Matter—that have swept America. He makes the Jets descendants of European immigrants (Polish, Italian, Irish), casts Tony as a convict on parole, gives the leading roles to women, and frees himself from the taboos of the first film (the word "rapists" is spoken; the tomboy Anybodys

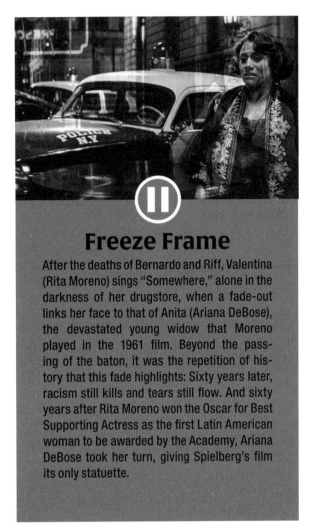

Freeze Frame

After the deaths of Bernardo and Riff, Valentina (Rita Moreno) sings "Somewhere," alone in the darkness of her drugstore, when a fade-out links her face to that of Anita (Ariana DeBose), the devastated young widow that Moreno played in the 1961 film. Beyond the passing of the baton, it was the repetition of history that this fade highlights: Sixty years later, racism still kills and tears still flow. And sixty years after Rita Moreno won the Oscar for Best Supporting Actress as the first Latin American woman to be awarded by the Academy, Ariana DeBose took her turn, giving Spielberg's film its only statuette.

is clearly identified as transgender). But his strongest gesture consists of reflecting the Puerto Rican community's real-world speech patterns by mixing English and Spanish, without subtitles, in their dialogues. We even hear the Sharks singing "La Borinqueña," a revolutionary song that was absent from the original score.

CASTING

In the first *West Side Story*, María and Bernardo were played by Natalie Wood and George Chakiris, of Russian and Greek origin, respectively, both slightly disguised, like the other actors playing the Sharks. The use of the blackface would be unthinkable today, hence Spielberg's choice of an ethnically appropriate cast: Out of fifty Latino actors, twenty are real Nuyoricans (New Yorkers of Puerto Rican origin). Moreover, the director wanted new faces, young talents who could sing and dance—unlike Natalie Wood, who was dubbed.

Finding a New María

For the role of María, thirty thousand contenders came forward. Rachel Zegler won the part at the ripe old age of eighteen; she had practiced ballet and singing since she was a child, but had never made a film. When she went out for the role of María, she had just played the character onstage for a few performances in a theater in New Jersey, where she lived. Zegler impressed Spielberg with her crystal-clear singing, but the director chose her a year later, after having seen many other candidates.

Tenacious Tony

The son of an opera director and a fashion photographer, New Yorker Ansel Elgort had already earned himself a reputation thanks to early roles in *The Fault in Our Stars* (Josh Boone, 2014) and *Baby Driver* (Edgar Wright, 2017). Determined to land the role of Tony, he sent casting director Cindy Tolan a demo tape on which he covered "María." Although he received no answer, he sent in more tapes, working with opera coach Gulnara Mitzanova in the process, and eventually landing himself an audition. He wasn't feeling well on the day of his audition, suffering from a sinus infection that he chose not to divulge. He sang in a different key that did not suit him. Spielberg learned about his illness and asked him to come back and try again. The filmmaker was eventually won over by his commitment and his performance, and Elgort got the job.

Revelations and a Resurrection

Ariana DeBose and Mike Faist, both of whom were Broadway regulars, are two of the film's most stunning revelations. DeBose plays Anita, and Faist appears as Riff. In addition to their new cast of young actors, Spielberg and Kushner also made changes to the original work to bring it into the twenty-first century. Anybodys, the tomboy relegated to the outskirts of the Jets gang, was played by nonbinary actor Iris Menas; and the character of Valentina, the drugstore owner and Tony's confidante, was played by eighty-nine-year-old Rita Moreno, who appeared as Anita in the 1961 film (and won an Academy Award in the process).

FILMING AND PRODUCTION

On March 20, 2019, 20th Century Fox was acquired by Disney after rehearsals for *West Side Story* had already begun. For five months, the actors had been working hard with choreographer Justin Peck, of the New York City Ballet, under the watchful eye of Spielberg—who filmed them with a camcorder or on his cell phone so he could work on his staging. Three weeks were devoted to recording the songs for the film, which were supervised by lyricist Stephen Sondheim, vocal producer Jeanine Tesori, and Venezuelan conductor Gustavo Dudamel. The latter, recommended to Spielberg by John Williams, became the musical director of the Paris Opera in April 2021.

New York Reinvented

This is a New York story, and so was the filming. It began on July 1, 2019, with the musical number "Cool" moved from a parking lot in the original to the landing of the Bush Terminal Piers Park in Brooklyn, redesigned by production designer Adam Stockhausen. Spielberg wanted a film that was more "street" than theatrical.[3] "Even the Robert Wise movie, which I adore, is still a hybrid between theater and cinema," he noted. "I kind of wanted *West Side Story* for us to be as street-real as humanly possible and Adam Stockhausen, the production designer, really made that possible by finding some extraordinary locations."[4] But the scenes are filmed with the expressionist colors and shadows of a dream that turns into a nightmare. Lincoln Square, the location of the action, had been razed, so the team fell back on Harlem, Washington Heights, Queens, and, less than twenty miles from Manhattan, the small town of Paterson, New Jersey,

FOR SPIELBERG ADDICTS

The tipping of Hollywood into the era of tentpoles and Netflix was something that Spielberg and his compatriot George Lucas prophesied in 2013 during a panel presented at the University of Southern California, in which the two filmmakers criticized the lack of audacity and imagination of the studios. Spielberg predicted an implosion of the system in the event of successive failures of big movies, and Lucas concluded that the interesting projects would be, in the long run, confined to the more adventurous "internet television"—that is to say, streaming platforms. Seven years later, after lamenting the impact of online platforms on cinema offerings and attendance and advocating for making their films ineligible for the Oscars, Spielberg was launching a new *Amazing Stories* series on Apple TV+ and, in June 2021, signing an exclusive deal with Netflix for select Amblin productions.

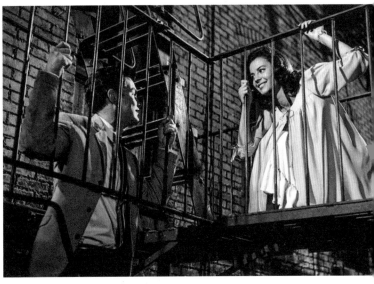

where Stockhausen found a real neighborhood in the process of demolition. While the gymnasium of St. Thomas Aquinas College hosted the dance and one of the "medieval" cloisters of the Metropolitan Museum of Art, the first meeting between María and Tony, the bleachers where the two lovers meet, and the façades and backyard that served as the setting for the song "María" were created from scratch at Steiner Studios. From a nocturnal face-off between Puerto Rican men and women on a rooftop, "America," at once a hymn to integration and a lament of the exploited, was transformed into a flamboyant daytime ballet in streets won over by the dancers' fervor. Shot in the middle of summer, in a stifling heat that melted the heels of the actresses, the sequence required more than ten days of shooting with thirty actors and four hundred extras. As for "I Feel Pretty"—a number for the ingenue in love that Sondheim had always hated, and that would have been dropped if Kushner had not insisted on moving it to follow Bernardo's murder by Tony in order to reinforce its tragic impact—it was transposed to Gimbels, a famous department store (re-created in a studio), where María worked on the maintenance staff.

A Nostalgic Rejuvenation

In the rubble of a Lincoln Square in the process of gentrification, through an indiscernible construction door, a member of the Jets reunites first with his gang, then with the animated streets of 1957 New York. The opening of *West Side Story* synthesizes Spielberg's approach: to give life to the ghosts of his youth and those of the city, and to give himself a rejuvenation—the direction is dazzlingly vital—by building a bridge between generations. A mixture of nostalgic joy and contemporary darkness, of romantic naivety and mortifying observation, *West Side Story* is the last Spielberg film edited by the faithful Michael Kahn, who passed the baton to his assistant Sarah Broshar. The film is dedicated to the director's father, Arnold, who died on August 25, 2020, at the age of one hundred and three. And on November 26, 2021, it was Stephen Sondheim who died, having found the film "great"—he who did not like the 1961 version.

RECEPTION

Originally intended to be released in December of 2020, the release of *West Side Story* was postponed for a year due to the COVID-19 pandemic and the closure of cinemas. A flat market, a hesitant recovery in attendance, viewers captured by online streaming platforms following the various confinements: The virus had reshuffled the cards of the audiovisual industry and consumer habits.

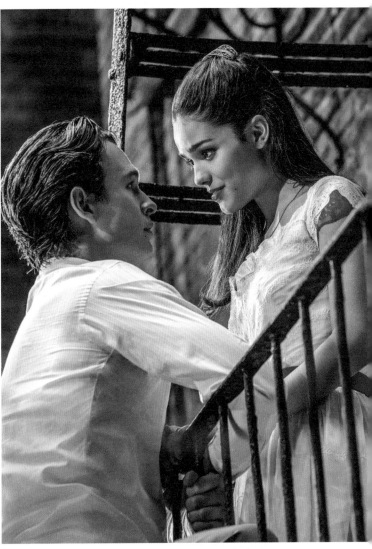

…to Ansel Elgort and Rachel Zegler: Each generation must have its Romeo/Tony and Juliet/María.

Riff (Mike Faist), Tony (Ansel Elgort), and Bernardo (David Alvarez) come face-to-face before the drama of a gang fight featuring shadows as sharp as their knives.

The End of a Reign?

Scheduled for the year-end holidays, Spielberg's first musical was one of the drivers that should have brought large audiences back to the cinema. For Disney, however, it started with two handicaps linked to the very uncertain destiny of the genre at the box office and the lack of awareness of *West Side Story* among young audiences. With its strong hold on the market—it owned many successful franchises, from Marvel to Star Wars—the company put pressure on exhibitors to keep the film in cinemas for at least a month. Unfortunately, despite a very positive reception from the American press and a slightly more mixed reception from the French press, there was no way around it: *West Side Story* stands out as one of Spielberg's most bitter commercial failures, especially

in the United States, as its receipts did not even cover its budget of more than $100 million. This failure has been much discussed and compared with the unprecedented success of *Spider-Man: No Way Home* (Jon Watts, 2021), released one week later. *West Side Story* failed to create enthusiasm, especially among young people, for whom Spielberg's name no longer meant much. He wanted to pass on his favorite musical and the taste for great cinema to future generations; he understood that the public had changed and that he no longer had its close confidence as he had done for forty years. To cap it all, nominated seven times for the Oscars, *West Side Story* was edged out by *CODA* (Sian Heder, 2021), a remake of *The Bélier Family* (*La famille Bélier*, Éric Lartigau, 2014) distributed on Apple TV+.

West Side Story
Romantic Sequence

A key moment in *West Side Story* is also a scene that's one of the closest to the original film, where, nevertheless, the Spielberg touch—agility, speed, dazzle—makes all the difference. During the dance, Tony and María see each other for the first time and are irresistibly attracted to each other. It is love at first sight for both of them. Time stops, the future lovers are alone in the world (1, 2, and 3), far from the clan wars; the frenzied mambo fades away, giving way to a romantic cha-cha. In the 1961 version, in a scene composed of fixed shots with a distractingly blurred musical cover, they join in the center of the dance floor, forgetting the surroundings, and their silhouettes harmonize with their pas de deux. In Spielberg's work, they deliberately isolate themselves, as if magnetized, walking backward from the collective movement and the general hysteria (4, 5, 6, 7, and 8), followed by lateral dolly shots, to hide in the wings behind a tier of bleachers (9 and 10). Less naïve, they know their love is condemned to the margins, and already accept it. In another nuance of scale, it is María who rushes toward Tony (11 and 12). In her virginal Disney heroine dress, soon tarnished by tears and hatred, she embraces her amorous impulses. Another era, another image of the woman, now proactive. Bathed in flares and halos of light, the sequence seems chimerical, caught between two realities—one idealized, the other tragic—in the purgatory of impossible loves.

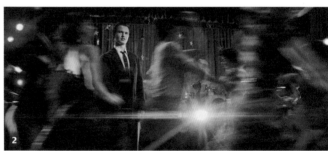

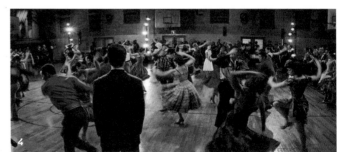

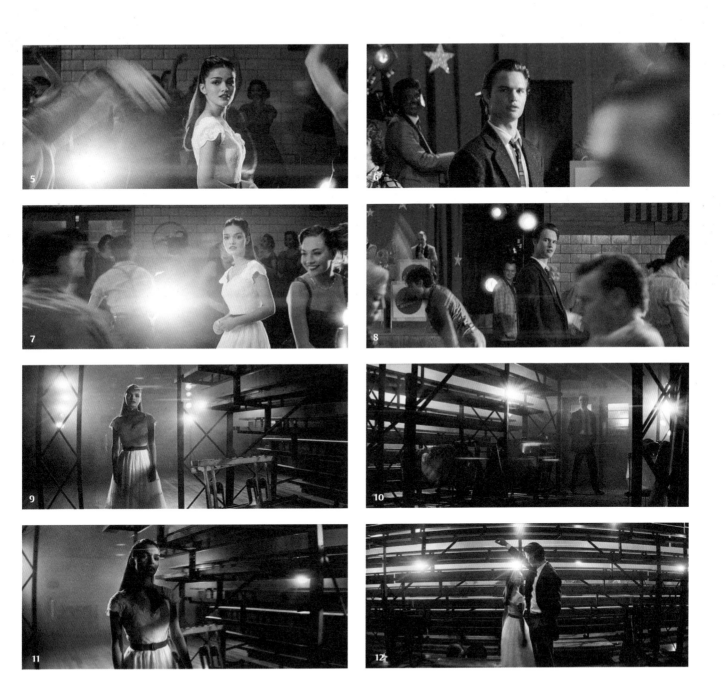

J. J. Abrams and
Steven Spielberg.

The Father of the Geek Generation
The Spielberg Legacy

Steven Spielberg's impact on popular culture is such that it is impossible for his influence on his peers to be anything less than considerable. His presence is diffuse and sometimes almost imperceptible, but no one can match the unique position and power he has acquired.

A Constellation of Descendants

Perhaps only James Cameron (*Titanic*, 1997; *Avatar*, 2009) and Peter Jackson (The Lord of the Rings trilogy, 2001–2003; *King Kong*, 2005) have approached Spielberg's mogul status while remaining rooted in a cinema of the imaginary (adventures, science fiction) and a classical tradition of storytelling. Both have openly acknowledged their debt to Spielberg, as have Kevin Williamson and brothers Matt and Ross Duffer—creators, respectively, of the series *Dawson's*

Creek (1998–2003) and *Stranger Things* (since 2016). The first features a teenager whose bedroom is a temple to the glory of *E.T.*'s creator; it is inspired by Williamson's, who, at the same age, shot short horror films in Super 8 to imitate his idol before renovating the genre in his turn by writing the screenplay for *Scream* (Wes Craven, 1996). The second is a nostalgic medley of Amblin productions that picks up on all the markers (the band of kids left to their own devices in a small town, the chosen child, the supernatural threat, the military plot, etc.). The intrusion of the fantastic in an everyday context seen at the level of a child characterizes the universe of Spielberg's emulators (*Attack the Block* by Joe Cornish, 2011; *Simon's Got a Gift* by Léo Karmann, 2019). As for the brilliance of his direction, its movement and fluidity, his play with the emotions of the viewer, and

A scene from Jeff Nichols's 2011 film *Take Shelter*.

his sense of iconic image, these have been a school of thought for filmmakers as different as Guillermo del Toro (*The Shape of Water*, 2017), Bong Joon Ho (*Parasite*, 2019), or those of the Pixar animation stable (John Lasseter, Pete Docter, Brad Bird).

Shyamalan and Nichols: The Acolytes

Two names stand out among the crusaders of the Spielbergian gesture. M. Night Shyamalan, an outstanding director of children (Spielberg spotted Haley Joel Osment for *A.I.* thanks to his role in *The Sixth Sense*), a virtuoso of Hitchcockian direction and suggestive off-screen, has taken up the baton of a cinema that plays with the viewer's belief and challenges the faith of its characters. In Shyamalan's work, as in Spielberg's, the figure of the chosen one, guided by a duty from which he cannot escape, questions our moral sense. Shyamalan and Spielberg are among the filmmakers whose work was so profoundly affected by the attacks of September 11, 2001, that they are now close to each other. Thus, the premise of *Signs* (2002) is reminiscent of *Night Skies*, the once-expected sequel to *Close Encounters of the Third Kind*, about a farm family persecuted by aliens. In *The Happening* (2008), humanity is decimated by a plague that overwhelms it, echoing *War of the Worlds*, where many of the motifs from *Signs* can be found. "The Next Spielberg"[1] was the title of *Newsweek* magazine's 2002 cover story on Shyamalan. It's a nickname that, success aside, Jeff Nichols could also claim. Raised in an Arkansas town similar to those where Spielberg grew up, mesmerized by *Jaws* and entranced by Amblin productions as a child, Nichols borrows several of the master's themes: the family trinity, the coming-of-age story, the question of belief. Better still, he reinvents the narrative frameworks of his films set in rural America, using a more earthy and intimate approach. With its father character haunted by visions of storms, *Take Shelter* (2011) is a kind of remake of *Close Encounters of the Third Kind* where tornadoes replace aliens. Focusing on a friendship between two young boys and an outsider wanted by the authorities, *Mud* (2012) follows the pattern of *E.T.*. These two patterns are reunited in *Midnight Special* (2016), which follows the escapades of a kid with supernatural powers saved from the clutches of a cult.

Bayona the Disciple and Abrams the Heir

The theme of childhood grappling with the violence of the world is at the heart of Juan Antonio Bayona's filmography. Hired by Spielberg (after he saw *The Impossible*—2012) to direct *Jurassic World: Fallen Kingdom* (2018), the Spanish director of *The Orphanage* was never more Spielbergian than in *A Monster Calls* (2016), a fantasy tale about a twelve-year-old boy, faced with the agony of his cancerous mother and bullied by his classmates, who finds refuge in a giant tree with a human face (voiced by Liam Neeson).

Even closer to Spielberg, J. J. Abrams appears as his official heir, even in his physical resemblance. At the age of sixteen, Abrams and his buddy Matt Reeves (*The Batman*, 2022) were contacted by Kathleen Kennedy on the initiative of Spielberg, who had just read an article about their participation in a Super 8 short film festival in Los Angeles. The two geeks were charged with restoring the master's early works. Years later, Abrams was the first person to whom Spielberg turned to write the screenplay for *War of the Worlds*—an offer Abrams declined, caught up in his *Lost* series (2004–2010). A skilled storyteller and all-terrain creator—cinema, TV, video games—adept at recycling, MacGuffins, and lens flares, Abrams has made the most beautiful tribute to the Amblin style to date with *Super 8* (2011), produced by Spielberg.

Shadows and Backlighting
A World of Silhouettes

It all begins in a child's bedroom in a New Jersey house. At night, little Steven Spielberg observes on the walls the shadows of a tree projected by a street lamp: enough to excite the imagination...and even to scare him. Largely inspired by the filmmaker's youth, *Poltergeist* bears witness to this, years later. But not only that: from *Amblin'*, his 1968 short film, Steven Spielberg sprinkles his films with Chinese shadows and silhouettes against the light. In this way, he brings cinema back to its simplest expression: that of an art of projection on a luminous background. The effect generally has the gift of suspending time for a few moments, leaving the spectator in suspense, but with the freedom to play with their own fantasies. In a child's bedroom, as on a cinema screen, one can imagine everything in front of a shadow.

Empire of the Sun, 1987.

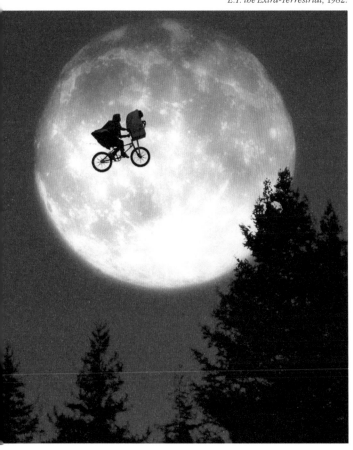

War Horse, 2011.
Right-hand page, *Amistad*, 1997.

CAPTURE EVERY MOMENT

A STEVEN SPIELBERG FILM

THE FABELMANS

AMBLIN ENTERTAINMENT AND RELIANCE ENTERTAINMENT PRESENT A STEVEN SPIELBERG FILM "THE FABELMANS" MICHELLE WILLIAMS · PAUL DANO · SETH ROGEN
GABRIEL LaBELLE AND JUDD HIRSCH MUSIC BY JOHN WILLIAMS COSTUME DESIGNER MARK BRIDGES EDITED BY MICHAEL KAHN ace SARAH BROSHAR PRODUCTION DESIGNER RICK CARTER
DIRECTOR OF PHOTOGRAPHY JANUSZ KAMINSKI EXECUTIVE PRODUCERS CARLA RAIJ JOSH McLAGLEN PRODUCED BY KRISTIE MACOSKO KRIEGER p.g.a. · STEVEN SPIELBERG p.g.a. · TONY KUSHNER p.g.a.
WRITTEN BY STEVEN SPIELBERG & TONY KUSHNER DIRECTED BY STEVEN SPIELBERG A UNIVERSAL RELEASE

PG-13

SOUNDTRACK ON SONY CLASSICAL

© 2022 UNIVERSAL STUDIOS AND
STORYTELLER DISTRIBUTION CO., LLC

The Fabelmans

United States 2 hrs 31 Color Surround
(Dolby Digital-
Surround 7.1) 1.85:1

Production dates: July 17–September 27, 2021
United States Release Date: November 11, 2022 (limited release),
November 23, 2022 (national release)

Worldwide Box Office: $41 million (as of March 13, 2023)

Production Companies: Amblin Entertainment, Amblin Partners,
Reliance Entertainment, Universal Pictures
Producers: Tony Kushner, Kristie Macosko Krieger, Steven Spielberg
Associate Producers: Brittani Lindman, Emma Molz
Executive Producers: Josh McLaglen, Carla Raij

Screenplay: Steven Spielberg, Tony Kushner
Cinematography: Janusz Kamiński
First Assistant Director: Josh McLaglen
Film Editing: Sarah Broshar, Michael Kahn
Music: John Williams
Art Direction: Andrew Max Cahn
Production Design: Rick Carter
Hair Styling: Gloria Pasqua Casny
Makeup: Eryn Krueger Mekash
Costume Design: Mark Bridges
Casting: Cindy Tolan

Starring: Michelle Williams (Mitzi Fabelman), Paul Dano (Burt Fabelman),
Seth Rogen (Bennie Loewy), Gabriel LaBelle (Sammy Fabelman as an
adolescent), Mateo Zoryan (Sammy Fabelman as a child), Judd Hirsch
(Uncle Boris), Keeley Karsten (Natalie Fabelman), Alina Brace (younger
Natalie Fabelman), Julia Butters (Reggie Fabelman), Birdie Borria (younger
Reggie Fabelman), Sam Rechner (Logan Hall), Oakes Fegley (Chad Thomas),
David Lynch (John Ford), Sophia Kopera (Lisa Fabelman), Jeannie Berlin
(Hadassah Fabelman), Chloe East (Monica Sherwood), Isabelle Kusman
(Claudia Denning)

SYNOPSIS

This film follows the life of Sammy Fabelman from the age of five to nineteen: First, the shock of seeing his first movie in the cinema, *The Greatest Show on Earth*, directed by Cecil B. DeMille, and his obsession with re-creating its scene of a train accident with his electric train, which he filmed one day using his father's Super 8 camera. This was the birth of a passion to which he gave expression by tirelessly taking his family and friends along on his amateur film shoots. Then, the numerous relocations from one region of the United States to another, dictated by the promotions of his father, Burt, a computer pioneer. Also, the routine anti-Semitism that Sammy experiences upon his arrival in California when he becomes the scapegoat of two high school friends. And in the midst of all this, the unspoken and repressed love between his mother, Mitzi, an eccentric artist who has shelved her ambitions as a concert pianist in order to bring up her children, and Bennie, Burt's colleague and best friend…a love that is gradually corroding the equilibrium of this loving home.

"Family, art. It will tear you in two."

—Uncle Boris to Sammy Fabelman

GENESIS

With this film, Spielberg finally tells his own story in the first person. Retracing his childhood and family history is a project that the filmmaker had been nurturing for more than forty years but that he had never dared to tackle head-on, preferring to approach the subject through his imagination or through the lives of others. Three elements in combination finally convinced him to take the step: Tony Kushner, the COVID-19 pandemic, and the deaths of his parents.

A Longstanding Wish

In 1978, while working on *1941* with his young protégés—and future authors of *Back to the Future*—Robert Zemeckis and Bob Gale, Spielberg had already commissioned a script about his own youth. Entitled "Growing Up," the project was officially announced before being supplanted by *E.T. the Extra-Terrestrial*, with its many autobiographical aspects. It was followed by the long-awaited "I'll Be Home," based on a script written by his sister Anne Spielberg. Exploring his family history was something that titillated Spielberg, but his modesty always got the better of him. The scrutiny of his parents, too. Although he finally set to work on it, just as one might unveil one's secret garden, it was because of the time that had passed and his meeting with Tony Kushner, his friend and faithful screenwriter since *Munich*, who was able

to tackle both difficult personal content (*West Side Story*) and politically ambitious subjects (*Lincoln*).

Maternal Approval

On June 29, 2005, the first day of the shooting of *Munich*, between two adjustments for a hotel explosion, Kushner asked Spielberg if he remembered the very first time he wanted to become a filmmaker. Spielberg recalled a camping trip with his family that he had filmed with his father's Super 8 camera. Kushner, surprised by the memory, suggested he should make a film about it. "Maybe one day," said Spielberg. The idea reappeared periodically in discussions between the two men, to the extent that after *Lincoln*, Kushner wrote a form of short story from the handful of anecdotes the filmmaker had reported to him. Spielberg said he was interested, but did not follow it up. In 2017, in a documentary-interview-compilation dedicated to the director (*Spielberg,* by Susan Lacy), Steven, his parents, and his sisters opened up like never before. "Right after my mother saw it," Spielberg explains, "we were having lunch at her restaurant, the Milky Way, when suddenly she took my hands in hers and said, 'Steve, why don't you make a movie of our story? I gave you such good material.' [laughs]"[1] Shortly afterward, Spielberg's mother died at the age of ninety-seven. "This autobiographical

The man with the camera: Spielberg works with Gabriel LaBelle, the actor who plays Sammy Fabelman as a teenager.

The original inspiration: Young Sammy Fabelman is awed by an early viewing of *The Greatest Show on Earth*.

⏸ Freeze Frame

After filming with his father's Super 8 camera the train crash that he has been obsessively re-creating with his electric train since he saw *The Greatest Show on Earth*, little Sammy Fabelman projects the result. Fascinated, he brings his hands close to the light of the projector as if he were trying to sculpt it. "He sees the first images he has ever created move across his flesh and blood,"[15] as Spielberg describes it. This brief and unforgettable shot, an expression of his organic relationship with the image, is the one that is the most cherished by the filmmaker.

project, which up to then had been a recurring joke, became a subject," says Kushner. "Steven gave me an initial long interview about his youth, and then *West Side Story* monopolized him—a very complicated film about which we had many disagreements. One evening, after a very tense altercation, he calls me: "You're not doing anything tomorrow night? Come to the apartment and we'll talk about this film." I think it was a way to make sure we weren't angry. It was a long and fruitful conversation."[2]

The Missing Story

With *West Side Story* completed, the COVID-19 pandemic struck. "So many people were dying because of the virus. When my wife Kate and my kids asked me what story I regretted not telling yet, all I could think of was my mom and dad, their divorce, the bullying I'd experienced in high school, the moment I fell in love with the camera and wanted to tell stories."[3] During the first weeks of lockdown, in the spring of 2020, Spielberg assiduously poured out his heart to Kushner via a videoconference link. Before Kushner shut himself away to draft a version of eighty-one pages, the filmmaker insisted on finding the names of the characters, as if to protect himself by establishing the detachment of fiction from the outset. The surname Vogelman (*Vogel* means "bird" in German) was

In a key scene from the film, young Sammy pursues his love of filmmaking while also covering up a secret from his family life.

considered, then Kushner thought of Bertolt Brecht and his theory of dramaturgical analysis around the concept of *Fabel*, "a word that exists in all languages,"⁴ he noted. So Fabelman it was, the "fable-man," instead of Spielberg, the "play-mountain." It is true that the initials S. F., as in science fiction, fit the director of *Schindler's List* much better than S. S. In the process, Spielberg chose the characters' names: Leah, Arnold, Uncle Bernie, and Steven became Mitzi, Burt, Uncle Bennie, and Sammy (short for Samuel, which is Shmuel in Hebrew, the name of his maternal grandfather).

Intimate but Universal

On August 25, 2020, Spielberg's father died at the age of 103. On October 2, still by videoconference link, Spielberg and Kushner began writing the script for *The Fabelmans*. Two months later, at the rate of four hours of work per day, three days a week, they achieved a first version. "I had never written so fast," said Kushner. "But I kept to that pace so that Steven wouldn't flinch. I kept his enthusiasm alive without putting pressure on him, because I could see him getting excited and at the same time becoming more and more afraid: afraid of exposing his family history; afraid of being accused of narcissism or self-indulgence, etc. The story had to speak to everyone, even to those who didn't know him or his films."⁵

CASTING

From a list of actors considered by Spielberg to play his parents, the names of Michelle Williams and Paul Dano very quickly stood out: two remarkable and understated actors, two faces familiar to the public—she for the *Dawson's Creek* TV series or *Manchester by the Sea* (Kenneth Lonergan, 2016), he for *Little Miss Sunshine* (Valerie Faris and Jonathan Dayton, 2006) or *There Will Be Blood* (Paul Thomas Anderson, 2007)—who had, as yet, not been stereotyped by any iconic role.

Two Lonely People in Love

Loving parents and a loving couple, Mitzi and Burt are filmed by Spielberg as two solitary souls in love, his mother having contained her (mutual) attraction to her husband's colleague and best friend for years in the face of a workaholic husband, a lovable nerd in total denial. Nominated for an Oscar for Best Actress, Michelle Williams, dressed, coiffed, and even perfumed like Leah Spielberg, with an almost disturbing gracility, admirably alternates between maternal affection, bouts of childishness, and flirting with madness and melancholy—signs of the depression that is eating away at her. Present but not really there, Paul Dano evinces disarmingly helpless benevolence.

Mitzi (Michelle Williams), is Sammy's mother, who doesn't want to upset her son's childhood with marital troubles.

His Better Self

Spielberg's double, Sammy, is played at the age of five to six by Mateo Zoryan (credited as Mateo Zoryon Francis-deFord), whose supernatural blue eyes (Spielberg has brown eyes) pierce the screen during the process of his discovery of cinema. The teenaged Sammy is played by Gabriel LaBelle; this unknown young actor, selected by casting director Cindy Tolan from hundreds of applicants, was chosen and auditioned by Spielberg via video conference. "I was looking for someone much more handsome than me, more likely to seduce the girls,"[6] he admits. He was also looking for an insatiable curiosity, a quality on which the filmmaker also prides himself. "Steven did not want me to imitate him: the story was enough on its own. He let me do a lot,"[7] explains LaBelle (who blew out his nineteenth-birthday candles during the filming).

A Cult Cameo

The last scene of the film, destined for cult status, orchestrates the meeting, as Spielberg would have experienced it at nineteen, between Sammy Fabelman and the most mythical of Hollywood's one-eyed directors, John Ford. How was one to embody such a legend? For a while Spielberg considered choosing an unknown, or one of his actor friends. When Kushner suggested giving the role to a filmmaker, his husband, Mark Harris, suggested David Lynch. A stroke of genius…but not so straightforward to make it actually happen! When Spielberg called Lynch, he resisted, on the grounds that he was not an actor, nor was he on the same level as John Ford. Lynch softened a little when Spielberg reminded him that he and his wife had learned transcendental meditation, a hobbyhorse of the *Twin Peaks* director, via Lynch's foundation. But it took the intervention of Laura Dern, a close friend of Lynch's whom Spielberg had directed in *Jurassic Park*, for Lynch to accept. With one condition, however: having the costume—eye patch and hat included—two weeks before filming, so that he could wear it every day…!

FILMING AND PRODUCTION

Filming began in mid-July 2021 with the scenes involving the teenagers. Although the story moved from New Jersey to Arizona, ending up in California, almost all the filming took place in California, either on location or at Universal Studios, in order to comply with COVID-19 health protection measures.

Reconstructions and Reunions

The very personal nature of *The Fabelmans* was an opportunity for Spielberg to bring two of his most trusted collaborators—composer John Williams and editor Michael Kahn—out of retirement. In addition, Steven and his three sisters unearthed a large number of family photos and films from which the actors, the costume crew, production designer Rick Carter (who re-created the various family interiors identically), and director of photography Janusz Kamiński—whose brightly colored rendering, close to the Technicolor of the time, became more monochromatic by the time of the divorce—drew inspiration. Seeing the world of his childhood reborn in front of his eyes in this way, with a wealth of detail, was upsetting for the filmmaker. "On several occasions," he confesses, "I had to leave the set to be alone after a scene. My actors always ended up finding me and holding me in their arms."[8]

The Artist and the Technician

In the manner of a family history that seems not to look like much, *The Fabelmans* sheds a precious light on both the work itself and the man behind it. A love letter to his parents, it is above all an ode to his mother, to whom Spielberg owes his artistic

Bennie, the best friend (Seth Rogen), with Burt (Paul Dano) and Mitzi (Michelle Williams) in *The Fabelmans*.

sensitivity. In reality, she was not present at the original screening of *The Greatest Show on Earth* that opens the film, but Spielberg—and this is a crucial dimension of his art—has never hesitated to reshape reality to serve his purpose, adjusting life through cinema. In this scene, little Sammy, frightened at the idea of finding himself in the dark with shadows, is reassured by the rationalism of his father, who explains to him how the projector works; and by the enthusiasm of his mother, for whom films are dreams. This is a way of establishing his two parents as the foundations of his identity as a director: on the one hand, the technical brilliance, the taste for technological innovation of the master of special effects; on the other, the wonderment, the appeal of the spectacle, for the virtuoso of emotions.

A Painful Secret

The most sensitive sequence for Spielberg to shoot? The discovery by the young Fabelman/Spielberg, as he unraveled the footage from a camping trip, of the attraction between his mother and the family's best friend. This is staged in a superb alternating montage, to the rhythm of the adagio of Bach's Concerto in D Minor BWV 974, between Mitzi, alone at the piano; Burt, working in his corner; and Sammy,

discovering this chance discovery, locked in his room. The Gordian knot of the story is shared by Sammy with his mother during another heartbreaking scene, where he projects the evidence into the louvered closet in his room, a Spielbergian place of childish fears and unspoken family tensions (*E.T.*, *Poltergeist*). From then on, mother and son kept the secret between them. This is the revelation of the film and the first anecdote told by Spielberg to

FOR SPIELBERG ADDICTS

Among its other virtues, *The Fabelmans* lifts the veil on the origins (real or imagined) of many Spielbergian motifs and echoes a good part of his filmography, from the shooting of the amateur war film (forerunner of *Saving Private Ryan*), to the journey of the Boy Scouts on bicycles in stereotypical suburbia (*E.T.*, *Indiana Jones and the Last Crusade*), to Mitzi's dance in front of the car's headlights and the ecstatic gazes of her men and son...a possible source of Spielberg's fascination with halos and backlighting.

A family united by what's been left unsaid...

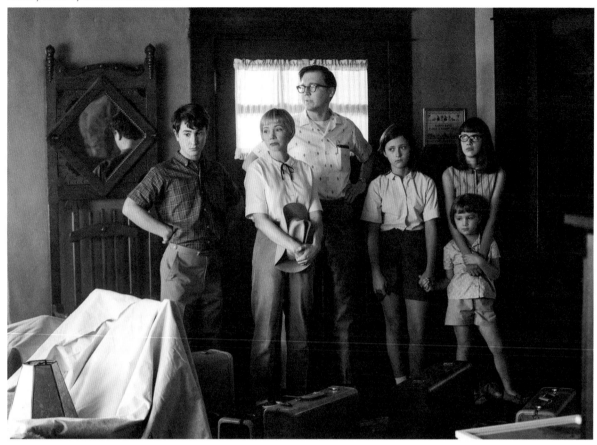

Kushner (on the set of *Munich*)...not entirely consistent with what he has always said about his parents' divorce, namely that the announcement of this separation was an incomprehensible shock and that he blamed his father for years afterward. "However, this is how things happened when I was sixteen years old," said the filmmaker. "But I didn't think for a second that it would lead to the breakup of our family. I kept it a secret. In reality, unlike what we see in the film, it took a year before I found the courage to show the images to my mother."[9]

Cinema as a Tonic for Reality

Cinema as a remedy for reality, revealing it and evading it, enduring it and fixing it: This idea is at the heart of *The Fabelmans*, a film that is a close cousin of *Catch Me If You Can*. Luminous, funny at times, often moving, full of a family warmth that we know is doomed, it is impregnated with the shimmering iconography of a phony American way of life—of which Spielberg, as a teenager, discovered one of the worst facets when he arrived in California, when he was harassed by an anti-Semitic high school classmate. Once again, he used his filmmaking skills to find his way out of it: In one of his school films, dedicated to "Ditch Day"

and screened at the end-of-the-school-year prom, he glorified his tormentor. In *The Fabelmans,* this translates into an amusing parody of a beach movie laced with white power imagery à la Leni Riefenstahl (Hitler's propaganda filmmaker), and then into a scene that speaks volumes about Jewish identity in WASP society. In this sequence, Logan (Sammy's persecutor) berates Sammy at length for making him a star; the teenager then discovers his power as a director and its perverse effects. "In reality, it was much simpler," says Spielberg. "He took me aside in the hallway, unable to articulate why he was so angry, continually repeating: 'Why did you show me like that? Why did you do this to me?' Then, sobbing, he left, leaving me to my incomprehension."[10] Kushner added: "I asked Steven if he had seen him afterwards, but according to him, the guy had died fighting in Vietnam. He was very uncomfortable with that scene. After seeing it edited, I realized that we had missed it by a mile and insisted that we rewrite it and reverse at least two-thirds of it. We even had to rebuild the high school corridor, which was no longer available. In the first version, we understood Logan's problems better and he befriended Sammy. Quite wrong! The whole point was that Sammy did not understand."[11]

...which cinema alone can exorcise.

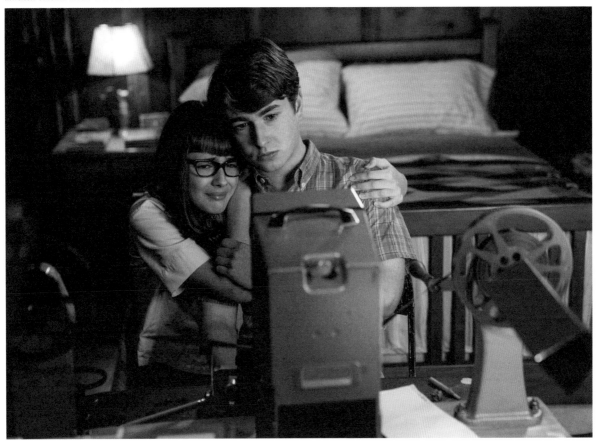

RECEPTION

Particularly vulnerable as the release of this very personal production approached, Spielberg was all the more exposed because the commercial failure of his previous film, *West Side Story*, marked a break in his long idyllic history with the public.

Critical Triumph, Box Office Failure

"An autopsy of a marriage and a homage to invention, it's a bittersweet delight," according to *Empire*,[12] "wonderful in both large and small ways," according to the *New York Times*,[13] "a stunning critical insight into his own work," in the eyes of the *Guardian*,[14] *The Fabelmans* was greeted with a glowing press reception. Nominated for seven Oscars, the film won two Golden Globes (for best film and director), but struggled to make fifteen million dollars at the box office: one of Spielberg's most bitter disappointments. Suddenly, it was as though the scales had turned for the director: He, whose status as a box-office wizard had long rendered him suspect among the critics, had become untouchable in the cinephile sphere—and in the post–COVID-19 film crisis—but he seemed to have lost his appeal for the big audiences. A pity: *The Fabelmans* would

have been a nice climax to a career (that he is not about to end...), if only as a return to popular success after the disappointment of *West Side Story*.

The Return of the Suppressed

"I've never been to a shrink, storytelling is my therapy."[16] This confession would be a cliché had it not come from Spielberg, who has never stopped translating his childhood fears into cinematic wonder. He waited until he became an orphan, at the age of seventy-five, to give us The Fabelmans, which provides the keys to his film inspirations in a movie that is as much about the return of that which has been suppressed (the importance of the maternal role says a lot about the suppression of sexuality in Spielberg's work) as it is a story of cinema apprenticeship. Nevertheless, in this respect, the final gag of the film, a mischievous wink at the lesson John Ford bestowed on Sammy Fabelman regarding the correct location of the horizon line, which is delivered in the form of an impromptu reframing when Sammy moves away on the backlot, resounds like a manifesto: when stripped of the intimate aspects and motivations that underlie it, spectacle and cinematic emotion take precedence.

Glossary

Animatronics: a portmanteau of "animation" and "electronics," describing a technique in which models and artificial creations are "animated" via hydraulic cylinders and levers, robotics, radio-controlled systems, and/or computerized instructions (depending on the era).

Anthology (television): a series of television episodes that exist independently of one another, usually with no common characters or plots, but often with a similar narrative structure or unifying theme (e.g., science fiction, police procedural). *The Twilight Zone* (1959) and *Black Mirror* (2011) are both examples.

Backlot: exterior sets built by a film studio, typically indoors and near the studio itself, to make the filming of exterior shots easier to control.

Blaxploitation: a cinematic genre that emerged in the United States in the 1970s, which focused on Black characters. Originally pejorative, the term was coined by the NAACP (National Association for the Advancement of Colored People) in 1972 to denounce the perpetuation of clichés about Black Americans in film.

Blockbuster: originally coined to describe a type of aerial bomb used during WWII that was strong enough to destroy an entire city block of buildings, the term was later used to describe a film released on as many screens as possible, on the same date, as part of a strategy to achieve a quick return on a movie studio's investment.

Cliffhanger: a writing device that involves stopping the plot at a critical moment in order to keep the audience interested (literally "hanging over a cliff") during a commercial break (in television) or in the months and years between installments of a franchise movie (in film).

Computer-generated imagery (CGI): special effects and images created on a computer, rather than using models, miniatures, optical effects, or other man-made solutions.

Dolly: a camera platform with wheels attached that allows a camera to move smoothly while filming.

Fish-eye lens: a very wide-angled lens that allows its user to create a wide panoramic view, but with strong visual distortion.

Go-motion: an improved version of "stop motion" that erases the jerking effect caused by cutting between frames (done in order to make inanimate objects look like they're moving) by incorporating a motion blur into each frame.

In-camera editing: a film technique that dates back to the earliest days of cinema, in which the shots of a film are done in strict chronological or sequential order, often with the camera being turned off and moved between shots, so that the final film is "edited" before it is removed from the camera and developed.

Jump cut: an edit made to film that gives the impression of a lack of images, thereby causing the action to seemingly "jump" forward in time without explanation.

Lens flare: an optical aberration caused by a diffusion of light, which produces a halo effect.

MacGuffin: an object or device that moves the plot of a story forward. The term was coined by British screenwriter Angus MacPhail, who worked for the most famous utilizer of the MacGuffin: Alfred Hitchcock.

Spielberg with his constant companion on every set: his baseball cap.

Major(s): group name given to the "major" film studios located in Hollywood that, beginning in the 1920s, helped build the movie industry. The five original majors were MGM, Warner Bros., 20th Century Fox, RKO, and Paramount.

Matte painting: a painted representation of a landscape used in film to modify the background of a scene, thereby allowing filmmakers to create the illusion of an environment that was not actually present while filming.

Mogul: term used to describe the people in charge of running major Hollywood studios.

Motion capture: a technical process wherein an animated character is created based on the movements of an actor or stuntperson outfitted with a suit covered in markers that are caught by infrared cameras and translated into a digital avatar.

Movie brats: a term coined to describe some of the most iconic American filmmakers of the 1970s, including Francis Ford Coppola, Brian De Palma, John Milius, William Friedkin, Martin Scorsese, Paul Schrader, and George Lucas. Trained in film schools rather than on film lots, these directors flourished in the years after the studio system collapsed. Spielberg is usually associated with this group in spite of the fact that he did not go to film school.

Performance capture: a version of motion capture that records body movement, voice, and finer motions (like facial expressions and finger movements) simultaneously.

Rack focus: a change of focus within a shot, wherein one object goes from being in focus to being out of focus, while another object does the opposite and goes from looking blurry to being sharply visible.

Screwball comedy: a subgenre of classic Hollywood comedies that rose to prominence in the 1930s, featuring wacky or quirky characters and frenetic pacing and dialogue.

Sequence shot: a continuous shot done in one continual take that moves from place to place, or from character to character, without cutting.

Serial: an episodic film format inspired by novels and radio shows, often featuring stories told in installments from one week to the next, and typically with a cliffhanger built in to ensure that the audience returns for the next installment.

Soundstage: a covered, soundproofed stage with no windows that often looks like a large airplane hangar. Filmmakers use soundstages to help them control their surroundings, since a soundstage eliminates the need to plan for naturally occurring obstacles like inclement weather and the loss of sunlight.

Split diopter: a type of removable partial camera lens that divides a camera's field of vision in half, thereby creating two distinct focal planes and allowing both the foreground and background of an image to be shown in focus within the same image.

Split screen: an effect wherein a screen is divided into two (or more) different images. Split screens can be used to depict scenes that take place at different times and places, or they can show one scene from different angles and perspectives.

Steadicam: a mechanism composed of articulated arms, ball bearings, and counterweights, onto which a camera (aka "cam") is fixed before being harnessed to a cameraperson. This offers a cameraperson freedom of movement while ensuring that the images being captured by the camera remain stable. The Steadicam was invented by Garrett Brown in 1972. Brown worked as a camera operator on many classic feature films, including *Marathon Man, Rocky, The Shining, Return of the Jedi, Indiana Jones and the Temple of Doom,* and *Casino.*

Stop motion: an animation process consisting of photographing a fixed object (a handmade model, a figurine, etc.) whose position is slightly modified from one photograph to the next. Movement is then generated by scrolling through the images, one after another.

Storyboard: a succession of drawings representing planned camera movements and angles (based on a film's script), created to help establish a work plan and evaluate a budget before the film is made.

Tentpole: a big-budget film whose entire development strategy (plot, marketing, distribution, etc.) is designed to limit financial risk and to guarantee a high return on investment. Classically, so-called tentpole films exploit already-proven artistic successes, like popular books (Harry Potter, The Hunger Games) and TV shows (*Star Trek, Mission Impossible*).

Virtual camera: originally developed for the film *Avatar* (James Cameron, 2009), a virtual camera allows a filmmaker to see an actor who is being filmed using motion capture technology in their digital form. A virtual camera is connected to computers, but it performs many of the functions of a typical camera, such as zooming, panning, and rotating.

Notes

Steven Before Spielberg (1946–1948)

1. *Time*, July 15, 1985.
2. Joseph McBride, *Steven Spielberg: A Biography*, Faber & Faber, 2012.
3. Anne Frantilla and Arnold Spielberg, Oral history interview with Arnold Spielberg, Charles Babbage Institute, 1987.
4. McBride, *Steven Spielberg*.
5. *Escape to Nowhere*, short film, 1962.
6. *Scottsdale Daily Progress*, May 1, 1963.
7. McBride, *Steven Spielberg*.
8. *Journey to the Unknown…A Production of the Desert Film Club* (high school film club program), October 1968.
9. https://www.bonhams.com/auctions/24837/lot/239/?category=list.
10. McBride, *Steven Spielberg*. *Spiel* in German: *Play* in English; *Berg* in German: *Mount* in English.

Amblin'

1. *Entertainment Weekly*, December 2, 2011.
2. *Ibid*.

Night Gallery Eyes

1. Dave Kaufman, *Daily Variety*, November 10, 1969.
2. John Mahoney, *Hollywood Reporter*, November 11, 1969.

The Name of the Game "LA 2017"

1. Michael Callahan, *Hollywood Reporter*, September 1, 2018.

The Psychiatrist "The Private World of Martin Dalton"

1. Adam Zanzie, "Spielberg Completist: The Psychiatrist—'Par for the Course/The Private World of Martin Dalton' (1971)," YouTube, September 17, 2017.
2. Steven Spielberg, interview by Mitch Tuchman, *Film Comment*, January–February, 1978.

The Psychiatrist "Par for the Course"

1. Joseph McBride, *Steven Spielberg: A Biography*, Faber & Faber, 2012.

A Kid from Universal City: The Childhood of a Filmmaker

1. *Hollywood Reporter*, December 16, 2010.

Columbo "Murder by the Book"

1. Joseph McBride, *Steven Spielberg: A Biography*, Faber & Faber, 2012.
2. Laurent Bouzereau, *Steven Spielberg and the Small Screen*, documentary, 2004.

Owen Marshall, Counselor at Law "Euology for a Wide Receiver"

1. Joseph McBride, *Steven Spielberg: A Biography*, Faber & Faber, 2012.

Duel

1. Bonus DVD interview, 2001.
2. Myra Forsberg, "Spielberg at 40: The Man and the Child," *New York Times*, January 10, 1988.
3. *Entertainment Weekly*, December 2, 2011.
4. Steven Spielberg, interview extract, Television Academy Foundation, April 16, 2002, https://interviews.televisionacademy.com/ interviews/richard-matheson?clip= 56290#interview-clips.
5. Lester D. Friedman and Brent Notbohm, *Steven Spielberg: Interviews*, University Press of Mississippi, 2011.

Savage

1. All quotes from *Hollywood Reporter*, April 3, 1973.

The Sugarland Express

1. Matthew Robbins, interview (in French) by the authors, December 22, 2021.
2. Ibid.
3. Steven Spielberg, interview by Andrew C. Bobrow, *Filmmakers' Newsletter*, Summer 1974.
4. Nigel Morris, *The Cinema of Steven Spielberg: Empire of Light*, Wallflower Press, 2007.
5. *New Yorker*, March 18, 1974.
6. *New York Times*, April 28, 1974.

Jaws

1. *New York Times*, May 15, 2016.
2. *BBC News Online*, February 1, 2004.

3. Excerpts and opinions cited in this paragraph are taken from columns published in *Variety* (June 18, 1975), the *New York Times* (June 21, 1975), *Newsweek* (June 16, 1975), the *Hollywood Reporter* (June 1975), the *New Yorker* (June 20, 1975), the *Los Angeles Times* (June 20, 1975), and the *Village Voice* (June 23, 1975).

Richard Dreyfuss: The Alter Ego

1. *Guardian*, June 24, 2020.
2. *CBS News*, February 23, 2020.
3. *Guardian*, June 24, 2020.

Close Encounters of the Third Kind

1. Laurent Bouzereau, *The Making of "Close Encounters of the Third Kind,"* documentary, 2001.
2. Ibid.
3. Ibid.
4. Ibid.
5. Joseph McBride, *Steven Spielberg: A Biography*, Faber & Faber, 2012.
6. *Los Angeles Times*, November 20, 1977.
7. *New Yorker*, November 28, 1977.
8. *Time*, November 7, 1977.

1941

1. Laurent Bouzereau, *The Making of "1941,"* documentary, 1996.
2. Chris Hodenfield, "1941: Bombs Away!," *Rolling Stone*, January 24, 1980.
3. Joseph McBride, *Steven Spielberg: A Biography*, Faber & Faber, 2012.
4. Ibid.
5. *Los Angeles Times*, December 14, 1979.

Spielberg and the New Hollywood

1. Matthew Robbins, interview (in French) by the authors, December 22, 2021.
2. Peter Biskind, *Easy Riders, Raging Bulls*, Simon & Schuster, 1998.
3. Matthew Robbins, interview (in French) by the authors, December 22, 2021.
4. Biskind, *Easy Riders, Raging Bulls*.

Raiders of the Lost Ark

1. *Empire*, May 2008.

2. All quotes taken from the transcription of a January 1978 work meeting that brought together George Lucas, Steven Spielberg, and Lawrence Kasdan.
3. Richard Schickel, *Time*, June 15, 1981.
4. Vincent Canby, *New York Times*, June 12, 1981.
5. Dave Kehr, *Chicago Reader*, August 1981.
6. Pauline Kael, *New Yorker*, June 15, 1981.

E.T. the Extra-Terrestrial
1. *New York Times*, May 30, 1982.
2. Laurent Bouzereau, *The Making of "E.T. the Extra-Terrestrial,"* documentary, 1996.
3. *Entertainment Weekly*, December 22, 2015.
4. Bouzereau, *The Making of "E.T. the Extra-Terrestrial."*
5. *American Cinematographer*, January 1983.
6. *Empire*, August 12, 2012.
7. *New York Times*, May 30, 1982.

Poltergeist
1. Open letter, *Variety*, June 9, 1982.
2. Dale Pollock, "Poltergeist: Whose Film Is It?," *Los Angeles Times*, May 24, 1982.
3. Michiko Kakutani, "The Two Faces of Spielberg: Horror vs. Hope," *New York Times*, May 30, 1982.
4. Warren Buckland, "Ghost Director: Did Hooper or Spielberg Direct *Poltergeist?*," *Digital Tools in Media: Analysis and Research*, Columbia University Press, 2009.

The Twilight Zone: The Movie
1. *Los Angeles Times*, April 13, 1983.
2. *New York Times*, June 24, 1983.

Indiana Jones and the Temple of Doom
1. Andrew Robinson, *The Inner Eye*, Andre Deutsch Ltd., 1989.
2. Stephen Schiff and Richard Avedon, "Seriously Spielberg," *New Yorker*, March 21, 1994.
3. *Time*, May 21, 1984.

Amblin Entertainment The Fantasy Factory
1. ShortList, October 20, 2014, https://www.shortlist.com/news/back-to-the-future-wouldnt-have-been-the-same-without-spielberg.

Amazing Stories "Ghost Train"
1. Aljean Harmetz, "Amazing Stories Tries New Tactics," *New York Times*, June 2, 1986.
2. Ibid.

Amazing Stories "The Mission"
1. Joseph McBride, *Steven Spielberg: A Biography*, Faber & Faber, 2012.

Amblin Television Back to the Small Screen
1. *Hollywood Reporter*, February 6, 2012.

The Color Purple
1. *Chicago Sun-Times*, December 15, 1985.
2. *Chicago Tribune*, January 5, 1986.
3. *Oprah*, November 11, 2005.
4. *American Cinematographer*, February 1986.
5. *AP News*, December 20, 1985.
6. *Harvard Crimson*, January 31, 1986.
7. *New Yorker*, December 30, 1985.

Empire of the Sun
1. Joseph McBride, *Steven Spielberg: A Biography*, Faber & Faber, 2012.
2. Ibid.
3. Les Mayfield, *The China Odyssey: The Making of "Empire of the Sun,"* documentary, 1987.
4. Myra Forsberg, "Spielberg at 40: The Man and the Child," *New York Times*, January 10, 1988.
5. Mayfield, *The China Odyssey.*
6. Ibid.
7. *Cahiers du Cinéma*, no. 500, March 1996.
8. According to the Academy of Motion Picture Arts and Sciences official website.
9. *New York Times*, December 9, 1987.
10. Myra Forsberg, "Spielberg at 40."

Indiana Jones and the Last Crusade
1. Richard Schickel, *Steven Spielberg: A Retrospective*, Union Square & Co., 2012.
2. *New Yorker*, June 12, 1989.

Always
1. *Première* (French), December-January, 1989–1990.
2. Ibid.
3. *Chicago Sun-Times*, December 22, 1989.

Bad Dads
1. *Business Insider*, October 22, 2012.

Hook
1. Douglas Brode, *The Films of Steven Spielberg*, Citadel Press, 1995.
2. *Los Angeles Times*, December 11, 1991.
3. *Empire*, March 2018.
4. "Steven Spielberg Interviewed by Kermode & Mayo," https://www.youtube.com/watch?v=cnwQDgssrwk.

Jurassic Park
1. *Smithsonian*, December 2, 2014.
2. Ibid.
3. John Schultz, *The Making of "Jurassic Park,"* documentary, 1995.
4. Ibid.
5. *Rolling Stone*, July 8, 1993.
6. *Variety*, June 7, 1993.

Schindler's List
1. The original title of the book was *Schindler's Ark.*
2. *Time*, January 21, 1994.
3. Steven Spielberg, interview celebrating the twentieth anniversary of the film during Tribeca Film Festival, April 2018.
4. *Variety*, November 19, 1993.
5. *Le Monde* (French), March 3, 1994.
6. Camille Nevers "*Schindler's List*: One + One," *Cahiers du Cinéma*, April 1994.
7. Joseph McBride, *Steven Spielberg: A Biography*, Faber & Faber, 2012.

The Lost World: Jurassic Park
1. *Hollywood Reporter*, June 19, 2020.
2. *MTV News*, May 24, 2017.
3. Janusz Kamiński, interview in Laurent Bouzereau, *Making "The Lost World,"* documentary, 1997.
4. *Chicago Sun-Times*, June 6, 1997.
5. *Empire*, August 1997.

Amistad
1. Joseph McBride, *Steven Spielberg: A Biography*, Faber & Faber, 2012.
2. Steven Spielberg, interview by Glenn Whipp, *Spokesman Review*, December 9, 1997.
3. Steven Spielberg, in Chris Harty's *Ships of Slaves: The Middle Passage*, documentary, 1997.

Dreamworks: The Ups and Downs of Independence
1. *Entertainment Weekly*, October 28, 1994.

Saving Private Ryan
1. Steven Spielberg, interview by Gerard Delorme, *Première*, October 1998.

2. Ibid.

3. *Première*, May 1997.

4. Roger Ebert, "Private Spielberg," rogerebert.com, July 19, 1998.

5. Ibid.

6. Steven Spielberg, interview by Christian Jauberty, *Première*, October 1998.

7. Film press release materials.

8. Roger Ebert, "Private Spielberg," rogerebert.com, July 19, 1998.

9. Steven Spielberg, interview by Stephen Pizzello, *American Cinematographer*, August 1998.

10. *Washington Post*, July 24, 1998.

11. *Variety*, July 20, 1998.

12. *Evening Standard*, September 9, 1998.

13. *Libération*, September 30, 1998.

14. *Le Monde*, October 1, 1998.

15. Steven Spielberg, Academy Awards acceptance speech, Oscar for Best Director, 1999.

A Child of War: From Fantasy to Reality

1. Steven Spielberg, interview in *L'Express*, September 24, 1998.

2. *Le Figaro*, February 20, 2012.

3. *American Cinematographer*, August 1998.

A.I. Artificial Intelligence

1. *Scientific American*, October, 1994.

2. Alison Castle, *The Stanley Kubrick Archives*, Taschen, 2008.

3. Laurent Bouzereau, *A.I.* DVD Blu-ray bonus, 2002.

4. Joseph McBride, *Steven Spielberg: A Biography*, Faber & Faber, 2012.

5. Ibid.

6. Laurent Bouzereau, *A.I.* DVD Blu-ray bonus, 2002.

7. *Guardian*, September 21, 2001.

8. *Libération*, October 24, 2001.

9. *Cahiers du Cinéma*, December, 2001.

10. Richard Schickel, *Steven Spielberg: A Retrospective*, Union Square & Co., 2012.

Steven and Stanley: A Secret Relationship

1. Chris Hodenfield, "1941: Bombs Away!," *Rolling Stone*, January 24, 1980.

Minority Report

1. Laurent Bouzereau, *The Making of "Minority Report,"* documentary, 2002.

2. Ibid.

3. *Entertainment Weekly*, June 14, 2002.

4. *Hollywood Reporter*, March 2002.

5. *New Zealand Herald*, June 21 2002.

6. *New York Times*, June 16, 2002.

7. *Daily Telegraph*, July 1, 2002.

8. *New Yorker*, June 23, 2002.

9. *Le Monde*, October 1, 2002.

10. *Positif*, no. 500, October 2002.

11. *Independent*, January 11, 2012.

Catch Me If You Can

1. Laurent Bouzereau, *The Making of "Catch Me If You Can,"* documentary, 2003.

2. Quote from *The Man Who Shot Liberty Valance*, John Ford, 1962.

3. Jeff Giles, *Première*, no. 312, February 2003.

4. Alan Vanneman, "Steven Spielberg, a Jew in America: Deconstructing Catch Me If You Can," *Bright Lights Film Journal*, July 31, 2003.

5. Laurent Bouzereau, *The Making of "Catch Me If You Can,"* documentary, 2003.

6. Ibid.

7. Ibid.

8. Nicholas Schaller, *Première*, no. 331, September 2004.

9. *Observer*, December 19, 2002.

10. *Variety*, December 16, 2002.

11. *Libération*, February 12, 2003.

12. Collection, "The Spielberg Primer," *Reparage*, no. 36, February 2003.

13. *Les Inrockuptibles*, January 1, 2003.

14. *Première*, no. 312, February 2003.

John Williams

1. *New Yorker*, July 21, 2020.

2. Ibid.

3. *Boston University Today*, 2009.

4. Jeff Giles, *Première*, no. 312, February 2003.

5. Excerpt from Steven Spielberg's statement at the American Film Institute honoring the career of John Williams, *Guardian*, June 10, 2016.

The Terminal

1. *Irish Times*, August 30, 2004.

2. *Première*, no. 331, September 2004.

3. Laurent Bouzereau, *The Making of "The Terminal,"* documentary, 2004.

4. *Première*, no. 331, September 2004.

5. *Chicago Sun-Times*, June 18, 2004.

6. *New York Times*, June 18, 2004

7. *Entertainment Weekly*, June 16, 2004.

War of the Worlds

1. Clement Safra, *Dictionnaire Spielberg*, Vendemiaire, 2011.

2. Laurent Bouzereau, *The Making of "War of the Worlds,"* documentary, 2005.

3. Ibid.

4. Susan Lacy, *Spielberg*, documentary, 2017.

5. Richard Schickel, *Steven Spielberg: A Retrospective*, Union Square & Co., 2012.

6. Bill Desowitz, "*War of the Worlds*: A Post 9/11 Digital Attack," *VFX World* (online magazine), July 7, 2005.

7. Ian Freer, *Empire*, October 17, 2012.

8. Desowitz, "*War of the Worlds*."

9. David Denby, *New Yorker*, July 5, 2005.

10. *Chicago Sun-Times*, June 28, 2005.

11. Thomas Sotinel, *Le Monde*, July 6, 2005.

The Two Toms

1. *Empire*, 20th Anniversary Edition, June 2009.

2. Laurent Bouzereau, *The Making of "Catch Me If You Can,"* documentary, 2003.

Munich

1. Rachel Abramowitz, "Spielberg Enters a Crossfire He Could Not Avoid," *Los Angeles Times*, December 18, 2005.

2. Nicholas Schaller, *Première*, February 2006.

3. Ibid.

4. Ibid.

5. Ibid.

6. Laurent Bouzereau, *The Making of "Munich,"* documentary, 2006.

7. Ibid.

8. Ibid.

9. "His Prayer for Peace," *Time*, December 14, 2005.

10. *Los Angeles Times*, December 18, 2005.

11. *Le Nouvel Observateur*, January 26, 2006.

12. "Munich, une odyssée a rebours," *Positif*, no. 540, February 2006.

13. "Le mur de Munich," *Technikart*, no. 99, February 2006.

Indiana Jones and the Kingdom of the Crystal Skull

1. *Vanity Fair*, January 2, 2008.

2. Quote from J. Robert Oppenheimer, extracted from the documentary *The Decision to Drop the Bomb* (Fred Freed and Len Giovannitti), aired on NBC in 1965. The physicist recounted his thoughts upon seeing the first atomic bomb detonated on July 16, 1945.

3. *Chicago Sun-Times*, May 18, 2008.

4. *Empire*, May 2008.

5. *New York Times*, May 22, 2008.

6. *Los Angeles Times*, May 19, 2008.

His Own Enterprise: Spielberg the Businessman
1. Olivier Bousquet interview, *VSD*, 2016.
2. Steven Spielberg interview, *Observer*, March 21, 1999.

The Adventures of Tintin: The Secret of the Unicorn
1. "A Conversation with Steven Spielberg and Peter Jackson," *Hollywood Reporter*, December 21, 2011, https://www.youtube.com/watch?v=Fe7Px-ddVS4.
2. Philippe Lombard, *Tintin, Hergé et le cinéma*, Democratic Books, 2011.
3. *Libération*, October 24, 2011.
4. *Le Soir*, October 11, 2011.
5. *La Libre Belgique*, October 12, 2011.
6. *Guardian*, October 16, 18, and 27, 2011.
7. *Le Monde*, October 25, 2011.
8. Philippe Lombard, *Tintin, Hergé et le cinéma*, Democratic Books, 2011.
9. *New York Times*, December 20, 2011.

War Horse
1. *Empire*, December 2011.
2. *Making of "War Horse,"* documentary, DVD Blu-ray, 2012.
3. *Variety*, December 11, 2015.
4. *Atlantic*, December 23, 2011.
5. Steven Spielberg, interview by Olivier Bousquet, *VSD*, 2016.

Lincoln
1. *The Making of "Lincoln,"* documentary, 2002.
2. *Le Point*, January 24, 2013.
3. *GQ*, April 2014.
4. Steven Spielberg, interview by Olivier Bousquet, *VSD*, 2016.
5. Peter Debruge, *Variety*, November 1, 2012.
6. *Cahiers du Cinéma*, February 2013.
7. *Transfuge*, February 2013.

The Inner Circle: A Loyal Team
1. Nicholas Schaller, *Première*, no. 331, February 2004.

Bridge of Spies
1. *Entertainment Weekly*, October 9, 2015.
2. *Première*, December 2015.
3. Ibid.
4. Film press release materials.
5. *Entertainment Weekly*, October 9, 2015.
6. *Cinemateaser*, December 2015.
7. Ibid.

The BFG
1. Steven Spielberg, interview by Olivier Bousquet, *VSD*, July 21, 2016.
2. *Cinemateaser*, July 2016.
3. Spielberg, Bousquet interview.
4. Film press release materials.
5. *Hollywood Reporter*, May 14, 2016.
6. *Première*, July 2016.

Mark Rylance: The Close Friend
1. *Hollywood Reporter*, June 15, 2016.
2. *Guardian*, January 8, 2022.
3. *Première*, July 2016.
4. Steven Spielberg, interview by Olivier Bousquet, *VSD*, July 21, 2016.

The Post
1. Comment made by Donald Trump (@realDonaldTrump), Twitter, October 29, 2018.
2. C. David Heymann, *The Georgetown Ladies' Social Club: Power, Passion and Politics in the Nation's Capital*, Atria Books, 2003.
3. Alfred A. Knopf, *Katharine Graham: Personal History*, 1998.
4. Ben Bradlee, *A Good Life: Newspapering and Other Adventures*, Simon & Schuster, 1996.
5. Mark Salisbury, "The Behind-the-Scenes Story of Steven Spielberg's *The Post*," screendaily.com, January 19, 2018, https://www.screendaily.com/features/the-behind-the-scenes-story-of-steven-spielbergs-the-post/5125714.article.
6. Commissioned by Robert McNamara, Lyndon B. Johnson's Secretary of Defense, a report entitled, "United States-Vietnam Relationships, 1945–1967: A Study Prepared by the Department of Defense."
7. *CNN*, January 23, 2017.
8. The judgment, *New York Times Co. v. United States 403 U.S. 713*, can be viewed at https://supreme.justia.com/cases/federal/us/403/713/.
9. *Vanity Fair*, December 8, 2017.
10. Comment made by Donald Trump (@realDonaldTrump), Twitter, January 9, 2017.
11. *IndieWire*, December 15, 2017.
12. *Collider*, January 8, 2018.
13. TheConversation.com, January 22, 2018.
14. *Variety*, December 6, 2018.
15. *Libération*, January 23, 2018.
16. *New York Times*, December 21, 2017.
17. *Guardian*, December 6, 2017.
18. *Daily Beast*, December 22, 2017.

Ready Player One
1. *Empire*, April 13, 2018.
2. *Den of Geek*, July 9, 2018.
3. *Deadline*, March 12, 2018.
4. *New York Times*, April 27, 2018.
5. *Wired*, March 30, 2018, https://www.youtube.com/watch?v=zglevXKpJGY.
6. *Le Monde*, March 28, 2018.
7. *New York Times*, March 28, 2018.
8. *Le Monde*, April 3, 2018.
9. Twitter profile: @mattzollerseitz, April 4, 2018.

West Side Story
1. Interview with François Forestier, "Danse avec Spielberg," *L'Obs*, December 2, 2021.
2. Ibid.
3. Ibid.
4. Laurent Bouzereau, *The Stories of "West Side Story," the Steven Spielberg Film*, documentary, 2022.

The Father of the Geek Generation
1. *Newsweek*, August 5, 2002.

The Fabelmans
1. Steven Spielberg, via Zoom, words collected by Nicolas Schaller, January 26, 2023.
2. Tony Kushner, via Zoom, words collected by Nicolas Schaller, January 26, 2023.
3. Spielberg, via Zoom, words collected by Schaller.
4. Kushner, via Zoom, words collected by Schaller.
5. Ibid.
6. In the behind-the-scenes feature on the film, which can be viewed on YouTube.
7. Ibid.
8. Spielberg, via Zoom, words collected by Schaller.
9. Ibid.
10. Ibid.
11. Kushner, via Zoom, words collected by Schaller.
12. Alex Godfrey, "The Fabelmans Review," *Empire*, January 16, 2023, https://www.empireonline.com/movies/reviews/the-fabelmans/.
13. Manohla Dargis, "'The Fabelmans' Review: Steven Spielberg Phones Home," *New York Times*, November 10, 2022, https://www.nytimes.com/2022/11/10/movies/the-fabelmans-review-spielberg.html.
14. Peter Bradshaw, "The Fabelmans Review—Spielberg's Beguiling Ode to a Life Made by Movies Will Leave You on a High," *Guardian*, January 25, 2023.
15. Steven Spielberg, interview by Aurélien Allin, *Cinémateaser*, December 2022–January 2023.
16. Interview with Samuel Douhaire, *Télérama*, no. 3813, February 11-17, 2023.

Bibliography

Awalt, Steven. *Steven Spielberg and "Duel": The Making of a Film Career.* Rowman & Littlefield, 2014.

Baxter, John. *Citizen Spielberg.* Nouveau Monde, 2004.

Biskind, Peter. *Easy Riders, Raging Bulls.* Simon & Schuster, 1998.

Blanchot, Louis. *Les Vies de Tom Cruise.* Capricci, 2016.

Bossy, Cyrille. *Steven Spielberg: Un Univers de jeu.* L'Harmattan, 1999.

Buckland, Warren. *Directed by Steven Spielberg: Poetics of the Contemporary Hollywood Blockbuster.* Continuum, 2006.

Castle, Alison. *The Stanley Kubrick Archives.* Taschen, 2005.

Chion, Michel. *La Musique au cinéma.* Fayard, 1995.

Cohen, Clélia. *Steven Spielberg.* Le Monde/Cahiers du Cinéma, 2007.

Collectif. *Steven Spielberg, Part I.* Rockyrama Classic. Ynnis Éditions, 2018.

_____. *Steven Spielberg, Part II.* Rockyrama Classic. Ynnis Éditions, 2019.

_____. *Steven Spielberg, Part III.* Rockyrama Classic. Rockyrama, 2022.

_____. *Spielberg—Les Secrets d'un enchanteur, hors-série.* Les Inrocks, 2012.

Couté, Pascal. *De l'inhumain chez Steven Spielberg,* Passage, 2019.

Crawley, Tony. *L'Aventure Spielberg.* Pygmalion/Cinéma, 1984.

Dupuy, Julien, Laure Gontier, and Wilfried Benon. *Steven Spielberg.* Dark Star, 2001.

Espinosa, Loïc Espinosa. *Dans l'oeil de Steven Spielberg: une analyse du film "La Liste de Schindler."* Éditions Universitaires Européennes, 2014.

Frantilla, Anne, and Arnold Spielberg. Oral history interview with Arnold Spielberg. Charles Babbage Institute, 1987.

Freer, Ian. *The Complete Spielberg.* Virgin Books, 2001.

Friedman, Lester D., and Brent Notbohm. *Steven Spielberg: Interviews.* University Press of Mississippi, 2000; new edition, 2019.

Godard, Jean-Pierre. *Spielberg.* Rivages/Cinéma, 1987.

_____. *Steven Spielberg: Mythes et chaos.* Horizon Illimité/Cinéma, 2003.

Gordon, Andrew M. *Empire of Dreams: The Science Fiction and Fantasy Films of Steven Spielberg.* Rowman & Littlefield, 2007.

Gottlieb, Carl. *The "Jaws" Log.* Expanded edition. Newmarket Press, 2012.

Jones, Brian Jay. *George Lucas: A Life.* Little, Brown & Company, 2016.

Klastorin, Michael. *"Close Encounters of the Third Kind: The Ultimate Visual History."* Harper Design, 2017.

Lombard, Philippe. *Tintin, Hergé et le cinéma.* Democratic Books, 2011.

Loshitzky, Yosefa. *Spielberg's Holocaust: Critical Perspectives on "Schindler's List."* Indiana University Press, 1997.

McBride, Joseph. *Steven Spielberg: A Biography.* Faber & Faber, 2017.

Morris, Nigel. *The Cinema of Steven Spielberg: Empire of Light.* Wallflower Press, 2007.

_____. *A Companion to Steven Spielberg.* Wiley Blackwell, 2017.

Morton, Ray. *"Close Encounters of the Third Kind": The Making of Steven Spielberg's Classic Film.* Applause, 2007.

Palowski, Franciszek. *Witness: The Making of "Schindler's List."* Orion, 1998.

Phillips, Julia. *You'll Never Eat Lunch in This Town Again.* Random House, 1991.

Quirke, Antonia. *Les Dents de la mer,* Akileos, 2018.

Rice, Julian. *Kubrick's Story, Spielberg's Film: "A.I. Artificial Intelligence."* Rowman & Littlefield, 2017.

Rinzler, J. W., and Laurent Bouzereau. *The Complete Making of Indiana Jones: The Definitive Story Behind All Four Films.* Del Rey, 2008.

Safra, Clément. *Dictionnaire Spielberg.* Vendémiaire, 2011.

Schickel, Richard. *Steven Spielberg: A Retrospective.* Union Square & Co., 2012.

Spielberg, Steven. *"War Horse": The Making of the Motion Picture.* Pictorial movie book. Dey Street Press, 2011.

Spielberg, Steven, and David James. *"Saving Private Ryan."* Pictorial movie book. Newmarket Press, 1999.

Ziegler, Damien. *"A.I. Intelligence Artificielle" ou l'adieu à la mélancolie.* LettMotif, 2020.

Spielberg on the set of *Saving Private Ryan* circa 1997.

Index

Index of Films, Documentaries, and TV Series

Index of People Cited

Spielberg made an iconic cameo in John Landis's *Blues Brothers* (1980).

Richards, Ariana 199, 229
Richards, Evan 147
Richards, Jack 65
Richardson, Miranda 185, 190
Richardson, Natasha 400
Richards, Paul 58
Rich, Frank 103
Richmond, George 387
Rich, Winnie 30
Ricker, Brad 331
Riefenstahl, Leni 474
Riley, Gary 170
Rilla, Wolf 415
Ringwood, Bob 185, 295, 300
Rios, Gabriela 437
Ritt, Martin 401
Riva, J. Michael 175
Rivera, Josh Andrés 449
Rizzo, Carl 81
Roach, Jay 322
Roach, Pat 119, 205
Robards, Jason 300, 431, 435
Robards, Sam 295, 300
Robbins, Jerome 449, 451, 453
Robbins, Matthew 27, 65, 67, 72, 93, 98, 115, 138, 169, 171, 405
Robbins, Tim 234, 339, 345-346
Robb-King, Peter 155, 201
Roberts, Julia 221, 223-225
Robertson, Cliff 33
Robillard, Kim 211
Robinson, Ann 339, 343
Robson, Mark 329
Rockwell, Norman 14-15, 371, 412
Rodat, Robert 279, 281
Rodgers, Mark 58
Rodwell, Nick 377, 381
Roe, Jack 56
Rogan, Josh (see Mathison, Melissa) 147, 151
Rogen, Seth 467, 473
Rogers, Will 409
Roker, Renny 168
Romano, Tony 319
Ronconi, George 56
Rooy, Robert 307
Rosa-Collazo, Nannette 267
Rose, Irwin 75

Rosenman, Leonard 30
Rose, Steve 331
Rose, Wayne 170
Ross, Dennis 356
Ross, Jerome 30
Ross, Steve 187, 250
Roth, Ann 427
Rothe, Caprice 131, 139
Roth, Eric 353, 355
Rothman, Tom 312
Roumieu, Florence 353
Rourke, Mickey 113
Rubinstein, John 56
Ruegger, Tom 172
Rushakoff, Sid 32
Rush, Geoffrey 353, 358
Russell, David O. 197
Russell, Ken 136
Russell, Mark 307
Russo, Joe 444
Ryan, Amy 339, 409, 413
Ryan, Lata 229
Ryba, Tom 267
Rydell, Mark 37, 70, 328
Rydstrom, Gary 211, 229, 279, 295, 307, 377, 395, 409, 417, 427
Rylance, Mark 409, 412, 417, 420-421, 424-425, 437, 441
Rywin, Lew 245

Sackheim, William 28-29
Sackler, Howard 79, 82
Sacks, Michael 65, 68, 72
Sagall, Jonathan 245
Sage, Carin 281
Saint, David 449
Saks, Gene 68
Saldaña, Zoe 331, 335
Salomon, Mikael 211, 215
Salter, Claudia 33
Salt, Jennifer 115
Sampson, Will 145
Sandales, Lee 387
Sandburg, Carl 135
Sanders, Chris 277
Sanders, Thomas E. 279
Sandoval, Miguel 229
Sangster, Thomas 382
Santantonio, Kim 319, 331

Sarafian, Richard C. 51
Sargent, Joseph 67
Sayles, John 133-135
Schatzberg, Jerry 197
Scheider, Roy 75, 77, 81, 87, 91
Schell, Richard 395
Schickel, Richard 128, 303
Schiff, Richard 259
Schindler, Emilie 245
Schindler, Oskar 187, 245-247, 250, 291
Schrader, Paul 95, 98, 149
Schumacher, Joel 197
Schwarzenegger, Arnold 281, 309
Scorsese, Martin 114-116, 169, 191, 197, 248, 322, 324, 356, 419, 446, 451
Scotch Marmo, Malia 221, 224, 229, 231, 234
Scott, Amber 221
Scott, Deborah 307
Scott, Elliot 155, 162, 201
Scott, Jacqueline 47, 51
Scott, Ridley 159, 270, 275, 309, 398, 440
Scott, Stephen 201
Scott, Tony 284, 342
Scruton, Mark 437
Sears, Fred F. 341
Seaward, Tracey 387
Selinsky, Wladimir 56
Selleck, Tom 123
Selway, Mary 119
Semel, Terry 149
Serkis, Andy 377, 383
Serling, Rod 9, 28-29, 32-33, 149-151, 169
Seth, Roshan 155
Seward, William 395
Shakespeare, William 288, 413, 424, 451
Shane, Michel 319
Shapiro, Robert 185
Sharif, Omar 189
Shaw, Bob 298
Shaw, Helen 147
Shaw, Ian 86
Shaw, Robert 75, 81-82, 91

Shea, Joseph 324
Sheen, Martin 319
Sheinberg, Sid 20, 27, 29, 33, 35, 40-41, 49, 59, 67, 79, 83, 112, 115, 135, 172, 247, 249
Shepherd, Scott 409
Sheppard, Anna B. 245
Sheridan, Jim 262
Sheridan, Tye 437, 441
Shields, Brooke 349
Shifman, Milton 44
Shoedsack, Ernest B. 233, 263
Shourt, Bill 75
Shriver, Tim 267
Shusett, Ronald 307, 309
Shyamalan, M. Night 299, 343, 355, 365, 461
Sides, Hampton 447
Siegel, Don 39, 292
Siegel, Michael 417
Siemaszko, Casey 170-171
Silvers, Chuck 17-18, 20, 27, 39-41
Silvestri, Alan 434, 437
Simons, Howard 433
Singer, Bryan 198, 262
Singer, Josh 427, 430
Singleton, John 269
Sirk, Douglas 43
Sizemore, Tom 279, 284
Skarsgård, Stellan 267
Skoll, Jeff 395, 409
Slepak, Sanford 168
Slocombe, Douglas 102, 119, 155, 162, 201, 207, 368
Smith, Cecil 39
Smith, Christina 221, 245
Smith, Dean 65
Smith, Elliott 275
Smith, Harkness 44
Smith, Lois 307
Smith, Maggie 221, 224
Smith, Michael Marshall 447
Smith, Robert S. 47
Smith, Will 164, 447
Snipes, Wesley 33
Soderbergh, Steven 311
Solomon, Ed 419
Solomon, Kelly 427

Somner, Adam 339, 353, 377, 387, 395, 404, 409, 417, 427, 437, 449
Sondheim, Stephen 449, 451, 453-455
Sonnenfeld, Barry 164, 172, 311
Sonski, Paul 259
Sorenson, Fred 119
Soul, David 44
Spader, James 395
Spall, Rafe 417
Sparkman, Jim 211
Spencer, Bud 196
Sperry, Stephane 377
Spicer, Melissa 417
Spicer, Sean 430
Spielberg, Anne 20, 25, 351, 469
Spielberg, Arnold 11-12, 14-17, 19, 219
Spielberg, Sasha 331
Spillers, Clint 437
Springsteen, Bruce 343
Stack, Robert 105, 108
Stafford, Nick 387
Stallone, Sylvester 183
Stanton, Andrew 277, 414
Starkey, Steve 168, 170
Starr, Howard 175
Starski, Allan 245
Stella, Raymond 221, 229
Stengel, Kim 377, 383
Stephens, Alexander 395
Stern, Itzhak 245-246, 249-250
Stevens, Fisher 43
Stevens, George 163
Stevenson, John 277
Stevens, Thaddeus 395, 401
Stewart, Denis L. 363
Stewart, James 5, 12, 41, 351, 446-447
Stiller, Ben 185, 190-191
Stockhausen, Adam 409, 437, 449, 454
Stoffer, Joel 363
Stoll, Corey 449
Stonebreaker, Leeann 331
Stone, Ian 395
Stone, Joseph J. 28, 58

Stone, Oliver 284, 398
Stone, Philip 155, 305
Stone, Sharon 159, 235
Stoppard, Tom 185, 187-188, 191, 204, 206, 361
Stormare, Peter 259, 262, 307, 314
Stovitz, Ken 170
Stowell, Austin 409
Strathairn, David 395
Streep, Meryl 300, 313, 350, 427, 431, 433-434
Strenge, Walter 30
Striepeke, Daniel C. 279
Stromberg, Robert 417
Strong, Jeremy 395
Sturges, John 78
Sudick, Daniel 339, 363
Sullivan, Barry 28-29, 34, 58-59
Sullivan, frères 281
Sullivan, Mark 221
Sullivan, Matt 449
Summers, Gary 279
Sutherland, Kiefer 170-171
Swain, Justin 427
Swayze, Patrick 207
Sweeney, Matt 175
Swicord, Robin 419, 447
Swingler, Richard 131
Sydow (von), Max 307, 313
Szwarc, Jeannot 33

Tambellini, Flávio Ramos 363
Tarantino, Quentin 235
Tartikoff, Brandon 169
Tate, Sharon 114
Tati, Jacques 337
Taylor, Elizabeth 165
Taylor, Judy 185
Taylor, Juliet 93
Taylor, Ron 75
Taylor, Terri 319, 339
Taylor, Valerie 81
Tazewell, Paul 449
Teegarden, William James 229, 259, 295
Terry, Sonny 180
Thewlis, David 387
Thielemans, Toots 70
Thinnes, Roy 36-39

Spielberg poses with E.T.

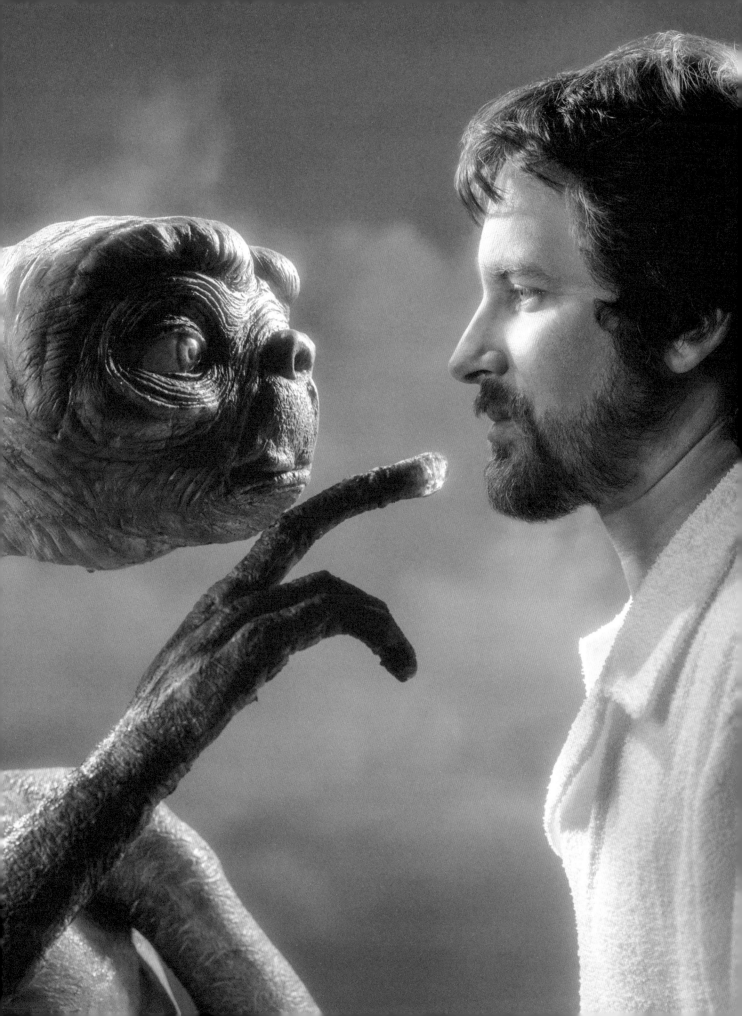

Photo Credits

Academy of Motion Picture Arts and Sciences
© American Society of Cinematographers collection / Margaret Herrick Library 68
© Cinefantastique magazine records / Margaret Herrick Library 231
© Core Collection, production files / Margaret Herrick Library 67
© Photo Murray Close, Cinefantastique magazine records / Margaret Herrick Library 236
© Richard Lasley / Production artwork collection / Margaret Herrick Library 142

DR
© courtesy of HBO / DR 10, 13, 14 (right), 14 (left), 32, 116

Getty Images
© 20th Century-Fox 309
© Aaron Rapoport / Corbis 497
© Allan Tannenbaum 370
© Angela Deane-Drummond / Evening Standard / Hulton Archive 500
© Ben Martin 58
© Bettmann 12, 153, 341 (bottom)
© CBS 124, 282, 284, 285, 286 (top), 287, 289, 310, 311, 314
© Columbia Pictures 90, 164
© FilmPublicityArchive / United Archives 16, 72
© Frank Trapper / Corbis 407
© Frazer Harrison / Getty Images North America / AFP 460
© Graham Morris / Evening Standard 115
© Guido Bergmann / Bundesregierung 414
© Images Press 168
© Jacky Coolen / Gamma-Rapho 419
© Jason LaVeris / FilmMagic 329
© Jemal Countess / WireImage 183
© Kim Kulish / Corbis 274
© LMPC 21(3), 21(6), 21(7), 21(8), 21(11), 213
© Metro-Goldwyn-Mayer 143
© Michael Ochs Archives 38, 73 (bottom)
© Mikki Ansin 177
© Movie Poster Image Art 21(10), 74
© Murray Close / Moviepix 208
© Murray Close 502–503
© Paramount Pictures 21(13), 160, 476
© Rafael Wollmann / Gamma-Rapho 247
© Ron Galella Ltd. / Ron Galella Collection 40
© Silver Screen Collection 21(9), 21(12), 64, 452 (top)
© Steve Schapiro / Corbis 19, 404, 406
© Sunset Boulevard / Corbis 7, 60–61, 96 (bottom), 107, 137, 139, 140, 182, 190
© Ullstein Bild 446
© Universal / Archive Photos 199 (top)
© Universal / Sunset Boulevard / Corbis 170
© Universal History Archive / UIG 21(5), 154
© Universal Studios 78, 91, 233, 239, 498
© Walt Disney Television Photo Archives / ABC 44
© Warner Brothers / Michael Ochs Archives / Moviepix 179, 180, 181

HEMIS.fr
© BFA / Alamy Stock Photo 184, 244, 258, 294
© colaimages / Alamy 8
© David Parker / Alamy 192
© Ekaterina Minaeva / Alamy 371
© JEP Celebrity Photos / Alamy 424
© Landmark Media / Alamy 62 (bottom), 86, 162, 205, 206 (bottom), 234, 242 (bottom), 261, 262, 263, 347 (bottom), 368
© Marka / Alamy 157, 158
© Masheter Movie Archive / Alamy 87
© Moviestore Collection Ltd / Alamy 288
© Pictorial Press Ltd / Alamy 301
© PictureLux / The Hollywood Archive / Alamy 36, 77, 95, 200, 297, 362
© Ralph Dominguez / MediaPunch Inc / Alamy 114
© Twentieth Century Fox/ Entertainment Pictures 400
© United Archives GmbH / Alamy 56, 70–71

Magnum Photos
© Robert Capa © International Center of Photography / Magnum Photos 283

Prod DB
© 20th Century Fox—Amblin—DreamWorks / DR 306, 312, 313, 315, 316, 317
© 20th Century Fox—DreamWorks SKG—Marc Platt Productions—Participant Media / DR 351, 408, 411, 412 (top), 412 (bottom), 413, 415
© ABC—Universal Television 30
© Amblin / DR 464 (top) (left)
© Amblin—DreamWorks / DR 330, 333, 334, 335 (top), 335 (bottom), 336, 337
© Amblin—DreamWorks—Paramount / DR 278, 281, 286 (bottom)
© Amblin—Magellin—Bungalow 78 / DR 318, 321, 322 (top), 322 (bottom), 323, 324, 325, 326 (right), 326 (bottom left), 327
© Amblin—Paramount / DR 328, 484
© Amblin—Universal / DR 130, 133, 134, 135, 138, 141, 197, 218, 232, 235 (top), 238, 374 (top)

© Amblin—Warner / DR 187, 188, 189, 191, 192-193, 194-195, 198, 298 (top), 298 (bottom), 299, 300, 302 (bottom), 302 (top), 303, 326 (top left), 464 (top right)
© Amblin Entertainment—DreamWorks—Pascal Pictures—Star Thrower Entertainment / DR 350 (right), 426, 429, 430-431, 432 (top), 432 (bottom), 433 (left), 433 (right), 435
© Amblin Entertainment—Universal TV / DR 293 (bottom)
© Amblin Entertainment—Warner Bros. / DR 15, 462–463
© Apple TV+—Amblin Television—Universal Television / DR 173
© BBC—DreamWorks SKG / DR 293 (top)
© Bryna Prod.—United Artists / DR 304 (right)
© Columbia—Amblin Entertainment—The Kennedy / Marshall Company / DR 376, 379, 380 (top), 380 (bottom), 381, 382, 383, 384, 385 (top), 385 (bottom)
© Columbia Pictures—Julia Phillips and Michael Phillips Productions—EMI Films / DR 374 (bottom)
© Columbia Pictures / DR 21(14), 22–23, 92, 96 (top), 97, 98, 99, 100, 101, 102, 103, 220, 223
© Denis C. Hoffman—Anne Spielberg / DR 24
© DreamWorks / DR 275, 277
© DreamWorks—HBO / DR 266, 269, 270, 271, 272, 273, 465
© DreamWorks Pictures—Twentieth Century Fox—Reliance Entertainment / DR 290, 394, 397, 398, 399, 401, 402, 403
© DreamWorks SKG—Amblin Entertainment—Kennedy/ Marshall Company—Touchstone Pictures / DR 292, 386, 389, 390 (top), 390 (bottom), 391, 392, 393, 464 (bottom)
© DreamWorks SKG / DR 352, 355, 356, 357, 358, 359, 360 (left), 360-361
© Films du Carrosse / DR 21(1)
© Grove Hill Productions—Strange Matter Films / DR 461
© LucasFilm Ltd / DR 304 (left)
© LucasFilm Ltd—Paramount Pictures / DR 125, 159, 161, 203, 204, 206 (top), 207, 209
© Magic Hour / DR 276
© Merie Weismiller Wallace—Amblin Entertainment—Amblin Partners—Reliance Entertainment—Universal Pictures 466, 469, 470, 471, 472, 473, 474, 475
© Metro-Goldwyn-Mayer (MGM)—SLM Production Group / DR 243
© MGM Productions / DR 21(2), 144, 145, 291

© NBC—Universal Television / DR 28, 34
© Niko Tavernise—Twentieth Century Fox—Amblin Entertainment / DR 451, 452 (bottom), 455 (bottom)
© Paramount Pictures / DR 341 (top)
© Paramount Pictures—Amblin—Lucasfilm / DR 365, 366 (top), 366 (bottom), 367, 369
© Paramount Pictures—DreamWorks—Amblin / DR 62 (top), 219, 242 (top), 338, 342, 343, 344, 345, 346-347, 347 (top), 348 (bottom), 349 (top), 349 (bottom), 350 (left), 375
© Paramount Pictures—LucasFilm / DR 118, 121, 122, 123 (top), 123 (bottom), 126, 127, 128–129
© RKO / DR 21(4)
© TriStar / DR 224, 225, 226, 227
© Twentieth Century Fox—Amblin Entertainment / DR 448, 453, 456 (top), 456–457, 458–459
© United Artists / DR 455 (top)
© Universal Pictures / DR 69, 73 (top), 210, 214, 215 (top), 215 (bottom), 216, 217, 489
© Universal Pictures—Amblin Entertainment—U-Drive Productions / DR 166
© Universal Pictures—Amblin Entertainment / DR 63 (top), 228, 235 (bottom), 237, 248, 249 (left), 249 (right), 250, 251, 252, 253 (top), 253 (bottom), 254, 255, 256–257, 264, 265, 348 (top)
© Universal Pictures—Columbia Pictures—A-Team / DR 104, 108 (top), 108 (bottom), 109, 110–111, 112, 113
© Universal Pictures—Zanuck-Brown / DR 79, 80, 81, 82–83, 84–85, 88–89, 117, 240–241
© Universal TV / DR 42, 46, 49, 50, 51, 52, 53, 54–55
© Walt Disney Pictures—Amblin Entertainment—Reliance Entertainment—The Kennedy/ Marshall Company / DR 199 (bottom), 405, 416, 420, 421, 422, 423 (top), 423 (bottom)
© Warner Bros.—Amblin Entertainment / DR 146, 149, 150, 151, 152, 167, 174, 178
© Warner Bros.—Village Roadshow Pictures—Amblin Entertainment—De Line Pictures—DreamWorks / DR 63 (bottom), 305, 372–373, 425, 436, 439, 440, 441, 442 (top left), 442 (center left), 442 (bottom left), 442–443, 444 (top), 444 (bottom), 445 (top), 445 (bottom)
© Warner TV—Amblin TV / DR 172

Shutterstock
© Columbia / Kobal 196
© John Dominis / The LIFE Picture Collection 41

In *E.T. the Extra-Terrestrial* (1982), Elliott faces a threat emerging from the mist: adults.

Acknowledgments

The authors would like to thank:

Matthew Robbins for his kindness, his willingness, and his anecdotes, both in French and in English;

Jay Cocks, for his memories of a special evening: the one where there was the first projection of *Star Wars* at George Lucas' house;

Emmanuelle Spadacenta of Cinemateaser, for her helping hand that saved us precious time;

Olivier Margerie at Disney, always there when you needed him;

Sylvie Forestier and Giulia Gié., for having told us stories while we were racing to complete *The Fabelmans*;

Michèle Abitbol and Séverine Lajarrige, a matchless duo of press agents in whom Spielberg had invested all his trust for a long time;

Olivier Lascar, for the adventures of Carl Gottlieb;

Laurence Lehoux for his confidence, Bénédicte Bortoli for her patience and rigor, and Laurence Basset for her self-sacrifice.

Olivier Bousquet would like to thank:

his father, who, one afternoon in summer 1982, took him to the Grand-Bornand cinema, to discover *The Raiders of the Lost Ark*, and never held it against him that he exited a few minutes after the beginning, as the author was overcome with fear for his (short) life;

his mother who, a few months later, dried his tears at the end of a screening of *E.T. the Extra-Terrestrial*;

his parents, who purchased a 45 rpm single of *E.T., petit copain de la nuit* sung by a certain Damien, as well as the novel version of the film published by the J'ai lu publishers – a book which, to this day has remained unread;

Fanny, Héloise, and Violette, for having endured several months during the doubts, exasperation, and also the adrenaline rushes inherent in this kind of project, all the instances of "This evening, shall we watch this one?" and otherwise, "Did you know that … ?" Sometimes the answer was "no", but when they answered "yes" it lifted our spirits and also enabled us to see this crazy adventure through to the end;

his two co-authors, united in the joyful moments as well as in the more challenging ones, whose undented fervor moved mountains.

Together, that meant everything.

Arnaud Devillard would like to thank:

his father for the screening of *E.T. the Extra-Terrestrial*, at the end, whose expression "on a child's scale," as used in this book, is a powerful echo, and for the first VHS from the video club, *Indiana Jones and the Temple of Doom*; his mother, for having not only given him permission, but also recommended that he stay up to watch *Duel* on television, even though he had school the next day;

Cécile, Margaux, and Constance, for having had to be around dinosaurs, bombers, a giant shark, aliens, Nazis and other actors wearing motion capture suits, without ever having asked for anything, and for evincing only a polite interest in the sequence shots and the *made in Steven* rack focus shots;

the two co-authors, founts of knowledge, always ready to fill in the slightest gap, ready to support a team mate in distress, and always up for the most appalling plays on words – which are the best kind.

Nicolas Schaller would like to thank:

his parents, without whom the book would not have had one of its authors;

E.T., for having enabled him to see mama Marguerite and auntie Francoise in floods of tears as they exited the cinema – tears that, at the age of five, he could not quite understand, but which stayed with him forever;

Alexis, only 30, dammit!, Jérôme and Sophie, for their kindness and confidence, Nicolas, for the intuitions and infinite discussions about films, and Jeff, for the good old days, and the innocence;

Nathalie and Milo, for the time taken away from them in the conception of this work and which they deserve to have given back to them a hundred times over . . . "A little Spielberg, this evening?";

and the two accomplices, Olivier and Arnaud, robust and good humored in the face of anything, who were able to channel all the zeal and untimely questioning.

Without them, this book would still not be finished. Going off on their own way, or an outstanding team? Both of these, of course!

Left: Steven Spielberg, the directing prodigy of the 1970s.

Following spread: Spielberg poses at the foot of a dinosaur on the set of *Jurassic Park* in 1993.

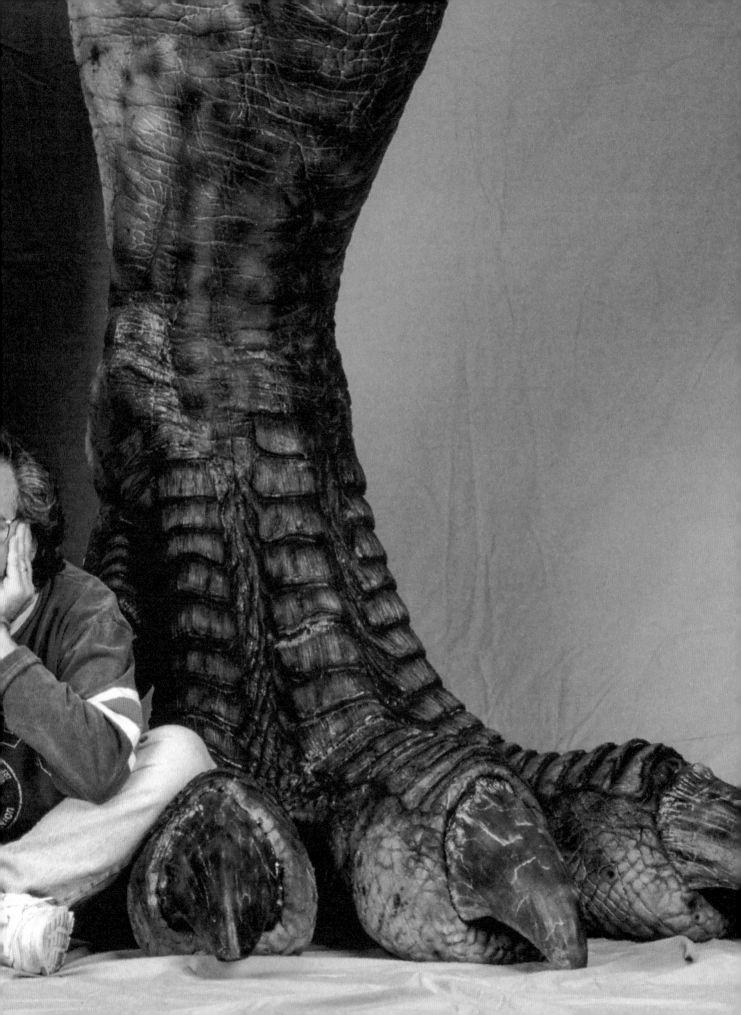

Translation by Caroline Higgitt and Paul Ratcliffe by arrangement with Jackie Dobbyne of Jacaranda Publishing Services Limited

Cover design by Katie Benezra
Cover copyright © 2023 by Hachette Book Group, Inc.
Front cover photograph © Murray Close/Getty Images
Back cover photograph © Steve Starr/CORBIS/Corbis via Getty Images

Original title: Steven Spielberg, *La Totale*

Texts: Olivier Bousquet, Arnaud Devillard, and Nicolas Schaller

Published by Éditions E/P/A—Hachette Livre, 2023

Black Dog & Leventhal Publishers
Hachette Book Group
1290 Avenue of the Americas
New York, NY 10104
www.hachettebookgroup.com
www.blackdogandleventhal.com

First English-language Edition: November 2023

Black Dog & Leventhal Publishers is an imprint of Perseus Books, LLC, a subsidiary of Hachette Book Group, Inc. The Black Dog & Leventhal Publishers name and logo are trademarks of Hachette Book Group, Inc.

LCCN: 2022950893

ISBNs: 978-0-7624-8372-3 (hardcover), 978-0-7624-8382-2 (ebook)

Printed in China

10 9 8 7 6 5 4 3 2 1